D1071114

GIORGIONE

PHAIDON

Giorgione

COMPLETE EDITION

BY

TERISIO PIGNATTI

PHAIDON

ALL RIGHTS RESERVED BY PHAIDON PRESS LTD
5 CROMWELL PLACE · LONDON SW7
FIRST PUBLISHED 1971

PHAIDON PUBLISHERS INC. · NEW YORK
DISTRIBUTORS IN THE UNITED STATES: PRAEGER PUBLISHERS INC.
111 FOURTH AVENUE · NEW YORK · N.Y. 10003
LIBRARY OF CONGRESS CATALOG CARD NUMBER: 70-118659

TRANSLATED FROM THE ITALIAN
BY CLOVIS WHITFIELD

ISBN 0 7148 1457 1

TEXT AND ILLUSTRATIONS PRINTED BY FANTONIGRAFICA · VENICE
COLOUR BLOCKS ENGRAVED BY CLICHÉ ELETTRA · MILAN

PRINTED AND BOUND IN ITALY

CONTENTS

ACKNOWLEDGEMENTS

At the completion of this work, which would not have been possible without the collaboration of a great number of colleagues, scholars and collectors in all parts of the world, it is a difficult task to thank each one of them appropriately.

The field of studies around Giorgione is so extensive — since it encompasses not only philology and art history, but also the literary and philosophical currents of the Renaissance — and the works to be taken into account are scattered so far afield, that it would be difficult indeed to enumerate all the phases of a study which began around the time of the Giorgione Exhibition in 1955 and which has continued virtually to the present time.

It would not, of course, have been possible to complete this work without the ready and generous assistance of the owners, to whom we express our cordial thanks. Particular mention should be made of the help given by Luisa Becherucci at the Uffizi, Justus Bier at the Museum in Raleigh, Perry Cott at the National Gallery in Washington, Irina Fomiciova at the Hermitage, Francis Haskell and Christopher Lloyd at the Ashmolean in Oxford, Friderike Klauner and Gunther Heinz at the Museum in Vienna, Clara Garas at the Museum in Budapest, Elizabeth Gardner at the Metropolitan Museum of Art in New York, Cecil Gould and Michael Levey at the National Gallery in London, Henner Menz at the Gallery in Dresden, Robert Oertel at the Museum in Berlin, Martin Petersen at the Gallery in San Diego, Pierre Rosenberg at the Louvre, George L. Stout at the Gardner Museum in Boston. Thanks are also due to Alessandro Bettagno for having placed at our disposal the facilities of the photograph library and bibliographical indexes at the Fondazione Giorgio Cini, and to Wolfgang Wolters for assistance in connection with the material in the Library of the Kunsthistorisches Institut in Florence.

We are grateful also for the assistance of Jim Byam Shaw for the drawings, Arnolfo Ferruolo as regards the background of humanist culture and philosophy, Mario Modestini on matters concerning technique and restoration, Antonio Morassi in the identification of lost works, Rodolfo Pallucchini for having generously made available the results of his study on Titian during the course of publication and for continuous help in all fields of study, Juergen Schulz for various matters concerning patronage in sixteenth-century Venice. Likewise thanks are due also to the Directors of Fine Arts and of the Correr Museum in Venice, Pietro Zampetti and Giovanni Mariacher, and to my colleagues at the Istituto di Storia dell'Arte of the University of Padua, for advice and assistance on various points.

Finally, my warmest thoughts go to my friends Giuseppe Mazzariol and Francesco Valcanover, who have followed the progress of this study day by day.

T.P.

I

GIORGIONE'S LIFE

The work of Giorgione has an important place in Venetian art at the beginning of the sixteenth century; his personality, together with that of Giovanni Bellini, is indeed central to its development. This is confirmed in the historical sources, and most especially by Vasari, who contrasts the 'crude, dry and forced' style of Bellini (judged of course from the point of view of his own taste) with the 'modern style' whose introduction he attributes to Giorgione along with Leonardo, Raphael, Correggio and Michelangelo. Vasari was writing in 1550, from notes made during a long stay in Venice some eight years earlier. But already before then Giorgione's fame is attested to by Baldassar Castiglione's mention of him in the *Cortegiano* (1524) as one of the greatest painters. The *Notizia d'opere di disegno* written between 1525 and 1543 by the Venetian Marcantonio Michiel (who very probably knew Giorgione personally) lists sixteen paintings by the artist in the most important Venetian collections; numerous palace façades had, according to the more reliable biographers, impressive fresco decoration he had painted, and the documents show that he also had a few public commissions, in the Doge's Palace and in the Fondaco dei Tedeschi.

Nevertheless, in spite of the great success and fame that accompanied Giorgione's short life, there is very little in the way of documents and reliable sources to enable us to write a biography that goes into any more detail than the very sketchy account that tradition has passed on. The majority of his paintings too have disappeared, so that the establishment of a catalogue of works has proved, as we shall see, one of the most remarkable ventures in modern art history. The historian who writes on Giorgione faces material that is slender and imprecise; this is particularly disconcerting because he is one of the greatest 'poets' of all time, and also because he is one of the most difficult, by reason of the brilliance of his invention and the intimate character of his work.

Giorgio da Castelfranco (in Venetian Zorzo or Zorzi, in the documents and sources) is called Giorgione (Zorzon) for the first time in the inventory of Marino Grimani's collection of 1528 (1). Vasari writes (1550) that he derived the name 'from his bodily looks and the greatness of his mind'; the statement is repeated unmodified in the second edition of the *Lives* (1568), while Ridolfi (1648) attributes the name to his ' particularly decorous appearance '. It is always difficult to assess the precise meaning of these biographical references. But it is not impossible that Vasari is reporting information he had first-hand from the many friends of Giorgione in Venice (the 'philosophers' and art-lovers mentioned

1. Paschini, 1926-7, V, 177. Up till now it has been believed that the first occurrence of 'Giorgione' was in Pino's *Dialogo* *della pittura*, Venice, 1548, p. 24 (ed. R. and A. Pallucchini, 1946).

in Michiel's *Notizia*). There is a ring of authenticity too in the comment that follows in Vasari's account, once again from the first edition of the *Vite*, that Giorgione 'although he was born from very humble stock, nevertheless he was not otherwise than gentle and of good manners throughout his life. He was brought up in Venice, and took unceasing delight in the joys of love; and the sound of the lute gave him marvellous pleasure, so much so that in his day he played and sang so divinely that he was often employed for that purpose at various musical assemblies and gatherings of noble persons'. Here then was a complete artist — a warm temperament, educated and of kindly disposition.

It could not be said that such a personality was immediately apparent from the features of the *Self-Portrait dressed as David* mentioned by Vasari, which is known through an engraving by Hollar, and which is certainly echoed in the paintings at Brunswick and Budapest (C 1 and C 2). So far as can be gathered from the study of these physiognomies, this person was certainly powerfully built, but somewhat hard and aggressive in personality, a characteristic that is evident from the prominent jaw, broad tight-lipped mouth and a look that is full of determination (2).

Another unsolved problem is that of Giorgione's date of birth, which is rendered uncertain by anomalies in Vasari's text — there are also different accounts in the first and second editions of the *Lives*. For in 1550 he writes that Giorgione 'was born in the year MCCCCLXXVII' and died in 1511 'in his XXXIIIIth year'. In 1568 Vasari makes the correction that the painter 'was born in the year 1478 during the reign of Doge Giovanni Mocenigo, brother of Doge Piero', and confirms that he died in 1511 at the age of thirty-four. The discrepancy between 1477 and 1478 may only be superficial if Giorgione was born in the first two months of 1478, for it is known that the years were counted in Venetian style from the 1 March. This would support the date of 1478, especially as Vasari refers to Doge Giovanni Mocenigo, who was elected in that very year. But it is difficult to reconcile the date of 1478 with a life-span of thirty-four years. If one could accept Vasari's date for Giorgione's death, during the plague of 1511, it would follow that it did indeed occur in his thirty-fourth year. But it is known that he died in fact a little before 25 October 1510, as is proved by the correspondence between Isabella d'Este and Taddeo Albano on the subject of a purchase of a 'Night' by Giorgione (3).

Various hypotheses are thus possible: 1) Vasari might have confused the name of Giovanni Mocenigo, who was Doge from 1478, with that of Pietro Mocenigo, Doge up to 1476: this would mean that Giorgione was born in 1475 or 1476 (4). 2) Vasari could have heard that Giorgione had died in the plague of 1510-11, in his thirty-fourth year, and have done his calculations from there. He would thus have worked out the date 1477 (correcting it later to 1478 with a reference to the reign of Doge Giovanni Mocenigo). This latter theory seems the most likely. It is most improbable that at that time the date of a person's birth, even if he was as important as Giorgione, would have been known. Our estimate

2. J. Brophy, *The Face in Western Art*, London, 1963. This is yet another reason for regarding the painting in Brunswick as a copy.

3. See Sources, 1510.
4. Richter, 1937, 44: not in our opinion a very probable hypothesis.

I - CHRIST CARRYING THE CROSS (Detail from Plate 1). *Boston, Isabella Stewart Gardner Museum.*

should thus, like Vasari's, work backwards. This would seem to point to 1477 as the most likely year of Giorgione's birth.

So far as the date of Giorgione's death is concerned, it is easy to explain why Vasari made the mistake of mentioning 1511; he had probably been informed that the artist's disappearance had been the result of the plague, whose precise duration — in 1510-11 — was uncertain. Giorgione's death is documented by the letter which Isabella d'Este wrote to Taddeo Albano on 25 October 1510, in which she refers to the 'inheritance of Zorzo da Castelfranco', and by the reply which Albano sent her on the 7 November, in which he mentions that 'the said Zorzo died some days ago of the plague': thus in all likelihood in October 1510. The reference to the plague is consistent with the account given by Vasari (who for obvious reasons did not know of this correspondence). Vasari also adds that Giorgione was infected with the plague by a woman. But the anecdote tentatively advanced by Ridolfi (1648) that Giorgione died in despair at having lost his girl 'who had been enticed from home by his pupil Pietro Luzzo da Feltre called Zarato' looks imaginary. We learn from Ridolfi (1648) where his house was: 'in Campo San Silvestro' and it was decorated with fresco painting in the window embrasures, under the cornice and on the chimney breasts (5).

Giorgione's parentage is also uncertain. In the documents and sources he is always referred to, as was the custom, by the name of the place where he came from: Giorgio da Castelfranco (6). Vasari makes no mention of his surname, and only notes that he was born of 'very humble stock'. Towards the beginning of the seventeenth century, when the legend of Giorgione began to evolve, the Barbarella family of Castelfranco started to claim the painter in their ancestry. This is proved by an inscription dated 1638 which was once in the Cathedral in Castelfranco, and which makes specific mention of it (7). Ridolfi (1648) immediately took this up and thus lent weight to the widely held belief — which has however no documentary foundation — that Giorgione was called Barbarella. This was played upon especially by the provincial biographers in the eighteenth and nineteenth centuries, to an extent that sometimes bordered on the ridiculous in romantic inventiveness (8).

Nor does any documentary evidence exist for Ridolfi's other suggestion, that Giorgione was born at Vedelago 'of one of the most prosperous families of that locality, of a wealthy father'; nor does Ridolfi himself appear to believe it (9). Yet another theory, advanced by Orlandini, who sought to identify Giorgione with Giorgio Bonetti, son of Bernardo, a

5. Foscari, 1936, 32, identifies it as the one bearing the number 1091 with a balcony and two chimneys, illustrated in a nineteenth-century print from F. Mitinelli's *Annali Urbani*, Venice, 1838, 22 (Fig. 4).

6. This is the form also of the two inscriptions that are regarded as contemporary, the one on the *Laura* (No. 10) in Vienna of 1506 and the other on the San Diego *Portrait of a Man* (No. 26) of 1510.

7. Federici, 1803, II, p. 4 (Sources, 1638). The stone disappeared during repairs to the church in 1732 (illustrated by Bordignon Favero, 1955, Pl. V).

8. The inscription, now invisible, reported by the *Quotidiano*

Veneto of 2 December 1803, to be on the back of the altarpiece is obviously fictitious 'Cara Cecilia / Vieni, t'affretta / Il tuo t'aspetta / Giorgio Barbarela,' ('Dear Cecilia / come hasten / awaiting you / your Giorgio Barbarela'). Nor does the commemorative statue by Benvenuti (1878) erected near the town walls of Castelfranco have any sounder iconographical foundation.

9. Gronau, 1909, VI, 105, discovered one 'Johannes dictus Zorzonus de Vitellaco' living at Castelfranco in 1460, but it is most improbable that this was the same family as that of the painter, since we know that the nickname 'Zorzon' (Giorgione) was only used after his arrival in Venice.

II - MADONNA AND CHILD (See Plate 4). *Bergamo, Private Collection.*

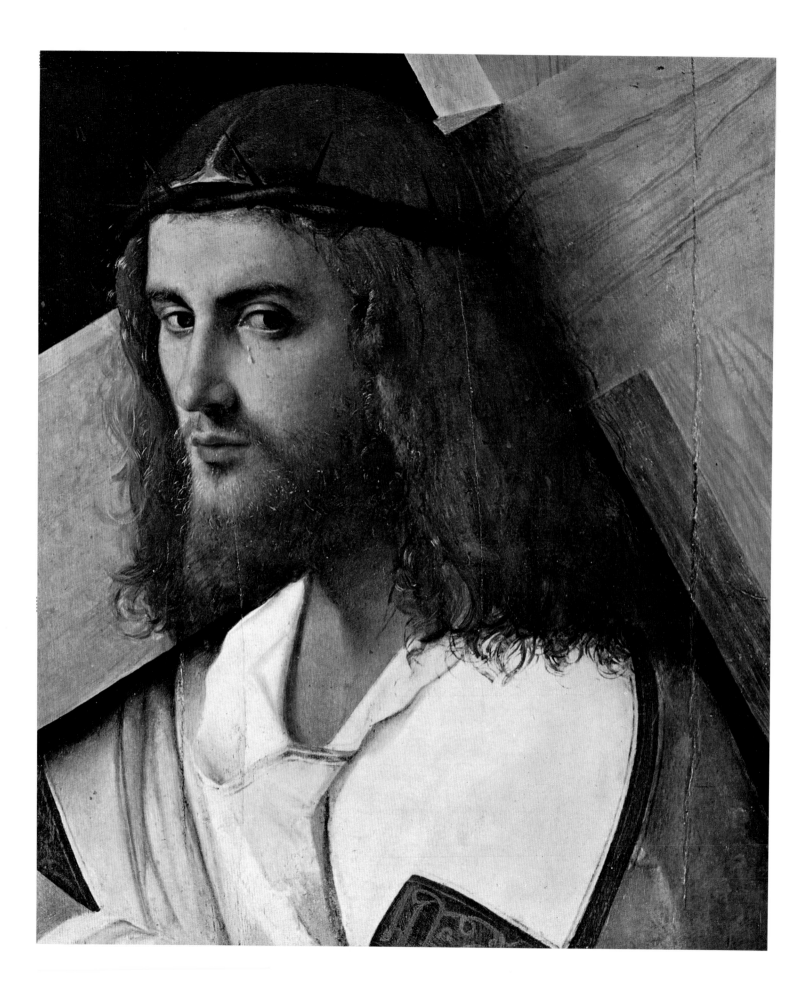

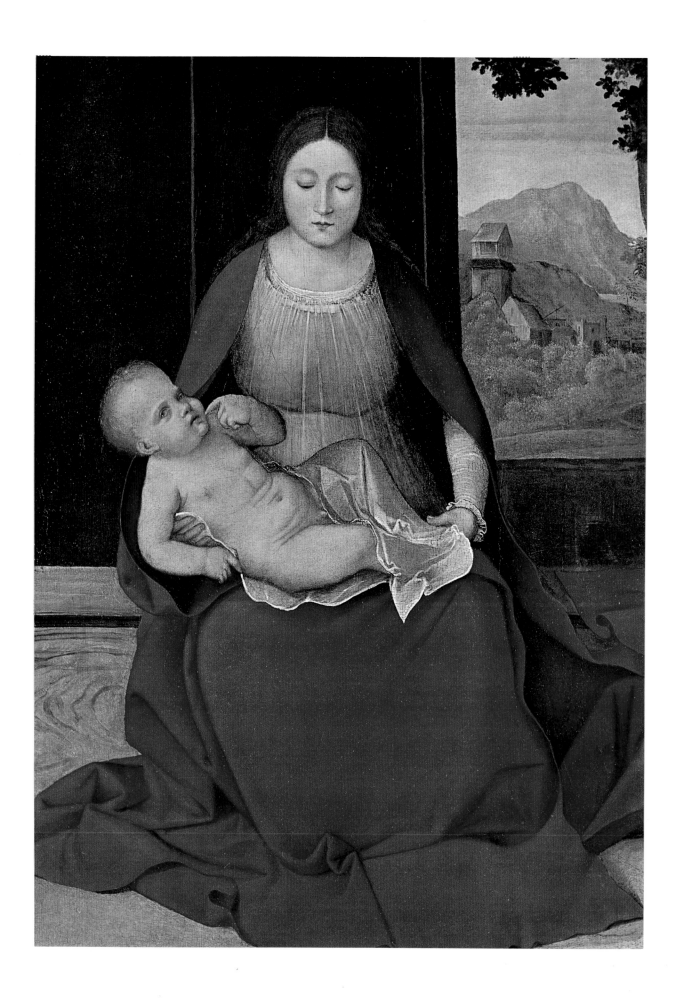

painter from Bergamo, was disproved when Pinetti showed that that person was still alive in the province of Bergamo in the year 1549 (10).

Few details are known of Giorgione's life. According to Vasari (1550) he worked with Giovanni Bellini 'at the very beginning' (11). Further on, in his Life of Giorgione, he states that he was 'raised in Venice' and that 'learning without modern style, he sought through being with the Bellini in Venice, and on his own, always to imitate Nature'. That he studied with the Bellini would seem to be supported by another reference, given once again by Vasari, that Giorgione 'in Venice at first worked on many paintings of Our Lady, and other portraits from the life': these were indeed Bellini's favourite subjects (12).

During his career, Giorgione obviously came into contact with many artists, among the great number who worked in or visited Venice. Apart from the Bellini, the documents and sources mention Leonardo, of whom Vasari notes that Giorgione had observed to advantage 'some things with a beautiful gradation of colours and with extraordinary relief achieved with dark shadows (13); Vincenzo Catena, who is documented as his 'colleague' (*cholega*) in the inscription on the back of the 1506 *Laura* in Vienna (14); Bastiani, Carpaccio and Vittore di Matteo, who appear as experts in Giorgione's action over the Fondaco frescoes in 1508 (15); and Garofalo, who according to Vasari 'was a friend of Giorgione'. This might support the idea of a visit by the painter in his youth to Ferrara (16): he could indeed have gone there in 1498 in company with Pietro Bembo, who appears later on to have been an acquaintance of Giorgione, since he owned one of his paintings (17).

The arrival of Titian must have represented one of the most important episodes in Giorgione's career, and also — as we shall see — one of the most artistically productive. The contact they had is first referred to by Michiel, who in 1525 records Giorgione's *Venus* in Casa Marcello, in which 'the landscape and Cupid were finished by Titian'. The connection between them is further documented by the mention in 1530 of the *Dead Christ*, which was 'retouched by Titian'. Vasari's account offers some explanation of this relationship, in recalling that Titian studied and worked with Giorgione soon after his arrival in Venice. The chronology of the contact between them is otherwise vague, and its clarification would be a notable contribution to the resolution of the difficult problem of Giorgione's mature style, as well as that of the young Titian.

Another uncertain factor in Giorgione's relationship with Titian stems from the fact that the latter's date of birth is not firmly established. This state of affairs is in large part due to Titian himself, who perhaps wittingly described himself as 95 years of age in a letter to Philip II of Spain in 1571. The situation is further confused by the entry in the Register of Deaths in the parish of San Canciano, which makes him a centenarian and more. In fact,

10. Orlandini, Atti I.V.S.L.A., 1926-7, II, 741; Pinetti, quoted by Ferriguto, 1933, 393.

11. Vasari, 1550, 454.

12. Vasari, 1550, 577.

13. Vasari, 1568, IV, 91.

14. Much has been written on the meaning of *cholega*, and we share the view that this is not a generic term, but rather

that it perhaps documents a period of artistic contact between Catena, who came from a rich family but whose style was not very lively at the beginning, and Giorgione. See Robertson, 1954, 12.

15. See Sources, 1508.

16. Richter, 1937, 53.

17. Michiel, 1888, 22.

III - THE HOLY FAMILY (Detail from Plate 8). *Washington, National Gallery of Art (Samuel H. Kress Collection)*.

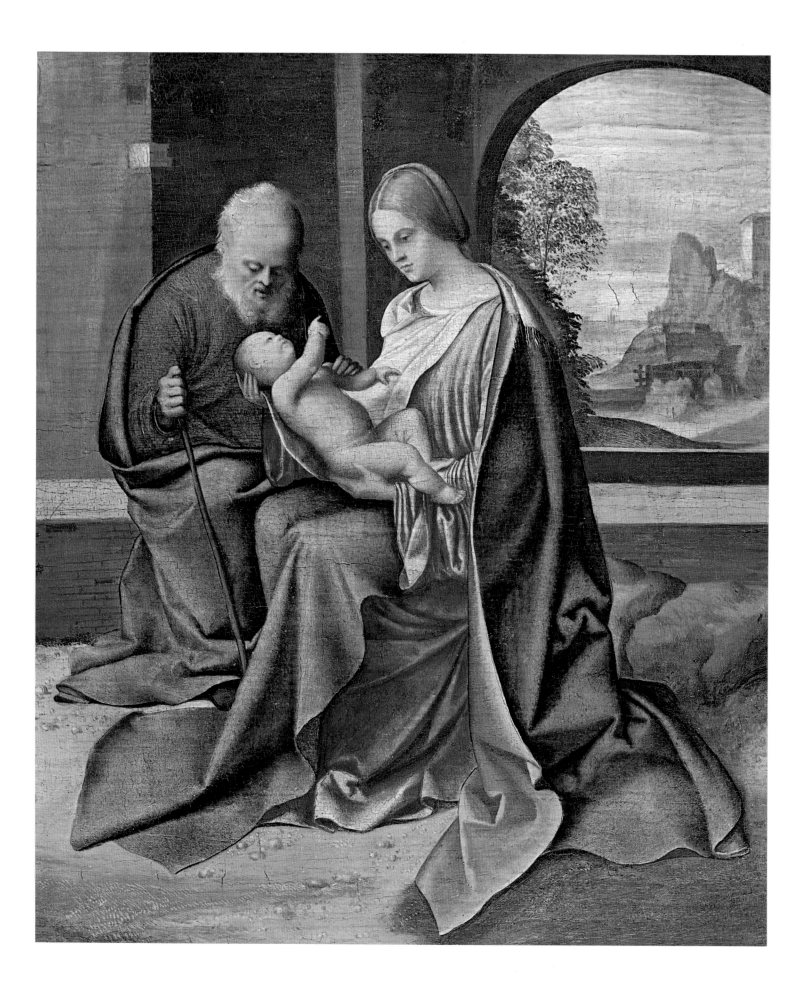

Titian was born at Pieve di Cadore in all probability in 1488-90, and came to Venice shortly after 1500. His first teachers, after the insignificant Zuccato, were the Bellini. But according to Vasari, Titian soon grew tired of their 'dry, crude and forced' painting, and 'having seen Giorgione's method and style, abandoned Gian Bellino's style, even though he had spent much time on it, and moved towards the former's, in a short time imitating his style so well that his paintings were sometimes mistaken for and believed to be Giorgione's' (18). It appears possible to establish from Vasari's text that this happened 'about the year 1507'. It was the time when Giorgione evolved his final style, endowing his work with 'great softness and relief with good style'. According to Vasari, Titian was then 'no more than eighteen', an age quite consistent with a birthdate of 1488-90; while shortly afterwards he was to complete the Fondaco (1508-9) 'when he was barely twenty' as Dolce (1557) writes.

What then was the relationship between Giorgione, who was some ten years older than Titian, and his very young and gifted follower? Only superficially easy, a fact that transpires perhaps from Vasari's account of the facility which Titian had for imitation, so much as to render his paintings indistinguishable from those of his master. A difference of this kind is recorded in the sources, when, as Dolce recounts, Titian's *Judith* painted on the façade of the Fondaco on the Merceria was seen: '...It being commonly believed, when it was uncovered, that it was by Giorgione, all his friends congratulated him, as if it was the best thing he had painted in a long time. To which Giorgione replied with great displeasure that it was by his pupil' (19). Vasari writes frankly that from then on he 'did not want Titian to associate with him any longer, or be his friend' (20).

Towards 1507, 'when he was no more than eighteen', Titian had painted the portrait of a member of the Barbarigo family, which was admired for its extraordinary realism (21). With this painting too, 'if Titian had not written his name on it in umber, it would have been taken for a work by Giorgione' (22).

From the numerous anecdotes in the sources, it is difficult to escape the conclusion that Titian's stay with Giorgione was coloured more by rivalry than by the respectful reverence of a pupil for his master, which would certainly have prevented the friction between them and their differences from reaching such a point (23). The benefit which both reaped from this situation, in which the two greatest painters of the Venetian school found themselves evenly matched, will be discussed later in connection with Giorgione's late works, some of which — like the *Venus* and the *Dead Christ* in New York (Plate 107) — through singular

18. Vasari, 1568, VII, 429.

19. Dolce, 1557, 54.

20. Vasari, 1568, VII, 430.

21. Vasari, 1568, VII, 429. 'The hair so well-defined that you could count each one, as you could the stitches of a jacket of silver satin'. See Sources, 1508 and below in the Catalogue, No. 31, on the subject of the suggestion to identify this painting as the *Portrait of a Man* (the so-called '*Ariosto*') in the National Gallery in London.

22. Vasari, 1568, VII, 429, should be interpreted that the name was written in the colour of *terra d'ombra*, and not 'in

acrostic', as has been thought. The letters *T V* do indeed appear on the sill in the portrait in London, in umber.

23. Furthermore, we believe that the apprenticeship with Giorgione which Vasari mentions should be backdated somewhat. It seems likely indeed that it was broken already at the time of the Fondaco frescoes, and confirmation of this is given by Vasari himself when he writes that Titian's work at the Fondaco was obtained 'through a Barbarigo' (1568, ibid.), that is to say clearly in competition with and not in the service of Giorgione , perhaps when the latter had completed his share.

IV - MADONNA AND CHILD WITH SAINTS FRANCIS AND LIBERALE (Detail from Plate 14). *Castelfranco, Cathedral.*

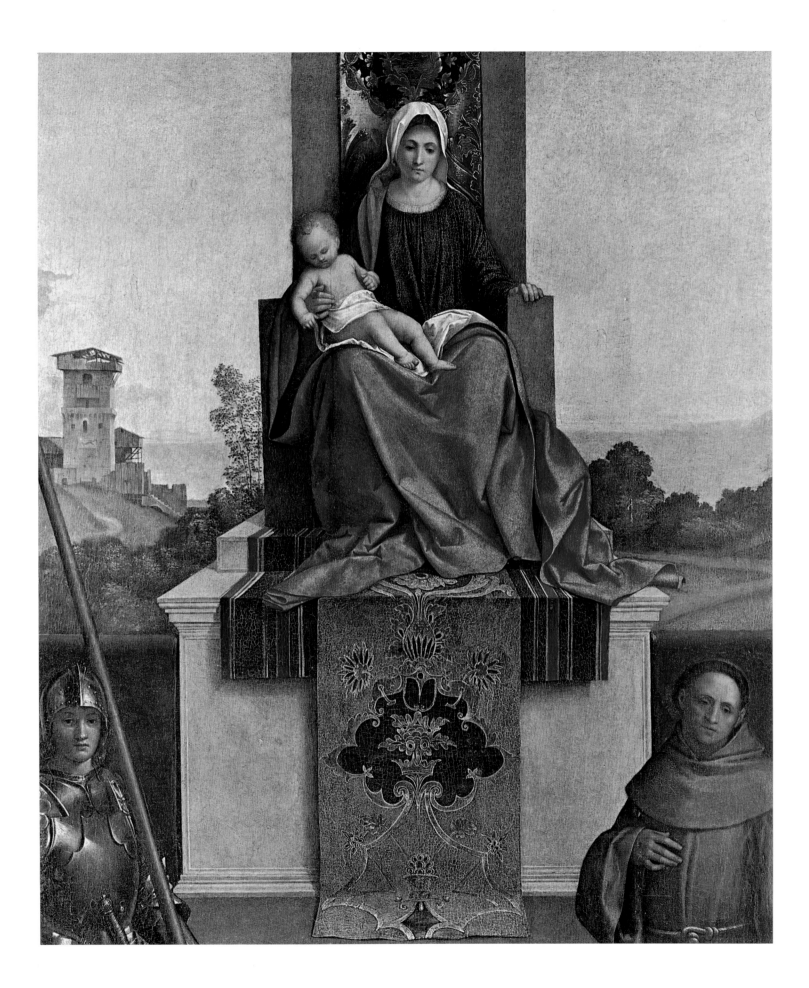

circumstances remained unfinished, and were completed by Titian. This was a period when the latter produced imitations of Giorgione's work, which have continued to confuse critics not only in the day of Dolce and Vasari, but even in our own times (24).

The last, but by no means the least important of the chapters in Giorgione's biography concerns his relationship with artistic patronage. In Venice in the fifteenth century there was a predominance of public commissions, which came from the Church, the religious Schools and partly from the State. Impressive fresco and canvas schemes decorated the Doge's Palace, San Giovanni Evangelista and Sant'Orsola. For these, Jacopo, Gentile and Giovanni Bellini, and Carpaccio, together with their followers, had been principally responsible. So far as religious subjects were concerned, there were innumerable paintings in churches and monasteries from the great schools of the Vivarini and the Bellini, and their followers. Regarding the patronage of the patrician families, the painting of devotional works and portraiture had prospered, the latter particularly after the arrival of Antonello da Messina, who brought a taste for Flemish precision to Venice, as well as introducing the technique of oil painting, with which he is credited in the sources.

Arriving in Venice around 1500, Giorgione found a place in the art market with no difficulty, through the great Bellini family. Vasari writes that Giorgione 'at first worked on many paintings of Our Lady, and other portraits from the life', which suggests that not only stylistic guidance but also his first commissions may have come through the prosperous Bellini workshop (25). Soon however Giorgione's style takes an individual turn, which sets him apart from his contemporaries. Vasari's remark should be understood as implying a move away from religious painting towards the 'northern style', in other words that of the Flemish, who were known in Venice not only for their trade (Venice was an important centre for northern Europe), but also for their paintings, some of which, by artists like Bosch and Memling, had entered the great Venetian collections (26). Indeed, even among the very limited number of works which make up the Giorgione catalogue, the artist is credited with at least six portraits, a fifth of his total attributed *oeuvre*; the sources also mention numerous others.

But it is noticeable that Giorgione showed a remarkable indifference towards public commissions, which then were so much sought after by Venetian artists. He worked for none of the Schools, nor for any religious establishment in Venice (27). Those paintings of his which have subjects that might seem to point to that source of artistic patronage, originated instead in the private field. His only altarpiece, the Castelfranco *Madonna and Child with Saints*, was in fact painted for the family chapel of General Costanzo, while the

24. See the Catalogue entries on the *Madonna and Child with Saints* in the Prado (A 27), the *Pastoral Concert* in the Louvre (A 42) and the *Concert* in the Palazzo Pitti (A 11).

25. This is shown by the *Christ Carrying the Cross* in Boston (No. 1) which is copied from Bellini, and also by his early representations of the *Holy Family* (No. 3).

26. Michiel saw a number of Northern paintings in the house of Cardinal Domenico Grimani in 1521 (1888, 100). Sixteen Northern paintings, including two by Bosch and three portraits by Memling, are listed in 1528 in the collection of Ma-

rino Grimani; other paintings by Bosch and Flemish artists are mentioned by Michiel in the houses of Andrea Odoni and Marco Foscarini (see Paschini, 1926-7, V; Levi, 1900, *passim*).

27. An exception would be the *Madonna* mentioned by Boschini (1664, 15) in the Scuola dei Sartori, but this would have been a small portable painting. For the Doge's Palace he painted — in 1507-8 — a canvas in the Consiglio dei Dieci (now no longer traceable).

V - THE ADORATION OF THE KINGS (Detail from Plate 22). *London, National Gallery.*

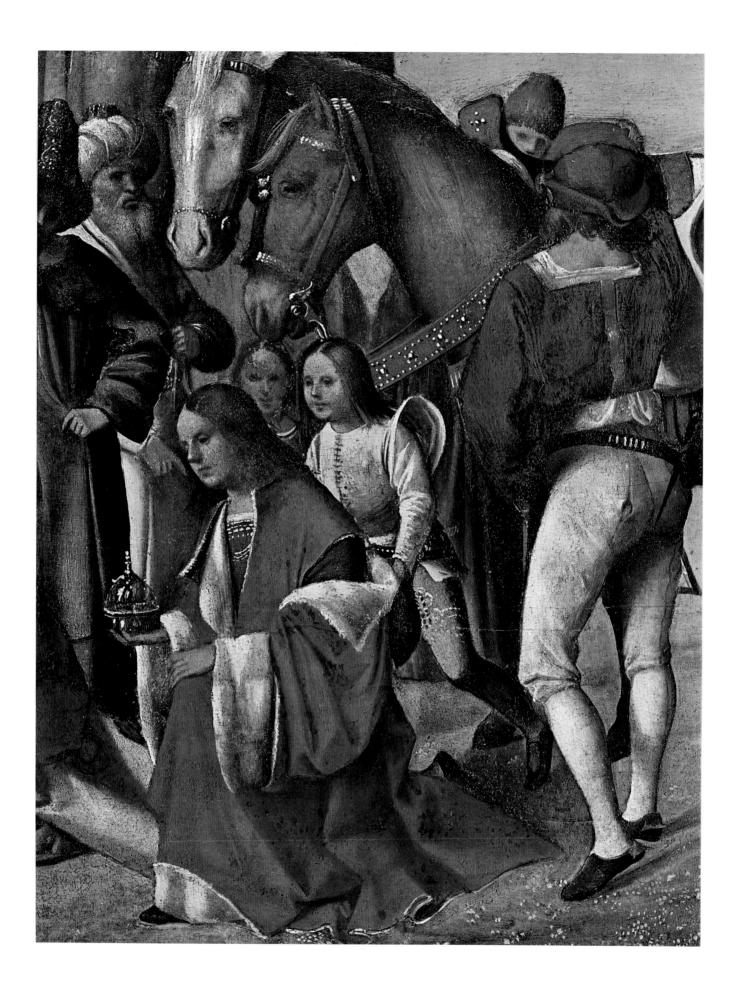

very dimensions of the other paintings with religious subjects point to their having been painted for the intimacy of the bedroom or a household altar. Of the portraits mentioned in the sources, very few were of public figures (the Doges Loredan and Barbarigo, and the Gran Consalvo) and it does not seem as though they were ever exhibited, as Gentile Bellini's were, in the Doge's Palace. The only 'external' work by Giorgione was that of the fresco decoration on the façades of Venetian palaces. It was a fashion whose introduction to Venice Giorgione contributed to, coming from the province of Treviso, where it was already well known in the fifteenth century. Apart from the Fondaco dei Tedeschi, Giorgione also decorated his own house at San Silvestro, the house of the Grimani at San Marcuola, that of the Soranzo family at San Polo and the Rettani by the Birri (28).

The rest of Giorgione's work was all for private commissions, made up of small paintings whose dimensions were suited more for the proportions of a cabinet of curiosities than for those of the audience chamber. In style, too, the paintings have an intimate quality that emphasizes their individual character and purpose. In many paintings the meaning of the subject itself has an unexpected importance, being difficult to interpret and even mysterious: so much so as to prompt the idea that Giorgione might have belonged to mystical or magical sects (29).

A most important element in Giorgione's work is his participation in the cultural background of Venice. He stands out from his contemporaries, who appear to have continued the traditional characteristics of the medieval artist, immersed in their own work and in the shop organization (as were the Bellini). By contrast, Giorgione appears as a new sort of figure in society, the artist who is 'involved' in a cultural milieu of which he is an essential and vital participant.

Marcantonio Michiel's *Notizia* fortunately provides a loophole through which one may glimpse something of Giorgione's world, and historians have exploited the information in it fully (30). It is clear that Giorgione — the first of that group from the province of Treviso which included the geographer Ramusio and held open court of poetry at Asolo with Pietro Bembo, the greatest Venetian man of letters of his day — moved straight into the narrow literary and philosophical circles in Venice. As Elwert (31) noted, 'the sixteenth century marks the climax of Venetian culture', since on account of its literary and philosophical schools and its printers, Venice had become 'the largest and most active intellectual and publishing emporium of Europe and the Renaissance' (32). It was a sort of 'polyglot universalism of culture' organized in different circles; a Latin one around Almorò Barbaro, a Greek one around the Aldine academy founded by Manutius, a historical-geographical

28. These are schemes mentioned in the sources, and of course we can be certain of the attribution only of those on the Fondaco, of which some traces still survive; but a traditional attribution is much more reliable in the instance of such decorations than for any painting in a private collection.
29. Hartlaub, 1926, 14 ff. Richter, 1937, 50, imagines that Giorgione could have been connected with magic sects through Giulio Campagnola. The latter is indeed mentioned by the famous alchemist Augurelli of Treviso, in the third

book of his *Crisopeia*.
30. Ferriguto, 1933, *passim*; Richter, 1937, 50 ff.
31. 'Pietro Bembo e la vita letteraria del suo tempo', *La civiltà Veneziana del Rinascimento*, (Florence, 1958), 127.
32. V. Cian, *La coltura e l'italianità di Venezia...* (Bologna, 1905), 32. A clue to Giorgione's relations with Manutius is offered by the presence of iconographic elements from the 'Dream of Poliphilus', in both the *Tempest* and the Dresden *Venus*.

VI - THE TRIAL OF MOSES (Detail from Plate 25). *Florence, Uffizi.*

one around Sabellico, Sanudo and Ramusio, and a poetical one around the figure of Pietro Bembo (33).

Many of the individuals who figure in Giorgione's biography played an important part in these intellectual circles, and it is logical to assume that they must have had a notable influence on the young artist, who let them have his paintings (34). Let us look first at Marcantonio Michiel, the author of the indispensable diary, the *Notizia*. Born in 1484, he had a house at Santa Marina, and had devoted himself to the study of Greek and Latin under the famous Egnazio, who held a private school in Venice. Married to a Soranzo (whose palace was decorated by Giorgione), he himself owned a *Nude in a Landscape* by his painter-friend. Michiel was obviously well-connected with the best literary and philosophical circles, and had access to the collections of many young and brilliant members of the patrician families, and to those of the important figures in Venetian culture. Among others who figure in the *Notizia* is Domenico Grimani, Patriarch of Aquileia, who was perhaps the greatest collector in Venice in the sixteenth century. Born in 1461, son of Doge Antonio Grimani, he became Cardinal in 1493, and never ceased collecting antiquities and contemporary works of art. Of his most famous pieces, many were of Northern origin, such as the great 'Breviary', three portraits by Memling, two paintings by Bosch, landscapes by Patenir, paintings by Dürer. His collection, kept partly in Venice and then given to the Republic after his death (35), was one of the key elements of the artistic climate, both as regards the taste for the antique and for its emphasis on the Flemish tradition, of which even the great name of Antonello had not ensured its survival into the sixteenth century. According to the old sources, Grimani possessed three paintings by Giorgione, which probably included the famous *Self-Portrait dressed as David* (36).

The other collectors named by Michiel belong to the same generation as Giorgione: Gerolamo Marcello was born in 1476, Taddeo Contarini in 1478, Gabriele Vendramin in 1484; they were all 'intellectuals'. Marcello is indeed linked with Bembo's literary circle, through the latter's father, Bernardo; he also turns out to have been a friend of the learned Gerolamo Donà, whose passion for music was certainly a point of contact with Giorgione (who 'played and sang ... divinely'). Gerolamo Marcello owned three paintings by Giorgione, including the famous *Venus*, which was later to be finished by Titian. Taddeo Contarini too, who owned four paintings by Giorgione, among them the *Three Philosophers* and the same 'Night' that Isabella d'Este vainly sought to purchase (37), belonged to a family

33. Elwert, *op. cit.*, p. 129 ff. A clue to his relations with Maurizio can be seen in the presence of iconographic themes taken from the *Hypnerotomachia Poliphili* in the *Tempest* and the *Venus* (see below in the Catalogue).
34. Confirmation of the intimate nature of Giorgione's relationship with his friends is to be had from Tomaso Albano's letter of 1510, where he writes to Isabella that Taddeo Contarini and Vittorio Beccaro will not part with their paintings by Giorgione 'since he painted them for their personal enjoyment' (see Sources, 1510).
35. Paschini, 1926-7, V, Appendix I, *passim*.

36. The composition is known through the prints by Coriolano and Hollar, and what it is presumed to be a copy, in Brunswick (C 1). In fact, the paintings by Giorgione are included in the *Memoria Generale* dated 22 November 1528, that is to say in the inventory of possessions that Marino Grimani, the nephew of Domenico, had moved to Rome in that year. But it is very likely that these had belonged to Domenico's collection, before his death.
37. Identified by some as the *Adoration of the Shepherds* in Vienna (A 60).

VII - THE JUDGEMENT OF SOLOMON (Detail from Plate 31). *Florence, Uffizi.*

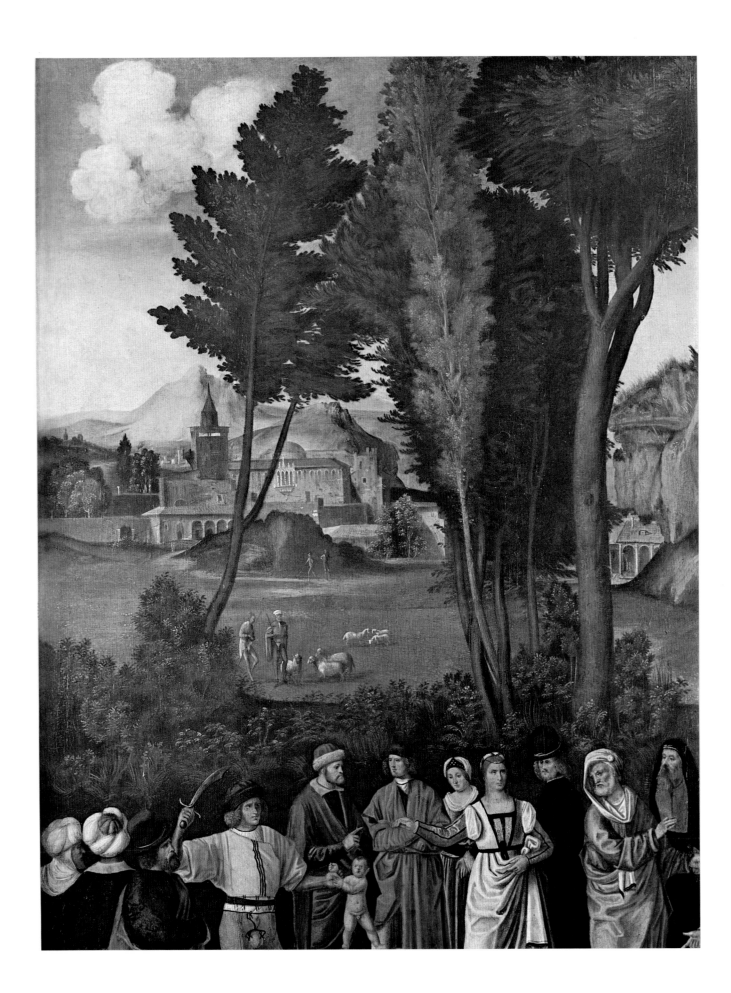

of scholars, among whom was the philosopher Pietro Contarini, who was a close relative of his. Gabriele Vendramin belonged to one of the noblest ducal families, and was very wealthy. His famous collection in the Santa Fosca Palace, of which sixteenth-century inventories have survived (38), included six works attributed to Giorgione, among them the *Tempest* and the *Portrait of an Old Woman* ('*La Vecchia*'; Cat. Nos. 13 and 29). Gabriele too belonged to the group of young Venetian intellectuals, if only through being related to the Barbaro family, the famous humanists, of whom Almorò and Daniele were the most notable. Another Vendramin, Andrea, of the San Gregorio branch, owned in the seventeenth century a very rich collection of fifteenth and sixteenth-century works, of which there survives an illustrated inventory of 1627 (39). As many as thirteen works by Giorgione are listed here, to which three more were added later; many of them are of very doubtful attribution (40). But nevertheless even if they were not by Giorgione himself, they must have been works from his circle, so that on a cultural level the account is equally valid.

Some members of the Soranzo family, whose palace at San Polo had on its façade frescoes attributed to Giorgione, also belonged to the intellectual circles, and among them Lucia Soranzo was one of the most highly thought-of young ladies among the philosophers and men of letters (she was well known for her sophisticated way of life, so much so that it earned her a denunciation in 1507) (41). The other people mentioned in the sources in connection with Giorgione are mainly rich merchants: the Loredan family, Giovanni Ram, Antonio Pasqualino, Andrea Odoni.

There remains Caterina Cornaro, the ex-Queen of Cyprus, who led a life full of refinement and magnificence between her palace on the Grand Canal and the Castello di Asolo. Although there is no proof, it is inconceivable that Giorgione did not belong to her circle, which included scholars, philosophers and poets. This should be read above all from the presence among them of Bembo, whose *Asolani* (of 1505) is the most important record of the sentiments and way of life of those refined and cultured young people. It is very likely, as Richter suggested, that Giorgione was introduced to Caterina Cornaro by General Tuzio Costanzo, who was a native of Castelfranco and who had accompanied the Queen of Cyprus on the occasion of her exile in 1489. Giorgione's connection with Costanzo is proved by the appearance of the latter's insignia in the altarpiece painted to commemorate the death of his son Matteo, which was placed in the family chapel around 1504. The altarpiece, which is among the earliest of Giorgione's known works, thus suggests a connection with the court of the Queen of Cyprus, who had maintained close links with her general from nearby Asolo (42). Apart from this, Vasari mentions a portrait of Caterina by Giorgione in the Casa Cornaro in Venice. Finally, the court at Asolo saw the birth of Pietro Bembo's

38. Ravà, 1920, 155; Savini-Branca, 1964, 17.
39. London, British Museum, MS. Sloane 4004. Reproduced in facsimile and critically assessed by Borenius, 1923.
40. See Lost Works (Figs. 59-74).
41. Richter, 1937, 52.

42. Richter, 1937, 50. Bordignon Favero, 1966, 33, mentions a painting in Tuzio Costanzo's house in the Vicolo del Paradiso in Castelfranco, in which there appears the same coat of arms as that represented in Giorgione's painting and the one graven on Matteo Costanzo's funerary plaque, which is located near the altarpiece.

VIII - THE ADORATION OF THE SHEPHERDS (Detail from Plate 35).
Washington, National Gallery of Art (Samuel H. Kress Collection).

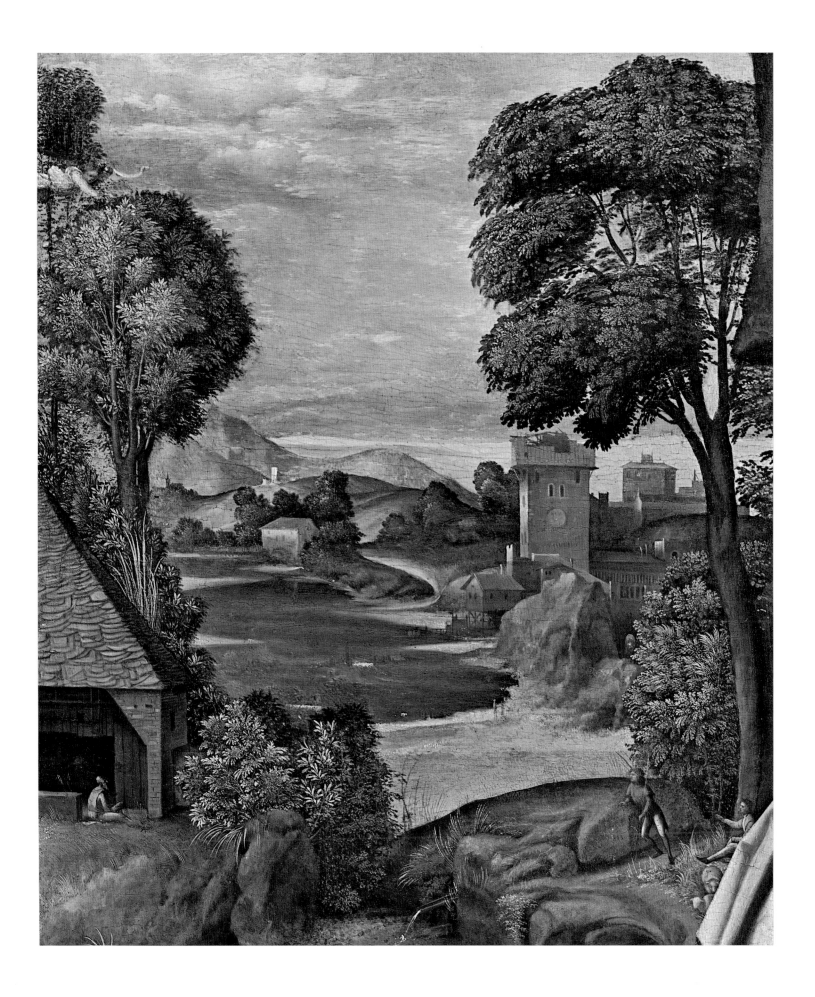

poetry, which derived elements from neoplatonic philosophy and transformed Petrarch's metaphysical conception of love into something involving more direct and human participation: such as can be recognized in the manner of existence of Giorgione's own characters, imbued as they are with a subtle melancholy (43). The connection between the important literary personality of Bembo and that of Giorgione is thus on a level of true spiritual sympathy. There is thus not only, as has often been noted, a similarity of feeling between the protagonists of Bembo's sentimental dialogue and the figures painted by Giorgione, but also a parallel cultural identity in their different and yet similar poetry: that is to say between the idea of Arcady that is advanced anew by the poet, and the renewed dependence on natural beauty that is achieved by the painter with the means that belong to his art. In brief, Giorgione's paintings represent the pictorial realization of the Arcadian dream sung by Bembo. 'Here then — according to Wittkower — is the reason behind Giorgione's immediate success. The new Eden which he painted was closely in tune with the ideas of his time. He knew how to give form in his paintings to the secret desires of his fellow-citizens' (44). There is in fact no passage of the *Asolani* which cannot be read in terms of the poetry which forms the figurative background of the images in Giorgione's paintings. And there are some passages which seem to evoke the very likeness of Giorgione himself, when the friends, poets and philosophers alike, gathered under the clear skies of Asolo 'passing from one subject to the next, to forget their pressing troubles, they spent almost the rest of that day wandering through shade, along river banks and delightful shores' (45).

II

SOURCES AND CRITICISM

The essence of Giorgione's style lies in its extraordinary capacity for innovation. There can be no doubt that his work represented a completely new figurative approach, even against the exceptionally varied background of Venetian painting at the turn of the fifteenth and sixteenth centuries. Contemporary writers from Vasari onwards were all aware of this; and none of the artists who had the good fortune to know Giorgione attempted or wanted to escape from his rejuvenating influence, whether they were young like Titian, Sebastiano or Palma, or revered figures like Bellini. But it is surprising that a fame that was so widespread was not accompanied by any clear idea of his painted work, on which a reconstruction of the real character of his art could be founded. The issue is a controversial one, and there are those who seek to limit, and others to augment, the list of works attributed to Giorgione. In this way some of the more 'primitive' paintings have been re-

43. Elwert, 1958, 148.
44. Wittkower, 1963, 484.

45. Bembo, *Asolani* (Florence, 1505), E IV.

IX - THE ADORATION OF THE SHEPHERDS (Detail from Plate 35).
Washington, National Gallery of Art (Samuel H. Kress Collection).

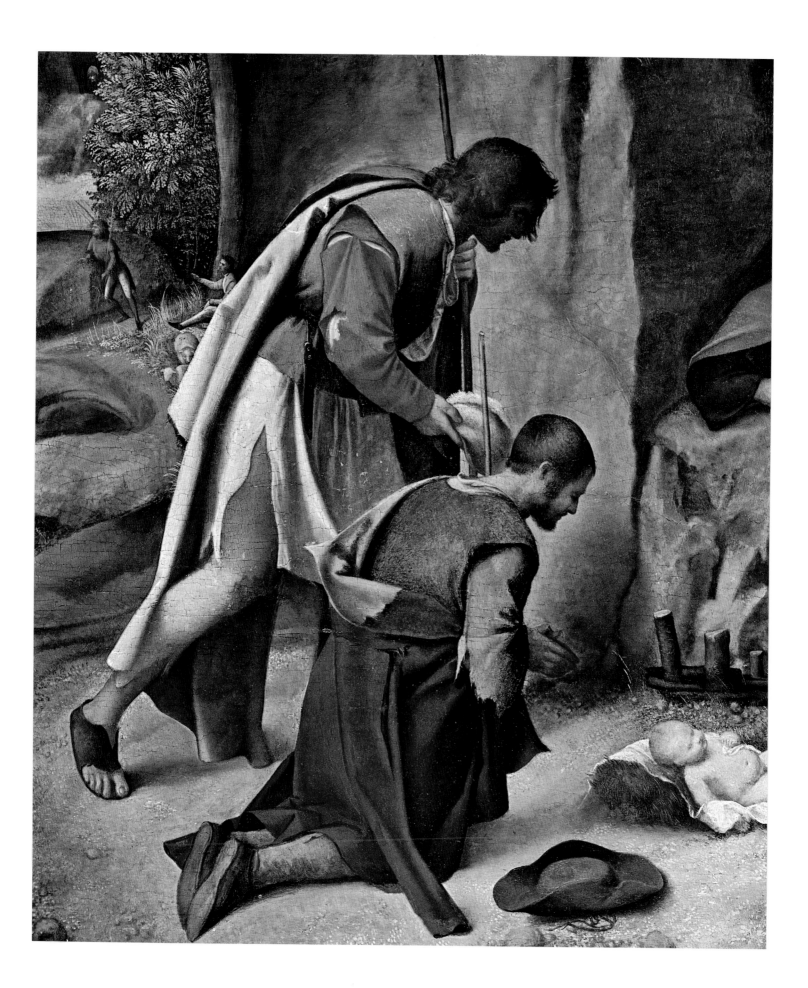

stored to Bellini, while many of the 'late' works are now given to Titian. Unanimity is limited to very few among the paintings mentioned by Michiel in his *Notizia*, such as the *Tempest* or, the *Three Philosophers*, and also the indisputable Castelfranco *Madonna and Child with Saints*. But there is doubt attached to nearly all the others; the most varied theories and collaborations have been advanced. Where in all this is the real Giorgione? For many critics his character exists in a very personal understanding, at least if that is the way we should interpret some of the surprising titles, which even go so far as to speak in the possessive (my Giorgione), barely concealing their authors' insecurity. Wittkower in a recent study quite rightly asked whether all this questioning of the authenticity of Giorgione's paintings did not amount to a 'limitation of his talent'. If all the experts were in such exceptional disagreement, this might be 'a sure indication of a flaw in his artistic personality' (46). Of course Wittkower's answer is in the negative. He sees the reason for the difficulties in which critics find themselves in the 'essential and distinctive character of Giorgione's painting'. Its compulsive power and poetic quality were such that all contemporary artists —some to a greater, some to a lesser degree — were affected by it. This is the origin of the 'Giorgionesque' style in its varying degrees of affinity with the master; it has rendered the problem of distinguishing the various hands which practised it extremely difficult and sometimes impossible. So on account of the very extensive production of works that run parallel to Giorgione's, having the same themes and inspired against the same background, Giorgione's real work, for which there is no objective documentation, is susceptible to the subjective judgement of individual critics. This is a situation that existed even in the near-contemporary sources (47) and which has now reached almost absurd proportions.

For these reasons we believe that all attempts to reconstruct Giorgione's *oeuvre* must start from an examination of the sources and from a study of the principal themes of those writings, which would lose some of their meaning if taken in isolation, outside their historical context (48).

Marcantonio Michiel's *Notizia*, which has the exceptional distinction of having been written by a friend of Giorgione's, has unfortunately no critical observations. Its value lies in the detached nature of its statements, which have the character almost of inventory entries. It dates from the period 1525-43, but it is clear that Michiel must have known some of the works much earlier, perhaps at the time of their creation.

Before the appearance of the first edition of Vasari's *Lives* the references in the sources are limited to incidental praise: Giorgione is 'most excellent' for Castiglione in his *Cortegiano* (1524); a 'most famous painter' in Pino's *Dialogo di Pittura* (1548), and among the 'things to see' for Doni in his *Disegno* (1549). In reality, Vasari's information dates from earlier than 1550, the date of the publication of the first edition of the *Lives*, since it was gathered during a stay in Venice in 1541-2. In the Introduction to his Book III, Vasari places Gior-

46. *Op. cit.*, 1963, 474.
47. For instance Vasari, 1568, 97, has doubts over the *Christ Carrying the Cross* in San Rocco (No. 30).

48. For complete transcriptions of the relevant passages, see Sources.

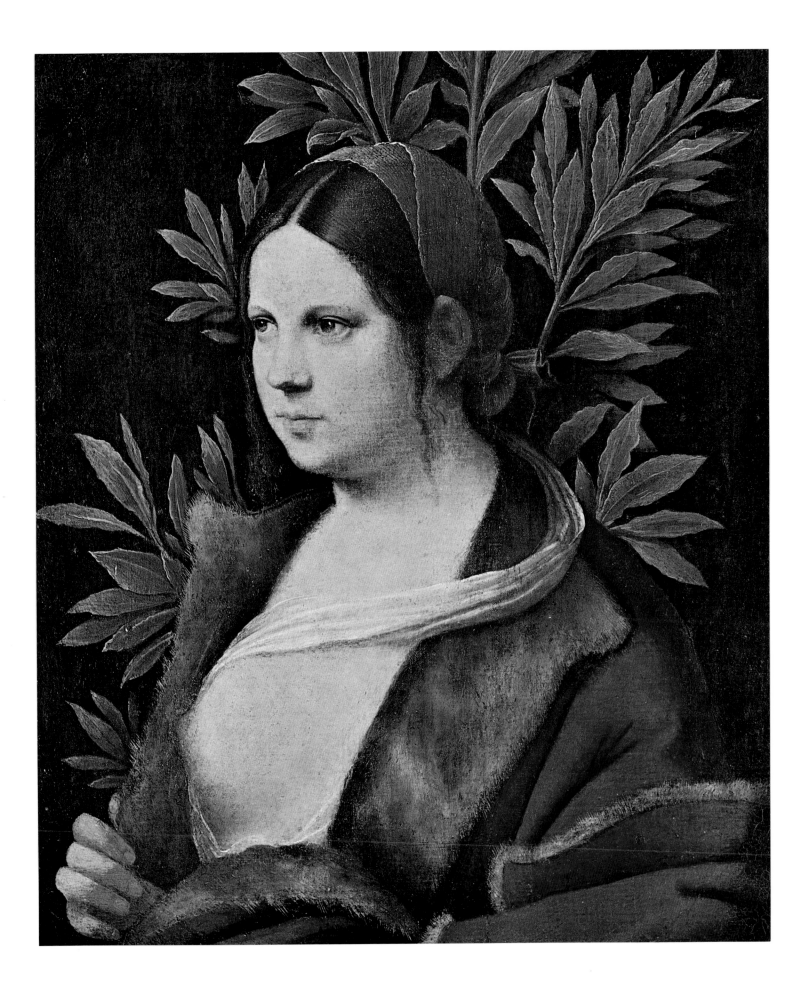

gione among the originators of the 'third style', that is to say the modern style, along with Leonardo, Raphael and Michelangelo. Earlier, in the Life of Giorgione, Vasari specified what his innovation was in relation to Bellini's style: 'both in oil painting and in fresco, he made certain living forms and other things so soft, so well harmonized, and so well blended in the shadows' that the other painters recognized that no-one could like him 'infuse spirit into figures ... and counterfeit the freshness of living flesh'. These are very precise critical observations, both in terms of the assessment of Bellini's style (which Vasari in the second edition describes as 'crude, dry and forced', following the estimation usual in his day), and as regards the description of the 'tonal' character of Giorgione's style, which Vasari — again in the 1568 edition — associated with a suggestion from Leonardo. But the catalogue of Giorgione's works mentioned in the first edition of the *Lives* is far from complete: rather than the most important works, Vasari tends to mention the 'curiosities' — those works that elicited surprise or had an anecdotal quality, such as the fanciful *Storm at Sea*, the miracle-working *Christ Carrying the Cross* at San Rocco, the showy frescoes at the Ca' Soranzo and the Fondaco (with figures that were 'very brightly coloured').

Titian is not mentioned in Vasari's first edition. Giorgione's great pupil and rival appears instead for the first time in Dolce's *Dialogo della Pittura* (1557), with the anecdote of Titian's *Judith* at the Fondaco, mistaken for a painting by Giorgione, to the latter's great vexation. 'I hear that Giorgione once said — one of Dolce's protagonists relates — that Titian was a painter even in his mother's womb'. It is interesting to note that for Dolce Giorgione exists as part of the background to Titian; he is credited especially with cabinet-pieces, so that the impression that is given is very individual, being almost that of a gentleman-painter, 'for Giorgione in working in oil had not so far had any public commission, and usually he only painted half-figures and portraits' (49).

The basis of our current knowledge of Giorgione as a historical figure is undoubtedly the second edition of Vasari's *Lives*, published in 1568 and combining the first version with information gained during a visit to Venice in 1566. Giorgione's stature is here considerably enhanced, he is called the Leonardo of Venice and the renewer of the school of the Bellini, who now have been left behind 'by a long way'. He also affirms that Giorgione had seen 'some things by Leonardo with a beautiful gradation of colours and with extraordinary relief achieved with dark shadows' which had prompted his attraction to the 'modern style' (50). Of course, Vasari is referring to Giorgione's last works, among which he actually names the *Self-Portrait dressed as David* and a *Cupid* 'with hair in a fleecy fashion' which suggests analogy with Leonardo's *St. John* in the Louvre, or with some of Giorgione's heads like the *Boy with an Arrow* in Vienna and the *Shepherd Boy with a Flute* at Hampton Court (Cat. Nos. 24, 27). The catalogue of Giorgione's work is thus considerably expanded; apart from the frescoes and the *Christ* at San Rocco already listed in the 1550 edition, Vasari mentions numerous portraits, and describes certain 'mirror' paintings, like a Nude by the Pool, in which the illusion of three-dimensional effects impressed Vasari himself:

49. Dolce, 1557, 54. 50. For the implications of Giorgione's encounter with Leonardo, see below, p. 50 ff.

XI - THE TEMPEST (Detail from Plate 50). *Venice, Accademia.*

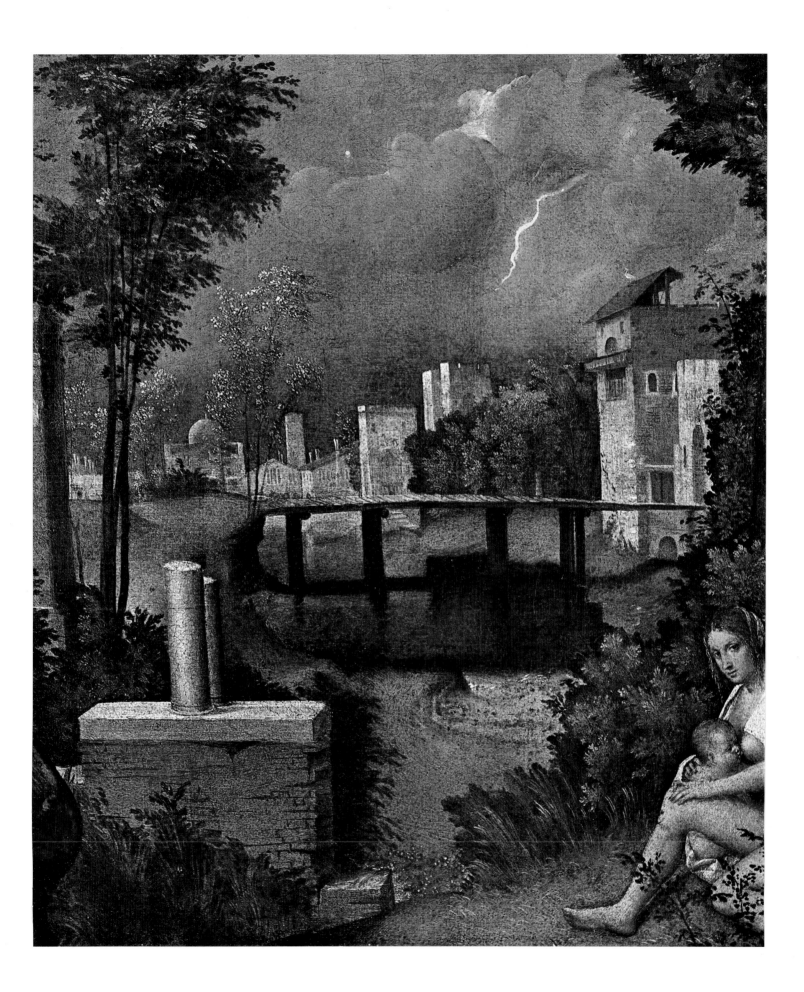

'things of a most beautiful and bizarre fancy, whereby he sought to show that painting involves more excellence and effort, and shows more from a single view from the life than does sculpture'.

A valuable source for our knowledge of Giorgione is Vasari's Life of Titian, which appears in this edition for the first time. Titian is described as Giorgione's protégé, working in the latter's 'modern style' which Vasari associates with the year 1507 (51). Indeed, he assimilated his style to such an extent 'that his paintings were sometimes mistaken for and believed to be Giorgione's'. From here Vasari takes up the story (related by Dolce, 1557) of the confusion over the authorship of the work on a façade of the Fondaco, and expresses further hints of doubt with regard to the *Christ Carrying the Cross* in San Rocco, the *San Giovanni Crisostomo* altarpiece (which is now attributed to Sebastiano) and the *Storm at Sea* (which is now attributed to Palma). Already in the space of fifteen years, the idea of the real Giorgione is beginning to fade, and the tide of 'Giorgionesque' works gains a foothold, even though Vasari makes a praiseworthy effort to distinguish them from the genuine paintings by Giorgione (52).

The critical contribution made by the old sources after the appearance of Vasari's second edition is practically non-existent. Vasari's account is repeated substantially by Francesco Sansovino (1581) and by Borghini (1584); while in Verdizotti's Life of Titian (1622) there are but a few intelligent remarks, such as when he describes the 'more delicate style' of Giorgione, comparing it with that of Bellini; while the anecdote of Giorgione — as a new Cimabue — finding the young Titian intent on copying 'in secret what was good' in his paintings 'while they were in a courtyard drying in the sun' has a much too fanciful ring. Nor do we know how much trust to place in the new account of the confusion over the Fondaco frescoes, in which Giorgione is described as far from 'jealous at the success of his good pupil', rather expressing his pleasure that 'Titian's work should have been considered equal to, and greater than his own'.

And so we come to Carlo Ridolfi's *Le Maraviglie dell'arte* (1648), which is a crucial step in the development of the criticism of Giorgione's work, since it is from this point that one can identify the rise of the so-called 'Giorgione legend'. The most outstanding novelty in Ridolfi's account is the number of works attributed to Giorgione, sixty-five in all. This is a figure which is clearly excessive, especially in view of the fashion for imitations that existed at that time in Venice, and of which Pietro Muttoni (called appropriately 'dalla Vecchia') admitted he was the author (53). So far as the frescoes are concerned, however, one should not make the mistake of underestimating the value of Ridolfi's information (54), since his remarks are clearly founded on a tradition that was then still fresh. In this field he makes significant additions to Vasari's list, and his account contributes to the understanding of

51. Vasari, 1568, IV, 98.
52. It was then that Giorgione 'began to endow his work with greater softness and relief with good style' (Vasari, 1568, VII, 461).
53. Savini-Branca, 1964, 53. For Boschini, 1660 (ed., Pallucchini, 1966, 540) too, Dalla Vecchia is 'the ape of Giorgione'

(*simia de Zorzon*).
54. Richter, 1937, 25, supports this view, and notes that Ridolfi's information is generally accurate, when it can be checked against other sources or subsequent inventories. His account of the Fondaco frescoes is indeed especially accurate.

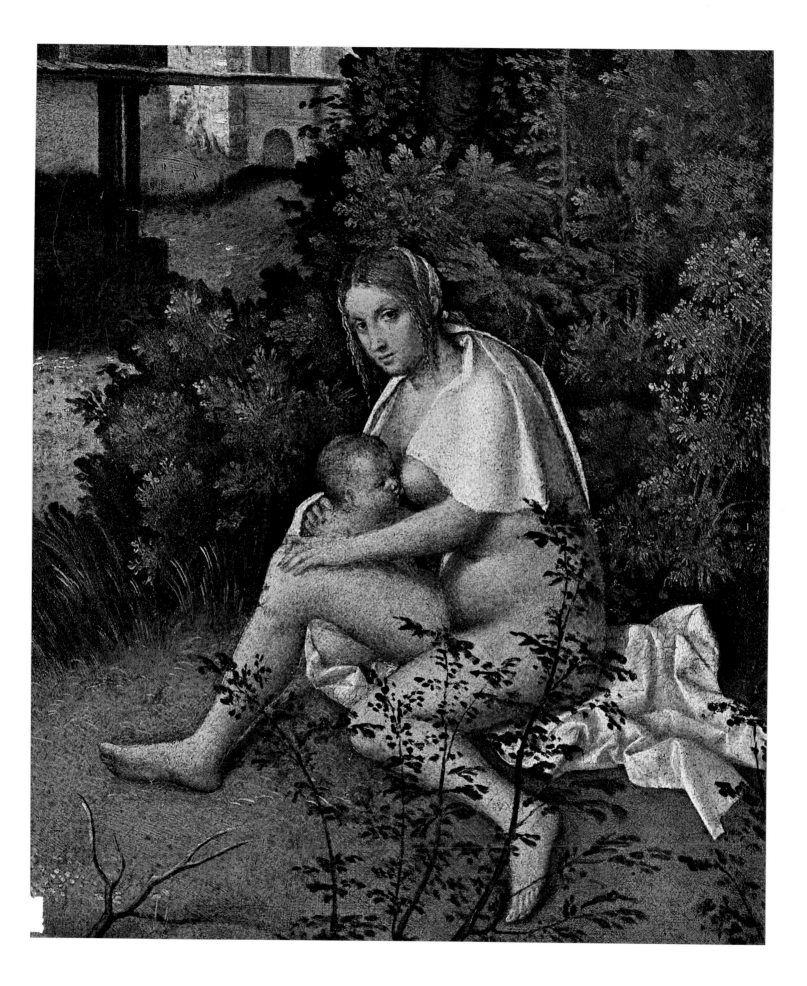

the character of a lost side of Giorgione's art that made up a large part of his fame, much more than that of his easel paintings, which were shut away in the intimate surroundings of collectors' cabinets and were thus easy to confuse. So far as his personality is concerned, Ridolfi's Giorgione is the Homer of his time, a figure whose birth is claimed by many towns. He describes his style very precisely, giving a strong suggestion of the technical advance implicit in the 'mixing of his colours' (that is to say tonal quality), 'harmonizing the shadows with the lights with supreme sweetness' so much so as to deserve 'the title of the most resourceful painter of modern times'. This is an unusually perceptive judgement, surpassing as it does the great esteem in which Titian and the other sixteenth-century painters were held, and recognizing as it rightfully does Giorgione's place as an innovator.

But however much one recognizes Ridolfi's perspicacity, there is no way of assessing the trustworthiness of his other information, especially that which relates to Giorgione's life. He gives various details, on his place of birth (Vedelago), his early moves between Castelfranco and Venice, and the account of his death from a broken heart.

But the *Maraviglie dell'arte*, together with the inventories of the collection of the Archduke Leopold Wilhelm of Brussels, of 1659, surely complete the list of reliable sources. From this time onwards mentions of Giorgione's paintings are ever more imbued with the 'legend', to a point where they have no connection with reality (55).

The relevant literature in the seventeenth century is thus mainly composed of the catalogues of the great collections: there is an exceptional contrast between the assessments of David Teniers, who drew up the illustrated inventory of the Collection of the Archduke Leopold Wilhelm in Brussels (published in 1658 under the title *Theatrum Pictorium*) and included thirteen paintings attributed to Giorgione, and Van der Baren, who wrote the catalogue (1659) and reduced the number of works given to Giorgione by half; clearly this was the result of a more critical appraisal (56). Nevertheless this is valuable documentation, especially as many of the works listed have ended up in galleries in Vienna, Budapest and elsewhere.

Among the first works to be excluded from the category of 'reliable sources' are Marco Boschini's *La Carta del Navegar Pitoresco* (1660), *Le Minere della Pittura* (1664) and *Le Ricche Minere* (1674). Boschini follows preceding sources in seeing Giorgione as the great innovator in sixteenth-century Venetian painting, and he distinguishes the works painted by dalla Vecchia, but he ends up by characterizing his work through the image presented by those seventeenth-century imitations: 'solemn figures with soft caps adorned with strange plumes, dressed in ancient garb, shirts showing from underneath their jackets, which are slashed, with puffed out sleeves ... other figures with armour shining like mirrors' (57). On the other

55. Richter (1937) gives a detailed list of all these references up to 1933. It has been thought unnecessary to bring this up to date, since references to works newly attributed to Giorgione can be traced in the critical literature listed in the General Bibliography.
56. Richter's (1937, 29) reaction to this that Van der Baren

was therefore 'the Morelli of his age' seems somewhat exaggerated.
57. *Ricche Minere*, 1674, 689, quoted by A. Pallucchini, 1966, XLVIII. The description does not fit any genuine painting by Giorgione easily, except perhaps for the lost original of the *Portrait of Giorgione dressed as David* (C 1), or other derivations

XIII - MADONNA WITH A BOOK (Detail from Plate 83). *Oxford, Ashmolean Museum*.

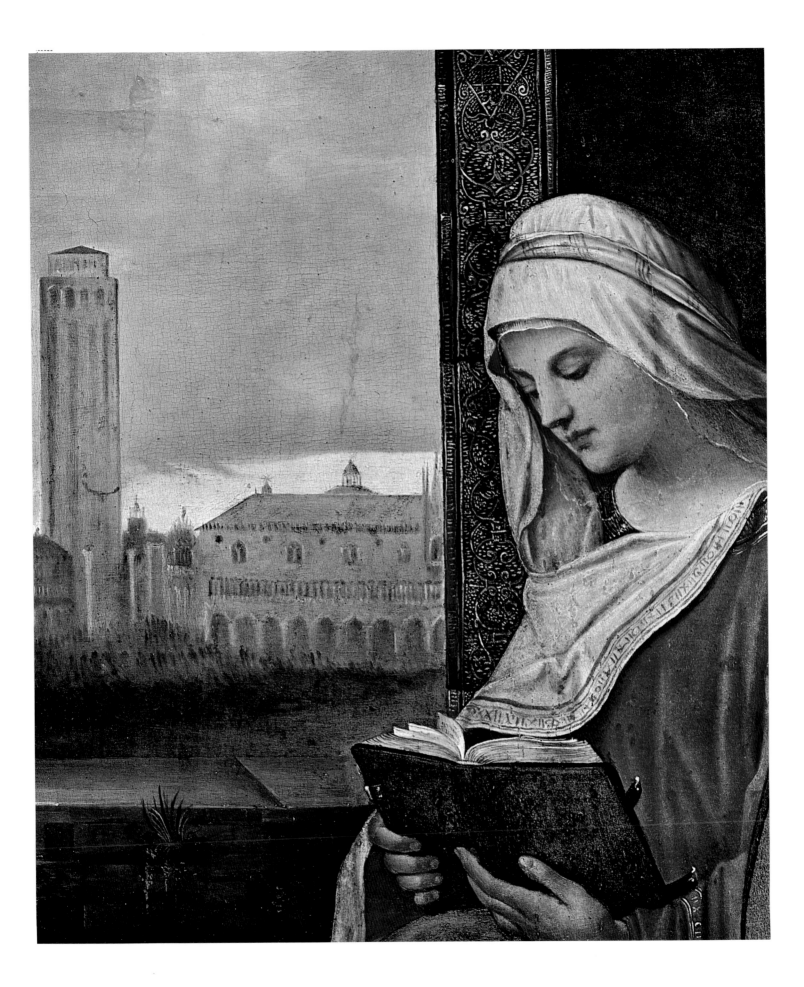

hand his remarks about the frescoes are worthwhile, and he gives them due prominence in Giorgione's *oeuvre*, while lamenting the destruction they are suffering through the saltiness in the air, as at Ca' Soranzo: '...A nude that is living flesh / and it will go on living, until from that wall / it disappears...' (58).

So far as the paintings attributed to Giorgione are concerned, those which are included by Boschini for the first time do not seem at all credible, so that this side of his work is not convincing.

The erudite Natale Melchiori's list of frescoes, made around the turn of the seventeenth and eighteenth centuries (59), which has survived in manuscript form, is purely descriptive in value; although he does not seem to have been entirely void of critical appreciation for Giorgione's style, since the only fresco which has survived of the many he mentions, the one in the Casa Marta Pellizzari, is regarded as genuine by modern criticism.

The contributions made by Anton Maria Zanetti, the very perceptive Venetian critic who was active in the second half of the eighteenth century, are indeed interesting. In his *Varie Pitture a Fresco* (1760) he reproduces and describes the frescoes by Giorgione and Titian that were still visible on the two façades of the Fondaco dei Tedeschi. In our opinion, however, his engravings, which are executed with a clean but academic handling, do not provide any basis for a possible differentiation between the contributions of the two artists. The text on the other hand is very precise, and Giorgione's style emerges as one with 'strong shadows and predominantly red in tone' very different from that of Titian, which has 'half tones and ... contrasts to achieve that natural tenderness in the flesh' (60).

Zanetti also characterizes Giorgione's technical innovation with regard to tones; in his *Della Pittura Veneziana* (1771) he describes the painter's style as one which 'illuminated the shadows appropriately ... and above all manifested a free handling between the forms and the dark areas ... at times making them more delicate by harmonizing them and softening their outlines, so that the detail in the forms shown were half perceived and half unseen'. This description identifies Giorgione's discovery of a tonal technique of painting, and it clearly relied on an assessment of the frescoes, which were the principal subject of Zanetti's interest. It is also to Zanetti's credit that he limited the number of works attributed to Giorgione to six, although of these unfortunately the only certain ones were the Fondaco paintings. This tendency to restrict Giorgione's *oeuvre* is followed, with however no great conviction, by Lanzi (1789), after which the critical appreciation of the artist's work endures the indifference of the Neoclassical and Romantic periods.

The modern period of Giorgione literature begins in 1871, with the publication of Crowe and Cavalcaselle's *History of Painting in North Italy*. For the first time all the material in

like the *Knight and Page* (C 4, C 8), or the *Man in Armour* in London (C 6).

58. '...Un nudo che xe carne che la vive / E viverà, sì ben che da quel muro / La se smarise...', *Carta etc.*, ed. 1966, *cit.*, 340.

59. *Repertorio di cose appartenenti a Castelfranco...*, MS. 163, Biblioteca Comunale, Castelfranco; *Catalogo historico crono-logico...*, MS. 205, Gradenigo Dolfin, Biblioteca del Museo Correr, Venice.

60. Zanetti, 1760, 5. It is going a little far to assert, as some scholars have done, that the *Diligence* from the Grimani Palace, attributed by Zanetti to Giorgione, can be seen *from the engraving* to be by Titian (see under Lost Works: Venice, Casa Grimani).

XIV - THE THREE PHILOSOPHERS (Detail from Plate 87). *Vienna, Kunsthistorisches Museum.*

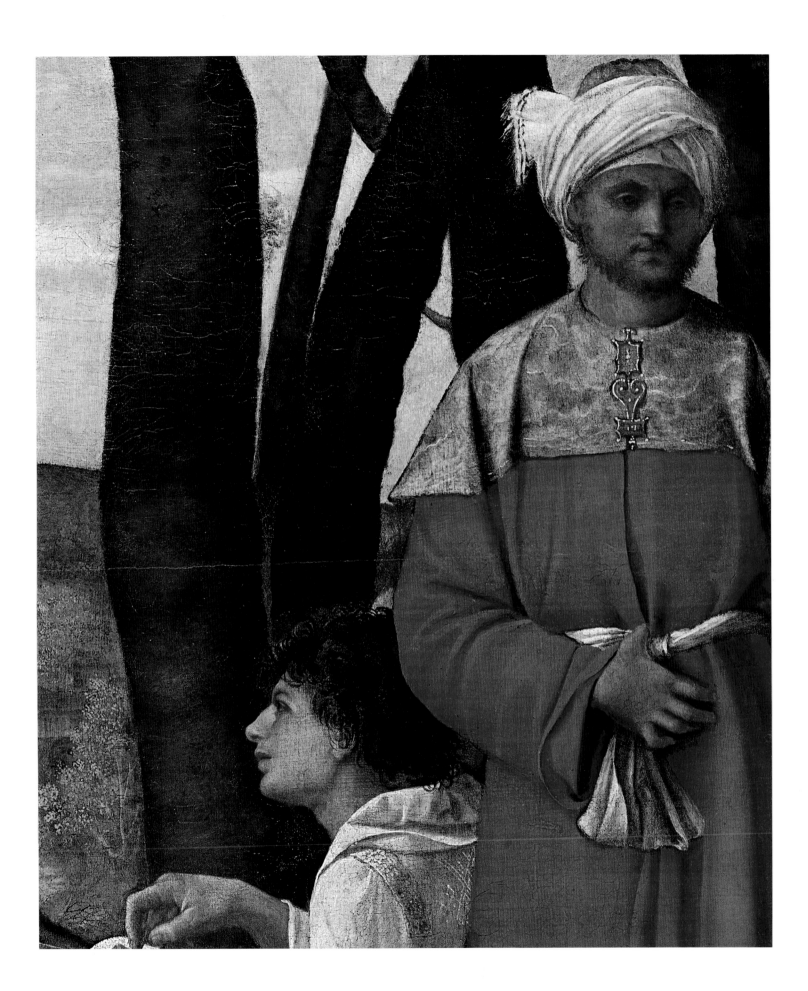

the sources is reviewed for the purpose of distinguishing the genuine paintings from the imitations and derivations by his followers. The application of the approach of connoisseurship, which was so well employed by Cavalcaselle, resulted in a catalogue of eighteen paintings, which included for the first time the *Three Philosophers* in Vienna and the San Rocco *Christ*.

Shortly afterwards Giovanni Morelli published (under the pseudonym of Lermolieff) his Giorgione catalogue, in his studies on the Galleries in Munich, Dresden and Berlin (1880, second edition in 1891). By applying his 'positive' method, based on stylistic comparisons, Morelli ended up with nineteen paintings, among them the *Venus* in Dresden, the *Portrait of a Young Man* in Berlin, the *Judith* in Leningrad, and the *Shepherd Boy with a Flute* at Hampton Court. There are of course wrong attributions — like the inclusion of the Prado *Madonna and Child with Saints* as a Giorgione — but Morelli's catalogue was certainly the platform for further work.

While Berenson (1894) and Adolfo Venturi (1900) essentially follow Morelli's attributions, Cook's (1900) massive work is conceived as a broadside against what he terms the 'restrictive' character of Cavalcaselle's and Morelli's attributions. Cook accepts as many as forty-six paintings as 'authentic', and this heralds a period of greater critical tolerance, continued by Justi (1908) to about the same degree. The positive side of this trend lies in the occasional rediscovery of genuine paintings that had up till then been ignored, like the Benson *Holy Family* and the *Laura* in Vienna (while some of the others have turned out to be by Titian, like the *Orpheus and Eurydice* in Bergamo, the Doria *Salome*, the '*Bravo*' in Vienna; or probably copies, like the *Self-Portrait* in Brunswick).

It was natural that Cook's and Justi's excessive critical tolerance should have been followed by the opposite tendency, represented by Borenius (1912), who went back to sixteen genuine paintings, and by Lionello Venturi, who accepted only thirteen. The most notable result of this critical attitude was two-fold: on the one hand light was cast on the problem of the 'Giorgionesque', as a product of the compelling force of the artist's vision, while on the other there emerged a homogeneous group of works which are not completely reconcilable with Giorgione's hand, but are nevertheless remarkably poetic and close in feeling to the artist's work. These comprise the *Pastoral Concert* in the Louvre, the *Christ and the Adulteress* in Glasgow, *The Concert* in the Pitti, and the *Madonna* in the Prado. A few years later Longhi (1927) gives them all to the young Titian, thus introducing a new critical chapter of exceptional interest.

The interrelation of problems in the work of Giorgione and Titian had however already been suggested by Hourticq in 1919. His studies contributed to the reconsideration of Titian's place as the initiator of the renewal of painting in sixteenth-century Venice, to the exclusion of Giorgione, as also Hetzer thought (1929). This also led to Hourticq's reduction to the minimum of the number of paintings he attributed to Giorgione, including only a few of the works mentioned by Michiel (whose notebook had been published by Frizzoni in 1884 and by Frimmel in 1888). But even of these paintings, the *Venus* in Dresden and the San Rocco *Christ* were given to Titian. This heralded the phase when Titian predominated in the critical interpretation; it was essentially the line taken by Suida (1933) and

XV - THE THREE PHILOSOPHERS (Detail from Plate 87). *Vienna, Kunsthistorisches Museum.*

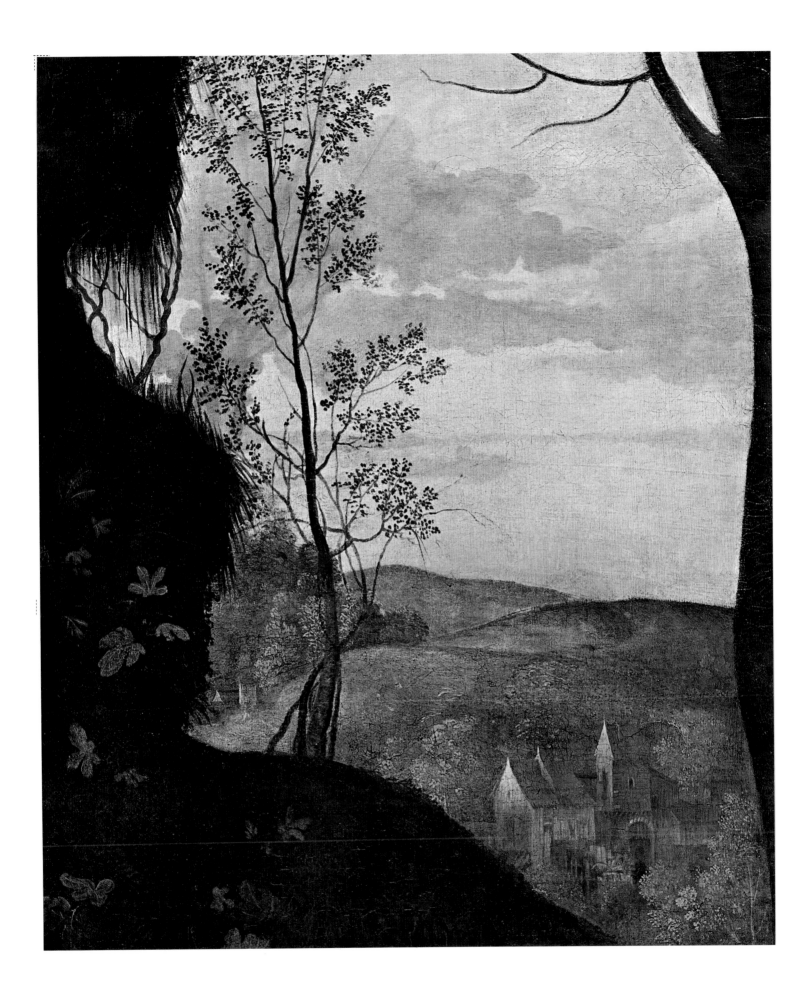

Morassi (1943); their studies were nevertheless beneficial in bringing critical examination to bear on every aspect of the Giorgione legend.

In the 1930s there appeared some of studies of especial interest, based on the X-ray examination of Giorgione's paintings, particularly by Wilde (1933), Morassi (1939) and others. These studies led to the discovery of the compositional changes the artist made in the *Three Philosophers* and in the *Tempest*. All this occurred during a period when the mysterious subject-matter of some of Giorgione's paintings was the subject of frequent debate, mainly in the studies by Hartlaub (1925), Wilde (1933) and Ferriguto (1933); the last-named is particularly useful for his picture of the cultural milieu around Giorgione, and of the personalities of his patrons.

The appearance of Richter's volume (1937) marked a milestone in the critical understanding of Giorgione's work. Armed with a research approach akin to that of Morelli, and with a Teutonic perseverance, Richter subjected the sources, literature and paintings to a thorough review. His work is thus a fundamental one, and has proved virtually the starting point for all recent scholarship. Its only shortcoming is the large number of paintings which Richter includes as by Giorgione; although he expresses doubt over a few, his *corpus* comprises ninety-nine works, including the drawings. The critical standards of Richter's monumental work are thus put in doubt, although it merits our closest consideration in all other respects.

There was renewed activity in the field of Giorgione studies during and immediately following the War. Notable here is the Tietzes' catalogue of the artist's drawings (1944), which possibly goes too far in admitting new attributions, but which nevertheless provides an indispensable foundation for future research. Another important contribution is that of the few but brilliant pages Longhi devoted to Giorgione in his *Viatico* (1946). Speaking of shedding the legend of Giorgione ('talking of him without mentioning music, lutes, poetry and without getting carried away by tone'), Longhi suggests that a possible Emilian training may have consolidated his early closeness to the Bellinis' style; he re-evaluates the importance of Vasari's idea of a 'modern style' after 1507; and finally he suggests that the last development of Giorgione's style lies in the direction of the 'half-figures with no drawing, only colour' which 'belonged to the master's last months, and they were something almost modern, close to Caravaggio, to Velasquez, to Manet'. Unfortunately the examples which Longhi chooses to illustrate this final style — the *Self-Portrait* in Brunswick, the *Warrior with a Page-boy* in the Uffizi, the *Double Portrait* in Palazzo Venezia, and even the *Singers* in the Borghese Gallery, are all for various reasons questionable, and certainly contrast with the one authentic late Giorgione, the *Portrait of a Man* dated 1510 in San Diego. Longhi's comments provoked considerable discussion among critics, who took up various attitudes to his suggestions and made numerous specialist contributions.

Meanwhile the news that Venice was preparing a Giorgione exhibition to be held in 1955 redoubled the interest and controversiality of the arguments. Giorgione became the object of a contest which was not without its grotesque elements: newspapers organized referendums in order to decide who was the author of the rediscovered Borghese Gallery *Singers* (1954). In the six months before the exhibition no fewer than six monographs

XVI - SUNSET LANDSCAPE (Detail from Plate 99). *London, National Gallery.*

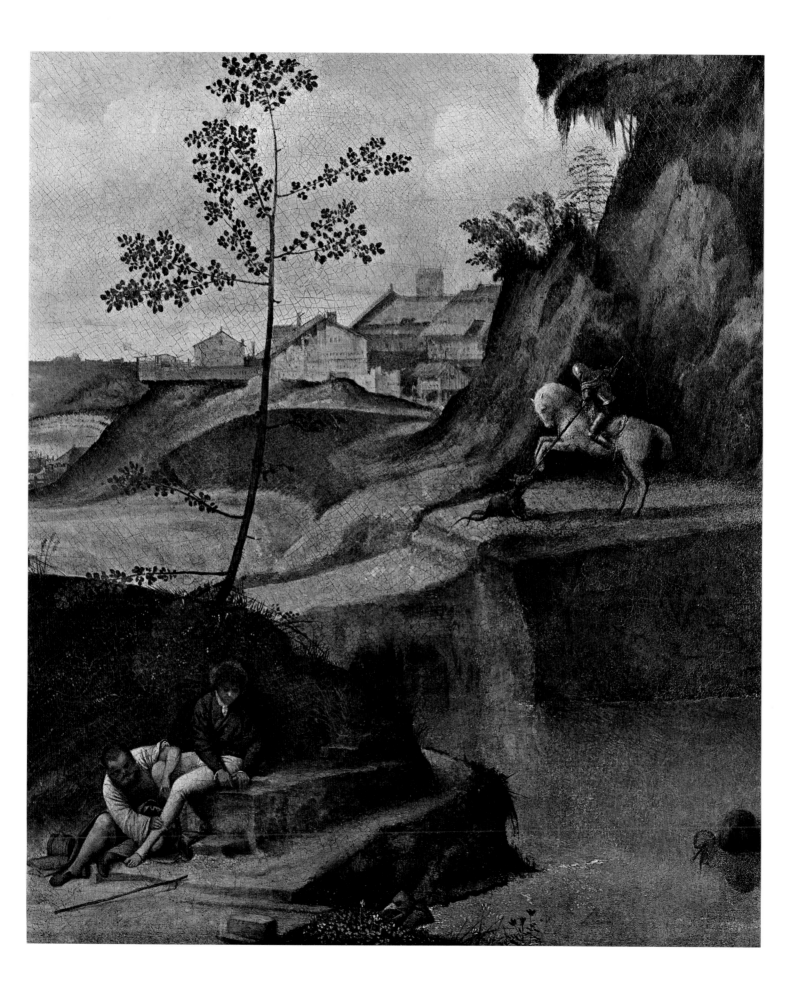

appeared, of varying seriousness and value, some of them with the weight of scholarship behind them. They have a common approach to the subject, in that they make a distinction between the question of the understanding of Giorgione's art, and the specific problem of the reconstruction of the artist's *oeuvre*. It is thus no chance that two of the monographs (those of Coletti and Pignatti, both published in 1955) are principally catalogues of Giorgione's complete works. Finally the exhibition Catalogue (Zampetti, 1955) deals with the vast amount of material that was exhibited, relying also on the opinions of a group of advisers which included nearly all the Giorgione specialists of the day, from Coletti to Fiocco, Longhi to Morassi, Pallucchini to Suida and Venturi. Of course the exhibition (in spite of the absence of the works in the National Gallery in London and those in Washington, the *Judith* in Leningrad, the *Venus* in Dresden and the *Portrait of a Man* in San Diego) made an important contribution to studies in the field, and this can be seen in the bibliography after that date. Indeed the reviews of the exhibition in 1955 by Castelfranco, Fiocco, Pallucchini and Robertson and others have the importance of full-scale Giorgione studies; while the more recent monographs by Baldass (1964) (in which Heinz's interpretative contribution is of primary importance) and Zampetti (1968) were inspired by the experience of the exhibition. Klauner's study on the *Three Philosophers* is also important (1955). Garas's contribution, presented in three essays which appeared between 1964 and 1966, is an original one, on the theme of the Giorgionesque in the seventeenth century. Garas also gives a lot of information on the location of Giorgione's paintings in the more famous private collections of that period. Nor should we forget, for his perceptive understanding of the literary and philosophic climate, Bonicatti's study (1964) on the Giorgionesque and the artistic situation in 1500-10, and E. Wind's valuable iconographic research on the *Tempest* (1969).

A final comment should be made on the tendency which has reappeared since 1950, to deal with problems of Giorgione's work in the context of those of Titian's early development. This is extensively the case in the monographs by Tietze (1950), Pallucchini (1953 and 1969), Dell'Acqua (1955), Morassi (1956), Gioseffi (1959) and Valcanover (1962 and 1969). By and large, these writers follow the line initiated by Hourticq and Longhi, attributing to Titian a large number of works whose content is more dramatic in pictorial and human terms: founded in other words on that sort of 'chromatic *largo*' which completely dispelled Giorgione's insuppressible timidity. Agreement is almost complete, however, on the attribution to Titian of the *Madonna and Child with Saints* in the Prado (Pl. 154), the *Christ and the Adulteress* in Glasgow, the paintings with small figures like the *Orpheus and Eurydice* in Bergamo, the *Stories of Adonis* in the Museum in Padua, the *Concert* in the Pitti, and numerous portraits, like the *Knight of Malta* in the Uffizi, the *Male Portrait* in the Metropolitan Museum in New York and the *Male Portrait* in Fullerton, California. There is still faint uncertainty over the *Pastoral Concert* in the Louvre, in which some see a compositional scheme (if not the actual design) by Giorgione.

So the development of the understanding of Giorgione's work has meant a sort of return to the beginning, that is to say to that situation of open comparison of the two greatest painters of the early sixteenth century in Venice on the scaffolding of the Fondaco. The most relevant problem today in Giorgione studies is the clarification of the beginnings, pro-

XVII - VENUS (Detail from Plate 103). *Dresden, Gemäldegalerie.*

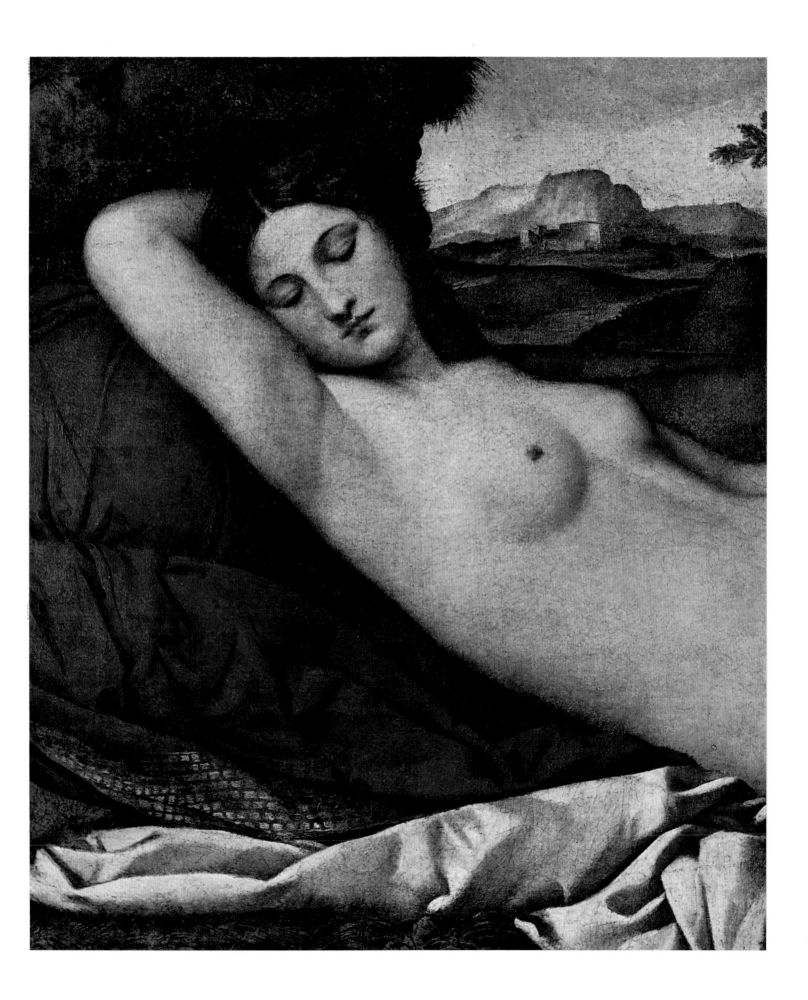

gression and results of this juxtaposition, not only on account of the interpretative aspects, but also by reason of the difference which it makes to our understanding of the different characters of Giorgione and Titian.

III

PROBLEMS OF ATTRIBUTION

The preparation of a *corpus* of works by Giorgione has always posed special interpretative difficulties. On the one hand, there is very little documentation, the few useful references in the sources are generic in character, and the differences between the various hands in the field of the 'Giorgionesque' are extremely subtle; on the other, Giorgione's own personality is an elusive one, and one which is not easy to reconcile with the known facts of his artistic environment.

The crucial problems in Giorgione's development are his beginnings, for which Vasari's comments about his relationship with the Bellini are oversimple, and his 'last style', which is a question often complicated by the possible intervention of Titian. But there are serious difficulties in the middle period too, when it comes to defining what constituted the 'modern style' that Giorgione is supposed to have taken up 'around 1507', both in terms of the contact he is reputed to have had with Leonardo that gave the impetus for this change, and in terms of the effect it had on his work at that time, which has unfortunately almost completely disappeared.

Symptomatic of these difficulties are the discrepancies between the various chronologies advanced for Giorgione's work: these are as varied as is imaginable in the various modern studies, with some surprising reversals. The principal reason for this is the great scarcity of objective facts about the artist's career. In fact the only firm dates in Giorgione's *oeuvre* are the 1506 of the *Laura* in Vienna, the 1508 of the Fondaco frescoes and the 1510 of the San Diego *Portrait of a Man* (here verified for the first time). If Giorgione was born in 1477, and was 'raised in Venice', following contemporary custom he would have found employment in the shop of some artist towards the end of the fifteenth century, and there is no reason why he should not have set up on his own, like so many others, between eighteen and twenty-one years of age. This calculation — which has no more foundation than that of historical logic — would place Giorgione's beginnings around the year 1500, and this might seem to be confirmed by Vasari, who describes his début as being 'without modern style ... while with the Bellini in Venice'; but he then adds that he continued 'on his own', which must refer to the period of Giorgione's maturity and independence.

There is thus a gap between 1500 — the date of the presumed beginning of Giorgione's work — and 1506, that must be made good with hypotheses, for which there are few factual grounds. According to Vasari and Dolce, Giorgione at first painted Madonnas and portraits; for the latter, is perhaps the date 1506 attached to the *Laura* and the *Portrait of a*

XVIII - BOY WITH AN ARROW (See Plate 106). *Vienna, Kunsthistorisches Museum.*

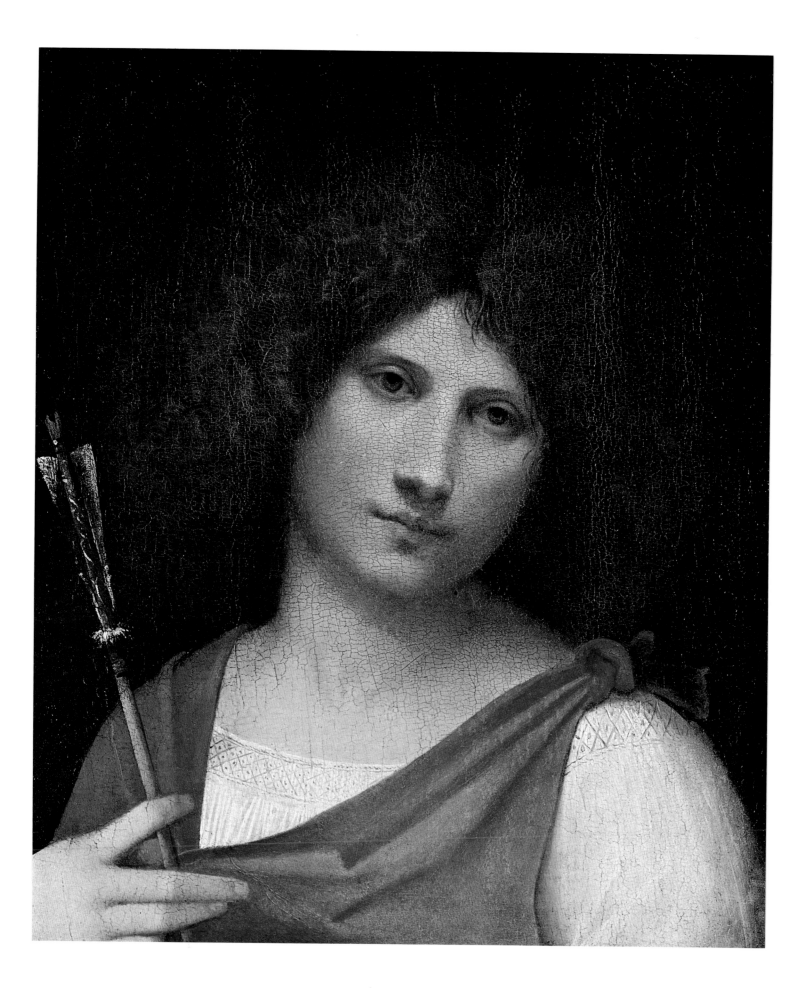

Young Man in Berlin relevant here? How much nearer to the imaginary date of 1500 are the Madonnas? The Castelfranco *Madonna and Child with Saints*, which is generally held to be a less mature work than the *Laura* and the Fondaco paintings, was certainly executed to a commission from Tuzio Costanzo, in order to set it in the family chapel at the tomb of his son Matteo. There are many indications that justify the belief that the painting was executed within a short time of the August 1504 inscribed on the tomb (61).

This would provide another firm point in Giorgione's development, and — if it is true that this beautiful painting does betray its author's youthful inexperience in some passages (see the discussion of the work for the nature of this) — we must here be close to Giorgione's early style. Working backwards, the 'primitive' paintings may thus be placed in the period before 1504; the next step is the *Laura* (1506), while the 'modern style' should be seen in the Fondaco paintings (1508), and the 'final style' in the San Diego *Portrait of a Man* (1510). This framework of four dates is a pretty insubstantial one when it comes to arranging in chronological sequence the thirty-odd paintings we are convinced are by Giorgione. But it is at least a credible working method, in the application of which we must be careful not to ignore any fundamental issue, even though it can only provide a fragmentary understanding of Giorgione's development during a career which spanned less than ten years and which came to an end at the age of thirty-four. This means that the usual divisions into youth, maturity etc., have little meaning, and we must beware of imposing too many subdivisions on his work, which even when it has revolutionary implications nevertheless maintains an unfailing poetical consistency.

The principal difficulty in the preparation of a Giorgione catalogue is however that of the attribution of his work, and it is in this field that the conclusions of scholars have been most contradictory. Obviously, we believe that our research has been conducted along the most propitious lines, but we also want to acknowledge the debt we owe to previous studies. Our catalogue comprises 27 paintings and 4 drawings (one of which is included for the first time). But among these there are very few which can be linked with our historical knowledge of Giorgione and thus be documented objectively. Works which fall into this category (in our view) are the *Laura* in Vienna and the San Diego *Portrait of a Man*, by reason of the contemporary inscriptions which they bear; the *Tempest*, the *Three Philosophers*, the *Venus* and the *Dead Christ*, from their mention by Michiel; and the frescoes of the Fondaco dei Tedeschi, through the evidence of the sixteenth-century sources. Nor should it be forgotten that even in the case of these few works, there are those who doubt the authenticity of the inscriptions, and likewise the accuracy of the information provided by Michiel and Vasari (62). It has been quite a common tendency for critics to work from the idea of a 'historical' Giorgione as a platform for the reconstruction of his entire acti-

61. The most convincing proof of this is the repetition of the coat of arms in the painting on Matteo's tombstone, dated 1504.

62. Vasari's account is frequently contradictory, and he sometimes confesses his inability to distinguish between Giorgione and his pupils: in this connection we should note the instances (discussed at length later) of the *Christ Carrying the Cross* in San Rocco, the *Storm at Sea* and the altarpiece with *Saint John Chrysostom and Six Saints*. The doubts concerning the identification of the *Venus* are discussed on pp. 108-9.

XIX - THE DEAD CHRIST (See Plate 107). *New York, Private Collection.*

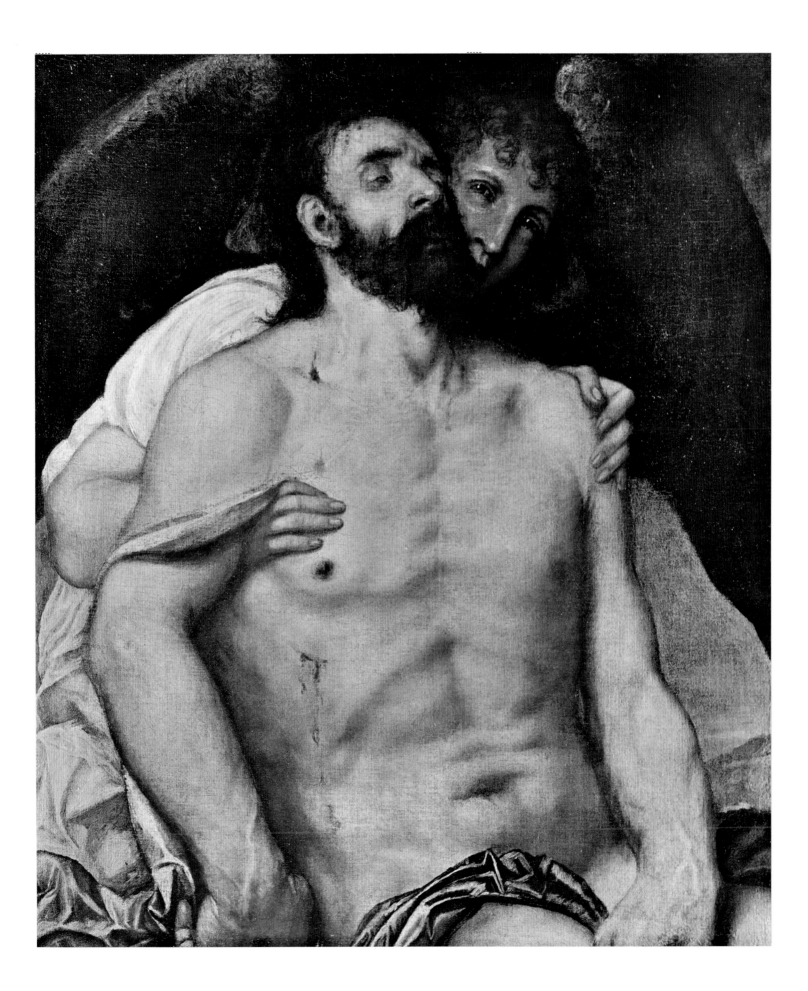

vity. This is certainly a positive approach, but it is one which may also produce some distortions of perspective. We cannot indeed wholly and exclusively rely on these 'headings' in the pursuit of the appropriate place for particular paintings; rather we should set the most acceptable paintings in a broader historical framework that also comprises those works which on stylistic grounds appear no less acceptable, even though they may bear no inscriptions and are not supported by more or less credible authentications in the sources.

The most characteristic example of this approach is the virtual unanimity over the Castelfranco *Madonna and Child*, a painting first mentioned in the seventeenth century, whose attribution to Giorgione has never been in doubt. We should also include in the category of 'certain' paintings the series of early Holy Families in Washington and London. Equally unquestionable are some of the 'half-figures' in Giorgione's final style, closely linked in style with the San Diego *Portrait of a Man* and with a tendency towards a clearly expressed naturalism which must have provided a challenge for Titian himself.

So various common factors are established which can provide a basis for study, alongside those which are somewhat arbitrarily described as 'historical'; enough to enable us to approach the various facets of the real Giorgione, that is to say the poetry of his art.

IV

GIORGIONE'S PAINTINGS

The sources are unanimous in saying that Giorgione began his artistic career in the Bellini workshop. There is no reason to doubt this, especially as the paintings themselves confirm it.

The *Christ Carrying the Cross* in the Gardner Museum in Boston (Cat. No. 1; Pl. 1) is a superficially faithful copy of Giovanni Bellini's painting in Toledo, which Giorgione could have seen in the painter's studio, or perhaps in the house of Taddeo Contarini, where Michiel mentions a painting of that subject in 1527. As is known, Contarini belonged to the circle of Giorgione's patrons, and owned, among other paintings by him, the *Three Philosophers*. Since the date of Bellini's *Christ* (Pl. 2) is around 1500, this would confirm the belief that Giorgione's career began around that year.

Giorgione indubitably followed the original literally, both as regards design and colour. Christ's robe is modelled with that 'dry' handling, with almost changing reflections, that is typical of Bellini's work in the years around the turn of the century when he often painted the theme of the Madonna and Child. We even find here that the hem of the robe stands out with a delicate edging of deep green silk, highlighted with gold damask work. But the essential character of the Christ has changed. Giorgione's Christ looks at us with an expression that is half naïve and half troubled, with a hint of a smile on His lips. The carmine ground, which shows through, is the earliest example we have of a feature that is charac-

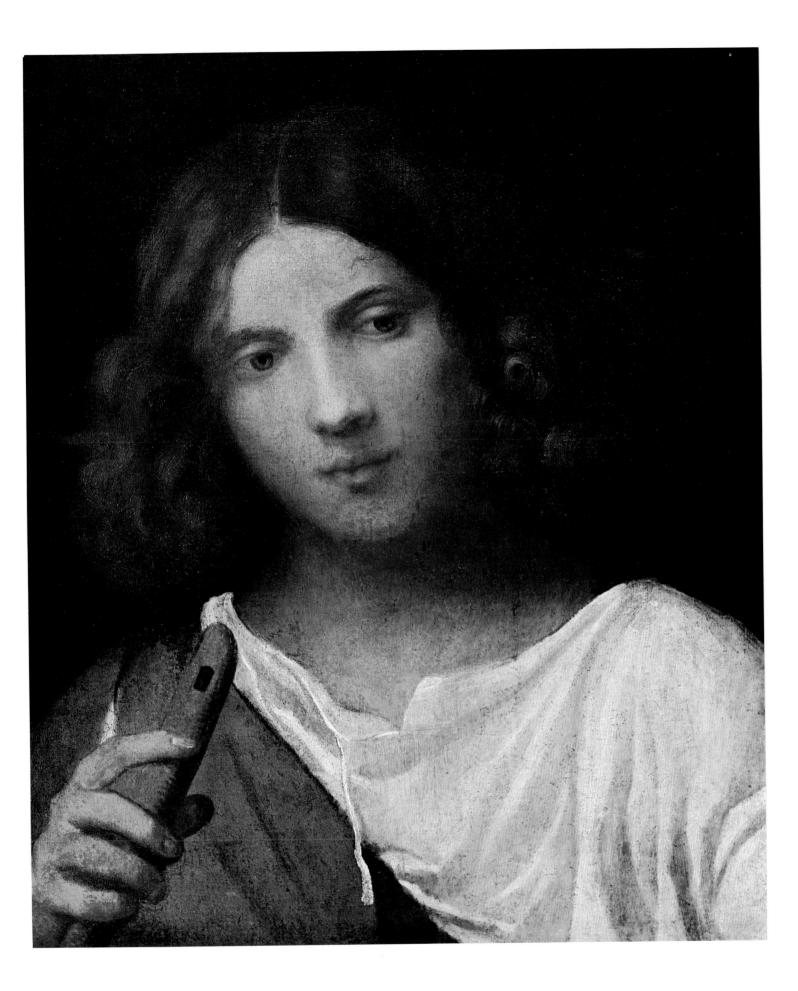

teristic of Giorgione's work. Even the light which envelops the figure of Christ has a more intense quality and a more precise direction, describing in detail the pattern of the grain of the wood of the Cross, which in Bellini's painting has the character of a 'noble' material, almost like marble. These elements of difference from the original are the features which for us point to the interpretation of the young pupil, who was already beginning to prepare to work 'on his own'. It is almost as if he wanted to remove some of Bellini's austere detachment, some of that severity of compositional structure that discoloured His face and veiled His looks, significantly turned aside as if to avoid a confrontation with reality.

So already in this first painting, which is stylistically too close to its model to give any real idea of his own pictorial style, Giorgione shows himself to be conscious of the need for a realism that surpasses the fifteenth-century naturalism of Bellini, which was one that was at times academically bucolic, at others geometrically abstract. Here we can grasp at its first appearance the second component in Giorgione's artistic development: the influence of Northern painting. A Venetian artist trained by the Bellini, confronted with the work of Flemish artists like Bouts, Memling or Bosch, could not fail to notice as an important novelty their astonishing faithfulness to reality, their space rendered with microscopic precision, their colours altered by the measured incidence of light. And there must have been, among the sixteen Northern paintings in the Grimani collection, or among those belonging to the Odoni or the Foscarini, a few portraits or paintings of Christ, which could have suggested such closeness to reality, to go beyond and outside the austere style of the Bellini family.

We learn from the sources that Giorgione at first executed many Madonnas. There was most likely a choice of models here too, between Bellini and the Flemish artists; of the latter, it was Memling's work that was probably most available in Venice, in compositions like the *Madonna* in the Prado or the one from the collection of the Duke of Devonshire. These are small paintings, in which the figures are no more than a third life size; they must have impressed Giorgione with their clarity of detail and with their spatial framework that was no longer encompassed by Bellini's fifteenth-century geometry, but rather by the response of surfaces of colour to the penetration of light.

The *Madonna and Child* in Bergamo (Cat. No. 2) must be one of the results of the impact of Flemish painting. It is comparable with Memling's paintings in its small dimensions, the frontal position of the Madonna with the Child in her lap, and in the intensity of the collour, as in the large red mantle that spreads in a very complicated series of folds (Pl. 4). The Madonna is seated on a step, apparently under a portico, from which the view of the distance recalls Northern examples more than Venetian ones. This is a compositional formula which Giorgione was often to employ, from the *Holy Family* in Washington to the *Madonna with a Book* in Oxford. Here however it reaches the full expressiveness of the intimacy of the 'interior' which the scene evokes, employing the oblique fall of the light to express a very subtle emotion.

Another important element in Giorgione's development that is evident in the Bergamo *Madonna and Child* is the 'Gothic' arrangement of the drapery, which is too pronounced even for Flemish artists. It is not impossible that we see here the result of the diffusion of

XXI - PORTRAIT OF AN OLD WOMAN ('LA VECCHIA') (Detail from Plate 118). *Venice, Accademia.*

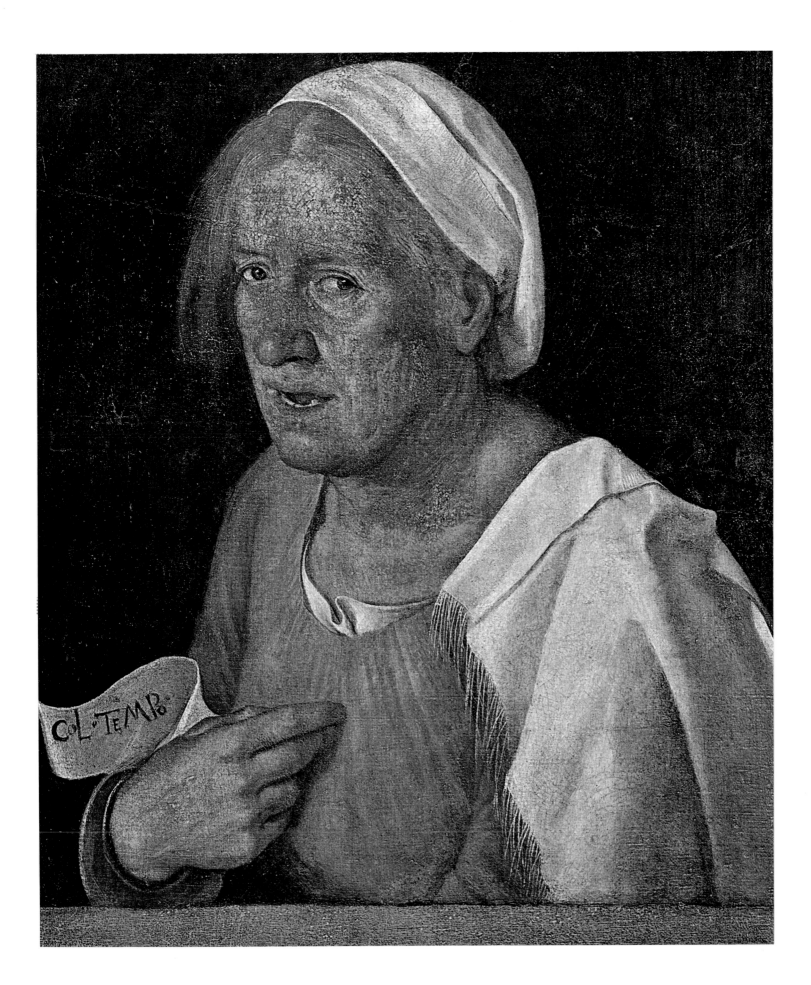

prints, both woodcuts and engravings, especially those of Germany, from Schongauer to Dürer (63). The idea of setting the Madonna on a seat of smooth veined marble instead of a throne could derive from a print by Zaisinger (of about 1501 - Fig. 2); while the constant references to landscape are certainly derived from compositions of that sort. In the painting, the landscape is no longer based on Bellini's Virgilian formulae, such as that of the *Madonna of the Meadow* in London (about 1505); rather it begins to take elements from reality — a tower, a rustic house, an ilex wood (64).

Finally we come to Leonardo. It is difficult to determine when Giorgione saw those things of his 'with a beautiful gradation of colours and with extraordinary relief achieved with dark shadows'. From the account in the 1568 edition it would appear that Vasari associated the meeting with the period of Giorgione's adoption of the 'modern style', which earlier in the Life of Titian he had dated around 1507. But Vasari's idea of Giorgione was based largely on the works like the *Self-Portrait dressed as David*, and it follows that his understanding of the early period would have been fragmentary. It is known that Leonardo came to Venice around the end of 1500 and the beginning of 1501; he had just completed the *Last Supper*, and it is possible that he might have brought with him some of the drawings associated with that work, like the *Christ* in the Brera (Fig. 13), or he could have shown Giorgione sketches for paintings like the *Benois Madonna* in Leningrad or the *Madonna with the Carnation* in the Alte Pinakothek in Munich (Pl. 6). The features of the Child in the Bergamo *Madonna and Child* are certainly identical with those of the Child in the Munich painting (65). This would appear to show that it was at the start of Giorgione's career that he was influenced by Leonardo, and that this coincided approximately with the latter's visit to Venice, which came to an end in 1501. However, it does not mean that Vasari may not have had good reason for speaking of certain aspects of the very late Giorgione — which might for him have resembled chiaroscuro effects — in the context of Leonardo's influence.

Once again, there exist precedents among the works of Bellini and the Flemish painters for the *Holy Family* in the National Gallery in Washington (Cat. No. 3, Pl. 8). One only needs to move a few paces away from it in the National Gallery to come across Bellini's *St. Jerome in a Landscape*, which bears the date 1505 and which makes a perfect comparison with Giorgione's *Holy Family*. Very similar in dimensions and proportions, the two paintings have a superficial similarity which barely disguises the radical differences between them. It is indeed evident that Giorgione in his interpretation pursues a 'realism' that is more immediate, fluent and even cursive, having regard to the rustic simplicity of the architecture and the limited number of colours (green and carmine, cobalt blue, gold and violet in the foreground figures). Bellini's on the other hand is a monumental composition, and its elements

63. As has already been observed in another context (cf. especially Hetzer, 1929, 107; Morassi, 1942, 29 ff.; Suida, 1954, 153).
64. There is a similar combination of a 'Northern' type figure with an open, naturalistic landscape, in some of G. Campagnola's prints, clearly derivatory from Giorgione, like the *St. Jerome reading* (Fig. 76). This shows that figures with wide 'Gothic' draperies were at one time familiar to Giorgione and his circle, and would tend to support the attribution of the *Madonna and Child* in Bergamo to Giorgione.
65. Whether or not this was actually painted by Leonardo, the composition was certainly of his invention.

XXII - CHRIST CARRYING THE CROSS (Detail from Plate 116). *Venice, Scuola Grande di San Rocco.*

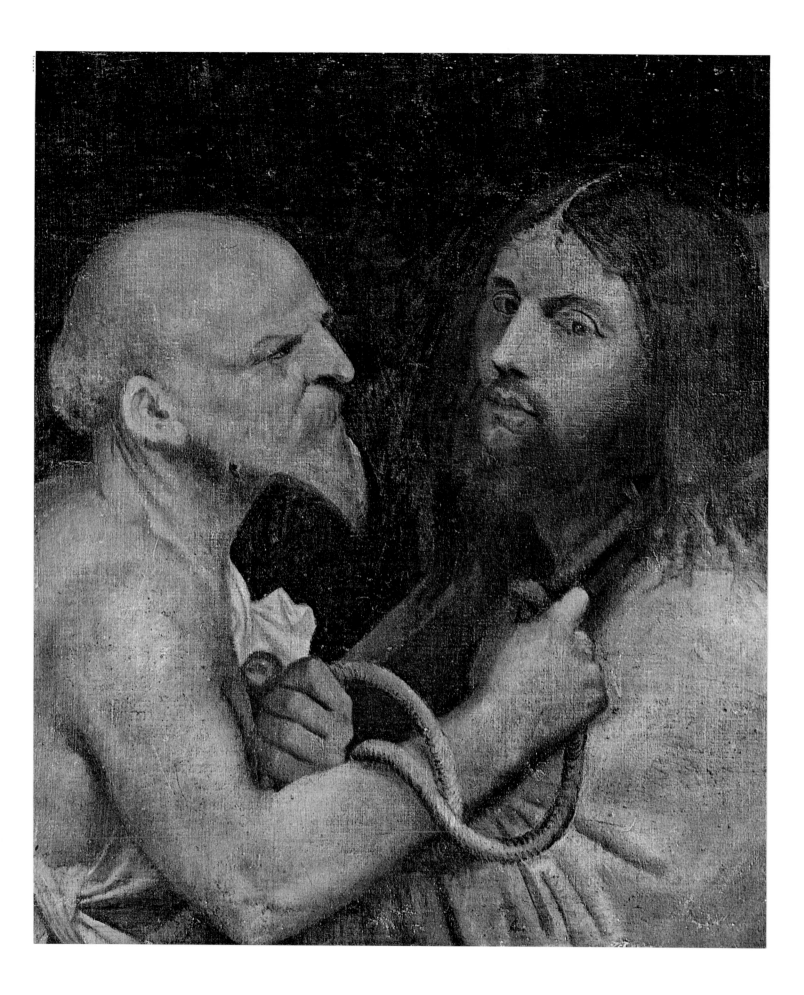

are rendered in the rustication and moulding of the rock forms, which are accompanied by a magnificent assortment of botanical details, animals and references to antique works. It is as though the two spiritual climates of the early Renaissance are here contrasted — the Arcadian and profoundly naturalistic feeling of Bembo's sentimental literary ideals set against the hallowed artistic forms of Tuscany and Mantegna.

The Washington *Holy Family* probably precedes Bellini's *St. Jerome*, on account of the still strongly Northern character of the spatial composition, in which the figures are projected forward to give greater play to the Gothic drapery folds. This recalls not only the Madonnas by Memling (whose use of interior lighting combined with a view of the landscape distance seen through the arch of a portico is repeated here), but also the broad placing of Dürer's figures, as in the engravings of the *Madonna with the Dragonfly* (about 1495) or the *Madonna with the Monkey* (about 1498) (Pl. 7).

Having thus argued for an early dating for the Washington *Holy Family*, it remains to discuss the distinctive characteristics of Giorgione's style which we can see in it. It seems to us that the feature that emerges as most obviously Giorgione's is the arrangement of the colours. Although this is tied to a graphic framework of Gothic origin, which makes the folds more emphatic and exaggerates the localized alteration of tone, Giorgione here succeeds for the first time in harmonizing a whole series of colour themes in an atmospheric unity, which suggests the tenderness of the Holy Family immersed in the harmony of the world around them. As symbols of good, they are set against a background of philosophical serenity, a vision of a benign Nature that might be a Paradise on earth, yet coloured with the noble refinement of an Arcadian dream.

The *Judith* in Leningrad (Cat. No. 4) shows a further development of this tendency to relate the function of colours in the composition to the spiritual content of the subject represented (Pl. 12). The figure of Judith rises like a pink and gold flame against the reassuring green of the landscape. But in the foreground Giorgione placed the outsize head of Holofernes, which he endowed with a quality of realism that far exceeded that of the examples he might have seen by Bosch (66) or Leonardo. This is the first example of a form of realism in Giorgione's work that was to be exploited over a long period by Lombard painters, right up to Caravaggio himself (67). Judith's ominous figure is rendered in pale green and grey hues that give her relief against the shadows on the low brick wall, towards which she appears to step backwards, with little taste for the kick which the narrative has her give her macabre trophy, as she balances with the tips of her fingers the great sword whose steel shimmers with reflections.

There are several new features which make Giorgione's *Judith* of especial interest, particularly in the field of iconography. It is indeed difficult to find a point of reference for this figure, which has acquired an altogether new monumentality (albeit within the usual less than life-size dimensions). Taken as a whole it seems to recall the Hellenistic refinement of

66. Gioseffi, 1959, 48 ff., draws attention to this painter's influence on the early Giorgione.

67. Volpe, 1964, 5: '...foreshadows the opening of a new season for *naturalized painting*. Right up to Caravaggio, up to Vermeer'.

XXIII - PORTRAIT OF A VENETIAN GENTLEMAN (See Plate 119).
Washington, National Gallery of Art (Samuel H. Kress Collection).

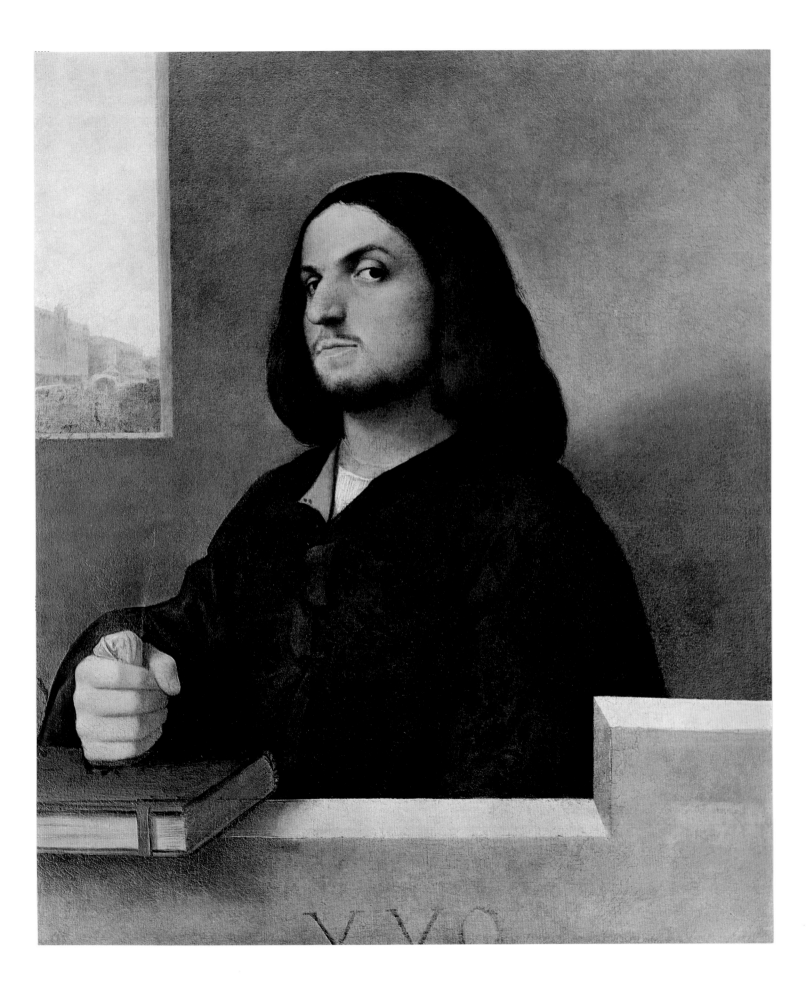

an antique statue, perhaps from Cardinal Grimani's collection of antiquities in his house at
Murano? That the virginal reserve of this figure should have been derived from some of
the German engravings of saints (like the *St. Agnes*, by Schongauer, Fig. 7) is perhaps
hardly credible although there is indubitably a Germanic element in the sophisticated dra-
ping of the robe. But we would be equally unlikely to find a saint in the same stance in one
of Bellini's compositions of the theme of the Madonna and Child with Saints. Nor can much
be gained from a comparison with Carpaccio's single figures, such as the *Prudence* and *Tem-
perance* in Atlanta (Kress No. 25), which, although they have affinities in the use of the
landscape background, are dominated by medieval forms to a far greater extent even though
they were painted later (Fig. 8).

Judith dominates the space in which she is placed with a new assurance, achieved once
more through the freedom of the colour elements, which are harmonized in an atmospheric
unity. This is the colour that is typical of Giorgione's work from now onwards; it is diffu-
se and tranquil, extending over forms that are monumental yet in no way harsh. Giorgione
is still far from painting 'without drawing' — as is evident from the beautiful head — but
we are conscious of a lighter feeling, an almost imperceptible tremor in the outlines which
replaces the strong impression of formal 'limits' of Bellini's paintings, in the direction of
the full depth of atmospheric space. To understand the importance of Giorgione's innova-
tion, one need only compare the head of *Judith* with the *Young Woman* by Dürer in Vienna, or
the one in Berlin, painted in Venice during the artist's stay there in 1505-7 and quite close
in subject-matter to Giorgione's painting, which however continue a dependence on graphic
foundations that the latter had already begun to discard around 1504 (68).

The date of 1504 inscribed on the tomb of Matteo Costanzo in the Cathedral of San
Liberale in August of that year represents the *terminus a quo* for the Castelfranco *Madonna
and Child with Saints Francis and Liberale* (Cat. No. 5, Pl. 14). It would be impossible to be sure
within a month or so of the date of delivery of the painting, but it seems very likely
that it was not long after and certainly not later than the following year 1505. It is indeed
significant that it should have been in 1505 that Bellini painted his dated San Zaccaria altarpiece,
and with it returned to the series of large-scale compositions which he seems to have inter-
rupted for the previous five years. So Giorgione's first altarpiece and the most beautiful of
Bellini's late altarpieces were conceived at the same time. Bellini and Giorgione, who alrea-
dy knew each other in a teacher-pupil relationship, must surely have exchanged ideas on
the subject. One might even go further and say that since Bellini's painting adheres so
much to his own pictorial values (with its classical framing of the Lombard apse and the
majesty of the colours employed in the monumental figures, which appear to almost elimi-
nate shading in order to emulate the painting without drawing which Giorgione had alrea-
dy mastered), it suggests that there might have been an element of competition, a se-
cretly-felt humiliation in the comparison for Giovanni Bellini. Are we to conclude that it
was Bellini who had to learn from Giorgione, when after all there are many traces of the

68. We should recall that Dürer, writing from Venice to with which he always remained in sympathy (Conway, *The
his friend Pirckheimer, had praise only for the art of Bellini, Writings of Albert Dürer*, New York, 1958, 48).

XXIV - Titian: PASTORAL CONCERT (Detail from Plate 157). *Paris, Louvre.*

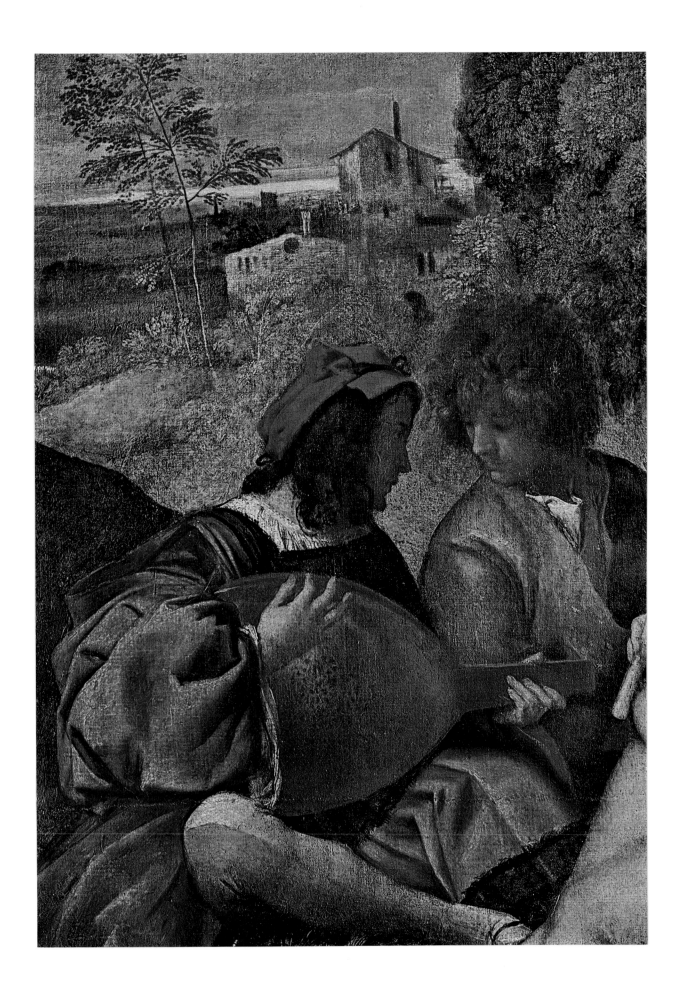

former's influence in the Castelfranco *Madonna and Child*? In any case, from the large number of derivations that date from the years immediately following, these two paintings seem to have founded a whole new tradition in Venetian sixteenth-century art, so that the year 1505 must be regarded as a crucial turning-point. One of the most unusual derivations is a painting executed for Santa Cristina al Tiverone near Treviso by Lorenzo Lotto in 1507. This small altarpiece preserves some of the magic of its models, between which Lotto seems to have been undecided; the figure of San Liberale is borrowed from the Castelfranco painting, while the Apostles and the Madonna clearly derive from the San Zaccaria altarpiece.

But Giorgione must have looked beyond Bellini, and farther than the earlier San Cassiano altarpiece by Antonello, for the invention of his most unusual *Madonna and Child with Saints Francis and Liberale*, where the Virgin is seated on a very high throne and the traditional architectural frame is dispensed with altogether. This 'elegant and decorative formula, half ogee and half pyramidal in form' was indeed 'very common in Umbria and Emilia in the last decades of the fifteenth century' (69). Giorgione's painting does differ in its very open setting, with its landscape occupying the entire area behind the figures. Nor can it be said that we find here any important break with earlier works, such as the *Madonna and Child* in Bergamo or the *Holy Family* in Washington (Pls. 4, 8). In fact Giorgione realizes the sort of landscape that corresponds with the development of his feeling for nature which will enable him to achieve the full independence of his Arcadian vision.

All this aside, the Castelfranco altarpiece is a revolutionary work in the context of Venetian painting at the beginning of the sixteenth century. Giorgione makes several innovations in this painting; to begin with, in the compositional structure, based on the high marble throne, which has the form of a somewhat improbable catafalque (70). Equally novel and surprisingly 'bourgeois' are the attitudes of the principal figures, which have even prompted the suggestion that these are portraits of the two Costanzos, an idea that is not altogether improbable in view of Giorgione's activity as a portraitist (71). Perhaps the most important innovation is in the use of colour; the Madonna's traditionally red tunic here becomes dark green, while the usually blue mantle is a warm and bright red, which stands out against the pattern of the green, gold and blue carpeting. If the Castelfranco altarpiece is revolutionary in any sense, it is in this free use of colour, which is now employed in the suggestion of tones and atmospheric changes. Who could have anticipated that the traditional grey or gold backgrounds of Venetian altarpieces would open out with such a striking expanse of dark red velvet, combined with the harmonious accents of a landscape that is recognizable as that of the hills around Asolo? There are thus two areas of vision — that of the foreground with the figures, and that of the background, which provides an altogether new experience of landscape — separated by the dividing line of the velvet and the throne, almost as if it was difficult to find an appropriate solution.

There are a number of indications that the Castelfranco altarpiece represented a turning-point in Giorgione's art, of which he was dimly aware. He felt the need to overcome the duality of focus in his painting, which threatened the unity he tried to achieve. Here he sought a solution through the raising of the point of view — to which effect the device of

69. Longhi, 1946, 20, points to the possibility of inspiration from the works of Francia and Costa (Figs. 9, 11, 12).
70. Gioseffi (1959, 53) believes that the altarpiece was in fact surmounted by a lunette; while Castelfranco (1955, 300)

in a perspective study of the painting (Fig. 10), shows that Giorgione eliminated the right-hand side of the pedestal in order not to break into the profile of St. Francis.
71. Bordignon Favero, 1955, 81.

the step in the pavement also contributes — taking the figures onto the next level up. The formal arrangement of the composition is founded on a pyramidal structure which follows the divergent lines of sight of the Madonna and Child downwards to the base. The figures, united in this ideal framework, come to have a relevance for the whole space in the painting, which thereby gains a sense of unity. In the background the painter expresses himself in lyrical forms, in the shady groves, quiet streams, tranquil paths, leafy bowers and rustic buildings. This is the Arcadian world of Bembo's *Asolani*, inspired by his sojourns at Caterina Cornaro's country court, at a time when he in all probability knew Giorgione.

So this painting, which is central to Giorgione's development, combines a certain amount of compositional naïvety with notable figurative innovations. Bathed in an atmospheric rendering which no longer resembles the stage-set appearance of Bellini's compositions up to 1500, but is rather a fluid coloured space, the figures move with an assurance which anticipates the development towards the *Three Philosophers* and the *Venus*. The free movement of the forms comes to be dominated spontaneously by colour, which is no longer regarded merely as the infill of areas defined by linear elements or by the function of modelling, but rather as a product of the new sense of space, which has a liberating influence akin to that of blank verse in sixteenth-century poetry. That which for Antonello, Giovanni Bellini and perhaps most notably Vittore Carpaccio had been merely a 'premature' technical discovery — the implications of atmospheric effects and their alteration of tone values — becomes the principal means of expression for Giorgione in his Castelfranco masterpiece.

It is at this juncture, around the beginning of 1505, that in our opinion Carpaccio began to make a real impression on Giorgione's development. Carpaccio had then completed the St. Ursula series and most of the Schiavoni paintings, in which his use of colour had reached exceptional intensity of expression. It appeared as though the figures, and even parts of the figures (such as a multicoloured turban, a piece of red drapery or a sunlit wall) had gained an absolute and abstract value, as elements in an almost symbolist composition. On a technical level, Carpaccio had developed ideas present in Antonello's and Giovanni Bellini's work, and arrived at the new tonal quality of Venetian painting through the integration of half tones and light. It was probably this quality of tonal colour which struck Giorgione and showed him the way out of the constraint imposed by Flemish faithfulness to detail. From the *Judith* and the Castelfranco altarpiece onwards it is evident that he regarded his style as founded on atmospheric space for the rendering of nature. The lead given in this direction by Bellini was not sufficient, even in the *Allegories*, of which the finest is the one in the Uffizi (it may also date from the early years of the sixteenth century); his approach is still too measured, too rigid in its framework, and still dominated by the graphic value of chiaroscuro (Pl. 23).

The *Adoration of the Kings* in London (Cat. No. 6) seems to proclaim, all of a sudden, the whole range of colours of Giorgione's maturity. A horizontal composition, it quivers with bright blues, greens, deep reds and purple (Pl. 22). It would not be difficult to find echoes of the figures in Bellini's various representations of the Adoration of the Magi, or of the Madonna and Child; while the armed figures beside the elegantly saddled horses are reminiscent of Carpaccio's footmen in the *Triumph of St. George*, poised on their robust legs dressed in fashionable tights. But one only needs to see the gold highlights on their blue shirts, or the sudden reflection on a steel cuirass, to grasp the sense of real space, that is to say the impression of life in a dimension created by colour, which is Giorgione's exclusive gift.

Giorgione was certainly only continuing the tradition of small history paintings with a number of figures set in a landscape, established by Bellini and Carpaccio, in the series of works which can in our view be placed between the Castelfranco *Madonna and Child with Saints* (post 1504) and the *Portrait of a Lady* ('*Laura*') in Vienna (1506). This includes the *Trial of Moses* in the Uffizi (and its pendant the *Judgement of Solomon*), the *Adoration of the Shepherds* in Washington and, in all probability, the lost *Finding of Paris*.

The *Trial of Moses* (Cat. No. 7; Pl. 25) is the first genuine example of the series of 'small landscapes with figures' which continues with the *Adoration of the Shepherds* in Washington and works up to the *Tempest* and the *Sunset Landscape*. It is a field in which much of Giorgione's activity was concentrated, and it is also one which was consistent with the increasing interest in Arcadian literature and in a harmony between man and nature. A number of scholars date the *Moses* to the very beginning of Giorgione's career, and this is understandable, on account of the obvious lack of assurance in the figures, which clearly derive from Bellini although they have features which might be mistaken for Ferrarese, but for which the real explanation is Carpaccio. The primitive quality which the painting has is in our opinion due to the immaturity of Giorgione's experience of landscape, which predominates in this composition for the first time.

It is remarkable, and it shows the originality of Giorgione's borrowing, that he turned once again to German art, apparently employing naturalistic features that originate in Dürer's work, albeit probably from the interpretations made of the latter by Giulio Campagnola: tall poplars and leafy acacias, the rounded forms of ilexes, fan-shaped boughs with their stems and leaves carefully described. In 1506 Albrecht Dürer was in Venice and was about to begin the altarpiece for the church of San Bartolomeo, a few steps away from the Fondaco dei Tedeschi, where Giorgione was soon to work.

In any case, the figures of the *Trial of Moses* continue the style of those of the *Adoration of the Kings* in London, and the delicate lines of their faces are perhaps even more refined, with an attention to detail that may well show cognizance of Northern precision. The tones of the clothes, which alternate light and sombre, evince a broad and solemn rhythm which on its own justifies the attribution to Giorgione. It is also worthwhile noting that the landscape alternates between sections that are very precise (the trees much in Dürer's manner) and others which are softer, showing the reflections of a blue-green lake or the veil of mist on the distant hills. Castles and rustic abodes take their place naturally amidst grassy outcrops and steep slopes, reflecting a calm sunset light cast on the occasional shepherd or warrior, immersed as it were in philosophical contemplation.

The lyrical quality of the *Judgement of Solomon* (Cat. No. 8), the pendant in the Uffizi to the *Moses*, is substantially similar (Pl. 31). This painting has been the subject of considerable debate, and critics have not failed to point out the pronounced difference in quality, especially in the rendering of the drapery of the figures, when compared with its companion. For some this has implied the authorship of Campagnola or Vincenzo Catena, but in our opinion it would be a mistake to dismiss the attribution to Giorgione on account of these differences. The attribution becomes more realistic if we accept the hypothesis that the *Solomon* may date from a later period: in other words, that it may have been commissioned by the owners of the *Moses* as a companion piece at a later date. This would explain the dryer handling and the more emphatic lights of the landscape in the *Solomon*, which is reminiscent of the period of the *Tempest* and the *Sunset Landscape*. Of the figures in the *Solomon*, clearly

only the heads are by Giorgione, but they are very close to those in the *Moses*. It is possible that an unknown assistant who was still influenced by Mantegna (with also a hint of Carpaccio) could have completed the draperies with their rather heavy handling.

The highest point of this series of small landscapes is reached in the ex-Allendale *Adoration of the Shepherds* (Cat. No. 9) in the National Gallery in Washington (Pl. 35). It is true that there are many elements in it from Giorgione's early development, but we share the opinion of a number of scholars in regarding it as a relatively mature work, close in time to the Uffizi *Trial of Moses*. A fact which contributes to making a date around 1506 more certain is that Lorenzo Lotto made a virtual copy of the central part of the landscape view, with the stony, winding stream, in his altarpiece at Asolo with the *Madonna and Saints*, which he completed in that year (Pl. 39). There is no lack of Germanic elements, especially in the landscape with its great Dürer-like trees, while there is a hardly casual relationship between the wicker manger-guard behind the Child and the same feature in an engraving by Martin Schongauer of the *Madonna and Child* (Fig. 3). Besides, the ochre and brown ground with its white stones, the conveniently placed cavern and the green shrubs growing in the cracks are features which still recall the work of Bellini (72). But the whole setting is different from that of the *Holy Family* in Washington or the *Adoration of the Kings* in London. The landscape begins to play a dominant role, with the cavern in the foreground placed to one side so that the eye can follow on the other the recession of a view down a valley, channelled by streams which run amidst rustic dwellings and castle towers. The countryside is peopled by numerous little figures — pensive shepherds, the taciturn inhabitants of Arcady.

If we are to choose a moment in Giorgione's career for the lost *Finding of Paris*, which Michiel describes as among the artist's earliest paintings, we can take the *Adoration of the Shepherds* in Washington as a point of reference, and our dating of the latter must be reinforced reciprocally as not later than 1506 (Pl. 221). As is well known, a *Finding of Paris* (whose dimensions were approximately 149 x 189 cms) was in the collection of Archduke Leopold Wilhelm in Brussels, where Teniers made a painted copy of it and also a print after it; a painting in Budapest shows the right-hand part of the composition with the two shepherds (C 3). Thus it is easy to surmise that the original was actually by Giorgione: the composition shows a landscape with a curving river similar to that of the *Adoration of the Shepherds*, and the young Paris is virtually the copy in reverse of the Christ Child in that painting, while the shepherds in both wear identical costumes (73).

The date of 1506 which appears on the back of the *Portrait of a Lady* ('*Laura*') in Vienna (Cat. No. 10) is the second milestone in the chronology of Giorgione's work. As is well known, an unknown hand, but one which was sufficiently knowledgeable of Giorgione to describe him as a 'colleague of maistro Vizenzo Chaena' guarantees the authenticity of the painting and its date in an inscription which all scholars regard as genuine.

The presence of the *Laura* amidst the series of 'small landscapes with figures' would be anomalous if one did not take account of the fact that portraits were more liable to be mis-

72. The Tietzes, 1949, 12, attributed the *Adoration of the Shepherds* to Bellini with assistance from Titian, but this proposal found little support.
73. Although one must take into account what Michiel says, one should also point out that for him Giorgione's 'earliest paintings' were perhaps not relatable to the short span of his life, so that we could possibly be justified in dating this *Finding of Paris* even later. The greater role which landscape plays in its composition, and the more placid figure grouping, could even foreshadow closely the *Tempest* and the *Three Philosophers*. These masterpieces are in any case the logical outcome of the earlier 'small landscapes'.

laid over the course of time, by reason of their small dimensions and the lack of immedia-te appeal in their subject-matter. We learn from the sources that Giorgione painted many 'at the beginning'; but once again we cannot take this chronological reference literally, es-pecially as Vasari in making it was contrasting the early period with the 'modern style' of the artist's last years. The *Laura* must therefore be one of many portraits painted by Gior-gione in the intermediary period, all the more so if it represents an allegory of marriage, with the laurel and the bare breast symbolizing the virtues and the pleasures of marriage. Teniers's small copy of the portrait, in the painting in the Prado, in which the woman seems to be pregnant with a hand on her lap, suggests that Giorgione might have known of the composition of a famous Northern painting, the *Arnolfini Marriage* by Van Eyck (in the Na-tional Gallery in London). It is certainly true that there is in the *Laura* a certain resurgence of the 'localized' intensity of colour values that had characterized Giorgione's early style: in the red cloak trimmed with brown fur, which frames and enhances the sensuality of the bare flesh, and in the laurel leaves, whose silver-green stands out against the dark background and reminds us all of a sudden, almost joyfully, of the feeling of light, as it were a breath of fresh air. In other words, Giorgione does not forget nature, which is always an essential part of his art.

Beside the *Laura*, the *Portrait of a Young Man* in the Staatliche Museen, Berlin-Dahlem (Cat. No. 11) appears timid and almost fifteenth-century in character: its three-quarter-length format with a dark background and a parapet at the base recalls the portraits of Bellini (Pl. 46). But closer examination shows the new character of the space around the young man in his lilac shirt, who is motionless and yet living in the realism derived from colour. Can we guess in what direction Giorgione's art is moving? We can illustrate this through the simple comparison with Titian's so-called *Portrait of Ariosto* in the National Gallery in Lon-don (Pl. 122), remembering that its author had by that time already come into contact with Giorgione. Does not the 'jacket of silver satin' painted by Titian exploit the same freedom of expression as that of the Berlin *Portrait of a Young Man*, in which Giorgione surpasses the tradition of Bellini and Antonello (and that of the Flemish too) in no longer regarding the function of colour as being subservient to outline or to modelling? (74). Giorgione here achieves the full realization of his style, playing on the variation of atmospheric tones and preparing the way for Titian to achieve modelling through light and thus introduce a new approach to form.

Having achieved the expressive freedom of colour in its natural medium, it was logical that Giorgione should return to images taken from the open air, following the schemes present in Arcadian literature and in the philosophy of nature developed by neo-Aristote-lians in Venice and nearby Padua. These must at any rate have been the subjects of discus-sion in the intellectual circle to which Giorgione clearly belonged, in a participation that was at least that of a creative artist.

This would explain how after 1506 he returned, in all likelihood, to the painting of 'small landscapes with figures' which had occupied him previously for some time in the preceding two years. The *Madonna and Child in a Landscape* in Leningrad (Cat. No. 12) should in our opi-

74. Giorgione's creativity is even more surprising if one com-pares his achievement with that of a portraitist like Lotto, who was energetically in pursuit, in paintings like the *Bishop De' Rossi* in Naples (1505) and the sublime *Young Man with a* *Lamp* in Vienna, of the graphic and objectively defined realism of Albrecht Dürer. Although they started from similar cultural backgrounds, Lotto and Giorgione already differ profoundly. Cf. T. Pignatti, 1954, *passim*.

nion be dated to this period (Pl. 49). It does in fact retain some Gothic elements in the involved forms of the drapery, but the advanced quality of the colour and the harmonious unison that is achieved with the surrounding landscape is well in advance of the Washington *Holy Family* and *Adoration of the Shepherds*. We may note especially a flickering quality in the surface, which is the same as that of the laurel in the *Laura*: it almost amounts to a breaking down of the colour base under the impact of light, as if to absorb it.

How Giorgione envisaged light when he had reached his stylistic maturity is a question we should certainly pose, if we are to grasp the full depth of his understanding of nature. If we look back over his figurative development, we cannot but be struck with the importance it had for him from the very start. Even in paintings that are certainly very early, like the *Christ Carrying the Cross* in Boston or the *Madonna and Child* in Bergamo, one can detect the presence of this consideration, albeit modified by the references to works by Bellini or Flemish artists. A most important step in Giorgione's development is marked by his assimilation of the tonal innovations introduced by Carpaccio. From this moment onwards the incidence of light employed brings out the changing qualities of colour and enhances its local intensities. Gradually Giorgione realizes his own conception of space, and achieves the representation of atmospheric values. At this point, midway between the Washington *Adoration of the Shepherds* and the *Laura*, a more profound spiritual feeling takes the place of the 'devices' which had paved the way for it. Colour and light cease to play separate, adverse roles, and unite in a harmonious view of nature, which clearly has a philosophical and literary background. It is also clearly related to the understanding of nature of the German engravers.

The *Tempest* in the Accademia in Venice (Cat. No. 13) is a masterpiece which combines all the expressive qualities of Giorgione's style (Pl. 50). The image of nature is here translated directly into a pictorial image, which is made up solely of colour, the single element which now dominates the artist's style. We will return later to the various interpretations of the subject-matter of the painting, whose meaning is difficult to comprehend by reason of the obvious presence of a theme which initially determined the basic form of the composition. But it is in this very effort which the artist makes to unfold his poetic vision within, but also above, the limits of contemporary philosophic and literary culture, that the incomparable greatness of the painting lies. Whether it is merely the 'little landscape with the tempest, with the gipsy and the soldier' of Michiel's description, or whether Giorgione intended it as a Finding of Moses, with all the spiritual inferences of such a subject, it is nature alone that is the animating force that inspired the artist. A summer storm bursts at sunset above the towers of a little town, by which runs a stream. The bridge and the grassy outcrops are reflected in the greeny-blue water, and the thick foliage of the ilexes and acacias is shaken by a sudden gust, the leaves momentarily glistening in the light. The figures are as it were caught by chance, momentarily stilled in the fleeting light of the lightning flash. The spectator echoes some of the reaction within the image itself — the wonderment of the figure who stands amazed, almost stunned, before the spectacle of nature.

Once again, as in the case of the Washington *Adoration of the Shepherds*, Teniers's seventeenth-century copies provide evidence of an allied composition of a lost painting by Giorgione. This is the *Aggression* which was formerly in the collection of Archduke Leopold Wilhelm in Brussels (Figs. 45, 46). The dimensions given in the inventory are close to those of the *Tempest*, with which the composition is also linked through the figure of the

bather, which is almost the same (in reverse) as that of the figure shown in the X-rays to be under the present figure of the 'soldier' (Figs. 15-16). Apart from the formal similarity in the trees, it might also be said that the composition does share other qualities of the *Tempest*, on the same level of the reflection of human events in natural surroundings. Such must be the implication — so far as can be gathered from the copies — of the rifts in the clouds, burst asunder with flashes of lightning above the figure of the aggressor threatening the naked woman with his sword.

The fact that Giorgione painted a number of small landscapes with a few tiny figures in the foreground, is shown by the existence of a number of paintings, like the *Homage to a Poet* in London (A 22), and drawings such as those in the Schwarz or Boymans Collections (A 37, A 51) which can be associated with the artist's immediate circle, not to mention the innumerable imitations of his more distant followers (Pls. 147-8).

The *Young Shepherd in a Landscape* in Rotterdam (Cat. No. 14) provides a means of assessing Giorgione's approach to reality in nature, central to his art at this point (Pl. 53). The detailed and incisive handling of the red chalk shows a clear intent to grasp the objectivity of nature and the relative values of space, light and colour. A faint shading provides depth, while the few areas of cross-hatching obviously represent colour-values (75).

Since March 1508, as the diarist Sanudo noted, work had been in progress on the frescoes of the exterior of the Fondaco dei Tedeschi, which had then reached the final stages of its reconstruction. From the records of a suit heard by the *Magistrato al Sal* we learn the name of one of the painters engaged on this decoration: Giorgione, who was paid 130 ducats on December 11, having finished his frescoes on November 8.

In 1557 Dolce writes that Titian also took part in the work at the Fondaco 'when he was barely twenty' and that he had assisted in various figures on the façade towards the Merceria, among them a *Judith* that was admired so much that it was mistaken for a work by Giorgione, to that artist's great vexation. In the second edition of the *Lives* (1568) Vasari adds that Titian's commission was obtained through a Barbarigo who was a friend of his (76) when Giorgione 'had already painted the main façade', which most probably implies that Titian's frescoes were not completed until 1509 (77).

Of the Fondaco frescoes, which were almost completely ruined by saline decay and neglect, there survive only faint traces of Giorgione's *Standing Nude*, of the *Justice* (or *Judith*) with its frieze, and of a *Levantine* (78), both by Titian (V 35, 36). Fortunately Zanetti in 1760 made a precise description of the few frescoes that could still be seen, which he accompanied with illustrations of six figures, three by Giorgione and three by Titian. A print from Albrizzi's *Forestiere illuminato*, published in 1740 (Fig. 19) provides some idea of the decorative scheme (79). The frescoes were arranged in the spaces between the windows on the upper floors, and there were friezes at the mezzanine level and between each floor. It was thus a scheme

75. This is also the technique that Giulio Campagnola employed when engraving Giorgione's compositions (Cf. Fiocco, 1948, 28).

76. Titian had, 'when he was no more than eighteen', painted a portrait of Barbarigo, a work which many regard, in our opinion convincingly, as the *Portrait of a Man* (the so-called 'Ariosto') in the National Gallery in London (See under No. 31).

77. Gioseffi, 1959, 55, notes that the confusion over the *Judith* occurred 'as it was not known that Giorgione was no longer working there', and so after November 1508.

78. With regard to these frescoes, which were miraculously retrieved in 1967, see the account of F. Valcanover, 1967, 226. They were located over the main doorway.

79. Nordenfalk, 1952, 101 ff., makes important contributions to the understanding of the iconography of the scheme. For Treviso frescoes, see: Botter, 1956.

whose pattern depended on the architectural framework, which divided the representation up into a number of pictures in a manner that was new in Venice but familiar on the Venetian mainland and particularly for decorative friezes in the area round Treviso whence Giorgione came.

It is not easy to build up an impression of what the Fondaco frescoes represented as a whole. Vasari was obviously unclear at first, so much so that he describes the frescoes only as 'heads and parts of figures'. His impression on his second visit to Venice is worse still: he declares 'there are no scenes to be found there with any order ... and I for my part have never understood them, nor have I found, for all the enquiries I have made, anyone who understands them' (1568). This seems rather exaggerated, both by reason of what we can deduce from the surviving fragments, and also on account of the much less critical accounts provided by Ridolfi and Zanetti, who apart from the *Judith* mention *Geometricians measuring a Globe*, while Van der Borcht's engraving shows an *Allegory of Peace*.

All the writers who had the good fortune to see Giorgione's frescoes while they were still in a reasonable state of preservation were struck by their colour. Vasari describes them as figures that were 'very brightly coloured', and this is enlarged upon by Zanetti, who says that they were 'sanguine and fiery' in hue, having almost 'a great fire ... glowing in the strong shadows and in the heavy redness overall'.

Very little of all this is apparent from the pale shadow that is all that remains of the *Standing Nude* (Cat. No. 15) detached from the Fondaco and now in the Gallerie dell'Accademia in Venice (Pl. 56). But it cannot be denied that it corresponds with Zanetti's description in its dark carmine shading around the hollows of the eyes and in the fleshy red of the breasts (Fig. 18). This was then the extent to which Giorgione had developed the 'modern style' to which Vasari refers in his 1568 edition: '...then, around 1507, he began to endow his work with greater softness and relief with beautiful style; giving prominence nonetheless to living and natural things, counterfeiting them as best as he was able through colours, mingling them with dashes of raw and gentle hues, just as he saw in life, without drawing beforehand; being of the firm conviction that painting with colours alone, with no preparation of drawings on paper, was the true and best method and the real way to design' (80).

Another novel feature about Giorgione's figures for the Fondaco was their larger-than-life size, and their background of classical architecture. For the sources refer to 'views with columns' in the Fondaco, while Zanetti's engraving shows the *Seated Woman* above a spherical feature (81). So the decorative schemes involved represent an innovation, for which various sources of inspiration have been suggested, from contemporary sculpture (in the form of the great funerary monuments in churches by Lombardo and Rizzo) to suggestions from or drawings by Tuscan masters, such as Fra Bartolomeo, who was indeed in Venice in 1508 (82). All this provides some explanation for the inescapable change of direction in Giorgione's art, which in the Fondaco frescoes develops almost as a contrast to the phase of 'small landscapes with figures'. But we should perhaps add that, if more of the numerous frescoes which Giorgione painted on Venetian palaces had survived, those of the Fondaco might not appear so exceptional. Giorgione may well have begun to develop his 'decorative

80. Vasari, 1568, VII, 427.
81. The form of the *Judgement of Solomon*, by Sebastiano del Piombo but attributed to Giorgione in the past, probably takes up the theme of a prospect of columns 'with figures within' from the Fondaco.
82. Richter, 1936, 61; Wilde, 1933, 116.

style' — as distinct from that of his easel paintings — before 1508, even though the element of colour moves in both categories at the same pace. Finally we should note that studies of the nude and the pursuit of the monumental beauty inherent in the human form were features that were common among artists at the beginning of the century, and did not belong exclusively to Giorgione. Even if only in representations of St. Sebastian, the rendering of the human nude was practised by nearly all late fifteenth-century artists; we should also pay particular attention to Dürer's many exercises in this field that were executed and indeed dated by him during the period of his stay in Venice from 1506 to 1507 (Albertina, British Museum, Berlin, Pl. 54). There are precedents for these in Dürer's own prints (like the *Four Witches*, 1497; the *Dream of the Doctor*, 1497-8; the *Adam and Eve* of 1504) and in those by Jacopo de' Barbari. There was thus no lack of examples of monumental nudes, and Giorgione must have borne them in mind as he worked in the new dimensions of fresco painting at the Fondaco.

But were the Fondaco frescoes so 'monumental' that this quality threatened the coherence of his style, as had occurred when Giorgione progressed from the intimacy of his Arcadian style? This is the right place to pose such a question, for after the Fondaco Giorgione's work (in the sequence we have given it) shows some reversals and uncertainties especially with regard to this quality of monumentality. Furthermore, it was certainly around the period of the Fondaco frescoes that Giorgione's contact with Titian became closer — a key factor in the consideration of the last three years of the former's life.

Zanetti, who saw what remained of the frescoes on the Fondaco towards the middle of the eighteenth century, provides the most reliable and perceptive account of them, and a re-reading of it provides some of the answers to our doubts. The greatest achievement of Giorgione's style is described as its *'artificious handling* of the shadows, arranged, shaded, reinforced...' and he occasionally excelled in a 'great fire ... a heavy redness overall'. Titian on the other hand excelled in realistic effects, which he achieved through the use of 'half-tones and contrasts, to realize that *natural tenderness* in the flesh' (83). Giorgione's artificiality is thus contrasted with the naturalism of Titian. Zanetti is definite on this point, and it lends weight to the doubts expressed above. From 1507 onwards Giorgione sought, through the 'modern style' which the Fondaco frescoes illustrated, to develop his style consistently in the direction of the 'naturalistic' and the 'monumental'. But he did not wholly achieve these goals, and he remained bound to the literary and formal limits of his Arcadian culture, which Titian on the other hand was already boldly overstepping (84). This provides an explanation for the re-appearance of some earlier features in the Oxford *Madonna with a Book*, the *Three Philosophers* and the *Sunset Landscape*, which on stylistic grounds (in their use of colour 'without drawing') are still close to the Fondaco frescoes.

To support the accuracy of the distinction Zanetti makes, let us compare what survives of Giorgione's and Titian's frescoes from the Fondaco — the *Standing Nude* and the *Judith* (which should rather be regarded as an 'Allegory of Justice'). While the attraction of Giorgione's painting lies in its suggestion of the flaming quality of colour, almost in the form of an abstract symbol, Titian's work has the full impact of relief, rendered in fluent brush-strokes — a very tangible presence firmly placed in its architectural setting (Pl. 245). The structural elements (such as the step and the balcony) lose the artificial character that the

83. Zanetti, 1760, VI, VII.
84. In which Titian already triumphed, in the Portrait of a

Member of the Barbarigo family, shown as Vasari describes (1568, VII, 428), in a wonderful silvery jacket.

niche and the stair have in Giorgione's frescoes, and are instead disposed more realistically, containing the strong relief of the figure (here we have the 'contrasts' cited by Zanetti). The monumentality which Titian's work shows here foreshadows the broad realism of his *Portrait of a Member of the Barbarigo family* and his frescoes in Padua, of 1511, which were to mark, only such a short time later, his complete severance from Giorgione's manner in spite of his earlier dependence on it.

Confirmation of the uncertainty of Giorgione's acquisition of monumental scale — around 1508 — is provided by his friezes with the *Attributes of the Liberal and Mechanical Arts* in the Casa Marta Pellizzari at Castelfranco (Cat. No. 16) (Pls. 57-73). From an examination of the high quality of the detail of the east wall (which became possible only following the 1955 restoration) it is our conviction not only that a substantial part of the frescoes are by Giorgione, but also that they should be dated much later than has previously been suggested; that is to say instead of being among his earliest works they should be thought of as contemporary with the frescoes at the Fondaco. The feature of the inscribed tablets surrounded by flowing ribbons is similar to that of Titian's recently discovered frieze from the Fondaco (Pl. 246), and it would seem difficult to dissociate the bearded heads in the frescoed medallions from the *Three Philosophers* in Vienna. The subject-matter itself, which is based on a complex programme of 'philosophy through images' on the theme of human frailty and the exaltation of virtues, is more consistent with the period of the *Tempest* or the *Three Philosophers* than with Giorgione's early style, when he sought to avoid the more 'difficult' themes suggested by his intellectual friends (85).

The *Madonna with a Book* in Oxford (Cat. No. 17), which many regard as an early work, should in our view be dated in this period of 'reminiscences', which themselves sometimes reveal an unsure hand (Pl. 83). This date is suggested above all by the colour, which is used 'without drawing', especially in the Madonna and in the view to the left of the green velvet curtain which forms the rest of the background. The underlining of the 'strong shadows' in Mary's face is precisely the same as we find in the *Standing Nude* from the Fondaco, with glowing strokes of carmine showing through the flesh-pink and umber, which resolves itself in a palpable gentleness that has an almost caressing quality (such as we find soon afterwards in the *Venus* in Dresden).

The *Three Philosophers* in the Kunsthistorisches Museum in Vienna (Cat. No. 18), which is one of Giorgione's most important works, should also in our opinion be dated to the period around the Fondaco frescoes (Pl. 87). It shares with the *Madonna with a Book* a similar handling of the colour, which is in places contained by a very sensitive graphic outline (especially in the wide area of drapery) and in others mingles with subtle shading 'with dashes of raw and gentle hues'. We can easily recognize Giorgione's intention here of integrating the 'monumental' scale of his figures with the lyricism of his landscape format. But he does not appear to rely on a wholly self-sufficient compositional framework based on the figures, nor does he link it artificially to natural elements. The three Philosophers — the old one purple and gold, the middle one red and blue, and the young one green and white — are arranged in space primarily through the juxtaposition of colour tones. These are modified by the bright colours of the foreground, which accomodate themselves gradually to the sur-

85. Mariuz (1966), who deals with the interpretation of the frieze in depth, confirms that Sacrobosco's *Sphaera Mundi* (1488) and Colonna's *Hypnerotomachia Poliphili* (1499) are points of reference for the subject-matter. This latter date is obviously too close for a dating of the frescoes to the beginning of the century.

roundings; in this way the dark green of the young man becomes more and more 'natural'. The consciousness of 'foreground colour' in the three Philosophers is evident from the artifice of the play of light, which is extremely realistic in its detail while at the same time its overall impression is wholly abstract. It registers its full impact on the robes, which are struck as it were by the 'solar rays' which come from the left (86); but at the same time the sun rises at the end of the valley, above the hills, in a golden glow. The 'figures' have thus not been wholly reconciled yet with the 'landscape' in Giorgione's painting, and he resorts to a dualistic solution, which does not, however, impinge on the poetic harmony which the work achieves through the atmospheric fusion of tones.

Scholars have been arguing over the meaning of the *Three Philosophers* for the last fifty years, proposing a variety of readings, which will be listed later. But it is in our opinion interesting that more weight is now being given to the old title, which dates back to 1525 when it was mentioned by Marcantonio Michiel, who was close to the tradition from Giorgione's own circle of friends: namely that the painting is intended as a representation of the philosophical and scientific currents of his day in allegorical form. While it is difficult to determine the specific identity of the figures, one is surely right in seeing references to the currents of philosophical thought represented by the Aristotelians, the Arabians and contemporary humanism. But it is important to remember that the painting also has a profoundly lyrical side, and that it is perhaps the masterpiece of the 'modern style' after the Fondaco frescoes, and one which achieves this integration without sacrificing Giorgione's instinctive genius for landscape.

This finds further expression in the *Sunset Landscape* in the National Gallery in London (Cat. No. 21), which represents in a way the culmination of Giorgione's series of 'small landscapes' and shows the full measure of his vision of nature (Pl. 99). Here too, in the tranquillity of a solitary valley, Giorgione achieves a poetic fusion of the human figures and the mysterious dark green shadows of the woods and hills, on which the light is gradually fading. The last rays of sunlight bring a sudden brightness to the white clothes of the figures in the foreground, just as in the *Three Philosophers*. The soft handling of the background, which is slightly veiled by a mist which seems to rise from the still water, endows the whole painting with an atmospheric unity. The eye can barely perceive the details of the blue hills, but the impact of the landscape is just as great there, imbued as it is with that sense of a country idyll for which Giorgione has always been famous.

This supreme harmony between the human element and nature which is achieved in the *Three Philosophers* and the *Sunset Landscape*, finds its fullest expression in a work which is symbolic of virtually the whole of Giorgione's career — the *Venus* in Dresden (Cat. No. 23). In this canvas too there is a touching harmony between the figure and the landscape, which are unified by the coloured space that forms the foundation of its infinite appeal (Pl. 103). But there can be no doubt that the relationship is in reverse here compared with the 'small landscapes' Giorgione had painted up to this point. Here the form of the young woman, naked and relaxed in sleep, limpid but full of all the subtle attractions of a Hellenistic marble statue, fills almost the whole space. This is no 'small landscape with figures' but rather the figure of 'the naked Venus, asleep in a landscape' as Michiel described her after seeing the painting in Casa Marcello in 1525. As a result, it matters little if 'the landscape and the Cupid were finished by Titian' since there can be no doubt that Giorgione's

86. This is how Michiel describes the painting, which he saw in Taddeo Contarini's house in 1525.

original composition included both the figure and the landscape in the same spatial relation-
ship as we now see them, even though a part of the execution may well have been
rearranged by Titian.

In recent years, there have been those who regard Titian's part in this painting as sub-
stantial, and for some he is the painter of the whole figure of Venus. In our opinion too
the work is predominantly the work of a single artist, because of its exceptional unity. But
this is surely Giorgione, with the experience of large-scale figures on the Fondaco finally
realizing a satisfactory formula for their combination with a landscape in which they can
dominate. That this is symptomatic of a crisis that was provoked by the creative energy of
Titian has already transpired to a certain extent from the contrast between the two artists'
work at the Fondaco. There are no documents to support this view, but perhaps it was not
irrelevant that Giorgione had to sue the Fondaco for payment in 1508, when he finally re-
ceived 130 ducats instead of the 150 which the experts assessed he should be awarded (87).
And why was the *Venus* in Casa Marcello left unfinished, although it does not seem styli-
stically so advanced that its interrupted completion could be attributed to Giorgione's death?
These are questions which could probably only be answered by Titian, who was now not
so much Giorgione's pupil as his rival; his temperament was certainly one which led him
to dominate, just as he was in the course of a few years to take the lead in Venetian paint-
ing. Concrete proof of this situation is indeed to be found actually in the *Venus* itself, in
those areas where Titian's hand is discernible — in the pictorial handling of the cushion
and the cloth, which are full of rich and loud colour, rather than in the landscape element.
There is a genuine break here with Giorgione's pastoral idyll, whose intensity and lyrical
abandon is somewhat diminished as a result.

At this point the separate positions of the two artists seem relatively distinct. On the one
hand Giorgione is attempting to show the human figure on a monumental scale, prompted
by Titian's ideas at the Fondaco, but he does not lose sight of the lyrical purity of his style
and of its basic affinity with nature. On the other hand Titian places emphasis on contrast,
discovers the potential of colour as a means of showing depth and exploits light as a dra-
matic element. Titian already foreshadows the great art of sixteenth-century Venice, while
Giorgione is still timid and veiled with melancholy, almost as if modesty prevented his art
from expressing itself too loudly. One might almost say that it was the slender and Arca-
dian vision of Bembo contrasted with the world of architecture and bright colours repre-
sented by Ludovico Ariosto.

The mystery of the unfinished *Venus* casts some light on the profound crisis which — in
our opinion — overtook Giorgione's art in the period 1508-10, when he was working in
rivalry with Titian. In the main, we can only grasp the nature of the contrast between them
through intuition. But it should not be impossible to find further signs of it in the later
works of both artists, particularly in paintings over which there is critical disagreement:
the *Pastoral Concert* in the Louvre, the *Christ and the Adulteress* in Glasgow, the *Concert* in
the Pitti, the *Christ Carrying the Cross* in San Rocco, the *Madonna and Child with Saints* in
the Prado.

From this study of their works of certain authorship it is possible to conclude that after
1508 the roles of the two artists were reversed. No longer the teacher, Giorgione was drawn

87. See below in the Sources (1508) for a transcription of the Bastiani and Vittore di Matteo.
documents relating to this, with the assessment of Carpaccio,

towards Titian's new manner as he saw it in the *Dead Christ* (Cat No. 25): it even had an impact on his drawing style, making it more consistent, with a stronger handling and chiaroscuro, such as we see in the *Head of an Old Man with a Beard* in Zurich (Cat. No. 19), the *Philosopher* at Christ Church (Cat. No. 20) and the *Jupiter and Callisto* in Darmstadt (Cat. No. 22). But he did not succeed in finishing the *Venus* and the *Dead Christ* and in the end they had to be 'retouched' by Titian. So far as the drawings are concerned, most writers have tended to give them to Titian instead (Pls. 95, 98, 102). Nor is this all, for Titian also rivals Giorgione directly in the genre of 'small landscapes' with the *Stories of Adonis* in Padua and the *Orpheus and Eurydice* in Bergamo; in the field of portraiture, with his Portrait of a Member of the Barbarigo family (which is perhaps the so-called *Ariosto* in London), the *Male Portrait* in the Metropolitan Museum in New York, the *Knight of Malta* in the Uffizi and the *Concert* in the Pitti. He then turns paradoxically 'Giorgionesque' in the *Madonna and Child with Saints* in the Prado and the *Gipsy* in Vienna, even counterfeiting Giorgione's style altogether in the *Pastoral Concert* in the Louvre and the *Christ and the Adulteress* in Glasgow. The chronology of this rivalry between the two artists is very difficult to establish on account of the scarcity of documented facts. The first certain date in Titian's career comes in fact after Giorgione's death with the frescoes at the Scuola del Santo in Padua, of 1511. But some artistic situations lie beyond the circumstances of time and place — experience shows that intuition alone can penetrate them. Giorgione must at any rate have been profoundly influenced by Titian, to an extent that may have inhibited him from completing real masterpieces like the *Venus* or the *Dead Christ*.

But it is time that we returned to the narrative — leaving the discussion of individual problems to the Catalogue — so that we do not lose sight of the personality of Giorgione himself, who in the meantime, after the *Venus*, clearly continued to take up new ideas and resort to new pictorial solutions. The Praxitelian gentleness of Venus's face is indubitably echoed in the *Boy with an Arrow* in Vienna (Cat. No. 24), whose tender red robe over an embroidered shirt recalls the colours of the *Three Philosophers* (Pl. 106). The soft, shaded colour makes extensive use of half-tones, almost as an answer to Titian's manner, in which, we learn from a description of the Portrait of a Member of the Barbarigo family, 'the hairs were so distinct the one from the next, that they could be counted' while the most dramatic effect of the painting was represented by the 'great jacket of silver satin', which with the effect of light must have absorbed all the spectator's attention.

The same softness of handling is visible through the massive 'retouching' undertaken by Titian in the *Dead Christ* in New York (Cat. No. 25) in those areas which are thought to have been painted by Giorgione (Pl. 107). In particular, the face of the angel holding Christ's powerful form repeats the features of the Venus with its 'gentle oval that gradually and imperceptibly becomes narrower towards the chin...' (88). Certainly the *Dead Christ*, dominated by Titian's repainting to an extent where it becomes virtually his own creation, represents further confirmation of the unfavourable situation in which Giorgione found himself immediately after 1508; there can be little doubt, despite what we know of his nature, that his part was that of the loser.

The new reading we are proposing, with the date 1510, of the inscription on the reverse of the *Portrait of a Man* in San Diego (Cat. No. 26), enables us to group together a number of

88. Castelfranco, 1955, 304, associates the physiognomies in these two paintings with the two Apollo heads which were in Venice in the Grimani collection of marbles, and which Giorgione might have taken as models of idealized beauty.

late works which all probably date from the last year of his activity: the *Shepherd Boy with a Flute* at Hampton Court, the *Portrait of an Old Woman* ('*La Vecchia*') in the Accademia in Venice, the *Three Ages of Man* in the Pitti, the *Christ Carrying the Cross* in San Rocco, the *Portrait of a Venetian Gentleman* in Washington and the lost *Self-Portrait dressed as David*. Giorgione seems here to meet the challenge posed by Titian, and to achieve in his 'final style' a sort of twilight naturalism that is an easily recognizable common feature in this whole group of works, which was interrupted by his premature death.

The melancholic gentleman in San Diego is very appealing on account of the openness of his humanity (Pl. 109). But it does seem strange that, compared with the *Portrait of a Young Man* in Berlin, Giorgione should have returned to the somewhat archaic Northern formula of placing his sitter in a very dark habit against a plain dark green curtain. The painting differs from the portraits of Antonello and Bellini in that Giorgione views his sitter from close up, limiting himself virtually to the face; and there can be no doubt that this compositional solution is the formal result of the artist's intention to make his portrait more penetrating and more immediate. The colour too, here used in unusual admixtures that are widely toned even though there is still a graphic foundation, gains a rapid, almost summary impression. This last phase, which we could call Giorgione's 'new realism', is neither a realistic representation nor an artificious creation; both of these are on the other hand fullfilled by Titian, for instance in his *Portrait of a Man* (the so-called '*Ariosto*') in the National Gallery in London, which is extremely 'real' but at the same time assumes the ideal form of a whole category (Pl. 122).

So Giorgione undergoes a renewal during the period characterized by the San Diego *Portrait of a Man*, but this does not involve a rejection of his original artistic premises; he still remains punctilious in his rendering of colour in a way that echoes his apprenticeship with the Bellini and his enthusiasm for Flemish artists. As a result, it would seem mistaken to attribute to him works like the *Singers* in the Borghese Gallery in Rome or the *Mocking of Samson* in the Mattioli Collection in Milan (A 47-48, 28), which seem to have no contact with the essential characteristics of Giorgione's style still apparent in the 1510 portrait, possibly one of his last works.

The *Shepherd Boy with a Flute* at Hampton Court (Cat. No. 27) also belongs to Giorgione's final period, and it is interesting to compare it with the *Boy with an Arrow* in Vienna, in order to make a direct assessment of Giorgione's stylistic development from the period of confrontation with Titian's work around 1508 to the new realism around 1510 (Pl. 110). The beautiful oval of the boy's face appears almost out of focus against the veiled shadows of the background. Here the colours are more fluid and in a sort of pictorial shorthand are broken down by the incidence of light in a manner that is typical especially of the hair in the San Diego *Portrait of a Man*; it is a technique which gives an immediate impression of reality.

The central and right-hand figures of the *Three Ages of Man* in the Pitti Gallery (Cat. No. 28) are also rendered in this same loose brushwork (Pl. 111). One is also struck by the realistic handling of the face of the old man, which is lined with deep furrows that hold the shadows. As is well known, the painting (whose high quality is still evident despite its disastrous state of conservation) has often been attributed to Bellini, but such an impression can easily be traced back to the origins of Giorgione's art; this reversion is his way of re-establishing his autonomy in the face of the progress Titian had made.

There can have been but a short interval of time between the painting of the troubled face of the old man and the almost anguished features of the *Portrait of an Old Woman* in the Accademia in Venice (No. 29; Pl. 118). Giorgione must have painted her from the life during one of his visits to his native country around Treviso. The painting represents the highest point of the artist's 'new realism', and certain elements from Dürer's *Avarice* (Fig. 33) in Vienna are not foreign to it. But there is no reason to seek biographical meanings for a work which achieves its whole effect in the application of colour. There are in fact four shades: the violet and white of the clothes, the brown of the face and the green of the marble parapet. This economy in the use of colours is one of the characteristics of Giorgione's late style (this is yet another feature which distinguishes his hand from Titian's, who uses a much richer and more varied palette): the *Three Ages of Man* is also founded on four hues — red, orange, dark green and the ivory colour of the faces. The same type of bland interior light permeates both paintings, penetrating the structure of the colours and softening their outward appearance, moving towards an *impasto* technique that sometimes foreshadows the work of the late Rembrandt.

In the *Christ Carrying the Cross* in the Scuola di San Rocco in Venice (Cat. No. 30), the colour becomes almost monochrome, with a whole range of washes from a grey-white to violet: the flesh has once again the burnt colour of the *Portrait of an Old Woman* and the *Three Ages of Man* (Pl. 116). The contradictory nature of Vasari's comments about this painting — he gives it at first to Giorgione but later mentions it as by Titian — has been the principal cause of the controversy surrounding it, and has exaggerated the difficulty of attributing it to one or other of the artists. A work which is also incidentally famous as a religious image, its quality of realism places it in our opinion among Giorgione's last works, in the year 1510. And it was probably precisely on account of the fact that there was no time for the establishment of a tradition of Giorgione's authorship — since he had died in the meantime — that doubt was quickly cast on it, and it would have been associated with Giorgione's 'unfinished' works, like the *Venus* or the *Dead Christ*. But the *Christ Carrying the Cross* cannot today be regarded as by any other than a single hand. Consequently, even though we can see that Titian employs the same compositional arrangement in his frescoes in Padua, these obviously possess a much more aggressive handling of colour and line so that it would be impossible to attribute both works to the same hand at the same period (Pl. 117).

Certainly, as Giorgione's life moved towards its close, Titian's increasing activity must have become an obsession once more. We should not perhaps accept literally what Dolce (1557) says, namely that Giorgione after his displeasure over Titian's *Judith* 'stayed several days indoors, in despair'; nor Vasari (1568), who would have us believe that Giorgione 'did not want Titian to associate with him or be his friend any longer'. But we cannot ignore the drama and possible truth of an episode narrated by someone who could have heard it first-hand from Titian himself. Nor should we be so naïve as to think that Giorgione's resentment stemmed only from the confusion over the Fondaco frescoes. The reasons for their differences must have been unlike those pointed to in the historical anecdotes. Giorgione was perhaps once more on the point of distrusting his own abilities — having tried in the *Venus* to beat his rival on his ground, he achieved an uncertain balance in his last period but remained prone to recurring crises, of which we can detect traces here and there in his work.

The *Portrait of a Venetian Gentleman* in the National Gallery in Washington (Cat. No. 31, Pl. 119) represents, in our way of thinking, yet another over-reaction on Giorgione's part to Titian's portrait style such as we see in the London *Portrait of a Man*. In this particular light we would like to cast doubt on the almost universal attribution of the painting to Titian, and advance the authorship of Giorgione, at the end of his life, the result of his final confrontation with Titian. There are a number of considerations which support this view (for a detailed discussion of the problem see the Catalogue entry). Seen in the context of Giorgione's 'new realism', the *Portrait of a Venetian Gentleman* takes its place easily beside the *Portrait of an Old Woman*, whose formal scheme it repeats precisely, and beside the *Three Ages of Man*, which it closely resembles in its psychological analysis. On the other hand, comparison with other portraits by Titian of the type of the London *Portrait of a Man* is not conclusive, because they are not dated. But if one were to insist on regarding it as belonging to the series by Titian, the *Portrait of a Venetian Gentleman* should necessarily be the first, and therefore be a product of a period when the artist's style was indistinguishable from that of Giorgione. But we do know that contemporaries always made a sharp distinction between their styles: the sources also confirm (Zanetti, 1760) that the frescoes on the Fondaco were painted in two very different manners.

Included at the end of Giorgione's list of works, the Washington portrait finds itself inevitably in company with the San Diego *Portrait of a Man*. Its compatibility with this painting seems to have been one of the most significant results of the 1962 restoration, which revealed an entirely similar modelling, with superficial colour glazes on top of a sound graphic foundation, which comes into prominence in details like the hand and the book, or the pronounced features of the face.

We have said nothing of the psychology of the sitter that emerges from the dramatic 'pose' he has adopted, his fist clenched and firmly planted on a closed book. We must admit that these features point superficially in favour of Titian's hand; up till now they are foreign to Giorgione's work, even though the realism of the *Three Ages of Man* or the *Portrait of an Old Woman* foreshadows this development. But we should make a further comment here, and one which may appear at first sight a little specious. How can we arbitrarily determine what the final point of Giorgione's career was? How can we decide whether his last style is to be seen in the *Venus*, the *Christ Carrying the Cross*, the *Portrait of an Old Woman*, the *Three Ages of Man* or the San Diego *Portrait of a Man*? A cursory perusal of the most respected monographs, all offering different solutions, shows the wide degree of latitude that exists here. It follows that, in this instance of a young painter whose life came to a sudden end at the height of his activity, some inconsistencies are inevitable — an account founded on too close a reading of style would be arbitrary and false.

Bearing in mind the stylistic continuity, some psychological discrepancy between the *Portrait of a Venetian Gentleman* and the melancholy *Portrait of a Man* in San Diego is therefore quite acceptable. This interpretation is supported also by the evidence of a number of copies of lost works, whose originals must have been by Giorgione: the *Orpheus*, known through the print after it in Teniers' *Theatrum Pictorium* (1658) and the same artist's copy in the Suida-Manning Collection (Figs. 50, 51); the *Judith* also reproduced in the same publication, and known also through a copy painted by Catena in the Querini Stampalia Collection in Venice (Figs. 48, 49); and the famous *Self-Portrait dressed as David*, which existed originally in probably two versions, now known through the copies in Brunswick

and Budapest (Pls. 214, 220). In all these paintings — in the romantic pose of Orpheus, the airy space of the *Judith*, the murky shadows of the *Self-Portrait* — there are indications of stylistic development which by the criteria usually applied in the instance of the Washington *Portrait of a Venetian Gentleman* would be described as Titianesque. But in these instances the name of Giorgione — as the inventor at least of the originals — is accepted.

There must thus have been, in the last days of Giorgione's life, a time when he was for ever facing up to the rivalry of Titian, a phase of which the Washington portrait is perhaps the sole example. It provides a pointer to the direction Giorgione's art would have taken had he survived, as Titian did, the plague of 1510. Quite a thought, that: if sixteenth-century Venetian painting had been miraculously allowed to benefit from both these geniuses, and if the fruitful exchange between them had continued a few years longer.

Unfortunately the critical discussion revolves instead around the activity of Giorgione's followers, *creati* as Vasari calls them, of whom the first are Titian, Sebastiano del Piombo and Palma Vecchio. As we have already had occasion to observe, some of the early work of these artists is tied up — sometimes inextricably — with that of Giorgione himself. The results of their contact with Giorgione's art are discernible for many years, and here we see the extent of the impact he made on his contemporaries. For Titian this involved a phase which lasted well into the second decade of the century, first with the 'retouching' (*reconzatura*) of Giorgione's works, then the 'imitations' and finally the 'variations' which are almost completely independent, ending perhaps in the *Sacred and Profane Love* in the Borghese Gallery in Rome (Pallucchini, 1969). For Sebastiano Giorgione's influence is relevant to those works he executed in Venice: after he moved to Rome in 1511 he came under the spell of Raphael (just like another Venetian, Lorenzo Lotto) and emerged with a transformed style. For Palma, it extends to the whole series of little works in the Giorgionesque vein, pastoral pieces, Holy Families and portraits, which he continued to paint until around 1515, when he came under the influence of Titian.

The detailed study of these questions, even though they have been taken into consideration, has no place in this *catalogue raisonné* of Giorgione's work. It would indeed enter upon the field of the 'Giorgionesque' — a subject substantial and attractive enough to merit being dealt with separately. Here it suffices to make occasional references to this field, where the attributions made in our Catalogue have called for it. Certainly it constitutes an almost unique occurrence in the history of art that alongside a single artistic personality — even taking Giorgione's greatness into account — there should have sprung up so many others who where dominated by his style or at least drew upon it. One has only to think of his closest assistants, like Morto da Feltre or Torbido; of his 'colleague' Vincenzo Catena; of the mysterious Mancini; or of portraitists like Cariani or Licinio, whose work is difficult to unscramble. Looking to a later period, we can see the ramifications of the 'Giorgionesque' among artists around Treviso, in the work of Bordone, in the Friuli with that of Pordenone, at Ferrara with that of Dosso and Garofalo, at Brescia with that of Romanino and Savoldo. The history of the Giorgionesque makes involved reading, complicated as it is by the visits of many artists to Venice, a city which emerged more and more, through the name of Giorgione, as the principal centre of painting in Northern Italy during the early years of the sixteenth century.

1. *View of Castelfranco*. Seventeenth-century print

2. G. ZAISINGER: *Madonna at the Fountain*. Engraving. About 1501

3. MARTIN SCHONGAUER: *Madonna and Child*. Engraving. 1475-80

4. P. CHEVALIER: *Giorgione's house at San Silvestro*. Lithograph. 1838

5. TOINETTE LARCHER: The *Judith* before it was cut at the sides. Engraving. 1729

6. GIULIO CAMPAGNOLA: *Saint John the Baptist* (detail). Engraving. About 1515

7. MARTIN SCHONGAUER: *Saint Agnes*. Engraving. About 1475

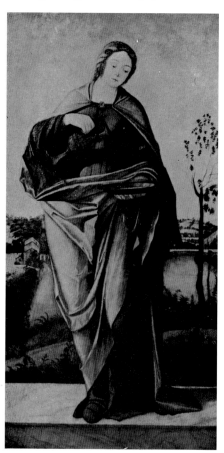

8. CARPACCIO: *Temperance*. Atlanta, Georgia, High Museum of Art (Samuel H. Kress Collection)

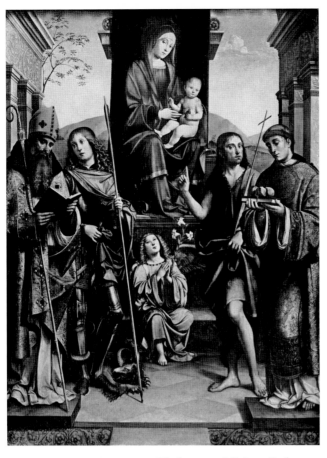

9. FRANCESCO FRANCIA: *Madonna and Saints*. Bologna, Pinacoteca

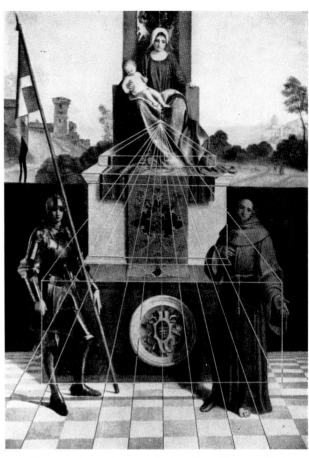

10. Perspective scheme of the *Castelfranco Madonna*. (After Castelfranco, 1955)

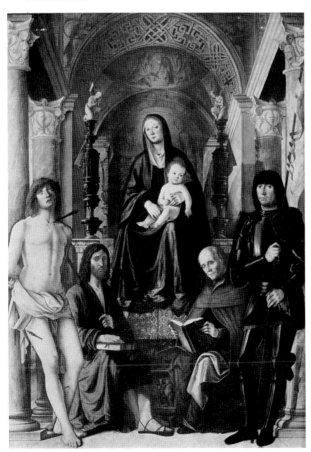

11. LORENZO COSTA: *Madonna and Four Saints*. Bologna, San Petronio

12. LORENZO COSTA: *Saint Petronius enthroned with Saints Francis and Dominic*. Bologna, Pinacoteca

13. LEONARDO DA VINCI: *Christ*. Drawing. Windsor, Royal Library

14. DAVID TENIERS THE YOUNGER: Gallery of the Archduke Leopold Wilhelm. (Detail with the *Laura*). Madrid, Prado

15. Reconstruction of the first version of *The Tempest*. From Morassi, 1962

16. X-ray of the *Nude* in *The Tempest*. Venice, Accademia

17. Inscription dated 1506 on the verso of the '*Laura*'. Vienna, Kunsthistorisches Museum

18. *The Nude from the Fondaco dei Tedeschi*. Venice, Accademia

19. *The Fondaco dei Tedeschi in 1740*. Engraving

22. Original position of the *Nude* by Giorgione on the Fondaco dei Tedeschi. From Foscari, 1936

20. Fra Bartolomeo: *Saint Stephen*. Florence, Uffizi

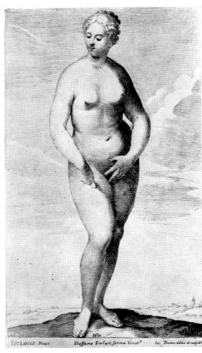

21. Jacopo Piccino: *The Nude by Titian on the Fondaco dei Tedeschi*. Engraving

23. Anton Maria Zanetti: *Remains of fresco of two Ladies by Titian on the Fondaco dei Tedeschi*. Engraving

24. Reconstruction of the first version of *The Three Philosophers*. From Wilde, 1933

25. Copy of *The Three Philosophers*. Engraving from David Teniers, 1658

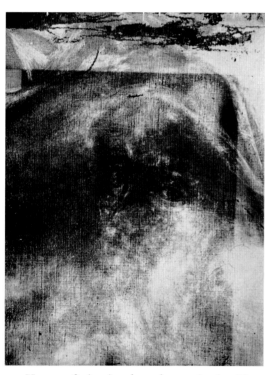

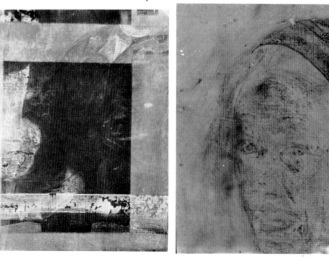

27. X-ray of the head underneath the Vendramin *Christ* (Plate 107). New York, Private collection

26. DAVID TENIERS THE YOUNGER: Copy of *The Three Philosophers*. Dublin, National Gallery of Ireland

28. X-ray of the hand of the *Venetian Gentleman* (Plate 119)

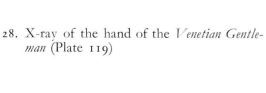

29. X-ray of '*La Vecchia*' (Plate 118)

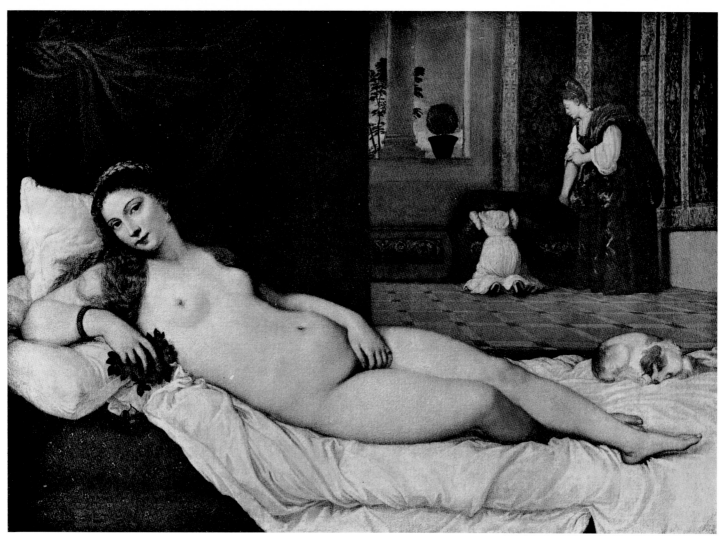

30. TITIAN: *The Venus of Urbino*. Florence, Uffizi

31. Inscription dated 1510 on the verso of the *Portrait of a Man* (Plate 109). San Diego, Fine Arts Gallery

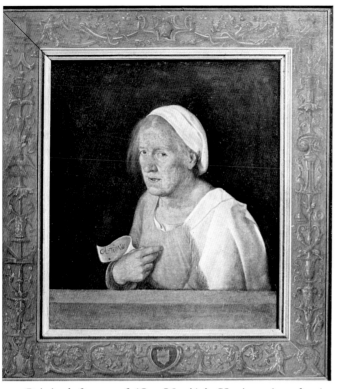

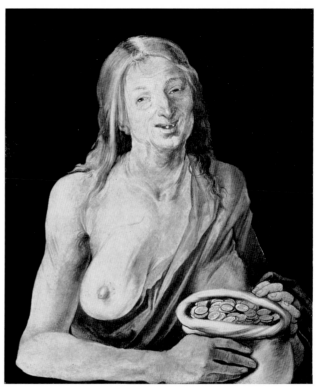

32. Original frame of '*La Vecchia*'. Venice, Accademia

33. DÜRER: *Avarice*. Vienna, Kunsthistorisches Museum

34. Engraving made in 1520 of *Christ Carrying the Cross*. (Plate 116)

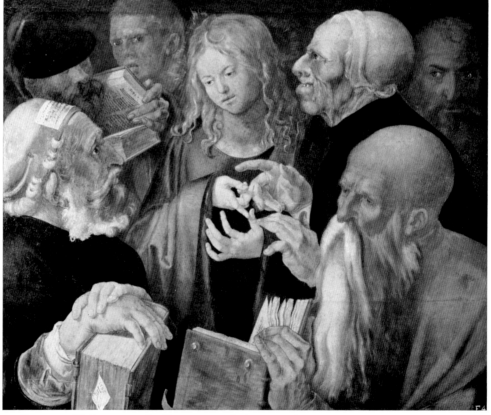

35. DÜRER: *Christ among the Doctors*. 1506. Castagnola, Thyssen-Bornemisza Collection

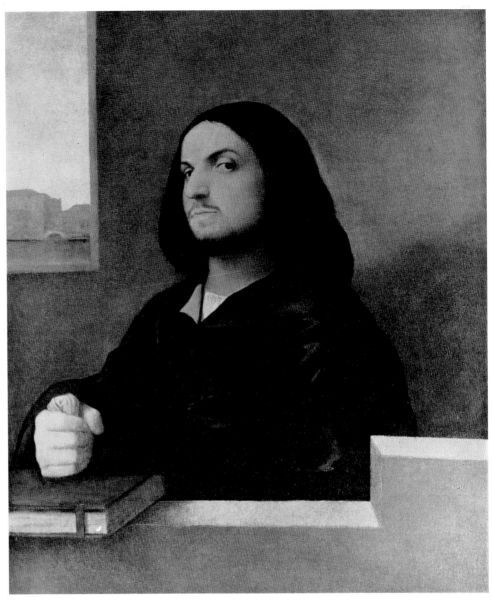

36. *Portrait of a Venetian Gentleman* (Plate 119) before restoration

37. X-ray of *Portrait of Antonio Brocardo*. (Plate 123)

38. Circle of Giorgione: *Portrait of a Young Man*. 1510. Milan, Brera

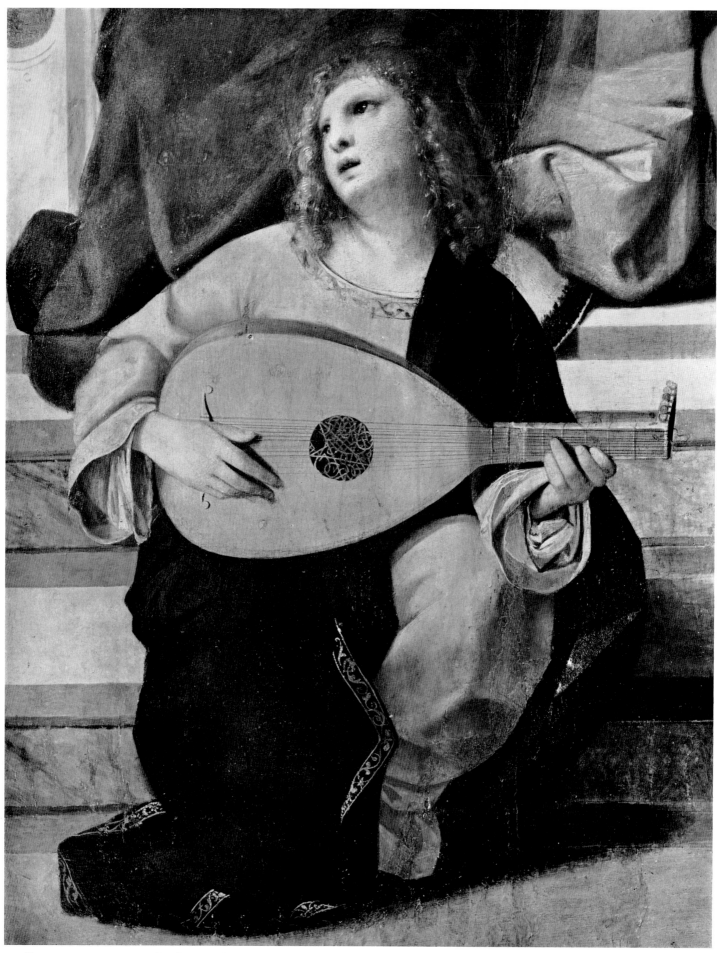

39. DOMENICO MANCINI: *Madonna and Child* (detail). 1511. Lendinara, Cathedral

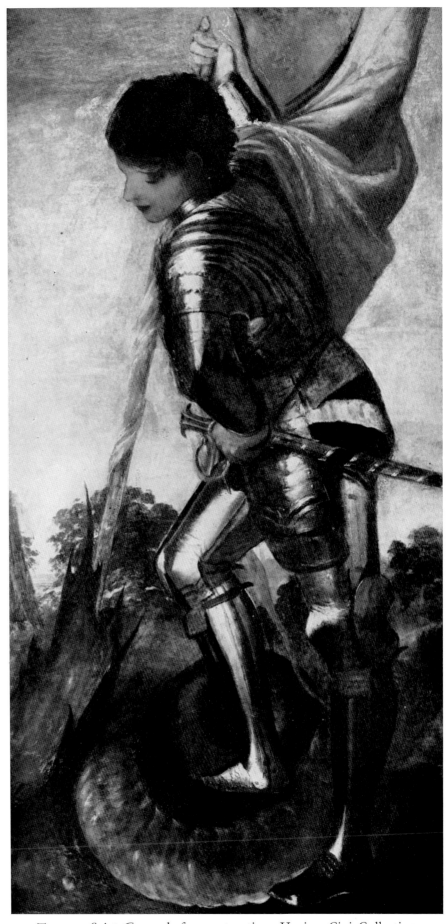

40. TITIAN: *Saint George*, before restoration. Venice, Cini Collection.
See Plate 189

41. *Portrait of a Warrior*. Engraving from David Teniers, 1658

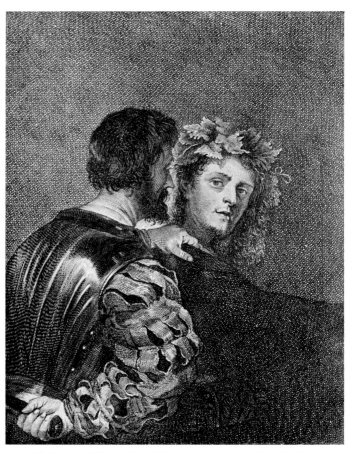

42. *'Il Bravo'* (Plate 187). Engraving from David Teniers, 1658

43. *Young Boy with a Helmet*. Engraving from David Teniers, 1658

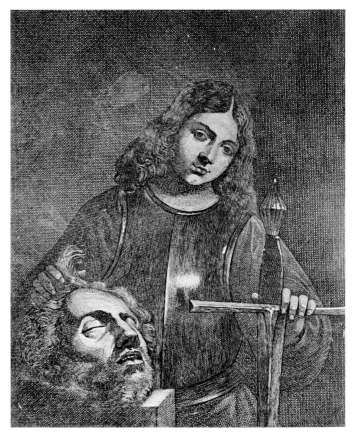

44. *David and Goliath*. Engraving from David Teniers, 1658

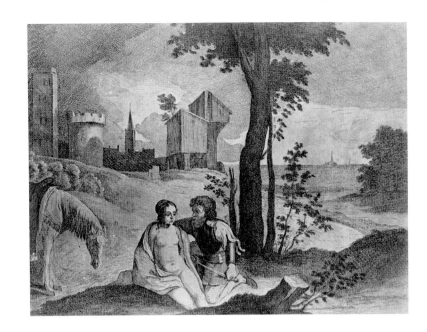

45. *Aggression*. Engraving from David Teniers, 1658

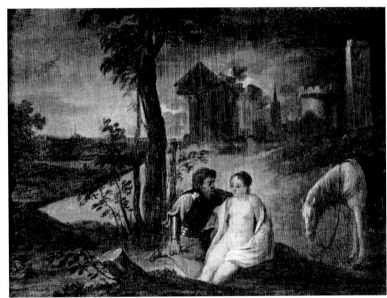

46. DAVID TENIERS THE YOUNGER: *Aggression*. London, Gronau Collection

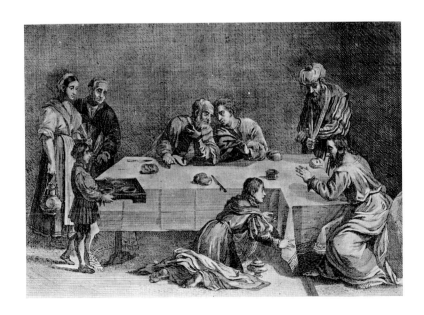

47. *Christ and the Pharisee*. Engraving from David Teniers, 1658

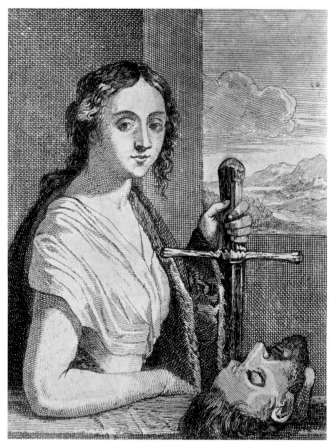

48. *Judith*. Engraving from David Teniers, 1658

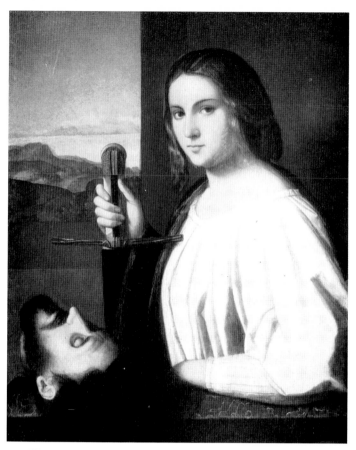

49. VINCENZO CATENA: *Judith*. Venice, Pinacoteca
Querini-Stampalia

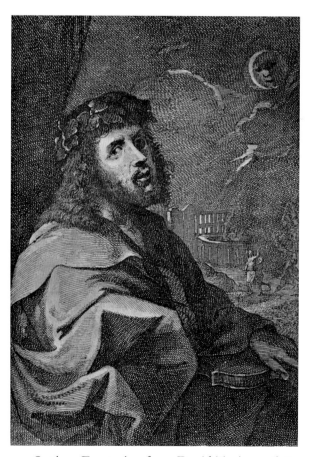

50. *Orpheus*. Engraving from David Teniers, 1658

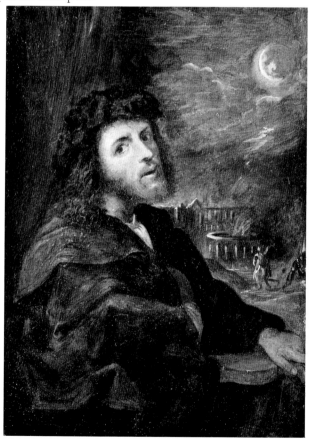

51. DAVID TENIERS THE YOUNGER: *Orpheus*.
New York, Suida-Manning Collection

52. *The Rape of Europa*. Engraving from David Teniers, 1658

53. DAVID TENIERS THE YOUNGER: *The Rape of Europa*. Chicago, Art Institute

54. ANTON MARIA ZANETTI: *The Seated Woman by Giorgione on the Fondaco dei Tedeschi*. 1760. Engraving

55. ANTON MARIA ZANETTI: *The Seated Man by Giorgione on the Fondaco dei Tedeschi*. 1760. Engraving

56. ANTON MARIA ZANETTI: *Figure of Diligence by Giorgione on Ca' Grimani*. 1760. Engraving

57. Copy of the *Diligence* of Ca' Grimani. Seventeenth-century drawing. Salzburg, University Library

Giorgion in

Candida PAX victrix, de victo MARTE triumphat,
Extollens nivea læta Trophæa manu.
Hanc colito æternum Reges, mundiq Monarchæ,
Quam gentes miseræ, quas fera bella premunt.

58. HENDRIK VAN DER BORCHT: *Allegory of Peace by Giorgione*. Engraving

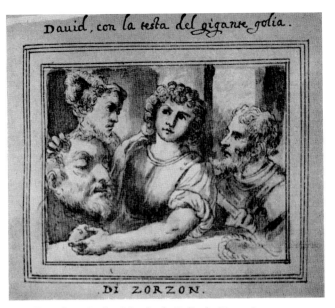

59. *David with the Head of Goliath*. Drawing, London, British Museum

60. *Two Lovers*. Drawing. London, British Museum

61. *Sacrifice*. Drawing. London, British Museum

62. *Sacrifice*. Drawing. London, British Museum

63. *Plenty*. Drawing. London, British Museum

64. *The Judgement of Paris*. Drawing. London, British Museum

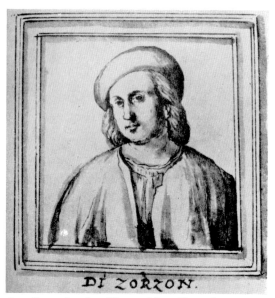

65. *Portrait of a Young Man*. Drawing. London, British Museum

66. *Landscape*. Drawing. London, British Museum

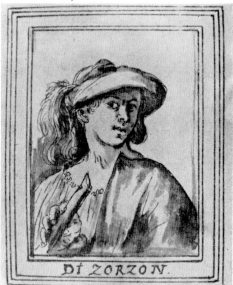

67. *Shepherd Boy with a Flute*. Drawing. London, British Museum

68. *Bust of Christ*. Drawing. London, British Museum

69. *Portrait of a Bearded Man*. Drawing. London, British Museum

70. *Giorgione, by his own hand*. Drawing. London, British Museum

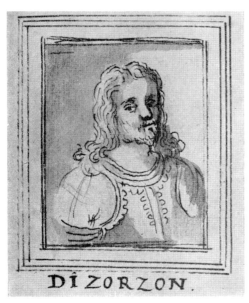

71. *Portrait of a Man in Armour*. Drawing. London, British Museum

72. *Nocturnal Concert*. Drawing. London, British Museum

73. *Nymph and Faun*. Drawing. London, British Museum

74. *A Sibyl*. Drawing. London, British Museum

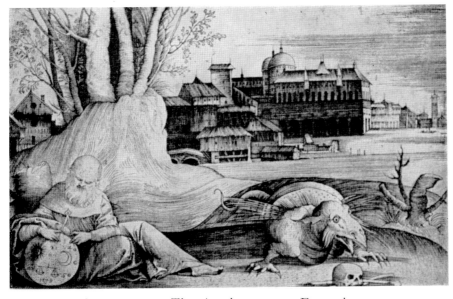

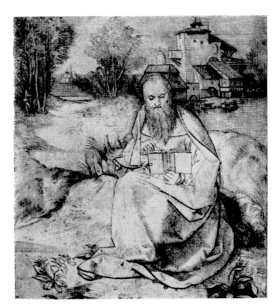

75. GIULIO CAMPAGNOLA: *The Astrologer*. 1509. Engraving

76. GIULIO CAMPAGNOLA: *Saint Jerome reading*. Engraving

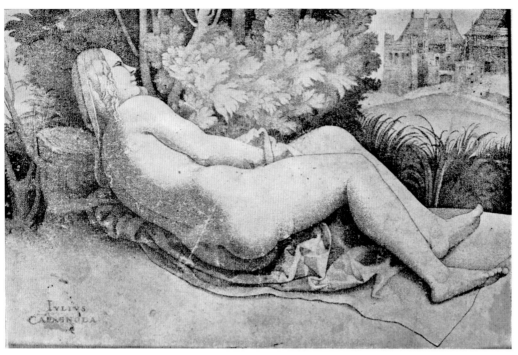

77. GIULIO CAMPAGNOLA: *The Nude*. Engraving

78. GIULIO CAMPAGNOLA:
Young Shepherd. Engraving

79. MARCANTONIO RAIMONDI: *The Dream of Raphael*. Engraving

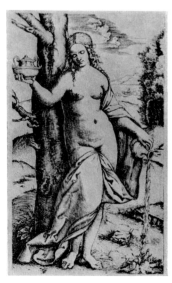

80. MARCANTONIO RAIMONDI:
Spring. Engraving

81. D. CUNEGO: *The Lovers*.
Engraving

CATALOGUE

PAINTINGS BY GIORGIONE
1–31

WORKS ATTRIBUTED TO GIORGIONE
A 1–A 68

COPIES
C 1–C 9

RELATED WORKS
V 1–V 40

LOST WORKS

PRINTS

PAINTINGS BY GIORGIONE

The catalogue of paintings by Giorgione is arranged chronologically, and follows the sequence of Plates 1-122. It includes only those works which the author considers to be certainly by Giorgione, whether on documentary or historical grounds, or through inferences of style. Each entry is followed by a basic bibliography, which refers to that particular work; for further references the General Bibliography should be consulted. An attribution to Giorgione should be assumed where not otherwise indicated in the bibliographical references for each entry.

Boston, Isabella Stewart Gardner Museum

1. CHRIST CARRYING THE CROSS Plate 1

Oil on panel, 52.9 × 42.3 cms
Provenance: Zileri dal Verme Collection, Vicenza (1898). In the Museum as «Attributed to Giorgione».

First attributed to Giorgione by Cavalcaselle (1871), followed by Morelli (1880) and Cook (1900). From Venturi (1928) followed by Richter (1937) onwards there has been a tendency to place the work closer to Bellini, to whom it is given outright by Morassi (1942) and Zampetti (1968). Among the many versions of this composition there are, indeed, two of the same subject by Bellini, in the Museum of Toledo, Ohio (Pl. 2), and in the Accademia dei Concordi of Rovigo. There is little doubt that the Boston painting derives from the first of these versions, which should be dated *circa* 1500 (Pignatti, 1969, No. 165). The *Christ* in Rovigo, on the other hand, dates from at least a decade later, and has characteristics in common with the last works of the old painter in his « Giorgionesque » phase (Pignatti, ibid., No. 199).
The Gardner Museum painting is a work of great beauty and excellent conservation, except for some retouching in the robe, in the lower half, and in the hair. While Giorgione preserves the somewhat dry handling of Bellini's painting, he endows his figure with a pronounced personality, accentuating the expression of emotion in a way that seems to anticipate the *Three Philosophers* in Vienna. The eyes, which in Bellini's versions look downwards or sideways, here look directly at the spectator with unmistakable melancholy. The flesh shows the characteristic flesh-pink ground and the darker shadows are very pronounced (especially in the eyelids and lips), a characteristic that was to become constant in works of his maturity. The unusual yellow-gold lettering in Arabic (?) characters on the green band of the robe recalls the analogous features in the *Three Philosophers*, the Oxford *Madonna* and

other Giorgionesque compositions. Any dating must necessarily be imprecise, but no earlier than the *circa* 1500 of Bellini's painting in Toledo, although it must have been painted before 1504, the likely date of the Castelfranco *Madonna and Child with Saints*, which is manifestly more advanced. Within these limits, the Boston *Christ Carrying the Cross* shows Giorgione's early closeness to Bellini, a fact confirmed by Vasari in his Life (1550): 'learning without modern style, he sought through being with the Bellini in Venice, and on his own, always to imitate Nature...'

Bibliography: Crowe-Cavalcaselle, 1871, II, 118; Morelli, 1880, 189; Cook, 1900, 18; L. Venturi, 1913, 246 (*circle of Giorgione*); A. Venturi, 1928, IX-III, 55 (*circle of Bellini*); Fiocco, 1929, Fig. 33 (*D. Mancini*); Hendy, 1930, 197 (*Palma Vecchio*); Richter, 1937, 238 (*circle of Bellini*); Morassi, 1942, 173 (*school of Bellini*); Fiocco, 1948, 19 (*D. Mancini*); Pignatti, 1955, 115 (*Giorgione?*); Zampetti, 1955, 90; Coletti, 1955, 61; Berenson, 1957, 83; Heinemann, 1962, 45 (*Titian*); Zampetti, 1968, no. 47 (*Bellini*); Pignatti, 1969, no. 200; Wethey, 1969, 170 (*circle of Giorgione*).

Bergamo, Private Collection

2. MADONNA AND CHILD Plate 4

Oil on panel, 68 × 48 cms.
Provenance: Cook Collection, Richmond, where it was catalogued by Borenius (1912) as Romanino (no. 153).

Attributed to Romanino by Gregori (1955) and by Ferrari (1961); in 1963 Testori advanced the attribution to Giorgione in a distinctly Leonardian phase of his career (1503-5), between the *Judith* in Leningrad and the Castelfranco *Madonna and Child with Saints*. The suggestion is supported by Volpe (1964) and Pallucchini (1965).
This is certainly a painting of great quality and despite the loss of part of the Madonna's veil and some damage in the landscape, it possesses the style which we might expect of Giorgione in that very early period

when, according to Vasari, he painted many Madonnas and felt the attraction of Leonardo's style. It is well known that Leonardo's visit to Venice occurred in 1500: this would therefore be the earliest possible date for this painting which already shows Giorgione incipiently moving away from the style of Bellini, which he is known to have practised at the very beginning of his career. The Gothic prominence which is given to the expanse of red drapery of the Madonna's robe takes us closer to the Castelfranco *Madonna and Child with Saints*, which makes *circa* 1504 the *terminus ante* for the painting in Bergamo.

It would be wrong to ignore the difficulty with which this painting can be reconciled with Giorgione's other work, but this stems in part from its very uniqueness. This is due of course to the absence of other contemporary works (of the numerous early Madonnas mentioned by Vasari, only the Castelfranco *Madonna and Child with Saints* and the Washington *Holy Family* survive apart from the present painting). The frontal compositional arrangement, the placing of the somewhat outsize Child on the Madonna's right knee – these are features that indubitably anticipate the composition of the Castelfranco altarpiece. Other details reinforce this, like the white cloth on which the Child is placed and partially covered by, and the dress and physiognomy of the Virgin; these are strong links, especially on account of the uniqueness of their occurrence, there being no other examples for comparision. But while it would be too easy to draw such a Morellian conclusion, the feeling of solemnity attached to the group figures in the immediate foreground, against a background which opens towards a poetic landscape in the distance on the right, framed by the curtain and the foliage (which may have been cut somewhat in an old reduction of the dimensions of the panel), can only remind us of other paintings by Giorgione from the period before 1504, especially the *Judith* in Leningrad and the *Holy Family* in Washington. As regards the influence of Leonardo, this would appear to be confirmed not only by the elaborate folds of the drapery, but also by the appearance of the Child, so much as to suggest that the artist must have seen an actual example of Leonardo's painting or drawing in Venice. The Child in fact rests on the Madonna's lap in a pose similar to that of the *Madonna Litta* in Leningrad, while the face seems identical with that of the Child in the *Madonna with the Carnation* which is attributed to Leonardo, in the Alte Pinakothek in Munich (Pls. 5 and 6). A key feature in the understanding of this panel is its Gothic quality of Germanic origin; this was an interest that appears to have fascinated Giorgione at this early period. There are precedents for the composition

in prints by Dürer such as the *Madonna with the Monkey*, and also in more ordinary but equally well-known illustrations like the *Madonna at the Fountain* by Zaisinger, which is conveniently dated 1501 (Pl. 7; Fig. 2).

Bibliography: Borenius, 1912, no. 153 (*Pseudo Boccaccino*); Gregori, 1955, no. 69; idem, 1957, no. 93, 16 (*Romanino*); Ferrari, 1961, Pl. 4a, (*Romanino*); Testori, 1963, no. 159, 45; Volpe, 1964, 4; Pallucchini, 1965, 264.

Washington, National Gallery of Art

3. THE HOLY FAMILY · Plate 8

Oil on panel (transferred to masonite) 37.2 × 45.4 cms. Inv. No. 1091 (Kress No. K. 1660).
Provenance: Almost certainly from the Collection of Charles I of England, and probably to be identified with the painting listed as by Giorgione in the inventory of James II's Collection (1688). Subsequently passed through a number of private collections before entering the Benson Collection, by which name it is commonly referred to; thence via Duveen to the Kress Collection (1949).

After having been initially attributed by Berenson (1894) to Catena, the painting was then included among the works attributed to the Master of the Allendale Adoration (a follower of Giorgione close to Catena and Cariani) by Gronau (1895), Holmes and Phillips (1909), Borenius (1912) and L. Venturi (1913). In the meantime, however, Cook (1900) supported the original attribution to Giorgione, which was later universally accepted. There is general agreement for a dating in the period before the Castelfranco *Madonna and Child with Saints*, and so F. R. Shapley's recent (1968) dating of the painting to « not after 1500 » seems unacceptable, as does that of Della Pergola (1955) who places it after the Castelfranco altarpiece.

To our understanding, the Washington *Holy Family* belongs in the group of very early works by Giorgione, and should be placed a little before 1504, the date of the Castelfranco altarpiece. References to Germanic examples in the form of Dürer's prints or those of other masters of the « late Gothic » style continue: we have only to look at the expanse of drapery that forms a sort of pedestal of folds and swirls to the figure of Mary (Suida 1954). But we cannot ignore the predominance of effects of colour, which by now characterize all Giorgione's work; waves of red, blue, violet and greeny-gold transform the sacred subject into a pattern of colours. Even the amber light, despite the fact it has no precise source, endows the scene with a greater naturalism than the contemporary com-

positions by Bellini, which are nevertheless still very present in Giorgione's imagination. The view to the background, seen through the arch, continues a feature which we have already seen in the Bergamo *Madonna and Child*, and enhances the intimate « interior » quality of the painting, probably following Flemish models, from Van der Weyden to Bouts.

Bibliography: Berenson, 1894, 103 (*Catena*); Gronau, 1895, 261 (*circle of Giorgione*); Cook 1900, 96; Holmes, 1909, 72 (*Master of the Allendale Adoration*); Phillips, 1909, 337 (*Allendale Master*); Borenius, 1912, III, II (*Cariani*); L. Venturi, 1913, 230 (*Catena*); Longhi, 1927, 220; Richter, 1937, 75; Morassi, 1942, 62; Pallucchini, 1944, VIII; Suida, 1954, 153; Della Pergola, 1955, 29; Coletti, 1955, XLII; Berenson, 1957, 85; Zampetti, 1969, no. 6; Shapley, 1968, 150.

Leningrad, Hermitage

4. JUDITH Plate 12

Oil on canvas, transferred from panel, 144 × 66.5 cms. Inv. 37.

Provenance: From the Forest Collection in Paris, then in the Crozat Collection. Catherine II of Russia acquired it for the Hermitage in 1772.

Up to the nineteenth century this painting was considered to be by Raphael, with the exception of Waagen (1854) who attributed it to Moretto. Morelli (1891) then attributed it to Giorgione, an attribution which has since been universally recognized. The original shape of the panel has been the subject of some debate. The engraving by Toinette Larcher made after the painting in 1729 when it belonged to Crozat, shows the composition as considerably wider, which confirms the inventory entries to the effect that the painting was broader by some 13 cms on either side. This has always been taken to mean that the painting was at some time cut down to the present size. But Robertson noted in 1955 that the seventeenth-century engraving by Bloteling, made before Larcher's version, shows the composition in its present form. Dr. Fomiciova, who kindly provided an account of the restoration which the painting is currently undergoing (1969), has also informed us that the *Judith* was originally 66.5 cms. wide, and that the additions that appear in Larcher's engraving were obviously made when the painting belonged to Crozat (see also: Fomiciova, 1956, where the existence of another seventeenth-century print initialled L. S. is adduced in confirmation of the theory). The *Judith* apparently had many layers of overpaint, and is emerging « completely altered in colouring ».

The composition of the painting derives only loosely, as regards the expansive drapery, from the traditional figures of saints in Germanic representations (cf. the St. Agnes by Schongauer, of *circa* 1475, Fig. 7). Perhaps it can be better related to such prints by Dürer as the *Dream of the Doctor*, or even De' Barbari's *Force and Victory*. The landscape, its distance veiled in blue, could have been influenced by Leonardo's ideas, which obviously also explain the « botanical » character of the foreground. Here however Giorgione introduces an altogether new feature in the dress which is drawn up over Judith's knee, a naturalistic element which becomes even more expressive through the juxtaposition of the grim image of the severed head of Holofernes. There can be little doubt — as Volpe (1964) noted too — that the branch of realistic Lombard painting, developed during their Giorgionesque phase by Romanino and Savoldo, was founded on images such as this one, finding its final development in Caravaggio. To see how much Giorgione's genius stands out from that of his contemporaries, one only has to put the *Judith* alongside any Carpaccio, like the *Temperance* (Washington, National Gallery; Fig. 8), which must then appear almost embalmed — even though it may be later — in its Gothic mould.

Bibliography: Galerie Crozat, 1729-42, I (*Raphael*); Waagen, 1854 (*Moretto*); Morelli, 1891, 286; Cook, 1900, 37; L. Venturi, 1913, 64; A. Venturi, 1928, IX-III, II; Richter, 1937, 80; Morassi, 1942, 59; Della Pergola, 1955, 20; Pignatti, 1955, 126; idem, 1955, 495; Coletti, 1955, 55; Pallucchini, 1955, IV; Fomiciova, 1956, 19; Berenson, 1957, 84; Gioseffi, 1957, 50; Volpe, 1964, 5; Zampetti, 1968, no. 5.

Castelfranco Veneto, Cathedral

5. MADONNA AND CHILD WITH SAINTS FRANCIS AND LIBERALE Plate 14

Oil on panel, 200 × 152 cms.

Originally painted for the Chapel of St. George, built by the Condottiere Tuzio Costanzo as the burial-place for his son Matteo who died of fever in 1504. The date of August 1504 is inscribed on the tombstone that is still in the Cathedral. According to Bordignon Favero (1955), the present location of the altarpiece and the tomb is different from their original site, altered in the course of the remodelling of the church in 1723 (Catalogo Melchiori, Mss. Gradenigo-Dolfin 205, Correr Museum, Venice).

It is Ridolfi who in 1648 first names Giorgione in connection with this painting. Federici (1803) then mentions the frescoes that decorated the chapel, giving them also to Giorgione, and which have since disappeared (they were of the Redeemer, the Evangelists and some arabesques). The presence in the painting of the Costanzo coat of arms, in the same form as on the tombstone, makes it very likely that Giorgione's altarpiece,

as the principal decoration in the chapel, also dates from 1504. There is some doubt as to the identity of the armed Saint, who should be St. George on account of the traditional name of the Costanzo family chapel; instead Giorgione's figure bears the attributes of St. Liberale, the patron saint of the earlier church. The painting has undergone numerous restorations, which include those of Pietro Vecchia (1674), Antonio Medi (1731), Rodolfo Manzoni (1851) and finally Pellicioli (1934). The painting has however suffered considerable damage, along the line of a vertical crack around St. Liberale's lance and hand, and in the face of the Madonna. The face of the Child has also been repainted, as have part of that of St. Liberale and St. Francis's left hand (Morassi, 1942, 76). In an account published anonymously in the *Quotidiano Veneto* of 1803 reference is made to some verse which was discovered on the back of the panel, under the reinforcement: « Dear Cecilia — Come hasten — Awaiting you — Your Giorgio Barbarela ». There is now no trace of this inscription, and doubt arises as to whether this was not a fabrication which could have been associated with the claimed ancestry of the painter in the Barbarella family. It is well known that this is based on the inconclusive evidence of a lost plaque of 1638, in which the Barbarella family appear to have asserted their descent from the painter (referred to by Federici, 1803, II, 2).

Although the Castelfranco altarpiece is not mentioned before 1648, its authenticity and its importance in Giorgione's *oeuvre* have never been doubted. Differences of opinion are expressed only as regards the dating, which is generally held to be between 1504 and 1506; only Gioseffi (1959) has placed it later than 1508. Without wishing to share the whole of Longhi's (1946) judgement — he describes the work as « timid » and as a « failure which fortunately had no sequel » — there is little doubt that the painting combines thoroughly innovatory features with others that reveal a certain inexperience. But these are not « errors of perspective » as Hourticq (1930) claimed; indeed Castelfranco (1955) has demonstrated that the very precise perspective scheme has its vanishing point in the figure of the Madonna herself (Fig. 10). But it seems as though the point of view is unusually high, so much so that Gioseffi (1959) suggested that in its original chapel the altarpiece might have been placed a step or so below the level of the pavement. It is more difficult to follow his idea that the painting originally had a rounded top which had a portrait of Matteo Costanzo set in the lunette (which he identifies with a portrait formerly in a collection in New York, which bears the name and the date MDX: see A 38). Longhi (1946) suggested

that the form of the composition derives from late fifteenth-century Umbrian and Emilian painting. It is certainly true that the placing of the Madonna on a high throne, against an open landscape, is not common in Venice in the early years of the century; Giorgione might well have been inspired here by altarpieces by Francia such as the one of the *Madonna with Saints Paul and Francis*, or the *Madonna and Saints*, now in the Pinacoteca in Bologna (Fig. 9). It is possible that in the latter there is a precedent in the armed figure of St. George for Giorgione's St. Liberale. We also find a St. Liberale in armour in Costa's *Madonna and Four Saints* in Bologna (1502), while Longhi has suggested that the figure of St. Francis in another painting by Costa, the *Saint Petronius enthroned with Saints Francis and Dominic* now in the Pinacoteca in Bologna, is the prototype for the figure of the same saint in the Castelfranco altarpiece (Figs. 11, 12).

But these objective observations cannot provide a real explanation of the very uniqueness of Giorgione's painting, which we see as attempting for the first time to render atmospheric effects through vibrant colour tones, encompassing both the foreground figures and the landscape in the distance. The result is a wide variety of novel hues in the red velvet, the green grass and the gold damask, which are unprecedented in Emilian or Venetian painting. This is a rational projection of the premises of Bellini's art, combined with experience drawn from Carpaccio's colour effects — the elements which form the background to Giorgione's highly personal style.

Bibliography: Ridolfi, I, 1648, 97; Crowe and Cavalcaselle, 1871, II, 129; Morelli, 1893, 210; Cook, 1900, 7; L. Venturi, 1913, 32; Longhi, 1927, 220; A. Venturi, 1928, IX-III, 14; Hourticq, 1930, 26; Richter, 1937, 212; Morassi, 1942, 74; Pallucchini, 1944, IX; Longhi, 1946, 20; Fiocco, 1948, 23; Bordignon Favero, 1955, 21; Della Pergola, 1955, 20; Pignatti, 1955, 118; idem, 1955², 494; Coletti, 1955, 39; Zampetti, 1955, 22; Pallucchini, 1955, V; Castelfranco, 1955, 298; Gioseffi, 1959, 52; Zampetti, 1968, no. 12.

London, National Gallery

6. THE ADORATION OF THE KINGS Plate 22

Oil on panel, 29 × 81 cms. No. 1160.
Provenance: From the Miles Collection, Leigh Court, where it was attributed to Bellini (1884).

Attributed to Giorgione by Cavalcaselle (1871), but given to Catena by Morelli (1893), L. Venturi (1913) and Berenson (1932); to Bonifazio by Holmes (1923); to Cariani by Borenius (1913); to Palma by Fiocco (1948). Finally, the attribution to Giorgione has prevailed. Gould (1959) suggested a dating around 1506-7, sup-

ported by an analysis of the costumes, which is close to the more acceptable date of 1505 which Longhi advanced as early as 1927, on account of the similarity with the *Laura* in Vienna (which later turned out to date from 1506).

There is no proof for the suggestion, made first by Richter (1937), that this painting is a predella panel. For us, there is only a reminiscence of the predella panels by Bellini and Carpaccio, which is patent from a comparison with Bellini's *Allegory* in the Uffizi, whose figures have similar clear-cut and well-defined outlines (Pl. 23). Pallucchini was also aware of this, in connection with the later *Moses* in the Uffizi (1955). Bellini's parallel planes are to be transformed, however, in Giorgione's work, into a much more realistic arrangement of space based on diagonals. In our opinion, this painting is the first of the series of compositions with small figures, which continues with those in the Uffizi right up to the Washington *Adoration of the Shepherds*.

Bibliography: Crowe and Cavalcaselle, 1871, II, 128; Morelli, 1893, 205 (*Catena*); Berenson, 1894, 96 (*Catena*); Cook, 1900, 53; Borenius, 1913, 10, (*Cariani*); L. Venturi, 1913, 229 (*Catena*); Holmes, 1923, 237 (*Bonifacio*); Longhi, 1927, 218; Berenson, 1932, 138 (*Catena*); Richter, 1937, 223 (*Giorgione?*); Morassi, 1942, 164; Fiocco, 1948, 22 (*Palma Vecchio*); Della Pergola, 1955, 28 (*Giorgione and assistant*); Pignatti, 1955, 126; idem, 1955², 497; Coletti, 1955, 53; Pallucchini, 1955, II; Berenson, 1957, 84; Gould, 1959, 38; Zampetti, 1968, no. 7.

Florence, Uffizi

7. THE TRIAL OF MOSES Plate 25

Oil on panel, 89 × 72 cms. No. 945.
Provenance: From the Medici Collection at Poggio Imperiale (1692); thence in the Uffizi from 1792 onwards, under the name of Bellini, together with the following entry, No. 8.

Attributed to Giorgione by Cavalcaselle (1871) and subsequently generally accepted, apart from the doubts raised by Fiocco (1915) who pointed to a collaboration with Giulio Campagnola: a suggestion that was supported by Richter (1937). Longhi (1946) however, distinguished a Ferrarese hand in the small figures in the middle distance « somewhere between Ercole and Mazzolino »; for Pallucchini (1955) too the only parts by Giorgione are the central figures and the landscape; while for Riccoboni (1953) the painter of this work is Romanino.

The problem should in our view be examined together with that of its pendant, the *Judgement of Solomon*, which is patently different, both as regards the figures and the landscape. On close observation, it also appears

that the two paintings may have been executed at different moments in Giorgione's career. In other words, having painted the *Moses*, Giorgione might have been asked — as often happened — to paint a pendant, which he might have done after an interval of some years, in a style that was altered. He would have left all the drapery of the figures (although not their heads) to an anonymous assistant, who happened to use a heavy chiaroscuro that derived from Mantegna's style. However that may be, there can be little doubt as to the stylistic coherence of the *Trial of Moses*, whose figures are not distant in technique from those of the *Adoration of the Kings* in London; while the landscape reveals a new and profound interest in the exploration of naturalistic effects, in the pursuit of spatial depth and the involved detail of foliage, a characteristic of which Giorgione would have been aware especially through German art. This was no chance, for in 1505 Dürer came to Venice, where his fame had preceded him through his engravings. The fact that Giorgione was linked with the circles in which Dürer moved is proven if by nothing else by his commission to decorate in fresco the restored Fondaco dei Tedeschi, perhaps at the same time as Dürer was engaged on the painting of the *Madonna of the Rosary* in the vicarial church of the Fondaco at San Bartolomeo. There is thus nothing inconsistent with a date of 1505 for the *Trial of Moses*. If we allow for the fact that the pendant would have been commissioned a few years later (probably between the date of the *Three Philosophers* and the *Sunset Landscape* in London), this provides an explanation for the differences between their landscapes: that of the *Moses* being more fluent and softer, akin to the style of the Castelfranco altarpiece, while that of the *Solomon* is dryer in handling, more incisive, punctuated with highlights and closer to the colder style of the *Sunset Landscape*.

Bibliography: See at the foot of the next entry.

8. THE JUDGEMENT OF SOLOMON Plate 31

Oil on panel, 89 × 72 cms. No. 947.
Provenance: From the Medici Collection at Poggio Imperiale (1692); thence in the Uffizi from 1792 onwards, under the name of Bellini, together with the preceding entry, No. 7.

The critical history of this panel has followed the same course as that of the *Trial of Moses*, although writers have tended to regard it is as an inferior painting. For Fiocco (1915, 1948) and Coletti (1955) the figures at least in the *Solomon* are by Giulio Campagnola, while for Morassi (1942) they are by Catena. As referred earlier in the discussion of the *Moses*, both

paintings should in our opinion be attributed to Giorgione's hand, although the drapery of the figures in the *Solomon* may have been completed by an assistant, since this is the only area where there is a real and indisputable difference of quality. Comparison of the facial features in the two paintings can only endorse their single authorship (as Zampetti, 1968, also notes).

Bibliography: Crowe and Cavalcaselle, 1871, II, 125; Morelli, 1893, 214; Gronau, 1894, 100; Cook, 1900, 15; L. Venturi, 1913, 249; Fiocco, 1915, 138 (*with Giulio Campagnola*); A. Venturi, 1928, IX-III, 62; Hourticq, 1930, 81; Richter, 1937, 217 (*with Giulio Campagnola*); Longhi, 1946, 20 (*Ferrarese assistant*); Morassi, 1948, 45; Fiocco, 1948, 15 (*with Giulio Campagnola*); Riccoboni, 1953, 195 (*Romanino*); Della Pergola, 1955, 18 (*Giorgione's hand excluded in the Solomon*); Pignatti, 1955, 122 (*with followers*); Pignatti, 1955², 500 (*derivations*); Zampetti, 1955, 10; Coletti, 1955, 51; Pallucchini, 1955², II; Robertson, 1955, 275 (*Ferrarese*); Berenson, 1957, 84; Gioseffi, 1959, 50 (*Catena for the figures in the Solomon*); Heinemann, 1962, 121 (*Rocco Marconi*); Zampetti, 1968, nos. 1-2.

Washington, National Gallery of Art

9. THE ADORATION OF THE SHEPHERDS Plate 35

Oil on panel, 90.8 × 110.5 cms. Inv. No. 400.
Provenance: From the Collection of Cardinal Fesch in Rome, dispersed in 1841; Tarral; Beaumont; Allendale Kress Collection 1938 (Kress No. K 509).

Given to Giorgione by Cavalcaselle (1871), the attribution was immediately challenged by Morelli (1880), Berenson (1894) and Venturi (1913) who suggested the name of Catena. Meanwhile Phillips (1909) had created the fictitious personality of the « Master of the Allendale Adoration » to whom he attributed the Washington painting, the *Adoration of the Kings* in London and the Washington *Holy Family*. It was Longhi who in 1927 drew the work of this invented master into the ambit of the young Giorgione, a solution which historians have generally accepted, although with widely differing datings — from Fiocco's (1948) « around 1500 » to Morassi's (1942) 1508 — 10. More recently, further doubts have raised the possibility of the intervention of various prominent artists — for Berenson (1957) it was Titian, working to a composition by Giorgione; while in 1949 the Tietzes had taken up a suggestion by Richter (1937) attributing the work to an artist near Bellini, although Titian was seen as having had a part in it. Heinemann (1962) actually attributes the work wholly to two or three of Bellini's pupils.

Another unsolved problem is the identification of this painting, suggested by Richter (1937), with the *Night*

which Isabella d'Este sought to buy, and which her correspondent refers to as being in the house of Vittorio Beccaro, in the well-known letter of 7 November 1510. But according to the Tietzes (1949) the word *nocte* could not, at the beginning of the sixteenth century, have had the meaning it later acquired of a Nativity. In fact, Isabella's correspondent also mentions a second « not very perfect *nocte* » in Taddeo Contarini's house, and it is tempting to follow Morassi (1942) in his identification of this painting with an almost identical copy — which is appropriately unfinished — which is now in the Kunsthistorisches Museum in Vienna (A 60); in our view this painting should be regarded as a copy by Titian. It is worth recalling that a « Nativity » attributed by Paris Bordone to Giorgione in an appraisal made in 1563, was in Giovanni Grimani's house in Venice (Fogolari, 1910).

The first-hand impression of this painting, of whose high quality there can be no doubt, confirms the attribution to Giorgione in a phase when his style was dominated by the influence of Bellini and Dürer; in other words, the same period as that of the Uffizi paintings. The landscape of the *Adoration of the Shepherds* has countless elements in common with that of the *Trial of Moses*, while the figures show a further stage in the development of the rich and dense application colours used in the London *Adoration* and the small panels in Florence. The representation of the Madonna and Joseph, and that of the shepherds too, already shows that warmth in the shadows, especially under the eyes and the nostrils, and in the folds of the lips, which was to become an ever more frequent feature of Giorgione's work. Here it anticipates the « fiery » hues which both Vasari (1550) and Zanetti (1760) mention in their descriptions of Giorgione's widely admired frescoes, and which by their accounts constituted one of the most distinctive characteristcs of his style.

So far as the dating of this painting is concerned, it is pertinent to note that in 1506 Lotto made a virtual copy of the central part of the landscape with the stream, in his altarpiece at Asolo of the *Madonna and Saints*; while there can be little doubt, despite some elements in common, that the *Tempest* and the *Three Philosophers* are more advanced in their atmospheric treatment of colour. A drawing at Windsor (Inv. no. 12803) cannot be regarded as any more than a contemporary derivation, by an artist close to Carpaccio (A 68). The double drawing of a bearded head in Zurich (Cat. No. 19) which Morassi (1955) connected with the St. Joseph in the *Adoration of the Shepherds*, should in our opinion be associated rather with the St. Peter in Bellini's San Zaccaria altarpiece (1505).

Bibliography: Crowe and Cavalcaselle, 1871, II, 119, 127; Morelli, 1880, I ?); Berenson, 1894, 103 (*Catena*); Cook, 1900, 20; Phillips, 1909, 337 (*Master of the Allendale Adoration*); Borenius, 1912, III, 19 (*Cariani?*); L. Venturi, 1913, 230 (*Catena*); Longhi, 1927, 220; Richter, 1937, 256 (*Bellinesque assistant of Giorgione*); Richter, 1942, 145; Morassi, 1942, 66; H. and E. Tietze, 1949, 12 (*Bellini and Titian*); Fiocco, 1948, 18; Della Pergola, 1955, 28; Pignatti, 1955, 146; Idem, 1955², 500; Coletti, 1955, 54; Pallucchini, 1955, III; Morassi, 1955, 149; Robertson, 1955, 275; Berenson, 1957, 65 (*Giorgione and Titian*); Heinemann, 1962, 25 (*pupils of Bellini*); Pallucchini, 1969, 5.

Vienna, Kunsthistorisches Museum

10. PORTRAIT OF A LADY (« LAURA ») Plate 44

Oil on canvas from panel, 41 × 33.5 cms. Inscribed on the verso « 1506 on the 1 June this was painted by maistro Zorzo de Chastel fr... colleague of maistro Vincenzo Chaena at the request of misier giacomo » (1506 a di primo zugno fo fatto questo de man de maistro Zorzi de Chastel fr... cholega de maistro Vizenzo Chaena ad istanzia de misier giacomo (sixteenth-century script). Inv. No. 219.
Provenance: From the Collection of Bartolomeo della Nave in Venice (1636), where it was described as the « Portrait of Petrarch's Laura » and attributed to Giorgione. It later belonged to the Duke of Hamilton in England, and from there entered the Collection of Archduke Leopold Wilhelm in Brussels (1659 Inventory) where its authorship was listed as « Unknown ».

The *Laura* appears in Teniers's *Galleries of Paintings* in Munich and in Vienna; the version in the Prado actually shows the lower half of the composition, including the left hand, which was obviously cut when the painting was placed in the oval frame in which it was exhibited up to 1932. Doubts about the inscription on the verso — which is certainly genuine — have been expressed only by Ferriguto (1933), for whom the use of the word « cholega » appears unacceptable in the sixteenth century. There is general agreement on the subject, which is usually held to be a representation of a Laura (on account of the laurel wreath around the woman's head), except for Richter (1937) who regards the figure as a Daphne. Verheyen (1968) regards the painting as an allegory of matrimony, with the breasts, one covered and the other bare, illustrating the antithesis between modesty and voluptuousness. The attribution to Giorgione was established by Justi (1908) who confirmed the importance of the inscription discovered by Dollmayr (1882) in dismissing Engerth's (1882) attribution of the painting to Romanino. In 1927 Longhi re-asserted Giorgione's authorship of the painting, which has since been universally accepted, apart from A. Venturi (1928: Boccaccino).

The conservation of the painting is excellent; it shows the by now familiar technique of enhancing the highlights with dashes of white, the outlines rendered with very delicate brushstrokes, which still preserve the integrity of the graphic structure, so that it still has a noticeably « Flemish » character.

Bibliography: Dollmayr, 1882, I; Engerth, 1882, I (*Romanino*); Justi, 1908, 262 (*Giorgione?*); Longhi, 1927, 220; A. Venturi, 1928, IX-III, fig. 538 (*Boccaccino*); Hourticq, 1930, 58; Wilde, 1931, 91; Ferriguto, 1933, 368 (*not by Giorgione*); Richter, 1937, 251; Morassi, 1942, 96; Fiocco, 1948, 27; Della Pergola, 1955, 34; Pignatti, 1955, 143; idem, 1955², VII; Berenson, 1957, 84; Baldass-Heinz, 1964, 120; Zampetti, 1968, no. 13; Verheyen, 1968, 220.

Berlin - Dahlem, Staatliche Museen

11. PORTRAIT OF A YOUNG MAN Plate 46

Oil on canvas, 58 × 46 cms. Inscribed: « V V ». Inv. No. 12 a.
Provenance: From the Giustiniani Collection in Padua; later it belonged to J.P. Richter, Florence (1891).
Apart from Wickhoff (1909) who believed it to be by Sebastiano del Piombo, the painting is universally accepted as by Giorgione. The mysterious inscription « V V » (which also reappeared during restoration on the parapet in the *Portait of a Venetian Gentleman* in Washington and in the *Portrait of L. Crasso* (Pl. 208), formerly in a private collection in London) has been interpreted in various ways, without a satisfactory solution being reached. For Schrey (1915) it represents the motto « Vanitas Vanitatum »; for Hartlaub (1925) it refers to a club; for Hermanin (1933) it is the initials of a Venetian surname; for Admiral Bechis (quoted in Della Pergola, 1955) it stands for Gabriele Vendramin. It can be excluded that it represents the initials of the person portrayed, since it appears under the representations of at least three different persons. The most likely explanation is that it is a sort of « collector's mark », although it is admittedly difficult to explain why it should appear in the form « V V O » in the *Portrait of a Venetian Gentleman* in Washington. It is also at least remarkable that Titian employed similar lettering to sign some of his early paintings, like the *Portrait of a Lady* and the so-called *Portait of Ariosto* in the National Gallery in London. It might be that Vasari's (1568) comment that if Titian « had not written his name on it in umber (*in ombra*) it would have been mistaken for a painting by Giorgione», could refer to this painting (for a contrary view see Gould, 1959, 114).

For the dating of the Berlin *Portrait of a Young Man*, the *Laura* in Vienna, of 1506, serves in our opinion as a very precise point of reference. Although the condition of the painting emerged as rather damaged during the 1932 restoration (see the account by Richter, 1937, 125), the surface of the paint has a density and consistency that is similar to that of the painting in Vienna. The hand leaning on the parapet is represented with the same technique of short, rounded brushstrokes. The localized toning of colours is consistent with the period in which Giorgione felt the impact of Flemish art, and in particular the work of Memling, who we know was represented in Venetian collections (Pl. 47). The extent to which this painting reveals Giorgione's own personal style may be understood through a comparison with the contemporary style of Bellini, in works such as the *Portrait of Pietro Bembo* at Hampton Court (Pl. 48). The latter is still in the fifteenth-century « medallion » tradition even though Bellini accompanied the figure with an adapted landscape background. Giorgione's painting on the other hand presents us with a disturbing character, who reveals how much Giorgione wanted, in Vasari's words, « to give relief to living and natural things ».

Bibliography: Morelli, 1893, 219; Berenson, 1894, 100; Cook, 1900, 30; Wickhoff, 1909, I; L. Venturi, 1913, 71; R. Schrey, 1915, 572; Hartlaub, 1925, Pl. 7, (*Sebastiano*); Hermanin, 1933, 90; Richter, 1937, 208; Morassi, 1942, 97; Fiocco, 1948, 36; Della Pergola, 1955, 38; Pignatti, 1955, 114; idem, 1955², 499; Coletti, 1955, 59; Zampetti, 1955, 58; Pallucchini, 1955, 4; idem, 1955², VI; Berenson, 1957, 83; Zampetti, 1968, no. 23.

Leningrad, Hermitage

12. MADONNA AND CHILD IN A LANDSCAPE Plate 49

Oil on canvas, transferred from panel, 44 × 36.5 cms. Inv. No. 38. The painting appeared for the first time in the Hermitage immediately after the transfer to canvas, as a work from the school of Bellini, while in the later catalogues it is listed as Bissolo (1899) and then as Bartolomeo Veneto (1916). First associated with Giorgione by Cook (1900), this interpretation was supported by Justi (1908). Renewed doubts were expressed by Richter in 1937, and this tendency is also illustrated by Coletti's (1955) assessment of it as an anonymous piece, Berenson's (1957) attribution to Cariani and Heinemann's (1962) to Rocco Marconi. But most historians have in fact favoured the attribution to Giorgione. Included in the exhibition in Venice in 1955, the quality of the painting showed itself to be very high and in better condition than had been anticipated, being substantially undamaged apart from a few areas of restoration in the landscape.

In our view, the full meaning of this painting can only be grasped if it is no longer considered as a product of Giorgione's early period, where it is clearly incompatible with the *Holy Family* in Washington and the *Adoration of the Shepherds* in the same gallery. Giorgione's palette is indeed more loaded here, with vibrant lights and a broken surface, approaching the ferment of colour that was to be achieved soon in the *Tempest*. It is remarkable that even in this subject there are still Gothic elements, especially in the emphatic folds of the drapery. But the placing of the figures in a realistic space, surrounded by objects that are ordered in terms of nearness and distance, is not comparable with the work of any other contemporary painter. The originality of this painting in this direction is such as to justify its attribution to Giorgione himself.

Bibliography: Cook, 1900, 136; Justi, 1908, 122; Richter, 1937, 223; Pallucchini, 1944, XI; Morassi, 1942, 72; Fiocco, 1948, 25; Pignatti, 1955, 126; idem, 1955², 496; Coletti, 1955, 66 (*anonymous*); Zampetti, 1955, 228; Berenson, 1957, 54 (*Cariani*); Heinemann, 1962, 116 (*Rocco Marconi*); Zampetti, 1948, no. 10.

Venice, Gallerie dell'Accademia

13. THE TEMPEST Plate 50

Oil on canvas, 83 × 73 cms. Inv. No. 881.
Provenance: From the Giovanelli Collection (1932).
The painting is first mentioned by Michiel, who saw it in 1530 in the house of Gabriele Vendramin: « The little landscape on canvas with the tempest with the gipsy and soldier, by the hand of Zorzi da Castelfranco ». The painting is also mentioned in the 1569 inventory of the inheritance of Gabriele Vendramin. In 1855 Burckhardt recognized the painting in the Collection of Girolamo Manfrin in Venice, under the erroneous title «Family of the Painter», which appears instead to have belonged to another work that had been sold from the same collection earlier (Calvesi 1962). In 1875, Bode was about to acquire the painting of behalf of the Museum in Berlin, when the Italian Government stepped in and enabled Prince Giovanelli to buy it instead, and the latter had it restored by Cavenaghi in 1887 (Morassi, 1942, n. 166). There have been innumerable attempts to fathom the meaning of the subject. Rejecting objective references to individuals (such as the « Family of the Painter ») or places (Castelfranco), there has been a concentration on interpretations which take account of the specific cultural environment in which Giorgione worked, and to which his patron Gabriele Vendramin (born in 1484) also belonged. For Wickhoff (1895) the subject is Adrastos with Hypsipyle suckling Opheltes, from

Statius' *Thebaid*; for Eisler (1925), Richter (1937) and Morassi (1942) it is the story of Paris being suckled with a shepherd watching; for Parpagliolo (1932-33) it is the legend of Geneviève; for De Minerbi (1939) Venus and Adonis; for Ferriguto (1933) an allegory of the forces of Nature; for Stefanini (1941-2) the allegory of Venus Genetrix from the *Hypnerotomachia Poliphili* published in 1499; for Hartlaub (1953) the Birth of Apollo; for Klauner (1955) it is Dionysus in his role as Messiah, and for Battisti (1960) it is Jupiter and Io; for Wind (1969), it is a pastoral allegory in which *Fortezza* and *Carità* are set by *Fortuna*.

In 1962 Calvesi took up the problem again and made the reasonable suggestion that the *Tempest* represents the Finding of Moses, as a symbol of the magic power with which he is to endow the faith he restores on the ruins of the past (the lightning). So the « gipsy » would be the Pharaoh's daughter, and the « soilder » Hermes Trismegistus, pastor of men. The discovery through X-ray examination of the painting of a second « nude » under the figure of the shepherd (Morassi, 1939), has lent weight to the arguments of those who, like L. Venturi (1913), Fiocco (1948), Clark (1949) and Gilbert (1952), maintain that Giorgione intended simply to represent a pastoral scene in a landscape setting or a storm. But Ferriguto (1933) notes that the second nude on the left could have been the first position of the «gipsy», who would then have been moved to the right of the composition to make way for the « soldier ». Of the various dates that have been suggested, there is no longer much support for the *circa* 1500 proposed by Cook (1900) nor for the « around 1505 » advanced by Hourticq (1930) and Richter (1937); a later dating has prevailed, which we also support, within the limits posed by the *Laura* in Vienna (1506) and the Fondaco frescoes (which were begun in 1508).

Bibliography: Michiel, 1530 [1888], 106; Burckhardt, 1855 [1952] 1050; Crowe and Cavalcaselle, 1871, II, 135; Morelli, 1886, 157; Wickhoff, 1895, 34; Cook, 1900, 10; L. Venturi, 1913, 82; Eisler, 1925, I; Hetzer, 1929, 107; Hourticq, 1930, 52; Parpagliolo, 1932-33, 282; Ferriguto, 1933, 201; Richter, 1937, 78; De Minerbi, 1939, 567; Morassi, 1942, 85; Stefanini, 1941-42; Fiocco, 1948, 34; Clark, 1949, 58; Gilbert, 1952, 202; Hartlaub, 1953, 76; Della Pergola, 1955, 30; Pignatti, 1955, 140; idem, 1955², 449; Coletti, 1955, 40; Zampetti, 1955, 48;. Pallucchini, 1955, II; Castelfranco, 1955, 303; Klauner, 145; Berenson, 1957, 84; Battisti, 1960, 146; Calvesi, 1962, 226; Bonicatti, 1964, 207; Baldass-Heinz, 1964, 134; Zampetti, 1968, no. 16; Wind, 1969, 4.

Rotterdam, Museum Boymans-van Beuningen

14. YOUNG SHEPHERD IN A LANDSCAPE Plate 53

Drawing, red chalk on yellowed paper, 20.3 × 29 cms. Inscribed: « K 44 » (Resta). Inv. No. I 485.

Provenance: From the Resta Collection in Florence; later Böhler, Lucerne, and Koenings, Haarlem.

Attributed to Giorgione for the first time by Becker (1922); this was supported by Justi (1926) and Hadeln (1926), since when the attribution has been universally accepted.

Popham (1936) makes reference to Resta's original attribution as « A view of Castel Franco drawn by the hand of Giorgione » and also notes that in that collector's album there was another similar drawing marked « K 43 ». Resta also refers to an unfortunate attempt of his to wash the drawing with hot water, which caused it extensive damage. The Tietzes (1937) confirm the attribution on stylistic grounds, and point to a certain similarity with the background of the *Tempest*, although they do not suggest that the drawing is preparatory to that painting (1944). Giorgione must however have been inspired by the forms of the towered walls of his own town, sections of which are still in existence.

In our opinion the closest parallel is with the *Madonna and Child in a Landscape* in Leningrad, which repeats landscape features from the drawing and its very meticulous handling. The figure in the foreground, on the other hand, seems to anticipate those of the *Sunset Landscape* in the National Gallery more than the « gipsy » in the *Tempest*. Giorgione's drawing style derives only in part from that of the known examples of Bellini's work, particularly as regards the delicate handling; but the lines are more incisive and detailed, and this must be associated with the influence of German prints, especially those of Dürer. As the Tietzes (1944) noted, the chalk shading in this drawing is reminiscent of the technique of « dotting » which Giulio Campagnola used in reproducing or imitating Giorgione's style in his engravings.

Bibliography: Becker, 1922, Pl. XXVI; Justi, 1926, 300; Hadeln, 1926, Pl. 3; Popham, 1931, 70 (*doubtful*); Popham, 1936, 19; H. and E. Tietze, 1937, 61; Morassi, 1942, 119; H. and E. Tietze, 1944, no. 709; Fiocco, 1948, 28; Pignatti, 1955, 139; Zampetti, 1955, 290; idem, 1968, no. 19.

Venice, Gallerie dell'Accademia

15. STANDING NUDE Plate 56

Detached fresco, 250 × 140 cms. Inv. No. 1133. Originally on the Grand Canal façade of the Fondaco dei Tedeschi, between the windows of the top floor (Foscari, 1936), whence it was detached in 1937.

This is the only one of Giorgione's frescoes in Venice that has survived the ravages of time and the vandalism of man: as late as the middle of the nineteenth century, during the restoration of the Fondaco « they

dismantled two stupendous figures by Giorgione, which were among the best-preserved » (Selvatico, 1847). There are many references to the fresco decoration, which was certainly the most impressive of its kind in Venice. Giorgione's work almost certainly began at the beginning of the fine season in 1508, since the Mass to celebrate the completion of the building was not held until May of that year (and in any case on 16 May 1507 work on the roof had not yet commenced). In August 1508 Sanudo notes in his *Diarii* that « now it is being completed inside and painted on the outside ». By 8 November 1508 Giorgione's frescoes had been completed, since they were the subject of a suit brought before the Provveditori al Sal in connection with payment for them, for which judgement was given and payment made on the 11 December of the same year (Sources, 1508). In the 1550 edition of the *Lives* Vasari mentions the frescoes on the façade, with « heads and parts of figures, coloured very brightly indeed ». In 1557 Dolce gives the information for the first time that apart from the frescoes on the principal façade, there was also fresco work on the Merceria side of the building, by Titian, and this included a *Judith*, painted when the artist « was not yet twenty ». Dolce also recounts that this painting was mistaken for Giorgione's work, and that the latter was congratulated on it, to his great vexation. In 1568 Vasari, writing in the second edition of the *Lives*, describes the frescoes of the principal and Merceria façades again, incidentally and probably through carelessness giving the *Judith* to Giorgione as well. In 1740 the frescoes on the main façade could still be seen clearly, and a print included in Albrizzi's *Forestiere illuminato* shows something of their form at that date (Fig. 19). A few years later, in 1760, A. M. Zanetti published his *Varie pitture a Fresco* which reproduced six of the best preserved Fondaco frescoes, as well as another at Cà Loredan, and described them in detail. These include a *Seated Man* (I), a *Seated Woman* (II) and a *Standing Nude* (III), all attributed to Giorgione (Figs. 55, 54, 18; Pl. 56), while the *Two Seated Women*, the *Justice* (« *Judith* ») and the « *Compagno della Calza* » are given to Titian (Fig. 23, Pls. 244, 248). It should be noted that Zanetti is very definite in his views about the attributions to the two artists: these are founded not only on tradition, but also on stylistic differences. He speaks of « Giorgione's » strong and graduated « shadows » and « Titian's most skilled half-tones ». He also mentions that he coloured a few copies of his publication with watercolour. Ricketts, in his volume on *Titian* (1910) describes his colours in these terms: « great use of golden yellow, dull purple, green and occasionally touches of bright scarlet. In one design

there are mauve clouds seen against a turquoise sky. Some of the accessory designs were done in terra verde ». According to Robertson (1955, 276) who quoted this source, these are colours similar to those of Giorgione's *Three Philosophers*, and the reference could therefore be taken as a description of Giorgione's work at the Fondaco. Two of the works from among the groups identified by Zanetti have survived, the *Standing Nude* and the *Justice* (Pls. 56, 245), and despite their ruined state they do perhaps reinforce the eighteenth-century writer's attributions — he saw them in conditions that were much better than ours and he was critically well equipped. In connection with the possibility that there were other assistants apart from Titian, we may note that Vasari comments (1550, 835) that the « ornaments » (in other words, the friezes between the various groups of figures, such as we can see from Albrizzi's print) were completed by Morto da Feltre. Not much can be gathered about Giorgione's pictorial style at the Fondaco from the *Standing Nude* in its present condition, and it is as well to follow Zanetti's faithful descriptions. The strong colour is still, however, in evidence; Zanetti described it as « a great fire... glowing in the strong shadows and in the heavy redness overall ». The monumental scale, a point on which emphasis has been placed in all the literature (from Wilde, 1933, 116, onwards; he is also the first writer to mention Fra Bartolomeo's visit to Venice in 1508), was perhaps a feature of other works apart from the Fondaco frescoes. It would most probably cause less surprise if all Giorgione's other outdoor frescoes had not disappeared.

Bibliography: Vasari, 1550, 577; Dolce 1557, 54; Vasari, 1568, IV, 91; Zanetti, 1760, IV; Zanetti, 1771, 94; Selvatico, 1847, 168; Cook, 1900, 65; L. Venturi, 1913, 107; Foscari, 1936, 36; Richter, 1937, 90; Brunetti, 1941, 73; Della Pergola, 1955, 42; Pignatti, 1955, 140; idem, 1955², 502; Coletti, 1955, 41; Zampetti, 1955, 46; Pallucchini, 1955, XIV; Berenson, 1957, 84; Moschini-Marconi, 1962, 126; Zampetti, 1968, No. 22.

Castelfranco Veneto, Casa Marta-Pellizzari

16a. FRIEZE WITH ATTRIBUTES OF THE LIBERAL ARTS

Plates 57-65

Fresco, 78 × 1588 cms.

Located below the beams on the east wall of the principal room in the Casa Marta, which later belonged successively to Zabbotini, Trevisan and Pellizzari (and now to the Ente Provinciale Turismo of Treviso) and which is situated next door to the Cathedral. There is another similar frieze on the west wall (see No. 16 b), and an *Emperor wearing a Laurel Crown* which originally formed part of the frieze, is in Casa Rostirolla-Picci-

nini (see No. 16 c). The frescoes were restored by Tintori (1955). The frieze is painted in yellow mono-chrome with white highlighting and bistre shading. According to Mariuz's recent study (1966), the earliest attribution of the fresco to Giorgione dates back to a seventeenth-century *Repertorio* by Melchiori, MS. 163 in the Biblioteca Comunale at Castelfranco. Later, Cavalcaselle (1871) recognized the Giorgionesque cha-racter of the work, as did Richter (1937) and Morassi (1942). Fiocco (1948) goes so far as to regard them as wholly by Giorgione, even « his earliest paintings » to be dated before 1500. The frescoes have subse-quently been accepted almost universally, with the single exception of Muraro (1960), who regards them as being of a later period than Giorgione's lifetime. In his cautious analysis, Mariuz brings out the cultural background to the friezes and implicitly recognizes that it is the same as that of Giorgione. In many instances the images are derivatory from works fami-liar to Venetian « philosophers » from Giorgione's known circle of friends; Sacrobosco's *Sphaera Mundi* (1488) is the literal source for the representations of the Liberal and Mechanical Arts, while the crepuscular melancholy clearly derives from the *Hypnerotomachia Poliphili* (1499). Thus although the theme behind the representation is hard to define, it is akin to a sort of « philosophy by images » with reference to the libe-ral and mechanical arts, in the context of human frailty and the exaltation of virtue.

So far as style is concerned, the frescoes cannot in our opinion be given unequivocally to Giorgione; those on the east wall are unquestionably of a higher quality. Absent from the latter is a particular stylistic feature that is characteristic of the cartouches on the other wall; this would tend to confirm the theory that an assistant took part in the work on the west wall. The east frieze is consistent in subject-matter, being devo-ted entirely to the Liberal Arts, and it includes the representations of many human figures, both in the medallions of Philosophers or Emperors (one of which has been transferred to Casa Rostirolla-Piccinini) and in the painted drawings placed on easels, looms or in open books (see Pls. 77-78). It is clear that these drawings are close in manner to, for instance, the frieze sketched in on the throne in the *Trial of Moses* in the Uffizi (Pl. 75); this tends to confirm Gior-gione's authorship of the frieze (as Zampetti, 1968, also observes). In the same way, the bearded head of a Philosopher (Pl. 92) has an unmistakable parallel in the central Philosopher in the painting in Vienna. The sheet showing a solar eclipse held by the bearded Phi-losopher in the painting in Vienna is also identical (though both may derive from the common source of

Sacrobosco) with the « eclipses » shown in the left-hand area of the frieze. Finally, the decorative cha-racter of the painting, with its volutes and cartouches, is not very distant from the remains of the frieze on the Fondaco, recovered unexpectedly from near Titian's *Justice* during the recent restoration, and which pro-bably followed the form of Giorgione's decoration on the façades (Pl. 246). As a whole, the east frieze is certainly not incompatible with the hand of Giorgione; it is indeed in our view of high quality. But its true significance will be more readily appreciated if instead of being dated around 1500, accepting the implications of the comparisons made above, it is seen as belonging to the middle period of Giorgione's work, when, around the time of the Fondaco commission, he is known to have been involved in a lot of fresco work.

16 b. FRIEZE WITH THE ATTRIBUTES OF THE LIBERAL AND MECHANICAL ARTS Plates 66-73

Fresco, 76 × 1574 cms.

Located below the beams on the west wall of the prin-cipal room in the Casa Marta-Pellizzari. Restored by Tintori (1955). The subject is principally concerned with elements from the Liberal and Mechanical Arts. There is however an immediately apparent stylistic difference from the frieze on the other wall, in that the majority of the objects are rendered in perspective with a strong emphasis on depth (note the cartouches): a particular manner of handling which points to the participation of an assistant.

But here too there are passages of great quality, such as the many-reeded organ, the expressive bearded head, the drawing of a female nude on a cartouche (Pl. 76). This latter is especially reminiscent of Giorgione's style, and recalls of course the *Standing Nude* from the Fondaco, whose curved pose and position of the arms it repeats. We would thus attribute the west frieze only in part to Giorgione himself, who must have employed an assistant for much of the minor detail.

Castelfranco Veneto, Casa Rostirolla-Piccinini

16 c. EMPEROR WEARING A LAUREL CROWN Plate 82

Detached fresco, 62 × 42 cms.

From the right-hand side of the east frieze, this fresco is of the same dimensions as the other roundels.
It was detached towards the middle of the last century, since Tescari refers to it in 1860 together with a « se-cond head also transferred to canvas », of which there

is no longer any trace. According to Mariuz (1966), the seventeenth-century manuscript by Melchiori makes especial reference to this « head in most beautiful painted marble » in his description of the frieze, made when it was still intact. Together with the east frieze, to which it belonged, this painting must be by Giorgione.

Bibliography: Crowe and Cavalcaselle, 1871, 170; Borenius, 1922, III, 16; Richter, 1937, 72; Morassi, 1942, 51; Fiocco, 1948, 16; Della Pergola, 1955, 26; Coletti, 1955, 51; Pignatti, 1955, 118; Muraro, 1960, 100 (*later than Giorgione*); Baldass-Heinz, 1964, 119; Mariuz, 1966, 49; Zampetti, 1968, no. 3.

Oxford, Ashmolean Museum

17. MADONNA WITH A BOOK Plate 83

Oil on panel, 76 × 61 cms. Inv. No. 177.
Provenance. From the Collection of the Duc de Tallard, sold in Paris as by Giorgione in 1756; Cathcart; sold Christie's, 1949, as by Cariani.

Re-attributed to Giorgione by Parker (1949), this has been generally accepted, with various datings — 1504 for L. Venturi, 1505-6 for Pallucchini (1955), 1507-8 for Morassi (1951). Berenson (1954) differs in the attribution, giving it once more to Cariani.
The painting's imperfect state of preservation has probably contributed to some of the negative judgements passed on it; in our opinion its authenticity is unquestionable. That it is a work of Giorgione's maturity is shown by the confidence in the harmonious distribution of forms, which is encountered only after the Fondaco paintings. It is quite true, as has often been noted, that the features of the Child and the Madonna's face recall those of the earlier *Adoration of the Shepherds* in Washington; while some of the delicate decoration on the cushion, the hem of the dress and the yellow cloth which covers Mary's head, is reminiscent of the Castelfranco *Madonna and Child with Saints*. But these are echoes whose significance should not be exaggerated: one of the painting's most essential characteristics is its greater freedom of handling, which we can associate with the « modern style » that Giorgione reached, as Vasari writes, « around 1507 », convinced that he should now « paint only with the colours themselves, with no preparatory drawing on paper ».

Bibliography: Tallard Sale, 1756 (in Richter, 1937, 334); Parker, 1949, 43; Pallucchini, 1949, 178; Morassi, 1951, 212; Berenson, 1954, 146 (*Cariani*); Venturi, 1954, 42; Della Pergola, 1955, 36; Pignatti, 1955, 134; idem, 1955², 501 (*?*); Coletti, 1955, 53; Zampetti, 1955, 20; Pallucchini, 1955, 3; Castelfranco, 1955, 306 (*?*); Robertson, 1955, 275; Berenson, 1957, 54 (*Cariani*); Zampetti, 1968, no. 11.

Vienna, Kunsthistorisches Museum

18. THE THREE PHILOSOPHERS Plate 87

Oil on canvas, 123.3 × 144.5 cms. Inv. No. 16.
Provenance: From the Collection of Taddeo Contarini in Venice, in whose house it was seen by Michiel in 1525: « The canvas in oil of the 3 Philosophers in the landscape, two standing and one seated observing the solar rays with that rock painted so admirably, begun by Zorzo da Castelfranco and finished by Sebastiano Venetiano » (« La tela a oglio delli 3 phylosophi nel paese, dui ritti ed uno sentado che contempla gli raggi solari cun quel saxo finto cusì mirabilmente, fu cominciata da Zorzo da Castelfranco, et finita da Sebastiano Venetiano »). In 1636 the painting was in the collection of Bartolomeo della Nave, then it passed to that of Feilding-Hamilton (1638) in London and later to that of Leopold Wilhelm in Brussels, in which it appears in an inventory of 1659 and is reproduced in the *Theatrum Pictorium* of 1658 (No. 20: Giorgione).

A painted copy by Teniers showing a somewhat free version of the composition, is in the National Gallery of Ireland in Dublin (Figs. 25, 26). The painting is also featured in Teniers's *Gallery* in the Museum in Brussels. From the measurements given in the inventory and from the print, it has been concluded that the painting has been cut on the left by about 17.5 cms. The X-rays (Wilde, 1932) show that Giorgione started to paint the figure on the right with a sort of diadem on his head, and the central figure dark-skinned, almost as if he wanted to represent an African; the seated young man originally was wearing a cap (Fig. 24). The interpretation of the subject-matter, which Michiel describes simply as « Three Philosophers », has provoked heated debate. At first Michiel's interpretation was accepted, with variations identifying the figures as Astrologers or Astronomers (L. Venturi, 1913), or the Magi, as the characters representing an allegory of the Three Ages of Man or of the contemplative life (Wilde, 1932). Ferriguto's study (1933) was the first of a series of « philosophical » interpretations, identifying the three figures as representing respectively Aristotelian scholastics, the Arabic-orientated following of Averroes and the new philosophy of Humanism; while for Hartlaub (1963) they are hermetic philosophers, followers of Saturn; for Wischnitzer-Bernstein (1945) — who reviews the existing literature — the three philosophers are Aristotle, Ptolemy and Regiomontano. Nardi (1955) returns to the theme of the astronomers, producing a wealth of comparative material to show that the figures are Ptolemy, his annotator Al-Battani and Copernicus. In the meantime,

Klauner (1955), working from Wilde's studies, produced an elaborate explanation of the subject as the Three Magi, dressed as scholars, paying a respectful visit to the scene of the Nativity, which would have been located in the cavern to the left, partially cut off. Wind (1969) thought of the three characters of the human soul: celestial, spiritual and earthly.

Sebastiano's part in the painting, mentioned by Michiel, is hard to identify. According to Hourticq (1930) and Wilde (1932) it involved the young Philosopher, while for Richter (1934) it is limited to the tree on the right and the landscape in the distance; Baldass (1953) notes some additions to the drapery of the standing figures. Pallucchini (1955) quite rightly expresses doubts about Sebastiano's intervention, which is indeed impossible to distinguish on account of the perfectly consistent distribution of the colours in the painting. Various dates have been suggested; here Fiocco (1948), who associates the *Three Philosophers* with the *Laura* (and also sees affinities with the frieze in the Casa Marta-Pellizzari), and Castelfranco (1955 — a date close to the Castelfranco *Madonna and Child with Saints*) are probably too early, while others have dated it later, around the time of the Fondaco frescoes, whose relevance as regards the monumental scale of the figures has been recognized, even though they are as is usual in Giorgione's work, somewhat less than life-size. A date of around 1508 would appear to be supported also by the compositional similarity with the original form of Bellini's *Feast of the Gods* — in the National Gallery in Washington — which although signed in 1514, is regarded by common consent of all scholars in the field as having been started at least five years earlier (Pignatti, 1969, no. 207). Once again, it is the older Bellini who takes up an idea from the younger artist.

Bibliography: Michiel, 1525 [1888], 86; Teniers, 1658, No. 20; Crowe and Cavalcaselle, 1871, II, 135; Morelli, 1893, 210; Cook, 1900, 12; L. Venturi, 1913, 90; Hartlaub, 1925, 7; A. Venturi, 1928, IX, III, 22; Hourticq, 1930, 60; Wilde, 1932, 141; Ferrigusto, 1933, 62; Richter, 1934, 274; Pallucchini, 1935, 40; Richter, 1937, 83; Morassi, 1942, 80; Wischnitzer-Bernstein, 1945, 193; Fiocco, 1948, 30; Gilbert, 1952, 202; Hartlaub, 1953, 57; Baldass, 1953, 121; Klauner, 1955, 145; Della Pergola, 1955, 33; Pignatti, 1955, 143; Coletti, 1955, 56; Zampetti, 1955, 34; Pallucchini, 1955, 4; Castelfranco, 1955, 301; Nardi, 1955, 23rd August; Berenson, 1957, 84; Baldass-Heinz, 1964, 131; Zampetti, 1968, 17; Wind, 1969, 6; Gould, 1969, 208 (*Giorgione and Sebastiano?*).

Zurich, Private Collection

19. HEAD OF AN OLD MAN WITH A BEARD (recto and verso) Plates 95, 97

Drawing, black clay on yellowish paper, 21.5 × 13.5 cms. Published by Morassi (1955) as a preparatory study for the head of St. Joseph in the *Holy Family* in the National Gallery in Washington (the verso being a first idea for it). Pallucchini (1955) regards the drawing as by Titian. Zampetti catalogued it in the 1955 exhibition among the « attributed » drawings; while Fiocco (1955) demoted it further and attributed it to the modest talents of Francesco Vecellio, associating it with the St. Joseph in his *Adoration* of *the Shepherds*, now in the Museum at Houston, Texas (Shapley, 1968, 177).

In our opinion this is a drawing by Giorgione himself, close in style and date to the *Three Philosophers* in Vienna. It should be sufficient to observe, for instance, the closeness of handling in the head of the philosopher with the turban — the forms rendered with a broad colour shading, with a vibrant atmospheric effect, broad and characteristically curved strokes, underlining of the shadows in the eyelids, under the nostrils, between the lips. Not to mention the emotional charge — that « grace and violence » which Zanetti (1771, 89) so aptly reminds us of, a characteristic that belongs to no other artist at the beginning of the century. So far as the figurative references that have been suggested, the link with the *Holy Family* in Washington is not convincing, nor is that with any of the other Adorations, principally on account of the stylistic incompatibility — the drawing seems to be more advanced. It has so far escaped attention that the study on the recto derives closely from the head of St. Peter in Bellini's San Zaccaria altarpiece, of 1505; while the verso could well be a « counterproof » (or more likely a preliminary sketch) for the head of the philosopher with a turban in the painting in Vienna. The authenticity of the drawing is thus in our view unexceptionable, especially on account of its very high quality. This is reinforced by the drawing of a *Philosopher* at Christ Church, which we also regard as genuine.

Bibliography: Morassi, 1955, 147; Pignatti, 1955, 161; Zampetti, 1955, 290 (*attributed to Giorgione*); Fiocco, 1955, 77 (*F. Vecellio*); Pallucchini, 1955, 17, (*Titian*); Zampetti, 1968, 102 (*connected with Giorgione*).

Oxford, Christ Church

20. PHILOSOPHER Plate 98

Drawing, red chalk on white paper, 15.3 × 11.1 cms. Provenance: From the Guise Collection (1756).

This unpublished drawing, previously listed among the anonymous drawings at Christ Church, has been

brought to our attention by James Byam Shaw, who suggested that it might be by Giorgione and kindly gave permission for it to be published here. This must be by Giorgione, around the time of the *Three Philosophers*; the affinity is such that we might venture to suggest that rather than an Evangelist or an Apostle, it must represent a Philosopher in antique garb, with a book under his arm. By accepting the drawing of the *Head of an Old Man with a Beard* (see above, No. 19),we have implicitly supported an interpretation of Giorgione's graphic style as one that was free and open, consistent with Vasari's description of his painting style after 1507 « when he began to endow his works with greater softness and more relief... ». There can be no doubt that the broad and monumental traits of the Christ Church *Philosopher* are consistent with such a description — the figure seems to echo in the handling of the drapery, the simple but massive shading of the *Three Philosophers* in Vienna. The bearded face reveals the same handling as the drawing in Zurich, with characteristic emphasis on the strong shadows and short, curved strokes. The cross hatching is a characteristic we have seen earlier in the other drawing which is certainly by Giorgione, the *Young Shepherd* in Rotterdam (although it is self-evident that the latter is a much less advanced work). Once again, we can recognize the real Giorgione in the unmistakable originality of the « meaning » of his figure, which is imbued with a thoughtful melancholy that takes one almost by surprise, raising the image from the limitations of technique and iconographic context into the realm of pure poetry.

London, National Gallery

21. SUNSET LANDSCAPE Plate 99

Oil on canvas, 73.3 × 91.5 cms.
Provenance: From the Donà delle Rose Collection, later London, Private Collection (1960).

The work came to light first in a publication by Sangiorgi (1933), who claimed to identify it as the painting « in oil of Hell with Aeneas and Anchises » (« a oglio de l'Inferno con Enea e Anchise ») which Michiel saw in 1525 in Taddeo Contarini's house. The painting had in fact been discovered by Lorenzetti in store in the Villa Garzoni at Ponte Casale, which, prior to belonging to the Donà delle Rose, had been owned by the Michiel family, heirs to the sixteenth-century writer. Lorenzetti (1934) discounted the attribution to Giorgione, as did Richter (1937). But as early as 1934 Longhi had argued decisively in favour of Giorgione's author-

ship, contested by Fiocco (1934) who preferred Giulio Campagnola, only to be convinced later of the attribution to Giorgione (1941), followed by Morassi (1942). In spite of this, the painting gained an export permit — as an « imitation or copy » — from a commission which included Fogolari, Modigliani and Gamba (who describes the episode in an article published in 1954).

Subsequently universally accepted, after entering the National Gallery, the painting turned out to be substantially less damaged than had originally been thought — it had some losses in the leaves of the tree on the left and some colour missing in the landscape in the distance. So far as the subject is concerned, it is clear that it can have nothing to do with that of the work Michiel saw in Taddeo Contarini's house. A landscape at sunset, even in the idea of an Arcadian solitude, could not represent Hell. Furthermore, the group on the right is clearly identifiable as St. George fighting with the dragon, while in the centre of the painting a man is tending the wounded leg of a younger boy (the Good Samaritan?). Of the various « monsters » noted by some critics, the feature in the middle of the water can only be a rock, and it is certainly not clear that the « long tail » of a second monster can be distinguished emerging from the rocks on the left (Zampetti, 1968). There remain only the one with a snout like a bird's beak, which one might say was inspired by Bosch, on the left bank of the pond, and the one on the right hand side, which has the shape of a large rat.

Compared with the landscape of the *Tempest*, that of the *Sunset Landscape* seems more advanced, with its phased rhythm harmonized by blue atmospherics that almost anticipate the *Venus* in Dresden. The outcrop of rustic dwellings already anticipates Campagnola's prints of around 1510. This is certainly a work of Giorgione's last years.

Bibliography: Sangiorgi, 1933, 789; Lorenzetti, 1934, VII (*not by Giorgione*); Fiocco, 1934, 787 (*G. Campagnola*); Longhi, 1934, 133; Richter, 1937, 250 (?); Fiocco, 1941, 31; Pallucchini, 1944, XIII; Morassi, 1942, 187; Longhi, 1946, 22; Gamba, 1954, 174 (*copy or imitation*); Della Pergola, 1955, 33 (*follower of Giorgione*); Pignatti, 1955, 129; idem, 1955², 501; Coletti; 1955, 52; Pallucchini, 1955, 3; Robertson, 1955, 275; Zampetti, 1955, 68; Gioseffi, 1959, 50; Bonicatti, 1964, 200; Zampetti, 1968, no. 18.

Darmstadt, Hessisches Landesmuseum

22. JUPITER AND CALLISTO Plate 102

Drawing, red chalk on yellowish paper, 14 × 19 cms. Inv. No. 175.

Inscribed: « by the hand of Giorgione da Castelfran-

co » (« man de zorzon da Castel francho ») (Autograph?)

Provenance: From the Mariette Collection, where it was listed as by Giorgione.

Published for the first time by Schrey (1915) as *Jupiter and Callisto*, it was also identified by the same writer as a preparatory study for the *Venus* in Dresden, a view which was opposed by Richter (1937) who regarded it as a later work than that painting. The Tietzes (1944) also regarded it as a late work, pointing to its relevance for such paintings as Titian's *Pardo Venus*. In fact the association with the Dresden *Venus* seems to be most convincing, by reason of the very unusual pose of the left arm. One must underline the fact that this can only be a drawing of Giorgione's final period. While the handling is still the same that we have seen in Giorgione's other drawings, the closer juxtaposition of figures in space, and their more definitive and incisive presence seem to anticipate the new horizons which Giorgione's premature death prevented him from achieving, and which can instead be seen fully realized in Titian's *Pastoral Concert*.

Bibliography; Schrey, 1915, 567; Richter, 1937, 214; H. & E. Tietze, 1936, 171; H. and E. Tietze, 1944, no. 706; Suida, 1956, 79 *(Titian)*.

Dresden, Gemäldegalerie

23. VENUS Plate 103

Oil on canvas, 108 × 175 cms.
Provenance: From the dealer Le Roy (1697).

Catalogued in eighteenth-century inventories of the Collection of the King of Saxony as by Giorgione, it is later listed as by Titian, before being finally relegated to the category of « anonymous » in the 1835 inventory. At that time, however, the Director Matthaei recognized the quality of the painting and suggested restoring it. In 1843 the restorer Schirmer came across traces of a Cupid on the right-hand side of the canvas, but covered them up again on account of the poor state of preservation of the painting. Finally Morelli (1886) restored the attribution to Giorgione, recognizing the painting as the one seen by Michiel in 1525 in the house of Gerolamo Marcello: « The painting of the naked Venus, asleep in a landscape with a Cupid, by the hand of Zorzo da Castelfranco, but the landscape and Cupid were finished by Titian » (« La tela della Venere nuda, che dorme in uno paese con Cupidine, fo de mano de Zorzo da Castelfranco, ma lo paese et Cupidine furono finiti da Tiziano »). From then on the attribution has been universally accepted, with the sole exception of Fogolari (1934) who draws attention to the discrepan-

cy implicit in Boschini's description of the painting in the Casa Marcello, in his *Carta del Navegar Pitoresco* (1660): « In the house of Marcello, with noble art / Zorzon da Castelfranco painted me / And his life-like rendering of my side / Made Mars pleased and admiring » (« In Ca' Marcelo pur, con nobil'arte, / m'ha depenta Zorzon da Castel Franco, / Che, per retrarme natural un fianco, / Restè contento e amirativo Marte »). An explanation of this may lie in the existence, noted by Fogolari, of another painting attributed to Giorgione in the Casa Marcello in 1742, that is to say after the *Venus* had entered the Dresden Gallery. This could have been the *Mars and Venus* described by Boschini. Furthermore, the existence of the Venus with a Cupid in the Casa Marcello is also supported by Ridolfi (1648), who adds that the Cupid was holding a bird. Finally, Oettinger (1944) suggests that the painting in Dresden is only a copy of a lost original, of which a fragment survives in the form of the *Cupid* in the Academy in Vienna, Inv. No. 466. Valcanover (1969, no. 625) rejects this, pointing out the very poor quality of this copy from the school of Titian. Gamba (1928) regards it as a missing section of the *Venus* in Dresden — an interpretation which is disproved by the dimensions of the painting (79 × 77 cms.) as well as by the existence of the original Cupid under the repainting.

The doubts over the identification of the *Venus* as the painting originally in Casa Marcello are largely responsible for the tendency to attribute the painting to Titian, started by Hourticq (1930) and supported by Suida (1935), Morassi (1942) and, albeit with some doubts, by Bonicatti (1964). An argument in favour of this interpretation seems to be offered by the uniform consistency of the paintwork, which makes it difficult to identify which part of the landscape Titian painted. It does indeed bear a striking resemblance to works now universally recognized as by Titian from his Giorgionesque phase: the houses in the background could be those of the *Noli me tangere* in London, while the castle on the hill (perhaps that of Asolo?) on the left, next to Venus's face, is the same as the one painted in the background of the *Madonna and Child* (the so-called « *Zingarella* ») in Vienna. But these arguments are not conclusive. In our opinion, the present condition of the painting, veiled by layers of thick varnish and obscured by the overpaint applied everywhere by the restorer Schirmer (who was responsible for the painting out of the Cupid, in 1843), makes the surface of the painting uniform: an appropriate restoration might make a distinction between the hands possible (Valcanover, 1969). In any case, the existence of the Cupid under the overpaint seems to be a conclusive

piece of evidence in favour of the identification of the Dresden *Venus* with the painting formerly in the Casa Marcello, thus making Michiel's statement attributing the work to Giorgione of fundamental importance. Nor does Morassi's recent (1954) theory that the *Venus* derives from a lost original by Titian (known through an engraving by Le Fèbre of 1682) cause us to doubt the attribution to Giorgione.

So far as the date of the *Venus* is concerned, it is our belief that it must have been painted shortly after the Fondaco frescoes, at the outset of Giorgione's mature phase in which the artist exploits above all the tonal relationship between figures and landscape, which is foreshadowed in the *Philosophers* and the *Sunset Landscape* in London. It is a feature which was to be further exploited by Titian, in works from the *Pastoral Concert* in the Louvre onwards. Regarding the choice of subject, Kahr (1966) derived it from the *Hypnerotomachia Poliphili*, Venice, 1499, I, cap. VII. Giorgione's innovation of representing the female nude in reclining profile enjoyed great popularity, from Palma's painting also in the Dresden Gallery to Titian's figures in his *Bacchanals* in the Prado and in the Louvre, to the singular version of Venus awake, painted by Titian for Guidobaldo of Urbino in 1538, now in the Uffizi Gallery (Fig. 30).

Bibliography: Michiel, 1525 (1888), 88; Ridolfi, 1648, I, 102; Boschini, 1660, 665; Morelli, 1886, 165; Cook, 1900, 35; L. Venturi, 1913, 96; Gamba, 1928, 205; Hourticq, 1930, 64 (*Titian*); Posse, 1931, 29; Fogolari, 1934, 232; Suida, 1935, 27 (*Titian*); Richter, 1937, 214; Morassi, 1942, 176 (*Titian*); Oettinger, 1944, 120 (*Titian*); Fiocco, 1948, 39; Tietze, 1950, II; Morassi, 1954, 201 (*Titian*); Della Pergola, 1955, 38; Pignatti, 1955, 120; Coletti, 1955, 59; Pallucchini, 1955², XIX; Castelfranco, 1955, 307; Berenson, 1957, 85; Gioseffi, 1959; 54; Bonicatti, 1964, 208 (*Titian?*); Baldass-Heinz, 1964, 157; Kahr, 1966, 122; Morassi, 1967, 206 (*Titian*); Zampetti, 1968, no. 21; Valcanover, 1969, no. 36; Pallucchini, 1969, 19 (*Giorgione and Titian*); Gould, 1969, 208 (*Giorgione and Titian*).

Vienna, Kunsthistorisches Museum

24. BOY WITH AN ARROW Plate 106

Oil on panel, 48 × 42 cms. Inv. No. 63.
Provenance: From the Collection of Archduke Sigismund at Innsbruck, later in the Castle at Ambras, where it was attributed to Andrea del Sarto (1773).

In the Gallery in Vienna it was attributed to the School of Correggio in the 1873 catalogue, until Ludwig (1903) identified it as the painting mentioned by Michiel in 1531 in the house of Giovanni Ram: « The head of the boy, holding in his hand an arrow, by the

hand of Zorzi da Castelfranco » (« La testa del garzone, che tien in man la frezza, fu de man de Zorzi da Castelfranco »). In 1532 the painting itself passed, according to Michiel, into the collection of Antonio Pasqualino, while Ram retained a copy of it «although he believes it to be the original » (« benché egli crede che sia el proprio »).

This confusion over the original version has been one of the factors in the varying attributions of the painting in Vienna: Berenson (1894) regarded it as a Cariani, only to change to Correggio, Lotto and finally Giorgione (1957); Justi (1908) and L. Venturi (1913) saw it as a copy, while Gronau (1921) finally regarded it as genuine. From that time on the attribution to Giorgione generally prevailed, especially after the cleaning of the painting for the Exhibition in Venice in 1955. Various dates have been suggested, from around the period of the Castelfranco *Madonna and Child with Saints* (Richter, 1937 and Baldass-Heinz, 1964), to around 1506, under the influence of Leonardo for Pallucchini (1955) and Zampetti (1968), and around 1609-10 for Gioseffi (1959).

In our opinion, the soft handling of the brushwork, which is often broken up even though the lighting is integral, points to a late date in Giorgione's career — the most relevant comparison is that of the *Venus* in Dresden, of which the Hellinistic sentimentality of the face is reminiscent.

Bibliography: Michiel, 1531 and 1532 (1888), 104, 78 (*copy*) Berenson, 1894, 95 (*Cariani*); Ludwig, 1903, I; Justi, 1908, 211; L. Venturi, 1913, 72; Gronau, 1921, 87; Richter, 1937, 252; Morassi, 1942, 53; Fiocco, 1948, 32; Della Pergola, 1955, 28; Pignatti, 1955, 143; idem, 1955², 499; Coletti, 1955, 58; Zampetti, 1955, 38; Pallucchini, 1955, 4; idem, 1955², XII; Berenson, 1957, 84; Gioseffi, 1959, 47; Baldass-Heinz, 1964, 154; Zampetti, 1968, no. 14.

New York, Private Collection

25. THE DEAD CHRIST Plate 107

Oil on canvas, 76 × 63 cms.
From the Polcenigo Collection, Venice; P.M. Bardi, New York.

Mentioned by Tietze (1950) as a work by Giorgione, and restored by Modestini in 1959, the painting was examined (1959/60) by Pallucchini, who supported its identification with the work seen by Michiel in Gabriele Vendramin's house in 1530: « The dead Christ on the tomb, with the Angel supporting him, which was by the hand of Zorzi da Castelfranco, retouched by Titian » (« El Christo morto sopra el sepulcro, con

l'Anzolo che el sostenta, fu de man de Zorzi da Castel-franco, reconzato da Tiziano »). Suggestions have been advanced for the identification of the *Dead Christ* for quite some time; first it was recognized as the *Pietà* belonging to the Cassa di Risparmio di Treviso, and then as the *Pietà* in the Pinacoteca Tadini at Lovere (Verga, 1929), as the *Pietà* in the Bernasconi Collection in Milan (Richter, 1942, 55) and finally as the *Pietà* in a Private Collection (Serra, 1962). The provenance of the present painting from the Palazzo Vendramin di S. Fosca, referred by Conte Polcenigo, the owner of the painting, to Pallucchini, combined with the obvious repainting (« retouched by Titian »), make it realistic to think that this is indeed the painting which Michiel saw.

Apart from this, Modestini's technical report on the painting (quoted by Pallucchini) confirms the presence of two different techniques: that for the figure of Christ being « broad and impressionistic » and that for the figure of the Angel « more precise and detailed, almost Flemish in character ».

Direct observation of the painting itself confirms the precise technical report. It is indeed easy to recognize, beside the heavy brushstrokes and vibrant colouring of Titian's hand, which have entirely reshaped the figure of Christ, the delicate and gently shaded handling of Giorgione around the period of the Dresden *Venus*.

The face of the Angel is indubitably the twin of that of the sleeping Venus, and it is also similar, in compositional terms, to the face which shows up in the X-rays (just under the right hand of the Angel) and which is consistent with features in X-ray studies of other paintings by Giorgione.

When was the *Dead Christ* painted, and why was it necessary for Titian to rework it? Clearly Giorgione must have left it unfinished, around the time of the *Venus*, but Titian can have returned to it probably only after the death of the painter; he might have come across it in his studio, or else have been asked to finish it by Vendramin himself, into whose possession it could already have come. According to Pallucchini (1969) this must have come « not before 1520 ». Yet another very similar composition appears at the top of Romanino's altarpiece in the Padua Museum, which dates from 1513. The invention of the *Dead Christ* might therefore be by Giorgione, while the reworking by Titian could have a later date, although not necessarily so late as was suggested. In our opinion, the powerful physiognomy of the *St. John* in Titian's altarpiece with *St. Mark enthroned with Four Saints* (c. 1510) in Santa Maria della Salute might seem to confirm this (Pl. 121).

Bibliography: Michiel, 1530 (1888), 106; Tietze, 1950, 12; (*Giorgione and Titian*); Pallucchini, 1959-60, 39; Serra, 1962, 14 (*not by Giorgione and Titian*); Zampetti, 1968, no. 29 (*Giorgione and Titian*); Valcanover, 1969, no. 88 (?); Pallucchini, 1969, 25 (*Giorgione and Titian*); Wethey, 1969, 171 (*Venetian painter c. 1530*).

San Diego (California), Fine Arts Gallery

26. PORTRAIT OF A MAN Plate 109

Oil on panel, 30 × 26 cms. Inv. No. 41-100. Inscribed on the back: « — 15.0 — by the hand of zorzi da castel franco » (« — 15.0 — Di man de m.ro zorzi da castel franco ») (autograph?).
Provenance: From the Curror Collection; later Terris, London; presented by Putnam (1941).

Richter (1937) who saw this portrait when it belonged to the Terris Collection in London, regarded it as a work of Giorgione's final period. The date in the inscription, which he adjudged contemporary, was only read as « 15.. ». Subsequently Morassi (1942) supported the attribution and read the inscription as « 1508 ». After this date the attribution and date have found general acceptance, with the exception of Fiocco (1948) and Berenson (1957), who suggest the name of Palma Vecchio. Della Pergola (1955) advanced a dating of around 1505, making note also of a copy in the Borghese Gallery with an old inscription « Giorgione ». Gethman Andrews, in her Catalogue of European Paintings in the San Diego Gallery (1947), supports the attribution to Giorgione and suggests that it may be a Self-Portrait by the artist: an idea that should obviously be rejected.

Direct observation of the painting itself led to an important conclusion, namely that the date of the inscription, which must be contemporary, is not as has been thought, illegible, nor is the final figure an 8, but rather o. (Fig. 31). 1510 is thus the date of the San Diego Portrait, which emerges as one of Giorgione's last works, and as material evidence of the « new style » (introduced after 1507, as Vasari recounts) in which he sought to represent « living and natural » things, « showing them with dashes of raw and gentle colour, just as occurrs in the life, without drawing beforehand ». This is indeed the culmination of a process of development which we have traced from its beginnings in the Oxford *Madonna with a Book*, the Fondaco frescoes and the *Three Philosophers*. Nor does the application of colour in the San Diego portrait retain too much of the traces of graphic preparation, which are by contrast so evident in the 1506 portraits, like the *Laura* in Vienna or the *Portrait of a Young Man* in Berlin.

Here instead the black of the sitter's coat with its grey reflections vibrates against the dark green background, of which the face itself takes on some of its colour, gaining thereby a disarmingly frank and profound espression. If this is then Giorgione's last manner, we can now see the relevance of it for the fluid handling of the young Titian, who in the Portrait of a Member of the Barbarigo family, mentioned by Vasari as having been painted when Titian was « no more than eighteen » (that is to say before the Fondaco frescoes), sought « the semblance of real and living flesh, his hair so distinct that one could count each one, as one could the stitches in the great jacket of silvery satin which he painted in that work». One gains an impression of the ostentatious handling of that «great jacket » which must have characterized his domineering personality.

Bibliography: Richter, 1937, 226; Morassi, 1942, 99; Fiocco, 1948, 30 (*Palma*); Gethman Andrews, 1947, 50; Della Pergola, 1955, 30; Pignatti, 1955, 139; idem, 1955², 499; Pallucchini, 1955², XV; Coletti, 1955, 62; Berenson, 1957, 29 (*Palma*); Baldass-Ludwig, 1964, 153; Morassi, 1967, 198; Zampetti, 1968, no. 24.

Hampton Court, Royal Collection

27. SHEPHERD BOY WITH A FLUTE («APOLLO») Plate 110

Oil on canvas, 61 × 51 cms. Inv. No. 101.
Provenance: From the Collection of Charles I, where it was attributed to Giorgione (1625-49).

After some doubts that the painting is a copy, as held by Cavalcaselle (1871), it was Morelli (1880) who first revived the old attribution to Giorgione, followed later by almost all criticism, with the exception of Cook (1900), L. Venturi (1913) and A. Venturi (1927) who regard it as by Torbido; for Fiocco (1948) it is a copy. Many doubts have been expressed in connection with the extensive repainting that is apparent and the poor state of conservation of the painting. Surprises are not to be ruled out in this instance, for the X-ray of the painting, made at the Courtauld Institute in 1952, shows another different figure underneath (*Italian Art in Britain*, 1960, 16). Richter (1937) who is among those who have reservations over this painting, notes that Michiel mentions as being in the house of Giovanni Ram a «young Apollo playing a pipe, in oil, from the hand again of Catena » (« Apolline giovane che suona la zampogna, a oglio, fu de man dell'istesso Cadena ») (1888, 104): he imagines, with no real justification, that this must have been a lost work by Giorgione of the type of the Hampton Court painting. It would have been more relevant to mention that among the paintings « by Zorzon » illustrated in

drawings in the catalogue of the Vendramin Collection of 1627 (British Museum), there is a Shepherd with a Flute that is not very different from the composition at Hampton Court, even though it would be unrealistic to imagine that it is the same painting.

In our opinion, the *Shepherd Boy with a Flute* is one of Giorgione's last works, and it is close to the San Diego *Portrait of a Man* in its atmospheric colour and summary, rapid handling of the brushwork. Despite the distortions afforded by successive cleanings and varnishings, the face has affinities also with the *Three Ages of Man* in the Pitti Gallery, which we also regard as one of Giorgione's very late works.

Bibliography: Crowe and Cavalcaselle, 1871, II, 164; Morelli, 1880, I; Cook, 1900, 47 (*Torbido*); L. Venturi, 1913, 74 (*Torbido*); Justi, 1926, II, 276 (*Giorgione?*); A. Venturi, 1928, IX-III, 916, (*Torbido*); Richter, 1937, 220 (*Giorgione?*); Morassi, 1942, 54; Fiocco, 1948, 36 (*copy*); Della Pergola, 1955, 28; Pignatti, 1955, 124; Coletti, 1955, 59; Zampetti, 1955, 40; Pallucchini, 1955, 5 (?); Castelfranco, 1955, 306; Robertson, 1955, 276; Berenson, 1957, 84; Baldass-Heinz, 1964, 155; Zampetti, 1968, no. 15.

Florence, Galleria di Palazzo Pitti

28. THE THREE AGES OF MAN Plate 111

Oil on panel, 62 × 77 cms. Inv. No. 110.
Provenance: From the inheritance of Grand Duke Ferdinand.

Initially Inghirami (1832) and Cavalcaselle (1871) suggested Lotto; then Morelli (1886) gave it to Giorgione, followed by Cook (1900), Justi (1908), Morassi (1942), Gamba (1954), Coletti (1955), Pignatti (1955), Berenson (1957) and Gioseffi (1959). For Richter (1937) the painting is by Pennacchi, while others, like Fiocco (1948) think of Torbido. In the meantime, Longhi (1927) had put forward the idea that the work might belong with Bellini's late activity, while Berenson (1932) came close to this, creating the fictional personality of the « Master of the Three Ages of Man», who would also have painted the *Concert* at Hampton Court and the *Double Portrait* (Borgherini) originally in the Cook Collection, and now in Washington, (A 18, A 67). In 1949 the painting was exhibited at the Bellini Exhibition (Pallucchini, 1949), without a conclusion being reached, however, with regard to its authorship.

In the light of the new character that the final phase of Giorgione's art gets through the 1510 dating of the San Diego *Portrait of a Man*, we can do away with the reservations expressed in 1955 and give the work wholly to Giorgione. Despite the repaintings, the layers of varnish and the desiccated colours (which might still

be recuperated through a careful restoration) one can still perceive that very free handling, which builds up form without employing modelling, that characterizes Giorgione's final style, in the San Diego *Portrait of a Man* and the *Shepherd Boy with a Flute* at Hampton Court. The striking head of the old man on the left (it should be recalled that the painting itself has been regarded as worthy of Bellini) forms a link with what may be seen as Giorgione's final development before his death — the « new realism » which is the basis for the *Portrait of an Old Woman* (« *La Vecchia* »), the *Christ Carrying the Cross* in San Rocco and the *Portrait of a Venetian Gentleman* in Washington.

Bibliography: Inghirami, 1832, 45 (*Lotto*); Crowe and Cavalcaselle, 1871, II, 502 (*Lotto*); Morelli, 1880, 182; Logan, 1894, I (*Morto da Feltre*); Cook, 1900, 42; Justi, 1908, 266; L. Venturi, 1913, 261 (*Morto da Feltre*); Longhi, 1927, 134 (*Bellini*); Berenson, 1932- 349 (*Master of the Three Ages of Man*); Richter, 1937, 235 (*Pennacchi*); Morassi, 1942, 106; Fiocco, 1948, 33 (*Torbido*); Pallucchini, 1949, 212 (*attributed to Bellini*); Gamba, 1954, 172; Pignatti, 1955, 121 (?); Coletti, 1955, 65; Zampetti, 1955, 94; Castelfranco, 1955, 310 (*copy?*); Pallucchini, 1955, 122 (*Torbido?*) Robertson, 1955, 277 (*circle of Giorgione*); Berenson, 1957, 84; Gioseffi, 1959, 47; Baldass-Heinz, 1964, 161 (*school of Bellini*); Zampetti, 1968, no. 36 (*Bellini*).

Venice, Gallerie dell'Accademia

29. PORTRAIT OF AN OLD WOMAN (« LA VECCHIA »)

Plate 118

Oil on canvas, 68 × 59 cms. Inv. No. 95.
Provenance: From the Galleria Manfrin in Venice (1856).

It is very likely that this is the painting described in the 1569 inventory of the collection of Gabriele Vendramin in Venice: « The portrait of the Mother of Zorzon by Zorzon with its frame painted with the arms of the Vendramin house » (« il retrato della Madre de Zorzon de man de Zorzon con suo fornimento depento con l'arma de chà Vendramin »). Giorgione's *Tempest* also passed from the Vendramin family to the Manfrin Collection, so that another element of probability is added to this identification (Fogolari, 1935). Furthermore, the painting still has its original frame with early sixteenth-century decoration on it; at the bottom this bears a small crest, now unreadable, which is probably the one described in the inventory entry (Moschini, 1949). Many different titles have been applied to it in the various collections through which it has passed; in the Manfrin Collection it was described as a « portrait of Titian's mother ». Suida (1935) regards the old woman as representing an allegory of Vanity; he also suggests that the painting might originally have been larger and could have included a

representation of a young woman. Berenson on the other hand (1954) associates the painting with the « gipsy » in the *Tempest*, seen here in old age. Battisti (1960) sees the motto « Col Tempo » (With Time) as being linked with forms common in early sixteenth-century poetry, exemplified by the recurrence of the phrase in each line of a sonnet by Pamphilo Sano, and in an Elegy by Cesare Nappi of 1508. Panofsky (1969) interprets it as a « memento senescere ».

The history of the attribution of the painting is also varied. The initial attribution to Torbido by Della Rovere in the nineteenth-century guide to the Gallerie (on the basis of a similarity with the St. Anne in the San Zeno altarpiece by that artist in Verona) put historians off the track for a long time, and indeed continued to be supported by Fiocco (Catalogue 1924), A. Venturi (1928), Arslan (1932) and Pallucchini (1944). After the painting's restoration in 1949, it was universally recognized as by Giorgione — with the exception of Pignatti (1955²), Muraro (1963) and Panofsky (1969) — with dates that varied from the 1506-7 suggested by Coletti (1955) to the 1508 favoured by the majority of writers. Morassi (1942) suggested a date close to 1507, in part on account of the similarity between the features revealed in the X-ray and a derivation from Dürer's *Avarice* that was painted in that year (Fig. 33). Considering that Giorgione's relationship with Dürer is certainly a continuous one — they almost progress in parallel — the connection for us is simply one of iconographic similarity. It is certainly undeniable that in 1507-8 Giorgione, in the *Venus* in Dresden and in the *Three Philosophers*, reached the high point of his « classicism » (Hellenistic in flavour on account of its very refinement); while it is later, around the time of the San Diego *Portrait of a Man* and thus in the final phase, that he employed — from the *Three Ages of Man* in the Pitti to the *Portrait of an Old Woman* — that « realism » which Pallucchini (1955) described as surpassing the « minute attention to detail of the Northerners... in the synthesis of a form represented wholly through colour ».

Bibliography: Zanotto, 1856, 346; Della Rovere, Guida, n. dc. 36 (*Torbido*); Berenson, 1894, 95 (*Cariani*); Della Rovere, 1903, 94; Fiocco, Catalogue, 1924, (*Torbido*); A. Venturi, 1928, IX-III, 912 (*Torbido*); Arslan, 1932, no. 6; Suida, 1935, 86; Fogolari, 1935, 5; Richter, 1937, 40; Fiocco, 1941, 30 (*Torbido?*); Morassi, 1942, 103; Pallucchini, 1944, XVI (*Torbido*); Fiocco, 1948, 30 (?); Moschini, 1949, 180; Berenson, 1954, 145; Gamba, 1954, 174; Della Pergola, 1955, 54; Pignatti, 1955, 140; idem, 1955², 504 (*Titian?*); Coletti, 1955, 39; Zampetti, 1955, 54; Pallucchini, 1955, 4; idem, 1955², XVIII; Castelfranco, 1955, 305; Robertson, 1955, 275; Fiocco, 1955, 19; Berenson, 1957, 84; Battisti, 1960, 156; Salvini, 1961, 231; Moschini-Marconi, 1962, 124; Muraro, 1963, 168 (*Titian*); Baldass-Heinz, 1964, 155; Zampetti, 1968, no. 20; Panofsky, 1969, 90 (*Titian*).

Venice, Scuola Grande di San Rocco

30. CHRIST CARRYING THE CROSS Plate 116

Oil on canvas, 70 × 100 cms.
Provenance: From the church of San Rocco in Venice.

A print of 1520 shows the painting incorporated in an altar, which the documents preserved in the School show to have been erected in 1519 « on the pillar of the large chapel on the right hand looking towards the high altar » (« sopra el pilastro della cappella grande sul lato destro di chi guarda l'altar maggiore »). The engraving shows that the altar had a lunette above, with what was probably a marble relief — seemingly Lombard in style — of the Holy Father with cherubs and the symbols of the Passion (Fig. 34). The earliest reference to the painting in the sources is that of Michiel, who in 1532 recorded a painting in the house of Antonio Pasqualino: « The head of St. James with the staff, by Zorzi da Castelfranco, or by some pupil of his, drawn from the Christ in San Rocho » (« La testa del San Jacomo cun el bordon, fu de man de Zorzi da Castelfrancho, over de qualche suo discipolo, ritratto dal Christo de San Rocho »). Although Michiel does not state explicitly that the painting in San Rocco is by Giorgione, his words have been taken to imply it, if for no other reason, because he does not mention the name of another painter, which he would very likely have done, as was his custom, had he known, for instance, that the *Christ Carrying the Cross* was by Titian (Richter, 1937). In the 1550 edition Vasari gives the painting to Giorgione, and he continues with this attribution in the 1569 edition of the *Lives*. Here however he unexpectedly contradicts himself with the assertion, in the Life of Titian, that the *Christ Carrying the Cross* is by the latter artist, even though many had « believed that it was by Giorgione ». This contradiction lies behind the confusion in the sources, on which we can have no reliance on this point.

Why then did Vasari insert this contradictory assertion that the work is by Titian? Is this only symptomatic of the attributional confusion that emerged so soon after the death of Giorgione, especially with regard to the latter's unfinished works? Or did Vasari have access to different information? For our part, we feel that the information imparted in the first edition of the *Lives* is more reliable, being the fruit of a stay in Venice in 1542. In our opinion the later attribution probably derived from the prejudiced interpretation of some fanatical admirer of Titian; this would account for Vasari's leaving some uncertainty, while he does also make clear that the traditional attribution to Giorgione was still current. Modern historians have, however,

been divided on the issue: those who have favoured an attribution to Giorgione include Wickhoff (1895), Cook (1900), L. Venturi (1913), Justi (1926), Richter (1937), Della Pergola (1955), Coletti (1955), Berenson (1957), Baldass-Heinz (1964), and Zampetti (1968); while those who favour Titian include Morelli (1880), Hourticq (1930), Suida (1935, Morassi (1942), Tietze (1950), Pignatti (1955) and Valcanover (1960 and 1969). An attitude between these points of view, adjudging the work to be the result of collaboration, is assumed by Fiocco (1948) and Pallucchini (1953).

In the context of the critical profile of Giorgione outlined so far, we believe that the *Christ Carrying the Cross* belongs clearly in the phase of « realism » at the very end of the artist's career. This interpretation is reinforced by the suffering expressiveness of the Christ (which even some of those who generally favour Titian's authorship of the painting recognize as by Giorgione), and the extremely «human» dialogue between the four figures in the composition. It is quite consistent as has already been noted in other late works, that there should be reference to the realism of Dürer's style; in this instance there is an explicit reference to the latter's painting of *Christ among the Doctors*, which was once in the Barberini Collection in Rome, now in the Thyssen Collection, and which was painted in Venice in 1506. The contrast with the aggressive physiognomies of the executioners in the composition in San Rocco is distinctly reminiscent of the caricature-like quality of Dürer's faces (Fig. 35). Further indication that the *Christ Carrying the Cross* is in fact by Giorgione is to be had from a comparison with Titian's frescoes in the Scuola del Santo in Padua (painted in 1511), where the same caricatured profiles certainly re-appear, behind the young man almost in the centre of the *Miracle of the New-born Child*; but here they have a greater impression of form, a more excited sense of colour and more aggressive expressions, when they are compared with the « insecurity » of Giorgione's figures (Pl. 117).

A final element of disagreement between scholars concerns the condition of the paint surface around the figure of Christ: for Pellicioli (quoted by Zampetti, 1955) it is unfinished, whilst for many others it is «very rubbed», but «almost intact» for Zampetti (1968). In fact, even in its present condition, which betrays the wear of successive cleanings of a base that was exceptionally thin to start with, the painting shows the cautious and measured brushwork that is characteristic of Giorgione's work, and is certainly very different from Titian's earliest certain works, like the frescoes in the Santo or the altarpiece in the Salute. The handling of the paint is not, however, consistent with its being

the product of a collaboration — it is stylistically perfectly coherent. That it has been repainted in the past is evident only in the right-hand figure, who is seen to be bearded in the painting, but who was certainly not originally so, as is demonstrated by the engraving of 1520 and numerous early copies (Puppi, 1961).

Bibliography: Michiel, 1532 (1888), 1480; Vasari, 1550, 577; Vasari, 1568, IV, 91 and VII, 437; Morelli, 1880, 200 (*Titian*); Wickhoff, 1895, 34; Cook, 1900, 54; L. Venturi, 1913, 60; Justi, 1926, I, 74; Hourticq, 1930, 17 (*Titian*); Suida, 1935, 35 (*Titian*); Richter, 1937, 246; Morassi, 1942, 141 (*Titian*); Fiocco, 1948, 38; H. Tietze, 1950, 397 (*Titian*); Della Pergola, 1955, 54; Pallucchini, 1953, 69 (*Titian*); Pignatti, 1955, 141 (*Titian?*); idem, 1955², 502 (*Titian*); Coletti, 1955, 61; Zampetti, 1955, 114; Robertson, 1955, 276; Berenson, 1957, 84; Valcanover, 1960, I, 42 (*Titian*); Puppi, 1961, 39; Baldass-Heinz, 1964, 156; Zampetti, 1968, no. 27; Valcanover, 1969, no. 41 (*Titian*); Pallucchini, 1969, 24 (*Giorgione and Titian*); Wethey, 1969, 80 (*Titian*); Wind, 1969, 29.

Washington, National Gallery of Art

31. PORTRAIT OF A VENETIAN GENTLEMAN Plate 119

Oil on canvas, 76 × 64 cms. Inscribed (autograph) « V V O ». Inv. No. 369.
Provenance: From the Nichols Collection, London (nineteenth century); thence through various collections to the Kress Collection, New York (K 475).

First published by Berenson (1897) as a copy after a lost original by Giorgione, the authenticity of the painting was then supported by Reinach (1905), with whom Cook (1906) concurred; L. Venturi (1913) regarded it as a work by Sebastiano del Piombo. In 1922 Valentiner attributed it to Titian, and this was followed by Berenson (1932), L. Venturi (1933), Suida (1933), Tietze (1935 and 1950), Pallucchini (1953), (Pignatti (1955), Valcanover (1960) and Salvini (1961). In contrast Burroughs (1938) continued the attribution to Giorgione, on the basis of X-ray studies which showed three underlying versions: in the first, the sitter holds what Burroughs described as a sword (in fact a dagger); in the second, the hilt is transformed into a piece of rolled paper standing on a book and a balcony, while in the third the piece of paper is transformed into a handkerchief (or rather a purse — Figs. 28, 36). Richter (1937) accepted Burroughs's thesis to the extent of attributing at least the first version to Giorgione. Despite his mention of Cariani, Morassi (1942) regarded the *Portrait of a Venetian Gentlemen* as mainly the work of Giorgione; more recently this line also been supported by Valcanover (1969).
In 1962 the painting was cleaned by Modestini, and

the results substantiated the three versions identified by Burroughs through the X-ray studies (in: Pallucchini, 1962). New features to emerge included the view of the Doge's Palace and the Prisons, previously overpainted; a correction to the hem of the shirt, which had been raised, and the discovery of the mysterious inscription « V V O » (compare Fig. 36). This is in exactly the same place as the inscriptions on Giorgione's *Portrait of a Young Man* in Berlin (Cat. No. 11) and on the *Portrait of L. Crasso* formerly in London (A 25), nor is it very different from the initials « T V » that Titian inscribed below his *Portrait of a Man* (the so-called « *Ariosto* ») and the *Portrait of a Lady* in the National Gallery in London (Pl. 122). The colour balance of the Washington picture, in the steel-grey background, the dull green of the book and the grey-green of the balcony, re-emerged as a result of the cleaning. The light from the window falls gently upon the black silk damask from which the incongruous highlights, reminiscent of Van Dyck, have been removed, restoring it to its original delicate glaze.

Pallucchini (1962), in illustrating the results of the restoration, saw these as confirmation of the attribution to Titian, although he had some difficulty over the dating. Such is the Giorgionesque character of the painting that he dates it around 1508-10, even though the closest stylistic analogy he draws from Titian's work is the *Portrait of a Lady* (« *La Schiavona* ») which he dates around 1511. Nor does he fail to note that in the latter painting « the colour is applied more broadly... and is given greater emphasis ». The second comparison is the obvious one with the so-called « *Ariosto* »: but here, in order to account for the obvious stylistic differences, Pallucchini is obliged to date it even later than 1511, observing that the colour element « plays a greater role in it, gaining at the same time in luminous freedom ».

Are two or three years enough to account for such an advance in the portrait style of a single artist, and — in any case— what proof is there that it took place in that space of time, given the fact that all the paintings in question are undated?

Really, in order to establish certain distinctions between the portrait styles of Giorgione and Titian, we have very incomplete factual material. So far as Giorgione is concerned, there is the « *Laura* » of 1506 (together with the Berlin *Portrait of a Young Man*, which belongs close to it), and the *Portrait of a Man* in San Diego, which we have here restored to its rightful date of 1510; so far as Titian is concerned, there is only what can be gleaned from what remains of the *Justice* from the Fondaco (1508?) and the heads in the Padua frescoes (1511), with which the heads in the Salute altarpiece

(painted afer the plague of 1510) are certainly to be connected. But we should not neglect that Vasari provides another valuable clue in his description of the Portrait of a Member of the Barbarigo family, painted when Titian « was no more than eighteen » (that is to say even before his work on the Fondaco — 1508-9 — which Dolce (1557, 54) attributes to him « when he was barely twenty »). It is clear that Vasari's description was motivated by an intuitive understanding, and he was prompted to make a distinction between Titian's style and that of Giorgione: « it was held in high regard, for the semblance of complexion was very real and natural, the hair on his head so well painted that you could count each one, as one could also the stitches in the great silvery satin jacket he painted in that work ». There could be no more apt description of the so-called « Ariosto » in the National Gallery, a painting which we believe actually to be the Barbarigo portrait mentioned by Vasari (or at least a work similar to it). It was Suida (1933, 31) who first identified the National Gallery picture with the work mentioned by Vasari; he was supported in this by Gioseffi (1959, 55), although Gould (1959, 115) discounted the suggestion. But there is certainly no documentation for the suggestion (ibid.) that the work dates from 1512, and we believe that it could be a great deal closer than has hitherto been thought, to the period of 1507-8 implied by Vasari for the Barbarigo portrait. This is supported by Morassi's recent (1969, 26) dating to « circa 1510 » of a number of Titian portraits that are considerably more advanced than the so-called « Ariosto », such as the ones in the Frick Collection and at Petworth House. If this was the case, then the beginnings of Titian's portrait style date from well within the span of Giorgione's career, indeed from before the Fondaco frescoes.

In the case of the controversial Portrait of a Venetian Gentleman, we have then to choose between linking it with the « new style » introduced by Titian and described by Vasari (and corresponding to that of the so-called « Ariosto » in London), or with the final style of Giorgione as evidenced in the San Diego Portrait of a Man. The straight comparison of the paintings leaves no doubt that the Washington painting belongs alongside the San Diego picture, of which it recalls the handling of the shading, with transparent washes in an emulsion of tempera and oil (Modestini), and the short curved brushstrokes that are characteristic of Giorgione. It is true that the « pose » is here very much more relaxed, turning the sitter round to a three-quarters position, as occurs in Titian's « Ariosto ». But Giorgione had already employed this pose in the Portrait of an Old Woman (« La Vecchia »); while the window with a view of Venice is also a feature of the Madonna with a Book in Oxford, the balcony with the initials a feature of the Portrait of a Young Man in Berlin. In our view then, if the Portrait of a Venetian Gentleman is by Giorgione around 1510, Titian would have been able before that time, and after the age of «eighteen» (circa 1507-8), to paint not only the Barbarigo portrait but also — if it was indeed a different picture — the so-called « Ariosto ». If we were to concede -- however untenable — that the Washington painting could be by Titian towards 1509, it would be as an altogether isolated instance, with no connection with the « Ariosto » or his other portraits, whether these precede or follow the death of Giorgione. We would also have to make the Concert in the Pitti Gallery and the Male Portrait in the Metropolitan Museum in New York considerably later than 1509, and we would then come up against works of Titian's maturity like the Pastoral Concert in the Louvre (if that is accepted), the little altarpiece in the Salute and the frescoes in Padua (1511). It is clear that in order to posit a chronology for Titian between 1507 and 1511, the most realistic suggestion is that of eliminating the Portrait of a Venetian Gentleman and restoring it to Giorgione's hand; it otherwise represents an insuperable stumbling block in the former's development.

Bibliography: Berenson, 1897, 275 (copy after Giorgione); Reinach, 1905, I, 463; Cook, 1906, 338; L. Venturi, 1913, 336 (Sebastiano); Valentiner, 1922, no. 5 (Titian); Berenson, 1932, 573 (Titian); L. Venturi, 1933, no. 505 (Titian); Suida, 1933, 151 (Titian); H. Tietze, 1935, 85 (Titian); Phillips, 1937, 55; Burroughs, 1938, I; Richter, 1942, 152; Morassi, 1942, 144; Douglas, 1949, 3; Tietze, 1950, 404 (Titian); Pallucchini, 1953, 53 (Titian); Pignatti, 1955, 147 (Titian?); Coletti, 1955, 67; (Titian); Valcanover, 1960, I, 45 (Titian); Salvini, 1961, 237 (Titian); Pallucchini, 1962, 234 (Titian); Shapley, 1968, 178 (Titian); Zampetti, 1968, 74 (Palma); Valcanover, 1969, No. 2; Pallucchini, 1969, 12 (Titian).

WORKS ATTRIBUTED TO GIORGIONE

The catalogue of works attributed to Giorgione is arranged by topographical location, and it follows the sequence of Plates 123-213, grouped in terms of individual artists or artistic circles. It includes all those works which, although not attributed to Giorgione by the present writer, have been reasonably regarded as his work in the past and continue to find some art-historical support. The designation « circle of Giorgione » is applied to those which, in varying degrees, approach Giorgione's style most closely; in these cases the occasional possibility of collaboration from the master himself cannot be totally ruled out.

Amsterdam, Rijksmuseum

A 1. ALLEGORY OF CHASTITY (« SAINT JUSTINA »)
Plate 143

Oil on canvas, 28 × 38 cms. Inv. No. 98181.
Provenance: From the Kaufmann Collection in Berlin, later in the Lanz Collection, Amsterdam.

Attributed to Giorgione by Bode, this view was also followed by Cook (1900), Richter (1937) and, with some doubts, by Morassi (1942), Fiocco (1948) and coletti (1955). But it was regarded as a work of the Circle of Giorgione by Frizzoni (1902), Justi (1908), Pallucchini (1944), Zampetti (1955 and 1968), Della Pergola (1955), Pignatti (1955) and Berenson (1957).
The painting itself is in a poor state of conservation, and this makes the question of attribution a difficult one. The type of foliage on the ground, which almost appears « printed », is close in style to the *Little Faun* in Munich (A 31), and suggests that the painting may originally have had more of that character before it was damaged. In any case, it belongs to the Circle of Giorgione, but it would be hard to justify its inclusion among the works of the artist himself.

Bibliography: Cook, 1900, 131; Kaufmann Catalogue, 1901, no. 110; Frizzoni, 1902, 299 (*copy*); Monneret de Villard, 1904, 86 (*school*); Justi, 1908, I, 267 (*school*); Richter, 1937-208; Morassi, 1942 57; Pallucchini, 1944, XII; Fiocco, 1948, 32; Fiocco, 1955, 7 (*copy*); Della Pergola, 1955, 33 (*follower*); Pignatti, 114 (*circle*); idem, 1955², 497; Coletti, 1955, 52; Zampetti, 1955, 66 (*copy?*); Berenson, 1957, 86 (*circle*); Zampetti, 1968, mo. 59 (*?*).

A 2. MALE PORTRAIT
Plate 204

Oil on canvas, 26 × 21 cms.
Provenance: From the Goudstikker Collection, Amsterdam, then Thyssen Collection up to 1934, when it returned to the Goudstikker Collection.

Attributed to Giorgione by Van Marle (1929), it entered the Thyssen Collection (Catalogue 1930) as such, but it was described by Oettinger (1929) as a replica of the painting (No. 299) in the Gallerie dell'Accade-mia in Venice, which he attributed to Giorgione. Later Troche (1934) supported the attribution to Cariani of the painting in Venice, and adjudged the Goudstik-ker painting as a copy; this view was also held by Gallina (1954). Richter (1937) on the other hand, brought the painting back into the discussion of Giorgione's paintings, witholding judgement himself by reason of the poor condition of the painting; with Morassi (1942) it belongs to the Circle of Giorgione. For us too the Amsterdam portrait precedes the broader and more assured composition of the painting in Venice: it may well be that it served as a *modello* for the latter. We also support the attribution to Cariani, bearing in mind not only the comparison with the portrait (No. 299) in the Gallerie dell'Accademia, but also the similarity with other portraits by the same artist, such as the one in the Accademia Carrara in Bergamo which bears the inscription « Jo. C ».

Bibliography: Van Marle, 1929, 100; Oettinger, 1929, 229 (*replica*); Troche, 1934, 120 (*copy*); Richter, 1937, 208 (*?*); Morassi, 1942, 217 (*follower of Giorgione*); Gallina, 1954, 117 (*copy*); Pignatti, 1955, 114 (*circle of Giorgione*); Moschini Marconi, 1962, 105 (*copy?*).

Bergamo, Accademia Carrara

A 3. ORPHEUS AND EURYDICE
Plate 175

Oil on panel, 39 × 53. Inv. No. 205.
Provenance: From the Lochis Collection.

Attributed to Giorgione by Cook (1900), followed with some doubts, by Justi (1908 and 1926). From 1903 onwards, however, with Berenson's study, the attribution to Cariani gained ground, supported by Monneret de Villard (1904) and Borenius (1912), while another to Palma was subsequently favoured by Berenson (1932 and 1957) and Coletti (1955). Suida (1933) introduced the attribution to Titian, now universally recognized, with the exception of Zampetti (1968) who regards the work as a copy.
There is no need to describe at any length the very realistic and animated character of the landscape, which

corresponds even in details with the landscape backgrounds of paintings by Titian, from the print of the *Passage of the Red Sea* to the *Sacred and Profane Love*, pointing to a date towards the end of Giorgione's life or after his death. This is in any case Titian's « Giorgionesque » phase, the period when he devoted himself to completing the artist's unfinished compositions and painted the *Pastoral Concert*, which has innumerable reminiscences of the little composition of the *Orpheus and Eurydice*.

Bibliography: Cook, 1900, 89; Berenson, 1903, 76; Monneret de Villard, 1904, 97 (*Cariani*); Justi, 1908, 197; Borenius, 1912, III, 459 (*Cariani*); L. Venturi, 1913, 255 (?); Justi, 1926, 319; Berenson, 1932, 408 (*Palma*); Suida, 1933, 17 (*Titian*); Richter, 1937, 208 (*Copy after Giorgione?*); Morassi, 1942, 134; Longhi, 1946, 64 (*Titian*); Fiocco, 1948, 36 (*Giorgione?*); Pallucchini, 1953, 52 (*Titian*); Suida, 1954, 160 (*Titian*); Morassi, 1954, 191 (*Titian*); Coletti, 1955, 67 (*Palma*); Robertson, 1955, 277 (*Titian*); Berenson, 1957, 85 (*copy after Giorgione*); Valcanover, 1960, I, 46 (*Titian*); Zampetti, 1968, no. 140 (*copy*); Valcanover, 1969, no. 7 (*Titian*); Pallucchini, 1969, 10, (*Titian*).

Berlin - Dahlem, Staatliche Museen

A 4. CERES Plate 196

Oil on canvas, transferred from panel, 70 × 54 cms.
Provenance: From a Private Collection in Augsburg.

Judged by Troche to be by Cariani (1934). In 1954 Zimmermann, after the painting had entered the Berlin Museum, attributed it to Giorgione, but for Pignatti (1955) it was closer in style to Sebastiano del Piombo, a view supported after the Exhibition in Venice by Pallucchini (1955) who dated it to *circa* 1512. Coletti (1955) on the other hand, suggested the name of Gerolamo da Treviso. The painting, which is poor in colouring and naïvely « Giorgionesque » as regards the landscape, can be seen as the product of an early undocumen-ted phase of Sebastiano's career, paralleled by some of the early works of Palma around the time of the *Nymphs* in Frankfurt and London (Mariacher, 1968, Nos. 6-7).

Bibliography: Troche, 1934, 121 (*Cariani?*); Zimmermann, 1954, 2; Pignatti, 1955, 115 (*Sebastiano?*); Pallucchini, 1955, 12 (*Sebastiano*); Coletti, 1955, 64 (*Gerolamo da Treviso il Giovane*); Robertson, 1955, 277 (*Sebastiano*); Zampetti, 1968, no. 77 (?).

Formerly Bowood, Marquess of Lansdowne

A 5. PORTRAIT OF AN ANTIQUE COLLECTOR Plate 209

Oil on canvas, 75 × 66 cms.

Included in the Catalogue of the Lansdowne Collection (1897), No. 49. Exhibited (1911) in London at the Grafton Galleries as by Giorgione, this attribution was contested by Berenson (1957) who lists it as a copy. It then passed into a Swiss private collection and was published again by Salvini (1961) as by Giorgione, with a dating between 1508 and 1510 and a tentative identification of the sitter as Pietro Contarini, the antiquarian and friend of the painter. Not having seen the original, we can only say that the « photographic » pose is somewhat conventional, and reminiscent rather of Palma's portraits in the second decade of the century. The closest parallel, both in terms of the compositional formula and as regards the psychological interpretation, is perhaps Cariani's *Portrait of a Man with a Fur* (Gabriele Vendramin?) in the Gallerie dell'Accademia in Venice, which dates from as late as 1526.

Bibliography: Lansdowne House Catalogue, 1897, no. 49; Grafton Galleries, 1911, no. 82; Berenson, 1957, 85 (*copy*); Salvini, 1961, 226.

Brunswick, Herzog Anton Ulrich-Museum

A 6. PORTRAIT OF A YOUNG MAN WITH A BOOK Plate 129

Oil on panel, 52 × 36 cms. Inv. No. 452.
Provenance: From the Collection of the Duke of Brunswick, there described as a « Self-Portrait by Raphael » (1776).

Giorgione's name was first mentioned in connection with this painting by Passavant (1860); it was then attributed to him by Gronau (1908) and, though with doubts on account of the poor state of conservation, by Morassi (1942). Berenson (1932) initiated the attribution to Palma, one which was also taken up by Richter (1937) and Coletti (1955), but not mentioned by Mariacher (1968).

As in 1955, we would stress the fact that this painting belongs in the close circle of Giorgione. This is evident in the compositional arrangement, which is altogether similar to that of the *Portrait of a Young Man* in Berlin; some details, like the hem of the garment, recall the *Three Philosophers*, and the hand holding the book is reminiscent of the same feature in the *Shepherd Boy with a Flute* at Hampton Court. The ruinous state of preservation of the canvas makes it, however, impossible to ascertain any further the authenticity of the painting.

Bibliography: Passavant, 1860, I; Gronau, 1908, 419; Berenson, 1932, 408 (*Palma*); Richter, 1937, 209 (*Palma*); Morassi, 1942, 144 (*Giorgione?*); Pignatti, 1955, 116 (*circle of Giorgione*); Coletti, 1955, 67 (*circle of Palma*).

Budapest, Museum of Fine Arts

A 7. PORTRAIT OF A YOUNG MAN (BROCARDO) Plate 123

Oil on canvas, 72.5 × 54 cms. Inscribed: « ANTONIUS
BROKARDUS MAR » (later?). Inv. No. 140.
Provenance: From the Collection of Cardinal Pyrker
(1846).

Attributed to Giorgione by Thausing (1884), this was
generally supported, with the exception of Frimmel
(1892) who suggested Pordenone instead; for A. Ven-
turi it was Licinio (1900); for L. Venturi (1913), anon-
ymous, like the portrait of St. Francis; for Richter
(1937), an artist from Treviso in the second or third
decade of the century. Kàkay (1960) supported Titian's
authorship of the painting, especially on account of the
relationship with the *Concert* in the Pitti Gallery. He
also published the X-ray of the painting, which shows
a window with a landscape on the left hand side of the
composition. As regards the identification of the sit-
ter, Auner (1958) noted that Brocardo died young in
1531, a fact which would place the painting well be-
yond the limits of Giorgione's career. The authentici-
ty of the inscription is also suspect. Richter mentions
Jacobs's view that the man is Vettor Cappello of Tre-
viso: this identification is derived from the symbols
painted on the parapet, the V on the hat and the three-
headed cameo (*Tre-viso* meaning 'three headed'). On
the other hand Hartlaub (1925) interpreted these as
the symbols of a sect, with the three-headed emblem
standing for Hecate.
The attraction of the painting derives largely from the
mystery which surrounds the character represented,
and it is not matched, in our opinion, by the actual
appearance of the painting. While the figure is indeed
expressive, there is a substantial lack of « colour »
which makes it impossible to sustain the attribution
to Giorgione, even though this has been maintained
with some authority. Furthermore, there is no trace
in the painting — whose surface is somewhat damaged
and overpainted — of the flesh-pink ground work that
is quite characteristic of all of Giorgione's work. On
the other hand, the sitter's pose is indubitably « Gior-
gionesque », and the rediscovery of the existence of
a window to the left shows that it derives in pattern
at least from the composition of works like the *Ma-
donna with a Book* in Oxford and the *Portrait of a Ve-
netian Gentleman* in Washington. Nor does an attri-
bution to the well-known artists of Giorgione's circle,
like Cariani or Pordenone or (even more improbably)
Titian, really seem possible, even though a dating in
the second decade of the century would thereby be
possible.

Bibliography: Thausing, 1884, 313; Frimmel, 1892, 233 (*Pordeno-
ne*); Morelli, 1893, 218; Berenson, 1894, 107; Cook, 1900, 31; A.
Venturi, 1900, 138 (*Licinio*); L. Venturi, 1913, 256 (*?*); Hartlaub,
1925, 67; Longhi, 1927, 220; Justi, 1926, II, 332; Richter, 1937,
211 (*?*); Morassi, 1942, 102 (*Cariani*); Pallucchini, 1944, XII;
Longhi, 1946, 22; Fiocco, 1948, 32; Gamba, 1954, 174; Della
Pergola, 1955, Pl. 107 (*anonymous*); Pignatti, 1955, 117 (*attributed
to Giorgione*); Coletti, 1955, 65 (*Pordenone*); Berenson, 1957, 83;
Auner, 1958, 151; Kàkay, 1960, 320 (*Titian?*); Volpe, 1964, 3;
Garas, 1968, no. 28, 82; Morassi, 1967, 205 (*Cariani*); Pigler,
1968, 264; Zampetti, 1968, no. 62 (*of the 2nd decade*).

A 8. SAINT ELIZABETH WITH THE INFANT SAINT JOHN
Plate 153

Drawing, pen and ink and wash, brown ink; 16.3 ×
11.2 cms. Inv. No. 1783.
Provenance: From the Esterházy Collection (1870).

Published as « anonymous » by Schoenbrunner-Meder
(1860-1908), the drawing was attributed to Giorgione
by the Tietzes (1944), principally on the grounds of the
similarity between the landscape and that of the *Ma-
donna and Child in a Landscape* in the Hermitage. The
same authors also suggested that the drawing had been
cut on the right, where there are traces of the figure
of St. Joseph. From this they imagined (with no factual
evidence) that the painting in Leningrad is a fragment
of a Holy Family, for which the drawing could repre-
sent a preparatory study. Fenyö (1965) supports the
thesis advanced by the Tietzes, placing emphasis once
again on the Giorgionesque character of the landscape.
Morassi (1955) on the other hand, dates the drawing
much earlier — around 1480 — and attributes it to
Bellini.
In our view, the handling of this drawing does not cor-
respond with the characteristic « painterly glaze » that
is a feature of the few drawings that are certainly by
Giorgione, not even with the most advanced of these
(the almost Titianesque drawing in Darmstadt, Cat.
No. 22).
Against an apparently Bellinian compositional for-
mula, the artist of the Budapest drawing seems to em-
ploy a much more modern graphic style, which endows
the figures with a strong realism — the aggressive
three-dimensionality of the infant St. John. Finally
the landscape is more Titianesque than Giorgionesque,
closer to those of the *Couple* in the Albertina in Vien-
na (T. 1970) or the *Jealous Husband* in the École des
Beaux-Arts in Paris (T. 1961).

Bibliography: Schoenbrunner-Meder, 1860-1908, no. 1137 (*ano-
nymous*); H. and E. Tietze, 1944, no. 703; Morassi, 1955, 158
(*Bellini*), Fenyö, 1965, 24.

Compton Wynyates (Warwickshire), Marquess of Northampton

A 9. IDYLL Plate 202

Oil on panel, 78 × 76 cms.
Provenance: From the Collection of Lord Ashburton.
Published by Conway (1928) as by Giorgione, this was contested by Berenson (1932) who attributed it to Titian. The attribution to Giorgione is followed by Fiocco (1941), Zampetti (1955) and Coletti (1955), while Morassi (1942), Pignatti (1955) and more recently Berenson (1957) and Wind (1969) have favoured an assessment locating the work in the circle of Giorgione's followers. In this connection, Zampetti quotes Longhi's opinion in favour of Sebastiano and Pallucchini's for Palma.
In our opinion, the similarity between the *Idyll* and the *Allegory* in Philadelphia by Palma, dated between 1510 and 1515 (Mariacher, 1968, No. 8) is so striking, that an attribution to that artist seems possible. It could well be a useful indication of the style of Palma's « small histories » at the time when he knew Giorgione.

Bibliography: Conway, 1928, 261; Berenson, 1932, 574 (*Titian*); Phillips, 1937, 134; Morassi, 1942, 217 (*pupil of Giorgione*); Fiocco, 1948, 35; Zampetti, 1955, 60; Pignatti, 1955, 128 (*circle of Giorgione*); Coletti, 1955, 53; Fiocco, 1955, 7 (*copy*); Berenson, 1957, 86 (*Giorgionesque*); Bonicatti, 1964, 201 (*Giorgionesque*); Zampetti, 1968, no. 60 (*follower*).

Detroit (Michigan), Institute of Arts

A 10. TRIPLE PORTRAIT Plate 203

Oil on canvas, 84 × 69 cms. Inscribed (later) on the reverse: « FRA SEBASTIANO DEL PIOMBO — GIORZON — TITIAN ». Inv. No. 26.108.
Provenance: From the Schönborn Gallery in Pommersfelden; later Oldenbourg.
Attributed to Giorgione when at Pommersfelden, the painting was then given to Cariani by Mündler (1867), followed by Cavalcaselle (1871), Morelli (1891), L. Venturi (1913), A. Venturi (1928), Berenson (1932), Pallucchini (1944) and Fiocco (1948). Morassi (1942) on the other hand suggests Palma il Vecchio. In the meantime the painting itself moved to the Institute of Arts in Detroit, and support was growing for the idea that three hands had worked on the painting, based largely on the inscription which Valentiner (1925-26) and Suida (1933) held to be substantially authentic. Mather (1926) on the other hand, disagreed, adjudging the painting to be a later « pastiche », as also more recently Valcanover (1969). Fol-

lowing the painting's inclusion in the Exhibition in Venice (Zampetti, 1955), the idea of a collaboration between Giorgione, Sebastiano and Titian gained ground once more, enjoying the support of Pallucchini (1955), Suida (1956), Berenson (1957), Volpe (1964) and Zampetti (1968).
We must agree with Mather (1926) above all in his distrust of the inscription, which is obviously apocryphal since Sebastiano only became « Frate del Piombo » in 1531. This must be — if we are to regard the inscription as evidence at all — the *terminus a quo* for the painting. We would add that direct observation of the picture rules out, in our opinion, any possibility of a stylistic differentiation between the three figures. To us they appear to be in the same hand, with a distinctive fluid brushwork and a broad wash, tending towards effects of « crumpling » that are quite characteristic of Palma around 1515 (*Head of Woman in Profile*, Vienna, No. 603). There are indeed no stylistic differences between the three figures; their difference lies in the stylized, almost « academic » interpretation of the styles of the three artists imitated: Sebastiano represented by a head taken in reverse from that of one of the Saints in the San Giovanni Crisostomo altarpiece (of 1509?), Titian by a head similar to the *Allegory* in the Louvre (of around 1530). The very difference in date of the « models » represented in this painting make the possibility of collaboration a remote one; the work most likely belongs (with, however, the caution one adopts in view of the exceptional) near to Palma around 1520-5. A copy that is close to Padovanino is in the Gallerie dell'Accademia in Venice.

Bibliography: Mundler, 1867, II, 14 (*Cariani*); Crowe-Cavalcaselle, 1871, VI, 615 (*Cariani*); Morelli, 1891, 32 (*Cariani*); L. Venturi, 1913, 234 (*Cariani*); Valentiner, 1925-6, 62 (*Giorgione, Sebastiano and Titian*); Mather, 1926, 73 (*imitation of circa 1600*); A. Venturi, 1928, IX-III, 462, (*Cariani*); Berenson, 1932, 10 (*Cariani*); Suida, 1933, 29 (*Giorgione, Sebastiano and Titian*); Morassi, 1942, 172 (*Palma*); Pallucchini, 1944, 113 (*Cariani?*); Fiocco, 1948, 14 (*Cariani*); Pignatti, 1955, 120 (*?*); Zampetti, 1955, 98 (*Giorgione, Sebastiano and Titian*); Pallucchini, 1955, 12 (*Giorgione, Sebastiano and Titian*); Robertson, 1955, 276 (*pastiche*); Suida, 1956, 72 (*Giorgione, Sebastiano and Titian*); Berenson, 1957, 184 (*partly by Titian*); Volpe, 1964, 6 (*Giorgione, Sebastiano and Titian*); Zampetti, 1968, no. 30 (*Giorgione, Sebastiano and Titian*); Valcanover, 1969, no. 19 (*imitation*); Pallucchini, 1969, 20 (*Giorgione, Sebastiano and Titian*).

Florence, Palazzo Pitti

A 11. THE CONCERT Plate 180

Oil on canvas, 109 × 123 cms. Inv. No. 185.
Provenance: From the Collection of Paolo del Sera in Venice (Ridolfi, 1648), where it was also seen by

Boschini (1660). In 1654 the painting was acquired by Cardinal Leopoldo de' Medici.

The traditional attribution to Giorgione, which was taken up by Cavalcaselle, was challenged for the first time by Morelli (1886), who suggested the young Titian. Despite the disagreement of Cook (1900), Justi (1908) and Hartlaub (1925), the interpretation in favour of Titian's authorship prevailed, supported by L. Venturi (1913), Suida (1935), Morassi (1942), Longhi (1946) and Pallucchini (1953), and the painting was also given this attribution when it was included in the Exhibition in Venice (Zampetti, 1955). In the meantime, following Richter's study, support was growing for the view that the work had been started by Giorgione and completed by Titian: this was the line taken, with some alight variations, by Fiocco (1948), L. Venturi (1954) and Berenson (1957). Those who attribute the work to Titian include among others Pignatti (1955), Valcanover (1960), Baldass-Heinz (1964) and Zampetti (1968); Tietze's (1946) reference (following suggestions from Hourticq and Friedeberg) to the possibility of the intervention of Sebastiano del Piombo has found no further support. The painting is in a poor state of conservation, owing to repaint and early alterations. Amongst other things, comparison with a print by Lasinio shows that the canvas has been cut down at the top and bottom by about 20 cms, the edge being drawn over the edge of the stretcher and considerably damaged in the course of its restoration to the original dimensions. For this reason it is difficult to accept the interpretation — advanced by Valcanover (1969) — that the work is the result of a collaboration between two hands, since this effect is probably due to the poor state of conservation of the head to the left. In this part of the picture which Gronau (1907) regarded as what survives of Giorgione's initial design — the little white shirt with pleats is in a good state of conservation, and its handling seems decidedly Titianesque in character. Although much has been rubbed away in successive cleaning, the same also appears to apply to the face of the monk with the viola da gamba (?) where there are strong affinities with the early portraits of Titian, to whom we believe the *Concert* should be attributed *in toto*.

Bibliography: Ridolfi, 1648, I, 99; Crowe and Cavalcaselle, 1871, II, 144; Morelli, 1886, 185 (*Titian*); Cook, 1900, 49; Gronau, 1907, I; Justi, 1908, 253; L. Venturi, 1913, 149 (*Titian*); Hartlaub, 1925, 32; Ferrigusto, 1933, 353 (*Titian*); Suida, 1933, 36 (*Titian*); Richter, 1937, 216 (*Giorgione and others*); Morassi, 1942, 131 (*Titian*); Longhi (1946,) 22 (*Titian*); E. Tietze, 1946, 83 (*Giorgione and Sebastiano*); Fiocco, 1948, 38 (*Giorgione and others*); R. Pallucchini, 1953, 70 (*Titian*); L. Venturi, 1954, 52 (*Giorgione and others*); Della Pergola, 1955, 62 (*Titian*); Pignatti, 1955, 121 (*Titian*); Pallucchini, 1955,

15 (*Titian*); Robertson, 1955, 277 (*Titian*); Berenson, 1957, 1957, 84 (*Giorgione and Titian*); Valcanover, 1960, I, 52 (*Titian*); Baldass-Heinz, 1964, 171 (*Titian*); Zampetti, 1968, No. 33 (*Titian?*); Valcanover, 1969, no. 42 (*Titian and assistant*); Pallucchini, 1969, 24 (*Titian*).

Florence, Uffizi

A 12. THE KNIGHT OF MALTA Plate 183

Oil on canvas, 80 × 64 cms. Inscribed (on the rosary): « XXXV »; on the reverse: « Giorgio da Castelfranco detto Giorgione » (seventeenth century?). Inv. No. 942.
Provenance: From the Collection of Paolo del Sera in Venice, acquired in 1654 by Cardinal Leopoldo de' Medici.

The old attribution to Titian was immediately put in doubt by Cavalcaselle (1871), who suggested Giorgione's hand, although with some reservations on account of the poor state of conservation. Morelli (1893) supported the attribution to Giorgione, which from then onwards was followed by most writers: Berenson, 1894, 1932 and 1957, Cook (1900), Hartlaub (1926), A. Venturi (1928), Richter (1937), Fiocco (1948), Gamba (1954), Della Pergola (1955) and Coletti (1955). As early as 1908 however Justi had maintained that the painting was by Titian, and this was supported by L. Venturi (in 1913; in 1954 he expressed a different opinion), Suida (1933), Morassi (1942), Pallucchini (1953), Pignatti (1955), Zampetti (1955), Valcanover (1960 and 1969) and Baldass-Heinz (1964).
The art-historical controversy over the attribution of this painting, surprising because of the startling differences of opinion, is due in part to the state of preservation of the surface, which is obscured by thick layers of repaint and yellowed varnish. In spite of this, we hold by the attribution to Titian, both on the grounds of the compositional arrangement, which is close to that of the *Portrait of a Man* (the so-called « *Ariosto* ») in the National Gallery in London, and it would be even closer if cleaning uncovered the balcony with a step that seems to show through the overpaint; and equally on account of the strong effects of light on the face and the hand, bringing whiteness to the shirt with a vibrant rendering that is characteristic of Titian's hand in for instance the *Male Portrait* in the Metropolitan Museum in New York (A 35) or the *Portrait of a Man* in the Louvre, included in the 1955 Exhibition in Venice (Cat. No. 77).

Bibliography: Crowe and Cavalcaselle, 1871, II, 154; Morelli, 1893, 216; Berenson, 1894, 200; Phillips, 1894, I, 58; Cook, 1900, 19; Justi, 1908, 266 (*Titian*); L. Venturi, 1913, 150 (*Ti-*

tian); Hartlaub, 1926, II; a. Venturi, 1928, IX-III, 28; Berenson, 1932, 233; Suida, 1933, 33; Richter, 1937, 217; Morassi, 1942, 133 (*Titian*); Fiocco, 1948, 38; Longhi, 1946, 25 (*Paris Bordone*); L. Venturi, 1954, 47; Gamba, 1954, 174 (*including participation by Titian*); Pallucchini, 1953, 100 (*Titian*); Della Pergola, 1955, 38 (*Giorgione?*); Pignatti, 1955, 122 (*Titian?*); idem, 1955², 505 (*Titian?*); Coletti, 1955, 61; Zampetti, 1955, 118 (*Titian*); Pallucchini, 1955, 15 (*Titian*); Castelfranco, 1955, 310; Robertson, 1955, 277; Berenson, 1957, 84; Valcanover, 1960, I, 94 (*Titian?*); Baldass-Heinz, 1964, 171, (*Titian*); Zampetti, 1968, No. 32 (*Titian*); Valcanover, 1969, No. 66 (*Titian?*); Pallucchini, 1969, 40 (*Titian*).

A 13. WARRIOR WITH A PAGE-BOY: PORTRAIT OF GAT-
TAMELATA Plate 126

Oil on canvas, 90 × 73 cms. Inv. No. 911.

Attributed by Cavalcaselle (1871) to Torbido, it was Justi (1908) who first associated the painting with Giorgione's hand, as a damaged original or a version. Subsequently there was a tendency to place the work closer to Verona, with attributions to Caroto (Boehn, 1908) and Cavazzola (Borenius, 1912). The attribution to Cavazzola was supported also by Berenson (1932), Gamba (1954) and Coletti (1955), while Fiocco proposed (1948) Torbido once more, and Riccoboni (1955) Romanino. In the meantime, Longhi (1946) put the weight of his authority on an attribution to the last period of Giorgione.

Zampetti repeats (1968) the position he adopted in the 1955 Exhibition catalogue, regarding the painting as « an old copy of a lost original by Giorgione » — a view that enjoys the support of Pallucchini (1955). By and large, art historians are agreed in recognizing the « Giorgionesque » character of the painting, but— with the exception of Longhi — none see his hand in the actual execution which is metallic in character, dry in modelling, and tending towards a use of light that reflects rather than absorbs colour. We cannot regard this painting even, however, as a copy — it is certainly of first-class quality. It must for the time being be placed in Giorgione's close circle, in the anticipation of the discovery of the name belonging to this highly individual style.

Bibliography: Crowe and Cavalcaselle, 1871, I, 511 (*Torbido*); Justi, 1908, 212 (*Giorgione?*); Boehn, 1908, 62 (*Caroto*); Borenius, 1912, II, 218 (*Cavazzola*); Berenson, 1932, 141 (*Cavazzola*); Longhi, 1946, 64; Fiocco, 1948, 33 (*Torbido*); Gamba, 1954, 177 (*Cavazzola*); Pignatti, 1955, 123 (*Giorgione?*); Coletti, 1955, 65 (*Cavazzola*); Zampetti, 1955, 82 (*copy?*); Pallucchini, 1955, 19 (*old copy*); Riccoboni, 1955, 59 (*Romanino*); Robertson, 1955, 276 (*Torbido*); Volpe, 1964, 6; Garas, 1965, No. 27, 52 (*Giorgione?*); Zampetti, 1968, 1968, No. 68 (*old copy*).

Fullerton (California), Norton Simon Museum of Art

A 14. FEMALE PORTRAIT (THE COURTESAN) Plate 177

Oil on canvas, 32 × 24 cms. On a card on the reverse: « Giorgione » (eighteenth century? no longer existing). Provenance: From the Collection of Prince Lichnowsky of Kuchelna; Cassirer, Berlin; Lord Melchett; Duveen.

Traditionally attributed to Giorgione, on the basis of a card on the back, which Richter (1937) records at the time that the painting was with Cassirer; at the same time Baldass (1929) and Troche (1932) already attributed the work to Cariani. Berenson (1932) was the first to suggest the hand of the young Titian, a view that was later supported by Suida (1933), Morassi (1942), Fiocco (1948), Pignatti (1955) and Valcanover (1960 and 1969). At the time of the 1955 Exhibition in Venice, at which it was exhibited as an original (Zampetti, 1955), the attribution to Giorgione was favoured once more, by Coletti (1955), Pallucchini (1955) and Berenson (1957).

The painting has certainly suffered damage, but the picture surface is still for the most part clearly defined. There is no doubt that it has greater affinities not with Giorgione's paintings around 1506 (the *Laura* in Vienna and the *Portrait of a Young Man* in Berlin) with which it has previously been associated, but rather with certain works by Titian, such as the *Madonna in a Landscape* in the Accademia Carrara in Bergamo or the *Christ and the Adulteress* in Glasgow (A 16). Even though the composition follows a Giorgionesque pattern, the soft and vibrant application of the paint is distinctly that of Titian.

Bibliography: Baldass, 1929, 104 (*Cariani*); Berenson, 1932, 575 (*Titian*); Suida, 1933, 17 (*Titian*); Richter, 1937, 226; Morassi, 1942, 218 (*Titian?*); Tietze, 1947, 141 (*?*); Fiocco, 1948, 16 (*Titian?*); Pignatti, 1955, 133 (*Titian?*); Coletti, 1955, 55; Zampetti, 1955, 56; Pallucchini, 1955, 4; Robertson, 1955, 277; Berenson, 1957, 84; Valcanover, 1960, I, 47 (*Titian*); Salvini, 1961, 239 (*Titian?*); Heinemann, 1962, 222 (*Rocco Marconi*); Zampetti, 1968, No. 84 (*Titian?*); Valcanover, 1969, No. 29, (*Titian*).

A 15. MALE PORTRAIT Plate 179

Oil on canvas, 69 × 52 cms.
Provenance: From the Eissler Collection in Vienna; Duveen; Bache, New York; Duveen (1955).

Attributed to Titian by Suida (1922) the painting was then given to Giorgione by L. Venturi (1933), followed, with some reservations, by Richter (1937), Morassi (1942), Pignatti (1955) and Berenson (1957). On the other hand Zampetti (1955 and 1968) attributed it

to Titian, and this view was supported by Pallucchini (1955) and Valcanover (1960). Coletti (1960) regards it as close to Palma. The picture is not in a good state of preservation, but it should be recognized that its character is predominantly that of Titian's style in the second decade of the century.

Bibliography: Suida, 1922, 169 (*Titian*); L. Venturi, 1933, III, n. 494; Suida, 1933, 32 (*Titian*); Richter, 1937, 230; Phillips, 1937, 143 (*Giorgione and Titian*); Morassi, 1942, 172 (*Gorgione?*); Pignatti, 1955, 133 (*Giorgione?*); Coletti, 1955, 67 (*close to Palma*) Zampetti, 1955, 74 (*Titian?*); Pallucchini, 1955, 15 (*Titian*); Robertson, 1955, 277 (*not by Gorgione or Titian*); Berenson, 1957, 84; Valcanover, 1960, I, 93 (*attributed to Tititian*); Zampetti, 1968, No. 82 (*Titian?*); Valcanover, 1969 No. 65 (*circle of Titian*).

Glasgow, Art Gallery

A 16. CHRIST AND THE ADULTERESS　　　　　Plate 168

Oil on canvas, 137 × 180 cms.
Provenance: From the Collection of Christina of Sweden (1689); then McLellan.

It is difficult to reconcile this painting with any of the many representations of the theme of Christ and the Woman taken in Adultery mentioned in the sources: in a letter from Camillo Sordi to Duke Francesco Gonzaga (1612); Michele Spietra in Venice (1656); Gio. Vincenzo Imperiale in Genoa (1661); the brothers Pesaro in Venice (1663); a Florentine collection mentioned by Livio Meo in a letter to Ciro Ferri (1672). A copy by Cariani in the Accademia Carrara in Bergamo (Pl. 170) shows that the Glasgow painting has been cut on the right-hand side, removing a *Soldier* whose head and shoulders (formerly in the Sachs Collection, New York) were until recently on loan to the National Gallery in London (A 23). Tietze (1945) sought to interpret the subject as « Daniel and Susanna », but the results of the recent restoration (Ruhemann, 1955) would seem to rule out this possibility, since the halo above the central figure has a cross to it, which would be more for Christ than for the prophet. In his technical report, Ruhemann notes that X-rays revealed a *pentimento* in the placing of the head of the Woman caught in adultery, which was originally some 5 cms to the left of where it is now: a fact that may be regarded as proof of the originality of the painting.

When the work was in the Collection of Queen Christina it bore a traditional attribution to Giorgione, which was however doubted by Cavalcaselle (1871), whose view was also shared by Berenson (1894), who suggested Cariani. After this the attribution to Giorgione prevailed once again, with Cook's (1900)

and Justi's (1908) studies, while L. Venturi (1913) introduced Sebastiano's name and A. Venturi (1928) that of Romanino. A decisive step in the history of the criticism of the painting was taken with Longhi's (1927) attribution of it to Titian, one which was followed by Berenson (1927-8), Suida (1933), Fiocco, (1941), Morassi (1942), Pallucchini (1944), and Gamba (1954). Richter (1937) on the other hand supports this interpretation only in part, accepting the idea of a collaboration between Giorgione and Titian, while Tietze (1945) returns to Giorgione, as do Hendy (1954) and L. Venturi (1954). After the 1954 restoration, which removed a thick layer of varnish, critical opinion became even more divided on account of the startling colours that had been revealed; on the one hand Coletti (1955) and Della Pergola (1955) were prompted to suggest Sebastiano del Piombo once again, while on the other Zampetti (1968) lowers the attribution to Domenico Mancini. Recent critical opinion, however, from Pignatti (1955), Pallucchini (1955) and Valcanover (1960 and 1969) has been in favour of Titian. The current resoration of Titian's frescoes in Padua also confirms that the latter painted, in 1511, with very violent and changing colour tones (communication from Dr. Valcanover, 1969).

In the context of the various controversial paintings whose authorship by the late Giorgione and Titian is in dispute, the *Christ and the Adulteress* belongs, in our opinion, in the work of the younger artist somewhere beside the *Pastoral Concert* in the Louvre and the frescoes in Padua. Especially taking into account the relative freshness of the colour in the painting in Glasgow, it does seem right to point out the undeniable affinities that exist in the diagonal framework of the compositions and in the characteristic views of distant landscape, rendered with alternate phases of light and shade. Furthermore, the head of the Woman caught in adultery is almost interchangeable with that of the *Madonna in a Landscape* by Titian in Bergamo, and with that of a female figure in the *Miracle of the New-born Child* in the Padua frescoes (Pl. 169). Finally, the colour shows all the ebullient impatience of the young Titian, at the very moment of his move away from the school of his teacher, despite the continuing attraction of Giorgione's style for him.

Bibliography: Crowe and Cavalcaselle, 1871, II, 547 (*Cariani*); Berenson, 1894, 99 (*Cariani*); Cook, 1900, 102; Bernardini, 1908 13 (*Sebastiano*); Justi, 1908, 157; Bode, 1930, 230; L. Venturi, 1913, 157 (*Sebastiano*); Longhi, 1927, 218 (*Titian*); Berenson, 1927-8, 147 (*Titian*); A. Venturi, 1928, IX, III, 812 (*Romanino*); Berenson, 1930, 570 (*Titian*); Richter, 1932, 128 (*Sebastiano*); Suida, 1933, 16 (*Titian*); Richter, 1932, 219 (*Giorgione and Titian*); Fiocco, 1941, 40 (*Titian*); Morassi, 1942, 178 (*Titian*); Pallucchini, 1944², 183 (*Titian*); E. Tietze, 1945, 189; H. Tietze, 1950, 9;

Ruhemann, 1954, 13; Hendy, 1954, 157; Gamba, 1954, 174 (*Titian*); Della Pergola, 1955, 89 (*Sebastiano*); Ruhemann, 1955, 278; Pignatti, 1955, 124 (*Titian?*); idem, 1955², 505, (*Titian*); Coletti, 1955, 66 (*Sebastiano*); Zampetti, 1955, 13 (*Titian*); Pallucchini, 1955, 13 (*Titian*); Robertson, 1955, 276; Baldass, 1957, 84 (*Titian*); Berenson, 1957, 84; Valcanover, 1960, I, 47 (*Titian*); Baldass-Heinz, 1964, 169 (*Titian*); Zampetti, 1968, no. 34 (*D. Mancini*); Morassi, 1969, 25 (*Titian*); Valcanover, 1969, no. 27 (*Titian*); Pallucchini, 1969, 14 (*Titian*); Wethey, 1969, 168 (*Giorgione*).

Hampton Court, Royal Collection

A 17. BUST OF A LADY Plate 130

Oil on panel, 44.5 × 34.4 cms. Inv. 505 - 130.
Provenance: From the Collection of Charles I.

Attributed to the School of Gentile Bellini in the 1898 Catalogue, and to Ercole de' Roberti by Collins Baker in the 1929 Catalogue, it was then numbered by Berenson (1957) in the group of works he attributed to the « Master of the Three Ages of Man » — that is to say likening it with the latter painting in the Pitti (No. 28) and the *Concert* at Hampton Court (A 18); perhaps the young Giorgione. This view was not apparently shared by Zampetti (1968). Although the condition of the painting makes it difficult to read fully, it is nevertheless very distinct from the Pitti *Three Ages of Man*, a painting which is of a very high quality and which we believe to be an authentic Giorgione (Cat. No. 28). By contrast, we find here a graphic approach akin to that of Bellini, which has virtually no parallel in any of the certain works of Giorgione. Even the half-length figures, such as the *Laura* or the *Portrait of a Young Man* in Berlin, have an altogether different chromatic intensity. This then is a work of a follower of Giorgione, and one who is still strongly influenced by Bellini.

Bibliography: Collins Baker, 1929, 130 (*De Roberti*); Berenson, 1957, 84 (*?*); Italian Art in Britain, 1960, 17; Zampetti, 1968 No. 61 (*?*).

A 18. CONCERT Plate 135

Oil on canvas, 76 × 99 cms. Inv. No. 144.
Provenance: From the Van Reynst Collection, Amsterdam; later Charles II.

Described in the old inventories as a Giorgione, the painting was attributed to Lotto by Cavalcaselle (1871) while Collins Baker regarded it as a School piece. For A. Venturi (1928) too it is the work of a follower of Bellini, « almost Lotto ». As early as 1927 Longhi suggested placing the work in the last period of Bel-

lini himself. Suida (1935) then took up the attribution to Giorgione once more, downgraded to a follower by Morassi (1942). Fiocco (1941) and Pallucchini (1944) regarded it as by Torbido; Gamba (1954) as by Mancini; Coletti (1955) as by Morto da Feltre. The attribution to Bellini was put forward once again at the Exhibition in Venice, by Zampetti (1955), making note again of the affinities with the *Three Ages of Man* in the Pitti. Fiocco (1955) returns towards Giorgione, followed by Berenson (1957). Having established quite clearly that the *Concert* at Hampton Court has no connection with the *Three Ages of Man* in the Pitti (which we attribute to Giorgione), it remains to decide which one of his contemporaries is responsibile for this picture, which is of good though not paramount quality. As in the instance of the *Bust of a Lady* (A 17) we would say that this painting is by a quite close follower of Giorgione, but one who was also still strongly linked to the Bellini. That it should be by Giorgione himself would appear to be altogether excluded.

Bibliography: Crowe and Cavalcaselle, 1871, II, 532 (*Lotto*); L. Venturi, 1913, 390 (*?*); Longhi, 1927, 134; (*Bellini*); A Venturi 1928, IX-III, 560 (*Bellinesque*); Collins Baker, 1929, 144 (*school of Giorgione*); Suida, 1935, 86; Fiocco, 1931, 30 (*Torbido*); Morassi, 1942, 105 (*imitator of Giorgione*) Pallucchini, 1944, XVI (*Torbido*); Gamba, 1954, 172 (*Mancini*); Coletti, 1955, 65 (*Morto da Feltre*); Pignatti, 1955, 125 (*circle of Giorgione*); Zampetti, 1955, 96 (*Bellini?*); Pallucchini, 1955, 22 (*Torbido?*); Fiocco, 1955, 13; Robertson, 1955, 277 (*copy*); Berenson, 1957, 64 (*?*); Italian Art in Britain, 1960, 18 (*attributed to Giorgione*).

Kingston Lacy, Wimborne (Dorset), Bankes Collection

A 19. THE JUDGEMENT OF SOLOMON Plate 190

Oil on canvas, 208 × 318 cms.
Provenance: From the Marescalchi Collection in Bologna, from which it was acquired by Lord Byron for Kingston Lacy (1821).

This must certainly be the painting with « la figura del ministro non finita » seen by Ridolfi in the Casa Grimani at S. Ermacora (Ca' Vendramin Calergi) in 1648, whose attribution to Giorgione is also supported by the 1664 inventory of the collection. The earliest modern attribution to Giorgione is that of Waagen (1857) followed by that of Cavalcaselle (1871). The latter regarded it as a work by Giorgione dating from 1507-8, and as identical with the « teller da esser posto a la Udienza » of the Council of Ten, mentioned in documents of those years. But considering that that painting must have been destroyed in the fire of 1574, that identification seems somewhat hazardous. It would have been strange indeed for the Council of Ten to

accept an unfinished painting such as this one is, in the right-hand figure. While Cook (1900) regarded this painting as the work of Giorgione, Berenson (1903) suggested Sebastiano del Piombo, to be followed also by L. Venturi (1913), while Justi (1908) and Richter (1937) restored the attribution to Giorgione. In Longhi's (1927) view the painting is by Sebastiano, and opinions from Pallucchini (1941) to Dussler (1942) predominantly follow this line. More recently there has been at least a partial revival of the attribution to Giorgione, by Morassi (1942), Fiocco (1948), Gamba (1954), Berenson (1957) and Gould (1969). That the *Judgement of Solomon* is by Sebastiano seems to us to be quite probable. In date, it must be close to the organ doors in San Bartolomeo and the San Giovanni Crisostomo altarpiece (*circa* 1510). From the latter painting we can indeed recognize features in the Kingston Lacy painting, especially the « Lombard » perspective framework, which is absolutely consistent with Sebastiano's style; the same can also be said of the facial types and the frequently changing pattern of the colour.

Bibliography: Ridolfi, 1648, I, 102; Waagen, 1857, I; Crowe and Cavalcaselle, 1871, II, 138; Cook, 1900, 25; Berenson, 1903 II, 233 (*Sebastiano*); Justi, 1908, 146; Borenius, 1912, III, 108 (*Catena*); L. Venturi, 1913, 162 (*Sebastiano*); Hourticq, 1919, 39 (*Titian*); Longhi, 1927, 218 (*Sebastiano*); A. Venturi, 1928, IX-III, 502 (*Campagnola*); Richter, 1937, 222; Pallucchini, 1941, 454 (*Sebastiano*); Fiocco, 1941, 28 (*Sebastiano*); Morassi, 1942, 136 (*Giorgione and Sebastiano*); Dussler, 1942, 144 (*Sebastiano*); Fiocco, 1948, 32 (*Giorgione and Sebastiano*); Gamba, 1954, 174; Pignatti, 1955, 125 (*Giorgione and Sebastiano*); Berenson, 1957, 84 (*Giorgione and assistant*); Zampetti, 1968, No. 70 (*not by Giorgione*); Gould 1969, 206 (*Giorgione*).

A 20. ALLEGORY OF AUTUMN Plate 191

Oil on panel, approx. 200 cms. in diameter.
Provenance: Traditionally believed to have come from the Palazzo Grimani at Santa Maria Formosa, whence it would have been purchased by John Bankes (1843).
According to Moschini, there were in the Palazzo Grimani paintings by Giovanni da Udine, and a canvas by Giorgione representing the Four Elements (1815, I, 194). Cook (1900) gives credence to the tradition and attributes the the painting to Giorgione, in which he was followed by Richter (1937) who however regards the work as the result of collaboration between Giorgione and Giovanni da Udine. There certainly were ceiling decorations by the latter in Ca' Grimani, although these were only commenced in 1524 (Schulz, 1968, 142). No other art historian seems to have taken the attribution to Giorgione seriously, and Fiocco rejected it decisively, pointing out that

the *Allegory of Autumn* could at the most be by Giovanni da Udine (1948).
So far as can be judged, the ceiling painting belongs to the tradition initiated by Correggio, which appears in Venice only around 1530, namely in Francesco Vecellio's frescoes at San Salvador (communication from Juergen Schulz).

Bibliography: Cook, 1900, 130 (*probably by Giorgione*); Richter, 1937, 221 (*Giorgione and Giovanni da Udine*); Fiocco, 1948, 16 (*Giovanni da Udine*).

London, Courtauld Institute Galleries

A 21. MOSES BEFORE THE BURNING BUSH Plate 173

Oil on canvas, 59 × 144.8 cms.
Provenance: Perhaps from the Castello di Montegalda near Castelfranco; then Lord Lee of Fareham.

The identification of this painting with the *sovrapporta* (painting over a door) of Moses included in the Dondi Orologio inventory from Padua of 1750 is not completely positive; later it was attributed to Giorgione by De Marchi (1856). Richter (1937) regarded it as an authentic work, to be dated close to the *Tempest*. Morassi (1942) on the other hand initially gave it to a pupil of Giorgione and then later to the young Titian, an interpretation which gained the support of Valcanover (1960).
We would also regard the attribution to Titian as the most likely, around the time of the early « mythologies » such as the *Orpheus and Eurydice* in Bergamo.

Bibliography: De Marchi, 1856, 404; Richter, 1937, 236; Morassi, 1942, 218 (*follower of Giorgione*); Morassi, 1954, 191 (*Titian*); Waterhouse, 1955, 295; Pignatti, 1955, 128 (*Titian?*); Berenson, 1957, 86 (*Giorgionesque*); Valcanover, 1960, I, 91 (*Titian?*).

London, National Gallery

A 22. HOMAGE TO A POET Plate 141

Oil on panel, 59 × 48 cms. Inv. No. 1173.
Provenance: From the Aldobrandini Collection in Rome (1626); later Day (1833); White; Bohn; Lesser (1885).

The identification of the subject as the Golden Age, suggested by Cook (1900) and followed by the National Gallery up to 1929, is regarded as having no foundation by Gould (1959). It is difficult too to accept some of the other themes that have been suggested, such as Jason, Pluto and Philomelos (Eisler, quoted by Richter, 1937), or the Sons of Jupiter (Pigler, 1950). Berenson's (1894) suggestion of Previtali as the author

of this panel was followed by a succession of writers favouring the hand of Giorgione — Cook (1900), A. Venturi (1900), Justi (1908), Hartlaub (1925) — attributions that were later to be discarded. L. Venturi (1913) regarded it as the work of an anonymous follower of Giorgione, as did A. Venturi (1928), Justi (1926), Richter (1937), Morassi (1942) and Pallucchini (1944). Only Fiocco suggested (1941 and 1948) the hand of Giulio Campagnola, while Coletti (1955) saw it as the work, at least in part, of Giorgione, as also did Pignatti (1955), Berenson (1957), and Volpe (1964). A contrary view was expressed by Gould (1959: imitation of around 1540) and Zampetti (1968). In fact the painting is anything but second-rate in quality. Although there is a concentration on detail, in the plants and the animals (which may even have been added later), there is a very noble handling in the figures that suggests that it is the work of an artist close to Giorgione. It is curious that the closest parallels are in the *Adoration of the Kings* in London (especially as regards the figures), the *Madonna and Child in a Landscape* in Leningrad and the *Tempest* (especially for the landscape). Indeed, the background of the painting is reminiscent not so much of the early Dürer-like landscapes of Giorgione's youth as of the more atmospheric view in the background of the *Three Philosophers*. How is one to explain the combination of these elements with others that are distinctly Bellinesque and Carpaccesque, if the painting is really by Giorgione? This is the weakness of this picture, which was probably painted by an assistant of Giorgione, who had before his eyes examples of his work around 1507-8, but who had distinct leanings towards the style of the master's early period. The same approach may be noted in the paintings of *Venus and Cupid* in the National Gallery in Washington (A 65) and in the *Venus and Mars* in Brooklyn (A 34), which can here be grouped together under the fictitious title of the « Master of the Venus and Cupid ». This is however merely a hypothesis for further study, which might be confirmed by an opportune analysis and examination of the material. For the time being, the attribution must remain a cautious one, in the close circle of Giorgione and during his lifetime.

Bibliography: Berenson, 1899, 126 (*Previtali*); Cook, 1900, 91; A. Venturi, 1900, I; Justi, 1908, 121; L. Venturi, 1913 (*anonymous*); Hartlaub, 1925, 22; A. Venturi, 1928, IX-III, 62, (*anonymous*); Justi, 1926, II, 287, (?); Richter, 1937, 224 (*not by Giorgione*); Pallucchini, 1944, XIII (*workshop*); Pignatti, 1955, 127 (*Giorgione?*); Idem, 1955², 497; Coletti, 1955, 64 (*Giorgione and workshop*); Fiocco, 1948, 15 (*G. Campagnola*); Pigler, 1950, 135 (*Giorgionesque*); Berenson, 1957, 84 (*Giorgione?*); Volpe, 1964, 5; Gould, 1959, 42 (*imitation*); Zampetti, 1968, No. 44 (*not by Giorgione*).

Private Collection, formerly on loan to the National Gallery

A 23. A SOLDIER Plate 171

Oil on canvas, 54.5 × 43.5 cms. Fragment from the right-hand figure of the *Christ and the Adulteress* in Glasgow (A 16).

As emerges from an examination of the copy of the *Christ and the Adulteress* by Cariani in the Accademia Carrara in Bergamo, the « Soldier » originally stood on the right of the composition, looking over his shoulder (Pl. 170). It was cut down to its present half-length size evidently on account of the damage to the lower half of the canvas. So as not to damage the dress of the Woman caught in adultery, the canvas was cut at a point which left the knee of the Soldier still in the Glasgow painting. Discovered by Berenson when it was in the Sachs Collection in New York (1927-8), the painting is, like the *Christ and the Adulteress*, attributed to Titian, and critical opinion of it has followed the same course as that of the latter painting.

Even more than in that controversial composition, Titian's hand is obvious in this fragment, which must be close to the Eissler *Portrait* at Fullerton or the *Male Portrait* in the Metropolitan Museum, New York (A 35). This association reinforces the dating of the Glasgow composition to Titian's earliest period, when he was still in contact with Giorgione.

Bibliography: Berenson, 1927-8, 146 (*Titian*); Mayer, 1932, 369; from this point onwards, see the entries under the *Christ and the Adulteress* (*A* 16).

Formerly London, Private Collection

A 24. ECCE HOMO Plate 201

Oil on canvas
Provenance: From the Collection of Princess Bourbon-Parma.

Published as by Giorgione by Richter (1942) with a dating around the time of the Dresden *Venus*; exhibited at the exhibition in Baltimore (1942), the attribution was contested by Tietze (1947) who ruled out Giorgione as the author.

Although we have not seen the painting itself, it is clear that the landscape could be later than Giorgione's lifetime by a least a decade, and the features of the Christ are distinctly like Palma's in style; close, for instance, to the Baptist in the *Holy Family* which is No. 65 in the Accademia Carrara in Bergamo (Mariacher, 1968, No. 18).

Bibliography: Richter, 1942, 224; De Batz, 1942, No. 10; H. Tietze, 1947, 140 (*not by Giorgione*); Pignatti, 1955, 130 (*circle of Giorgione*).

Formerly London, Private Collection

A 25. PORTRAIT OF L. CRASSO Plate 208

Oil on canvas. Inscribed: « L. CRASSUS F. — MDVIII »; « V V » (on the balcony).

Following a restoration that removed extensive over-painting, the portrait has regained the appearance that Ridolfi (1648) described when he saw it in Nicolò Crasso's house in Venice: « the portrait of Luigi Crasso famous Philosopher, his Ancestor, sitting with [his] glasses in his hand » (« il ritratto di Luigi Crasso celebre Filosofo Avo suo posto à sedere con occhiali in mano »). But according to Cicogna (Iscrizioni, 1834, IV, 163) it appears that there were no individuals with the name of Alvise (Luigi) in the Crasso family. Savini-Branca (1965, 116) confirms that there is listed in the 1626 Crasso Inventory a Portrait of the Late Eccellentissimo Ser Alvise Crasso.

Attributed by Richter (1942) to Giorgione with the collaboration of Titian, the painting, which we have not seen, offers few clues as to its identity, apart from the inscription and the date. If the latter are genuine (and this we doubt very much), it would be difficult to explain the echoes of Titian and Palma that characterize the style of the representation. In reference to the date 1508, the most likely candidate would be Cariani.

Bibliography: Ridolfi, 1648, I, 102; Richter, 1942, 223 (*Giorgione and Titian*); Pignatti, 1955, 130 (*attributed to Giorgione*).

Lausanne, Stroelin Collection

A 26. SEATED NUDE Plate 166

Pen drawing, 19.5 × 12.5 cms. Inscribed on the verso: « Giorgione » (old hand).
Provenance: From the Cérenville Collection.

According to the Tietzes, this is a work by Giorgione from around the time of the Fondaco frescoes. They also recognized in it a number of features from the works of Dürer and Titian, which in fact predominate over the Giorgionesque elements.
The drawing should thus be associated more with Titian, among other reasons since it has not been demonstrated that Giorgione ever attained the incisive fluency that is a characteristic of this drawing.

Bibliography: H. and E. Tietze, 1944, No. 710; Pignatti, 1955, 130 (*attributed to Giorgione*).

Madrid, Museo del Prado

A 27. MADONNA AND CHILD WITH SAINTS ANTHONY AND ROCCO Plate 154

Oil on canvas, 92 × 133 cms. Inv. No. 288.
Provenance: From the Collection of the Duca di Medina de Las Torres, Viceroy of Naples; Philip IV of Spain had it placed (around 1650) by Velasquez in the Escorial, with an attribution to Pordenone.
Cavalcaselle (1871) attributed this altarpiece (the landscape of which seems to be unfinished) to Francesco Vecellio, since he recognized characteristics of Titian's school in it. Immediately afterwards, however, Morelli (1893) attributed it to Giorgione, a view that prevailed, with Cook (1900), Frizzoni (1902) and Justi (1908), until Schmidt (1908) suggested that the work was by the young Titian. Critical opinion is divided from this point onwards, with those favouring Giorgione's authorship including Hartlaub (1925), A. Venturi (1928), Berenson, (1932, 1957), Richter (1937), Coletti (1955) and Baldass-Heinz (1964). Those favouring Titian's hand include L. Venturi (1913), Longhi (1927), Hourticq (1930), Suida (1933), Fiocco, (1941 and 1948), Morassi (1942), Pallucchini (1953) and Valcanover (1960 and 1969). These interpretations are founded on purely stylistic grounds. There seems indeed to be no substance to the claims that the « composition » is Giorgionesque in character, nor that the florets on the drapery are those of the Loredan family, whose place in Venice it is well known was decorated by Giorgione (Richter, 1937).
In favour of the attribution to Titian, which we regard as certain, there are a number of parallels that can be drawn between the Madrid painting and the *Christ and the Adulteress* in Glasgow (the figure of San Rocco is interchangeable with the « Soldier »), the *Zingarella* in Vienna (the Madonna and typical Child are characteristic models for the early Titian) and the *Concert* in the Pitti Gallery (the monk playing the spinet is painted in the same manner as the St. Anthony). This is a work of probably around 1510, and it is certainly true that Titian must still have been drawn towards the work of his teacher, which he had perhaps around him at the time. But even in the somewhat immobile composition — a fact explained by Titian's relative inexperience — the forms of the three figures have a three-dimensional impact, vibrancy of colour and impasto of light and paint that we have certainly not encountered in Giorgione's work between 1508 and 1510: a period that is well known to us through the *Three Philosophers* and the San Diego *Portrait of a Man*.

Bibliography: Crowe and Cavalcaselle, 1871, II, 292 (*F. Vecellio*); Morelli, 1893, 216; Berenson, 1894, 100; Cook, 1900, 45;

Frizzoni, 1902, 298; Monneret de Villard, 1904, 60; Boehn, 1908, 62; Gronau, 1908, 425; Justi, 1908, 140; Schmidt, 1908, 115 (*Titian*); Bode, 1913, 232 (*not by Giorgione*); L. Venturi, 1913, 134 (*Titian*); Gronau, 1921, 188; Hartlaub, 1925, 41; Justi, 1926, I, 140; Longhi, 1927, 218 (*Titian*); A. Venturi, 1928, IX-III, 33; Hourticq, 1930, 185 (*Titian*); Berenson, 1932, 233; Hermanin, 1933, 85; Richter, 1937, 228; Suida, 1933, 21 (*Titian*); Fiocco, 1941, 55 (*Titian*); Morassi, 1942, 131 (*Titian*), Oettinger, 1944, 129; Pallucchini, 1953; 56 (*Titian*); Gamba, 1954, 174; Coletti, 1955, 61; Zampetti, 1955, 136 (*Giorgione or Titian*); Berenson, 1957, 84; Valcanover, 1960, 48 (*Titian*) ;Baldass-Heinz, 1964, 156; Valcanover, 1969, no. 32 (*Titian*); Pallucchini, 1969, 11 (*Titian*); Wethey, 1969, 174 (*Giorgione*).

Milan, Mattioli Collection

A 28. THE MOCKING OF SAMSON Plate 211

Oil on canvas, 68 × 70 cms.

Published by Longhi (1946) as by Giorgione from around the period of the Fondaco frescoes. He identifies it as the painting formerly in the possession of the painter Nicolò Renieri, described in a work in the Biblioteca Marciana in Venice (Misc. I. 841 Opuscolo No. 15). The attribution to Giorgione given there is further confirmed in the inventory of the Renieri inheritance of 1666, published by Savini Branca (1965, 99) which runs as follows: « Samson, half-length, larger than life-size, leaning with his hand on a stone, showing his sorrow at his shorn locks, with two figures behind, mocking him, five and a half *quarte* high, five wide ». Exhibited at the exhibition in Venice as of uncertain attribution (Zampetti, 1955), the painting has been rejected by Pignatti (1955), Pallucchini (1955) and Salvini (1961), and accepted by Volpe (1964).

The *Mocking of Samson* cannot, in our view, be located in Giorgione's last style, between the Fondaco frescoes and the *Portrait of a Man* in San Diego. During the course of these last two years, indeed, Giorgione's development followed a very restrained pattern, a long way from opening out — as Longhi had opined before the establishment of the date of 1510 of the San Diego *Portrait of a Man* (Cat. No. 26) gave different terms of reference to the whole problem — into a type of figures « with no drawing, only colour... almost Caravaggio, almost Velasquez, almost Manet ». This group would have included the *Mocking of Samson* and the other paintings which have been associated with it (such as the *Self-Portrait dressed as David* in Brunswick, the *Singers* in the Borghese Gallery: for us these are all products of a later period of the « Giorgionesque »).

Bibliography: Longhi, 1946, 64; Pignatti, 1955, 131 (*attributed*); Zampetti, (1955, 88 (*Giorgione?*); Pallucchini, 1955, 9 (*not by Giorgione*); Robertson, 1955, 276 (*2nd half 16th century*); Salvini, 1961, 238 (*not by Giorgione?*); Volpe, 164, 6; Zampetti, 1968, No. 40 (*Giorgione?*).

Milan, Rasini Collection

A 29. JUDITH Plate 150

Oil on canvas, 50 × 60 cms.

Attributed to Giorgione's earliest period by Coletti (1953) on the basis of its claimed « admixture of characteristics from the work of Giorgione and Cima in a Giorgionesque mood ». From here Coletti goes on to suggest that Giorgione may have been taught by Cima, without however adducing any concrete proof. In 1955 Coletti himself seems more doubtful over the attribution to Giorgione, recognizing that there are in the painting « passages that definitely seem to have been drawn and painted by Cima » while « in the landscape there are also reminiscences of Giovanni Bellini ». Rejected by Zampetti (1968), it now appears as though the attribution to Giorgione should be discarded altogether. The painting has a place in the group of works (Gerli, Milan; Lebel, Paris; Städelsches Kunstinstitut, Frankfurt; National Gallery, London) which are variously attributed to artists ranging from Catena to Previtali. There may be here an element of influence from Carpaccio which has so far been ignored by critical opinion, but it is that, together with derivation from Cima, that forms the cultural background of this unknown follower of Giorgione, the painter of the *Judith*.

Bibliography: Coletti, 1953, LXXVII; Coletti, 1955, 32 (*Giorgione?*); Zampetti, 1968, No. 51 (*Giorgionesque*).

Milan, Private Collection

A 30. THE MAGDALENE Plate 136

Oil on canvas, 51.5 × 49 cms.

Published by Zampetti (1955) on the occasion of the exhibition in Venice, quoting the opinion of Longhi — shared by Fiocco and Suida — that the *Magdalene* is « the earliest known painting by Giorgione ». It was seen to prove that Giorgione was under the influence of Carpaccio at an early stage, since the style of the latter is reflected in the drapery and in the facial characteristics. Doubts however were raised in this regard by Pallucchini (1955), and Zampetti himself seems later (1968) to have been more uncertain about this attribution.

It may well be that Giorgione was drawn towards Carpaccesque colour around the time of the latter's

work on the Riva degli Schiavoni (post 1502), with all its implications of opposition to the style of Bellini. There are indeed traces of this in the *Madonna and Child with Saints* in Castelfranco and in the small « history paintings » in London and in the Uffizi; but it would be difficult to interpret these as evidence of an apprenticeship with Carpaccio, since Giorgione so consciously rejects the fifteenth-century linear quality that still pervades the St. Ursula series and the Schiavoni paintings. A comparison between the drawings of the two artists, in so far as one can be made, is conclusive in this regard. In the case of the *Magdalene*, on the other hand, it seems as though the affinity with Carpaccio is genuine, intermixed with an element of already well-advanced Giorgionesque influence. The facial characteristics are certainly perhaps vaguely reminiscent of the Castelfranco *Madonna and Child with Saints*, or the figures in the Uffizi paintings; but the colour is rendered with cool precision and held within graphic limits, punctuated by the vitreous reflections in the drapery and the porcelain roundness of the face. It is difficult to determine who could be the author of this figure, which is despite all our criticism noble and eloquent: but it would come as no surprise if it turned out to be a provincial artist, working during Giorgione's lifetime, against a different cultural background from that of the capital city. The *Holy Family with a Donor* in the Bassano museum, signed by Pennacchi and datable to around 1510-15, could prove a useful suggestion for further study.

Bibliography: Zampetti, 1955, 14 (*Giorgione?*); Pallucchini, 1955, 6 (*?*); Volpe, 1964, 4; Zampetti, 1968, No. 42 (*?*).

Munich, Alte Pinakothek

A 31. LITTLE FAUN Plate 144

Oil on canvas, 20 × 16 cms. Inv. No. 1094.
Provenance: From the Schleissheim Gallery (1781); later Hofgarten up to 1836.

Traditionally attributed to Correggio, the painting was given to Lotto by Morelli (1880). Subsequently the prevailing attribution was one to Palma, advanced by Schmidt (1900) and Phillips (1907) and supported by Gombosi (1932), Berenson, (1932), Pallucchini (1955) and Coletti (1955), although doubts have been raised by Spahn (1930) and Mariacher (1968). Baldass (1929) attributed the painting to Titian. In the meantime, support was growing for the attribution to Giorgione, suggested by Longhi (1927) and favoured by Fiocco (1948), Pignatti (1955) and Zampetti (1955 and 1968). In fact, the contrasting critical opinions of this painting

are an accurate reflection of the uncertain nature of its style, which is impressive for its delicate Giorgionesque character, but which also has obvious compositional limitations and a certain flatness in the colouring, which is partly due to its imperfect state of conservation. If we take Palma's earliest work as being represented by the *Nymphs* in Frankfurt and London, or the *Allegory with a Halbardier* in Philadelphia (Mariacher, 1968, Figs. 6-8), one would be inclined to say the *Little Faun* represents a more advanced stage of the « Giorgionesque », and one which achieves a higher poetical quality. But if we locate the *Little Faun* as Longhi (1946) would have it, adjacent to the Fondaco frescoes (and thus indeed the *Tempest*), the quality of the work is anomalous. Similar convolutions were, in fact, achieved by Previtali in his *Stories of Damon and Thirsis* (*Scenes from an Eclogue of Tebaldeo*) in the National Gallery in London (which also have been in the past attributed to Giorgione and Palma — see Zampetti, 1968, no. 46). It would not be impossible to ascribe the *Little Faun* also to Previtali, following the suggestion made by Heinemann (1962). This is still, nevertheless, within Giorgione's close circle.

Bibliography: Morelli, 1880, 42 (*Lotto*); Schmidt, 1900, 395 (*Palma*); Phillips, 1907, 343 (*Palma*); Longhi, 1927, 222; Baldass, 1929, 91 (*Titian?*); Spahn, 1930, 185 (*Palma?*); Gombosi, 1932, 74 (*Palma*); Berenson, 1932, 410 (*Palma*); Longhi, 1946, 63; Fiocco, 1948, 36 (*Giorgione?*); Pignatti, 1955, 131 (*Giorgione?*); Zampetti, 1955, 64; Coletti, 1955, 67 (*Palma*); Pallucchini, 1955, 19 (*Palma*); Berenson, 1957, 124 (*Palma*); Heinemann, 1962, 144 (*Previtali?*); Mariacher, 1968, No. 59 (*not by Palma*); Zampetti, 1968, no. 75 (*Giorgione?*).

A 32. PORTRAIT OF A YOUNG MAN IN A FUR Plate 186

Oil on panel, 70 × 54 cms. Inscribed, on reverse « Giorgione de Castelfranco F. Maestro de Titiano ». Inv. No. 524.
Provenance: From the Van Verle Collection, Antwerp (1650); then the Grand-ducal Gallery in Munich (1748) as a « self-portrait » by Giorgione.

The painting is also known through Hollar's engraving (1650) which provides the information that it was then in the Van Verle Collection in Antwerp. The sitter is at first identified, in the print's first state, as « Bonamico Buffamalco. Painter in Venice », and in a later state as « Portrait of a German of Casa Fuchera ». The second inscription was obviously inspired by the idea that this is a representation of one of the Fugger family, of whom Vasari (1568) mentions a drawing by Giorgione in his own collection of drawings. But the connection is unfounded, as Ragghianti (1945) has shown, the more so because the painting

in Munich is not a drawing, but rather a panel painting. After being attributed to Palma by Cavalcaselle (1871) and to Cariani by Morelli (1891) and Berenson (1899), the painting was given to Giorgione by Justi (1908) and he was followed, although with some reservations, by Spahn (1932) and Gombosi (1937), Zampetti (1955), Buchner (1957) and Mariacher (1968). From Bode (1913) onwards, there was a revival in the attribution to Palma, which later came to predominate with L. Venturi (1913), Suida (1931), Berenson (1932 and 1957), Coletti (1955), Pallucchini (1955) and Garas (1966), who connects it with Vasari's mention of Palma's *Self-Portrait* (1568, V, 246). More recently, there has been a tendency to attribute the painting to the young Titian, with Morassi (1942), Ragghianti (1945), Pignatti (1955) and Valcanover (1960). As Pallucchini also believes now (1969), the painting certainly belongs in a period of Titian's youth when he was already independent of Giorgione, that is to say around the middle of the second decade of the century. In our view, the closest parallel in Titian's work is that of the *Portrait* in the Frick Collection, where the application of colour is similarly broad and brilliant.

Bibliography: Crowe and Cavalcaselle, 1871, II, 482 (*Palma*); Morelli, 1891, 30 (*Cariani*); Berenson, 1899, 100 (*Cariani*); Justi, 1908, I, 176; Bode, 1913, 237 (*Palma*); L. Venturi, 1913, 1913, 174 (*Palma*); Hadeln, 1914, I, 206 (*Palma*); A. Venturi, 1928, IX-III, 491 (*Mancini*); Suida, 1931, 139 (*Palma*); Berenson, 1932, 410 (*Palma*); Spagn, 1932, 194 (*Palma*); Gombosi, 1932, 174 (*Palma*); Wilde, 1933, 120 (*Master of the Self-Portraits*); Suida, 1934-5, 98 (*Palma*); Gombosi, 1937, 130 (*Giorgione ?*); Richter, 1937, 229, (*follower of Giorgione*); Morassi, 1942, 191 (*Titian*); Ragghianti, 1945, IV, 396 (*Titian*); Della Pergola, 1955, 64 (*?*); Pignatti, 1955, 131 (*Titian?*); Coletti, 1955, 67 (*Palma*); Zampetti, 1955, 122 (*close to Giorgione*); Pallucchini, 1955, 19 (*Palma*); Robertson, 1955, 277 (*Master of the Self-Portraits*); Berenson, 1957, 125, (*Palma*); Buchner, 1957, 41; Valcanover, 1960, I, 95 (*Titian*); Baldass-Heinz, 1964, 160 (*follower of Giorgione*); Mariacher, 1968, 103 (*Giorgione?*); Garas, 1966, No. 28, 83 (*Palma*); Zampetti, 1968, No. 80, (*?*); Valcanover, 1969, No. 610 (*Palma*); Pallucchini, 1969, 26 (*Titian*).

New Haven (Connecticut), Yale University Art Gallery

A 33. THE CIRCUMCISION Plate 174

Oil on panel, 36.7 × 79.3 cms. Inv. No. 1871-95.
Provenance: From the Jarves Collection (1871).

The original attribution to Giorgione, maintained in the Catalogue of the Jarves Collection (1860), was substituted by Rankin (1905) with one to Cariani, but taken up again by Mather (1914), Phillips (1937), Richter, (1942), Tietze (1947) and Berenson (1957).

As early as 1932 however, Berenson had suggested Titian's authorship, and this view has come to be that of the majority of writers, from Suida (1933) to Morassi (1942), Pallucchini (1953), and Valcanover (1960 and 1969). The spatial arrangement and character of the painting, which is considerably damaged, correspond with Titian's style in the second decade of the century, as it is seen in the *Madonna* in the Bache Collection and the early Holy Families, such as the ones belonging to the Marquess of Bath and the one in Munich (Valcanover, 1960, I, Pl. 13, 42 × 49).

Bibliography: Jarves, 1860, 58; *Rankin*, 1905, 12 (*Cariani*); Mather, 1914, I; Berenson, 1932, 573 (*Titian*); Suida, 1933, 185 (*Titian*); Phillips, 1937, 152; Richter, 1942, 148 (*Giorgione?*); De Batz, 1942, 27; Morassi, 1942, 218 (*Titian*); H. Tietze, 1947, 141 (*Giorgione?*); Pallucchini, 1953, 50 (*Titian*); Berenson, 1957, 84; Valcanover, 1960, I, 46 (*Titian*); idem, 1969, No. 29 (*Titian*); Pallucchini, 1969, 10 (*Titian*); Wethey, 1969, 171 (*circle of Giorgione*).

New York, Brooklyn Museum

A 34. VENUS AND MARS Plate 142

Oil on panel, 20 × 16 cms. Inscribed on the back « Giorgione » (? Sixteenth century). Inv. No. 37-529. Provenance: From the Hume Collection; later Brownlow; Babott; Donald, New York (1962).

Attributed to Palma by L. Venturi (1931), followed by Richter (1931), Berenson (1932), Gombosi (1937), Zampetti (1955), Pallucchini (1955) and Mariacher (1968). Different opinions have however been voiced by Richter (1942: Circle of Giorgione), Pignatti (1955; Circle of Giorgione), and Heinemann (1962: Previtali). This work belongs to a group of paintings that are Giorgionesque and which are traditionally ascribed to Palma, although there is not the slightest proof of the accuracy of this attribution. Rather than the *Little Faun* in Munich (A 31) — with which the painting is often connected — the painting should be associated more with *cassone* panels such as the *Venus and Cupid* in Washington (A 65) or the *Homage to a Poet* in London (A 22). The surface of the painting is very flat and worn by successive cleanings. But the « printed » foliage and the grained, originally opaque application of the paint suggest an artist in Giorgione's close circle — the « Master of the Venus and Cupid » — who in our opinion cannot be identified with Palma.

Bibliography: L. Venturi, 1931, 368 (*Palma*); Richter, 1931, 261 (*Palma*); Berenson, 1932, 408 (*Palma*); Gombosi, 1937, 17 (*Palma*); Richter, 1942, 143; De Batz, 1942, 26; Tietze, 1947, 140 (*not by Giorgione*); Pignatti, 1955, 132 (*circle of Giorgione*); Zampetti, 1955, 202 (*Palma*); Pallucchini, 1955, 132 (*circle of Giorgione*); Zampetti, 1955, 202 (*Palma*); Pallucchini, 1955, 19 (*Pal-*

ma); Robertson, 1955, 277 (*copy after Palma*); Berenson, 1957, 123 (*Palma*); Heinemann, 1962, 144 (*Previtali*),; Mariacher, 1968, 45 (*Palma*).

New York, Metropolitan Museum of Art

A 35. MALE PORTRAIT Plate 178

Oil on canvas, 50.2 × 45.1 cms. Inv. No. 14.40.640. Provenance: From the Savage Landor Collection, later Altman (1913). Unsubstantiated traditional provenance from the Casa Grimani in Venice.

The earliest attribution is that made by Berenson, with some doubts, to Titian (1903); this was rapidly discarded in favour of Giorgione by Bode (1913), Gronau (1921), A. Venturi (1928), Hermanin (1933) and Phillips (1937). In the meantime Longhi (1927) took up the attribution to Titian once more, and this now has almost universal support, except from Richter (1937) who suggests Palma, and Berenson (1957) who restores the painting to Giorgione.

The painting has been extensively damaged through cleaning, which has thinned the colour to the extent of allowing the ground to show through in some parts, especially in the face. But it is not difficult to recognize the hand of the young Titian, with the fresh and rapid brushwork of the *Knight of Malta* in the Uffizi or the *Man with a Glove* in the Louvre. The sitter here too, who once for no good reason was called « Ariosto », is also putting a glove on his right hand.

Bibliography: Berenson, 1903, 145 (*Titian*); Bode, 1913, 225; Gronau, 1921, 88; A. Venturi, 1927, 129; Longhi, 1927, 220 (*Titian*); Hermanin, 1933, 32 (*Titian*); Phillips, 1937, 69; Richter, 1937, 230 (*Palma*); Morassi, 1942, 180 (*Titian*); Pignatti, 1955, 132 (*Titian*); Coletti, 1955, 67 (*Titian*); Berenson, 1957, 84; Valcanover, 1960, I, 84 (*Titian*); Salvini, 1961, 237 (*Titian*); Valcanover, 1969, No. 37 (*Titian*); Pallucchini, 1969, 13 (*Titian*).

A 36. CUPID Plate 188

Sanguine drawing, 15.8 × 6.3 ms. Inv. No. 11.65.5. Provenance: From the Mariette Collection (1775: Giorgione); later von Fries.

Published as by Giorgione by E. Tietze-Conrat (1940), on the basis of Vasari's (1568) description of a Cupid in the Fondaco dei Tedeschi decorations. The writer also recognizes that the drawing belongs to a borderline period in the work of Giorgione and Titian; she also supports her attribution with a reference to the *Zingarella* in Vienna, which is universally attributed to Titian, to whom this drawing must, in our view, be given.

Bibliography: Mariette Catalogue, 1775; E. Tietze-Conrat, 1940, 32; H. and E. Tietze, 1944, No. 712; Pignatti, 1955, 132 (*Titian*).

New York, S. Schwarz Collection

A 37. LANDSCAPE WITH NUDE MAN Plate 147

Drawing, pen and ink and brown wash, 18.7 × 26.1 cms.
Provenance: From the Resta Collection, Milan; later Marchetti, Arezzo; Lord Somers.

Attributed to Giorgione by Froelich-Bum (1930). The Tietzes referred to the possibility of identifying it as the « pen drawing of a nude in a landscape » (nudo a pena in un paese) seen by Michiel in the house of Michele Contarini by the Misericordia, but they are not definite about this identification, since in the end they recognize features in it that belong to the graphic style of the young Titian. We would regard it as too weak to be by Titian; rather, it should be placed somewhere near Giulio Campagnola (see the *Landscape with Figures*, No. 4648 in the Louvre, T. 579).

Bibliography: Froelich-Bum, 1930, I, 86; H. and E. Tietze, 1944, No. 713 (?); Pignatti, 1955, 134, (*attributed to Giorgione*); Bean-Stamfle, 1965, No. 40.

Formerly New York, Private Collection

A 38. PORTRAIT OF MATTEO COSTANZO Plate 205

Oil on panel, 26 × 21.2 cms. Inscribed: « M. MATHEUS. D. CONSTANTIUS X ».
Provenance: From the Gentili di Giuseppe Collection, now in Paris, Private collection.

Different readings have been made of the inscription: for Richter (1937) and Zampetti (1955, 1st edition) it is MDX, while for Robertson (1955) and Pallucchini (1955) it is MDXX. In fact, while the three letters of the date MDX were originally placed respectively at the beginning, the middle and the end of the two names of the sitter, a fourth letter X was obviously added later and covers exactly the letters « ... IUS » of the surname. This is obviously a later addition, and one that should not be taken seriously. Hourticq (1930) attributed the portrait to Giorgione, but the only other writer to maintain this attribution is Gioseffi (1959) who suggests that it may have been a sort of head-piece to the Castelfranco altarpiece (which he dates around 1510). The other writers all exclude Giorgione's hand — from Richter (1937) to Morassi (1942), Coletti (1955). Zampetti (1955) and Pallucchini (1955). Leaving aside the inscription — which must

certainly be read as 1510 and is in any case of little importance — the painting verges towards Titian in style, although in quality it is no better than the work of a follower.

Bibliography: Hourticq, 1930, 50; Mayer, 1932, 380; Richter, 1937, 234 (*Giorgionesque*); Morassi, 1942, 144 (*manner of Giorgione*); Coletti, 1955, 67 (*Pordenone?*); Zampetti, 1955, 72 (*not by Giorgione*); Robertson, 1955, 277 (*follower*); Pallucchini, 1955, 9 (*imitation*); Gioseffi, 1959, 54; Salvini, 1961, 239 (*not by Giorgione*); Heinemann, 1962, 145 (*Previtali*); Zampetti, 1968, No. 85 (?).

Oxford, Strode-Jackson Collection

A 39. YOUNG SHEPHERD WITH A FRUIT Plate 131

Oil on panel, 24.1 × 20.6 cms.
Provenance: From the Bossi Collection, Milan; later Mason-Jackson; Martin, New York.

The meaning of the figure is not altogether clear: it might seem to be a shepherd-boy (or page) with his hand placed on a large browny-orange fruit. This is the argument used by Suter (1928) in identifying the painting as the « shepherd-boy holding a fruit in his hand » (« Pastorello che tienne in man un frutto »), seen by Michiel in 1531 in Giovanni Ram's house in Venice (Frimmel, 1888, 104). There are doubts however over the authenticity of the painting itself, which has been regarded as an old version of a lost original (Richter, 1937). In 1942, when the painting was shown in the exhibition at Baltimore, Richter supported full attribution to Giorgione. Fiocco (1929) interpreted the figure as a *Salvator Mundi*, recalling a version of the painting in the Ambrosiana in Milan and attributing it to Mancini. The latter painting, the only one mentioned by Zampetti (1968), is now thought by Morassi to be by Giorgione (verbal communication). It is difficult to assess the painting in the Ambrosiana in its unrestored state. But we would regard (as also Richter, 1937) the painting in Oxford as the original. There are in it many features of Giorgione's style from around the period of the *Three Ages of Man* in the Pitti Gallery, but Giorgione's hand is altogether impossible. A comparison with the angel in the Lendinara altarpiece (1511) suggests the possibility of Mancini's authorship of the painting.

Bibliography: Arundel Club, 1913, No. 5; Hartlaub, 1925, 10 (*Giorgione?*); Suter, 1928, 169; Fiocco, 1929, 97; Richter, 1937, 231 (*copy?*); Richter, 1942, 147; De Batz, 1942, 26; Tietze, 1947, 141 (*variant*); Pignatti, 1955, 125 (*attributed to Giorgione*); Zampetti, 1968, No. 66.

Padua, Museo Civico

A 40. LEDA AND THE SWAN Plate 138

A 41. RUSTIC IDYLL Plate 139

Oil on panels, 12 × 19 cms. Inv. Nos. 162, 170.
Provenance: From the Emo-Capodilista Collection in Padua (1864).

The initial attribution to Giorgione was made by Cook (1900), followed by Conway (1929), Fiocco (1941), Richter, (1942), Morassi (1942 and 1967), Coletti (1955), Zampetti (1955) and Grossato (1957). These attributions are however often tinged with some doubt, and the painting was demoted to being a workshop piece by Justi (1908), L. Venturi (1913), A. Venturi (1928), Della Pergola (1955), Pallucchini (1955) and Berenson (1957). Gronau (1908) and — at first — Pallucchini (1946) actually suggested the hand of Giulio Campagnola.

The problem of Giorgionesque « furniture pictures » — as Berenson described them — is a matter of style and quality. While these paintings in Padua are undeniably attractive and poetic in their landscape and figure elements, there is actually no direct parallel for them in any of Giorgione's works: they cannot date from his early period, because they are already too fluid in the handling of colour and almost « Palmesque »; they are not anywhere near the *Tempest*, since they lack the graduated tonal definition of space that is characteristic of that painting. Close examination of the pictures reveals that they are well-painted, with lively, albeit conventional, colouring in the foreground, and the blue of the distance disguising the comparative rapidity of execution. Are these swiftly-executed *cassone* panels? But we have no knowledge that Giorgione ever worked at such a speed. Rather, in works where we do find some affinity, from his close circle, such as the *Homage to a Poet* (A 22) in London and the *Venus and Cupid* in Washington (A 65), Giorgione's influence takes the form of a measured and pensive character, with even some concern for detail. There is, however, still a formal similarity and a Giorgionesque feel to these paintings which justifies their placing for the time being in the close orbit of Giorgione (not to say workshop, since we do not know that he had one for such small paintings, only for the frescoes). But contrary to what Coletti (1955) opined, it is obvious that only the *Astrologer* in the Phillips Memorial Gallery (A 66) can belong in series with the two paintings in Padua. The *Venus and Cupid* in Washington (A 65), which belongs if with anything with the *Homage to a Poet* (A 22) and the *Venus and Mars* (A 34), is in a different hand; while the *Page* in the Suardo Collection, Bergamo, is now established to be by Carpaccio.

Bibliography: Cook, 1900, 90; Gronau, 1908, 506 (*G. Campagnola*); Justi, 1908, 268 (*imitator*); L. Venturi, 1913, 254 (*imitator*);

Gronau, 1921, 88 (*G. Campagnola?*); Holmes, 1923, 169 (*G. Campagnola*); A. Venturi, 1928, IX-III, 65 (*Giorgionesque*); Justi, 1926, 256 (*imitator*); Conway, 1929, 49; Clark, 1937, 199 (*school of Giorgione*); Richter, 1942, 142 (*Giorgione?*); Fiocco, 1941, 30; Morassi, 1942, 55; Pallucchini, 1944, XII; Pallucchini, 1946, 123 (*G. Campagnola*); Pallucchini, 1947, 32 (*Giorgione?*); Tietze, 1947, 140 (*not by Giorgione*); Fiocco, 1948, 34 (*Giorgione?*); Gamba, 1954, 177 (*follower*); Pignatti, 1955, 135, (*Giorgione?*); idem, 1955², 500 (*Giorgione?*); Coletti, 1955, 52; Zampetti, 1955, 28; Pallucchini, 1955, 6 (*not by Giorgione*); Berenson, 1957, 86 (*follower*); Zampetti, 1967, 202; Grossato, 1957, 64 (*Giorgione?*); Bonicatti, 1961, 200 (*derived from Giorgione*); Morassi, 1967, 187; Zampetti, No. 55, 56 (*?*).

Paris, Musée du Louvre

A 42. PASTORAL CONCERT Plate 157

Oil on canvas, 109 × 137 cms. Inv. No. 1136.
Provenance: From the Collection of the Duke of Mantua (1627); later Charles I of England (1649); Jabach, (1671); Louis XIV.

In the eighteenth-century engravings and catalogues the title is given simply as a « Pastoral ». It was only with Chataigner and Villerey's engraving of 1804 that the word « Concert » was associated with the painting, which soon became popularly known as « Le Concert champêtre ». As is apparent from a comparison with Bloteling's engraving (after 1671), the picture was at one time enlarged with the addition of strips to the top and bottom, which left it however somewhat askew, tilted to the left. A later restoration removed the additions but failed to correct the slant. The traditional attribution of the painting to Giorgione was first put in doubt by Waagen, who suggested Palma instead (1839); subsequently Cavalcaselle (1871) favoured Sebastiano del Piombo, an attribution that gained the authoritative support of Lionello Venturi (1913). Wickhoff (1893) thought in terms of Domenico Campagnola. It was Morelli who in 1893 suggested Giorgione's hand once more, and he was followed in this by Berenson (1894), Cook (1900), Gronau (1908), Justi (1908), Bode (1913) and Hartlaub (1925). From this point on, writers are divided into two camps: the attribution to Giorgione continues to be supported, by A. Venturi (1928), Berenson (1932), Richter (1927), Fiocco (1941 and 1948), Pallucchini (1944), Gamba (1954), Coletti (1955) and Wind (1969); but Longhi (1927), taking up ideas from Lafenestre (1909) and Hourticq (1919), declared himself to be in favour of Titian's authorship for the painting. This attribution gained the support of Hourticq (1930), Mayer (1030), Suida, (1933), and Morassi (1942). Faced with these apparently irreconcilable differences of opinion (since they were based on stylistic attribution), Pallucchini in 1953 adopted an interpretation that respected both points of view: that Giorgione was responsible for the whole invention of the *Pastoral Concert*, but only actually painted part of it, the rest remaining incomplete at the time of his death and terminated by Titian. This presents an analogy with the conclusion reached with regard to the *Venus* in Dresden, except that in this instance there is no documentary confirmation for this interpretation in the sources. Following the Exhibition in Venice in 1955, Pallucchini's gained further support — from Castelfranco (1955), Fiocco (1955), Salvini (1961), and Baldass-Heinz (1964), while Morassi (1954), Pignatti (1955), Zampetti (1955 and 1968) and Valcanover (1960 and 1969) remained firmly in support of Titian's authorship. Most recently, Gould (1969) proposes Giorgione for the female nudes, and Titian for the males and the landscape.

In the meantime Magdeleine Hours published (in Castelfranco, 1955) the results of an X-ray study of the *Pastoral Concert*, which showed unequivocally that the paintwork of the whole picture is perfectly coherent; only the standing nude on the left showed traces of having been painted on different occasions, with some modest *pentimenti*. This repainting, which must have taken place when the first layer was not yet dry, shows on the surface in the *craquelure* of the paint, which has a concentric pattern as one might expect from paint drying on a ground that was still fresh. Hours added a personal comment that in her view it was possible that the standing figure had been executed by Titian, although she was inclined to believe that it represented a *pentimento* by the same artist who had painted the rest of the picture. Hours's account has been variously interpreted: according to Castelfranco (1955) it proves that Giorgione was responsible for painting the initial composition of the *Pastoral Concert*, leaving it incomplete, to be finished only after the latter's death by Titian, who is seen as having completed the standing nude and also other passages, such as the tree on the left and the heads of the two young men. According to Pallucchini (1955²) and a second statement by Hours (1964), Titian's hand is discernible in the standing nude and also in the landscape on the right, while the figures of the three musicians are from Giorgione's original composition. Thus, while these interpretations seek to respect the conclusions reached in the technical account of the painting, they are neither of them wholly consistent with them.

In our view there are a few factors that are certain from which one must start, if one is to arrive at an interpretation that is at least logical. The first of these is the fact, supported not only by Hours's account but also

by the appearance of the painting itself, that the *Pastoral Concert* is the work of a single artist, whoever this may be. No changes in the *craquelure*, however much one makes of them and however difficult they are to explain (*and they are not*) here impinge upon the majestic unity of space created by the painter to endow his figures with mass and lyrical presence. The play of light-reflecting opaque areas (the nudes and the drapery) against others resplendent with transparent colour (the sky seen through the foliage, the green of the field behind the shepherd, the rays of the setting sun on the rustic dwellings) — everything evinces an aesthetic unity, a controlled and unhesitating rhythm of creation. The second element of certainty is that there is no other work in Giorgione's *oeuvre* that is in any way comparable to the *Pastoral Concert*. And one is speaking here not of the « pictorial arrangement » of the *Pastoral Concert*, but of its « invention », that is to say the manner of placing elements in the poetic imagination. What of the *Tempest*? It would be easy to argue its role as an archetype, but it remains essentially foreign to the predominance of naturalism that is the driving force of the *Pastoral Concert*. The monumental figures in the Fondaco frescoes? Even Zanetti's engravings show that they are not echoed in the figures of the Louvre painting. The *Three Philosophers*? The comparison brings out the absence of those areas of calm colour, created to reflect a dream-like light, as opposed to the vibrant colour, the harshness of the shadows in the faces of the « musicians » or the fieriness of colours in their clothes. Not even the landscape of the *Venus* in Dresden, « retouched » by Titian (according to the sources), has anything in common with this manner of building up with leaves infused with a sense of impeding storm, full of a naturalistic breadth, an open contrast with that symbolical balance of primordial elements that survives in the *Venus* from Giorgione's original composition. And if the *Pastoral Concert* is a work of 1510 or shortly thereafter (since the first paint was still not dry...) how can one see the same hand in the *Portrait of a Man* in San Diego, or even the *Portrait of a Venetian Gentleman* in Washington? The brushwork in the *Pastoral Concert* is one which builds up an impression through violent juxtapositions, bold strokes and broad areas of colour, shadows sculpted deep in the faces of the figures, such as are to be found in Titian's frescoes in Padua, signed and dated 1511. Finally one only has to compare the pungent naturalism of the landscape, with twilight advancing on the right and the sun setting, with the Virgilian, balanced and serene quality of the painting which nevertheless bears the title of *The Tempest* and the certain authorship of Giorgione's hand.

In our view, therefore, the *Pastoral Concert* was painted by Titian, during that very early period when he was « in competition » with Giorgione himself; a period which is also that of a number of other controversial works, such as the *Christ and the Adulteress*, the *Concert* in the Pitti Gallery, the *Knight of Malta* and the little altarpiece in the Prado. These are all works about which critical opinion has come to generally exclude the hand of Giorgione himself.

Bibliography: Waagen, 1839, I (*Palma*); Crowe and Cavalcaselle, 1871, II, 146 (*Sebastiano del Piombo?*); Wickhoff, 1893, 315 (*D. Campagnola*); Morelli, 1893, 224; Berenson, 1894, 100; Cook, 1900, 39; Jacobsen, 1902, 181; Monneret de Villard, 1904, 57; Boehn, 1908, 66; Gronau, 1908, 428; Justi, 1908, 141; Lafenestre, 1909, I (*Titian*); Phillips, 1912, 271 (*Giorgione and Palma*); Bode, 1913, 230; L. Venturi, 1913, 166 (*Sebastiano del Piombo*); Hourticq, 1919, 8 (*Titian*); Gronau, 1921, 88; Hartlaub, 1925, Pl. 33; Justi, 1926, I, 223; Longhi, 1927, 218 (*Titian*); A. Venturi, 1928, IX-III, 38; Hourticq, 1930, 27 (*Titian*); Berenson, 1932, 233; Fiocco, 1941, 35; Morassi, 1942, 129 (*Titian*); Pallucchini, 1944, XII; Oettinger, 1944, XIII; Longhi, 1946, 65 (*Titian*); Fiocco, 1948, 39; H. Tietze, 1950, 389 (*Giorgione and Sebastiano?*); Pallucchini, 1953, 60 (*Giorgione and Titian*); Gamba, 1954, 174; Hendy, 1954, 167; Morassi, 1954, 185 (*Titian*); Della Pergola, 1955, 39; Pignatti, 1955, 136 (*Titian?*); idem, 1955², 506 (*Titian*); Coletti, 1955, 60; Zampetti, 1955, 104 (*Titian*); Pallucchini, 1955², XX (*Giorgione and Titian*); Robertson, 1955, 276; Baldass, 1957, 125 (*Titian*); Berenson, 1957, 84; Egan, 1959, 303; Valcanover, 1960, I, 48 (*Titian*); Salvini, 1961, 231 (*Giorgione and Titian*); Hours, 1964, 155 (*Giorgione and Titian*); Volpe, 1964, 6 (*Titian*); Bonicatti, 1964, 196; Baldass-Heinz, 1964, 163 (*Giorgione and Titian*); Pallucchini, 1965, 266 (*Giorgione and Titian*); Zampetti, 1968, no. 35 (*Titian*); Morassi, 1969, 25 (*Titian*); Valcanover, 1969, No. 31 (*Titian*); Pallucchini, 1969, 20 (*Giorgione and Titian*); Wind, 1969, 19; Gould, 1969, 208 (*Giorgione and Titian*).

A 43. CALLISTO AND THE NYMPHS Plate 192

Sanguine drawing, 33 × 27.5 cms. Inscribed « Giorgione » (eighteenth century?). Inv. No. 4649.

Attributed by Gamba (1909) to Pordenone, the drawing was then given to Moretto by Fiocco (1943) on the grounds of its similarity with the *Madonna del Carmelo* by the latter artist in the Accademia, Venice. For the Tietzes (1944) both these interpretations should be discarded in favour of the traditional attribution to Giorgione, since the drawing has affinities with the *Judgement of Solomon* at Kingston Lacy; furthermore, Ridolfi (1648, 1, 98) mentions a painting with Callisto by Giorgione.

In fact it is now patent that the *Judgement of Solomon* (A 19) is by Sebastiano, and it is precisely to this artist, who was so close to Giorgione before his departure for Rome in 1511, that we would attribute this drawing. Comparison with one of the few certain drawings by Sebastiano, one of the studies for Venus and Cupid in

the *Death of Adonis* in the Uffizi, (Milan, Ambrosiana, T. 1470) is convincing in this respect, both as regards the sanguine technique that is identical in the *Callisto* study, and as regards the handling, which is one composed of broad curved strokes, flexible but at the same time constructive, emphasizing volume. But this three-dimensional quality is still superficial, and is different from that of Pordenone's drawing style, which is punctuated by bands of light (St. Peter Martyr at Chatsworth, T. 1301). The Ambrosiana drawing dates from before 1513, since the painting in the Uffizi mentioned above lacks the point of the campanile, completed in that year. The Giorgionesque character of the drawing of *Callisto and the Nymphs* is thus readily accounted for, amongst Sebastiano del Piombo's earliest work.

Bibliography: Gamba, 1909, 37 (*Pordenone*); Fiocco, 1943, 152 (*Moretto*); Tietze, 1944, No. 714; Pignatti (1955), 137 (*attributed to Giorgione*); Zampetti, 1955, 292 (*Giorgionesque*); Pallucchini, 1955, 27 (*Pordenone*).

Paris, Private Collection

A 44. PORTRAIT OF CONSIGLIERE BEVILACQUA

Plate 206

Oil on canvas. Inscribed: « I DAN. BEVILAC. CANCELLARI. AL. CONSIGLIE. ASTE. I..O ».

Proposed by Richter (1942) as possibly by Giorgione; although we have not seen the painting itself, it would not appear possible to sustain this attribution. The work comes closer to the style of Licinio (*Portrait of a Widow with her Children*, Leningrad; see Berenson, 1957, Fig. 847).

Bibliography: Richter, 1942, 220.

Princeton (New Jersey), Princeton University Art Museum

A 45. PARIS EXPOSED ON MOUNT IDA Plate 149

Oil on panel, 38 × 57 cms.
Provenance: From the Fitch Collection; later F. J. Mather.

Attributed to Giorgione by Conway (1928) and accepted with some reservations — particularly on account of the ruinous state of preservation — by Richter (1937), Morassi (1942) and Della Pergola (1955). Subsequently it made headway as an original with Shapley (1932) and Coletti (1955). Phillips (1937), Fiocco (1941), Zampetti (1955), Pallucchini, (1955)

and Berenson (1957) rightly however demoted it to being the work of a follower or a Giorgionesque copy. Difficult to assess on account of the loss of a large part of the original surface, the pattern of the landscape in this painting might locate it among Giorgione's followers close to Palma, around works such as the *Idyll* at Compton Wynyates (A 9).

Bibliography: Conway, 1958, 259; Shapley, 1932, 128; Richter, 1937, 235 (*Giorgione?*); Phillips, 1937, I (*copy*); Fiocco, 1941, 32 (*follower*); De Batz, 1942, No. 3; Morassi, 1942, 57 (*Giorgione?*); H. Tietze, 1947, 140 (*circle of*); Della Pergola, 1955, 33 (*close to Giorgione*); Pignatti, 1955, 148 (*attributed to Giorgione*); Coletti, 1955, 53; Zampetti, 1955, 62 (*follower*); Pallucchini, 1955, 9 (*not by Giorgione*); Berenson, 1957, 85 (*copy*); Bonicatti, 1964, 205 (*Titian?*); Zampetti, 1968, No. 50 (*?*).

Raleigh (North Carolina), North Carolina Museum of Art

A 46. THE ADORATION OF THE INFANT CHRIST Plate 151

Oil on panel, 19 × 16.2 cms. Inscribed: « Zorzon » (Sixteenth century). Kress Inv. No. 1874.
Provenance: From Mont's Gallery, New York (1952; then Kress, on loan to Raleigh since 1960.

The composition is the same as that of a painting catalogued as « School of Giorgione » in the Hermitage (see below, No. V 14) and that of a print by the Master F N dated 1515 (illustrated in Hind, 1948, VII, Pl. 830). Attributed by Suida (1954) to Titian, as the original of the version in the Hermitage, which he regarded as a copy. Morassi (1955) on the other hand regarded the work as by Giorgione, noting similarities between the features of the St. Joseph and the analogous figures in the *Holy Family* in Washington (Pl. 8), the *Adoration of the Kings* in London (Pl. 22) and the *Adoration of the Shepherds* in Washington (Pl. 35). In his interpretation, all these derive from a single model, which he identifies as the drawing of the *Head of an Old Man* in a private collection in Zurich, which we have here however connected with Bellini's figure of St. Peter in San Zaccaria (see above under Cat. No. 19). After the exhibition in Venice as by Titian (Zampetti, 1955), this attribution was also supported by Pallucchini (1955), Bonicatti (1964) and Shapley (1968), while Fiocco (1955) suggested F. Vecellio, and Berenson (1957) continued in the belief that it derives from the composition in Leningrad, which he classified as a work of Giorgione's school.
The question is further complicated by the discovery which we have been able to make recently of an old inscription « Zorzon », written in sixteenth-century longhand at the lower edge of the panel, previously

covered up by the frame. Despite this, it is our belief that the painting is by Titian and not by Giorgione, precisely on account of the immediacy of the rendering of the landscape, which Morassi (1955) himself described as possessing a « realism that is almost surprising for that period ».

There are in addition other elements that link this painting with works by Titian of around 1510, such as the figure of the Madonna, wholly comparable to the *Madonna in a Landscape* in the Accademia Carrara in Bergamo, with which there are also other similarities in the Child and in the sketchy background of rustic dwelling and hills (Pl. 159).

Bibliography: Suida, 1954, 155 (*Titian*); Morassi, 1955, 149; Zampetti, 1955, 174 (*Titian*); Pallucchini, 1955, 15 (*Titian*); Fiocco, 1955, II (*F. Vecellio*); Berenson, 1957, 86(*Giorgionesque*); Bonicatti, 1964, 203 (*Titian*); Shapley, 1968, 185 (*attributed to Titian*); Pallucchini, 1969, 10 (*Titian*).

Rome, Borghese Gallery

A 47. THE IMPASSIONED SINGER Plate 212

A 48. A SINGER Plate 213

Oil on canvases, 102 × 78 cms.
Provenance: Probably from the Vendramin Collection, Venice; later in the Collection of Cardinal Scipione Borghese (1618-19).
Catalogued for the first time in the Borghese Collection by Manilli (1650) as « the two Buffoons by Giorgione », they were later attributed to Capriolo by A. Venturi (1893) and to Mancini by Longhi (1927) who in 1945 suggested Giorgione's hand, a view published by Dalla Pergola (1954). She identified the Singers as being fragments of the composition of « the painting by Giorgione da Castelfranco, with three large heads singing » (« quadro de man de Zorzon de Castelfranco, con tre testoni che canta ») included in the inventory of the inheritance of Gabriele Vendramin (1569). The canvas would have been cut up before Manilli's (1650) cataloguing of the Borghese Gallery, and the central portion containing the third figure would have been removed. Two copies of these heads, painted according to Della Pergola towards the end of the sixteenth century or the beginning of the seventeenth century, were formerly in the Donà delle Rose Collection in Venice (cf. Lorenzetti-Planiscig, 1934, Nos. 59-60). The dating of the Borghese painting would be from the final period of Giorgione's career « closed by the death of Giorgione himself in 1510 ».
The subject of a discussion in a « referendum » in the *Scuola e Vita* Review in 1954, Della Pergola's argument

provoked an alignment of critical opinion in two directions: on the one hand Longhi, Grassi, Wittgens and Zeri were all for the attribution to Giorgione, while on the other Fiocco and Berenson continued to support the authorship of Capriolo, and Gamba (1954) suggested a follower of Pordenone; Coletti (1955), Dosso Dossi; Robertson (1955), a seventeenth-century imitator; Pignatti (1955). Zampetti (1955), and Pallucchini also registered their disagreement.
In the light of the new understanding that we have of Giorgione's final style, illustrated in the *Portrait of a Man* in San Diego of 1510, it is clear that the two *Singers* lie outside the scope of the artist's work, by reason of a stylistic incompatibility such as we have already noted in the *Mocking of Samson* in the Mattioli Collection (A 28, Pl. 211). They are painted in a changing medium, and one which suggests a follower of Giorgione in the provinces at least a few decades after the death of the latter.

Bibliography: Manilli, 1650, 68; A. Venturi, 1893, 97 (*Capriolo*); Berenson, 1906, 98(*Capriolo*); Longhi, 1927, 14 (*Mancini*); Fiocco, 1929, 124 (*Capriolo*); Wilde, 1933, 130 (*Venetian School, circa* 1530-40); Della Pergola, 1954, No. 49, 27; Grassi, 1954, No. 8, 15; Wittgens, 1954, No. 8, 13; Longhi, 1954, No. 9, 13; Zeri, 1954, No. 16, 6; Fiocco, 1954, No. 8, II (*Capriolo*); Berenson, 1954, 15 April (*Capriolo*); Gamba, 1954, 176 (*follower of Pordenone*); Collobi Ragghianti, 1955, 630; Della Pergola, 1955, 34; Pignatti, 1955, 138 (*attributed to Giorgione*); Pallucchini, 1955, 9 (*not by Giorgione*); Pignatti, 1955², 505 (*not by Giorgione*); Coletti, 1955, 67 (*Dosso?*); Zampetti, 1955, 84 (*attributed to Giorgione*); Fiocco, 1955, 18 (*Capriolo*); Robertson, 1955, 276 (*seventeenth century*); Berenson, 1957, 52 (*Capriolo*); Salvini, 1961, 238 (*not by Giorgione*); Volpe 1964; Zampetti, 1968, Nos. 38, 39 (*attributed to Giorgione*).

A 49. PORTRAIT OF A LADY Plate 207

Oil on canvas, 97 × 75 cms. Inv. No. 143.
Recorded for the first time in the Borghese Inventory of 1693 as by Titian, the attribution to Giorgione of this painting was made initially by Morelli (1892). Accepted by Berenson (1894) and Cook (1900), it was included in Giorgione's Catalogue by Justi (1908), Gronau (1908), Borenius (1912), Mayer (1932) and again by Berenson (1932). In the meantime however some disagreement was voiced, by L. Venturi (1913) and Longhi (1928) who connected it with Lotto. For Richter (1937) also the portrait is not by Giorgione, and Fiocco (1941) quoting Wickhoff, suggested Licinio. More recent opinion has favoured attribution to a follower of Giorgione, from Morassi (1942) to Longhi (1946) and Della Pergola (1955), while only Berenson (1957) persists in recognizing Giorgione's hand in the painting.

The work would appear in our view to date from the second decade of the century, apart from any other factor on account of the costume, which is Lombard in character: a useful comparison may be made with Lotto's portraits of around 1520-3, such as the *Brembate* in Bergamo or the *Casotti and his Wife* in the Prado, which have the same hairstyle. Della Pergola (1955) noted « clear affinities » with portraits by Licinio, and it may be as well to leave the attribution of this fascinating portrait in that area for the time being.

Bibliography: Morelli, 1892, 248; Berenson, 1894, 100; Cook, 1900, 33; Monneret de Villard, 1904, 44 (*Venetian School*); Gronau, 1908, 426; Justi, 1908, I, 137; Boehn, 1908, 54; Borenius, 1912, III, 37; L. Venturi, 1913, 259 (*not by Giorgione*); Dreyfous, 1914, 45; Gronau, 1921, 88; Justi, 1926, II, 154; Longhi, 1928, 190 (*circle of Lotto*); Mayer, 1932, 375; Berenson, 1932, 233; Mather, 1937, 600 (*?*); Phillips, 1937, 47; Richter, 1937, 237 (*not by Giorgione*); Fiocco; 1941, 38 (*Licinio*); Morassi, 1942, 145 (*follower of Giorgione*); Longhi, 1946, 84 (*Giorgionesque*); Fiocco, 1948, 38 (*follower of Giorgione*); Della Pergola, 1955, 114 (*follower of Giorgione*); Berenson, 1957, 84.

Rome, Museum of Palazzo Venezia

A 50. DOUBLE PORTRAIT (LUDOVISI) Plate 124

Oil on canvas, 80 × 67.5 cms.
Provenance: From the Collection of Cardinal Ludovisi in Rome, dispersed in 1660, as by Giorgione; later Ruffo (1915).

Identified — although without convincing proof — by Ravaglia (1922) as the portrait of the musicians Verdelot and Obrecht, by Sebastiano del Piombo, this attribution was followed for the painting in the catalogue by Hermanin (1925), but contested by Pallucchini (1944). In the meantime Longhi (1927) suggested an attribution to Giorgione, one which was subsequently favoured only by Coletti (1955) and Zampetti (1955) around the time of the exhibition in Venice, but further doubted by Pignatti (1955) and Pallucchini (1955). More recently, the attribution to Giorgione has come back into favour, with Garas's (1965) identification of the Ludovisi provenance and the old attribution of the painting; the latter was accepted also by Volpe (1964) and Pallucchini (1965), who now sees the portrait as being « in all probability » close to Giorgione. In 1929 Fiocco adjudged the painting to be by Mancini, an opinion that was later to be shared by Gamba (1954) and Berenson (1957).
It cannot be denied that the *Double Portrait* possesses some of the qualities and appeal of Giorgione's art, characteristic of the work of his closest circle, but it is difficult to reconcile the style of this painting with that of the *Laura* of 1506 or that of the *Portrait of a*

Young Man in Berlin, and still less with that of the *Portrait of a Man* in San Diego (1510) with which it has on occasion been associated. In this regard the Ludovisi painting seems stylistically far more advanced, and in chronological terms this locates the painting beyond the span of Giorgione's career.

Bibliography: Ravaglia, 1922, 474 (*Sebastiano*); Hermanin, 1925, 68 (*Sebastiano*); Justi, 1926, II, 104 (*not by Giorgione*); Longhi, 1927, 220; Fiocco, 1929, 39 (*Manicini*); Pallucchini, 1944, 188 (*not by Sebastiano*); Longhi, 1946, 63; Gamba, 1954, 176 (*Mancini*); Pignatti, 1955, 139 (*attributed to Giorgione*); Coletti, 1955, 62 (*probably by Giorgione*); Zampetti, 1955, 80; Pallucchini, 1955, 9 (*not by Giorgione*); Robertson, 1955, 276 (*Torbido*); Berenson, 1957, 107 (*Mancini?*); Salvini, 1961, 239 (*not by Giorgione*); Volpe, 1964, 6; Baldass-Heinz, 1964, 160 (*follower of Giorgione*); Garas, 1965, No. 27, 51; Pallucchini, 1965, 226 (*Giorgione?*); Garas, 1967, 287; Zampetti, 1968, No. 69 (*?*).

Rotterdam, Museum Boymans-van Beuningen

A 51. LANDSCAPE WITH A CASTLE Plate 148

Silverpoint drawing on prepared paper, 15.8 × 27.1 cms.
Provenance: From the Koenings Collection in Haarlem.
Attributed by the Tietzes (1944) — with some hesitation — to Giorgione, and associated by them with the *Finding of Paris* now in the Gerli Collection in Milan. The latter painting — pendant to another showing *Paris being entrusted to his Nurse*, in the same collection (Zampetti, 1955, Nos. 1-2) does indeed include the same landscape as in the drawing, with the characteristic crenellated tower on the left. In terms of the point of view, it could be said however that the drawing represents something of a close-up and is taken from a less elevated position: a fact which might suggest that the view was taken from reality. No-one any longer takes the attribution to Giorgione of the Gerli *Paris* paintings seriously, and the Tietzes' lone suggestion should thus be abandoned. Since those paintings are now generally thought to be by G. Campagnola (Zampetti 1968, No. 48 A-B), it would not appear unlikely that this drawing in Rotterdam could also be by the same follower of Giorgione.
Bibliography: H. and E. Tietze, 1944, No. 707; Zampetti, 1968, p. 102 (*?*).

San Francisco (California), M. H. De Young Memorial Museum

A 52. PORTRAIT OF A YOUNG MAN (ONIGO) Plate 125

Oil on canvas, 68.6 × 55.9 cms. Inscribed: « PLUTARCO » (?) on the book. Kress Inv. No. 2060.

Provenance: According to an undocumented tradition, the painting originally belonged to the Onigo family in Treviso; it later entered the Volpi Collection in Florence, the Cook Collection at Richmond; Rosenberg and Stiebel's, New York; Kress (1954).

Published in 1907 by the Arundel Club as by Giorgione, this attribution was supported by Cook (1908) but discarded in favour of Licinio by Phillips (1909) and even Cook (1910) and more recently Suida (1954). A. Venturi (1928) and Morassi (1942) adjudged it to by Cariani, while Berenson's (1932) suggestion of Pordenone was accepted by Fiocco (1939), Pallucchini (1955), Coletti (1955) and Ballarin (1965). The picture has recently been cleaned, and it has lost the cool shading that previously made an attribution to Pordenone seem possible. Suggested by Berenson thirty years ago, this interpretation has been rendered even more unlikely by Berenson's own more recent (1957) uncertainty. The painting can now be seen to be characterized by a rich impasto of colours with a compact structure that is strongly reminiscent of the late Giorgione and the early Titian, and which a close follower of the master could have attained, certainly not many years after 1510. The embroidered black silk cloak, which is barely interrupted by the white of the shirt with its soft pleats, endows the green morocco book (Plutarch, it seems, rather than Petrarch, as had been thought in the past) with immediacy and relief. In this figure set against and standing away from the grey background there is an impression of realism that suggests Lombardy rather than Venice or — even worse — the Friuli. It is therefore impossible to sustain the attribution to Pordenone, for which there has never been adequate proof, especially as Pordenone's known work does not at present contain any portrait that is at all close to this painting. On the other hand, the *Portrait of a Young Man* dated 1510 in the Brera Gallery (Fig. 38), which has borne a fruitless attribution to Savoldo, is much closer in character. Recent opinion has tended to draw this painting closer into the field of the Giorgionesque, with Gilbert's (1949, p. 104) attribution to Torbido (although that in itself is not convincing). We mention this portrait in this context, not because it might seem to be by the same hand as the portrait in the De Young Memorial Museum, but rather in order to show that there are paintings that are much closer to it than the work of the remote Pordenone, in Giorgione's close circle, with which attribution we should leave it for the time being.

Bibliography: Arundel Club, 1907, No. 12; Cook, 1908, 57; Phillips, 1909, 6 October (*Licinio*); Holmes, 1910, 72(*Licinio*); Cook, 1910, 329 (*Licinio*); L. Venturi, 1913, 258 (*?*); A. Venturi, 1928, IX-III, 465 (*Cariani*); Berenson, 1932, 470 (*Pordenone*); Fiocco,

1939, 56 (*Pordenone*); Morassi, 1942, 103 (*Cariani*); Coletti, 1955, 46 (*Pordenone*); Zampetti, 1955, 144 (*Giorgionesque*); Pallucchini, 1955, 22 (*Pordenone*); Berenson, 1957, 146 (*Pordenone?*); Ballarin, 1965, 64 (*Pordenone*); Zampetti, 1968, No. 63 (*Giorgionesque*).

Venice, Gallerie dell'Academia

A 53. SACRA CONVERSAZIONE Plate 197

Oil on panel, 51 × 81 cms. Inv. No. 70.
Provenance: From the Contarini Collection (1838).

The work bore a traditional attribution to Previtali; Cavalcaselle (1871) was the first to note its Giorgionesque character, although the latter writer did not go so far as to claim Giorgione's authorship. Subsequently Paoletti (1903) suggested Cariani, and Gronau (1908) associated it with the group of works including the *Adoration of the Shepherds* now in Washington (Pl. 35), the *Holy Family* in Washington (Pl. 8) and the *Adoration of the Kings* in London (Pl. 22), for all of which he suggested Catena. This opinion was followed by Justi (1908) and L. Venturi (1913), but in 1927 Longhi proposed Giorgione's authorship once more, associating the *Sacra Conversazione* with the *Laura* in Vienna, around 1505. This interpretation was generally accepted: by Suida (1935), Morassi (1942, who also held that the X-rays supported this attribution), Dussler (1942), Zampetti (1955 and 1968); but doubt was cast upon it by Pignatti (1955) and Castelfranco (1955). In the meantime, support was growing for Pallucchini's (1935) suggestion of Sebastiano, from Fiocco (1941), Della Pergola (1955), Robertson (1955) and with some hesitation by Coletti (1955); Berenson on the other hand lists the painting under Licinio and Previtali (1932), and later under Previtali and Cariani (1957); Richter (1937) and Douglas (1950) favour Palma, and Moschini Marconi (1962) attributes the painting to an anonymous follower of Giorgione. The connection with the *Sacra Conversazione* in the Louvre, which Pallucchini noted in support of his attribution of the painting to Sebastiano del Piombo, is convincing. One can now also add the revealing comparison with the female figures in the recently-cleaned *Saint John Chrysostom* altarpiece (Pl. 193) which is perhaps a little later in date, but which has a similar Giorgionesque structure, chilled somewhat by the easily recognized classicistic references which the young artist gained from the Lombardo family (of whom Tullio was in fact working in the same church).

Bibliography: Pinacoteca Contarini, 1841, 7 (*Previtali*); Crowe and Cavalcaselle, 1871, I, 277 (*Giorgionesque*); Paoletti, 1903, 30 (*Cariani*); Gronau, 1908, 509 (*Master of the Allendale Adoration*); Justi, 1908, I, 124 (*Catena*); L. Venturi, 1913, 230 (*Catena*);

Longhi, 1927, 218; Berenson, 1932, 284 and 474 (*Licinio, Previtali*); Pallucchini, 1935, 43 (*Sebastiano*); Suida, 1935, II, 76; Richter, 1937, 264 (*Palma?*); Fiocco, 1941, 17 (*Sebastiano*); Morassi, 1942, 64; Dussler, 1942, 1942, 149; Pallucchini, 1944², 17 (*Sebastiano*); Longhi, 1946, 19; Douglas, 1950, 31 (*Palma?*); Morassi, 1951, 212; Berenson, 1954, 146 (*Cariani*); Della Pergola, 1955, 64 (*Sebastiano*); Pignatti, 1955, 141 (*attributed to Giorgione*); idem, 1955², 501 (*Sebastiano?*); Coletti, 1955, 66 (*Sebastiano?*); Zampetti, 1955, 16; Pallucchini, 1955, 12 (*Sebastiano*); Robertson, 1955, 275 (*Sebastiano*); Castelfranco, 1955, 298 (?); Berenson, 1957, 56 and 149 (*Cariani, Previtali*); Moschini-Marconi, 1962, 126 (*Giorgionesque*); Zampetti, 1968, No. 4.

Venice, San Giovanni Crisostomo

A 54. SAINT JOHN CHRYSOSTOM AND SIX SAINTS

Plate 193

Oil on canvas, 200 × 165 cms.

Vasari in the first edition of the *Lives* (1550) attributes this painting to Giorgione, but in the second edition (1568) he gives it to Sebastiano, explaining that the figures « have so much the character of Giorgione's style that they have sometimes been mistaken, by those who have little understanding of artistic things, to be by Giorgione himself ». This is probably the origin of Sansovino's (1581) belief that the painting was started by Giorgione and completed by Sebastiano. This interpretation is not borne out by the altogether consistent handling of the paint, which emerged as intact as a result of Pelliccioli's cleaning in 1955. Sansovino's statement has, however, provided the mainstay for those who continue to see Giorgione's hand in the execution of the painting — although less in its actual design — from Handel (1910) to Richter (1937), Morassi (1942), Fiocco (1948) and Robertson (1955), while Berenson (1957) goes so far as to list the painting under the name of Giorgione, who would also have been responsible for the 'lay-in' of the two Saints on the right. Gould (1969) thinks (also with X-ray observations) that the central saint reading and the lay-in of the other male saints are by Giorgione. The three female saints would have been added by Sebastiano, after Giorgione's death. Pallucchini (1944 and 1955) on the other hand is quite opposed to these interpretations, noting that even in the course of restoration it was impossible to make any distinction of a hypothetical division of the painting between Giorgione and Sebastiano.

The *Saint John Chrysostom* altarpiece is thus in our opinion entirely by Sebastiano, even though it must have been conceived in Giorgione's circle, after March 13, 1510, as Gallo proved (1953).

Bibliography: Vasari, 1550, III, 579; Vasari, 1568, V, 566 (*Sebastiano*): Sansovino, 1581, 154 (*Giorgione and Sebastiano*); Cro-

we and Cavalcaselle, 1871, VII, 366 (*Rocco Marconi*); Hadeln, 1910, 158 (*Giorgione and Sebastiano*); Pallucchini, 1935, 41 (*Sebastiano*); Richer, 1937, 244 (*Giorgione and Sebastiano*); Dussler, 1942, 23 (*Sebastiano*); Morassi, 1942, 137 (*Giorgione and Sebastiano*); Pallucchini, 1944², 154 (*Sebastiano*); Longhi, 1946, 22 (*Sebastiano*); Fiocco, 1948, 16 (*Giorgione and Sebastiano*); Gallo, 1953, 152 (*Sebastiano*); Zampetti, 1955, 184 (*Sebastiano?*); Pallucchini, 1955, 54 (*Sebastiano*); Robertson, 1955, 277 (*Giorgione and Sebastiano*); Berenson, 1957, 84, (*Giorgione and Sebastiano*); Gould, 1969, 206 (*Giorgione and Sebastiano*).

Venice, Biblioteca dell'Ospedale Civile

A 55. STORM AT SEA

Plate 200

Oil on canvas, 360 × 406 cms. Inv. No. 37.
Provenance: From the Albergo della Scuola Grande di San Marco (now the Civic Hospital).

The painting illustrates the scene from a Venetian legend according to which on the night of 25 February 1340, Saints Mark, George and Nicholas stilled a violent storm which threatened the city. The boatman who was reputed to have ferried the three Saints to the mouth of the port of San Nicolò, in order to repel the ship of the demons, was entrusted with a ring by St. Mark, which he was to give to the Doge (this scene is in fact illustrated in Bordone's well-known painting in the Gallerie dell'Accademia in Venice). Moschini Marconi (1962) argues that the canvas must have been in place already some time in 1534, when the School decided to order further works « since our *albergo* is short of paintings » (« che manca in tel nostro albergo »). Bailo and Biscaro (1900) imagined, however, that at that date the *Storm at Sea* was unfinished or else in a damaged state, through fire or another misfortune. Certainly the restoration, carried out by Pelliccioli in 1955, revealed many layers of paintwork. The oldest parts are the landscape and the sea, the ship with the demons and the nude figures in the foreground; the boat with the Saint was repainted not long after, in a style that is characteristic of the mid-sixteenth century. The group of nudes was repainted in a manner characteristic of the eighteenth century, while the marine monster and part of the landscape in the background were added (the former on a rectangle of modern canvas) in a style typical of the nineteenth century. Moschini-Marconi recognized Paris Bordone as the artist responsible for the repainting of the boat with the Saints, while she saw the nudes as dating from D. Giuseppe Zanchi's restoration in 1733, and the marine monster and the landscape as being attributable to Sebastiano Santi's 1833 restoration. But the attribution of the initial composition is still uncertain; while Vasari in the

first edition of the *Lives* (1550) mentions it as a work by Giorgione, he attributes it to Palma Vecchio in the second (1568), and Sansovino describes it as being by Palma while noting that others attributed it to Paris Bordone. Zanotto (1833) was the first to recognize Paris Bordone's hand in the boat with the Saints, an interpretation that was followed by Cavalcaselle and later writers. Opinion then moved in favour of the idea that the *Storm at Sea* was initially conceived by Giorgione, as Vasari had indeed said at first; this line was followed by Berenson (1894), Justi (1908), Gronau (1908), Richter (1937), Suida (1954), Pallucchini (1955), Muraro (1963; perhaps the painting for the Doge's Palace started in 1507?) and Mariacher (1968). But the prevailing opinion is that the actual execution of the painting is the work of Palma, with later contributions from Bordone and the other restorers.

In our opinion, it is difficult to see any trace of Giorgione in the painting, while the figures that have emerged as a result of the restoration on the left of the painting, just as the nudes in the foreground and what is original of the landscape, which is quite close to that of Palma's *Sacra Conversazione* in the Gallerie dell'Accademia in Venice (No. 147; Mariacher, 1968, No. 42), all point to that artist's hand. We would on the other hand support the interpretation of the later intervention by Paris Bordone and the restorers.

Bibliography: Vasari, 1550, 454, 577; Vasari, 1568, V, 245 (*Palma*); Sansovino, 1581, 102 (*Palma or Bordone*); Zanotto, 1833, I, 22 (*Palma and Bordone*); Crowe and Cavalcaselle, 1871, 151 (*Palma and Bordone*); Berenson, 1894, 92 (*Giorgione, Palma and Bordone*); Bailo-Biscaro, 1900, XXXV (*idem*); Justi, 1908, I, 201 (*idem*); Gronau, 1908, 435 (*idem*); Richter, 1937, 245 (*idem*); Suida, 1954, 159 (*idem*); Zampetti, 1955, 198 (*Giorgione and Palma?*); Pignatti, 1955², 503 (*Giorgione (?) and Palma*); Pallucchini, 1955, 19, (*Giorgione, Palma and Bordone*); Robertson, 1955, 277 (*Palma*); Moschini-Marconi, 1962, 119; Mariacher, 1968, No. 77, (*Palma and others*); Zampetti, 1968, No. 73 (*Palma and Bordone*).

Venice, Scuola Grande di San Rocco

A 56. PIETÀ Plate 128

Oil on canvas, 55 × 81 cms.

This painting, which has been discussed very little in the literature, was according to Coletti (1955) attributed by Venturi to Titian, a view apparently started by Cavalcaselle (1871). The association with Giorgione as made by ourselves (1955²) and we would still support the interpretation that this painting belongs in Giorgione's close circle — despite its poor state of conservation — around the last works, such as the

Shepherd Boy with a Flute (Pl. 110) at Hampton Court.

Bibliography: Crowe and Cavalcaselle, 1871, I, 58 (*Titian*); Fogolari 1935, 1 (*Titian*); Suida, 1935, 21 (*Titian*); Coletti, 1955, 61 (*Titian*); Berenson, 1957, 191 (*Titian ?*); Pignatti, 1955², 491 (*possibly by Giorgione*); Heinemann, 1962, 51 (*Titian*); Wethey, 1969, 115 (*Titian ?*).

Venice, Seminario Patriarcale

A 57. APOLLO AND DAPHNE Plate 176

Oil on panel, 64 × 130 cms.
Provenance: From the Manfredini Collection (1829).

Perhaps to be identified with the « chest » painted, according to Ridolfi (1648) by Giorgione, with « the serpent Python killed by Apollo and the same God pursuing the beautiful daughter of Peneius » (« Pitone serpente ucciso da Apolline & il medesimo Deo seguendo la bella figlia di Peneo »). The panel does indeed appear to have been cut on the left, where the scene with the slaying of the serpent occurs. Cavalcaselle's attribution (1871) to Schiavone would seem to place the painting too late. This was however countered by Morelli (1880) with an attribution to Giorgione, and this was also supported by Berenson (1894) and Cook (1900) right up to Boehn (1908) and Fiocco (1941), albeit with some doubts. Schmidt (1908) was in favour of Cariani; Richter (1937) Mancini; Morassi (1942) Polidoro; Pallucchini (1946) Bordone; the Tietzes (1949) Campagnola. In 1955 Zampetti proposed an attribution to Titian, and Coletti (1955) one to Palma, while Pallucchini (1955) and Canova (1964) supported Paris Bordone's authorship. Despite the many allusions to Titian's *cassoni* from around the period of this association with Giorgione, the painting is not in our opinion of sufficient quality to be by the former artist, while there is a much greater likelihood of Bordone's hand, considering the closeness of the landscape with that of the *St. Jerome* in the Johnson Collection in Philadelphia (illustrated in Canova, 1964, Fig. 31).

Bibliography: Ridolfi, 1648, I, 99; Crowe and Cavalcaselle, 1871, II, 166 (*Schiavone*); Morelli, 1880, 162; Berenson, 1894, 95; Cook, 1900, 135; Monneret de Villard, 1904, 116; Boehn, 1908, 55 (*?*); Schmidt, 1908, 117, (*Cariani*); L. Venturi, 1913, 273 (*Schiavone*); Richter, 1937, 249 (*Mancini?*); Fiocco, 1941 32 (*Giorgione?*); Morassi, 1942, 136 (*Polidoro?*); Pallucchini, 1946, 131 (*Bordone?*); H. and E. Tietze, 1949, 95 (*G. Campagnola*); Della Pergola, 1955, 60 (*Titian*); Pignatti, 1955, 141 (*Titian*); Coletti, 1955, 67 (*Palma*); Zampetti, 1955, 168 (*Titian or circle of*); Pallucchini, 1955, 27 (*Bordone*); Robertson, 1955, 277 (*Titian*); Berenson, 1957, 84 (*partly by Giorgione*); Canova, 1964, 114 (*Bordone*); Zampetti, 1968, No. 64 (*Titian*).

Venice, Cini Collection

A 58. SAINT GEORGE Plate 189

Oil on panel, 124 × 65 cms.
Provenance: From the Neeld Collection; then Agnew.
Traditionally attributed to Giorgione, this was also
favoured by Waagen (1854) before being given to Pal-
ma by Borenius (1912) and Fiocco (1919) although
this was contested by Gronau (1915) and Spahn (1932).
Longhi then (1934) suggested Titian's hand around
1511, and Tietze (1950) confirmed this attribution, iden-
tifying the painting as the surviving fragment of the
altarpiece with « S. Michel con S. Zorzi e S. Thodaro
de le bande » which Doge Andrea Gritti promised to
give to the Visconte di Lautrec, Governor of Millan,
on the 27 May 1517 (Sanudo, *Diarii*, 1879, XXIV,
303, 326, 364). In 1954 L. Venturi brought up the old
attribution to Giorgione once more, and he was fol-
lowed by Calvesi (1956) who sought to identify the
painting as the *St. George* by Giorgione described by
Pino in his *Dialogo di Pittura* of 1548. Berenson (1957)
also came out in favour of Giorgione, noting that the
head had been repainted. The restoration, reported
by Valcanover (1965), did indeed show that the head
had been completely reworked, to the extent that the
Saint now appears in profile, whereas before he was
looking downwards (Fig. 40). It is further possible
to discern the wing of Lucifer, who was on the ground
before St. Michael in the middle of the composition,
which in its present state represents but a third of the
original. Valcanover quite rightly points out that Sanu-
do's mention of the work in 1517 indicates that it was
already in existence at that date, perhaps from several
years earlier.
With the advent of this new information, there is no
reason to doubt that this painting belongs with Titian's
early work, at the beginning of the second decade of
the century.

Bibliography: Waagen, 1854, 243; Borenius, 1912, III, 387 (*Pal-
ma*); Gronau, 1915, app., 68 (*not by Palma*); Fiocco, 1919, 383
(*Palma*); Spahn, 1932, 177 (*not by Palma*); Longhi, 1934, 148
(*Titian*); H. Tietze, 1950, 375 (*Titian*); Pallucchini, 1953, 113
(*Titian*); L. Venturi, 1954, 73; Morassi, 1954, 192 (*Titian*); Pi-
gnatti, 1955, 142 (*Titian?*); Coletti, 1955, 67 (*Titian*); Zampetti,
1955, 116, (*Titian*); Pallucchini, 1955, 15 (*Titian*); Fiocco, 1955, 5
(*Dosso?*); Calvesti, 1956, 254; Berenson, 1954, 87; Valcanover,
1960, I, 59 (*Titian*); Valcanover, 1965, (*Titian*); Zampetti, 1968,
1968, No. 83 (*Titian*); Valcanover, 1969, No. 34 (*Titian*); Pal-
lucchini, 1969, 39 (*Titian*); Wethey, 1969, 133 (*Titian*).

Vienna, Albertina

A 59. ADORATION OF THE INFANT CHRIST Plate 145

Brush drawing, 25.9 × 21.6 cms. Inv. No. 1649.
Provenance: From the Collection of the Prince de
Ligne.

The initial tentative attribution to Giorgione was
made by Stix-Froelich Bum (1926) who associated
the drawing with the *Holy Family* in Washington (Pl. 8)
and a study for an *Adoration of the Shepherds* at Windsor
Castle (A 68) which was closely linked with the *Ado-
ration of the Shepherds* in Washington (Pl. 35); Benesch
(1964) also supported this attribution to Giorgione.
But A. Venturi (1922) had previously attributed the
drawing to Savoldo, while Frizzoni and Morassi
(1942) had given it Romanino. The Tietzes (1944)
on the other hand rejected all these interpretations,
particularly the suggestion that it could be by Gior-
gione, for which it seemed to them to be lacking in
quality. Fiocco (1948) suggested that could be a deri-
vation, in the style of Fogolino.
In our opinion, this is an exercise by an anonymous
Giorgionesque figure at the beginning of the sixteenth
century, not distant in style from that of Cariani in,
for instance, the *Doetsch Madonna* (illustrated in Beren-
son, 1957, Fig. 741).

Bibliography: A. Venturi, 1922, 112 (*Savoldo*); Stix-Froelich Bum,
1926, No. 36, (*Giorgione?*); Morassi, 1942, 123, (*Romanino*); H. and
E. Tietze, 1944, No. A. 718 (*follower of Bellini*); Fiocco, 1948, 22
(*Fogolino?*); Pignatti, 1955, 142 (*circle of Giorgione*); Zampetti,
1955, 290 (*attributed to Giorgione*); Benesch, 1964, 322.

Vienna, Kunsthistorisches Museum

A 60. THE ADORATION OF THE SHEPHERDS Plate 152

Oil on panel, 91 × 115 cms. Inv. No. 1835
Provenance: From the Collection in Venice of Barto-
lomeo della Nave (1636), where it was attributed to
Giorgione; then Lord Feilding-Hamilton (1649), Lon-
don; listed in the Collection of the Archduke Leopold
Wilhelm in 1659.

The painting is almost identical in size and composi-
tion to the *Adoration of the Shepherds* (Cat. No. 9, Pl. 35),
differing from it only in some details, such as the tree
on the left, the mantle of the Virgin, and in the absence
of the announcing angel and one of the cherubs. We
are faced here with a painting that remained unfini-
shed, especially with regard to the central area of the
landscape; furthermore, all the foliage is much more
simplified, more cursive and less detailed. The colour
itself seems to be warmer in tone than the original
in Washington, and is dominated by brown-umber
and dark green. It almost seems as though, whereas
the Washington picture is brightly lit, in this painting

the artist sought to give the impression of a sunset. Fiocco (1941) suggested that this might be the « not very perfect night [picture] » (« nocte non molto perfecta ») which Albano referred to as being in Casa Contarini in 1510. This theory must, however, be abandoned, since it does not appear that the word « nocte » was ever interchangeable with « nativity » (see Cat. No. 9).

Regarded as an original version of the Washington picture by Cook (1900), Fiocco (1941), Zampetti (1955 and 1968) and Garas (1964), the painting was described as a copy for Morassi (1942), Della Pergola (1955) and Pallucchini (1955). Recently Baldass-Heinz (1964), have taken up Berenson's (1932) suggestion that the painter of the Vienna *Adoration* is in fact Titian, which would account for this being a simplified version of Giorgione's original. This is a theory which it is difficult to substantiante in consideration of Titian's early landscape work, but it is not wholly to be cast out of hand, since it would account for the quality of this copy of the *Adoration of the Shepherds*.

Bibliography: Cook, 1900, 74; Monneret de Villard, 1904, 93 (*school of Giorgione*); Justi, 1908, 119 (*copy after Giorgione*); Borenius, 1912, III, 10 (*copy*); Holmes, 1923, 230 (*Bonifazio*); Berenson, 1932, 576 (*copy after Titian*); Richter, 1937, 257 (*copy*); Fiocco, 1941, 16 (*Giorgione and assistants*); Morassi, 1942, 69 (*copy?*); Tietze, 1949, 13 (*copy*); Della Pergola, 1955, 29 (*copy*); Coletti, 1955, 64 (*attributed to Giorgione*); Zampetti, 1955, 18; Pallucchini, 1955, 5 (*copy*); Baldass, 1957, 109, (*Titian*); Berenson, 1957, 85 (*Flemish copy*); Garas, 1964, No. 25, 73; Baldass-Heinz, 1964, 164 (*Titian*); Zampetti, 1968, No. 9; Pallucchini, 1969, 5 (*replica by Giorgione*); A. Pallucchini, 1969, 43 (*Giorgione with assistants*); Wethey, 1969, 168, (*copy*).

A 61. « IL BRAVO » Plate 187

Oil on canvas, 75 × 67 cms. Inv. No. 64.
Provenance: From the Collection of Archduke Leopold Wilhelm in Brussels, where it was listed as by Giorgione (1659). Engraved in Teniers's *Theatrum Pictorium* (1658; No. 23: Giorgione).

This is probably the picture that was seen by Ridolfi (1648) in the Collection of Bartolomeo della Nave in Venice (1636); later it was in the Feilding-Hamilton Collection (1649). It is probably to be identified with the « two half-length figures attacking each other » (« le due mezze figure che si assaltano ») which Michiel saw in the house of Zuan Antonio Venier, and which he named as by Titian (Engerth, 1882). The subject is to be identified, better than «Claudio and Celio», as «The Wreath of Trebonius» (Wind, 1969). Attributed to Giorgione by Waagen (1866-7), it was then given to Cariani by Cavalcaselle (1871), Morelli (1893) and Berenson (1899); to Palma by Wickoff (1895), L.

Venturi (1913) and Berenson (1932 and 1957). In the meantime, however, Suida (1927) and Longhi (1927) suggested Titian's authorship for the painting, and they were followed by Morassi (1942), Pallucchini (1955), Baldass (1957) and Valcanover (1960 and 1969). Richter (1937) rejected the attribution to Giorgione, and noted that the X-rays showed that the right-hand head was originally in profile. Since it appears in profile in Van Dyck's sketchbook of 1625, he deduced that the present version is not original. Instead it might be the result of a restoration, carried out between the latter date and 1658, when it was engraved, as it is seen today, in Teniers's publication. While this seems tenable, we are nonetheless convinced that what is original in the painting is by Titian, from the second or third decade of the century.

Bibliography: Ridolfi, 1648, I, 101; Waagen, 1866-7, 33; Crowe and Cavalcaselle, 1871, II, 152 (*Cariani*); Engerth, 1882, I (*Titian*); Wickhoff, 1895 (*Palma*); Morelli, 1893, 21 (*Cariani*); Berenson, 1899, 101 (*Cariani*); Justi, 1908, 181; L. Venturi, 1913, 177 (*Palma*); Suida, 1927, 211 (*Titian*); Longhi, 1927, 216 (*Titian*); Hartlaub, 1925, 3 (*Giorgione?*); A. Venturi, 1928, 644 (*Dosso*); Berenson, 1932, 412 (*Palma*); Wilde, 1933, 121 (*Master of the Self-Portraits*); Suida, 1935, 30 (*Titian*); Justi, 1936, 279; Richter, 1937, 250 (*prompted by Giorgione?*); Morassi, 1942, 133 (*Titian*); Fiocco, 1941, 32 (*copy after Giorgione*); Della Pergola, 1955, 105 (*anonymous*); Pignatti, 1955, 145 (*attributed to Titian*); Coletti, 1955, 15 (*Titian*); Robertson, 1955, 277 (*Master of the Self-Portraits*); Baldass, 1957, 134 (*Titian*); Berenson, 1957, 127 (*Palma, after Giorgione*); Valcanover, 1960, I, 61 (*Titian*); Garas, 1964, No. 25, 79 (?); Baldass-Heinz, 1964, 170 (*Titian*); Valcanover, 1969, No. 97 (*Titian*); Wind, 1969, 11 (*Cariani?*).

A 62. DAVID WITH THE HEAD OF GOLIATH Plate 210

Oil on panel, 65 × 74 cms. Inv. No. 21.
Provenance: From the Collection of Archduke Leopold Wilhelm in Brussels, where it was listed in 1659 as by Pordenone. It was engraved in Teniers's *Theatrum Pictorium* (1658, No. 25: Giorgione); this shows the composition extended at the top and with the entire head of Goliath on a marble step.

Regarded as a copy after Giorgione by Cook (1900) and Berenson (1903), the painting was the held to be more or less authentic, by Boehn (1904), Justi (1908), Gronau (1908), Morassi (1942), Suida (1954) and Coletti (1955). Included in the exhibition in Venice in 1955 as a copy (Zampetti, 1955), it was so rated also by Pallucchini (1955).

The painting, which is obscured by a thick layer of varnish, has recently been subjected to a trial cleaning in the Gallery, the results of which have been kindly made known to us through the courtesy of our colleagues there. These have convinced us that the painting

is neither repainted (Hermanin, 1933) nor really da-
maged (Morassi, 1942; Berenson, 1957); rather it is
painted mainly in a rather dull bituminous substance,
with a handling that is remote from that which one
might expect in a genuine Giorgione. Since the Gior-
gionesque character of the work is undeniable, the
most appropriate attribution is one to a follower of
the artist.

Bibliography: Cook, 1900, 126 (*copy*); Berenson, 1903, 72 (*copy*);
Boehn, 1904, 47; Justi, 1908, 184; Gronau, 1908, 430; L. Venturi,
1913, 74 (*imitation*); Hartlaub, 1925, Pl. 4 (*copy?*); Justi, 1926,
II, 275 (*wreck of a Giorgione?*); Hermanin, 1933, 89 (*Giorgione,
repainted*); Morassi, 1942, 53 (*Giorgione, damaged?*); Suida, 1954,
166; Pignatti, 1955, 144 (*circle of Giorgione*); Coletti, 1955, 58;
Zampetti, 1955, 42 (*copy*); Pallucchini, 1955, 5 (*copy*); Robertson,
1955, 276 (*copy*); Berenson, 1957, 84 (*a ruined Giorgione or a copy*).

A 63. PORTRAIT OF A YOUNG BOY WITH A HELMET
Plate 195

Oil on canvas, transferred from panel, 73 × 64 cms.
Inv. No. 10.
Provenance: From the Collection of Bartolomeo della
Nave in Venice (1636) as by Raphael; later in the Col-
lection of the Archduke Leopold Wilhelm in Brussels,
as by Correggio (1659); engraved in Teniers's *Thea-
trum Pictorium* (1658, No. 191: Palma).

Is this to be identified with the « young boy with soft
hair and armour, which reflects his exquisitely beau-
tiful hand » (« giovinetto con molle chioma et arma-
tura, nella quale gli riflette la mano di squisita bellez-
za ») which Ridolfi (1648) saw in Venice? According
to a suggestion made by Gronau and quoted by Suida
(1935), the painting could represent instead Francesco
Maria della Rovere — referred to in the emblem of the
oak-leaves on the helmet — and could be the picture
listed in the inventory of the Guardaroba di Pesaro in
1623-4. Given the small difference in terms of years,
it could well be that both theories are correct. The pic-
ture was attributed to Pordenone or Licinio by Caval-
caselle (1871); to Pellegrino da San Daniele by Morelli
(1893) and Borenius (1912); to Michele da Verona by
Berenson (1932). Suida (1935) attributed it to Gior-
gione, as a portrait of Francesco Maria della Rovere.
In truth, as Klauner (1960) noted, the helmet is too
big for the young man; perhaps this is only a page
bearing the emblems of his master. Morassi (1942)
accepts the attribution to Giorgione, but it is contested
by Pallucchini, who prefers to see the painting as the
work of Sebastiano del Piombo in his Giorgionesque
phase.
In 1954 Suida proposed Giorgione's name once more,
and the painting was exhibited at the exhibition in

Venice in 1955 with that attribution, with some doubts
in the direction of Sebastiano (Zampetti, 1955). Fur-
ther uncertainties were voiced by Coletti (1955; Pel-
legrino da San Daniele?); and Berenson (1957; Mi-
chele da Verona?).
The painting, which has heavy folds in the drapery
and rather grey colouring which lacks luminosity, has
suffered damage to the face, where the hair has been
repainted, and it possesses a style that is foreign to
Giorgione's work in any period of his activity. Com-
parison with the Berlin *Portrait of a Young Man* (Pl. 46)
which should be relevant, is sufficient in our opinion
to show that the picture must date after 1506. Seba-
stiano is therefore the most likely candidate for the
authorship of this work.

Bibliography: Ridolfi, 1648, I, 106; Crowe and Cavalcaselle,
1871, II, 488 (*Pordenone or Licinio*); Morelli, 1893, 36 (*Pellegrino
da San Daniele*); Borenius, 1912, III, 383 (*Pellegrino da San Daniele*);
Berenson, 1932, 364 (*Michele da Verona or Domenico Mancini*);
Suida, 1935, 82; Morassi, 1942, 101 (*Giorgione?*); Pallucchini,
1944², 153 (*Sebastiano del Piombo*); Suida, 1954, 161; Pignatti,
1955, 144 (*circle of Giorgione*); Coletti, 1955, 67 (*Pellegrino da San
Daniele*); Zampetti, 1955, 102 (*Giorgione or Sebastiano?*); Beren-
son, 1957, 85 (*copy by Michele da Verona?*); Klauner, 1960, 62;
Zampetti, 1968, No. 72 (*?*).

A 64. PORTRAIT OF A WARRIOR (GEROLAMO MARCELLO)
Plate 127

Oil on canvas, 72 × 56.5 cms. Inv. No. 1526.
Provenance: From the Collection of Archduke Leo-
pold Wilhelm in Brussels, where it was listed in 1659
as by Giorgione. Engraved in Teniers's *Theatrum Pic-
torium* (1658, No. 24: Giorgione).
Engerth (1884) and Suida (1954) identified the painting
as the « portrait of Gerolamo Marcello in armour, down
to the waist, with his back turned and glancing back-
wards, painted by Zorzo da Castelfranco » (« ritratto di
Gerolamo Marcello armato, che mostra la schiena, insi-
no al cinto, et volta la testa, fo de mano de Zorzo da Ca-
stelfranco ») seen in his house in 1525 (Frimmel, 1888, 88).
Michiel does however mention another portrait of an
« Armed soldier down to the waist but without a hel-
met » (« Soldato armato insieme al cinto ma senza
celada ») which he saw in Zuan Antonio Venier's
house in 1528 (*loc. cit.*, p. 98). Recent cleaning has re-
moved the overpainting and has uncovered part of
the face of the old man (or old woman, as Richter,
1937, sees it) which appeared intact in Teniers's print.
The matter of attribution has been virtually precluded
for a long period up to 1955 on account of its repainted
condition. Crowe and Cavalcaselle (1871) regarded it
as by Cariani or Torbido; for Berenson (1932 and 1957)
it was perhaps a copy, and Richter (1937) thought it

was by Cariani, after a lost original. Suida (1954) and Zampetti (1955 and 1968) restored the full attribution to Giorgione's hand, and this was followed by Pallucchini (1955), Castelfranco (1955), Klauner (1960) and Salvini (1961).

In the ups and downs of its critical fortune, we believe that it is going too far to attribute this wreck of a painting to Giorgione's hand. Of the nobility of the invention there can be no doubt, and it may well derive from an original by Giorgione such as those described by Michiel; but this can only be a workshop version of the original work. The detailed handling of the face contrasts with the too fluent brushwork in the breastplate. In our view this summary « Giorgionesque » technique points to the hand of a close follower of the master himself.

Bibliography: Crowe, and Cavalcaselle, 1871, II, 490 (*Cariani or Torbido*); Engerth, 1884, I, 171; Berenson, 1932, 594 (*copy*) Richter, 1937, 254 (*Cariani?*); Suida, 1954, 165; Zampetti, 1955, 78; Pallucchini, 1955, 4; Pignatti, 1955, 145 (*copy*); Castelfranco, 1955, 308; Berenson, 1957, 85 (*copy*); Klauner, 1960, 62; Salvini, 1961, 221; Zampetti, 1968, No. 25.

Washington, National Gallery of Art

A 65. VENUS AND CUPID Plate 140

Oil on panel, 10.6 × 20.3 cms. Kress Inv. No. 284.
Provenance: From the Falier Collection at Asolo; later Contini Bonacossi, Florence; Kress (1932).

Attributed to Giorgione by Suida (1940) who connected it with the two small panels in Padua (A 40-41), the painting was then given to Previtali by Morassi (1942) and associated with the *Scenes of Damon and Thirsis* in the National Gallery in London. The attribution to Giorgione was restored by Coletti, who drew together a group consisting of the two panels in Padua, the *Astrologer* in the Phillips Collection (A 66) and the *Page Boy* in the Suardo Collection in Bergamo. Berenson (1957) and Shapley (1968) however, placed the work once more among the followers of Giorgione. This very charming painting (which evidently originally formed part of a small chest, since the keyhole still shows through the restoration) brings up once again what Berenson termed « Giorgionesque Furniture Paintings ». This consists of a series of paintings that are principally of very small dimensions and which originally clearly formed the decoration of the front or sides of small chests. From Berenson's list it is now accepted that the paintings in Frankfurt, London, Milan, the two *Scenes of Adonis* in Padua, the two *Landscapes* in the De Ganay Collection in Paris and the *Perseus* in the Venturi Collection should be dropped. But we

would add to the list the *Homage to a Poet* in London (Pl. 141), the *Venus and Mars* in Brooklyn (Pl. 142), the *Little Faun* in Munich (Pl. 144) and the *Chastity* in Amsterdam (Pl. 143), which, together with the two panels in Padua and the two in Washington, form a series which, although not homogeneous in style, merits consideration for location in Giorgione's close circle. Three sub-divisions can, in our view, be made among them: the first, which we will call the « Master of the Venus and Cupid» includes, apart from the painting of that title in Washington (A 65), the *Homage to a Poet* in London (A 22) and the *Venus and Mars* in Brooklyn. The second group, of the « Master of the Phillips Astrologer » takes its name from the painting of that title (A 66) and includes the two panels in Padua (A 40-41); the third group, which is less consistent in style, comprises the *Little Faun* in Munich (A 31) and the *Chastity* in Amsterdam (A 1). There are of course some subtle differences of quality and handling between the various paintings, especially in the first and third groups; but at least this has the advantage of identifying certain figurative tendencies. The « Master of the Venus and Cupid » draws upon a relatively early phase of Giorgione's career, and is still immersed in the language of Bellini and Carpaccio; the handling is rather dry and incisive, rather solid in the distribution of warm and golden colour. The « Master of the Phillips Astrologer » is on the other hand linked with the late Giorgione, after the *Sunset Landscape* in London (Pl. 99) by reason of its subtle shading, thin glazes and its tendency towards a blue tonality. The *Little Faun* and the *Chastity*, so far as can be judged from their imperfect state of preservation, have echoes of the presence of Titian and the minor followers of Giorgione, such as Palma and Previtali, who now give a romantic key to Giorgione's pictorial language.

Bibliography: Suida, 1940, 174; Morassi, 1942, 147 (*Previtali*); Pignatti, 1955, 147 (*Giorgione?*); idem, 1955², 500 (*Giorgione?*); Coletti, 1955, 52; Berenson, 1957, 86 (*Giorgionesque*); Zampetti, 1968, No. 58 (*?*); Shapley, 1968, 152 (*follower of Giorgione*).

Washington, Phillips Memorial Gallery

A 66. THE ASTROLOGER Plate 137

Oil on panel, 12 × 19.5 cms.
Provenance: From the Pulsky Collection in Budapest; later Thyssen.

The subject has not been satisfactorily identified; it is perhaps an Allegory of Time (represented in the figure of the old man with the hour-glass). For Justi (1908) and L. Venturi (1913) this was in the field of the

Giorgionesque, while Gronau (1921) and Holmes (1923) held it to be by Giulio Campagnola. The name of Giorgione was restored — with various degrees of reservation — by Richter (1937), Morassi (1942), Tietze (1947), Fiocco (1948), Pignatti (1955) and Coletti (1955). Berenson (1957) and Zampetti (1968) bring doubt to this attribution once more.

The painting forms a group with the two little panels in Padua (A 40-41) which have been identified under the authorship of the « Master of the Phillips Astrologer ».

Bibliography: Justi, 1908, 268 (*close to Giorgione*); L. Venturi, 1913, 254 (*imitation*); Gronau, 1921, 88 (*G. Campagnola*); Holmes, 1923, 181 (*G. Campagnola*); Richter, 1942, 146 (*probably by Giorgione*); De Batz, 1942, 24; Morassi, 1942, 146 (*probably by Giorgione*); Tietze, 1947, II; Fiocco, 1948, 34; Della Pergola, 1955, 33 (*derivation from Giorgione*); Pignatti, 1955, 147 (*Giorgione?*); idem, 1955², 500 (*Giorgione?*); Coletti, 1955, 52; Berenson, 1957, 87 (*Giorgionesque*); Zampetti, 1968, No. 57 (*?*).

Washington, Private Collection

A 67. DOUBLE PORTRAIT (BORGHERINI) Plate 132

Oil on canvas, 46.5 × 59 cms. Inscribed: « NON VALET INGENIUM NISI FACTA VALEBUNT ».

Provenance: From the Cook Collection, Richmond (1923). Prior to that it was in a Milanese collection, to which it passed in 1718 from that of Pier Francesco Borgherini.

Probably to be identified with the portrait of Giovanni Borgherini « when he was young in Venice, and in the same painting his tutor » (« quando era giovane in Venezia, e nel medesimo quadro il maestro che lo guidava ») seen by Vasari (1568) in the Borgherini's house in Florence. The X-rays and ultraviolet photographs that have recently been taken of the picture, in Washington, show that the paintwork is original and is unobscured by any repainting (communication from M. Straight — Pls. 133-4). A very obvious *pentimento* under the present head of the boy, which shows that the latter originally had his head inclined and turned to the right, makes it unlikely that this is a copy. Cook (1926) recognizes the picture as the one mentioned by Vasari, and this is basically the attitude of Morassi (1942) who has however some reservations in the text. In 1932, Berenson had associated this *Double Portrait* with the work of the « Master of the Three Ages of Man » (that is to say the young Giorgione) — an interpretation which he maintains, with some doubts, in his 1957 text. Richter (1937) too accepts the provenance of the picture, although he regards it as the work of Pier Maria Pennacchi. Fiocco (1948) gives it to Torbido, and Coletti (1955) prefers Morto da Feltre.

As can be seen, critical opinion is agreed that the painting belongs in Giorgione's circle (Pignatti, 1955), but has some doubts over the actual quality of the work. In fact the *Double Portrait* is a fine painting, painted in a soft hand with subtle glazing effects, akin to Giorgione's own hand (at the end of his career, between the *Three Philosophers* and the *Three Ages of Man* in the Pitti Gallery). Its weakness lies, in our opinion, in the lack of that intimate and coherent poetry that characterizes authentic Giorgione portraits. A certain similarity with the *Young Shepherd with a Fruit* (A 39, Pl. 131) takes us in the direction of Mancini, whose Lendinara altarpiece presents a similarly « sweetened » version of Giorgione's style.

Bibliography: Vasari, 1568, IV, 91; Cook, 1926, 23; Berenson, 1932, 349 (*Master of the Three Ages of Man*); Suida, 1935, 86; Richter, 1937, 235 (*P. M. Pennacchi*); Morassi, 1942, 172 (*Giorgione or a copy?*); Fiocco, 1940, 30 (*Torbido*); Gamba, 1954, 174 (*imitator*); Pignatti, 1955, 138 (*circle of Giorgione*); Coletti, 1955, 65 (*Morto da Feltre?*); Berenson, 1957, 84 (*Giorgione?*).

Windsor Castle, Royal Library

A 68. THE ADORATION OF THE SHEPHERDS Plate 146

Charcoal and pen drawing, heightened with white, on grey-blue paper, 22.7 × 19.4 cms. Inv. No. 12803.

The drawing reproduces the central part of the *Adoration of the Shepherds* in Washington (Cat. No. 9, Pl. 35) with significant variations. Of these the most important are the absence of the second shepherd, the fact that the Child is seated instead of reclining, while the background appears to be more of a wall than a cave. The history of critical opinion of the drawing has followed that of the painting closely. Thus Gronau (1908) thought of it as by Catena, while Justi (1908) suggested Giorgione, followed by Hadeln (1925) and Gronau (1936). The negative opinion of Constable (1930) and Popham (1931) gave direction to a large proportion of subsequent critical opinion, which held that the drawing derived from the painting and ruled out the possibility of its being a preparatory study for it. Richter (1937) initiated a tendency to date the drawing before the painting, exaggerating the differences between them. The Tietzes (1944) advanced the theory that both were executed in the workshop from a lost original. But as is well-known, they held that the Washington picture is the work of a follower of Bellini, finished by Titian. Their stylistic assessment of the drawing emphasizes the characteristics that are drawn from Bellini. This view is once again contested by Popham and Wilde (1949), who persist in the opinion that the drawing is a copy after the Washington pic-

ture, by a painter taught by Carpaccio.

In our view, Popham's judgement here is correct. This is definitely a study « after Giorgione » by a young pupil, whose technique of pen and white highlighting recalls — as has already been noted — Carpaccio's style.

Bibliography: Gronau, 1908, 508 (*Catena?*); Justi, 1908, 132; Hadeln, 1925, 32; Constable, 1930, 740 (*copy*); Popham, 1931, 256 (*copy*); Fiocco, 1931, 94 (*Carpaccesque*); Gronau, 1936, 95; Richter, 1937, 256; Morassi, 1942, 164 (*derivation*); H. and E. Tietze, 1944, No. A 719 (*workshop of Bellini*); Fiocco, 1948, 21 (*Palma?*); Popham-Wilde, 1949, 234 (*copy*), Pignatti, 1955, 148 (*circle of Giorgione*); Baldass-Heinz, 1964, 115.

COPIES

The catalogue of copies is arranged topographically, and the paintings are illustrated on Plates 214-229. It comprises only those works which represent with some degree of probability derivations from lost originals by Giorgione, or which fall into this category through references in the early sources and documents.

Brunswick, Herzog Anton Ulrich Museum

C 1. PORTRAIT OF GIORGIONE DRESSED AS DAVID

Plate 214

Oil on canvas, 52 × 43 cms. Inv. No. 544.

Provenance: From the Collection of the Duke of Brunswick at Salzdahlum (1744), in which it bore an attribution to Giorgione.

The picture was first identified as a Self-Portrait of Giorgione in the Catalogue of the Gallery (1776). Justi (1908) then noted the connection with Wenceslaus Hollar's engraving (Pl. 216) which bears the inscription: « The True Portrait of Giorgone (sic) de Castel Franco painted by himself as Vasari's book describes. — Drawn by W. Hollar [from the picture] in the collection of Johann and Jacob van Verle, 1650. Engraved by F. van de Wyngarde » (« VERO RITRATTO DE GIORGONE DE CASTEL FRANCO da luy fatto come lo celebre il libro del VASARI. — W. Hollar fecit ex collectione Johannis et Jacobi van Verle, 1650. F. van de Wyngarde excudit »). This is the basis for supposing that the painting in Brunswick is the one mentioned by Vasari (1568) as being in Giovanni Grimani's cabinet in Venice which « is said to be his self-portrait » (« per quel che si dice, è il suo ritratto »). Paschini (1926-7), however, unearthed a mention of the painting as early as the 1528 Grimani inventory, where it is described as « the portrait of Zorzon painted by his own hand through [the subject of] David and Goliath » (« ritrato di Zorzon di sua mano fatto per David e Golia ») (an interesting comment, for apart from anything else, this is the first use by about twenty years of the nickname *Zorzon*, previously thought to have been coined by Paolo Pino in his *Dialogo di Pittura* of 1548). The *David* in the Grimani Collection

must certainly have been the model for Coriolano's engraving in the 1568 edition of Vasari's *Lives* (Pl. 215); the picture then passed into the Van Verle Collection in Antwerp. The majority of critical opinion now accepts that this is the picture now in Brunswick, although this has never been proved. While the authenticity of the *David* in the Grimani Collection in 1528 is most probable, since the inventory entry has the weight of a still fresh tradition in that famous Venetian collection, it seems also possible that the painting in Brunswick is merely a copy of the original. In this connection, it is worth noting that in 1675 Vecchia declared that he was the painter of a false Self-Portrait of Giorgione, then in the possession of Cavalier Francesco Fontana (Savini-Branca, 1965, 53).

There cannot, however, have been any confusion with another version of Giorgione's « Self-Portrait », the one in the Museum of Fine Arts in Budapest (C 2). In our opinion this latter painting echoes an altogether different likeness of Giorgione from that of the *David*. In connection with the identification of the sitter, we may note Morassi's recent (1969) suggestion that Giorgione's likeness appears also in two of Titian's portraits, the *Young Man in a Fur* in the Frick Collection in New York, and the *Young Man with a Plumed Cap* in Petworth House. Comparison of the various features makes it difficult, however, to agree with the identification, which the same writer confesses is purely a hypothesis.

Critical opinion has generally been in favour of Giorgione's authorship. Those in favour include Gronau (1921), Hartlaub (1925), Richter (1937), Oettinger (1944), Morassi (1942 and 1967), Della Pergola (1955), Coletti (1955), Zampetti (1955), Müller-Hofstede (1956 and 1957) and Baldass-Heinz (1964). Those who concluded that the painting is a copy include L. Venturi

(1913), Fiocco (1941 and 1948), Pallucchini (1944 and 1955), Longhi (1946) and Gamba (1954). Berenson (1932 and 1957) regarded it as by Palma, and Suida (1954) as by Dosso.

The question of the authenticity of the *David* is one which is closely linked with the possibility of identifying it with the version formerly in the Grimani collection, which there are no grounds to suspect. Close observation of the painting, on the other hand, is not favourable to Giorgione, to whom the loaded brushstrokes (in the areas where the paintwork is intact, that is to say in some of the cloak and armour) are foreign in style. There are certain highlights that are reminiscent of Titian, and a fluidity of handling that is not to be found even in Giorgione's very latest works, such as the *Portrait of a Man* in San Diego, and if at all, in the work of his close followers, such as, for instance, Mancini. That the painting dates at least from a period close to Giorgione's lifetime is demonstrated by the X-ray, published by Müller-Hofstede (1956). This shows that the features of the *David* are superimposed over an earlier composition of the Madonna and Child with a landscape, whose arrangement, in the way the Child has his arm around the neck of his mother, recalls a painting by Catena at Poznan, which Robertson (1954) dated to around 1510-11. The Catena-like character of the underlying painting is not, however, a proof that the picture in Brunswick was executed before Giorgione's death (even though Catena is called a « colleague » of *Maestro Zorzi* as early as 1506, in the inscription of the *Laura* in Vienna). Quite to the contrary, Robertson's dating of the *Holy Family* in Poznan is to 1510-11, and it consequently reduces to the very minimum the possibility of the authenticity of the *David* in Brunswick.

Bibliography: Vasari, 1568, IV, 91; Ridolfi, 1648, I, 105; Justi, 1908, I, 253; L. Venturi, 1913, 68 (*copy*); Gronau, 1921, 7; Hartlaub, 1925, Pl. 2; Justi, 1926, I, 201; Paschini, 1926-7, V, 171; Berenson, 1932, 408 (*Palma?*); Richter, 1937, 209; Fiocco, 1941, 281 (*copy*); Morassi, 1942, 152; Oettinger, 1944, 132; Pallucchini, 1944, XIII (*copy*); Longhi, 1946, 22 (*copy*); Suida, 1954, 166 (*Dosso*); Gamba, 1954, 174 (*copy*); Della Pergola, 1955, 48; Pignatti, 1955, 116 (*Giorgione?*); Coletti, 1955, 55; Zampetti, 1955, 44; Pallucchini, 1955, 5 (*copy*); Castelfranco, 1955, 307 (*copy*); Robertson, 1955, 276; Müller-Hofstede, 1956, 252; idem, 1957, 13; Berenson, 1957, 123 (*Palma*); Baldass-Heinz, 1964, 153; Prinz, 1966, 109; Zampetti, 1968, No. 26; Morassi, 1969, 28.

Budapest, Museum of Fine Arts

C 2. PORTRAIT OF GIORGIONE Plate 220

Oil on paper on panel, 31.5 × 28.5 cms. Inv. No. 86.
Provenance: From the Collection of Bartolomeo della Nave in Venice (1636); later in the Collection of Arch-

duke Leopold Wilhelm in Brussels, in whose 1659 inventory it is listed as the « Original Self-Portrait by Giorgione » (No. 246).

The painting appears in Teniers's two paintings showing the Picture Gallery of the Archduke, in the Prado and in Vienna (Pl. 219). Frimmel (1896) attributed it to Cariani. Later A. Venturi (1900) gave it to Dosso, but it was restored to Giorgione by Justi (1908 and 1926), Wilde (1930), Garas (1964) and Baldass-Heinz (1964). Hadeln (1914), Gronau (1921), Richter (1937) and Suida (1954) regarded it as a copy. Berenson (1932 and 1957) and Zampetti (1968) favoured Palma; A Venturi (1928) Dosso.

This little portrait is indubitably of the same likeness as the person identified as Giorgione at the beginning of Vasari's 1568 Life of the artist, but the features do not correspond either with the woodcut or with Hollar's engraving, or with the painting in Brunswick. By contrast with the latter, it shows an individual in civilian clothes and with his head in a different position. We must therefore imagine that if this person is really Giorgione, the Budapest portrait represents an altogether different sitter, as indeed Garas (1964) has already established. We believe that it was from this representation of the presumed Giorgione that the print in Ridolfi's *Le Meraviglie dell'Arte* (Pl. 218) was drawn; in our opinion the latter differs from the *David* in Brunswick and from the woodcut in Vasari (for a contrary view, see Prinz, 1966). So far as the attribution of the little painting in Budapest is concerned, the matter is made more difficult by reason of it being too strong to be tacitly attributed to Palma, and too Titianesque in character to be given to Giorgione; we should leave it for the time being in the area of his close followers.

Bibliography: Frimmel, 1896, 23 (*Cariani*); A. Venturi, 1900, 138 (*Dosso*); Justi, 1908, I, 183; Hadeln, 1914, 106 (*copy*); Gronau, 1921, 87 (*copy*); Cook, 1926, XLVIII, 311; Justi, 1926, I, 200; Wilde, 1930, 253; A. Venturi, 1928, IX-III, 975 (*Dosso*); Berenson, 1932, 409 (*Palma*); Richter, 1937, 210 (*copy*); Suida, 1954, 166 (?); Garas, 1964, No. 25, 78 (*Giorgione?*); Baldass-Heinz, 1964, 154; Prinz, 1966, 109; Zampetti, 1968, No. 26 (*Palma?*); Mariacher, 1968, 96 (?); Pigler, 1968, 266 (*follower of Giorgione*).

C 3. THE FINDING OF PARIS Plate 221

Provenance: From the Collection of Cardinal Pyrker in Venice.

A painting of this subject which originated in the Bartolomeo della Nave Collection in Venice was in the Collection of the Archduke Leopold Wilhelm in Brussels, in whose 1659 inventory it is listed as by Giorgione (No. 132). It was engraved by Teniers in the *Theatrum Pictorium* of 1658, No. 21, as by Giorgione.

Teniers's painted copy was formerly in the Loeser Collection in Florence (Pls 224-5). As early as 1525 Michiel mentioned a *Finding of Paris* in Taddeo Contarini's house, together with the *Three Philosophers*, of which it was a pendant of approximately the same dimensions, as is apparent from the Brussels inventory (Frimmel, 1888, 88). That this painting was by Giorgione is credible also because Michiel mentions that it was one of the artist's earliest paintings: and indeed Teniers's engraving shows a composition with figures on either side and a stream to the middle, halfway between the *Adoration of the Shepherds* in Washington (Pl. 35) and the *Tempest* (Pl. 50).

The painting in Budapest was published as an original by Morelli (1880), and then as a fragment of the canvas formerly in Brussels by Thausing (1884). After this point the work was regarded by all writers as a copy, up to Gombosi (1935), who suggested once again that it was by Giorgione. Subsequently Morassi (1942), Della Pergola (1955), Coletti (1955) and Wind (1969) were also inclined to regard the painting in Budapest as a repainted wreck of an original Giorgione. Garas (1964) displays some uncertainty, noting that the fragment did not come to the Museum in Budapest along with the original group of works from the Collection of the Archduke Leopold Wilhelm.

In fact, the painting has all the appearances of being a fragment of a larger original, and it is much overpainted, so much so as to make an assessment of its quality impossible. Not even the X-ray, taken for Gombosi in 1935, demonstrated anything apart from the existence of a completely repainted composition identical with that of Teniers's 1658 print. The painting could at any rate be a fragment from a faithful copy of the original, since the dimensions are compatible with those of the whole canvas given in the 1659 Brussels inventory (about 149 × 189 cms.).

Bibliography: Teniers, 1658, No. 21; Morelli, 1880, 190; Thausing, 1884, 321; Berenson, 1903, I, 75 (*copy*); Cook, 1900, 125 (*copy*); Justi, 1908, 114 (*copy*); L. Venturi, 1913, 87 (*copy*); Gronau, 1921, 87 (*copy*); Hartlaub, 1925, Pl. 43 (*copy*); A. Venturi, 1928, IX-III, 42 (*copy*); Gombosi, 1935, LXVIII, 157; Richter, 1937, 210 (?); Fiocco, 1941, Pl. 128 (*copy*); Morassi, 1942, 92 (*Giorgione?*); Della Pergola, 1955, 33; Coletti, 1955, 53; Berenson, 1957, 85 (*copy*); Pignatti, 1955, 117 (*attributed to Giorgione*); Garas, 1964, No. 25, 72 (*copy*); Zampetti, 1968, No. 51 (*copy?*); Pigler, 1968, 268 (*copy*); Wind, 1969, 19.

Castle Howard (Yorkshire), Howard Collection

C 4. KNIGHT AND PAGE Plate 228

Oil on panel, 21 × 18 cms.
Provenance: From the Carlisle Collection (?).

There are copies of this composition in the Kunsthistorisches Museum in Vienna and in other private collections, apart from a variant in the Spanio Collection in Venice (see below under No. C 8). The Carlisle version, engraved by A. Cardon in 1811, was published as a Giorgione by Waagen in 1854, and is presumably to be identified with the picture at Castle Howard. Critical opinion has generally held that it is a copy of a lost original, something which is also suggested by the large number of existing versions. Morassi (1942) thought it was perhaps by Paris Bordone; Coletti (1955) alone declared it to be the work of Giorgione himself, associating it with the Spanio version. Zampetti (1955) believed it to be by Titian.

We have doubts that this is really a « copy » after Giorgione, rather than a later exercise in his manner. But it is a work of high quality, for which Paris Bordone's name is a possibility.

Bibliography: Waagen, 1854, I; Crowe and Cavalcaselle, 1871, II, 151 (*copy*); Justi, 1908, 213 (*copy*); Borenius, 1912, III, 32 (*copy*); Richter, 1937, 229 (*copy?*); Morassi, 1942, 217 (*Paris Bordone?*); Longhi, 1946, 64 (*Titian?*); Zampetti, 1955, 124 (*Titian*); Pignatti, 1955, 152 (*attributed to Paris Bordone*); Coletti, 1955, 62; Coletti, 1955², 205; Berenson, 1957, 85 (*copy*); Zampetti, 1968, No. 81 (?).

Formerly Florence, Koudacheff Collection

C 5 PORTRAIT OF A YOUNG MAN Plate 222

Oil on canvas (?), 38 × 32 cms.
Provenance: Bought at Christie's in 1906; then in the Carfax Collection.

Both Richter (1937) — who notes the similarity with the St. Francis in the Castelfranco *Madonna and Child with Saints* (Pl. 14) — and Morassi (1942) indicate, with some reserve, that this may be a copy. Although we have not seen the painting itself, we note that it has compositional characteristics akin to those of Lotto, which would place the work in the area of the province of Bergamo, around 1520.

Bibliography: Richter, 1937, 219 (*copy*); Morassi, 1942, 21 (*copy or replica?*); Pignatti, 1955, 150 (*Venetian, early sixteenth century*).

London, National Gallery

C 6. A MAN IN ARMOUR (GASTON DE FOIX? SAINT GEORGE?) Plate 226

Oil on panel, 39 × 26 cms. Inv. No. 269.
Provenance: From the Vigné de Vigny Collection (1773); Prince de Conti (1777); Benjamin West (1816); Rogers (1855).

Numerous versions of this composition in Cracow, Versailles and in private collections are mentioned by Richter (1937), who seems to be convinced that they all derive from a lost Giorgione original. Cavalcaselle (1871) saw it as a preparatory study for the figure of St. Liberale in the Castelfranco *Madonna and Child with Saints* (Pl. 14); this was also the view of Cook (1900), Morassi (1942) — who makes reference to the X-rays —, Della Pergola (1955) and Coletti (1955). All the other writers regard it as a copy. Gould (1959) recognizes seventeenth-century features in the execution.

Even without suggesting such a late date, above all because some of the versions are Venetian, of the early sixteenth century in character, we believe that it is likely that this is one of the many copies of the popular figure of St. Liberale, taken from the Castelfranco altarpiece. The style of the painting — despite its poor condition — does not seem to be distant from that of the *Young Shepherd with a Fruit* in Oxford (A 39, Pl. 131).

Bibliography: Crowe and Cavalcaselle, 1871, II, 131; Cook, 1900, 20; Justi, 1908, 266 (*not by Giorgione*); Gronau, 1908, 505 (*follower*); Borenius, 1912, III, 12 (*?*); A. Venturi, 1928, IX-III, 67 (*anonymous Giorgionesque*); Richter, 1937, 212 (*copy*); Fiocco, 1941, 25 (*copy*); Morassi, 1942, 79; Della Pergola, 1955, 31; Pignatti, 1955, 127 (*attributed to Giorgione*); Coletti, 1955, 56; Berenson, 1957, 85 (*copy*); Gould, 1959, 40 (*copy*); Zampetti, 1968, No. 12 (*copy*).

Formerly Marostica, Sorio Collection

C 7. THE DELPHIC SIBYL Plate 223

Oil on canvas, 92 × 72.5 cms.
Provenance: From the Sorio-Melchiori Collection, Marostica (Vicenza).

Richter (1937) lists six other version of the *Sibyl*, one of which was in the Collection of Andrea Vendramin in 1627 (No. 70 in the book of drawings; Fig. 74), and others in the G. B. Sanudo Collection in Venice (Ridolfi, 1648, 102) and the Cook Collection, Richmond. He concluded that the picture formerly in the Sorio Collection was the best version, and indeed it was the one which Hadeln (1914) imagined had come from the Sanudo family in Venice.

From the photograph, it can be seen that this is a work which belongs in Giorgione's circle, perhaps nearer to Palma. It could reasonably be the copy of a lost original.

Bibliography: Monneret de Villard, 1904, 141 (*copy*); Hadeln, 1914, I, 102 (*copy*); Cook, 1926, 311 (*copy*); Richter, 1937, 235, 263

(*copy*); De Batz, 1942, 32 (*Giorgionesque*); Morassi, 1942, 218 (*copy after Titian, perhaps by Palma*).

Venice, T. Spanio Collection

C 8. KNIGHT AND PAGE Plate 227

Oil on canvas, 70 × 86.5 cms.
Provenance: From the Barozzi Collection in Venice.

According to Coletti (1955), who first published this picture, it is a version by Giorgione of a subject known also in another original, the picture at Castle Howard (C 4), apart from further versions in Vienna, Turin, Stockholm and Berlin (of which the latter two are recognized as apocryphal). Soon after Zampetti (1955), who included the painting in the Exhibition in Venice, expressed his own doubts, which he reiterated in 1968. In our opinion, this is a later variant of the picture at Castle Howard.

Bibliography: Coletti, 1955, 62; Coletti, 1955², 205; Zampetti, 1955, 126 (*?*); idem, 1968, No. 81 (*copy*).

Washington, Howard University

C 9. PORTRAIT OF A YOUNG LADY Plate 229

Oil on panel, 33.4 × 28.3 cms. Kress Inv. No. 1533.
Provenance: From the Silberman Collection in New York; later Aram's; Kress (1948).

Richter (1937) lists a further eight versions, of which one is in the Museum in Padua (No. 432) and another in the Galleria Sangiorgi in Rome, bearing the inscription « Laura ». The laurel wreath which the girl holds in her hand has been seen as further proof that this is an idealized portrait of Petrarch's Laura. Exhibited in Baltimore (De Batz, 1942) as by Boccaccino, the painting was regarded as perhaps by Pietro degli Ingannati by Heinemann (1962), and as being perhaps by Mancini by Shapley (1968). The extensive damage to the surface of the picture makes any assessment of its stylistic character difficult, but account should be taken of the affinity with certain works of the young Palma, such as the *Concert* in the Ardencraig Collection, or the *Woman in Profile* in the Kunsthistorisches Museum in Vienna (illustrated in: Mariacher, 1968, Fig. 5 and 14).

Bibliography: Richter, 1937, 237 (*copy*); De Batz, 1942, 36 (*Boccaccino*); Heinemann, 1962, 110 (*Pietro degli Ingannati?*); Shapley, 1968, 152 (*Mancini?*).

RELATED WORKS

The catalogue of related works (Opere Varie) is arranged topographically, and the paintings are illustrated on Plates 230-250. It comprises those works which, although once attributed to Giorgione, are now for good reason generally given to other painters.

Attingham Park, (Shropshire), National Trust

V 1. CONCERT OUTSIDE ASOLO Plate 231

Oil on canvas, 98.7 × 79.8 cms.
Provenance: Fom the Cook Collection at Richmond; then Lady Berwick.

The picture was included in the 1955 Exhibition in Venice as a « replica » of Giorgionesque character (Zampetti, 1955, 148). The extensive repainting makes an attribution difficult; Gore (1957, 138) has recently suggested the name of Francesco Vecellio. It is likely that the painting represents Caterina Cornaro, Queen of Asolo and patron of the group of artists to which, in the years between 1500 and 1510, Giorgione himself belonged (although not so Titian). We would be inclined therefore to support an attribution to a follower of the master.

Formerly Brussels, Archduke Leopold Wilhelm

V 2. PHILOSOPHER. Now in Vienna, Kunsthistorisches Museum, attributed to Savoldo (Inv. No. 213).

V 3. SAINT JOHN THE EVANGELIST. Now in Vienna, Kunsthistorisches Museum, attributed to Palma il Vecchio.

V 4. RESURRECTION. Now in Vienna, Kunsthistorisches Museum, attributed to Palma (Inv. No. 260 A).

The paintings were attributed to Giorgione in Teniers's *Theatrum Pictorium* (1658).

Chatsworth (Derbyshire), Devonshire Collection

V 5. MARTYRDOM OF A SAINT Plate 235

Brown wash drawing, 15.2 × 17.4 cms. Inv. No. 742.

Attributed to Giorgione by Morelli (1893, II, 225), the drawing was generally accepted up to Suida (1935, LXXVII, 90). It was rejected by Richter (1937, 213) and by the Tietzes (1944, A 714) and for Morassi

(1942, 176) its authorship is uncertain. In our opinion its stylistic characteristics are predominantly those of Romanino.

V 6. TRIUMPH OF PEACE OVER WAR

Drawing in charcoal and brown wash, heightened with white, 9.2 × 12.5 cms. Inv. No. 714 A.

Published by the Tietzes (1940, 31) as an early copy of a lost fresco by Giorgione, the drawing is undoubtedly later in date (Tietze, 1944, A 705). In our opinion it derives from Van der Borcht's well-known etching, which Nordenfalk (1952, 105) believed shows one of the lost frescoes by Giorgione on the façade of the Fondaco dei Tedeschi in Venice (see below, under the Lost Works).

Chiavari, Lanfranchi Collection

V 7. THE JUDGEMENT OF PARIS Plate 232

Oil on canvas, 60 × 74 cms. Inscribed on the back: « Titian ».

Formerly Cremona, Chiesa dell'Annunziata

V 8. SAINT SEBASTIAN. Now in the Pinacoteca di Brera, Milan, where it is attributed to Dosso.

This is a work which Ridolfi (1648, 105) named as by Giorgione.

Formerly Dresden, Gemäldegalerie

V 9. THE ASTROLOGER Plate 234

Oil on panel, 132 × 192 cms. Inv. No. 186 (destroyed in 1945).
From the Manfrin Collection in Venice, where it was attributed to Giorgione.

Reinhardt (1886, 250) notes that there were two versions of this subject in the Manfrin Collection, of which one was sold to England: Calvesi (1962, 249) belie-

ved that the latter was the original by Giorgione. Morelli (1880, 183) also believed the painting in Dresden to be a copy; Venturi (1913, 391) suggested Palma, and Suida (1935, II, 75) and Morassi (1942, 156) identified the copyist as Bonifacio. The little figure of the « page » standing behind the child is reminiscent of the *Young Shepherd with a Fruit* in Oxford (A 39, Pl. 131). Contrary to what Berenson (1957, 85) supposed, the idea that this could be a copy after a lost Giorgione original would seem to be ruled out by the architectural framework of the composition, a feature characteristic of the second decade of the sixteenth century.

Edinburgh, National Gallery of Scotland

V 10. ARCHER

Oil on panel, 52 × 39.5 cms. Inv. No. 690.
Provenance: From the Collection of Lady Ruthwen (1885).

Attributed to Cariani by L. Venturi (1913, 235) and to Torbido by Arslan (1932, 6), the picture was wrongly described by Richter (1937, 216) as a copy after a lost original by Giorgione. In contrast, Garas (1965, No. 25, 28) believed that it was possibly original, and to be identified with the « putto with flaxen hair » (« putto con certi capelli a uso di velli ») mentioned by Vasari as belonging to Cardinal Domenico Grimani and later engraved by Hollar when the picture was in the Van Verle Collection in Antwerp. Berenson (1957, 86) rightly attributed the work — as also the Catalogue of the Gallery (1946, 359) — to a follower of Giorgione.

Florence, Print Room of the Uffizi

V 11. YOUTH WITH A SWORD

Pen and charcoal drawing, 20.2 × 11 cms. Inv. No. 1757.

Attributed to Giorgione by Hadeln (1925, Pl. 2) and by Morassi (1942, 176), the drawing was rightly rejected by the Tietzes (1944, No. 1372), who suggested Previtali. The graphic style still bears the imprint of the Bellini, and while the features are reminiscent of paintings by Giorgione such as the panels in the Uffizi (Pls. 25, 31) or the *Adoration of the Kings* in London (Pl. 22), they are closer to those of the early Lotto (the pages in the *Onigo Monument*).

Formerly Haarlem, Koenigs Collection

V 12. STANDING NUDE

Charcoal and white chalk drawing, 26.5 × 14 cms. Inv. No. 1, 187.
Provenance: From the Koenigs Collection in Haarlem; now in the Museum Boymans — van Beuningen in Rotterdam.

Published as by Giorgione by Lees (1913, 44), this drawing was rightly associated by the Tietzes (1944, A 708) with the style of Flemish artists working in Venice during the second half of the sixteenth century.

Hampton Court, Royal Collection

V 13. TWO LOVERS

Oil on canvas, 74 × 64 cms.
Provenance: From the Collection of Charles I (1625).

Attributed to Titian in the 1639 inventory and subsequently to Giorgione in the 1688 inventory; this later interpretation was supported by Cust (1906, IX, 71). Cust and Cook (1906, IX, 73) then rightly gave the painting to Paris Bordone, a view also accepted by Richter (1937, 226) and, with some reservations, by Canova (1964, 107). Berenson (1957, 186) regards it as an early work by Titian.

Leningrad, Hermitage

V 14. THE ADORATION OF THE HOLY CHILD Plate 233

Oil on panel, 48.9 × 40 cms.
Provenance: From the Castle at Gatchina.

Initially attributed to Cariani, the attribution was replaced by Berenson (1932, 571) with one to the young Titian, and by Morassi (1967, 196) with one to Giorgione. The Tietzes at first thought in terms of Giorgione, but then after their attribution of the Washington *Adoration of the Shepherds* (Pl. 35), they gave it also to the young Titian (1949, 12). They believe that this could be the « nativity by the hand of Zorzi di Chastel Franco » (« prexepio da man de Zorzi di Chastel Franco ») listed as by Paris Bordone in Giovanni Grimani's 1563 inventory (Fogolari, 1910, 3). More credibly, Suida (1954, 135) maintains that the picture is a workshop version of the little *Adoration* by Titian in the Kress Collection (A 46, Pl. 151) with which the composition corresponds.

V 15. PORTRAIT OF A YOUNG MAN IN A FUR Plate 230

Oil on canvas, 117 × 85 cms. Inscribed: « MDXII Dominicus a. XXV ». Inv. No. 21.
Provenance: From the Muselli Collection in Verona (1648); later Crozat, Paris (1772).

Ridolfi (1648, 105) mentions a « Young man with a fur cast curiously over his shoulders » (« Giovinetto con pelliccia tratta bizzarramente à traverso le spalle ») in the Muselli Collection in Verona, which Garas (1966, No. 28, 70) identified as the present painting, of which other versions exist (the best being the one in the Collection of the Duke of Grafton in London, dated 1512). Attributed to the « Master of the Self-Portraits » by Wilde (1944, 113), the picture for a long time bore the name of Capriolo, a view still supported by Berenson (1957, 52), despite the fact that the artist was only born in 1494. The Catalogue of the Hermitage (1958, 128) follows a suggestion from Longhi in giving the painting to Domenico Mancini; an attribution which should in our opinion be rejected by reason of the stylistic discrepancy between it and the Lendinara altarpiece. We would be more sympathetic to Garas's (loc. cit., 86) suggestion of Palma.

Lille, Musée Palais des Beaux–Arts

V 16. PORTRAIT OF A LADY (THE MAGDALEN)

Oil on panel, 41 × 38 cms. Inv. No. 1050.

Attributed to Giorgione by L. Venturi (1929, 169), but decisively rejected by A. Chatelet (who has kindly made his view known to me) among other reasons on account of its ruinous state of conservation. To us it would appear generally Palmesque in character.

London, National Gallery

V 17. NYMPHS AND CHILDREN IN A LANDSCAPE

Plate 239

Oil on panel, 46.5 × 87.5 cms. Inv. No. 1695.
Provenance: From the Mitchell Collection (1878); Victoria and Albert Museum (loaned in 1900).

Berenson (1957, 85) claimed that this painting was a copy of a lost Giorgione, but Gould (1949, 43) suggests instead that it is a pastiche of Giorgionesque elements dating from the turn of the sixteenth and seventeenth centuries. It appears as though there may also be Flemish elements in the composition (in the manner of Sustris), so that the work should be studied in the context of Northern artists who visited Venice during the second half of the century.

V 18. DAMON AND THYRSIS: FOUR SCENES FROM AN ECLOGUE OF TEBALDEO

Two panels, each 45.3 × 20 cms. Inv. No. 4884.
Provenance: From the Manfrin Collection in Venice (?); then the Conti da Porto, Schio; Podio (1937).

Published by Cook (1937, LXXI, 199) as possibly by Giorgione, these panels were adjudged by Borenius (loc. cit., 286) to be by Palma; for Richter (1938, LXII, 33) they were by Previtali, and this attribution was also followed by Morassi (1942, 186), Longhi (1946, 64) and Zampetti (1968, No. 46). Gould (1959, 70) supports this realistic attribution to Previtali, first suggested by Pouncey.

London, Guy Benson Collection

V 19. THE ADMONISHED LOVERS Plate 238

Oil on canvas, 49 × 77 cms.
Provenance: From a sale at Christie's, May 1911.

According to Fiocco (1915, 150 and 1948, 22) this is a Giorgionesque imitation of Giulio Campagnola; Berenson (1957, 52) attributed it to Capriolo. In our opinion, the composition is reminiscent of the style of the destroyed Astrologer in Dresden (V 9).

London, V. Koch Collection

V 20. LANDSCAPE

Pen drawing, 15.5 × 18.3 cms.

According to the Tietzes (1944, No. 711) the drawing is in such a ruinous state of preservation that it is difficult to determine whether it is an original Giorgione or an imitation.

Formerly London, F. T. Sabin Collection

V 21. SALOME Plate 240

Oil on canvas, 79 × 53.5 cms.
Provenance: From the Baring Collection (1848); then Lord Northbrook (1889); Hinsler (1931).

Richter (1937, 227) notes that as early as 1648 an Herodias with the Baptist was in the Collection of Rudolph II in Prague. The painting passed into the Collection

of Queen Christina in Rome in 1689, with an attribution to Giorgione; it then went through the hands of the Marchese Azzolini, Prince Odescalchi and the Duke of Orléans (1792), after which date the latter's collection was dispersed. Richter claims that it is likely that this *Salome* is in fact the *Herodias* originally in the possession of Rudolph II, since the dimensions correspond. There exist other versions of the composition, in the Doria Gallery in Rome, in the Museum at Nîmes, in the Norton Simon Museum at Fullerton (formerly Ottley, Benson and Duveen) and in other private collections.

While Richter maintains that the Doria and Ottley versions are close to Titian, he suggests that the Sabin version is nearer to Giorgione. From Morassi (1942, 217) onwards, critical opinion has moved generally in favour of Titian, both with regard to the prototype (which for many is the Doria version) and the supposed derivations. This, quite rightly, is also the opinion of Tietze (1947, 141), Valcanover (1969, No. 58) and Pallucchini (1969, 30, 244).

Mirfield, Walker Collection

V 22. PRUDENCE

Published by Richter (1942, 211), who claimed that it is a copy of one of the lost frescoes on the Ca' Grimani, and associated it also with the drawing of a nude seen from behind, by Dürer, in the Print Room in Berlin (Panofsky, 1948, Fig. 163). The suggestion is accompanied by no proof; there remains only the fact that the same figure reappears in a painting by a similar follower of Giorgione in the Schwyzer Collection in Zurich (V 40).

New York, Metropolitan Museum of Art

V 23. MADONNA AND CHILD Plate 241

Oil on panel, 42,5 × 30,4 cms.
Provenance: From the Chester D. Tripp Collection (1957).

This much damaged painting is very interesting by reason of its obviously Giorgionesque character, and for its connections with early works by Titian, such as the *Gipsy Madonna* in Vienna (Pl. 243) or the *Madonna* in the Prado. The luminous colour and the physiognomies, especially that of the Child, are reminiscent of Romanino in the St. Giustina altarpiece in Padua (1513), and sufficiently so to attribute the picture

to that artist, especially on account of the similarity of the figures with those in the *tondi* set in the frame of that altarpiece. Since it would be impossible to imagine that Titian could have copied Romanino, the presence of the Tripp *Madonna and Child* is a further argument in favour of an ante-1513 dating for the little altarpiece in the Prado and the *Gipsy Madonna* (Pl. 243).

Novara, Pozzi Collection

V 24. THE FORGE OF VULCAN

Oil on canvas, 149 × 160 cms.

Attributed to Giorgione in the catalogue of the Giacobone Collection (1967, No. 23) when it was up for sale in the Galleria Geri in Milan and reconfirmed by Gamulin (1969, 29). The subject is an interesting one, and includes a figure of Mars with a shiny helmet and, on the ground, some armour with bright reflections: does this relate with the « mirroring » paintings by Giorgione mentioned in the sources? (see Suida, 1954, 1964). This is most probably one of Palma's earliest works (Pignatti, 1964, 264).

Oxford, Christ Church

V 25. THE JUDGEMENT OF MIDAS

Oil on panel, 33 × 50 cms.
Provenance: From the Guise Collection (1765).

Cavalcaselle (1912, III, 55) includes this painting among those attributed to Giorgione, although too damaged for an entirely confident assessment. It has generally been given to Schiavone (Berenson, 1957, 161), a view which was rightly opposed by Byam Shaw, who recognized that it belonged in the first quarter of the sixteenth century (1967, 72). In the few areas which remain intact (Apollo) it reveals an extremely high quality, reminiscent particularly of Previtali in the style of the *Scenes of Damon and Thyrsis* in London (V 18).

Paris, École des Beaux-Arts

V 26. THE VIOLINIST Plate 237

Pen drawing, 19.2 × 14.6 cms. Inv. No 34782.
Provenance: From the Cosway Collection; then Mayor.

Attributed to Giorgione by Hadeln (1925, Pl. 4), Justi (1927, II, 305), Richter (1937, 234; copy?)

and Morassi (1942, 176), it was however rightly given by Kristeller (1907, Supplement) and Fiocco (1915, 150) to Giulio Campagnola. The Tietzes (1944, No. 582) are in agreement with this, pointing out stylistic features from Dürer (especially the tree sketched on the left).

V 27. HEAD OF A BEARDED MAN

Pen and brush drawing.

Formerly attributed to Giorgione by Venturi (1927, 127), Morassi (1942, 123) and Zampetti (1968, 102, repr.) and associated with the *Three Philosophers* in Vienna. This interpretation was contested by the Tietzes (1944, A 715) and by Pignatti (1955, 136) who recognized some characteristics of Lotto's style in it.

Paris, De Hevesy Collection

V 28. LANDSCAPE WITH A CASTLE

Sanguine drawing, 6.2 × 10.4 cms.

Recorded by the Tietzes (1944, A 716), who however ruled out the possibility that it could be by Giorgione. It does indeed appear to be in the stylistic area of the late Bellini.

V 29. A NATIVITY

Pen and brush drawing, 14.7 × 18.8 cms.

Mentioned by Richter (1937, 257) in connection with the Washington *Adoration of the Shepherds* (Pl. 35) as « attributed to Giorgione ». Rejected by the Tietzes (1944, A 717), who also take into account the poor condition of the drawing.

Formerly Philadelphia, McIlhenny Collection

V 30. SAINT GEORGE AND THE DRAGON Plate 236

Oil on canvas, 76.8 × 87.3 cms.
Provenance: From the Hamilton Collection; then Graham; Wildenstein, New York.

Included in the 1955 exhibition in Venice as by an anonymous Giorgionesque artist (Zampetti, 1955, 30), this attribution was also supported by Berenson (1957, 86), while Fiocco (1955, 7) adjudged it to be a copy. It is difficult to believe that the painting actually represents St. George: it is however of an allied theme, showing two warriors with a monster-animal.

Formerly Rome, Collection of Prince Borghese

V 31. DAVID

Now in the Borghese Gallery in Rome, attributed to Dosso. This is a painting mentioned by Ridolfi (1648, 105).

Stockholm, National Museum

V 32. SAINT JEROME IN THE DESERT

Oil on canvas, 53 × 63 cms. Inv. No. 2660.
Provenance: From the Holford Collection in London (1927).

This is an almost identical version of Titian's painting in the Louvre (Valcanover, 1960, I, Pl. 130). At the Gallery it bears an attribution to Domenico Campagnola, a view that is also shared, with some reservations, by Morassi (1942, 218). Richter (1937, 238) claimed that the painting in Stockholm is more Giorgionesque in character than the version in Paris (which of course he leaves with Titian) and made the unfounded suggestion that it might be the « naked Saint Jerome sitting in the wilderness in the moonlight » (« San Heronimo nudo che siede in un deserto al lume della luna ») mentioned by Michiel as being in Andrea Odoni's house in 1532 (Frimmel, 1888, 86). The painting is clearly, however, a copy after the painting by Titian (usually dated around 1530).

Treviso, San Nicolò

V 33. ONIGO MONUMENT (TONDO WITH A TRITON, NEREIDS AND SATYRS)

Fresco painting.

According to Richter (1937, 240 and 264) this might be an early work by Giorgione, in the style of the frescoes in the Casa Marta-Pellizzari in Castelfranco (Pls. 57-73). The *Onigo Pages* are now attributed to Lotto, and the decorative friezes of this fresco have nothing to do with Giorgione (Berenson, 1957, 106).

Treviso, Cassa di Risparmio

V 34. THE DEAD CHRIST Plate 242

Oil on canvas, 132 × 200 cms.
Provenance: From the Monte di Pietà in Treviso, where it is mentioned by Ridolfi (1648, I 97) who at-

tributed it to the young Giorgione. Semenzi (1864, 174) reported that the earliest mention of the painting was in a sixteenth-century manuscript by Andrea Meneghini (which can now no longer be traced) in the possession of the Spinelli family, later passing into the hands of Bishop Alvise Molin. The picture continued to be attributed to Giorgione up to Cavalcaselle (1871), who gave it to Pordenone, and it is now rightly considered to be by one of his followers: for Berenson (1932, 67) and Fiocco (1943, 116) it is by Beccaruzzi, while Longhi (1927, 641), A. Venturi (1928, IX-III, 740) and Morassi (1942, 183) considered it to be by Florigerio. Zampetti (1955, 140) suggests the name of Francesco Vecellio, under the influence of Pordenone.

Venice, Gallerie dell'Accademia

V 35. JUSTICE (« JUDITH ») Plate 245

Detached fresco, 345 × 212 cms.

Removed from the Merceria façade of the Fondaco dei Tedeschi, where it was located with the remains of a frieze of figures and monsters, above the main doorway. Detached by Tintori (Valcanover, 1967, 226).
According to Vasari (1568, IV, 91) the fresco is the work of Giorgione. It is, in fact, the well-known painting which Titian painted after Giorgione had completed his frescoes on the Grand Canal façade, and which was mistaken for the work of Giorgione, occasioning an unpleasant « exchange » between the two artists (Dolce, 1557, 54). According to Nordenfalk (1952, XL, 101) the subject is one of the various allegories which Titian (as Giorgione had for the Grand Canal façade) had conceived for the decoration of the Fondaco in 1508. Described as a *Judith* by Dolce, the painting was called *Germany* by Vasari (1568, IV, 91), but most probably represents Divine Justice allegorically contrasted with human justice. The painting is mentioned in 1760 by Zanetti (p. vii) who records Bambini's and Sebastiano Ricci's admiration for Titian's colouring: « half-tones and contrasts, in order to achieve that natural tenderness of the flesh, and moderate the great fieriness of Giorgione in the deep shadows and the heavy redness overall... » Although the detached fresco is but a shadow of its former self, it does still give some idea of the majesty of Titian's composition, revealing a confidence and authority far beyond the artist's twenty years of age (Valcanover, 1969, No. 9; Pallucchini, 1969, 7). Gioseffi (1959, 54) is probably right in suggesting that the *Justice* may have been completed in 1509, since Dolce relates Titian's participation to the time when Giorgione had

already been painting on the Grand Canal façade. Wind (1969) thinks that the *Justice* is based on Giorgione's drawing, corresponding to the *Peace* which is recorded in Van der Borcht's etching (See: p. 162, n. 8).

Venice, Doge's Palace

V 36. THE « LEVANTINE » Plate 247

Detached fresco, 241 × 159 cms.
Removed from the Merceria façade of the Fondaco dei Tedeschi, where according to the sources it was painted by Titian at the age of twenty (detached in 1937).
It has generally been believed that this painting is identical with Zanetti's illustration No. 7: the so-called « Compagno della Calza », a work by Titian, see Pallucchini (1969, 7). As however Della Pergola (1955, 42) pointed out, Zanetti's print does not correspond at all with the faint outline that survives of the fresco. The only possible identification is thus with the figure of the *Levantine* mentioned by Boschini (1664, 110) as being alongside the « *Compagno della Calza* », otherwise known only through the engraving (Pl. 248).

Formerly Venice, Widmann Collection

V 37. THREE SCENES FROM OVID

Perhaps to be identified with the *Birth of Adonis* and the *Forest of Polidoro*, now in the Museum in Padua, attributed to Titian (Pallucchini, 1969, 8). A work mentioned by Ridolfi (1648, 99).

Vicenza, Museo Civico

V 38. PORTRAIT OF A FERRAMOSCA
Oil on panel, 72 × 61 cms. Inv. No. A 340.

Attributed to Giorgione by Franceschini (1920, 311) and by Ferriguto (1933, 362), this painting was later given to Licinio by Arslan (1929, 11) and this attribution has been universally recognized (Barberini, 1962, 87).

Zurich, Private Collection

V 39. PORTRAIT OF A YOUNG MAN Plate 249

Oil on panel, 44 × 37 cms.
Provenance: From the Collection of Horace Walpole, Strawberry Hill; later Phipps; Johnston.

Included in the Baltimore Exhibition (De Batz, 1942, No. 14) as by Giorgione, this attribution was rejected by Richter, although the picture was subsequently exhibited in Venice (Zampetti, 1955, 76) as « probably by Giorgione ». It is rightly given to Palma by Berenson (1957, 127), while Mariacher (1968, 113) remains uncertain (Pignatti, 1969, 264).

Zurich, Schwyzer Collection

V 40. PAN AND SYRINX Plate 250

Oil on panel, 34.5 × 45 cms.

Provenance: From the Collection of Lord Bentinck.

Published as by Giorgione by Richter (1942, 213) and exhibited as such at Baltimore (De Batz, 1942, No. 4). The picture is close to Giorgione also for Morassi (1942, 148) and Zampetti (1955, 123); the latter also quotes L. Venturi's opinion as being in favour of Palma. Tietze (1947, 140) and Fiocco (1955, 7) are altogether opposed to Giorgione's authorship. The nude Syrinx is much the same figure as one which Richter noted in the painting in the Walker Collection at Mirfield, a work which, like the present painting, is by a follower of Giorgione (V 22).

LOST WORKS

The Catalogue of lost works is arranged topographically, and the works are illustrated in Figs. 45 - 74. Included here are works mentioned in the sources up to Boschini (1644), Teniers's Theatrum Pictorium *(1658) and a few other later references which are founded on credible local tradition. No reference is made however to inventories of collections and sale catalogues, of which a list is to be found in Richter (1937). Translations from the original texts are in quotation marks.*

Antwerp, Van Verle

« *A large head of Polyphemus with a cap on* ».

« *A Commander in antique garb and jacket, with a red cap in his hand* ».

« *A half-figure of a pensive nude with a green drape on his knees, and a breastplate beside* ».

Ridolfi, 1648, I, 105, 106. Suida (1954, 163) associated the Nude with the « mirroring » paintings. It is not altogether clear from Ridolfi's account whether the Polyphemus was in the Van Verle Collection, or elsewhere.

« *A youth with long hair in armour* ».

Engraved by W. Hollar. According to Garas (1964, No. 25, 58) this was the painting mentioned by Vasari as being in the collection of Domenico Grimani.

Brussels, Archduke Leopold Wilhelm

Aggression

Listed in the Inventory of Bartolomeo della Nave, 1636; in Brussels in 1659 as No. 215, by Giorgione (dimensions about 60 × 74 cms); illustrated as such in Teniers's *Theatrum Pictorium* of 1658, No. 27. A

painted copy by Teniers (on panel, 22 × 32 cms.) is in the Gronau Collection in London (Pignatti, 1955, 150). It is curious that the figure of the woman is almost the same in reverse as that of the nude which X-rays have shown to exist under the present surface of the *Tempest* (Figs. 15, 45, 46).

Christ and the Pharisee

Listed in the 1659 Inventory, No. 253 by Giorgione; illustrated with the same attribution in Teniers's *Theatrum Pictorium* of 1658, No. 19 (Fig. 47).

Judith

Previously in the Bartolomeo della Nave Collection in Venice, as by Catena (1636); then in the 1659 Inventory, No. 37, as by an anonymous artist; reproduced in Teniers's *Theatrum Pictorium*, 1658, No. 13, as by Giorgione. A painted copy by Catena is in the Pinacoteca Querini Stampalia in Venice (Figs. 48, 49).

Orpheus

Listed in the 1659 Inventory, No. 270, as by Giorgione; reproduced with the same attribution in Teniers's *Theatrum Pictorium*, 1658, No. 18. A painted copy by Teniers is in the Suida-Manning Collection in New York (oil on canvas, 20 × 13 cms.) and is reproduced by Suida (1954, 158) (Figs. 50, 51).

Rape of Europa

Listed in the 1659 Inventory, no. 270, as by Giorgione; reproduced with this attribution in Teniers's *Theatrum Pictorium*, 1658, No. 18. A painted copy by Teniers is in the Art Institute in Chicago (oil on panel, 21.5 × 31 cms.) (Figs. 52, 53).

Castelfranco, Casa Bovolini in parochia di fuori

A façade with « *Hercules and Antaeus and in the other scene the same Hercules about to dismember a Lion, with various figures above...* ».

Castelfranco, Casa Cesconi in Castello

« *A family coat of arms, arabesques and red and green chiaroscuro paintings with an eagle* ».

Castelfranco, Casa Stievani in Borgo d'Asolo

« *Our Lady* ».

Castelfranco, Cathedral, Costanzo Chapel

« *The Redeemer in the act of blessing and symbolizing in four other* tondi *the Evangelists with arabesques around*».

Nadal Melchiori, MSS. Codex Gradenigo Dolfin b. 205, f. 163, 148, 148 and 137 (Venice, Museo Correr, 1724-35). No trace remains of the frescoes, but it is not unlikely that Giorgione would have executed works such as these at Castelfranco, apart from the surviving fresco in Casa Marta-Pellizzari (No. 16).

Faenza, Giovanni da Castelbolognese

Portrait of his father-in-law (?)
Vasari, 1550, 579.

Florence, Giorgio Vasari

« *A head coloured with oil, drawn from a German of Casa Fucheri* » (in the book of drawings).
Vasari, 1568, IV, 99.

Florence, Antonio de Nobili

A Captain in Armour
Vasari, 1568, IV, 94.

Genoa, Cassinelli

Allegory of Human Life
Ridolfi, 1648, I, 100.

Rome, Prince Aldobrandini

Saint Sebastian « *to mid-thigh* »
Ridolfi, 1648, I, 105.

« *A man dressed in black with a shock of hair and an inscription* »,
« *Portrait of the Great Captain* »,
« *Self-Portrait* »,
« *A painting on canvas with the portrait of an old man* »
« *A woman in Venetian costume* ».
Della Pergola, 1960, 427; idem, 1963, 83.

Rome, Vincenzo Giustiniani

Christ and the Adulteress; a copy of the painting is noted by Garas (1965, No. 27, 35) in Berlin.

Salome: Garas (*loc. cit.*, 38) notes that there is a copy in Sarasota.

A Sibyl: Garas (*loc. cit.*, 40) mentions various copies, among them the one formerly at Marostica (C 7) and the one in Budapest (Inv. No. 626).

Lucretia;
A Priest in antique costume;
A portrait in antique style;
Self-Portrait.

Salerno, 1960, 21, 93, 136.

Rome, Ludovisi Collection

« *A man touching the wrist of a woman* »;

« *A painting of a portrait... with a death's head* » (according to Garas, 1965, No. 27, 56, this may be the painting by Licinio in Oxford).

« *A painting of the Falling of Christ with the Cross* » (perhaps the painting mentioned by Ridolfi, 1648, I, 105, according to Garas, *loc. cit.*, 56).
Garas, 1965, No. 27, 48ff.

Venice, Vittorio Beccaro

A « *night of finer design and better finished* ».
Mentioned in the letter of 7 November 1510 from Taddeo Albano to Isabella d'Este (Luzio, 1888, 47). Regarding the theory that this painting is the Washington *Adoration of the Shepherds* (Pl. 35), see under No. 9.

Venice, Michele Contarini by the Misericordia

« *A pen drawing of a nude in a landscape by the hand of Zorzi, and it is the nude which I have in a painting by the same Zorzi* ».
Recorded by Michiel, August 1543 (Frimmel, 1888, 114).

Venice, Taddeo Contarini

« *The great oil painting of Hell with Aeneas and Anchises* »; « *The painting of the landscape with the birth of Paris, with two shepherds standing... one of his earliest works* ».

Recorded by Michiel in 1525 (Frimmel, 1888, 88). With regard to the suggested identification of the *Hell* in the *Sunset Landscape*, see Catalogue No. 21; for the presumed fragment of the *Birth of Paris* in Budapest, see C 3.

A « *not very perfect night* ».

Mentioned in Taddeo Albano's letter to Isabella d'Este of 7 November 1510 (Luzio, 1888, 47). Regarding the suggestion that this is the *Adoration of the Shepherds* in Vienna, see No. A 60.

Venice, the Contarini by San Samuele

« *A Knight in black armour* »
Ridolfi, 1648, I, 102.

Venice, Giovanni Cornaro

Caterina, Queen of Cyprus
Vasari, 1568, IV, 99.

Venice, Bortolo Dafino

A « *Little Bacchus with cup in hand* ». Gronau (1939, 217) suggests that this may be the painting by Bellini in the National Gallery in Washington (Kress 1679).
Ridolfi, 1648, II, 201.

Venice, Bartolomeo della Nave Collection

« *A beautiful head* ».

According to Garas (1964, No. 25, 77) this is not to be identified with any of the various heads which passed in 1638 from the Della Nave Collection into that of Archduke Leopold Wilhelm in Brussels (see Waterhouse, 1952). Among the other works attributed to Giorgione in the inventory Garas identifies the following: the « Boy with a Tambourine » in the Kunsthistorisches Museum in Vienna (Inv. No. 181), perhaps by Titian; the « Woman dressed in White » in the Museum of Fine Arts in Budapest (Inv. No. 84), associated with Giorgione's portraits that are also initialled « V V »; the so-called « Engaged Couple » in the Museum of Fine Arts in Budapest (Inv. No. 939, 3460), held to be by the young Giorgione rather than Palma.

Venice, Alvise di Sesti

« *Four paintings in a square with the exploits of Daniel* ».
Molment i, 1878, 22. Named in a contract dated 13 February 1508 which is now no longer traceable and whose authenticity is seriously in question (Richter, 1937, 303).

Venice, Fondaco dei Tedeschi, Grand Canal Façade

« *Heads and parts of figures* ».
Vasari, 1550, 579.

« *...in one place there is a woman, in another a man, in diverse attitudes, while one has the head of a lion near him, and another an angel in the guise of a Cupid...* »
Vasari, 1568, IV, 96.

« *Trophies, nude figures, heads in chiaroscuro; and in the corners he painted Geometricians, measuring the globe; perspective views of columns, and between the latter men on horseback* ».
Ridolfi, 1648, I, 100.

« Philosophers measuring a globe, and other figures drawn and described by us in our book on the fresco paintings » *« Other figures in the courtyard »* (with Morto da Feltre). Zanetti, 1760, 89, 94.

The most complete surviving impression of Giorgione's decoration on the Grand Canal façade is that of the print included in Albrizzi's *Forestiere illuminato* of 1740 (Fig. 19), which at least conveys an idea of the distribution of the frescoes between the windows and on the surfaces between the floors. Nordenfalk (1952, XL, 101) studied the iconography of the whole façade, and with good reason concluded that Giorgione must have worked (as Titian did also on the Merceria façade) from a pattern of Allegories. This would be confirmed by the figure of *Peace*, known through Van der Borcht's engraving (Fig. 58), which has the same compositional arrangement as the *Divine and Earthly Justice* and *Sacred and Profane Love* by Titian. Zanetti (1760) gave a precise account of the colours of the frescoes, of which only the *Standing Nude* by Giorgione, the *Justice* or «*Judith*» with the frieze and the *Levantine*(?) by Titian have survived (see No. 15; V 35, 36). Zanetti also illustrates in etchings the figure of a *Seated Man* (Pl. 1; our Fig. 55) — perhaps an Ancient Philosopher? — and a *Seated Nude* (Pl. II, our Fig. 54; perhaps a Fortune?), both of which he attributes to Giorgione. Foscari (1936, 36 ff.) gives a precise account of the references in the sources to the Fondaco, and notes that as early as 1733 (Zanetti, *Descrizione*, 191) only the figures in the upper section, to the left, had survived. Giorgione's *Standing Nude* was located there, between the little windows under the eaves (Fig. 22). Brunetti (1941, 72) also imagined that Van der Borcht's engraving of the *Allegory of Peace* represented one of Giorgione's lost frescoes.

Venice, Giorgione's House by San Silvestro

Frescoes on the façade « *at the top of which he painted some ovals with musicians, Poets and other fancies, and on the chimney-breasts, groups of children, skulls in chiaroscuro, and in another part he painted two half-length figures, believed to represent the Emperor Frederick I and Antonia da Bergamo... and in the lower half there are two histories, which are difficult to comprehend, since in time they have been damaged* ».

Ridolfi, 1648, I, 97. It remains uncertain which Giorgione's house was, although Foscari (1936, 33), working on the basis of the above literary sources, recognized it as the Casa Bernardo, the present No. 1088 in Campo San Silvestro. Mutinelli (1838, 22) illustrates a lithograph of it (Fig. 4).

Venice, Giorgione's estate

« *A painting of a night, most singular and beautiful* ». Mentioned in Isabella d'Este's letter of 25 October 1510 to Taddeo Albano (Luzio, 1888, 47). Albano replies that this *Night* was not part of the estate, but that two others belonged to Vittorio Beccaro and Taddeo Contarini (q.v.).

Venice, Domenico Grimani

The Inventory of 1528 (Paschini, 1926-7) lists the following as works by Giorgione :
« 3. *A head with a red crest painted from life* »;
« 16. *A head of a child painted by the hand of Zorzon* »;
« 18. *A portrait of Zorzon by his own hand done through* (i.e., in the dress of) *David and Goliath* ».
Apart from these, the inventory also includes another painting, without naming the painter:
« 7. *A head of an old woman with a fleece* (vello) *round her head* ».
Castelfranco (1955, 305) notes that the first three are the same as paintings mentioned by Vasari 1568, IV, 93); the last mentioned could be the *Portrait of an Old Woman* (« *La Vecchia* ») (No. 29), subsequently passing into the hands of the Vendramin. It is interesting to note that this is the first occurrence of the name Zorzon (and not, as had been previously maintained, in Pino's *Dialogo della Pittura*) instead of the previous Zorzo or Zorzi. Garas (1964, No. 25, 55) suggests that the « child » might be the *Archer* in Edinburgh (V 10).

Venice, Giovanni Grimani

« *A Nativity* »
Included in the 1563 Inventory, valued at 10 ducats by Paris Bordone (Fogolari, 1910, 8).

Venice, Casa Grimani by Sant'Ermacora (San Marcuola)

« *... by the same Giorgione, above a door, can be seen the figure of a woman, representing Diligence, and above the other one on the other side, Prudence, rare things. There are also painted some heads of lions, above the doorway towards the bank, painted to resemble stone...* ».
Boschini, 1664, 60. These are the same frescoes that Ridolfi (1648, 155) fifteen years earlier had attributed to Titian. Zanetti (1765, VI) insisted on Giorgione's

authorship, and described the *Diligence* as the best preserved of the artist's paintings, praising the « *artificious handling of the shadows, arranged, shaded and reinforced so effectively that the figures seem to emerge from the painting* ». The attribution to Giorgione is also supported by Hadeln (1914, I, 155, No. 4) and Richter (1942, 211) despite the emergence in the meantime of a tendency to give the *Diligence* to Titian (Morassi, 1942, 174). It is clear that the argument based on the formal analysis of Zanetti's print is a somewhat fruitless line of enquiry, nor can the results drawn from it be conclusive. But a significant element in favour of Giorgione's authorship — which we support — was introduced by E. Tietze, who published a seventeenth-century drawing after the fresco of *Diligence*, now in the Library of the University of Salzburg (1940, 35). As Tietze notes, the figure in the drawing is considerably more delicate, especially in the area of the head, sketched from the side; the existence of this evidence confirms the attribution to Giorgione, which is better documented in the sources.

Venice, Casa Grimani by the Servi

Frescoes on the façade with « *some nude women of fine form and good colouring* ».
Ridolfi, 1648, I, 99. Hadeln (1914, I, 99, No. 3) notes however that Boschini (1664, 52) gives these paintings to Titian; they should not be confused with the frescoes (also attributed variously to Giorgione or Titian) on the Palazzo Grimani at Sant'Ermacora (now Vendramin Calergi) which up to 1594 belonged to the Loredan family.

Venice, Cavalier Gussoni

« *Our Lady, Saint Jerome and other figures* ».
Ridolfi, 1648, I, 102.

Venice, Signori Leoni by San Lorenzo

« *Saul holding by the hair the head of Goliath, given to him by the youthful David* ».
« *Paris with the three Goddesses* ».
Ridolfi, 1648, I, 102.

Venice, Gerolamo Marcello

« *Saint Jerome down to the waist, reading* ».

« *Gerolamo Marcello in armour from behind, down to the waist, with his head turned...* ».

Seen by Michiel in 1525 (Frimmel, 1888, 88). The description of the St. Jerome is identical with that of the one belonging to the Malipiero family, and thus it is possible that it entered that collection after Michiel saw it in Gerolamo Marcello's house. The portrait has been identified (Suida, 1954, 165) as the *Portrait of a Man in Armour* in the Kunsthistorisches Museum in Vienna (see No. A 64), although not conclusively, since Michiel also mentions another similar portrait in the Venier Collection (see below).

Venice, Marcantonio Michiel

« *Painted nude* ».
Mentioned by Michiel in connection with the pen drawing of the same subject which he lists in the Casa Contarini by the Misericordia in 1543 (Frimmel, 1888, 114).

Venice, Doge's Palace, Audience Chamber of the Council of Ten

« *Canvas to be placed in the audience (chamber)* ».
Commissioned from Giorgione on 14 August 1507, but evidently not completed by 24 January 1508, when Giorgione received an advance of 25 ducats (Lorenzi, 1868, 141, 144). Cavalcaselle's supposition (1871, II, 138) that this painting was the *Judgement of Solomon* now at Kingston Lacy (A 19; in 1648 the picture was in the Grimani Collection) is unfounded.

Venice, Doge's Palace, Greater Council Chamber

« *Federigo Barbarossa on his knees before Pope Alexander IV* ».
Borghini, 1584, 1525; the latter cites the work as having been left unfinished by Giorgione and completed by Titian. According to Vasari (1568, VII, 432) the artist was Bellini, and not Giorgione.

Venice, Antonio Pasqualino

« *The head of St. James with the pilgrim's staff* ».
Recorded by Michiel in 1532 (Frimmel, 1888, 80).

Venice, Casa Pisani

Portrait of a young man with a fur
According to Garas (1966, No. 28, 72) this is a copy
of the *Portrait of a Young Man* in Leningrad (V 15).

Venice, Giovanni Ram by Santo Stefano

« *Head of a shepherd boy holding a fruit in his hand* ».
Recorded by Michiel in 1531 (Frimmel, 1888, 104).
It has been suggested that this may have been the ori-
ginal of the paintings in Oxford and the Ambrosiana,
Milan (see A 39).

Venice, Casa Rettani by San Canziano

« *... above the bank, towards the Rio, one can discern the
beautiful figure of a woman in chiaroscuro, and some other
traces* ».
Boschini, 1664, 8.

Venice, Senator Domenico Ruzzini

« *Portrait of a Captain in armour* ».
Ridolfi, 1648, I, 102.

Venice, Façade on a canal by Santa Maria Zobenigo

« *... in an oval the busts of Bacchus, Venus and Mars, with
grotesques in chiaroscuro at the sides and children* ».
Ridolfi, 1648, I, 99. Boschini (1664, 63, 84) also men-
tions the frescoes, and gives the additional information
that they were on the Rio di Ca' Pisani « by the Palazzo
di Ca' Flangini », and that they included chiaroscuro
friezes, Cupids, Venus, Mars and Mercury. Foscari
(1936, 35) thinks this was the Palazzo Pisani-Gritti.

Venice, various façades on Campo Santo Stefano

« *A few well-painted half-length figures* ».
Ridolfi, 1648, I, 99.
« *Beautiful figures in antique costume* ».
Boschini, 1664, 87. Foscari (1936, 36) refers to a note
by Urbani del Ghetlof, who had seen « disfigured
remnants » on a chimney-breast.

Venice, G. Battista Sanudo

« *The half-length figure of a woman in Gipsy costume,
displaying the lively whiteness of her fair bosom, her hair
gathered with a thin veil, leaning with her right hand on a
book printed with various characters...* ».
Ridolfi, 1648, I, 102. Hadeln (*loc. cit.*, No. 2) maintained
that the painting is to be identified with the *Delphic
Sibyl* formerly in the Sorio Collection at Marostica;
its authorship he regarded as being close to Titian
(see under C 7). This identification cannot be conclu-
sive, by reason of the large number of versions that
exist of the composition.

Venice, Scuola dei Sartori by the Gesuiti

« *In the room above before the Bench, there is a painting
by Giorgione, with Mary, the Child, St. Barbara, St.
Joseph, and a Portrait; an exquisite piece of work...* ».
Boschini, 1664, 16. Zanetti (1771, 92) mentions the
painting, at that time still in its original location;
but in an early-nineteenth-century note in the copy of
his book belonging to G. A. Moschini (Library of the
Museo Correr in Venice) he observed that it had been
moved to Milan: thus most probably around the time
of the Napoleonic requisitions. The picture is perhaps
to be identified with Bonifacio de' Pitati's painting in
the Accademia in Venice, dated 1533 (Richter, 1937,
336).

Venice, Fiera della Sensa

Portrait of Doge Leonardo Loredan
Vasari, 1568, IV, 95.

Venice, Piero Servio

« *Portrait of his father from the hand of Giorgio da Castel-
franco* ».
Recorded in a note in the margin of Michiel's manus-
cript, with the date 1575 (Frimmel, 1888, 110, No. 1).

Venice, Ca' Soranzo by San Polo

« *... a whole façade... in which apart from many paintings
and histories, and other fantasies of his, there is a painting
worked in oils on the plaster* ».
Vasari, 1550, 577.

He repeats the description, and adds « *There is also a (paintings of) Spring there* ».
Vasari, 1568, IV, 95.

« *History paintings, friezes of children and figures in niches...* ».

Ridolfi, 1648, 97. E. Tietze (1940, 35) believed that a drawing formerly in the Koenigs Collection, showing a *Nude with a Putto* and inscribed « in the campo San Polo », is after the lost work, which must have been among Giorgione's most famous. While it appeared youthful in style (Ridolfi refers to it « after staying for some time in Castelfranco... » — 1648, I, 97), it foreshadowed, so far as we can gather from the description (history-paintings, friezes, niches), the decorative framework of the Fondaco frescoes. Foscari (1936, 34) notes that by as early as 1852 the Soranzo frescoes had wholly disappeared.

Venice, Andrea Vendramin

The illustrated inventory of the collection, drawn up in 1627 (British Museum, MS Sloane 4004), includes thirteen drawings after paintings attributed to Giorgione:

f. 3 - « *David with the head of the Giant Goliath* ». Fig. 59.

f. 7 - *Two lovers*. Fig. 60.

f. 8 - « *A Sacrifice* ». Fig. 61.

f. 9 - « *A Sacrifice* ». Fig. 62.

f. 11 - « *La Divitia* ». Fig. 63.

f. 14 - « *The Fable of Paris* ». Fig. 64.

f. 14 - *Portrait of a young man*. Fig. 65.

f. 15 - *A Landscape*. Fig. 66.

f. 15 - *Shepherd with a flute*. Fig. 67.

f. 20 - *Bust of Christ*. Fig. 68.

f. 35 - *Portrait of a Bearded Man*. Fig. 69.

f. 40 - « *Giorgione, by his own hand* ». Fig. 70.

f. 42 - *Portrait of a Man in Armour*. Fig. 71.

Borenius (1923), who published the Vendramin manuscript in facsimile, noted that the *David* is the painting by Giorgione mentioned by Ridolfi (1648, I, 101). Garas (1964, No. 25, 29) records two copies of the painting, at Nymphenburg and in Prague, but denies that the painting is a Self-portrait, as Ridolfi would have it. Borenius claimed that only the Portrait on f. 14

could be after an original by Giorgione. Richter (1937, pp. 261, 262) on the other hand accepts all but the *Shepherd* on f. 15 and the *Portrait* on f. 40. Morassi (1942, 150) regards the following especially as probably after originals by Giorgione: the *Sacrifice* on f. 8, the *Paris* and the *Portrait of a Young Man* of f. 14, the *Landscape* on f. 15 and the *Portrait* on f. 40. He also includes, from amongst the drawing with no indication as to the identity of the painter, a *Concert by Night* (f. 16; Fig. 72) and a *Nymph and Faun* (f. 29; Fig. 73). The *Sibyl* on f. 70 (Fig. 74) may be connected, in our opinion, with the series of paintings of which we have illustrated the example from the Sorio Collection (C 7; Pl. 223). So far as the other drawings are concerned, we would note a connection between the *Shepherd with a Flute* on f. 15 (Fig. 67) with the *Shepherd Boy with a Flute* at Hampton Court (No. 27, Pl. 110), but it would be hazardous to base any conclusive identification on the insubstantial evidence offered by the anonymous copyist.

Venice, Gabriele Vendramin

Attributed to Giorgione in the family inventories:
1567: « *Two figures in chiaroscuro* »;
1569: « *Three heads singing* »; « *Our Lady* »: » *A little painting with three heads with its soazeta* [frame] *of wood* ».

Ravà, 1920, 155. Apart from the paintings listed above, Gabriele Vendramin owned the *Tempest* (No. 13) and the *Portrait of an Old Woman* (« La Vecchia » — No. 29). Recently Della Pergola (1954, No. 49, 27) has attempted to identify the two *Singers* in the Borghese Gallery (A 47, 48) as cutdown sections of the « *Three heads singing* ».

Venice, Zuan Antonio Venier

« *A soldier in armour, down to the waist, but without a helmet* ».

Recorded by Michiel in 1528 (Frimmel, 1888, 98). The subject is the same as that of the painting in Vienna (A 64) which Suida however is inclined to identify with the work in Gerolamo Marcello's house (see above).

Venice, Signori Vidmani

Three Stories of Adonis

Ridolfi, 1648, I, 99. Perhaps those by Titian in the Museo Civico in Padua.

Venice, unknown location

Portrait of Doge Barbarigo.
Ridolfi, 1648, I, 99.

Portrait of a gelded cat (« *a large canvas* »).
Ridolfi, 1648, I, 101.

« *The Gran Consalvo in armour* ».
Vasari, 1568, IV, 95.

This was the Spanish General Gonsalvo Fernandez, who paid a visit to Doge Agostino Barbarigo in 1501. A supposed portrait of Don Gonsalvo is in the Castle at Ambras, but the sitter is not wearing armour; Richter (1937, 207) believes it to be a copy after a lost Giorgione.

Christ on Calvary.
Ridolfi, 1648, I, 105. According to Garas (1966, No. 27, 56) this is perhaps the same painting as one mentioned in the manuscript inventories of the Ludovisi Collection in Rome.

Saint George in armour, standing by a spring.
Pino, 1548, 29. The passage in question is the long description of Giorgione's figure reflected in the water and in mirrors. It is an image that is taken up later by Vasari, 1568, IV, 91 (for the « Nude » he mentions, see below). On the question of Giorgione's « mirroring » paintings, see Suida, 1954, 160. Calvesi (1956, 254) identifies the *St. George* as the fragment now in the Cini Collection, which has since been shown to be by Titian (A 58); Zampetti (1968, No. 99) identifies it as Savoldo's *Gaston de Foix* in the Louvre.

« *The nude St. Jerome sitting in the wilderness in the moonlight by the hand of...drawn from a painting by Zorzi da Castelfranco* ».
This is Michiel's description in 1532 of this lost work by Giorgione, which he maintained was a copy of a painting he had seen in Andrea Odoni's house (Frimmel, 1888, 86). According to Richter (1937, 238), it is the painting now in Stockholm (V 32).

« *A nude by a spring, having taken his armour off, in whhic he is looking at himself* ».
Vasari, 1568, IV, 98. Vasari seems to have drawn upon Pino's description of the *St. George* (see above).

« *Many paintings of Our Lady, and other portraits from the life* ». Vasari, 1568, IV, 93.

A nude Woman with a Shepherd
Ridolfi, 1648, I, 101.

The Story of Psyche (in twelve scenes)
Ridolfi, 1648, I, 102.

A story from Ovid (with various subjects).
Ridolfi, 1648, I, 98, 99.

A Portrait in majesty, in the Antique manner.
Ridolfi, 1648, I, 101.

Verona, Giovan Pietro Cortoni Collection

« *Our Lord with the Apostles and the Canaanite woman* »; « *A lively portrait with a landscape and buildings* »; « *Achilles shot at by Paris* ».
Ridolfi, 1648, II, 112.

PRINTS ASSOCIATED WITH LOST WORKS BY GIORGIONE

1. G. CAMPAGNOLA, *The Astrologer*, 1509, Fig. 75. (Hind, 1948, No. 9).
According to Richter (1937, 258) this engraving is reminiscent of a lost work by Giorgione. The monster is similar to the one in the little panel in Philadelphia (V 30, Pl. 236), and the astronomical symbols are similar to those which recur in Giorgione's works.

2. G. CAMPAGNOLA, *Saint Jerome reading*, Fig. 76. (Hind, 1948, 7).
According to Richter (1937, 258) the print is reminiscent of a lost work by Giorgione. Michiel mentions a St. Jerome in the Casa Marcello; Ridolfi mentions one in the Casa Malipiero. Both the latter references are, however, to half-length figures.

3. G. CAMPAGNOLA, *The Nude* (Venus?), Fig. 77 (Hind, 1948, No. 13).
According to Richter (1937, 262) the print derives from a prototype by Giorgione. Michiel records a copy from an original by Giorgione of a nude woman « reclining and turned » that was seemingly like the figure in the print, in Bembo's house in Padua (Frimmel, 1888, 22).

4. G. Campagnola, *Young Shepherd*, Fig. 78 (Hind, 1948, No. 10).
According to Richter (1937, 258) this recalls a lost Giorgione.

5. D. Cunego, *The Lovers* (after Giorgione), Fig. 81.
The print is one of the series forming the *Schola Italica Picturae* by Gavin Hamilton (1773), which describes the original as being in the Borghese Collection in Rome (Richter, 1937, 258).

6. Marcantonio Raimondi, *The Dream of Raphael*, Fig. 79 (Bartsch, 1867, XIV, No. 359).
Wickhoff first suggested that the so-called *Dream of Raphael* might reflect a lost composition by Giorgione. Richter (1937, 259) supports this interpretation, which has also been favoured recently by Suida (1954, 158), who regards the Bosch-like monsters as a further indication of Giorgione's influence.

7. Marcantonio Raimondi, *Spring*, Fig. 80 (Bartsch, 1867, XIV, No. 383).
According to Richter (1937, 259) this print, which can be dated to before 1510, may represent a detail from Giorgione's lost frescoes at Ca' Soranzo.

8. H. Van Der Borcht, *Peace*. Fig. 58. Wind (1969, 35) thinks that this print was made when the master was in Venice as an agent of the Duke of Arundel (1936-46). As for Nordenfalk (1952, 101), the etching reproduces one of the lost allegories by Giorgione on the façade of the Fondaco.

SOURCES AND DOCUMENTS

This section comprises transcriptions of the original documents and sources pertaining to the work of Giorgione, up to Boschini's Minere della Pittura Veneziana (1664). Subsequent literature up to 1933 is to be found listed in Richter's «Giorgione» (Chicago, 1937), and thereafter in our Bibliography.

Commissions for the Doge's Palace

1507 Nos Capita Consilii X dicimus et ordinamus vobis Magnifico Domino Francisco Venerio Provisori Salis ad Capsam Magnam deputato, che numerar dobiate a conto dila fabrica di la Cancellaria et del loco dil Conseglio di X a maistro Zorzi Spavento protho ducati trenta et a maistro Zorzi da Castelfranco depentor per far *el teller da esser posto a la udientia de* lo Illustrissimo Conseglio ducati 20.

Archivio di Stato, Venice. Notatorio 2, del Magistrato 1491-1529, for. 114 verso.

Nos Capita Illustrissimi Consilii X dicimus et ordinamus vobis Domino Aloysio Sanuto Provisori Salis ad capsam magnam: Che dar et numerar dobiate a maistro Zorzi da chastelfranco depentor per *el teller el fa per l'audientia novissima* di Capi di esso illustrissimo Conseio ducati venticinque, videlicet 25, di quel instesso denaro fu deputato et speso in la fabrica di la audientia per deliberation dil prefato Illustrissimo Conseglio.

Duc. 25
Datum die XXIV Januarii 1507 (more veneto).
Notatorio 2, del Magistrato al Sal 1491-1529, fol. 119.

1508 Nos Capita Illustrissimi Consilii X dicimus et ordinamus vobis Domino Alovisio Sanuto Provisori Salis ad Capsam magnam, che dar et numerar dobiate a maistro Zorzi Spavento protho per la tenda di *la tella facta per Camera di la audientia nuova*, monta in tutto come appar per il suo conto, Lire 35 Soldi 18 di pizoli: videlicet Lire trentacinque Soldi 18...
...Lire 35 Soldi 18
Datum die 23 Maij 1508.
Notatorio 2, del Magistrato al Sal 1491-1529, fol. 121
1868, Lorenzi, 141, 144, 145.

Contract with Alvise de Sesti for the Story of Daniel

1508 El se dichiara per el presente come el clarissimo messer Aluixe di Sesti die a fare a mi Zorzon da Castelfrancho quatro quadri in quadrato con le geste di **Daniele** in bona pictura su telle, et li telleri sarano sominostrati per dito m. Aluixe, il quale doveva stabilir la spexa di detti quadri quando serano compidi et di sua satisfatione entro il presente anno 1508.

Io Zorzon de Castelfrancho di mia man scrissi la presente in Venetia li 13 febrar 1508.

Published by Molmenti (1878, 22) who indicates that it was a discovery by Urbani del Ghetlof; supported by Justi (1908, II, 12). Richter (1937, 303) suspects the authenticity of the document, and cites the concurring opinions of Della Rovere and Gronau. The document itself can now no longer be traced.

Documents relating to the Fondaco dei Tedeschi

1508 8 Novembris 1508
Riferì sier Marco Vidal d'ordine dell'Ill.ma Signoria alli Magnifici Signori Provedatori al Sal, che sue magnificentie, nella causa di mistro Zorzi da Chastelfrancho per el depenzer dil **fondego de Todeschi,** ministrar debano giustitia, et fu rifferito al magnifico messier Hieronimo da Mulla, et missier Aloixe Sanudo, et omnibus Aliis.

11 Decembris 1508
Ser Lazaro Bastian, ser Vettor Scarpaza, et ser Vethor de Matio per nominati da ser Zuan Bellin depentori costituidi alla presentia dei mag.ci Signori m. Caroso da cha da Pexaro, m. Zuan Zentani, m. Marin Gritti, et m. Aloixe Sanudo provedadori al Sal, come deputadi electi dipintori a veder quello pol valer la pictura facta sopra la faza davanti del fontego de thodeschi, et facta p. m.o Zorzi da Castel francho et durati dachordo dixero a giuditio et parer suo meritar al ditto m.o per dicta pictura ducati cento e cinquanta in tutto.
Die dicta
Col consenso del prefato messer Zorzi gli furono dati ducati 130.
1842. Gualandi, III. 90.
1840. Gaye, II. 137.

M. Sanudo, *I Diarii*

1508 Dil mese di avosto 1508. A dì primo, marti. Fo cantà una messa, preparato in corte dil fontego di todeschi, fabrichato novamente... li todeschi comenzono a intrar et ligar balle, e tutavia dentro si va compiando et depenzendo di fuora via.
1879. Sanudo, VII, 597.

Correspondence between Isabella d'Este and Taddeo Albano

1510 *Isabella d'Este to Taddeo Albano*
Sp. Amice noster charissime: Intendemo che in le cose et heredità de Zorzo da Castelfrancho pictore se ritrova una pictura de **una nocte,** molto bella et singulare; quando cossì fusse, desideraressimo haverla, però vi pregamo che voliati essere cum Lorenzo da Pavia et qualche altro che habbi judicio et disegno, et vedere se l'è cosa excellente, et trovando de sì operiati il megio del m.co m. Carlo Valerio, nostro compare charissimo, et de chi altro vi parerà per apostar questa pictura per noi, intendendo il precio et dandone aviso. Et quando vi paresse del concludere il mercato, essendo cosa bona, per dubio non fusse levata da altri, fati quel che ve parerà; chè ne rendemo certe fareti cum ogni avantagio e fede et cum bona consulta. Offeremone a vostri piaceri ecc.
Mantue XXV oct. MDX.

Taddeo Albano to Isabella d'Este
Illma et Exc.ma M.a mia obser.ma Ho inteso quanto mi scrive la Exc. V. per una sua de XXV del passatto, facendome intender haver inteso ritrovarsi in le cosse et eredità del q. Zorzo de Castelfrancho una pictura de **una notte,** molto bella et singulare; che essendo cossì si deba veder de haverla. A che rispondo a V.Ex. che ditto Zorzo morì più dì fanno da peste, et per voler servir quella ho parlato cum alcuni mie amizi, che havevano grandissima praticha cum lui, quali mi affirmano non esser in ditta heredità tal pictura. Ben è vero che ditto Zorzo ne feze una a m. Thadeo Contarini, qual per la informatione ho autta non è molto perfecta sichondo vorebe quella. Un'altra pictura de la nocte feze ditto Zorzo a uno Victorio Becharo, qual per quanto intendo è de meglior desegni et meglio finitta che non è quella del Contarini. Ma esso Becharo al presente non si atrova in questa terra et sichondo m'è stato afirmatto nè l'una nè l'altra non sono da vendere per pretio nesuno, però che li hanno fatte fare per volerle godere per loro; sicchè mi doglio non poter satisfar al dexiderio de quella ecc.
Venetijs VII novembris 1510.
Servitor
Thadeus Albanus.

1888. Luzio, 47.

MARCANTONIO MICHIEL, *Notizia d'opere del disegno*
In Padua

In casa di Misser Pietro Bembo.
Li dui quadretti di capretto inminiati furono di mano di Julio Compagnola; l'uno è **una nuda** tratta da Zorzi, stesa e volta, et l'altro una nuda che da acqua ad uno albero, tratta dal Diana, cun dui puttini che zappano. p. 22

Works in Venice.

1525 In casa de M. Taddeo Contarino, 1525.
La tela a oglio delli 3 **phylosophi** nel paese, dui ritti et uno sentado che contempla gli raggii solari cun quel saxo finto così mirabilmente, fu cominciata da Zorzo da Castelfranco, et finita da Sebastiano Venitiano. p. 86
La tela grande a oglio de **linferno cun Enea et Anchise** fo de mano de Zorzo da Castelfranco.
La tela del paese cun el **nascimento de Paris,** cun li dui pastori ritti in piede, fu de mano de Zorzo da Castelfranco, et fu delle sue prime opere. p. 88

1525 In casa de M. Hieronimo Marcello, a S. Thomado, 1525.
Le **ritratto** da esso **M. Hieronimo armato,** che mostra la schena, insino al cinto, et volta la testa, fo de mano de Zorzo da Castelfranco.
La tela della **Venere nuda,** che dorme in uno paese cun Cupidine, fo de mano de Zorzo da Castelfranco, ma lo paese et Cupidine forono finiti da Titiano. p. 88
El **S. Hieronimo** insin al cinto, che legge, fo de mano de Zorzo da Castelfranco. p. 90

1528 In casa de M. Zuanantonio Venier, 1528.
El **soldato armato** insino al cinto ma senza celada, fo de man de Zorzi da Castelfranco. p. 98

1530 In casa de M. Chabriel Vendramin, 1530.
El paesetto in tela cun **la tempesta,** cun la cingana et soldato, fo de man de Zorzi da Castelfranco.
El **Christo morto** sopra el sepolcro, cun lanzolo chel sostenta, fo de man de Zorzi da Castelfranco reconzata da Titiano. p. 106

1531 In casa de M. Zuan Ram, 1531, a S. Stephano.
La pittura della testa del **pastorello** che tien in man un frutto, fo de man de Zorzi da Castelfranco.
La pittura della **testa del garzone che tien in man la saetta** fo di man di Zorzo da Castelfranco. p. 104

1532 In casa di M. Antonio Pasqualino 1532, 5 Zener.
La **testa del gargione** che tiene in mano la frezza, fu de man de Zorzi da Castelfrancho, havuta da M. Zuan Ram, della quale esso M. Zuane ne ha un ritratto, benche egli creda che sii el proprio. p. 78
La **testa del S. Jacomo** cun el bordon, fu de man de Zorzi da Castelfrancho, over de qualche suo discipulo, ritratto dal Christo de S. Rocho. p. 80

1532 In casa de M. Andrea di Oddoni, 1532.
El **San Hieronimo nudo** che siede in un deserto al lume della luna fu de mano de... ritratto da una tela de Zorzi da Castelfrancho. p. 86

1543 In casa de M. Michiel Contarini alla Misericordia, 1543 austo.
Il nudo a pena in un paese fu di man di Zorzi, et è il nudo che ho io in pittura delistesso Zorzi. p. 114

1588. [Michiel], ed. Frimmel, 1888.

BALDASSARE CASTIGLIONE, *Il Cortegiano*

1528 Eccovi che nella pittura sono eccellentissimi

Leonardo Vincio, il Mantegna, Raffaello, Michelangelo, Georgio da Castelfranco: nientedimeno, tutti son tra sè nel far dissimili; di modo che ad alcun di loro non par che manchi cosa alcuna in quella maniera, perchè si conosce ciascun nel suo stil essere perfettissimo.

1528. Castiglione.

PAOLO PINO, *Dialogo di Pittura*

1548 LAURO. Voglio che sappiate, ch'oggi dì ui sono de ualenti pittori. Lasciamo il Peruggino, Giotto Firentino, Raphaello d'Urbino, Leonardo Vinci, Andrea Mantegna, Giuan Bellino, Alberto Duro, Georgione... Non ui pongo Michel Angelo, ne Titiano, per questi duo li tengo, come Dei, & come capi de pittori, & questo lo dico ueramente senza passione alcuna... LAURO. Voi m'hauete sodisfatto benissimo, & se la memoria mia conserua il ragionamento uostro, chiuderò la bocca à questi, che uoranno diffendere la scultura, come per un'altro modo furno confusi da Georgione da castel franco nostro pittor celeberrimo, & non manco degli antichi degno d'honore. Costui à perpetua confusione de gli scultori dipinse in un quadro un **san Georgio** armato in piedi appostato sopra un tronco di lancia con li piedi nelle istreme sponde d'una fonte limpida, & chiara nella qual trasuerberaua tutta la figura in scurzo sino alla cima del capo, poscia hauea finto uno specchio appostato à un tronco, nel qual riflettaua tutta la figura integra in schena, & un fianco. Vi finse un'altro specchio dall'altra parte, nel qual si uedeua tutto l'altro lato del S. Georgio, uolendo sostentare, ch'uno pittore può far uedere integramente una figura à uno sguardo solo, che non può cosi far un scultore, & fù questo opera (come cosa di Georgione) perfettamente intesa in tutte tre le parti di pittura, cio è disegno, inuentione, & colorire.

FABIO. Questo si può facilmente credere, perch'egli fù (come dite) huomo perfetto, & raro, & è opera degna di lui, & atta d'aggrandire l'ali alla sua chiara fama.

1548. Pino, 124, 139, ed. Pallucchini, 1946.

DONI, *Disegno*

1549 In una lettera a Simone Carnesecchi l'autore gli suggerisce di vedere:
A Vinegia Quattro cavalli divini, le cose di Giorgione da Castel Franco Pittore, la storia di Titiano (huomo eccellentissimo) in palazzo, la facciata della casa dipinta dal Pordonone sopra il Canal grande e poche altre cose'.

1549. Doni, 51.

GIORGIO VASARI, *The Lives of the most excellent Painters, Sculptors and Architects*
(in italics those passages which do not differ in the 1568 Edition)

1550 Proemio della terza parte, delle vite
Seguitò dopo lui (Lionardo) ancora che alquanto lontano, Giorgione da Castelfranco; Il quale sfumò le sue pitture, et dette una terribil' movenzia a certe cose come è una **storia nella scuola di San Marco** a Venezia, dove è un tempo torbido che tuona, et trema il dipinto et le figure si muovono, et si spiccano da la tavola, *per una certa oscurità di ombre bene intese.*

GIOVANNI BELLINI
Dicesi che ancora Giorgione da Castelfranco attese a quella arte seco ne suoi primi principii.

1550. Vasari, 454.

GIORGIONE DA CASTEL FRANCO PAINTER OF VENICE
Quegli che con le fatiche cercano la virtù: ritrovata che l'hanno, la stimano come vero tesoro; et ne diventano amici; nè si partono giamai da essa. Conciosia che non è nulla il cercare delle cose: ma la difficultà è poi che le persone l'ànno trovate, il saperle conservare et accrescere. Perchè ne' nostri artefici si sono molte volte veduti sforzi maravigliosi di natura, nel dar saggio di loro: i quali per la lode montati poi in superbia, non solo non conservano quella prima virtù, che hanno mostro e con difficultà messo in opera: ma mettono oltra il primo capitale in bando la massa de gli studi nell'arte da principio dallor cominciati; dove non manco sono additati per dimenticanti, ch'e' si fossero da prima per stravaganti et rari, et dotati di bello ingegno. Ma non già così fece il nostro Giorgione il quale imparando senza maniera moderna, cercò nello stare co' Bellini in Venezia, et da sè, di imitare sempre la natura il più che e' poteva. Nè mai per lode che e' ne acquistasse, intermisse lo studio suo, anzi quanto più era giudicato eccellente da altri, tanto pareva allui saper meno, quando a paragone delle cose vive considerava le sue pitture; le quali per non essere in loro la vivezza dello spirito, reputava quasi non nulla. Perilchè tanta forza ebbe in lui questo timore, che lavorando in Vinegia fece maravigliare non solo quegli, che nel suo tempo furono, ma quegli ancora, che vennero dopo lui. Ma perché meglio si sappia l'origine et il progresso d'un Maestro tanto eccellente, cominciando da' suoi principii, dico *che in Castelfranco in sul Trevisano nacque l'anno* MCCCCLXXVII *Giorgio dalle fattezze della persona et la grandezza dell'animo chiamato poi co'l tempo* GIORGIONE. *Il quale quantunque elli fusse nato di umilissima stirpe, non fu però se non gentile et di buoni costumi in tutta sua vita. Fu allevato in Vinegia, et dilettossi continuamente delle cose d'amore, et piacqueli il suono del liuto mirabilmente: Anzi tanto, che egli sonava et cantava nel suo tempo tanto divinamente, che egli era spesso per quello adoperato a diverse musiche, et onoranze, et ragunate di persone nobili. Attese al disegno, et lo gustò grandemente; et in quello la natura lo favorì sì forte, che egli innamoratosi* di lei *non voleva mettere in opera cosa, che egli dal vivo non la ritraessi. Et tanto le fu suggetto, et tanto andò imitandola: che non solo egli acquistò nome di aver passato Gentile et Giovanni Bellini; ma di competere con coloro che lavoravano in Toscana et erano autori della maniera moderna. Diedegli la natura tanto benigno spirito: che egli nel colorito a olio et a fresco fece alcune*

vivezze et altre cose morbide, et unite, et sfumate talmente negli scuri: che fu cagione che molti di quegli che erano allora eccellenti, confessassino lui esser' nato per metter lo spirto nelle figure; et per contraffar la freschezza della carne viva, più che nessuno che dipignesse, non solo in Venezia, ma per tutto. Lavorò in Vebezia nel suo principio molti quadri di Nostre Donne, et altri ritratti di naturale, che son et vivissimi et belli; come ne può far fede uno che è *in Faenza in Casa Giovanni da* **Castél Bolognése** *intagliatore eccellente; che è fatto per il Suocero suo, lavoro veramente divino; perche vi è una unione sfumata ne' colori, che pare di rilievo più che dipinto. Dilettosi molto del dipignere in fresco: et fra molte cose che fece, egli condusse tutta una facciata di* **Ca Soranzo** *in su la piazza di S. Polo. Nella quale oltra molti quadri et storie, et altre sue fantasie, si vede un quadro lavorato a olio in su la calcina; cosa che ha retto alla acqua, al Sole, e tetal vento; et conservatasi fino ad oggi.* Crebbe tanto la fama di Giorgione per quel città che avendo il Senato fatto fabricare il Palazzo detto il **Fondaco de' Todeschi** al ponte del Rialto: ordinarono che Giorgione dipignesse a fresco la facciata di fuori: dove egli messovi mano si acese talmente nel fare; che vi sono teste e pezzi di figure molto ben fatte, e colorite vivacissimamente, et attese in tutto quello che egli vifece, che traesse a 'l segno delle cose vive: et non a imitazione nessuna della maniera. La quale opera è celebrata in Venezia: et famoso non meno per quello che e' vi fece: che per il comodo delle mercanzie, et utilità del publico. Gli fu allogata la tavola di **San Giovan' Grisostomo** di Venezia che è molto lodata, per avere egli in certe parti imitato forte il vivo della natura e dolcemente allo scuro fatto perdere l'ombre delle figure. *Fugli allogato* ancora una storia che poi quando l'ebbe finita, fu posta nella scuola di San Marco in su la piazza di San Giovanni et Paulo, nella stanza dove si raguna l'Offizio, in compagnia di diverse storie fatte da altri Maestri, nella quale è una **tempesta di mare,** et barche che hanno fortuna, et un Gruppo di figure in aria et diverse forme di diavoli che soffiano i venti, et altri in barca che remano. La quale per il vero è tale e sì fatta che nè pennello nè colore, nè immaginazion' di mente può esprimere la più orrenda et più paurosa pittura di quella, Avendo egli colorito sì vivamente la furia dell'onde del mare; il torcere delle barche, il piegar' de' remi et il travaglio di tutta quell'opera, nella scurità di quel tempo, per i lampi, et per l'altre minuzie che contraffece Giorgione, che e' si vede tremare la tavola, e scuotere quell'opera come ella fusse vera. Per la qual cosa certamente lo annovero fra que' rari che possono esprimere nella pittura il concetto de' loro pensieri. Avvenga che, mancato il furore: suole addormentarsi il pensiero: durandosi tanto tempo, a condurre una opera grande. Questa pittura è tale per la bontà sua, et per lo avere espresso quel concetto difficile, che e' meritò di essere stimato in Venezia; et onorato da noi fra i buoni Artefici. *Lavorò un quadro d'un* **Christo che porta la croce,** *et un Giudeo lo tira: il quale co'l tempo fu posto nella chiesa di Santo Rocco: et oggi per la devozione che vi hanno molti, fa miracoli, come si vede. Lavorò in diversi luoghi, come a Castel Franco ,et nel Trevisano, et fece molti ritratti a vari principi Italiani: et fuor di Italia furon' mandate molte de l'opere sue, come*

cose degne veramente, per far testimonio che se la Toscana sovrabbondava di artefici in ogni tempo, la parte ancora di là vicino a' monti non era abbandonata et dimenticata sempre dal Cielo. Mentre Giorgione attendeva ad onorare et se et la patria sua, nel molto conversar che e' faceva per trattenere con la musica molti suoi amici, si innamorò di una Madonna, et molto goderono l'uno et l'altra de' loro amori. Avvenne che l'anno MDXI, ella infeto di peste non ne sapendo però altro: et praticandovi Giorgione al solito, se li appiccò la peste di maniera, che in breve tempo nella età sua di XXXIIII anni, se ne passò a l'altra vita, non senza dolore infinito di molti suoi amici, che lo amavano per le sue virtù. Et ne increbbe ancora a tutta quella città: Pure tollerarono il danno et la perdita con lo essere restati loro duoi eccellenti suoi creati Sebastiano *Viniziano che fu poi frate del Piombo a Roma: et* Tiziano da Cador' *che non solo lo paragonò ma lo ha superato grandemente.* Come ne fanno le rarissime pitture sue, et il numero infinito de' bellissimi suoi ritratti di naturale, non solo di tutti i principi Christiani, ma de' più belli ingegni che sieno stati ne' tempi nostri. Costui dà vivendo vita alle figure che e' fa vive, come darà et vivo et morto fama et alla sua Venezia, et alla nostra terza maniera. Ma perché e' vive, et si veggono l'opere sue, non accade qui ragionarne. p. 577

MORTO DA FELTRE, PAINTER
Perchè venutogli a noia lo stare a Fiorenza; si trasferì a Vinegia. Et con Giorgione da Castelfranco, ch'allora lavorava il **fondaco de' Tedeschi,** *si mise ad aiutarlo, facendo gli ornamenti di quella opera. Et in quella città dimorò molti mesi, tirato da i piaceri et da i diletti, che per il corpo vi trovava.* p. 835

1550. Vasari, pp. 454-835.

Lodovico Dolci, *Dialogo della Pittura intitolato l'Aretino*

1557 Aretino. (Giambellino) è stato dipoi vinto da Giorgio da Castelfranco; e Giorgio lasciato a dietro infinite miglia da Titiano: il quale diede alle sue figure una Heroica Maestà, e trovò una maniera di colorito morbidissima, e nelle tinte cotanto simile al vero, che si può ben dire con verità, ch'ella va di pari con la Natura. p. 5

Aretino. (La Signoria di Venezia) fece ancora (ma molto a dietro) dipinger dal di fuori il **fondaco de' Tedeschi** a Giorgio da Castelfranco: et a Titiano medesimo, che alhora era giovanetto, fu allogata quella parte, che riguarda la Merceria. p. 21

Aretino. Fu appresso Pittor di grande stima ma di maggiore aspettatione Giorgio da Castelfranco, di cui si veggono alcune cose a olio vivacissime e sfumate tanto, che non si scorgono ombre. Morì questo valente huomo di peste, con non poco danno della pittura. p. 52

Aretino. Per questo Tiziano lasciando quel goffo Gentile, ebbe mezzo di accostarsi a Giovanni Bellino; ma nè anco quella maniera compiutamente piacendogli, elesse Giorgio da Castelfrano. Disegnando adunque Tiziano et dipingendo con Giorgione (che così era

chiamato) venne in poco tempo così valente nell'arte, che dipingendo Giorgione la faccia del **fondaco de' Tedeschi,** che riguarda sopra il Canal grande, fu allogata a Tiziano, come dicemmo, quell'altra che soprasta alle mercerie, non avendo egli allora appena venti anni. Nella quale vi fece una **Giuditta** mirabilissima di disegno e di colorito, a tale, che credendosi comunemente, poi che ella fu discoverta, che ella fosse opera di Giorgione, tutti i suoi amici seco si rallegravano, come della miglior cosa di gran lunga ch'egli avesse fatto. Onde Giorgione con grandissimo suo dispiacere, rispondeva ch'era di mano del discepolo; il quale dimostrava già di avanzare il maestro, e che è più, stette alcuni giorni in casa, come disperato, veggendo, che un giovanetto sapeva più di lui.
FABRINI. Intendo che Giorgione ebbe a dire, che Tiziano insino nel ventre di sua madre era pittore.
ARETINO. Non passò molto che gli fu data a dipingere una gran tavola all'altar grande della chiesa de' Frati minori; ove Tiziano pur giovanetto dipinse a olio la Vergine, che ascende al cielo, fra molti angioli che l'accompagnano, e di sopra lei raffigurò un Dio Padre attorniato da due angioli... E tuttavia questa fu la prima opera pubblica, che a olio facesse: e la fece in pochissimo tempo, e giovanetto. Con tutto ciò i pittori goffi, e lo sciocco volgo, che insino allora non avevano veduto altro che le cose morte e fredde di Giovanni Bellino, di Gentile e del Vivarino (perchè Giorgione nel lavorare a olio non aveva ancora avuto lavoro pubblico; e per lo più non faceva altre opere, che mezze figure e ritratti) le quali erano senza movimento, e senza rilievo, dicevano della detta tavola un gran male. Dipoi raffreddandosi l'invidia, ed aprendo loro a poco a poco la verità gli occhi, cominciarono le genti a stupir della nuova maniera trovata in Venezia da Tiziano: e tutti i pittori d'indi in poi s'affaticarono d'imitarla: ma per esser fuori della strada loro, rimanevano smarriti. E certo si può attribuire a miracolo, che Tiziano senza aver veduto allora le anticaglie di Roma, che furono lume a tutti i pittori eccellenti, solamente con quella poco favilluccia ch'egli aveva scoperta nelle cose di Giorgione, vide e conobbe l'idea del dipingere perfettamente. p. 54
1557. Dolce.

Giovanni Antonio di Grimani Collection

1563 «Uno quadro de uno **prexepio** de man de zorzi da chastelfranco per ducati 10 ».
Stima di Paris Bordone. 1910. Fogolari, 8.

LODOVICO DOLCE, *Dialogo nel quale si ragiona delle qualità, diversità, e propria dei colori*

1565 'Ti potrei dir di molti: ma ti dirò dei più eccellenti. Questi sono, Michel'Agnolo, Rafaello d'Urbino, Titiano, Giorgio da Castelfranco, Antonio da Correggio, il Parmegianino, il Pordonone, e simili.'
1565. Dolce, 64.

GABRIELE VENDRAMIN's *'Cabinet of Curiosities'*

1567 Die x Septembris 1567.
Uno quadreto con **do figure** dentro de *chiaro scuro* de man de Zorzon de Castelfranco.
1569 Die 14 Martii 1569.
Un quadro de man de Zorzon de Castelfranco con **tre testoni che canta.**
Un altro quadro de **una cingana un pastor in un paeseto** con un ponte con suo finimento da noghera con intagli et paternostri doradi de man de Zorzi de Castelfranco.
Una **nostra Dona** de man De Zorzi de Castelfranco con suo fornimento dorado et intagiado.
Un quadreto con **tre teste** che vien da Zorzi con sue soazete de legno alla testa de mezo ha la goleta de ferro.
Il **retrato della madre de Zorzon** de man de Zorzon con suo fornimento depento con l'arma de chà Vendramin.
1920. Ravà, 155.

GIORGIO VASARI, *The Lives of the most excellent Painters, Sculptors and Architects*
1568 Second Edition
(The passages taken from the First Edition of 1550 are in italics)

Proemio di tutta l'opera.
Soggiungono ancora, che dove gli scultori fanno insieme due o tre figure al più d'un marmo solo, essi ne fanno molte in una tavola sola, con quelle tante e sì varie vedute, che coloro dicono che ha una statua sola, ricompensando con la varietà delle positure, scorci ed attitudini loro, il potersi vedere intorno intorno quelle degli scultori: come già fece Giorgione da Castelfranco in una sua pittura, la quale, voltando le spalle ed avendo due specchi, uno da ciascun lato, ed una fonte d'acqua a' piedi, mostra nel dipinto il dietro, nella fonte il dinanzi, e negli specchi i lati; cosa che non ha mai potuto far la scultura.

Proemio Alla Parte Terza
Seguitò dopo lui, ancora che alquanto lotano, Giorgione da Castel Franco, il quale sfumò le sue pitture, e dette una terribil movenzia alle sue cose, per una certa oscurità di ombre bene intese. IV. 11

GIORGIONE DA CASTELFRANCO
Ne' medesimi tempi che Fiorenza acquistava tanta fama per l'opere di Lionardo, arrecò non piccolo ornamento a Vinezia la virtù ed eccellenza d'un suo cittadino, il quale di gran lunga passò i Bellini da loro tenuti in tanto pregio, e qualunque altro fino a quel tempo avesse in quella città dipinto. Questi fu Giorgio, *che in Castelfranco in sul Trevisan nacque l'anno 1478 essendo doge Giovan Mozenigo, fratel del doge Piero; dalle fattezze della persona e dalla grandezza dell'animo chiamato poi col tempo Giorgione; il quale, quantunque egli fusse nato d'umilissima stirpe, non fu però se non gentile e di buoni costumi in tutta sua vita. Fu allevato in Vinegia, e dilettossi continuamente delle cose d'amore, e piacqueli il suono del liuto mirabil-*

mente e tanto, che egli sonava e cantava nel suo tempo tanto divinamente, che egli era spesso per quello adoperato a diverse musiche e ragunate di persone nobili. Attese al disegno, e lo gustò grandemente, e in quello la natura lo favor' s' forte, che egli innamoratosi delle cose belle di lei *non voleva mettere in opera cosa che egli dal vivo non ritraesse. E tanto le fu suggetto e tanto andò imitandola, che non solo egli acquistò nome d'aver passato Gentile e Giovanni Bellini, ma di competere con coloro che lavoravano in Toscana, ed erano autori delle amaniera moderna.* Aveva veduto Giorgione alcune cose di mano di Lionardo molto fumeggiate e cacciate, come si è detto, terribilmente di scuro: e questa maniera gli piacque tanto, che, mentre visse, sempre andò dietro a quella, e nel colorito a olio la imitò grandemente. Costui gustando il buono dell'operare, andava scegliendo di mettere in opera sempre del più bello e del più vario che e' trovava. *Diedegli la natura tanto benigno spirito, che egli nel colorito a olio fece alcune vivezze ed altre cose morbide ed unite e sfumate negli scuri, che fu cagione che molti di quegli che erano allora eccellenti, confessassino lui esser nato per mettere lo spirito nelle e per contraffar la freschezza della carne viva più che nessuno che dipignesse non solo in Venezia, ma per tutto.*

Lavorò in Venezia nel suo principio molti quadri di Nostre Donne ed altri ritratti di naturale, che sono e vivissimi e belli, come se ne vede ancora tre bellissime teste a olio di sua mano nello studio del reverendissimo Grimani patriarca d'Aquileia, una fatta per **Davit** (e, per quel che si dice, è il suo ritratto), con una zazzera, come si costumava in que' tempi, infino alle spalle, vivace e colorita che par di carne: ha un braccio ed il petto armato, col quale tiene la testa mozza di Golia. L'altra è una testona maggiore, ritratta di naturale, che tiene in mano una berretta rossa da **comandatore,** con un bavero di pelle, e sotto uno di que' saioni all'antica: questo si pensa che fusse fatto per un generale di eserciti. La terza è d'un **putto,** bella quanto si può fare, con certi capelli a uso di veli, che fan conoscere l'eccellenza di Giorgione, e non meno l'affezione del grandissimo Patriarca ch'egli ha portato sempre alla virtù sua, tenendole carissime, e meritamente.

In Fiorenza è di man sua in casa de' figliuoli di **Giovan Borgherini** il ritratto d'esso Giovanni, quando era giovane in Venezia, e nel medesimo quadro il maestro che lo guidava; che non si può veder in due teste né miglior macchie di color di carne né più bella tinta di ombre. In casa Anton de' Nobili è un'altra testa d'un **capitano armato,** molto vivace e pronta, il qual dicono essere un de' capitani che Consalvo Ferrante menò seco a Venezia, quando visitò il doge Agostino Barbarigo; nel qual tempo si dice che ritrasse il gran **Consalvo** armato, che fu cosa rarissima, e non si poteva vedere pittura più bella che quella, e che esso Consalvo se la portò seco.

Fece Giorgione molti altri ritratti, che sono sparsi in molti luoghi per Italia, bellissimi, come ne può far fede quello di **Lionardo Loredano** fatto da Giorgione quando era doge, da me visto in mostra per un'Assensa, che mi parve veder vivo quel serenissimo principe; oltra che ne è uno *in Faenza in casa Giovanni da* **Castel Bolognese** *intagliatore di camei e cristalli eccellente, che è fatto per il suocero suo: lavoro veramente divino, perchè vi è una unione sfumata ne' colori, che pare di rilievo più che*

dipinto. Dilettosi molto del dipignere in fresco, e fra molte cose che fece, egli condusse tutta una facciata di **Cà Soranao** in su la piazza di San Polo, nella quale, oltra molti quadri e storie ed altre sue fantasie, si vede un quadro lavorato a olio in su la calcina; cosa che ha retto all'acqua ,al sole ed al vento, e conservatasi fino a oggi. Ècci ancora una **Primavera,** che a me pare delle belle cose che e' dipignesse in fresco, ed è gran peccato che il tempo l'abbia consumata sì crudelmente. Ed io per me non trovo cosa che nuoca più al lavoro in fresco che gli scirocchi, e massimamente vicino alla marina, dove portono sempre salsedine con esso loro.

Seguì in Venezia l'anno 1504 al ponte del Rialto un fuoco terribilissimo nel **Fondaco de' Tedeschi** il quale le consumò tutto con le mercanzie, e con grandissimo danno de' mercanti: dove la signoria di Venezia ordinò di rifarlo di nuovo, e con maggior comodità di abituri e di magnificenza e d'ornamento e bellezza fu speditamente finito; dove essendo cresciuto la fama di Giorgione, fu consultato ed ordinato da chi ne aveva la cura, che Giorgione lo dipignesse in fresco di colori, secondo la sua fantasia, purché e' mostrasse la virtù sua e che e' facesse un'opera eccellente, essendo ella nel più e nella maggior vista di quella città. Per il che messovi mano Giorgione, non pensò se non a farvi figure a sua fantasia per mostrar l'arte; chè nel vero non si ritrova storie che abbino ordine o che rappresentino i fatti di nessuna persona segnalata o antica o moderna; ed io per me non l'ho mai intese, nè anche, per dimanda che si sia fatta, ho trovato chi l'intenda; perchè dove è una donna, dove è un uomo in varie attitudini; chi ha una testa di lione appresso, altra con un angelo a guisa di **Cupido;** nè si giudica quel che si sia. V'è bene sopra la porta principale che riesce in Merzerìa una femina a sedere, c'ha sotto una testa d'un gigante morta, quasi in forma l'una **Iudita,** ch'alza la testa con la spada, e parla con un Todesco quale è a basso; nè ho potuto interpretare per quel che se l'abbi fatta, se già non l'avesse voluta fare per una Germania. Insomma e' si vede ben le figure sue esser molto insieme, e che andò sempre acquistando nel meglio; *e vi sono teste e pezzi di figure molto ben fatte e colorite vivacissimamente; ed attese in tutto quello che egli vi fece che traesse al segno delle cose vive, e non a imitazione nessuna della maniera: la quale opera è celebrata in Venezia e famosa non meno per quello che e' vi fece, che per il commodo delle mercanzie ed utilità del pubblico.*

Lavorò un quadro d'un **Cristo che porta la croce** *ed un Giudeo lo tira, il quale col tempo fu posto nella chiesa di San Rocco, ed oggi, per la devozione che vi hanno molti, fa miracoli, come si vede. Lavorò in diversi luoghi come a Castelfranco e nel Trivisano, e fece molti ritratti e varj principi italiani; e fuor d'Italia furono mandate molte dell'opere su come cose degne veramente, per far testimonio che se la Toscana soprabbondava di artefici in ogni tempo, la parte ancora di là vicino a' monti non era abbandonata e dimenticata sempre dal cielo.*

Dicesi che Giorgione ragionando con alcuni scultori nel tempo che Andrea Verrocchio faceva il cavallo di bronzo, che volevano, perchè la scultura mostrava in una figura sola diverse positure e vedute girandogli attorno, che per questo avanzasse la pittura, che non mostrava in una figura se non una parte sola; Giorgione,

che era d'oppinione che in una storia di pittura si mostrasse, senza avere a caminare attorno, ma in una sola occhiata tutte le sorti delle vedute che può fare in più gesti un uomo, cosa che la scultura non può fare se non mutando il sito e la veduta, tal che non sono una, ma più vedute; propose di più, che da una figura sola di pittura voleva mostrare il dinanzi ed il dietro e i due profili dai lati; cosa che e' fece mettere loro il cervello a partito; e la fece in questo modo. Dipinse **uno ignudo** che voltava le spalle ed aveva in terra una fonte d'acqua limpidissima, nella quale fece dentro per riverberazione la parte dinanzi: da un de' lati era un corsaletto brunito che s'era spogliato, nel quale era il profilo manco, perchè nel lucido di quell'arme si scorgeva ogni cosa; dall'altra parte era uno specchio che drento vi era l'altro lato di quello ignudo; cosa di bellissimo ghiribizzo e capriccio, volendo mostrare in effetto che la pittura conduce con più virtù e fatica, e mostra in una vista sola del naturale più che non fa la scultura: la quall'opera fu sommamente lodata e ammirata per ingegnosa e bella. Ritrasse ancora di naturale **Caterina regina** di Cipro, qual viddi io già nelle mani del clarissimo messer Giovan Cornaro. È nel nostro libro una testa colorita a olio, ritratta da un **Todesco di casa Fucheri**, che allora era de' maggiori mercanti nel fondaco de' Tedeschi; la quale è cosa mirabile; insieme con altri schizzi e disegni di penna fatti da lui.
Mentre Giorgione attendeva ad onorare a sè e la patria sua, nel molto conversar che e' faceva per trattenere con la musica molti suoi amici, s'innamorò d'una madonna, e molto goderono l'uno e l'altra de' loro amori. Avenne che l'anno 1511 ella infettò di peste; non sapendo però altro e praticandovi Giorgione al solito, se li appiccò la peste di maniera, che in breve tempo nella età sua di trentaquattro anni se ne passò all'altra vita, non senza dolore infinito di molti suoi amici che lo amavano per le sue virtù, e danno del mondo che perse. Pure tollerarono il danno e la perdita con lo esser restati loro due eccellenti suoi creati: Sebastiano Viniziano, che fu poi frate del Piombo a Roma, e Tiziano da Cadore, che non solo paragonò, ma lo ha superato grandemente: de' quali a suo luogo si dirà pienamente l'onore e l'utile che hanno fatto a questa arte. IV. 91

JACOPO, GIOVANNI AND GENTILE BELLINI
Dicesi che anco Giorgione da Castelfranco attese all'arte con Giovanni, en' suoi primi principj. III. 172

GIOVANNI ANTONIO LICINIO DA PORDENONE
Costui nacque in Pordenone, castello del Friuli, lontano da Udine 25 miglia; e perchè fu dotato dalla natura di bello ingegno ed inclinato alla pittura, si diede senza altro maestro a studiare le cose naturali, imitando il fare di Giorgione da Castelfranco, per essergli piaciuta assai quella maniera da lui veduta molte volte in Venezia. V. 111

MORTO DA FELTRE
Perchè venutogli a noia lo stare a Fiorenza, si trasferì a Vinegia; e con Giorgione da Castelfranco, ch'allora lavorava il **Fondaco de' Tedeschi**, *si mise a aiutarlo, facendo gli ornamenti di quella opera; e così in quella città dimorò molti mesi, tirato dai piaceri e dai diletti che per il corpo vi trovava.* V. 204

JACOMO PALMA
Fece oltre ciò il Palma, per la stanza dove si ragunano gli uomini della Scuola di San Marco, in su la piazza di San Giovanni e Paulo, a concorrenza di quelle che già fecero Gian Bellino, Giovanni Mansueti, ed altri pittori, una bellissima storia, nella quale è dipinta una nave che conduce il corpo di San Marco a Vinezia; nella quale si vede finto dal Palma una orribile **tempesta di mare,** ed alcune barche combattute dalla furia de' venti, fatte con molto giudicio e con belle considerazioni; sì come è anco un gruppo di figure in aria, e diverse forme di demonj che soffiano a guisa di venti nelle barche, che andando a remi e sforzandosi con vari modi di rompere l'inimiche ed altissime onde, stanno per somergersi. Insomma quest'opera, per vero dire, è tale e sì bella per invenzione e per altro, che pare quasi impossibile che colore o pennello, adoperati da mani anco eccellenti, possino esprimere alcuna cosa più simile al vero o più naturale; atteso che in essa si vede la furia de' venti, la forza e destrezza degli uomini, il muoversi dell'onde, i lampi e baleni del cielo, l'acqua rotta dai remi, ed i remi piegati dall'onde e dalla forza de' vogadori. Che più? Io per me non mi ricordo aver mai veduto la più orrenda pittura di quella; essendo talmente condotta e con tanta osservanza nel disegno, nell'invenzione e nel colorito, che pare che tremi la tavola, come tutto quello che vi è dipinto fusse vero: per la quale opera merita Iacopo Palma grandissima lode, e di essere annoverato fra quegli che posseggono l'arte, ed hanno in poter loro facultà d'esprimere nelle pitture le difficultà dei loro concetti; conciosiachè, in simili cose difficili, a molti pittori vien fatto nel primo abbozzare l'opera, come guidati da un certo furore, qualche cosa di buono e qualche fierezza, che vien poi levata nel finire, e tolto via quel buono che vi veva posto il furore: e questo avviene, perchè molte volte chi finisce considera le parti e non il tutto di quello che fa, e va (raffreddandosi gli spiriti) perdendo la vena della fierezza; là dove costui stette sempre saldo nel medesimo proposito, e condusse a perfezione il suo concetto, che gli fu allora e sarà sempre infinitamente lodato. V. 524

LORENZO LOTTO
Fu compagno ed amico del Palma Lorenzo Lotto pittor veneziano, il quale avendo imitato un tempo la maniera de' Bellini, s'appiccò poi a quella di Giorgione, come ne dimostrano molti quadri e ritratti che in Vinezia sono per le case de' gentil'uomini. V. 249
Essendo anco questo pittore giovane, ed imitando darte la maniera de' Bellini e parte quella di Giorgione, fece in San Domenico di Ricanati la tavola dell'altar maggiore, partita in sei quadri. V. 250

FRANCESCO TORBIDO
Francesco Torbido, detto il Moro, pittore veronese, imparò i primi principii dell'arte, essendo ancor giovinetto, da Giorgione da Castelfranco, il quale immitò poi sempre nel colorito e nella morbidezza. V. 291
Ma è ben vero, che sebbene tenne sempre la maniera di Liberale, immitò nondimeno nella morbidezza e colorire sfumato Giorgione suo primo precettore, parendogli che le cose di Liberale, buone per altro, avessero un poco del secco. V. 292

SEBASTIAN VINIZIANO

Venutagli poi voglia, essendo anco giovane, d'atten-
dere alla pittura, apparò i primi principj da Giovan
Bellino allora vecchio. E doppo lui, avendo Giorgione
da Castel Franco messi in quella citta i modi della
maniera moderna più uniti, e con certo fiammeggiare
di colori, Sebastiano si partì da Giovanni e si acconciò
con Giorgione; col quale stette tanto, che prese in
gran parte quella maniera...
Fece anco in que' tempi in **San Giovanni Grisostomo**
di Vinezia una tavola con alcune figure, che tengono
tanto della maniera di Giorgione, ch'elle sono state al-
cuna volta, da chi non ha molta cognizione delle cose
dell'arte, tenute per di mano di esso Giorgione: la
qual tavola è molto bella, e fatta con una maniera di
colorito, ch'ha gran rilievo.
Andatosene dunque a Roma, Agostino lo mise in ope-
ra; e la prima cosa che gli facesse fare, furono gli ar-
chetti che sono in su la loggia, la quale risponde in sul
giardino, dove Baldassarre Sanese aveva nel palazzo
d'Agostino in Trastevere tutta la volta dipinta: nei
quali archetti Sebastiano fece alcune poesie di quella
maniera ch'aveva recato da Vinegia, molto disforme
da quella che usavano in Roma i valenti pittori di que'
tempi. Dopo quest'opera avendo Raffaello fatto in que'
medesimo luogo una storia di Galatea, vi fece Bastiano,
come volle Agostino, un Polifemo in fresco a lato a
quella; nel quale, comunque gli riuscisse, cercò d'avan-
zarsi più che poteva, spronato dalla concorrenza di
Baldassarre Sanese, e poi di Raffaello. Colorì similmente
alcune cose a olio, delle quali fu tenuto, per aver egli
da Giorgione imparato un modo di colorire assai mor-
bido, in Roma grandissimo conto. V. 565-7

BENVENUTO GAROFALO

Fu amico di Giorgione da Castelfranco pittore, di Ti-
ziano da Cador, e di Giulio Romano, ed in generale
affezionatissimo a tutti gli uomini dell'arte. VI. 468

GIOVANNI DA UDINE

Questa inclinazione (al disegno) veggendo Francesco
suo padre, lo condusse a Vinezia, e lo pose a imparare
l'arte del disegno con Giorgione da Castelfranco; col
quale dimorando il giovane, sentì tanto lodare le cose
di Michelangelo e Raffaello, che si risolvè d'andare a
Roma ad ogni modo. E così, avuto lettere di favore da
Domenico Grimano, amicissimo di suo padre, a Bal-
dassarri Castiglioni, segretario del duca di Mantoa ed
amicissimo di Raffaello da Urbino, se n'andò là.
Giovanni adunque essendo stato pochissimo in Vine-
zia sotto la disciplina di Giorgione, veduto l'andar dol-
ce, bello e grazioso di Raffaello, si dispose, come gio-
vane di bell'ingegno, a volere a quella maniera attenersi
per ogni modo. VI. 550

TITIAN OF CADORE

Ma venuto poi, l'anno circa 1507, Giorgione da Castel-
franco, non gli piacendo in tutto il detto modo di fare
cominciò a dare alle sue opere più morbidezza e mag-
giore rilievo con bella maniera; usando nondimeno di
cacciarsi avanti le cose vive e naturali, e di contrafarl
quanto sapeva il meglio con i colori, e macchiarle con
le tinte crude e dolci, secondo che il vivo mostrava,
senza far disegno; tenendo per fermo che il dipingere
solo con i colori stessi, senz'altro studio di disegnare
in carta, fusse il vero e miglior modo di fare ed il vero
disegno. Ma non s'accorgeva, che egli è necessario a
chi vuol bene disporre componimenti, ed accomodare
l'invenzioni, ch'e' fa bisogno prima in più modi dif-
ferenti porle in carta, per vedere come il tutto torna
insieme. Conciosiachè l'idea non può vedere nè imma-
ginare perfettamente in sè stessa l'invenzioni, se non
apre e non mostra il suo concetto agli occhi corporali
che l'aiutino a farne buon giudizio: senza che pur bi-
sogna fare grande studio sopra gl'ignudi a volergli in-
tender bene; il che non vien fatto, nè si può, senza
mettere in carta: ed il tenere, sempre che altri colorisce,
persone ignude innanzi ovvero vestite, è non piccola
servitù. Laddove, quando altri ha fatto la mano dise-
gnando in carta, si vien poi di mano in mano con più
agevolezza a mettere in opera disegnando e dipignendo:
e così facendo pratica nell'arte, si fa la maniera ed il
giudizio perfetto, levando via quella fatica e stento con
che si conducono le pitture, di cui si è ragionato di
sopra: per non dir nulla che, disegnando in carta, si
viene a empiere la mente di bei concetti, e s'impara a
fare a mente tutte le cose della natura, senza avere a
tenerle sempre innanzi, o ad avere a nascere sotto la
vaghezza de' colori lo stento del non sapere disegnare;
nella maniera che fecero molti anni i pittori viniziani,
Giorgione, il Palma, il Pordenone, ed altri che non
videro Roma nè altre opere di tutta perfezione. Tiziano
adunque, veduto il fare e la maniera di Giorgione,
lasciò la maniera di Gian Bellino, ancorchè vi avesse
molto tempo consumato, e si accostò a quella, così bene
imitando in brieve tempo le cose di lui, che furono le
sue pitture talvolta scambiate e credute opere di Gior-
gione, come di sotto si dirà.
A principio, dunque, che cominciò seguitare la manie-
ra di Giorgione, non avendo più che diciotto anni,
fece il ritratto d'un gentiluomo da ca **Barbarigo** amico
suo, che fu tenuto molto bello, essendo la somiglianza
della carnagione propria e naturale, sì ben distinti i
capelli l'uno dall'altro, che si conterebbono, come anco
si farebbono i punti d'un giubone di raso inargentato
che fece in quell'opera. Insomma, fu tenuto sì ben fatto
e con tanta diligenza, che, se Tiziano non vi avesse
scritto in ombra il suo nome, sarebbe stato tenuto opera
di Giorgione. Intanto avendo esso Giorgione condotta
la facciata dinanzi del **fondaco de' Tedeschi**, per
mezzo del Barbarigo furono allogate a Tiziano alcune
storie che sono nella medesima sopra la Merceria.
Nella quale facciata non sapendo molti gentiluomini
che Giorgione non vi lavorasse più, nè che la facesse
Tiziano, il quale ne aveva scoperto una parte, scontran-
dosi in Giorgione come amici si rallegravano seco,
dicendo che si portava meglio nella facciata di verso la
Merceria, che non aveva fatto in quella che è sopra il
Canal grande: della qual cosa sentiva tanto sdegno
Giorgione, che infino che non ebbe finita l'opera del
tutto, e che non fu notissimo che esso Tiziano aveva
fatta quella parte, non si lasciò molto vedere, e da indi
in poi non volle che mai più Tiziano praticasse, o
fusse amico suo.
Appresso, tornato a Vinezia, dipinse la **facciata de'
Grimani**; e in Padoa nella chiesa di Sant'Antonio,

alcune storie, pure a fresco, de' fatti di quel Santo; e in quella di Santo Spirito fece in una piccola tavoletta un San Marco a sedere in mezzo a certi Santi, ne' cui volti sono alcuni ritratti di naturale fatti a olio con grandissima diligenza; la qual tavola molti hanno creduto che sia di mano di Giorgione. Essendo poi rimasa imperfetta, per la morte di Giovan Bellino, nella sala del gran Consiglio una storia, dove **Federigo Barba-rossa** alla porta della chiesa di San Marco sta ginocchioni innanzi a papa Alessandro terzo, che gli mette il piè sopra la gola, la fornì Tiziano, mutando molte cose, e facendovi molti ritratti di naturale di suoi amici ed altri; onde meritò da quel Senato avere nel fondaco de' Tedeschi un uffizio che si chiama la Senseria, che rende trecento scudi l'anno. VII. 427-32
Per la chiesa di Santo Rocco fece, dopo le dette opere, in un quadro, **Cristo con la croce** in spalla e con una corda al collo tirata da un ebreo; la qual figura, che hanno molti creduto sia di mano di Giorgione, è oggi la maggior divozione di Vinezia, ed ha avuto di limosine più scudi, che non hanno in tutta la loro vita guadagnato Tiziano e Giorgione. VII. 437

PARIS BORDONE

Ma quegli che più di tutti ha imitato Tiziano, è stato Paris Bordone, il quale, nato in Trevisi di padre trivisano e madre viniziana, fu condotto d'otto anni a Vinezia in casa alcuni suoi parenti. Dove imparato che ebbe gramatica e fattosi eccellentissimo musico, andò a stare con Tiziano: ma non vi consumò molti anni; perciochè vedendo quell'uomo non essere molto vago d'insegnare a' suoi giovani, anco pregato da loro sommamente, ed invitato con la pacienza a portarsi bene, si risolvè a partirsi; dolendosi infinitamente che di que' giorni fusse morto Giorgione, la cui maniera gli piaceva sommamente, ma molto più l'aver fama di bene e volentieri insegnare con amore quello che sapeva. Ma, poi che altro fare non si poteva, si mise Paris in animo di volere per ogni modo seguitare la maniera di Giorgione. E così datosi a lavorare ed a contrafere dell'opere di coui, si fece tale che venne in bonissimo credito; onde nella sua età di diciotto anni gli fu allogata una tavola da farsi per la chiesa di San Niccolò de' frati Minori. VII. 461

1878. Vasari-Milanesi.

G. B. Semenzi, *Treviso*

1574 Il signor Luigi Tescari di Castelfranco mi fu gentile additandomi un manoscritto di Andrea Meneghini juniore che fioriva nel 1574 dal quale risulterebbe che questo dipinto, di cui s'ebbe per tanto tempo incerta la provenienza, fosse eseguito dal Giorgione per la famiglia Spinelli di Castelfranco, che poscia passasse presso il vescovo di Treviso Alvise Molin e per ultimo dopo la morte di questo prelato al S. Monte.

1864, Semenzi, 714.

Marcantonio Michiel, *Notizia d'opere del disegno*

1575 Di mano posteriore:

In casa di M. Piero Servio, 1575.
Un **ritratto di suo padre** di mano di Giorgio da Castelfranco.

1888. [Michiel] ed. Frimmel, 110.

Francesco Sansovino, *Venetia città nobilissima*

1581 S. Giouanni Chrisostomo
Fu parimente restaurato San Giouanni Chrisostomo sul modello di Sebastiano da Lugano, ò secondo altri del Moro Lombardo, amendue assai buoni Architetti. Et nobilitato poi da Giorgione da Castel Franco famosissimo pittore, il quale vi cominciò la **palla grande con le tre virtu theologiche,** et fu poi finita da Sebastiano, che fù Frate del piombo in Roma, che vi dipinse à fresco la volta della tribuna. p. 56 b

San Rocco
Dalla destra in entrando, Titiano vi dipinse quella **palla famosa di Christo,** per la quale s'è fatta ricca la Fraterna, & la Chiesa. p. 71 b

Scuola di San Marco
Il quadro alla destra doue è espressa quella fortuna memorabile per la quale **S. Giorgio, San Marco,** est **San Nicolo,** usciti come dicono l'antiche scritture, dalle Chiese loro, **saluarono la Città,** fu di mano di Iacomo Palma, altri dicono di Paris Bordone. p. 102 a

1581. Sansovino.

Palazzo Vendramin
Et poco dicosto sono i Vendramini, il cui Palazzo con faccia di marmo, fu già ridotto de i virtuosi della Città. Percioche viuendo Gabriello amantissimo della Pittura, della Scultura, & dell'Architettura, vi fece molti ornamenti, & vi raccolse diuerse cose de i più famosi artefici del suo tempo. Percioche vi si veggono opere di Giorgione da Castel Franco, di Gian Bellino, di Titiano, di Michel Agnolo, & d'altri conseruate da suoi soccessori. p. 387

Feste
Belle & honorate parimente furono, le dimostrationi singolari di allegrezza, che si fecero l'anno 1571. per la Vittoria che si hebbe del Turco... S'adornò poi partita mente ogni bottega d'armi, di spoglie, di trofei de nemici presi nella giornata nauale, & di quadri marauigliosi di Gian Bellino, di Giorgione da Castel Franco, di Raffaello da Urbino, di Bastiano dal Piombo, di Michelagnolo, di Titiano, del Pordenone, & d'altri eccellenti Pittori. p. 415

1581. Sansovino (ed. Martinioni, 1663).

Raffaello Borghini, *Il Riposo*

1584 Libro Primo
Siccome allegano hauer fatto Giorgione da Castel Franco in una sua pittura, doue appariua una **figura, che** dimostraua le spalle rimirando una fontana, e **da cia-**

scun de lati haueua uno spécchio, talmente che nel dipinto mostraua il di dietro, nell'acqua chiarissima il dinanzi, e nelli specchi ambidue i fianchi, cosa che non può fare la scultura. p. 31

Libro Terzo
GIORGIONE **da** CASTEL FRANCO

Nel medesimo tempo che Firenze per l'opere di Lionardo s'acquistaua fama, Vinegia parimente per l'eccellenza di Giorgione da Castel Franco sul Treuigiano facea risonare il nome suo. Questi fu alleuato in Vinegia, e attese talmente al disegno che nella pittura passò Giouanni, e Gentile Bellini, e diede una certa viuezza alle sue figure che pareuan viue. Di sua mano ha il Reuerendissimo G4imani Patriarca d'Aquileia tre bellissime testa à olio, una fatta per un **Dauit**, l'altra è **ritratta** dal naturale, e **tiene una berretta rossa** in mano, e l'altra è d'un **fanciullo** bella quanto si possa fare co' capelli à vso di velli, che dimostrano l'eccellenza di Giorgione. Ritrasse in vn quadro **Giouanni Borgherini** quando era giouane in Vinegia, & il maestro, che il guidaua, e questo quadro è in Firenze appresso à figliuoli di detto Giuanni, sicome ancora è in casa Giulio de' Nobili una testa d'un **Capitano armato** molto viuace, e pronta. Fece molti altri ritratti, e tutti bellissimi, che sono sparsi per Italia in mano di più persone. Dilettosi molto di dipignere in fresco, e fra l'altre cose dipinse tutta una facciata di **cà Soranzo** su la piazza di San Polo in Vinegia, nella quale oltre à molti quadri, & historie, si vede un quadro lauorato à olio sopra la calcina che ha retto all'acqua, & al vento, e si è conseruato infino à hoggi: e dipinse etiandio à fresco le figure, che sono à **Rialto**, doue si veggono teste, e figure molto ben fatte, ma non si sa che historia egli far si volesse. Fece in un quadro **Christo, che porta la Croce**, e un Giudeo, che il tira, il quale fu poi posto nella Chiesa di San Rocco, e dicono che hoggi fa miracoli. Disputando egli con alcuni, che diceuono la scultura auanzar di nobiltà la pittura; percioche mostra in vna sola figura diuerse vedute, propose che da vna figura sola di pittura voleua mostrare il dinanzi, il didietro, & i due profili da i lati in una sola occhiata, senza girare attorno, come è di mestiero fare alle statue. Dipinse adunque uno **ignudo, che mostraua le spalle,** & in terra era una fontana di acqua chiarissima, in cui fece dentro per riuerberatione la parte dinanzi, da un de' lati era un corsaletto brunito, che si era spogliato, e nello splendore di quell'arme si scorgeua il profilo del lato manco, e dall'altra parte era uno specchio, che mostraua l'altro lato, cosa di bellissimo giudicio, e capriccio, e che fu molto lodata, & ammirata. Molte altre cose fece, che per breuità tralascio, e molte più perauentura ne harebbe fatte, e con maggior sue lode, se morte nell'età sua di 34 anni non l'hauesse tolto al mondo con dolore infinito di chiunque lo conoscea. p. 372

Libro Quarto

Titiano da Cador della famiglia, non degli Vcelli, come dice il Vasari, ma de' Veccelli, essendo di età di dieci anni, e conosciuto di bello ingegno, fu mandato in Vinegia, e posto con Giambellino pittore; acciochee egli l'arte della pittura apprendesse, col quale stato alcun tempo, & intanto essendo andato à stare in Vinegia

Giorgione da Castelfranco, si diede Titiano ad imitare la sua maniera, piacendoli piu che quella di Giambellino: e talmente contrafece le cose di Giorgione, che molte volte furono stimate le fatte da lui quelle di Giorgione stesso. Molte, e molte son l'opere, che fece Titiano, e particolarmente fu eccellentissimo ne' ritratti, e chi di tutti volesse fauellare lungo tempo ne bisognerebbe; però delle cose sue più notabili brieuemente farò mentione. In Vinegia di sua mano sono queste opere, nella sala del gran Consiglio l'historia, che fu lasciata imperfetta da Giorgione, in cui **Federigo Barbarossa** stà ginocchioni innanzi a Papa Alessandro quarto, che gli mette il piè sopra la gola. Nella Chiesa di San Rocco, un quadro entroui **Christo, che porta la croce** con una corda al collo tirata da un'hebreo, la qual opera è hoggi la maggior diuotione, che habbiano i Vinitiani: laonde si può dire, che habbia piu guadagnato l'opera che il maestro. p. 525

1584. Borghini.

G. P. LOMAZZO, *Trattato*

1585 Compositione dal dipingere & fare i paesi diversi... è stato felicissimo, Giorgione da Castelfranco nel dimostrar sotto le acque chiare il pesce, gl'arbori i frutti, & ciò che egli uoleua con bellissima maniera. p. 474

1595 *Lelio Cinquini Collection, Rome*

16. Il ritratto di un dottore di *chiaroscuro.* Giorgione.

1894. Voltellini, cxxxii.

1600 *Fulvio Orsini Collection, Rome*

11. Il quadro corniciato di noce, con due **teste d'una vecchia et un giovine,** di mano dal Giorgione. 20
12. Quadretto corniciato d'hebano, con un **San Giorgio,** di mano dal medesimo. 20

1884. Nolhac, 427.

1602 *Count Giovanni Battista Guerriero, in a letter to Consigliere Chieppo*

Mesr Stefano Sanvito copia un quadro de un **S. Sebastiano,** di mano de Zorzone da Castelfrancho.
Marcho Leon copia un altro quadro de una meza figura, che sono **la prudencia** di mano de Zorzone da Castelfranco.

1913. Luzio, 281.

1612 *Camillo Sordi, in a letter from Venice to Duke Francesco Gonzaga*

L'Adultera, di Giorgione, duc. 60.
Venere, di Giorgione, duc. 50.

1913. Luzio, 110.

1621 *Inventory of the Collections of Rudolf II at Prague*

934. Ein **contrafect,** vom Giorgon. (Orig.)
937. Ein **contrafect,** vom Giorgion gemahlt. (Orig.)

1905. Zimmermann, xiv.

GIO. M. VERDIZOTTI (Tizianello), *Vita del Famoso Titia-no Vecellio di Cadore*

1622 Fù dunque d'anni dieci in circa mandato (Titia-no) à Venetia in casa d'un suo Zio materno, & accomo-dato da lui con Gio: Bellino Pittore famosissimo in quell'età, dal quale per alcun tempo apprese i termini della Pittura, & aprì in modo l'ingegno alla cognitione di quella, che stimando più grave, e più delicata maniera quella di Giorgione da Castel Franco, desiderò so-pramodo d'accostarsi con lui, & favorì la Fortuna il suo generoso pensiero, perchè guardando spesso Titiano l'opere di Giorgione, & cavandone il buono di na-scosto, mentre erano in una Corte ad asciugarsi al Sole, fu più volte osservato, & veduto da lui, che perciò comprendendo l'inclinatione del giovane, quasi un'altro Democrito, che scoprì l'ingengo di Protagora, à se lo trasse, et affettuosissimamente gl'insegnò i veri lumi dell'Arte, onde non solo potè in pochi anni ugguagliare il maestro, ma poscia di gran lunga superarlo, come seguì, quando hebbe Giorgione il carico di dipingere il **Fondaco** della Natione Alemanna in Venetia, posto appresso il Ponte di Rialto, l'opera del quale conoscen-do l'ingegno, & sufficienza di Titiano compartì con lui, & egli fece quella parte, che è sopra il Canal grande, come quella, che in sito più riguardevole era esposta à gli occhi d'ognuno, & l'altra verso terra, diede al sudet-to Titiano, & se ben il Maestro vi pose ogni studio, fù però Titiano superato, come l'opera medesima ne fà chiara fede, & confermò l'universale consenso di tutti, che si rallegravano con Giorgione particolarmente per l'opera della facciata verso Terra, stimandola fatta da lui; non fu però egli invidioso della gloria del suo buon discepolo, anzi confermando la realtà del fatto si gloriò d'haverlo ridotto à tal perfettione, che l'opere di lui fussero stimate uguali, & maggiori delle sue medesime.

B. 2

1625-49 *Collection of Charles I*

Done by Georgione, bought by the King, of Geldrop, when he was Prince.
1. Imprimis, a dark painted **man's head,** in a black cap and a cloak, without hands or ruff, done by Geor-gione; said to be his own picture, being pasted upon a new board, set in a black frame, painted on the right light. 1 ft. 10 in. + 1 ft. 4 in. p. 1

Hampton Court, no. 103.

Done by Georgione.
9. Item. A piece containing six half figures, **our Lady,** Christ, Joseph, St. Katherine, St. Sebastian, and ano-ther private Gentleman, painted upon board, in an all-

over gilded frame. Bought by my Lord Cottington for the King. 3 ft. 2 in. 4 ft. 5 in. p. 106

Louvre, no. 1135 (Sebastiano del Piombo).

Done by Georgione. Bought by the King.
12. Item. a **shedherd** without a beard with long han-ging hair, holding a pipe in his right side some drape-ry, so big as the life to the shoulders. 1 ft. 11 in. + 1 ft. 8 in. p. 127

Hampton Court, no. 101.

Done by Georgione.
3. Item. A piece being **Actaeon,** containing in a tro-ope upon the first ground some Twelve figures, where Diana and her nymphs are washing, and in a landskip some Fourteen little intire figures, more Mfar off, ina gilded frame: bought by the King of Mr. Endymion Porter. 3 ft. 1 in. + 6 ft. p. 131

Hampton Court, no. 73 (Schiavone ?).

1627 *Inventory of the Gonzaga Gallery at Mantua*

444. Nove quadertini d'asse dipintovi nove teste d'ari-trati, in uno una donna pelosa, nel 2. Consalvo Ferran-do, nel 3. Gaston Fois, nel 4. un giovine sbarbato con un beretino in testa, nel 5., 6., 7., 8., e 9., capitani diversi vestititi alla todesca, doi con cornici et gli altri senza, L. 90.

1913. Luzio, 122.

Elenco di D. Nys delle collezioni Gonzaga.
Una testa di Zorgione.

1913. Luzio, 153.

1627 *Illustrated inventory of the Collection of Andrea Vendramin*

This is an illustrated list of the Collection, which was in the Palazzo di San Gregorio. Thirteen paintings in it are attributed to "Zorzon".

1923. Borenius (for a discussion of the works, see under Lost Works).

1631 *List drawn up by Pelli of the paintings taken from the Ducal Palace in Urbino to Florence*

22. Giorgione. Ritratto di soldato armato (Uguccione della Faggiola?).

1909. Hutton, III, 482.

1632 *Inventory of the possessions of Roberto Canonici in Ferrara*

Due Figure dal mezo in sù di Giorgione da Castel-franco, cioè un huomo con un gran capello in testa, et una donna paiono **Pastori,** che siano in viaggio, ha la cornice con fili d'oro, scudi cento.

1870. Campori, 115.

1635 *Collection of the Duke of Buckingham at York House*

Georgione. A little picture of a man in armour.

Tablet of the Barbarella family, formerly in the Cathedral at Castelfranco

1638 Ob perpetuum laboris ardui monumentum / in hanc fratris / obtinendo plebem suscepti / virtutisque praeclarae Jacobi et Nicolai seniorum / ac Giorgionis summi pictoris memoriam / vetustate collapsam pietate restauratam / Mattheus et Hercules Barbarella fratres / sibi posterisque construi fecerunt / donec veniat dies / Anno Domini MDCXXXVIII Mense Augusti.

1803. Federici, 11, 4.

1640 *(circa) Catalogue of the Paintings and Drawings in the Studio Coccapani at Reggio*

Una dei rivendi quadri ha compro **puattro teste** di Giorgione e non sono poi della sua buona maniera; con tutto ciò le ha pagate 1200 ducatoni ed io lo so di certo. p. 143

Paintings
72. Il **ritratto** di Giorgione. p. 147
128. Un **paese** di mano di Giorgione. p. 149

Drawings
Una **testa d'un vecchio** di lapis nero grande di Giorgione non certa D. 3. p. 157
1870. Campori.

1646 *The Cabinet of M. de Scudery. Paris, chez Augustin Courbe*
Ariane
de la main du Georgeon.

1648 Carlo Ridolfi, *Le Maraviglie dell'arte*

VITA DI GIORGIONE DA CASTEL FRANCO PITTORE,
Haueua di già la Pittura nel Teatro del Mondo per il corso di più d'vn secolo, dispiegato le industriose fatiche de suoi fauoriti Pittori li quali con la bellezza, e nouità delle opere dipinte haueuano recato diletto, e merauiglia à mortali: quando cangiando il prospetto in più adorna, e sontuosa scena diede à vedere più deliciosi oggetti, e più riguardeuoli forme nella persona di Giorgio da Castel Franco, che per certo suo decoroso aspetto fù detto Giorgione. Hor questi facendo vn misto di natura, e d'arte, compose vn così bel modo di colorire, che io non saprei, se si douesse dire vna nuoua Natura prodotta dall'arte, ò vn'arte nouella ritrouata dalla natura per gareggiare con l'arte sua emulatrice, come cantò quel famoso Poeta.

Di Natura arte par, che per diletto
L'imitatrice sua scherzando imiti.
 Tasso: Cant. 16.

Contendono Castel Franco Terra del Triuigiano, e Vedelago, Villaggio non guari lontano, chi di loro fosse Patria di Giorgione, come fecero le Città della Grecia per Homero, come trasse dal Greco Fausto Sabeo.

Patriam Homero vni septem contenditis Vrbes,
Cumae, Smyrna, Chios, Colophon, Rhodos, Argos, Athenae.

La Famiglia Barbarella di Castel Franco si vanta hauerui dato l'essere, e se ne può con ragione vantare, hauendo Giorgio recato à quella Patria i più sublimi honori; così i Fabi Patritij Romani si pregiarono, che nella loro prosapia fosse vscito Fabio chiarissimo Pittore. Affermano alcuni però, che Giorgione nascesse in Vedelago d'vna delle più commode famiglie di quel Contado, di Padre facoltoso, che veduto il figliuolo applicato al disegno, condotto à Venetia il ponesse con Gio. Bellini, dal quale apprese le regole del disegno dando egli poi in breue tempo manifesti segni, del viuace suo ingegno nel colorire: il che cagionò alcuna puntura di gelosia nel Maestro, vedendo con quanta felicità fossero dispiegate le cose dallo Scolare: e certo che fù marauiglia il vedere, come quel fanciullo sapesse aggiungere alla via del Bellino, (in cui pareuano addunate le bellezze tutte della Pittura) certo, che di gratia, e tenerezza nel colorire, come se Giorgio partecipasse di quella virtù con la quale suol la natura comporre le humane carni col misto delle qualità degli elementi, egli accordando con somma dolcezza le ombre co'i lumi, e col far rosseggiare con delicatezza alcune parti delle membra, oue più concorre il sangue, e si esercita la fatica in modo, che ne compose la più grata, e gioconda maniera, che giamai si vedesse: onde con ragione segli deue il titolo del più ingegnoso Pittore de' moderni tempi, hauendo inuentato così bella via di dipingere: mà non essendogli conceduti dal Cielo, che pochi anni di vita, non puote in tutto dar à vedere le bellezze del ingegno suo, mancato nel fiorire delle sue grandezze.
Uscito dalla Scuola del Bellino si trattenne per qualche tempo in Venetia, dandosi à dipingere nelle botteghe di Dipintori, lauorandoui **quadri di diuotione, recinti da letto, e gabinetti,** godendo ogn'vno in tali cose della bellezza della Pittura.
Desideroso poscia di veder i parenti, se n'andò alla Patria, oue fù da quelli, e dal vicinato accolto con la maggior festa del Mondo, vedutolo fatto grande, e Pittore. Dipinse poi à Tutio Costanzo, condottiere d'huomini d'armi **la tauola di nostra Donna** con nostro Signore Bambinetto; per la Parocchiale di Castel Franco, nel destro lato fece San Giorgio in cui si ritrasse, e nel sinistro S. Francesco, nel quale riportò l'effigie d'vn suo fratello, e vi espresse qualunque cosa con naturale maniera, dimostrando l'ardire nell'inuitto Cavaliere, e la pietà nel Serafico Santo. Fece ancora qualche **ritratto** de que' Cittadini: la figura di **Christo morto con alcuni Angeletti,** che lo reggano, conseruasi nelle camere del monte di Pietà di Treuigi, che in se contiene

elaborato disegno, & vn colorito così pastoso, che par di carne.

Dopo qualche dimora in Castel Franco, ritornò Giorgio à Venetia, essendo quella Città più confacente al genio suo, e presa **casa in Campo di San Siluestro,** trauea con la virtù, e con la piaceuole sua natura copia d'amici co' quali tratteneuasi in delitie, dilettandosi suonar il Liuto, e professando il galant'huomo, onde fece acquisto dell'amore di molti.

Dipinse in tanto lo aspetto della casa presa, acciò seruir potesse d'eccitamento à coloro, che hauessero mestieri dell'opera sua, accostumandosi all'hora per pompa il far dipingere le case da galant'uomini, nella cui cima fece alcuni ouati entroui suonatori, Poeti, & altre fantasie, e ne corsi de camini, groppi di fanciulli, techi à chiaro oscuro, & in altra parte dipinse due mezze figure, credesi vogliono inferire, **Federico I Imperadore, & Antonia da Bergomo,** trattogli il ferro dal fianco in atto d'vccidersi, per conseruar la virginità, del cui auuenimento è diuulgato vn dotto elogio del Signor Iacopo Pighetti, & vn poema celebre de Signor Paolo Vendramino; e nella parte inferiore, sono due historie, che mal s'intendono, essendo danneggiate dal tempo.

Piaciuta l'opera à quella Città gli furono date à dipingere le facciate di **casa Soranza** sopra il Campo di San Paolo, oue fece histore, fregi de' fanciulli, e figure in nicchie, hor à fatto diuorate dal tempo, non conseruandosi, che la figura d'vna donna con fiori in mano, e quella di **Volcano** in altra parte, **che sferza Amore.**

Seguiua in tanto Giorgio à dipingere nella solita habitatione, oue dicesi, che aperta hauesse bottega dipingendo rotelle, armari, e molte casse in particolare, nelle quali faceua per lo più **fauole d'Ouidio,** come **l'aurea età** diuisandoui liete verdure, riui cadenti da piaceuoli rupi, infrascate di fronde, & all'ombra d'amene piante si stauano dilitiando huomini, e donne godendo l'aurea tranquilla: qui vedeuasi il Leone superbo, colà l'humile Agnellino, in vn altra parte il fugace Ceruo, & altri animali terrestri.

Appariuano in altri i **Giganti** abbattuti dal fulmine di Gioue, caduti sotto il peso di dirupati monti, Pelio, Olimpo, & Ossa; **Decalione e Pirra,** che rinouauano il Mondo col gettar de' sassi dietro alle spalle, da quali nasceuano groppi di fanciullini.

Haueua poi figurato **Pitone serpente vcciso da Apolline,** & il medesimo Deo seguendo la bella figlia di Peneo, che radicate le piante nel terreno, cangiaua le braccia in rami, & in frondi d'alloro; e più lungi fece **Io tramutata in Vacca** data in custodia dalla gelosa Giunone ad Argo, & indi addormentato dalla Zampogna di Mercurio, veniuagli da quello tronco il Capo, versando il sangue per molte vene, poiche non vale vigilanza s'occhio mortale, doue asiste la virtù d'vn Nume del Cielo.

Vedeuasi ancora il temerario **Fetonte** condottiere infelice, del carro del Padre suo, fulminato da Gioue, gli assi, e le ruote sparse per lo Cielo; Piroo, e Flegonte, e Eoo, che rotto il freno correuano precipitosi per i torti sentieri dell'aria; e le sorelle del sfortunato Auriga sù le ripe del Pò cangiate in Pioppi, e'l Zio addolorato vestendo di bianche poume gli homeri, tramutauasi in Cigno.

Ritrassè il oltre **Diana** con molte Ninfe ignude ad vna fonte, che della bella Calisto le violate membra scopriuano; **Mercurio** rubatore de gli armenti di Apolline, e **Gioue conuertito in toro,** che riportaua oltre il mare la bella Regina de' Fenici: così puote la forza d'Amore di trasformare in vile animale vn fauoloso Nume benche principale fra tutti.

Finse parimente **Cadmo** fratello d'Europa, che seminaua i denti dell'vcciso serpente, da quali nasceuano huomini armati, e di lontano ergeua le mura alla Città di Tebe; **Atteone** trasformato in Cruo da Diana, **Venere e Marte** colti nella rete da Vulcano; **Niobe** cangiata in sasso; & i di lei figliuoli saettati da Diana, e da Apolline; **Gioue, e Mercurio** alla mensa rusticale d **Baucci e Filomene, & Arianna** abbandonata da Teseo sopra vna spiaggia arenosa.

Lungo sarebbe il raccontar le fauole tutte da Giorgio, in più casse dipinte di **Alcide, di Acheloo,** e della bella **Deianira rapida de Nesso Centauro** saetato nella fuga dall'istesso Alcide; degli **amori di Apollo** e di **Giacinto,** di **Venere** e di **Adone:** e tre di queste fauole si trouano appresso de' Signori Vidmani; in vna è la nascita d'Adone, nella seconda, vedesi in soaui abbracciamenti con Venere, e nella terza vien vcciso dal Cinghiale: & altre delle descritte furono ridotte parimente in quadretti poste e in vari studij.

Mà di più degne cose fauelliamo. Auanzatosi il grido di Giorgio, hebbe materia in tanto di far opere di maggior consideratione, onde ritrasse molti Personaggi, tra quali il **Doge Agostin Barbarigo,** di **Caterina Cornara** Regina di Cipro, di **Consaluo Ferrante** detto il Gran Capitano, e d'altri Signori. **Tre ne fece ancora in vna medesima tela,** posseduti dal Signor Paolo del Sera Gentil-homo Fiorentino di costumi gentili, e che si fà conoscere di bello ingegno nella Pittura. Quel di mezzo è d'vn Frate Agostiniano, che suona con molta gratia il clauicembalo, e mira vn altro Frate di faccia carnosa col rochetto, e mantellina nera, che tiene la viuola; dall'altra parte è vn giouinetto molto viuace con beretta in capo, e fiocco di bianche poume, quali per la morbidezza del colorito, per la maestria, & artificio vsatoui vengon riputati de i migliori dell'Autore: ne fia vanità il dire, che Giorgio fosse il primiero ad approssimarsi con mirabile industria al naturale, confermandosi questa verità in que' rari esemplari.

Lauorò in questo tempo la facciata di **Casa Grimana** alli Serui; e vi si conseruano tuttauia alcune donne ignude di bella forma, e buon colorito. Sopra il **Campo di Santo Stefano,** dipinse alcune mezze figure di bella macchia. In altro aspetto di casa sopra vn Canale à **Santa Maria Giubenico,** colorì in vn'ouato **Bacco, Venere e Marte** sino al petto, e grottesche à chiaro scuro dalle parti, e bambini.

Rinouandosi indi à poco il **Fondaco de' Tedeschi,** che si abbrugiò l'anno 1504, volle il Doge Loredano, di cui Giorgio fatto haueua il ritratto, che à lui si dasse l'impiego della facciata verso il Canale (come à Titiano fù allogata l'altra parte verso il ponte nella quale diuise trofei, corpi ignudi, teste à chiaro scuro; e ne cantoni fece Geometri, che misurano la palla del Mondo; prospettiue di colonne, e trà quelle huomini à cauallo; & altre fantasie, doue si vede quanto egli fosse pratico nel maneggiar colori à fresco.

Hor seguitiamo opere sue à oglio. In quadro di mezze figure quanti il naturale, fece **il simbolo dell'humana vita**. Iui appariua vna donna in guisa di Nutrice, che teneau trà le braccia tenero bambino, che à pena apriua i lumi alla diurna luce prouando le miserie della vita dirottamente piangeua: alludendo à quello cantò Lucretio dell'homo nascente in questi versi.

> *Tùm porrò puer, vt saeuis proectus ab vndis*
> *Nauita, nudus humi iacet, infans, indigus omni*
> *Vitai auxilio; tum primum in luminis oras*
> *Nixibus ex alueo Matris Natura profudit:*
> *Vagitumq; locum lugubri complet, vt aequum est*
> *Cui tantum in vita restet transire malorum.*
>
> Lucret. lib. 5.

E l'istesso concetto fù poscia maruigliosamente, e con più numerose forme dal Marino nel seguente Sonetto dispiegato.

> *Apre l'huomo infelice all'hor, che nasce,*
> *In questa vita di miserie piena,*
> *Pria ch'al Sol, gli occhi al pianto, e nato à pena*
> *Và prigionier fra le tenaci fasce.*
> *Fanciullo poi, che non più latte il pasce,*
> *Sotto rigida sferza i giorni mena:*
> *Indi in età più fosca, che serena,*
> *Trà Fortuna, & Amor more, e rinasce.*
> *Quante poscia sostien tristo, e mendico,*
> *Fatiche, e morti in fin che curuo, e lasso*
> *Appoggiato à debil legno il fianco antico.*
> *Chiude al fin le sue spoglie angusto sasso*
> *Ratto così, che sospirando io dico,*
> *Dalla cuna, alla tomba è vn breue passo.*
>
> I. delle morali.

Nel mezzo eraui vn huomo di robusto aspetto tutto armato, inferendo il bollore del sangue dell'età giouanile, pronto nel vendicare ogni picciola offesa, e preparato negli aringhi di Marte à versar il sangue per lo desio della gloria, il quale punto non ralenta il furore, benche altro gli rechi innanzi il simolacro di morte, ò volesse ingegnosamente dimotrare il Pittore (secondo il detto del pacientissimo) la vita dell'uomo altro non essere, che vna specie di militia sopra la terra, & i giorni suoi simili à quelli de' mercenari. Poco lungi vedeuasi vn giouinetto in dispute co' Filosofanti; e tra negotiatori; e con vna vecchiarella, per dinnotare le applicationi varie della giouentù, e finalmente vedeuasi vn vecchio ignudo curuo per lo peso degli anni, ondeggiante il crine di bianca neue, che meditaua il teschio d'vn morto, considerando come tante bellezze, virtù, e gratie del Cielo, all'huomo compartite, diuenghino in fine esca de vermi entro ad vn'oscura tomba, qual Pittura dicesi essere in Genoua appresso de' Signori Cassinelli.

Si videro ancora in Venetia due mezze figure, l'vna rappresentaua **Celio Plotio assalito da Claudio,** che lo afferraua pel collare del giubbone, tenendo l'altra mano al fianco sopra il pugnale; e nel volto di quel giouinetto appariua il timore; et l'impietà nell'assalitore, che finalmente rimase da Plotio vcciso, la cui generosa ressolutione fù commendata da Caio Imperadore, Zio del morto Claudio; & vn altro **ritratto in maestà all'antica.**

Ma consideriamo vn gentil pensiero gratiosamente dispiegato dal pennello di Giorgio. In capace tela haueua fatto il congresso d'vna famiglia, standoui nel mezzo vn vecchio **castratore** con cappellaccio, che gli adombraua mezzo volto, e lunga barba ripiena di molli giri in atto di castrare vn gatto, tenuto nel grebo da madonna, la quale dimostradosi schiffa di quell'atto, altroue riuolgenua il viso: eraui presente vna fantesca con la lucerna in mano, & vn fanciullo teneua il tagliere com empiastri, & vna fanciulla recaua vn altro gatto, che defendendosi con le vnghie le stracciaua il crine.

Fece ancora vna donna ignuda, & con essa lei vn **Pastore,** che suonaua il zufolo, ed ella miradolo sorrideua; e si ritrasse in forma di **Dauide** con braccia ignude, e corsaletto in dosso, che teneua il testone di Golia: haueua da vna parte vn Caualiere con giuppa, e beretta all'antica, e dall'altra vn Soldato, qual Pittura cadè dopò molti giri in mano del Signor Andrea Vendramino.

Vna deliciosa **Venere** ignuda dormiente; è in casa Marcella, & à piedi è Cupido con Augellino in mano, che fù terminato da Titiano.

Altra mezza figura di **donna in habito Cingaresco,** che del bel seno dimostra le animate neui co' crini raccolti in sottil velo, e con la destra mano si appoggia ad vn libro di vari caratteri impresso, è nelle case del Signor Gio. Battista Sanuto, e gli Signori Leoni da San Lorenzo, conseruano due mezze figure in vna stessa tela di **Saule,** che stringe ne' capelli il capo di Golia recatogli dal giouinetto Dauide, ed in questi ammirasi l'ardire, in quello la regia maestà; & in altra tela **Paride con le tre Dee** in picciole figure: & in casa Grimana di Santo Ermacora, è la **sentenza di Salomone,** di bella macchia, lasciandoui l'Autore la figura del ministro non finita.

Il Signor Caualier Gussoni grauissimo Senatore ha vna **nostra Donna, San Girolamo,** & altre figure di questa mano. Il Signor Domenico Ruzzini Senatore amplissimo, possiede il ritratto d'vn **Capitano armato.** I Signori Contarini da San Samuello, conseruano quello d'vn **Caualiere in arme nere,** & i Signori Malipieri **San Girolamo** in mezza figura molto naturale, che legge vn libro; ed il Signor Nicolò Crasso il **ritratto di Luigi Crasso** celebre Filosofo Auo suo posto à sedere con occhiali in mano.

Io vidi ancora dell'Autore in mezzani quadri dipinta la **fauola di Psiche** della quale, descriuendo il modo tenuto da Giorgio nel diuisarla, toccheremo gli auuenimenti.

Nel primo quadro appariua quella fanciulla, il cui bel viso era sparso del candore dei gigli, e del vermiglio delle rose, formaua tra le labra di rubino vn souaue soriso, e co' bei lumi saettaua i cuori; nell'aureo crin spuntauano à gara i fiori, formando quasi in dorata siepe vn lasciuetto Aprile. Stauasi quella in atto modesto, sostenendo con la destra mano il cadente velo, e con l'altra stringendo l'estremità di quello nascondeuasi il morbido seno; e dinanzi le stauano ossequiosi molti popoli, che le offeriuano frutti, e fiori, tributandola come nouella Venere.

Nel secondo l'amorosa Dea priua de' douunti honori

asisa sopra è gemmato carro tirato da due placide Colombe, imponeua al figlio Amore, che della sua riuale prendesse vendetta, facendola d'vn huomo vile ardere in amorosa fiamma: ma questa fiata il bel Cupido preda rimase di bellezza mortale, prouando de' begli occhi di Psiche le amorose punture.

Nel terzo il Rè Padre (conforme la risposta dell'Oracolo di Mileto) accompagnaua Psiche con lugubre pompa alla foresta (si prepari sempre il cataletto chi nella cima delle grandezze si ritroua) oue attender doueua lo sposo suo ferino sprezzatore degli Dei, & era accompagnata dalla Corte, e dal popol tutto con faci accese, e rami di cipresso in mano in segno di duolo.

Appariua nel quarto la sconsolata fanciulla portata da leggieri zefiri al Palagio d'Amore, doue lauata in tepido bagno, stauasi poi ad vna ricca mensa tra musicali suoni, & in rimota stanza, vedeuasi più lungi corcata sotto padiglione vermiglio appresso al bello Amore.

Nel quinto quadro desiderosa Psiche di riueder le sorelle (benche ammonita delle sue disauenture da Amore) portato anch'elleno da Zefiri, si vedeuano in gratiose attitudini nel reale palagio in ragionamenti con le sorelle, le quali marauigliate delle ricche supelletili, e dello stato suo felice, punte da inuidioso veleno le fan credere, ch'ella ad vn bruto serpe ogni notte si accompagni, da cui deue attendere la morte in breue, persuadendola, che di notte tempo, qual'hor dorme l'vccida, sottraendosi in tale guisa dalla di lui tirannia.

Poi nel sesto stauasi la credula amante col ferro, e la lucerna in mano sopra l'addormentato fanciullo, e vagheggiando il bel viso, l'oro de' crini, le ali miniate di più colori, soprafatta dallo stupore non pensa al partire. Spiccasi in tanto dall'ardente lucerna insidiosa fauilla, auida anch'ella di toccare le morbide carni, e cadendo sopra l'homero d'Amore, turba ad vn tratto i piaceri di Psiche.

Così le gioie han per confine i pianti.

Onde Cupido, riscuotendosi dal sonno, mentre quella tenta ritenerlo, rapidissimo in altra parte si vedeua fuggire, riprendendo la di lei ingratitudine.

Nel settimo Giorgio haueua rappresentato il pellegrinaggio dell'infelice amante, come incontrauasi in Pane tinto di color sanguigno, dal cui fianco pendeuano forati bossi, che la consola; e di lontano si vedeuano le inique sorelle ingannate da Psiche (fatta scaltra nelle proprie disauenture) precipitarsi dal monte, credendo diuenir spose d'Amore.

E nell'ottauo era Venere cinta di sbara celeste, accompagnata dalle Gratie sopra conchiglia di perle, che adirata riprendeua il figliuolo per gli amori di quella fanciulla; & in altre sito appariua la sofrtunata Psiche, peruenuta dopò molti disagi al Tempio di Cerere, à cui limitati erano fasci di spiche, rastri, e vagli: è spargendo amare lagrime, pregaua quella Dea della sua protettione: la quale per non dispiacere all'amica Venere (anteponendosi spesso l'interesse alla pietà) non ode d'vn cuor orante le affettuose preghiere: e di la partita (dopò lungo camino) stauasi di nuouo

nel Tempio di Giunone, diuenuta sorda anch'ella alle di lei preghiere, poiche ad vn rubelle del Cielo, hà turate le orecchie ogni Deità.

In così misero stato agitata da tanti pensieri, che farà l'infelice amante, in odio al Cielo à gli Dei, & allo sposo suo? doue si nasconderà da Venere sua fiera nemica? (ò con quanto disauantaggio contende l'huomo col Cielo?) gli sarà forza in fine ridursi in braccio alla potente sua nemica, la quale per ogni luogo fattala bandire da Mercurio, promette baci, e doni à chi di quella nouelle le rechi.

Onde nel nono vedeuasi la meschina presa per le chiome da Venere, e battuta con miserabile scempio, e dopò molte ingiurie, e rampogne, in diuidere gran cumulo di confusi semi l'impiega, assignandole quel di tempo, che alla cena del gran gioue si trattenghi, quali in virtù d'Amore veniuano dalla nera, e sollecita famiglia diuisi.

Nel decimo la Dea del terzo Cielo vie più incrudelita, desiderosa della morte di Psiche, l'inuia ad vn folto bosco, oue pasceuano fatali pecore, perche di quelle vn fiocco di aurata lana le porti (così per la via delle afflitioni si purgano le colpe,) & esequito l'ordine imposto, dinanzi à quella Dea la pouera Psiche si presenta. Poi con l'aiuto dell'augel di Gioue le acque di stigie le riporta; e per vltimo delle fatiche scesa per commissione di Venere all'inferno, e riceuuto da Proserpina il creduto vnguento per abbelire il viso: stimolata dalla vanità, scoprendo il letale sonnifero cadè tramortita, onde risuegliatala Amore col dorato strale, e rimessole il sonnifero nel vase la rimandaua alla madre sua.

Nell'vndecimo (non potendo il bel Cupido più sofferire gli stratij della sua donna, ottenuto in fine ,che gli diuenghi sposa, vedeuasi Gioue nel mezzo al Concistoro degli Dei, decretare il matrimonio di quella con Amore, mentre dalla bassa terra veniua la bella fanciulla da Mercurio portata al Cielo.

E nell'vltimo Giorgio finto haueua belle, e sontuose nozze, oue ad vna ricca mensa imbadita d'aurei vasi, di fiori, e d'altre vaghezze, sedeuano nel più sublime luogo Amore, l'amorosa Psiche, e gl'altri Dei di mano in mano; le Gratie somministrauano al diuino conuito laute viuande; Ganimede d'aria, di crespi, e d'aurei crini, e di rosate vesti adorno seruiua di coppiere co' nettari diuini. Le Muse anch'elleno formando due lieti cori co' stromenti loro riempiuano di celeste armonia le beate stanze, e'l Dio di Delo sul canoro legno intuonaua soaui canzoni, mentre le hore veloci dibattendo le ali d'ogni intorno ricamauano di rose bianche, e vermiglie il Cielo.

In tale guisa Giorgio figurati haueua gli auuenimenti della famosa Psiche, la quale dopò molte fatiche gionse à godere il desiato suo sposo. E sotto questo nome intesero quegli antichi saggi, l'anima humana della quale inuaghitosi il diuino Amore, l'abbellisce d'ogni virtù: mà perseguitata dall'appetito con nome di Venere, cerca d'accoppiarla all'habito vitioso, quindi stimolata dall'irascibile, e concupiscibile potenze, deuiando da diuini precetti, cade negli errori: alla fine per sentieri delle fatiche, mediante l'vso degli habiti morali si riduce di nuouo in gratia dello sposo suo, partorendo quel diletto, ch'è la fruitione della

celeste Beatitudine; alle quali inuentioni Giorgio reso haueua tale gratia, e naturalezza nelle forme, nelle attitudini, e negli effetti, che ogn'vno fisandoui lo sguardo, non istimaua unanità la fauola; mà uera è naturale.

Ma ricerchiamo altre pitture dell'Autore. Dicesi essere in Cremona nella Chiesa dell'Annunciata una tauola co **San Sebastiano,** che hà legato alle spalle un panno, & ui è tratta per terra una celata, e nel frontespitio dell'Altare sono due Angeletti, che tengono una corona.

Il Signor Prencipe Aldobrandino in Roma, hà una figura del detto **Santo** à mezza coscia, & il Signor Prencipe Borghese un **Dauide.**

Li Signori Christoforo, e Francesco Muselli in Verona hanno un **giouinetto** con pelliccia tratta bizzaramente à trauerso le spalle stimato singolare.

Si uide ancora di questa mano un quadro in mezze figure quanto il naturale di **Christo condotto al Monte Caluario** da molta sbiraglia; vn de quali lo tiraua con fune, & altro con cappello rosso di lui rideuasi; lo accompagnauano le pietose Marie, e la Verginella Veronica porgeuagli vn panno lino per raccorre del cadente sangue le pretiose stille.

Dipinse in oltre vn gran testone di **Polifemo** con cappellaccio in capo; che gli formaua ombre gagliarde sul viso, degna fatica di quella mano per l'espressione di si gran volto. Ritrasse **molte donne con bizzarri ornamenti,** e piume in capo, conforme l'vso di quel tempo. Fece Giorgio di nuouo il **ritratto di se medesimo in vn Dauide** con lunga capigliatura, e corsaletto in dosso, e con la sinistra mano afferraua ne' capelli il capo di Golia, e quello d'vn **Comandatore** con veste, e giubbone all'antica, e beretta rossa in mano, creduto d'alcuni per vn Generale, & altro d'vn **giouinetto** parimente con molle chioma, & armatura, nella quale gli riflette la mano di esquisita bellezza, & vno d'vn **Tedesco di casa Fuchera** con pellicia di volpe in dosso, in fianco in atto di giarsi, & vna mezza figura d'vn **ignudo pesoso** con panno verde sopra à ginocchi, & corsaletto à canto in cui egli traspare, nelle quali cose diede à vedere la forza dell'Arte, che hà virtù di dar vita alle imagini dipinte; che sono nelle case degli Signori Giouanni, e Iacopo Van Voert in Anuersa. Vogliono alcuni, che il medesimo ancora hauesse dato principio ad **vna historia** per la Sala del maggior Consiglio di Papa Alessandro III. à cui l'Imperadore Federico I. baciaua il piede (che altri han detto fosse incominciata da Gio. Bellino) che fù poscia terminata da Titiano, con qual fatica hauerebbe conseguito la pienezza della lode, interuenendoui molte figure, che formar poteuano vn degno componimento: ma piacque à Dio leuarlo dal Mondo d'anni 34. il 1511. Infetandosi di peste, per quello si dice, praticando con vna sua amica; benche altrimenti il fatto si racconti, che godendosi Giorgio in piaceri amorosi con tale donna da lui ardentemente amata, le fosse suiata di casa da Pietro Luzzo da Feltre detto Zarato suo Scolare, in mercè della buona educatione, & insegnamenti del cortese Maestro, perloche datosi in preda alla disperatione (mischiando sempre Amore tra le dolcezze lo assentio) terminò di dolore la vita, non ritrouandosi altro rimedio alla infettatione amorosa, che la morte,

e lo disse Ouidio.

Nec modus, & requies, nisi mors reperitur Amoris.

Così restò piuo il Mondo d'huomo così celebre, e d'vn Nume della Pittura, à cui si conuengono perpetue lodi, & honori, hauendo seruito di lumiera à tutti coloro, che vennero dietro di lui. E certo, che Giorgio fù senza dubbio il primo, che dimostrasse la buona strada nel dipingere, approssimandosi con le mischie de' suoi colori ad esprimere con facilità le cose della natura; poiche il punto di questo affare consiste nel ritrouar vn modo facile, e non stentato, celandosi quanto più si può le difficoltadi, che si prouano nell'operare: quindi è, che nelle mischie delle carni di questo ingegnoso Pittore non appaiono le innumerabili tinte di bigio di rancio, d'azzurro, e di si fatti colori, che si accostumano, inseriruui da alcuni moderni, che si credono con tali modi toccar la cima dell'Arte, allontanandosi con simili maniere dal naturale, che fù da Giorgio imitato con poche tinte, adequate al soggetto, che egli prese ad esprimere, il cui modo fù ancora osseruato trà gli antichi (se prestiamo fede à gli Scrittori) da Apelle, Echione, Melantio, e Nicomaco chiari Pittori, non vsando eglino, che quattro colori nel comporre le carni; quali termini, però non si possono basteuolmente rappresentare in carte, e che più si apparano dall'esperienza, che si fà sopra le opere de' valorisi Artefici, che dal discorso: e come che da pochi Professori sono intesi, così mal vengono osseruati da coloro, che men sono istrutti nell'arte; ingannandosi molti ancora dalla vaghezza de' colori, quali souerchiamente vsati, apportano nocumento alle carni: ne già come alcuni si credono il dipingere dipende dal capriccio, ma dalle osseruationi della natura, e dalle regole fondate sopra la simmitria de' corpi più perfetti, da quali trassero rarissimi documenti ne' scritti loro, fra gli antichi, Apelle, Eufranore, Ischinio, Antigono, e Senocrate; e tra moderni Alberto Durero, Leon Battista Alberti, il Lomazzo, & altri, che ne prescrissero parimente accurate regole; non douendosi meno imitare ogni natural forma: ma quelle solo, che più si appressano alla perfettione, di che esser deu giudice l'ingegnoso Pittore, ch'eleger sempre deue le più belle, & eccellenti.

Mà ritornando à Giorgio dico, che gli Artefici, che sono doppò lui seguiti, con gli esempi delle opere sue, hanno apparata la facilità, e 'l vero modo del colorire, onde si sono auanzati nella maniera, che dipoi si è veduto.

La fama nondimeno nell'immatura sua morte appese nel Tempio dell'Eternità la tabella dell'effigie sua, che con gentile prosopopea così di se ragiona.

Pinsi nel Mondo, e fù si chiaro il grido
Della mia fama in queste parti, e in quelle,
Che glorioso al par di Zeusi, e Apelle,
Di me rissona ogni rimoto lido.
In giouanile etade il patrio nido,
Lasciai per acquistar gratie nouelle;
Indi al Ciel men volai frà l'auree stelle.
Oue hò stanza migliore, albergo fido.
Qui frà l'eterne, & immortali menti,

Idee più belle ad emulare io prendo
Di gratie adorne, e di bei lumi ardenti.
Et hor del mio pennel l'opre riprendo,
Che vaneggio con l'ombre trà viuenti,
Mentre nel Ciel forme diuine apprendo.

I. 95-108

LIFE OF THE PAINTER GIO: BATTISTA CIMA DA CONEGLIANO

Mà frà tutti i Scolari del Bellino i più famosi & eccellenti furono Giorgione da Castel Franco e Titiano da Cadore, i quali col sublime ingegno loro fecero conoscere, quanto la Pittura sia fra le humane operationi grandi & eccellente. I. 78

LIFE OF THE PAINTER IACOPO DA PONTE OF BASSANO
In Venice

Il Signor Francesco Bergontio hà di questa mano il ritratto d'un Contadino singolare & uno di **donna** di mano di Giorgione, & altro dipinto dal Morone, d'un Poeta, ambi rarissimi. I. 400

LIFE OF TITIANO VECELLIO OF CADORE

Alterò poscia la maniera all'hor, che vide il miglioramento, che fatto haueua Giorgione. Errando nondimeno il Vasari, facendolo suo Discepolo, e che d'anni 18 facesse un ritratto su la maniera di quello, poiche Titiano era di pari età & alleuato con esso lui nella casa di Gio. Bellino.

E però vero, che piacendo à Titiano quel bel modo di colorire, posto in uso dal Condiscepolo, e praticando seco, ne diuenne ad un tempo imitatore & emulo.

TITIAN EMULATES GIORGIONE

Non reualeau all'hora ne' studenti, benche adulti l'albagia, hauendo eglino per solo fine l'auanzarsi in perfettione col seguir la via più lodata; il cui bel modo di colorire fù per molto tempo practicato da passati Pittori Veneti, fin tanto, ch'è rimasto perduto tra miscugli delle maniere introdotte in quellà Città, non essendo lodato il dipingere à capriccio, ma il seguir la natura con que' modi, che ci vengono prescritti dell'Arte; poiche essendo gli humani corpi composti della mistione degli elementi non appaiono già di così viuaci colori, come da alcuni si costuma il dipingerli, partecipando eglino d'un mezzano colore, che più o meno tira all'opaco, conforme la qualità del suo misto, quali termini quanto bene fossero intesi da Giorgione e da Titiano, non è da farne digressione, onde quelli, che ha caminato per le orme loro, sono arriuati con facilità alla perfettione dell'Arte.

Ma seguendo il discorso, trasformossi Titiano in guisa nella maniera di Giorgione, che non scorgeuasi tra quelli differenza alcuna. Quindi è, che molti ritratti vengono confusamente tenuti senza distintione hor dell'uno, hor dell'altro; e col medesimo stile dipinse la facciata verso terra del **Fondaco de' Tedeschi** (essendo la parte verso il canale locata à Giorgione, come nella vita sua dicemmo). Nel cantone, che mira il Ponte di Rialto collocò una donna ignuda in piedi delicatissima, e sopra alla cornice un giouinetto ignudo in piedi, che stringe un drappo in guisa di vela, &

un bamboccio lograto dal tempo; e nella cima fece un altro ignudo, che si appoggia à grande tabella, oue sono scritte alcune lettere, che mal s'intendono. Ma più fiera é peró la figure di Giuditta, collocata sopra la porta dell'entrata, che posa il piè sinistro sul reciso capo d'Oloferne, con spada in mano vibrante tinta di sangue, & à piedi vi è un seruo armato con berettone in capo, di gagliardo colorito; errando ancora in questo luogo il Vasari, facendola di Giorgione. Sopra la detta cornice diuise altre figure, e nel fine un Suizzero e un Leuantino & un fregio intorno à chiaro scuro ripieno di varie fantasie.

TITIAN SURPASSES GIORGIONE

Dicesi, che cosi piacquero quelle Pitture à Venetiani, che ne riportò comunemente la lode, e che gli amici suoi fingendo non conoscere, di chi si fossero, si rallegrauano con Giorgio della felice riuscita dell'opera del Fondaco, lodandolo maggiormente della parte verso terra, à quali con sentimento alterato rispondeua loro, quell'essere dipinta da Titiano, e cosi puote in lui lo sdegno, che più non volle, che praticasse in sua casa.

S. Marcuola

Con l'intrapresa maniera lauorò nel porticale di **Casa Calergi, hor Grimana,** à Sant'Ermacora alcune armi e due figure di virtù. I. 154-5

Circa lo stesso tempo oprò Titiano il **Christo del capitello di San Rocco,** posto dal Vasari nella vita di Giorgio, tirato con fune da perfido hebreo, che per esser piamente dipinto, hà tratto à se la diuotione di tutta la Città. I. 158

LIFE OF DOMENICO RICCIO CALLED IL BRUSASORCI

Ma auuanzando in poco tempo Domenico il sapere del Maestro, si risolse il padre mandarlo à Venetia, acciò con la veduta delle opere di Titiano e di Giorgione potesse maggiormente erudirsi, tenendo la via del Carotto della vecchia maniera, doue studiando per qualche tempo, apprese certo che di grandezza e miglior modo nel colorire. II. 108

Pitture di varij Autori presso il Sig. CORTONI. Verona

Di Giorgione: Nostro Signore con gli Apostoli e la **donna Cananea** con la figliuola indemoniata di manierose forme eccedenti il viuo; un viuace **ritratto** con paese & architetture; **Achille saettato** da Paride. II. 109

LIFE OF THE PAINTER IACOPO PALMA THE YOUNGER

Varie pitture di eccellenti Autori in Casa del Signor Bortolo Dafino.

Un **bachetto** con vase in mano di Giorgione.

II. 201

1648. Ridolfi, ed. Hadeln.

c. 1648 *Collection of George Villers, Duke of Buckingham*

No. 1. By Giorgione. **A Lady and a Soldier.** 2 ft. 6 in. + 2 ft.

No. 2. **The Head of an armed Man.** 1 ft. 6 in. + 1 ft. 6 in.

1758. Fairfax, 6.

1650 Estat de quelques Tableaux exposés en vente à la MAISON DE SOMERSET.

May 1650.

B.

 Liv. ster.
No. 21 Un **saint Sebastien,** en long, par Georgion
 0.40

F.

No. 34 Une **Vierge, Christ, sainte Catherine,** par Giorgione 1.00

H.

No. 258 Un **ieune homme** avec un pasté dans sa main, par Giorgion 0.30

Suite de la lettre E.

No. 139 Un **berger** avec une cornemuse, par Giorgion
 0.80

1884. Cosnac, 413.

1650 *Manuscript in the Biblioteca Marciana in Venice*

Due pitture di Giorgione al Museo Gualdo di Vicenza: **Sacra Famiglia** in un paese e **San Sebastiano.**

Ms. Marciano, 5102.

1650 *Inventory of the paintings belonging to the Sovelli family in Rome*

Un ritratto di **donna con chitarino con un huomo dietro,** del Giorgione di Castelfranco, p.mi 3 in quadro, D. 50.

1870. Campori, 162.

1653 JEREMIAS WILDENS, Antwerp.

172. Eenen **Christus** met een vrouwken aenden put, van Jorgon.

1932. Denucé, 158.

1654 *Inventory of paintings in the possession of Alethea, Countess of Arundel*

Giorgion. Una **testa di homo** con Beretino, **Paese con un Cavaglier et una Donna** & homini che tengono gli cavalli. Giorgion.
Giorgion. **Un homo a cavallo.**
Giorgion. **bagno de Donne.**

Giorgion. **Resurrectione de Lazaro.**
Giorgion. **Una dama tenendo una testa de morte piccola.**
Gior: **Hercules & Achelous.**
Giorgion. **David con la testa di Goliah.**
Giorgion. **fuga d'Egipto.**
Giorgion. **Orpheo.**
Giorgion. **Christo nel horto.**
Giorgion. **un homo & Donna con una testa in Mano.**

1655 Novembre 30. Di GIOVANNI PIETRO TIRABOSCO nelle case di S. Canciano e S. Agostino.

Un quadro antico maniera di Giorgion con la **Madona** S. Antonio, San Giov. Evangelista. p. 16
Un **retratto armato,** maniera di Giorgion.
Un **ritratto con una testa di morte,** maniera di Giorgion.
Un **S. Girolamo** di Giorgion. p. 18

1900. Levi.

1656 Oggetti d'arte di MICHELE SPIETRA della contrada dei SS. Apostoli.

Un quadro copia di Zorzon.
L'istoria dell'**adultera** vien da Zorzon. p. 20
Tre musichi che vien da Zorzon. p. 23

1900. Levi.

1657 Oggetti d'arte posseduti da GASPARE CHECHEL a S. Lio.

Un quadro sopra tela con cornice mezze dorate con 3 **figure,** una pare del Tintoretto e l'altra di Zorzon, e la 3. di Titiano. p. 33
Un **ritratto armato** maniera di Giorgion. p. 38
Un **ritratto con una testa di morte** maniera Giorgion.
 p. 39
1900. Levi.

1658 THEATRUM PICTORIUM DAVIDIS TENIERS ANTWERPIENSIS.

Contains etchings by various hands, after thirteen paintings attributed to Giorgione in the Collection of the Archduke Leopold Wilhelm in Brussels. It is linked with the Inventory of the Collection which was drawn up in 1659 (see below).

1659 Inuentarium aller vnndt jeder Ihrer hochfurstlichen Durchleucht Herrn Herrn LEOPOLDT WILHELMEN Ertzherzogen zue Osterreich, Burgundt etc. zue Wienn vorhandenen Mahllereyen, etc.

13. Ein **Contrafait** von Ohlfarb auf Holcz. Ein gewaffneter Mahn mit einer Oberwehr in seiner linckhen Handt vnd neben ihme ein andere Manszpersohn.
In einer glatt vergulden Ramen, 4 Span 5 Finger hoch vnd 5 Span 7 Finger braidt.

Original von Gorgonio.

Vienna, no. 206.

37. Ein Stuckh von Ohlfarb auf Holcz, die **Judit** mit des Holofernis Kopf vor ihr auff einem Tisch, auf ihr rechten Achsel ein rothen Belcz, in der rechten Handt ein Schwerth, und den linckhen Arm bloss. In einer vergulden, aussgearbeithen Ramen, 5 Span 1 Finger hoch undt 3 Span braidt. Von einem unbeckhandten Mahler.

Copy in the Galleria Querini-Stampalia, Venice.

95. Ein Stuckhl von Ohlfarb auf Holcz, warin die **Europa** auf einem weissen Oxen durch das Wasser schwimbt, auf einer Seithen ein Hurrth bey einem Baum, welcher auf der Schallmaeyn spilt, vdn auf der andern zwey Nimpfhen. In einer glatt vergulden Ramen 2 Span 2 Finger hoch vnd 4 Span 4 Finger braith. Original de Giorgione.

123. Ein Stuckh von Ohlfarb auf Holcz: der **Dauidt** gewaffent, in der rechten Handt ein Schwert vnd in der linckhen desz Goliats Kopf. In einer glatt gantz vergulden Ramen, die Hoche 5 Span vdt die Braidte 4. Man halt es von Bordonon.

Vienna, no. 21.

128. Ein Landtschafft von Ohlfarb auf Leinwath, warin **drey Mathematici,** welche die Mass der Hochen des Himmels nehmen. In einer vergulden Ramen mit Oxenaugen, 7 Span hoch und 8 Span 8½ Finger braidt. Original von Jorgonio.

Vienna, no. 16.

132. Ein **Landtschafft** von Ohlfarb auf Leinwath, warin zwey Huerthen vff einer Seithen stehen, ein Kindl in einer Windl auf der Erden ligt, vnd auff der andern Seithen ein Weispildt halb blosz, darhinter ein alter Mahn mit einer Pfeyffen siczen thuet. In einer vergulden Ramen mit Oxenaugen, hoch 7 Span 1& Finger, braith 9 Span 7& Finger braith. Original von Jorgione.

Fragment in Budapest, no. 145;
Copy by Teniers formerly in the Loeser Collection, Florence.

176. Ein klein **Contrefait** von Ohlfarb auff Leinwath vnd auff Holcz gepabt einer Frawen in einem rothen Klaidt mitt Pelcz gefuettert, mit der rechten Brusst ganz blosz, auf den Kopf ein Schaler, so bisz uber die Brusst herunder hangt, hinder ihr vndt auf der Seithen Laurberzweig. In einer eberen Ramen vnd das innere Leistl verguldt, 2 Span 4 Finger hoch vnd X Span 1 Finger braith. Von einem vnbekhandten Mahler.

Vienna, no. 219.

215. Ein **Landtschafft** von Ohlfarb auf Leinwath, warin ein Schloss vndt Kirchen, wie auch ein grosser Baum, dabey siczt ein gewaffneter Mahn mit einem blossen Degen neben einer gancz nackhendten Frawen,

auf der Seithen ein weisz Pferdt mit einer Waltrappen, so grassen thuet. In einer gantz vergulden Ramen mit Oxenaugen, hoch 3 Span 7 Finger vnd 4 Span 3 Finger braidt. Man halt es von dem Giorgione Original.

Copy by Teniers in the Gronau Collection, London.

217. Ein **Nachtstuckh** von Ohlfarb auf Holcz, warin die Geburth Christi in einer Landtschafft, das Kindtlein ligt auf der Erden auf unser liben Frawen Rockh, wobei Sct. Joseph und zwey Hierdten undt in der Hoche zwey Englen. In einer glatt verguldten Ramen, hoch 5 Span 4 Finger undt 6 Span 4 Finger braith. Man halt es von Giorgione Original.

Vienna, no. 23.

237. Ein Stuckh von Ohlfarb auff Leinwath, warin ein **Brauo.** In einer schmallen, auszgearbeithen vndt verguldten Ramen, die Hoche 4 Span vnd die Bradite 3 Span 3 Finger. Original von dem Giorgione.

Vienna, no. 207.

246. Ein klein **Contrafait** von Ohlfarb auff Papier vnd auf Holcz gepabt eines Junglings ohne Huet vnd Kappel, mit langen schwartzen Haaren vnd Klaidt. In einer glatt vergulden Ramen, hoch 2 Span 2 Finger vnd 2 Span braidt. Man sagt, es sey von Giorgione Original.

Budapest, no. 161.

253. Ein Stuckh von Ohlfarb auff Leinwath, warin **Christus der Herr bey dem Phariseer** zu Gast wahr, vnd Maria Magdalena die Fuesz gesalbet. In einer verguldten Ramen mitt Oxenaugen, hoch 3 Span 8½ Finger vndt braith 5 Spann 2½ Finger. Original von Giorgione.

265. Ein **Contrafait** von Ohlfarb auf Holcz eines Mahns mit dickhen Haar vnndt braunen Barth, in einem grunen Rockh, hat die rechte Handt offen vndt in der linckhen ein zusamben geroldt beschriebnes Papier. In einer glatt vergulden Ramen, hoch 4 Span 6 Finger vnd braith 3 Span 9 Finger. De Giorgione Original.

Vienna, no. 265.

270. Ein Stuckh von Ohlfarb auf Leinwath, warin **Orphaeus** in einem grunen Klaidt vnd Krancz vmb den Kopf, mit seiner Geigen in der linckhen Handt, vnd auff der Seithen die brennende Holl. In einer vergulten Ramen mit Oxenaugen, hoch 5 Span 4 Finger vnndt 4 Span 2 Finger braidt. Man halt es von Giorgione Original.

Copy by Teniers in the Suida Manning Collection, New York.

319. Ein Stuckh von Ohlfarb auff Holcz, warin **Christi Aufferstehung,** dabey funff Wachter, darunder vier schlaffen, vnd der funffte den Kopff kraczt, vnd in der Lufft 8 Engel.

In einer glatt vergulten Ramen, hoch 3 Span 4 Finger
vnd 3 Span brait.
Man halts von Bordenon.

Vienna, no. 260 a.
1883. Berger, 79.

F. SANSOVINO, *Venetia, Città Noblissima*, with an
addition by D. GIUSTINIANI MARTINIONI

1663 Studi d'Anticaglie
Questo nobil studio, passò in Eredità in CARLO RU-
ZINI, il quale haueua anch'egli Eccellenti pitture di
Gio: Bellino, di Giorgione, di Andrea Schiauone, di
Titiano, di Paolo Veronese, e d'altri valorosi Pittori.
Fù riguardeuole anco il Studio di OTTAUIO FABRI, come
riferisce il Stringa, adorno di pitture di Gio: Bellino,
di Raffael d'Urbino, di Giorgione, di Titiano, de i
Dossi, del Tintoretto, del Palma, e del Caualier Giouan-
ni Contarini. p. 374

E lodato lo studio di GIROLAMO CONTARINI da S.
Samuele, formato di rarissime Pitture, di Medaglie, di
quantità di Anticaglie, e d'altre curiosità. Frà le Pit-
ture, vi è una **Europa rapita da Gioue** in forma di
Toro con colte Ninfe, pittura merauigliosa, come sono
ancora altri Quadri della detta mano; vedendosi di
più un viaggio di Abramo numeroso di figure di mano
del Bassano, & altri Quadri di Giorgione, e d'altri
famosi Pittori.
GIROLAMO, e BARBON PESARI fratelli, nel loro Palazzo,
situato sopra il Campo di S. Benedetto, descritto dal
Sansouino, possedono una copiosa raccolta di Eccellenti
Pitture così antiche, come moderne, frà le quali sono
marauigliose una Samaritana di mano del Pordenone;
Un'**Adultera** di Giorgione, e due ritratti di due suoi
maggiori fatti dal medesimo Pordenone. p. 376

Deue anco ponersi trà memorabili Studi quello del
Barone OTTAUIO DE TASSIS, Cameriere della chiaue
d'oro di S. Maestà Cesarea, & suo Generale delle
Poste Imperiali in Venetia.
Delle Pitture, è impossibile farne particolar racconto,
essendoui più che cento Quadri di mano de più famo-
si, Eccellenti, e nominati Pittori d'Italia, e fuori; cioè,
di Pordenone, di Titiano, di Giorgione, del Palma
Vecchio, di Andrea Schiauone, del Tintoretto, di Raf-
fael d'Urbino, del Correggi, del Parmesano, del Bas-
sano, del Morone, di Leonardo di Vinzi, e d'altri
più celebri, siche questa è una Galleria delle nobili
d'Italia.
Finalmente NICCOLO RENIERI, grande & Eccellente
Pittore del Rè Christianissimo hà una gran raccolta di
Quadri de più stimati Pittori del secolo zssato, e del
presente, quali meriteriano esser descritti per la loro
rarità ad'uno, ad'uno; tuttauia ne dirò solo gl'Auttori,
e qualche cosa di quello si contiene in essi.
Ha di Giorgione tre Quadri, in uno è dipinto la **Ver-
gine** con Christo Bambino nelle braccia; in altro
Sansone, che stà appoggiato con una mano sopra un
sasso, in atto di rammaricarsi de tagliati Capelli, con
due figure di dietro che di lui si ridono; nel terzo,
è **l'età dell'huomo;** da un canto sono tre Puttini, due
di essi giuocano, e l'altro stà à dormire, nella'tro

canto à un giouane appresso una Ninfa, posti à sedere
sotto ad'un'Albero, quali scherzano co' flauti; E poi
nel lontano in bellissimo paese è un Vecchio, che si
scalda al fuoco. p. 377

 Palazzi
E prima à Santa Lucia nel solo posto, sopra esso Cana-
le, ch'è fiancheggiato da spatiosa fondamenta d'ambi
le parti, si vede il Palazzo del Conte GIROLAMO CA-
UAZZA, con facciata tutta di marmo, di vaga Architet-
tura. Quadri grandi di buone mani, sendone più alto
quattro de retratti al naturale di Giorgione, con par-
ticolar diligenza elaborati. pp. 393, 394

1663. Martinioni.

1664 Cose di GIOVANNI GRIMANI CALERGI esistenti
nel Palazzo Non Nobis Domine.
Un quadro grande col **Giuditio di Salomone** di Zor-
zon con soase di pero nere.

1900. Levi, 48.

MARCO BOSCHINI, *Le Minere della Pittura Veneziana*

1664 Giorgione da Castel Franco
Giorgione da Castel Franco fù discepolo di Gio: Bel-
lino, e fù d'ingegno cosi sottile, che penetrò anco più
oltre del Maestro nelle viscere della Pittura; a segno,
che le tolse quel velo, che ancora la teneua un poco
(er cosi dire) offuscata; e ben si può credere, che
Giorgione sia stato nella Pittura un'altro Gio: Gu-
sthembergo inuentore de Caratteri di Stampe, facili-
tando la manuscrizione, tanto faticata, e lunga; riu-
scendo all''incontro le cose sue ben composte, pronte,
rissolute, e ben aggiustate. E veramente se Gio: Bel-
lino (come habbiamo detto) leuò la Pittura dalle tene-
bre, e Giorgione le hà posto in fronte un Diamante
così purgato, e risplendente che abbaglia la vista à
chiunque lo mira: poiche sopra la aggiustatezza della
Simmetria aggiunse la grazia, e la perfezione. Nel co-
lorito trouò poi quell'impasto di pennello così morbido,
che nel tempo addietro non fù; e bisogna confessare,
che quelle pennellate sono tanta carne mista col sangue:
ma an maniera cosi pastosa, e facile, che più non
può dirsi finzione pittoresca, ma verità naturale: per-
che nel sfumar de dintorni (che anco il Naturale si
abbaglia) nel collocar chiari, e meze tinte, nel rosseg-
giar, abbassar, & accrescer di macchie, fece un'armo-
nia cosi simpatica, e veridica, che bisogna chiamar la
Natura dipinta, ò naturalizzata la Pittura. L'Idee di
questo pittore sono tutte graui, maestose, e riguarde-
uoli, corrispondenti appunto à quel nome di Giorgione,
e per questo si vede il suo genio diretto à figure graui,
con Berettoni in capo; ornati di bizzare pennacchiere,
vestiti trinciati con maniche à buffi, bragoni dello
stile di Gio: Bellino ma con più belle forme: i suoi
panni di Seta, Velluti, Damaschi, Rasi strisciati con
fascie larghe; altre figure con Armature, che lucono
come specchi; e fù la vera Idea delle azioni humane.
Ma osseruiamo di grazia con la contemplazione una
sola sua opera, e da quella facciamo il riflesso di tutte
le altre sue. Vedeuasi in Venezia e lo vidi anch'io,

un quadro, che fù poi trasportato nella Galleria del Serenissimo Arciduca LEOPOLDO GUGLIELMO d'Austria. L'Historia è questa. **Celio è assalito da Claudio,** & afferrato da lui con la sinistra nel capezzo, tiene la destra sopra il pugnale al fianco: e chi non vede la semplicità di quel giouinetto spauento dal timore non sa cosa sia afflizione d'animo, ne spauento di Morte: affetto viuamente espresso, benche si vegga semiuiuo l'assalito, all'incontro Claudio cosi rigido, cosi crudele, cosi furioso, che rende terrore alle stesse Furie. Due poositi d'affetti, che formano un concerto pittoresco, che più non può far l'Arte. Giorgione tu hai animate le tele con la verga incantata del tuo pennello. L'armatura poi, che tiene in dosso Claudio si può dire, che sia del più fino acciaio, che possi ressister à colpo di Moschetto: acciaio cosi ben tempestato col pennello di Giorgione, che ne meno qual sia altro pennello lo può colpitre. Questa è la maniera di Giorgione, condiscepolo di Tiziano, ed in fatti molto suo emulo, e riuale; a segno che (in particolare ne Ritratti) di quando, in quando vacillano i più intendenti per distinguere da chi de gli due siano formati. Veramente non si può togliere la Gloria à Tiziano ma ben si può dire, che Tiziano, caminando dietro a quelle pedate, s'imbeuesse dello stesso carattere. E di quà nasce tal volta gran dubbietà. Se Giorgione dipingesse poi frescamente à fresco, l'opere sue lo dicono. L'opere sue, respettiue alle innumerabili d'altri Torrenti Veneziani non sono molte: la ragione è che sul fine della sua età d'anni 34. quando appunto doueua maggiormente profondere in gran copia la sua virtù passò al Cielo, chiamato dal Diuin Motore. Il mio ingegno non può più inoltrarsi à decantare la eccelsa maniera di questo subblime pennello: però riceua il Dilettante la buona mia volontà.

A gloria di Giorgione, e di Pietro Vecchia Pittor viuente Veneziano, & à l'intelligenza de Dilettanti, deuo dire, che habbino l'occhio à questo Vecchia: perche incontreranno tratti di questo pennello trasformati nelle Giorgionesche forme in modo, che resterano ambigui se siano parti di Giorgione, ò imitazioni di quello: poiche anco alcuni de più intendenti hanno colti de frutti di questo, stimandoli dell'Arbore dell'altro. E queste imitazioni non sono copie, ma astratti del suo intelletto, ben si per imitare i tratti Giorgioneschi; e per confermazione di ciò si vedono nella Galleria del Serenissimo Arciduca Leopoldo Guglielmo d'Austria altra volta nominato, parti di questo pennello, che ingannano. Così nella Galleria del Serenissimo Gran Duca di Toscana, & in molte altre Città, e Gallerie, & in Venezia, trà le molte, nella Casa Tebaldi à San Moisè, si vede in meza figura un'Huomo con berettone, vestito, alla antica, con habito di raso bianco, che pone la mano sopra un pugnale, che in fatti chi lo vede dice quello esser gemello di Giorgione: poiche nella espressione dell'attitudine fiera, nell'Idea graue, nel vestimento bizaro altro, che cosi non si può dire.
 p. 2-4

Sestier di S. Marco
Church of Santa Maria Giobenico
Preti

Sopra una **facciata di Casa in Rio di Cà Pisani, à** Santa Maria Zobenico per mezo il Palazzo di Cà Flan-

fregi di chiaro oscuro, di rosso in rosso, di giallo in giallo, e di verde in verde, con varij capriccij de Puttini, nel mezzo de' quali, vi sono dipinte quattro meze figure, cioè Bacco, Venere, Marte, e Mercurio, coloriti al naturale. pp. 83, 84

Campo di Santo Stefano

Più auanti dalla stessa parte, vi sono **due Case, dipinti da Giorgion,** con bellissime figure, vestite all'antica: ma il vorace dente del tempo distrugge la virtù del pennello. p. 87

Fontico de Tedeschi

Nella facciata sopra il Canal grande, sonovi molte figure, & Architetture, dipinte da Giorgione.

Dalla parte della terra, euui la facciata dipinta da Tiziano; doue si vede sopra la Porta Giuditta, con la spada alla mano, e sotto a piedi il reciso capo d'Holoferne, con un soldato appresso armato: opera delle più singolari dell'Autore.

Euui poi un fregio, che continua la facciata, di chiaro oscuro, con varietà de Puttini, & altro sopra il cantonale verso il Ponte di Rialto trà le altre vedesi una figura ignuda in piedi, che pare il Ritratto di quella perfetta Donna, che creò Iddio di sua mano, e sopra à questa in altri due comparti, si vedono altre due figure di huomini ignudi, che paiono di carne; & varie altre, che seguitano l'ordine: ma trà quelle dell'altro Cantonale corrispondente, si vedono due figure, una d'un Leuantino, l'altra d'uno di quei compagni della Calza antico, che più non può far la Pittura.
 p. 109, 110

Sestier di Castello
Hostelry of the Scuola di San Marco

Entrando nell'albergo, a mano sinistra, vi si vede un temporale, che seguì per opera diabolica al Lito, quando per **miracolo di San Marco** fù disfatto; opera bellissima di Giorgione. p. 70

Sestier di San Polo
Church of San Polo

Nel Campo pure di S. Polo, si vede la facciata di **Casa Soranza** conseruare alcune figure di Giorgione, trà le quali una Donna in piedi ignuda, & un'altro nudo d'huomo; cose preziose. p. 5

Church of S. Silvestro, Preti

Nello stesso Campo sopra **la Casa, oue solleua habitar Giorgione,** si vede ancora qualche figura dello stesso Autore. p. 9

Church of S. Rocco

Vi è anco nella Capella sinistra, sopra l'Altare, un quadro con **nostro Signore, che porta la Croce: opera** famosissima di Tiziano. p. 49

Sestier di Dorso Duro
Church of the Hospital of the Incurables

Sopra una porta in un quadretto posticcio, v'è **Cristo con la Croce in spalla,** & un manigoldo, che lo tira con un laccio; opera di Giorgione. p. 20

Sestier di Canareggio
Church of San Canziano, Preti

Fuorì di detta Chiesa, dalla parte, che si và in Birri Picciolo, vi è **Casa Rettani**, dipinta da Giorgione, ma dal tempo oltraggiata: però sopra la riua, verso il Rio, si vede una bellissima figura di Donna di chiaro oscuro, & alcuni altre vestigi. p. 8

Scuola de Sartori, by the Jesuit Fathers

Nel salotto di sopra auanti il Banco, vi è un quadro di Giorgione, con **Maria, il Bambino, S. Barbera, S. Gioseffo, & un Ritratto**: opera esquisita, e da molti desiderata. pp. 15, 16

Scuola de' Tintori, close by the Servi

Ma torniamo à i Servi, e vederemo la **casa Grimana** tutta dipinta da Tiziano: ma maltrattata dal Tempo, pure vi si vede ancora una Conna nuda d'esquisita bellezza, & altre cose. p. 52

Church of Saints Ermacora, and Fortunato, called S. Marcuola, Preti

Vi'è poi in detta Contrata nell'Andito di **Casa Grimana,** l'Arma di essa Casa, sopra varie porte dipinta, con alcuni huomini maritimi, che le tengono: cose veramente rare di Giorgione.

E pure dello stesso Giorgione, sopra una porta, si vede una figrua di Donna rappresentante **la Diligenza,** e di sopra l'altra corrispondente, **la Prudenza,** cose rare. Di più vi sono dipinte alcune teste di Leoni, sopra la porta della riua, finte di pietra; cosi bene espresse, pigliando i lumi dal di sotto in sù, che di quando in quando v'è alcuno, che le crede di pietra e; sono dello stesso Autore. p. 60

1664. Boschini.

BIBLIOGRAPHY

1488 Sacrobosco J., *Sphaera Mundi*, Venice.

1499 Colonna F., *Hypnerotomachia Polifili*, Venetiis (ed. G. Pozzi and L. Ciapponi, Padua, 1964).

1502 Sannazaro J., *Libro pastorale*, Venice.

1505 Bembo P., *Gli Asolani*, Vinegia.

1528 Castiglione B., *Il Cortegiano*, Florence.

1548 Pino P., *Dialogo di Pittura...*, in Venezia per Paolo Gherardo MDXLVIII (ed. R. and A. Pallucchini, Venice, 1946).

1549 A. Doni, *Disegno*, Venice.

1550 Vasari G., *Le Vite de' più eccellenti pittori, scultori ed architetti* (I ed.), Florence.

1556 Guisconi A., *Tutte le cose notabili... in Venezia*, Venice.

1557 Dolce L., *Dialogo della Pittura intitolato l'Aretino*, Venice.

1565 Dolce L., *Dialogo del quale si ragiona delle qualità, diversità e proprietà dei colori*, Venice.

1568 Vasari G., *Le Vite de' più eccellenti pittori, scultori ed architetti* (II ed.), Florence (ed. G. Milanesi, Florence, 1878-85; C.L. Ragghianti, Milan, 1945).

1581 Sansovino F., *Venetia città nobilissima*, Venice.

1584 Borghini R., *Il Riposo*, Firenze (ed. M. Rosci, Milan, 1967).

1585 Lomazzo G.P., *Trattato dell'arte della Pittura, Scoltura et Architettura*, Milan.

1587 Armenini G.B., *De' veri precetti della pittura*, Ravenna.
 Bardi G., *Delle cose notabili della città di Venetia*, Venice.

1603 Ripa C., *Iconologia*, Rome.

1604 Stringa G., *Venetia città nobilissima et singolare descritta da Francesco Sansovino*, Venice.

1605 Zuccaro F., *Lettera a principi et signori amatori del dissegno...*, Mantua.

1622 Verdizotti G.M., *Breve compendio della Vita del Famoso Titiano Vecellio di Cadore*, Venice.

1624 Goldioni L., *Le cose maravigliose et notabili della Città di Venezia*, Venice.

1648 Ridolfi C., *Le maraviglie dell'arte*, Venice (ed. D. von Hadeln, Berlin, 1914).

1649 *Catalogue of the Collection of King Charles I.*

1650 Manilli J., *Villa Borghese fuori di Porta Pinciana*, Rome.

1654 *Inventory of the Arundel Collection.*

1657 Scannelli F., *Il Microcosmo della Pittura*, Cesena.

1658 Teniers D., *Theatrum pictorium Davidis Teniers antwerpiensis*, Antwerp.

1659 *Inventar der Kunstsammlung des... Leopoldt Wilhelmen* (ed. A. Berger, 1883).

1660 Boschini M., *La Carta del Navegar Pitoresco*, Venice (ed. A. Pallucchini, Venice, 1966).
 Variarum Imaginum... Gerardi Reynst..., Amstelodami.

1663 Martinioni G., *Venetia città nobilissima descritta da F. Sansovino*, Venice.

1664 Boschini M., *Le minere della Pittura*, Venice.

1665 De Monconys, *Journal des Voyages*, Lyon.

1666 Félibien A., *Entretiens sur les vies et sur les ouvrages des plus excellents peintres anciens et modernes*, Paris.

1671 Barri G., *Viaggio pittoresco*, Venice.

1674 Boschini M., *Le ricche Minere della Pittura veneziana*, Venice.
 Scaramuccia L., *Le finezze dei pennelli italiani*, Pavia.

1675 Sandrart van J., *L'Academia Nobilissimae Artis Pictoriae*, Nürnberg.

1682 Bullart J., *Académie des sciences et des arts...*, Paris.

1685 Aglionby W., *Painting illustrated in three dialogues...*, London.

1688 *Catalogue of the Collection of King James II.*

1697 Coronelli P.V.M., *Viaggi del P. Coronelli, viaggio d'Italia in Inghilterra*, Venice.

1699 De Piles R., *Abrégé de la vie des Peintres*, Paris.

LE COMTE FL., *Cabinet des singularités d'Architecture, Peinture, Sculpture et Gravure*, Paris.

1704 ORLANDI E.P.A., *Abecedario Pittorico*, Bologna.

1718 DAL POZZO B., *Le Vite dei Pittori, degli Scultori et Architetti Veronesi*, Verona.

1720 STORFFER, *Gemaltes Inventarium der Gemäldegalerie in der Stallburg*, Vienna.

1728 DE PRENNER A.J., *Theatrum Artis Pictoriae*, Vienna.

1729 *Galerie Crozat*, Paris, 1729-42, I, plate 33.
 Recueil d'estampes... de Monsigneur le Duc d'Orléans..., Paris.

1733 PARRINO N., *L'Abecedario Pittorico*, Naples.
 ZANETTI A.M., *Descrizione di tutte le pubbliche pitture della città di Venezia*, Venice.

1740 ALBRIZZI G., *Forestiere illuminato della città di Venezia*, Venice.

1741 MARIETTE P.J., *Description sommaire des dessins... du Cabinet du feu M. Crozat*, Paris.

1742 HARMS A.F., *Tables historiques et chronologiques des plus fameux Peintres anciens et modernes*, Brunswick.

1745 DÉZALLIER D'ARGENVILLE, *Abrégé de la vie des plus Fameux Peintres*, Paris.

1750 ROISECCO, *Roma Antica e Moderna*, Rome.

1751 KEYSSLER J.G., *Neueste Reisen*, Hannover.

1752 HOET G. - TERWESTEN P., *Catalogus of naamlyst van Schilderyen...*, The Hague.

1753 ORLANDI P. - GUARIENTI S., *Abecedario Pittorico*, Venice.

1754 BOTTARI G.M., *Raccolta di lettere sulla pittura...*, Rome.

1757 BOTTARI G.M., *Raccolta di lettere sulla pittura*, Rome.
 A Catalogue and Description of King Charles the First's Capital Collection, London.

1758 *A Catalogue... of George Villiers...*, London.
 A Catalogue... of King James III, London.

1760 ZANETTI A.M., *Varie Pitture a Fresco de' Principali Maestri Veneziani*, Venice.

1762 MENGS R., *Gedanken über die Schönheit und den Geschmack in der Malerei*, Zurich.

1769 *Serie degli uomini più illustri nella pittura...*, Florence.

1770 PILKINGTON M., *The Gentleman's and Connoisseur's Dictionary of Painters from the year 1250 to the year 1767*, London.
 VOLKMANN D.J.J., *Historisch-kritische Nachrichten von Italien*, Leipzig.

1771 ZANETTI A.M., *Della Pittura Veneziana...*, Venice.

1773 HAMILTON G., *Schola Italica Picturae*, Romae.
 RICHARDSON J., *The Works of Mr. Jonathan Richardson*, London.

1776 BARTOLI F., *Notizia delle pitture...*, Venice.

1780 MENGS A.R., *Opere*, Rome.

1782 CHIUSOLE A., *Itinerario*, Vicenza.

1783 DU FRESNOY C.A., *The Art of Painting*, York.
 MECHEL VON C., *Verzeichnis der Gemälde der K.K. Bilder Galerie*, Vienna.

1786 COUCHÉ J., *Galerie du Palais Royal*, Paris.
 RATTI C.G., *Istruzione di quanto può vedersi... in Genova*, Genoa.

1795 BRANDOLESE P., *Pitture, Sculture, Architetture ed altre cose notabili di Padova*, Padua.

1795-96 LANZI L., *Storia pittorica dell'Italia*, Bassano.

1796 ROSA J., *Gemälde der K.K. Gallerie. I. Italienische Schulen*, Vienna.

1798 FUORILLO J.D., *Geschichte der Künste und Wissenschaften...*, II, Göttingen.

1799 DE BROSSES, Ch., *Lettres Historiques et Critiques sur l'Italie*, Paris.

1800 FÜSSLIN H.R., *Kritisches Verzeichnis...*, Zurich.
 MICHIEL M.A., *Notizia d'opere del disegno*, ed. Morelli F., Bassano; (ed. Frizzoni G., Bologna, 1884; Frimmel T., Vienna, 1888).

1803 FEDERICI D.M., *Memorie trevigiane sulle opere di disegno*, Venice.
 Belle Arti, in « Il Quotidiano Veneto », 2 December.

1804 FILHOL, *Galerie du Musée Napoléon*, Paris.

1805 PILKINGTON M., *A Dictionary of Painters*, London.

1811 CICOGNARA L., *Elogio del Giorgione*, Venice.

1812 DELAROCHE H., *Catalogue historique et raisonné des Tableaux... Galerie Giustiniani*, Paris.
 LANDON C.P., *La Galerie Giustiniani...*, Paris.

1813 QUANDT G., *Streifereien im Gebiete der Kunst auf einer Reisen von Leipzig nach Italien im Jahre 1813*, Leipzig.

1815 MOSCHINI G., *Guida per la città di Venezia*, Venice.

1818 GILLOW G., *Select Engravings from a Collection of Pictures...*, London.

LANZI L., *Storia pittorica della Italia*, Bassano.

TICOZZI S., *Dizionario dei Pittori...*, Milan.

1821 QUADRI A., *Otto giorni a Venezia*, Venice.

1822 CHABERT J.CL., *Galerie des Peintres*, Paris.

1823 ORLOFF G., *Essai sur l'histoire de la peinture en Italie*, Paris.

ZANI P., *Storia pittorica della Italia*, Paris.

1824 BUCHANAN W., *Memoirs of Painting*, London.

1826 DUCA BENEDETTI DA MONTEVECCHIO, *Lettera pittorica sopra un interessante quadro di Giorgio Barbarelli da Castelfranco*, Spoleto.

Le Belle Arti in Venezia, Venice.

1827 RUMOHR VON G.F., *Italienische Forschungen*, Berlin.

1827-29 SEROUX D'AGINCOURT, *Storia dell'Arte dimostrata coi monumenti*, Prato, voll. IV, VI.

1829 DENON V., *Monuments des Arts du dessin...*, Paris.

DUCHESNE AINÉ, *Musée de Peinture et de Sculpture*, Paris.

1830 HIRT A., *Kunstbemerkungen auf einer Reise über Wittenberg und Meissen nach Dresden und Prag*, Berlin.

LANZI L., *Geschichte der Malerei in Italien*, Leipzig.

SCHLEGEL A.G., *Leçons sur l'histoire et la théorie des Beaux Arts, etc.*, Paris.

1831 ZANOTTO F., *Pinacoteca della Imperiale Regia Accademia veneta*, Venice.

1832 DE CLARAC CTE F., *Musée de Sculpture Antique et Moderne*, Paris.

1833 BYRON G., *Works*, London.

SCHOTTKY J.M., *Über München's Kunstschätze*, in « Museum », n. 9.

ZANOTTO F., *Pinacoteca della R. Accademia...*, I, n. 22, Venice.

1834 LANZI L., *Storia pittorica della Italia*, Florence.

PULIERI G., *Pinacoteca Trevigiana*, Treviso.

1835 NAGLER G.K., *Neues Allgemeines Künstler-Lexikon*, Munich.

1836 PASSAVANT M., *Tour of a German artist in England*, London.

1837 KRAFFT A., *Verzeichnis der K.K. Gemälde-Galerie im Belvedere*, Vienna.

KUGLER F., *Handbuch der Geschichte der Malerei in Italien*, Berlin.

PAOLETTI E., *Il Fiore di Venezia*, Venice.

WAAGEN F., *Kunstwerke und Künstler in England and Paris*, Berlin.

1838 FOERSTER E., *Briefe über Malerei*, Stuttgart.

MUTINELLI F., *Annali urbani di Venezia*, Venice.

ZANOTTO F., *Storia della Pittura veneziana*, Venice.

1840 GAYE G., *Carteggio inedito d'artisti*, Florence.

1841 CAVALCASELLE G.B., *Pinacoteca Contarini*, Venice.

1842 CADORIN G., *Memorie originali italiane...*, Bologna.

GUALANDI, *Memorie originali di Belle Arti*, Bologna.

1843 HAZLITT W., *Criticism on Art and Sketches...*, London.

ROSINI G., *Storia della Pittura Italiana*, Pisa.

VALLARDI G., *Letter to Count Cesare di Castelbarco Visconti*, Milan.

1844 JAMESON, *Private Galleries of Art in London*, London.

LECOMTE G., *Venezia*, Venice.

MOSEN J., *Die Dresdner Gemäldegalerie...*, Dresden.

1845 D'ARCO C., *Notizie di Isabella Estense...*, in « Archivio Storico Italiano », Appendix.

HELLER J., *Die Gräflich Schönbornsche Gemälde-Sammlung...*, Bamberg.

1847 ROSINI G., *Venezia e le sue lagune*, Venice, vol. I.

1848 EASTLAKE CL.L., *Contributions to the Literature of the Fine Arts*, London.

1850 MÜNDLER O., *Essai d'une analyse de la Notice des tableaux italiens du Musée National du Louvre*, Paris.

1851 MARIETTE P.J., *Abecedario*, Paris.

RUSKIN J., *The Stones of Venice*, London.

1852 BURCKHARDT J., *Der Cicerone*, Lipsia.
 RIGOLLOT M., *Essai sur le Giorgione*, in « Memoires de l'Académie d'Amiens ».
 SELVATICO P., *Storia estetico-critica delle Arti del Disegno*, Venice.
 SELVATICO P. - LAZARI V., *Guida artistica e storica di Venezia*, Venice.
1853 CICOGNA E.A., *Iscrizioni Veneziane*, Venice.
 DUMESNIL J., *Histoire des plus célèbres amateurs italiens*, Paris.
1854 KUGLER F., *Kleine Schriften und Studien zur Kunstgeschichte*, Stuttgart.
 UNGER M., *Giorgio Barbarelli gen. Giorgione*, in « Deutsches Kunstblatt ».
 WAAGEN G.F., *Treasures of art in Great Britain*, London.
1855 SIRET A., *Dictionnaire historique des Peintres*, Paris.
 SPRINGER A.H., *Handbuch der Kunstgeschichte*, Stuttgart.
1856 DE MARCHI A., *Nouveau guide de Padoue*, Padua.
 HÜBNER J., *Historische Einleitung des Verzeichnisses der Dresdner Gemäldegalerie*, Dresden.
 QUANDT VON J.G., *Der Begleiter durch die Gemälde-Säle des Königl. Museum zu Dresden*, 2 ed., Dresden.
 WORNUM R.N., *Catalogue of the Pictures in the National Gallery*, London.
 ZANOTTO F., *Nuovissima guida di Venezia*, Venice.
 ZANOTTO F., *La Sibilla Delfica...*, Venice.
 Catalogo dei quadri esistenti nella Galleria Manfrin in Venezia, Venice.
1857 BLANC CH., *Le Trésor de la curiosité tiré des catalogues de vente*, Paris.
 BURGER W., *Trésors d'art exposés à Manchester in 1857*, Paris.
 WAAGEN G.F., *Galleries and Cabinets of Art in Great Britain*, London.
 Catalogue of the Art Treasures of the United Kingdom, Manchester.
1858 ENGERT E., *Catalog der K.K. Gemäldegalerie in Belvedere*, Vienna.
1859 JAMESON, *Memoires of Early Italian Painters...*, London.
 WYATT A., *Marques et Monogrammes*, in « Gazette des Beaux-Arts », I, p. 298.
1860 GALICHON E., *Albert Dürer*, in « Gazette des Beaux-Arts », p. 24.
 JARVES J.J., *Descriptive Catalogue*, New Haven.
 LAGRANGE L., *Le chateau Borély, à Marseilles*, in « Gazette des Beaux-Arts », p. 160.
 PASSAVANT J.D., *Raphael*, Paris.
 PUPPATI L., *Degli uomini illustri di Castelfranco*, Castelfranco.
 SCHÄFER W., *Die Königliche Gemäldegalerie im Neuen Museum zu Dresden*, Dresden.
 TESCARI L., *Per nozze Puppati-Fabeni*, Castelfranco.
 VIARDOT L., *Les Musées d'Angleterre...*, 3 ed., Paris.
1861 LAGRANGE L., *Exposition des Beaux Arts à Marseilles*, in « Gazette des Beaux-Arts », p. 437.
1862 BASCHET A., *Correspondance particulière*, in « Gazette des Beaux-Arts », p. 89.
 LAGRANGE L., *Catalogue des Dessins de Maitres...*, in « Gazette des Beaux-Arts », p. 276.
 Description sommaire des objets d'art faisant partie des collections du Duc d'Aumale...
1863 CAMPORI G., *Documents inédits sur Raphael*, in « Gazette des Beaux-Arts », p. 449.
 TASSINI G., *Curiosità Veneziane*, Venice.
1864 SEMENZI G.B.A., *Treviso e la sua provincia* (2 ed.), Treviso.
1865 DAVASIÉS DE PONTÉS L., *Études sur la Peinture vénitienne et Giorgione*, in « Revue Universelle des Arts... ».
 UNGER M., *Kritische Forschungen im Gebiete der Malerei...*, Leipzig.
 WEIGEL R., *Die Werke der Maler in ihren Handzeichnungen*, Leipzig.
1866 CAMPORI G., *Lettere artistiche inedite*, Modena.
 REINHART H., *Castelfranco und einige weniger bekannte Bilder Giorgione's*, in « Zeitschr. f. bild. Kunst. ».
 VALENTINELLI, *Marmi scolpiti dal Museo archeologico della Marciana*, Venice.
1867 DUDIK, in « Mittlgn. der K.K. Zentralkommission, XXXIII ».
 MÜNDLER, in « Kunstchronik », II, 134.
1868 BLANC CH., *Histoire des Peintres*, Paris.
 LORENZI, *Monumenti per servire alla storia del Palazzo Ducale di Venezia*, Venice.
1869 SCHAUFUSS L.W., *Notizen zum Gemälde G. Barbarellis gen. Giorgione...*, Dresden.
1870 BARTSCH A., *Le peintre-graveur*, Leipzig.
 BOUILLIER, *L'Art vénitien*, Paris.

CAMPORI G., *Raccolta di Cataloghi...*, Modena.

SÉGUIER F.P., *Dictionary of the works of Painters*, London.

WOODWARD B.B., *Specimens of the Drawings of ten Masters...*, London.

1871 CROWE J.A., CAVALCASELLE G.B., *A History of Painting in North Italy*, London.

1872 NICOLETTI, *La Galleria Manfrin*, Venice.

1873 COLBACCHINI F., *Quadro prezioso rappresentante l'Adorazione dei Re Magi...*, Venice.

1874 DYCE A., *Dyce Collection*, London.

MÜNDLER O., *W. Bode, Beiträge...*, Leipzig.

SCHAUFUSS L.W., *Zur Beurteilung der Gemälde Giorgiones*, Dresden.

1875 LERMOLIEFF I., [MORELLI G.], *Die Galerien Roms*, in « Zeitschr. f. Bild. Kunst », pp. 97, 207, 264.

1877 BRAGHIROLLI W., *Carteggio di Isabella d'Este Gonzaga intorno ad un quadro di Giambellino*, in « Archivio Veneto », p. 370.

PATER W., *The School of Giorgione in the Renaissance*, London.

REISET, *Une visite aux Musée de Londres en 1876*, in « Gazette des Beaux-Arts », p. 1.

1878 BIANCHETTI G.V., *Giorgione...*, Castelfranco Veneto.

CAMAVITTO, *La famiglia di Giorgione da Castelfranco*, in « Giornale Arcadico ».

DAL MEDICO A., *Il Giorgione...*, in « Boll. di Arti, Industria e Curiosità Veneziane », 2, p. 27.

FABRIS R., *Giorgione*, Venice.

FAPANNI F., *Della Madonna di Giorgione...*, in « Boll. di Arti, Industria e Curiosità Veneziane ».

LÜBKE W., *Geschichte der italienischen Malerei*, Stuttgart.

LÜCKE H., *Giorgione*, in « Jul. Meyer's Allg. Künstler-Lexikon », p. 692.

MOLMENTI P., *Giorgione*, in « Boll. di Arti, Industria e Curiosità Veneziane », p. 17.

URBANI DE GHELTOF G.M., *La Casa di Giorgione a Venezia*, in « Boll. di Arti, Industria e Curiosità Veneziane », p. 24.

VIANI L., *Giorgione in Venezia*, Venice.

Sopra la statua di Giorgione..., Castelfranco.

1879 ARUNDEL SOCIETY, *Giorgione's Madonna and Child*, London.

DE CHENNEVIÈRES Ph., *Les Dessins de maîtres anciens exposés à l'École des Beaux-Arts*, in « Gazette des Beaux-Arts », p. 505.

LÜCKE H., *Giorgione*, in « R. Dohme, Kunst und Künstler... », Leipzig.

SANUDO M., *I Diarii*, Venice.

1880 LERMOLIEFF I., [MORELLI G.], *Die Werke italienischer Meister in den Galerien von München, Dresden und Berlin*, Leipzig.

1881 EISENMANN O., *Die neueren Erwerbungen der Dresdner Galerie*, in « Kunstchronik », p. 650.

FULIN-MOLMENTI, *Guida artistica e storica di Venezia*, Venice.

LAW E., *Historical Catalogue of the Pictures of Hampton Court*, London.

PALUSTRE L., *Exposition de Tours*, in « Gazette des Beaux-Arts », p. 184.

1882 DOLLMAYR, *Catalogue du Louvre*, Paris.

ENGERTH E.R., *Catalogue du Louvre*, Paris.

ENGERTH E.R., *Gemaelde—Beschreibendes Verzeichnis*, Vienna.

GAUTIER TH., *Guide de l'amateur au Musée du Louvre*, Paris.

H.J., *Pest Nationalgalerie*, in « Repertorium f. Kunstwiss. », p. 81.

SANUDO M., *Diarii 1496-1533*, Venice.

WOLTMANN-WOERMANN, *Geschichte der Malerei*, Leipzig.

1883 BERGER A., *Inventar der Kunstsammlung der Erzherzogs Leopold Wilhelm...*, in « Jahrbuch der Kh. Samml. », I, p. LXXIX.

BODE W., *Die Ausstellung von Gemaelden aelterer Meister*, in « Preuss. Jahrbuch », p. 146.

RICHTER J.P., *Italian Art in the National Gallery*, London.

1884 BONNAFÉ E., *Dictionnaire des Amateurs français au XVII siècle*, Paris.

DE COSNAC, *Les Richesses du Palais Mazarin*, Paris.

MICHIEL M., *Notizia di opere di disegno* (ed. Frizzoni), Bologna.

NOLHAC P., *Les Collections de Fulvio Orsini*, in « Gazette des Beaux-Arts », p. 427.

PHILLIPS C., *Correspondance d'Angleterre*, in « Gazette des Beaux-Arts », p. 286.

RUSKIN J., *Oxford Lecture*, « Pall Mall Gazette », 10 Nov.

SCHAUFUSS L.W., *Giorgione's Werke...*, Leipzig.

THAUSING M., *Wiener Kunstbriefe*, Leipzig.

THAUSING M., *Giorgione...*, in « Wiener Kunstbriefe ».

YRIARTE C., *Les Portraits de Lucrèce Borgia*, in « Gazette des Beaux-Arts », p. 214.

1885 LARPENT S., *Le Jugement de Paris attribué au Giorgione*, Cristiania.

PHILLIPS C., *Correspondance d'Angleterre*, in « Gazette des Beaux-Arts », 447.

RICHTER J.P., *Commentary to Vasari's « Lives »*, London.

THODE H., in « Der Kunstfreund », Berlin.

VENTURI A., *Zur Geschichte der Kunstsammlungen Kaiser Rudolf II*, in « Rep. f. Kunstwiss », p. 12.

1886 BODE W., *Aus oesterreichischen Galerien*, in « Rep. f. Kunstwiss. », p. 308.

C. v. F., *London. National Gallery. Neuerwerbungen*, in « Rep. f. Kunstwiss. », p. 454.

MEYER J., *Das Frauenbildnis des Sebastiano del Piombo...*, in « Preuss. Jahrbuch », p. 59.

MORELLI G.B., *Le opere dei maestri italiani nelle Gallerie di Monaco Dresda e Berlino*, Bologna.

1887 MARES F., *Beiträge zur Kenntnis der Kunstbestrebungen...*, in « Oesterr. Jahrbuch », p. 343.

REISET, *Une visite à la Galerie Nationale de Londres*, Paris.

YRIARTE C., *Les Portraits de César Borgia*, in « Gazette des Beaux-Arts », p. 296.

1888 DELLA ROVERE A., *Guida alla Reale Galleria a Venezia*, Venice.

FAPANNI F., *Della « Madonna » di Giorgione in S. Liberale di Castelfranco...*, in « Boll. di Arti, Industria e Curiosità Veneziane ».

LUZIO A., *Isabella d'Este e due grandi quadri di Giorgione*, in « Archivio Storico dell'Arte », p. 47.

MICHIEL M., *Notizia d'opere del disegno* (ed. Frimmel), Vienna.

REDFORD G., *Art Sales*, Vienna.

ZIMMERMANN H., *Urkunden, Akten und Regesten...*, in « Oesterr. Jahrbuch », 7, II, p. 15.

ZIMMERMANN H., *Prodromus*, in « Oesterr. Jahrbuch », 7, VII.

1889 CAMAVITTO L., *Giorgione da Castelfranco e la sua Madonna nel Duomo della sua patria*, Castelfranco.

KÖPL K., *Urkunden, Acten, Regesten...*, in « Oesterr. Jahrbuch », p. 10.

MÜNTZ E., *Histoire de l'art pendant la Renaissance*, Paris.

RICHTER J.P., *A Descriptive Catalogue...*, London.

1890 ARMSTRONG W., *The Corporation Gallery of Glasgow*, in « Magazine of Art », p. 91.

LERMOLIEFF I., [MORELLI G.], *Kunstkritische Studien über italienische Malerei. Die Galerien Borghese und Doria Panfili in Rom*, Leipzig.

1891 GRUYER F.A., *Voyage autour du Salon Carré au Musée du Louvre*, Paris.

KRISTELLER P., *Un'antica riproduzione del Torso di Belvedere*, in « Archivio Storico dell'Arte », IV.

LERMOLIEFF I., [MORELLI G.], *Kunstkritische Studien über italienische Malerei. Die Galerien zu München und Dresden*, Leipzig.

MÜNTZ E., *Le Musée de l'École des Beaux-Arts*, in « Gazette des Beaux-Arts », p. 47.

SEIDLITZ v. W., *I. Lermolieff. Kunstkritische Studien...*, in « Rep. f. Kunstwiss. », p. 314.

1892 FRIMMEL T., *Kleine Galerie-Studien*, I, Folge.

MORELLI G., *Handzeichnungen italienischer Meister*, in « Kunstchronik », p. 545.

1893 BODE W. - BURCKHARDT J., *Der Cicerone*, Lipsia.

BYLES S.A., *Temple Newsam and its Collections*, in « Magazine of Art », p. 208.

DELLA ROVERE A., *Zorzi da Castelfranco*, in « Arte e Storia ».

DICKES W.F., *The Portrait of a Poet*, in « Magazine of Art », pp. 156, 202.

FRIZZONI G., *I capolavori della Pinacoteca del Prado in Madrid*, in « Archivio Storico dell'Arte », p. 278.

LERMOLIEFF I., [MORELLI G.], *Kunstkritische Studien über italienische Malerei. Die Galerien zu Berlin*, Leipzig.

PAOLETTI P., *L'Architettura e la scultura del Rinascimento in Venezia*, Venice.

PHILLIPS C., *L'exposition des maîtres anciens à la Royal Academy*, in « Gazette des Beaux-Arts », p. 227.

VENTURI A., *Nelle Pinacoteche minori d'Italia*, in « Archivio Storico dell'Arte », p. 409.

VENTURI A., *Catalogo della Galleria Borghese*, Rome.

WICKHOFF F., *Les Écoles Italiennes au Musée Impérial de Vienne*, in « Gazette des Beaux-Arts », pp. 5, 130.

ZIMMERMANN E., *Die Landschaft in der Venezianischen Malerei*, Lipsia.

1894 BERENSON B., *The Venetian Painters of the Renaissance*, New York.

CONTI A., *Giorgione*, Florence.

GRONAU G., *Notes sur les dessins de Giorgione et des Campagnola*, in « Gazette des Beaux-Arts », p. 322.

GRONAU G., *Zorzon da Castelfranco...*, in « Nuovo Archivio Veneto », p. 447.

HOFSTEDE DE GROOT C., *Entlehnungen Rembrandts*, in « Preuss. Jahrbuch », pp. 178, 180.

LOGAN M., *Guide to the Italian Pictures at Hampton Court*, London.

MORSOLIN B., in « Nuovo Archivio Veneto », p. 191.

SCHACK VON F., *Meine Gemäldesammlung*, Stuttgart.

VOLTELINI VON H., *Urkunden und Regesten...*, in « Oesterr. Jahrbuch », CXXXI, n. 12219.

1895 BERENSON B., *Venetian Painting at the New Gallery*, London.

D'ANNUNZIO G., *Note su Giorgione e la sua critica*, in « Il Convito », p. 82.

FOULKES C.J., *L'esposizione dell'arte veneta a Londra*, in « Archivio Storico dell'Arte », p. 261.

FOERSTER R., *Amor und Psyche von Raffael*, in « Preuss. Jahrbuch », p. 216.

FRIZZONI G., *La Pinacoteca Scarpa di Motta di Livenza*, in « Archivio Storico dell'Arte », p. 416.

GRONAU G., *L'Art Vénitien à Londres...*, in « Gazette des Beaux-Arts », p. 427.

HARCK F., *Notizen über italienische Bilder...*, in « Rep. f. Kunstwiss. », p. 426.

ILG A., *Das Galeriewerk des Johann Christoph...*, in « Oesterr. Jahrbuch », p. 122.

MÜNTZ E., *Histoire de l'art pendant la Renaissance*, Paris.

PHILLIPS C., *A probable Giorgione*, in « Magazine of Art », p. 347.

R.A., *La Madone de Castelfranco*, in « Gazette des Beaux-Arts », p. 433.

RICHTER J.P., *Catalogue of the Doetsch Collection*, London.

RICHTER J.P., *The Winter Exhibition of Works...*, in « The Art Journal », p. 90.

SEIDLITZ VON W., *Die Ausstellung venezianischer Kunst...*, in « Rep. f. Kunstwiss. », p. 209.

WICKHOFF F., *Giorgiones Bilder*, in « Preuss. Jahrbuch », p. 34.

Venetian Art, exhibited at the New Gallery, London.

1896 A.C. (CONTI), *Bibliografie. Giorgione*, in « Gazette des Beaux-Arts ».

FRIMMEL T., *Gemalte Galerien*, Berlin.

FABRICZY VON C., *Giorgione da Castelfranco*, in « Rep. f. Kunstwiss. », p. 82.

GRONAU G., *Giorgione*, in « Das Museum », p. 2.

GRONAU G., *Zu Giorgione*, in « Rep. f. Kunstwiss. », p. 167.

HARCK F., *Notizen über italienische Bilder...*, in « Rep. f. Kunstwiss. », p. 413.

PHILLIPS C., *The Picture Gallery of Charles I*, London.

R.A., *La nouvelle critique d'art...*, in « Gazette des Beaux-Arts », p. 262.

ULLMANN H., *Piero di Cosimo*, in « Preuss. Jahrbuch », p. 120.

1897 BERENSON B., *De quelques copies d'après les originaux perdus de Giorgione*, in « Gazette des Beaux-Arts », p. 265.

PHILLIPS C., *The Earlier Work of Titian*, London.

Lansdowne House Catalogue, London.

1898 BRINTON S., *The Renaissance in Italian Art*, London.

BURCKHARDT J., *Beiträge zur Kunstgeschichte von Italien*, Berlin.

DELLA ROVERE A., *Zorzi da Castelfranco*, in « Arte e storia », p. 3.

FRIMMEL T., *Galeriestudien*, Vienna.

KENNER F., *Die Porträtsammlung des Erzherzogs Ferdinand von Tirol*, in « Oesterr. Jahrbuch », p. 19.

LAW E., *The Gallery of Hampton Court Illustrated*, London.

1899 DE VASCONCELLOS J., *Francisco de Hollanda...*, Vienna.

JACOBSEN E., *Bilderbenennungen in Venedig*, in « Rep. f. Kunstwiss », p. 341.

PHILLIPS C., *The Picture gallery of the Hermitage*, in « North American Review », p. 466.

SCHAEFFER E., *Die Frau in der Venezianischen Malerei*, Munich.

SCHLOSSER VON J., *Die Werkstatt der Embriachi in Venedig*, in « Oesterr. Jahrbuch », p. 200.

SOMOF A., *Ermitage Impérial...*, St. Pétersbourg.

1900 COOK H., *Giorgione*, London.

GRONAU G., *Tizian*, Berlin.

LEVI C.A., *Le collezioni veneziane*, Venice.

MUTHER R., *Geschichte der Malerei*, Leipzig.

SCHLOSSER VON J., *Jupiter und die Tugend*, in « Preuss. Jahrbuch », p. 267.

VENTURI A., *La Galleria Crespi in Milano*, Milan.

VENTURI A., *Un nuovo quadro di Giorgione*, in « Annales Internationales d'Histoire », Congrès de Paris, 7th Section.

VENTURI A., *Un'opera di Giorgione nella Galleria Nazionale di Palazzo Corsini*, in « L'Arte », p. 316.

VENTURI A., *I quadri di scuola italiana nella Galleria Nazionale di Budapest*, in « L'Arte », p. 220.

WEIZSÄCKER H., *Catalog der Gemälde-Gallerie...*, Frankfurt a. M.

1901 BERENSON B., *The Study and Criticism of Italian Art*, London.

BRUNELLI E., *Review of H. Cook, Giorgione*, in « L'Arte », p. 126.

DELLA ROVERE A., *La Galleria Nazionale d'Arte Antica a Roma*, in « Arte e Storia », p. 13.

JACOBSEN E., *Italienische Gemälde in der Nationalgalerie zu London*, in « Rep. f. Kunstwiss. », p. 30.

JUSTI L., *Die Venezianische Malerei in der ersten Hälfte des XVI Jahrhunderts*, in « Das Museum ».

STEARNS F.P., *Four Great Venetians*, New York.

Kaufmann Sale, catalogue, Berlin.

1902 BAYERSDORFER A., *Leben und Schriften*, Munich.

BERENSON B., *The Study and Criticism of Italian Art*, London.

COOK H., *Trésors de l'Art Italien en Angleterre*, in « Gazette des Beaux-Arts », p. 445.

D'ANCONA P., *Le rappresentazioni allegoriche delle Arti liberali*, in « L'Arte », p. 269.

FRIZZONI G., *Ricordi...*, in « L'Arte », p. 292.

HANNOVER E., *Die Seele Giorgiones*, in « Kunst und Künstler », p. 341.

JACOBSEN E., *Italienische Gemälde im Louvre*, in « Rep. f. Kunstwiss. », p. 178.

LOESER C., *Über einige italienische Handzeichnungen...*, in « Rep. f. Kunstwiss. », p. 355.

MICHEL E., *Le paysage chez les maîtres vénitiens*, in « Revue des Deux-Mondes », p. 818.

RUSCONI A.F., *La Galerie Nationale Romaine...*, in « Les Artes », I, n. 8.

SCHMIDT W., *Gemäldestudien*, in « Helbings Monastber. üb. Kunstwiss. », p. 426.

STRONG A., *Reproductions of Drawings by Old Masters in the collection of the Duke of Devonshire at Chatsworth*, London.

VENTURI A., *R. Galleria Nazionale d'Arte Antica in Roma*, Rome.

1903 BERENSON B., *The drawings of the Florentine Painters*, London.

COOK H., *Two alleged Giorgiones*, in « The Burlington Magazine », p. 78.

DELLA ROVERE A., *Zorzi da Castelfranco*, in « Rassegna d'Arte », p. 90.

EISLER R., *Mantegnas frühe Werke...*, in « Heilbings Monatsber. üb. Kunstwiss. », p. 159.

HAACK F., *Zu dem Laendlichen Konzert im Louvre*, in « Helbings Monatsber. üb. Kunstwiss. », p. 77.

KANTOROWICZ G., *Über den Meister des Emmausbildes in S. Salvatore zu Venedig*, Zurich.

LANDAU P., *Giorgione*, Berlin.

LUDWIG G., *Archivalische Beiträge*, in « Jahrbuch Preuss. Ksamml. », p. 1.

MONNERET DE VILLARD U., *Note sui concerti del Giorgione*, in « Emporium », p. 114.

PAOLETTI P., *Catalogo delle Gallerie di Venezia*, Venice.

PHILLIPS C., *Two Beautiful Ruins*, in « The Art Journal », p. 37.

ROSEN F., *Die Natur in der Kunst*, Leipzig.

SAITSCHICK R., *Menschen und Kunst der italienischen Renaissance*, Berlin.

SCHAEFFER E., *Giorgione Landschaft mit 3 Philosophen*, in « Monatshefte für Kunstwiss. », p. 340.

SCHMERBER H., *Das Konzert im Palazzo Pitti*, in « Helbings Monatsber. üb. Kunstwiss. », p. 200.

SCHMIDT W., *Giorgione und Correggio*, in « Helbings Monatsber. üb. Kunstwiss. », p. 47.

SIREN O., *Giorgione*, in « Ord. Och. Bild. », p. 465.

WICKHOFF F., *Aus der Werkstatt Bonifazios*, in « Oesterr. Jahrbuch », p. 97.

Giorgione Barbarelli, in « L'Art pour tous », p. 212.

1904 COLASANTI A., *Un quadro ferrarese nella Galleria Colonna*, in « L'Arte », p. 481.

COOK H., *Giorgione* (II ed.), London.

COOK H., *Two early Giorgiones in Sir Martin Conway's collection*, in « The Burlington Magazine », p. 156.

D'ACHIARDI P., *Galleria Nazionale. Acquisti*, in « L'Arte », p. 793.

FRY R.E., *Titians's Ariosto*, in « The Burlington Magazine », p. 136.

Monneret De Villard U., *Giorgione da Castelfranco*, Bergamo.

Poggi G., *U. Monneret de Villard: Giorgione*, in « Marzocco », p. 51.

Schmidt W., *Zu Giorgione*, in « Rep. für Kunstwiss. », p. 160.

Solerti A., *Il ritratto dell'Ariosto di Tiziano*, in « Emporium », p. 465.

Wickhoff F., *Tizian*, in « Kunstgesch. Anzeigen », p. 114.

1905 Eisler R., *An Unknown Fresco-Work by Guido Reni*, in « The Burlington Magazine », p. 313.

Frimmel T., *Wann ist Giorgiones Venus aus Venedig fortgekommen?*, in « Blätter für Gemäldekunde », I, p. 13.

Leclerc T., *Obnotiveli v umêni a tradice: od Venûse Giorgiony k Olympii Manetove*, in « Volnê Smêry », p. 237.

Malcangi A., *Da Jacopo Bellini a Giorgione*, Trani.

Philippi A., *Die Kunst der Renaissance in Italien*, Leipzig.

Phillips C., *The « Ariosto of Titian »*, in « The Art Journal », p. 1.

Rankin, *Notes on collections of old Masters*.

Reinach, *Répertoire des peintres*, Paris.

Russel A.G.B., *Titian's Ariosto*, in « The Burlington Magazine », p. 412.

Zimmermann H., *Das Inventar der Prager Schatz und Kunstkammer vom 6 Dezember 1621*, in « Oesterr. Jahrbuch », 25, XIV.

1906 Benkard, *Die Venetianische Frühzeit des Sebastiano del Piombo*, Berlin.

Boehn von M., *Giorgione*, in « Velhagen und Klasings Monatshefte », p. 313.

Bredius A. - Schmidt Degener F., *Die Grossherzogliche Gemälde-Galerie im Augusteum zu Oldenburg*, Oldenburg.

Cook H., *L'Esposizione del Burlington Fine Arts Club*, in « L'Arte », p. 143.

Cook H., *Notes on the Study of Titian*, in « The Burlington Magazine », p. 102.

Cook H., *Some Venetian portraits in English possession*, in « The Burlington Magazine », p. 338.

Cust L. - Cook H., *Notes on Pictures in the Royal Collections. Article IX. « The Lovers » at Buckingham Palace*, in « The Burlington Magazine », p. 71.

Foerster R., *Laokoon im Mittelalter und der Renaissance*, in « Preuss. Jahrbuch », p. 149.

Lederer S., *A Szépmüvészeti*, in « Muzeum das Mesterei Müvészet », p. 271.

Ludwig G. - Molmenti P., *Vittore Carpaccio*, Milan.

Venturi A., *La Galleria Sterbini*, Rome.

L'Esodo di un quadro di Giorgione, in « Rassegna d'Arte », p. 17.

1907 Brinton S., *The City Triumphant* (II ed.), London.

Cust L., *La Collection de M.R.H. Benson*, « Les Arts », 6, n. 70.

Davies R., *An Inventory of the Duke of Buckingham's Pictures...*, in « The Burlington Magazine », p. 376.

Eisler R., *Die illuminierten Handschriften in Kärnten*, Leipzig.

Essling F., *Les Livres à figures Vénitiens*, Florence and Paris.

Frizzoni G., *Le Gallerie dell'Accademia Carrara in Bergamo*, Bergamo.

Frizzoni G., *Giorgione, Tiziano e Van Dyck...*, in « Rassegna d'Arte », p. 152.

Frizzoni G., *Le raccolte artistiche in Bergamo*, Bergamo.

Gronau G., *Das Konzert des Giorgione im Palais Pitti*, in « Starye Gody », November.

Hadeln D. von, *Domenico Campagnola und das Concert in Pitti*, in « Sitzungsber. der Kunstgesch. Ges. Berlin », p. 52.

Kristeller P., *G. Campagnola*, Berlin (with supplement).

Logan M., *Giorgione*, in « Gazette des Beaux-Arts », p. 337.

Logan M., *Quelques ouvrages récents sur l'histoire de l'art*, in « Gazette des Beaux-Arts », p. 357.

Michel E., *Au pays de Giorgione et de Titien*, in « Revue de l'art ancien et moderne », p. 321.

Phillips C., *Notes on Palma Vecchio*, in « The Burlington Magazine », pp. 245, 315.

Schaukal R., *Giorgione oder Gespräche über die Kunst*, Munich.

Schubring P., *Johannes Spinetus*, in « Sitzungsber. der Kunstgesch. Ges. Berlin », p. 45.

Tencaioli O.F., *La scoperta di un quadro di Giorgione*, in « Pensiero Latino », 6, p. 1.

Wilkinson N.R., *Wilton House Pictures*, London.

Giorgione's Portrait of Giovanni Onigo..., in « Arundel Club », n. 12.

1908 Barbantini N., *La Quadreria Giovannelli*, in « Emporium », p. 183.

BENKARD A.A., *Ein Porträt Raffaels von der Hand des Sebastiano del Piombo*, in « Monatsh. f. Kunstwiss. », p. 654.

BERNARDINI G., *Sebastiano del Piombo*, Bergamo.

BOEHN VON M., *Giorgione und Palma Vecchio*, Bielefeld.

BORINSKI K., *Das Novellenbild in der Casa Buonarroti*, in « Monasth. f. Kunstwiss. », p. 906.

CAMAVITTO L., *Giorgione da Castelfranco...*, (II ed.), Castelfranco.

COOK H., *L'Esposizione invernale al Burlington Fine Arts Club*, in « L'Arte », p. 57.

FRIMMEL T., *Blätter für Gemälde-Kunde*, Beilage II, Lieferung.

GRONAU G., *Kritische Studien zu Giorgione*, in « Rep. f. Kunstwiss. », p. 403.

JUSTI L., *Giorgione*, Berlin.

KEHRER H., *Die Heiligen Drei Könige in Literatur und Kunst*, Leipzig.

SAXL F., *Zu einigen Bildnissen Ruprechts von der Pfalz*, in « Mitteilungen d. Gesellschaft f. vervielf. Kunst », p. 57.

SCHMIDT W., *Zur Kenntnis Giorgione*, in « Rep. f. Kunstwiss. », p. 155.

SWARZENSKY G., *Bemerkungen zu Palma Vecchio...*, in « Kg. Jahr. der K.K. Zentralkomm. », p. 54.

X.Y., *Ludwig Justi, Giorgione*, in « Archivio Stor. Veneto », p. 247.

1909 CHIUPPANI G., *Per la biografia di Giorgione da Castelfranco*, in « Boll. del Museo Civico di Bassano », p. 73.

COOK H., *The Concert at Asolo after Giorgione*, in « The Burlington Magazine », p. 38.

DACIER E., *Catalogues de ventes et livrets de salon...*, Paris.

DVORÀK M., *Relazione*, in « Offizieller Bericht über die Verhandlungen des IX Internationalen Kunsthistorischen Kongresses in München », Leipzig.

FRY R., *On a picture attributed to Giorgione*, in « The Burlington Magazine », p. 6.

GAMBA C., *A proposito di alcuni disegni del Louvre*, in « Rassegna d'Arte », p. 37.

GOWANS, *Carpaccio and Giorgione*, London.

GRONAU G., *Il cognome Zorzi da Castelfranco*, in « Bollettino del Museo Civico di Bassano », p. 105.

GRONAU G., *Neue Untersuchungen zur Biographie Giorgiones*, in « Kunstchronik », p. 173.

GRONAU G., *Giorgione Entdeckungen*, in « Kunstchronik », p. 532.

HADELN D. VON, *Ludwig Justi, Giorgione*, in « Zentralblatt für Kunstwiss. Literatur », 1, n. 3.

HOLMES C.I., *The school of Giorgione at the Grafton Galleries*, in « The Burlington Magazine », p. 72.

HOLROYD C., *A Catalogue of the Exhibition in the Grafton Galleries*, London.

HUTTON E., *Memoirs of the Dukes of Urbino*, London.

KEHRER H., *Die Heiligen Drei Könige in Literatur und Kunst*.

LAFENESTRE G., *La vie et l'oeuvre de Titien*, Paris.

PHILLIPS D., in « Daily Telegraph », 6 October.

PHILLIPS D., *Some figures by Giorgione (?)*, in « The Burlington Magazine », p. 331.

RANKIN W., *Two Figures by Giorgione*, in « The Burlington Magazine », p. 198.

SCHAEFFER E., *Ludwig Justi, Giorgione*, in « Rep. f. Kunstwiss. », p. 540.

SKETCHLEY R.D.E., *The National Loan Exhibition*, in « Art Journal », p. 359.

WICKHOFF F., *Ludwig Justi, Giorgione*, in « Kunstgesch. Anzeigen », p. 34.

WOERMANN K., *Ludwig Justi, Giorgione*, in « Kunstchronik », p. 513.

Carpaccio e Giorgione. Weichers Kunstbücher, Berlin.

1910 BECKERATH VON A., *Die Ausstellung in der Grafton-Gallery*, 1909-1910, in « Rep. f. Kunstwiss. », p. 278.

BURCKHARDT J., *Der Cicerone* (Ed. X, Bode, Fabriczy), Leipzig.

COOK H., *Venetian Portraits and some problems*, in « The Burlington Magazine », p. 328.

FOGOLARI G., *Arte Nostra*, Treviso.

FORATTI A., *L'Arte di Giovanni Cariani*, in « L'Arte », p. 177.

FRY R., *La Mostra di Antichi Dipinti alle Grafton Galleries di Londra*, in « Rassegna d'Arte », p. 35.

HADELN D. VON, *Sansovinos Venetia...*, in « Jahrbuch der Preuss. », p. 149.

LIPHART E., *Giorgione*, in « Stary Gody », January.

RICHTER J.P., *The Mond Collection*, London.

RICKETTS C., *Titian*, London.

SCHAEFFER E., *Giorgiones Landschaft mit den Drei Philosophen*, in « Monatshefte für Kunstwiss. », p. 340.

WEINER P.P., *Notizie di Russia*, in « L'Arte », p. 144.

1911 CAGNOLA G., *La Schiavona*, in « Rassegna d'Arte », p. 67.

CUST L., *Notes on the collections formed by Thomas Howard...*, in « The Burlington Magazine », p. 278.

FRY R. - BROCKWELL M., *A Catalogue of an Exibition of Old Masters. Grafton Galleries*, London.

GRONAU G., *Giorgione*, Berlin.

HADELN D. VON, *Beiträge zur Geschichte des Dogenpalastes*, in « Jahrbuch der Preuss. Kunstsammlg. », p. 17.

MIREUR H., *Dictionnaire des Ventes d'Art...*, Paris.

SCHAEFFER E., *Bildnisse der Caterina Cornaro*, in « Monatsh. f. Kunstwiss. », p. 12.

WILHELM F., *Neue Quellen zur Geschichte des fürstlich Liechtensteinschen Kunstbesitzes*, in « Kunstgesch. Jahrbuch d. K.K. Zentralkommission », 5, Beiblatt 89; 8, Beiblatt 37.

WOERMANN K., *Geschichte der Kunst aller Zeiter und Völker*, Leipzig.

ZOTTI E., *Morto da Feltre*, Padua.

1912 BURLINGTON FINE ARTS CLUB, *Eearly Venetian Pictures*, London.

COOK H., *Reviews and Appreciations*, London.

CROWE J.A.-CAVALCASELLE G.B., *A History of Painting in North Italy* edited by T. Borenius, London.

ERLANDE A., *Il Giorgione*, Paris.

FRIZZONI G., *Einige Kritische Bemerkungen...*, in « Kunstgesch. Jahrbuch d. K.K. Zentralkommission », p. 83.

FRY R., *Exhibition of pictures of the early Venetian school at the Burlington Fine Arts Club*, in « The Burlington Magazine », p. 96.

GEIGER B., *Marco Marziale...*, in « Preuss. Jahrbuch », p. 122.

GRAMM J., *Ideale Landschaft*, Freiburg.

GRUNEWALD M., *Das Kolorit in der Venezianischen Malerei*, Berlin.

G.L., *L'esposizione della « Primitiva pittura Veneziana »*, in « L'Arte », p. 218.

PHILLIPS C., *The Venetian « Temperance » of the Diploma Gallery*, in « The Burlington Magazine », p. 270.

VENTURI L., *Saggio sulle opere d'arte italiana a Pietroburgo*, in « L'Arte », p. 137.

WOERMANN K., *L. Justis Giorgione, von Apelles zu Boecklin*, Esslingen.

1913 BODE W., *Portrait of a Venetian nobleman by Giorgione in the Altman Collection*, in « Art in America », p. 225.

BORENIUS T., *Catalogue of the Paintings at Doughty House*, Richmond-London.

BORENIUS T., *The Venetian School...*, in « The Burlington Magazine », p. 26.

BUSTICO G., *Giorgione*, in « Arte e Storia », p. 139.

COX K., *On certain portraits generally ascribed to Giorgione*, in « Art in America », p. 115.

FRIZZONI G., *L. Venturi, Giorgione e il Giorgionismo*, in « Kunstchronik », p. 188.

GRUNEWALD M., *Die Stimmung in der venezianischen Malerei*, in « Monatsh. f. Kunstwiss. », p. 281.

HADELN D. VON, *Über Zeichnungen der früheren Zeit Tizians*, in « Preuss. Jahrbuch », p. 244.

JUSTI L., *L. Venturi über Giorgione*, in « Monatsh. fur Kunstwiss. », p. 391.

LEES F., *The art of the great masters*, London.

LIPHART VON E., *Reiseeindrücke*, in « Zeitschr. f. bild. Kunst », p. 207.

LUZIO A., *La Galleria dei Gonzaga venduta all'Inghilterra nel 1627-28*, Milan.

REYMOND M., *Le Concert Champêtre de Giorgione*, in « Gazette des Beaux-Arts », p. 341.

SEIDLITZ VON M., *L. Venturi, Giorgione e il Giorgionismo*, in « Deutsche Literaturzeitg. », p. 3049.

SOULIER G., *L. Venturi, Giorgione e il Giorgionismo*, in « France-Italie », p. 120.

VENTURI L., *Giorgione e il Giorgionismo*, Milan.

Giorgione: Portrait of a Youth, Arundel Club, London.

1914 BELL C.F., *Drawings by the Old Masters in the Library of Christ Church Oxford*, Oxford.

BENSON R., *Catalogue of Pictures collected by R. and E. Benson*, London.

CHUSID E., *Giorgione i Giorgionism*, Sofia.

DREYFOUS G., *Giorgione*, Paris.

FRIZZONI G., *L. Venturi, Giorgione e il Giorgionismo*, in « Kunstchronik », p. 188.

HOURTICQ L., *Promenades au Louvre, Le Concert Champêtre*, in « Revue de l'Art Ancien et Moderne », p. 81.

MADSEN K., *Larpents Gave til Kunstmuseet*, in « Kunstmuseets Aarskrift », p. 122.

MATHER F.J., *Yale Alumni Weekly*, New Haven.

RIDOLFI C., *Le Meraviglie dell'Arte*, ed. von Hadeln, Berlin.

SEGARIZZI A., *Una lotteria di quadri nel secolo XVII*, Venice.

VECHTEN BROWN VAN A. - RANKIN W., *A short History of Italian Painting*, London.

VENTURI L., *L'auteur du Concert Champêtre du Louvre*, in « Gazette des Beaux-Arts », p. 170.

1915 BURLINGTON FINE ARTS CLUB, *The Venetian School...*, London.

COOK H., *The portrait of Caterina Cornaro by Giorgione*, London.

FIOCCO G., *La giovinezza di Giulio Campagnola*, in « L'Arte », p. 138.

SCHERRY R., *Tizians Gemälde Jupiter und Callisto...*, in « Kunstchronik », p. 572.

WOERMANN K., *Geschichte der Kunst aller Zeiten und Völker*, (II ed.), Leipzig.

1916 BERENSON B., *The Study and Criticism of Italian Art*, London.

BERENSON B., *Venetian Painting in America*, London.

FRIEDLÄNDER M.I., *Eine übersehene Dürer-Zeichnung...*, in « Jahrbuch f. Bild. Kunst », p. 99.

LIPHART VON E., *Reiseeindrücke*, in « Kunstchronik », N.F., p. 33.

TIETZE-CONRAT E., *Correggio-Studien*, in « Jahrb. d. Zentralkommission », p. 176.

1917 FRIEDEBERG M., *Über das Konzert im Palazzo Pitti*, in « Zeitschift für bild. Kunst », N.F., p. 169.

LONGHI R., *Cose bresciane del Cinquecento*, in « L'Arte », p. 99.

OSTWALD W., *Die Farbenfibel*. Leipzig.

POPPELREUTER J., *Giorgiones Porträt im Kaiser Friedich Museum zu Berlin und das Konzert im Palazzo Pitti*, in « Amt. Ber. a. d. Kgl. Kunstsammlg. », p. 104.

1918 FRY R., *Drawings at the Burlington Fine Arts Club*, in « The Burlington Magazine », p. 52.

GRAVES A., *Art Sales*, London.

1919 BODE VON W., *Leonardo und das Weibliche Halbfigurenbild...*, in « Jahrbuch der Preuss. K.K. Sammlungen », p. 61.

HOURTICQ L., *La jeunesse de Titien*, Paris.

1920 FRANCESCHINI G., *Un nuovo Giorgione alla Pinacoteca di Vicenza*, in « Emporium », p. 311.

GLÜCK G., *Rubens Liebesgarten*, in « Oesterr. Jahrbuch », p. 49.

HETZER TH., *Die frühen Gemälde des Tizian*, Basel.

LORENZETTI G., *Per la storia del « Cristo Portacroce » della chiesa di San Rocco*, in « Venezia - Studi di Arte e Storia a cura della Direzione del Museo Civico Correr », p. 181.

RAVÀ A., *Il Camerino delle anticaglie di Gabriele Vendramin*, in « Nuovo Archivio Veneto », p. 155.

SCRINZI A., *Studi di Arte e Storia*, Venice.

TEA E., *La Mostra d'arte antica a Venezia*, in « Rassegna d'Arte », p. 302.

1921 FIOCCO G., *Pordenone ignoto*, in « Bollettino d'Arte », p. 193.

GRONAU G., *Giorgione*, in « Thieme-Becker A.L. », Lipsia.

LOCATELLI A.M., *Due ritratti di Bartolomeo Veneto all' Accademia Carrara*, in « Atti dell'Ateneo di Scienze, Lettere ed Arti in Bergamo », p. 26.

SCHIAPARELLI A., *Leonardo ritrattista*, Milan.

SCHMARSOW A., *Gotik in der Renaissance*, Stuttgart.

1922 BALDASS L., *Giorgiones Drei Philosophen*, Vienna.

BECKER F., *Handzeichnungen alter Meister in Privatsammlungen*, Leipzig.

FERRIGUTO A., *Almorò Barbaro*, in « Miscellanea di Storia Veneta », p. 5.

FERRIGUTO A., *Il significato della « Tempesta » di Giorgione*, Padua.

FRIMMEL T., *Gemäldesammlungen in Venedig...*, in « Neue Blätter für Gemälde-Kunde », p. 104.

RAVAGLIA A., *Un quadro inedito...*, in « Bollettino d'Arte », p. 474.

SUIDA W., *Unbekannte Bildnisse von Tizian*, in « Belvedere », p. 168.

VALENTINER, *The H. Goldman Collection*, New York.

1923 BORENIUS T., *The Picture gallery of Andrea Vendramin*, London.

FRIEDEBERG M., *Ein Doppelbildnis des Giorgione*, in « Kunst und Künstler », p. 92.

GAMBA C., *La raccolta Crespi Morbio*, in « Dedalo », p. 548.

GERSTENBERG F., *Die ideale Landschaftmalerei*, Halle.

HAHR A., *Giorgione och Giorgionelegenden*, in « Ord och Bild », p. 513.

HOLMES C., *Giorgione problems at Trafalgar Square*, in « The Burlington Magazine », pp. 169 and 230.

HOLMES C., *The National Gallery. Italian School*, London.

1924 BALDASS L., *Neuaufgestellte Venezianische Bilder...*, in « Belvedere », p. 86.

GRONAU G., *Venezianische Kunstsammlungen des 16 Jahrhunderts*, in « Jahrbuch für Kunstsammler », p. 9.

LUCAS E.V., *Giorgione*, London.

ORTOLANI S., *Cultura ed Arte*, in « L'Arte », p. 16.

VENTURI A., *La critica d'arte in Italia...*, in « Gazette des Beaux-Arts », p. 39.

The Holford Collection, London.

1925 CONWAY M., *The Allington Giorgiones*, in « The Burlington Magazine », p. 129.

EISLER R., *Orphisch-Dionysische Mysterien...*, Vorträge II, Leipzig.

FERRIGUTO A., *I committenti di Giorgione*, in « Atti dell'Istituto Veneto di Scienze, Lettere, ed Arti », p. 339.

FERRIGUTO A., *Fonti della critica giorgionesca*, in « Miscellanea di Studi in onore di Camillo Manfroni », Padua, p. 287.

FRÖLICH-BUM L., *Eine Zeichnung Tizians zu dem Paduaner Fresko*, in « Kunstchronik », p. 220.

GOLZIO V., *Walter Pater critico d'Arte*, in « L'Arte », p. 63.

HADELN D. VON, *Venezianische Zeichnungen der Hochrenaissance*, Berlin.

HAENDCKE B., *Der französisch-deutsch-niederländische Einfluss...*, Strasbourg.

HARTLAUB G., *Giorgiones Geheimnis*, Munich.

HENDY P., *Titian at Hertford House*, in « The Burlington Magazine », p. 236.

JACOBS E., *Das Museum Vendramin und die Sammlung Reynst*, in « Rep. für Kunstwiss. », p. 15.

JUSTI L., *G.F. Hartlaub, Giorgiones Geheimnis*, in « Der Cicerone », p. 962.

LANDAU L., *Ludwig Justi, Giorgione und die moderne Biographik*, in « Kunstwanderer », p. 240.

LONG B.S., *Catalogue of the Costantine Alexander J. Collection*, London.

NICODEMI D., *Gerolamo Romanino*, Brescia.

SANDRART VON J., *Academia*, ed. Peltzer, Munich.

VALENTINER W.R., *Il Triplo Ritratto di Detroit*, in « Bulletin », VII, p. 72.

1926 BALDASS L., *Betrachtungen zum Werke des Hieronymus Bosch*, in « Oesterr. Jahrbuch », N.F., p. 103.

BUSCAROLI R., *Il Paesaggio nell'Arte Italiana*, Bologna.

CIRAOLO C., *Hartlaub, Giorgiones Geheimnis*, in « L'Arte », p. 284.

COOK H., *A Giorgione Problem*, in « The Burlington Magazine », p. 23.

COOK H., *Dr. Justi on Giorgione*, in « The Burlington Magazine », p. 311.

FERRIGUTO A., *Trilogia Giorgionesca*, in « Annuario Istituto Tecnico di Udine », Udine.

HARTLAUB G.F., *Zu einem Bilde des Giorgione*, in « Berliner Tageblatt », Jan. 21.

JUSTI L., *Giorgione* (II ed.), Berlin.

KNAPP F., *L. Justi, Giorgione*, in « Zeitschrift für bild. Kunst, Kunstchronik », p. 5.

KURTH B., *Über ein verschollenes Gemälde Tizians*, in « Zeitschrfit fur bild. Kunst », p. 288.

LUCAS E.V., *The Work of Giorgione*, London.

ORLANDINI G., *Il casato di Giorgione da Castelfranco*, in « Atti del R. Istituto Veneto di Scienze, Lettere ed Arti », p. 741.

SCHUBRING P., *Ludwig Justi, Giorgione*, in « Rep. für Kunstwiss. », p. 63.

STIX A. - FROELICH-BUM L., *Beschreibender Katalog... der Albertina*, Vienna.

SUTER K.F., *Giulio Campagnola als Maler*, in « Zeitschr. f. Bild. Kunst », p. 132.

VALENTINER W.R., *A combined work by Titian, Giorgione and Sebastiano del Piombo*, in « Detroit Bulletin », p. 62.

VENTURI A., *Tre ignoti quadri di Giambellino*, in « L'Arte », p. 68.

WEILL E., *Venezianische Sonne. Der Roman des Malers Giorgione*, Vienna.

1926-27 ORLANDINI G., *Il casato di Giorgione da Castelfranco*, in « Atti Ist. Veneto di S.L.A. », t. 86, II, p. 741.

PASCHINI P., *Le collezioni archeologiche dei Grimani*, in « Atti della Pontificia Accademia », Rendiconti, V.

1927 ALEXANDRE A., *La collezione Benson*, in « Renaissance », p. 477.

T.D.B., *Conway, Giorgione « Birth of Paris »*, in « L'Arte », p. 276.

BERCKEN VON DER E. - MAYER A.L., *Malerei der Renaissance in Italien*, Wildpark-Potsdam.

COLETTI L., *La Pinacoteca Comunale di Treviso...*, in « Bollettino d'Arte », p. 468.

CONWAY M., *Giorgione's Birth of Paris*, in « The Burlington Magazine », p. 208.

EIGENBERGER R., *Die Gemäldegalerie der Akademie der Bildenden Künste in Wien*, Vienna.

FREUND F.E.W., *Die Sammlung Benson*, in « Cicerone », p. 495.

GOLZIO V., *Giorgione*, in « La Cultura », VI.

HARTLAUB G.F., *Giorgione und der Mythos der Akademien*, in « Rep. f. Kunstwiss. », p. 233.

JUSTI L., *Giorgione oder Campagnola?*, in « Zeitschrift für bild. Kunst », p. 79.

JUSTI L., *Giorgionefragen...*, in « Zeitschrift für bild. Kunst », p. 132.

LONGHI R., *Due dipinti inediti di G.G. Savoldo*, in « Vita Artistica », p. 72.

LONGHI R., *Domenico Mancini*, in « Vita Artistica », p. 14.

LONGHI R., *Un chiaroscuro e un disegno di G. Bellini*, in « Vita Artistica », p. 133.

LORENZETTI G., *Venezia e il suo estuario*, Venice.

MATHER F.J., *An enigmatic Venetian picture*, in « Art Bulletin », p. 70.

MOLMENTI P., *La storia di Venezia nella vita privata* (7 ed.), Bergamo.

MOSER L. - HARTLAUB G.F., *Giorgiones Geheimnis*, in « Kunst und Künstler », p. 478.

PARKER K.T., *North Italian Drawings of the Quattrocento*, London.

RICHTER J.P., *Giorgionefragen*, in « Zeitschrift f. bild. Kunst », p. 297.

ROSENBERG J., *Die Gemäldesammlung der Ermitage*, in « Kunst und Künstler », p. 217.

SAXL F., *Antike Götter in der Spätrenaissance*, Leipzig.

SCHILLING E., *Eine Zeichnung Giorgiones*, in « Festschrift für M.F. Friedlander ».

SCHUBRING P., *A surmise concerning... in the Detroit Museum*, in « Art in America », p. 35.

SCOTT-TAYLOR J., *Problems in Giorgionesque Portraiture*, in « The Burlington Magazine », p. 202.

SUIDA W., *Rivendicazioni a Tiziano*, in « Vita Artistica », p. 206.

VENTURI A., *La Biblioteca di Sir Robert Witt*, in « L'Arte », p. 239.

VENTURI A., *Giorgione*, in « Vita Artistica », p. 215.

VENTURI A., *Studi dal vero*, Milan.

WAETZOLDT W., *Das Klassische Land*, Leipzig.

WOERMANN K., *Über unsichere Jugendwerke bekannter Meister*, in « Zeitschr. f. bild. Kunst », p. 6.

1928 BERCKEN VON DER E., *Über einige Grundprobleme...*, in « Münch. Jahrb. », p. 311.

BERENSON B., *The Missing Head of the Glasgow Christ and Adulteress*, in « Art in America », p. 147.

BRION M., *Giorgione*, in « L'Art Vivant ». p. 11.

CONWAY M., *A Giorgione discovery*, in « The Burlington Magazine », p. 127.

CONWAY M., *Giorgione again*, in « The Burlington Magazine », p. 259.

DEBRUNNER H., *A Masterpiece by Lorenzo Lotto*, in « The Burlington Magazine », p. 116.

GAMBA C., *La Venere di Giorgione reintegrata*, in « Dedalo », p. 205.

LONGHI R., *Precisioni nelle Gallerie Italiane: I, La R. Galleria Borghese*, Rome.

LONGHI R., *Cartella tizianesca*, in « Vita Artistica », p. 220.

NICODEMI G., *La Raccolta Augusto Lurati*, Milan.

SUTER K.F., *Giorgiones « Testa del Pastorello che tiene in man un frutto »*, in « Zeitschr. f. bild. Kunst », p. 169.

VALENTINER W.R., *Once more the Venetian three-figure-painting in Detroit*, in « Art in America », p. 40.

VELANDER-PHILIP A., *Venezianska Bilder...*, Stockholm.

VENTURI A., *Storia dell'Arte, IX-III*, Milan.

1929 BALDASS L., *Ein unbekanntes Hauptwerk des Cariani*, in « Jahrb. der P.K. », p. 100.

BEIRMANN G., *Tizians Judith mit dem Haupt des Holofernes*, in « Cicerone ».

COLLINS BAKER C.H., *Catalogue of the Pictures at Hampton Court*, Glasgow.

CONWAY M., *Giorgione*, London.

DE NORA A., *Giorgione*, Leipzig.

FIOCCO G., *Pier Maria Pennacchi*, in « Rivista dell'Istituto di Archeologia », p. 97.

FRÖLICH-BUM L., *Zu Giorgione*, in « Belvedere », p. 8.

FRÖLICH-BUM L., *Die Landschaftzeichnungen des Domenico Campagnola*, in « Belvedere », p. 258.

FRY R., *Sir Martin Conway on Giorgione*, in « The Burlington Magazine », p. 276.

F., *New Yorker Versteigerungen*, in « Cicerone », p. 210.

HETZER T., *Das deutsche Element in der italienischen Malerei des XVI Jahrhunderts*, Berlin.

JUSTI L. - SCHUDT L., *Neue Giorgione-Literatur*, in « Rep. f. Kunstwiss. », p. 250.

KONODY P.G., *Giorgione, by Sir Martin Conway*, in « Apollo », p. 242.

KUTZER L.M., *Italienische Renaissancefürstinnen*, in « Italien », 2, p. 71.

MARLE VAN R., *Ein Bildnis des Giorgione*, in « Der Cicerone », p. 100.

M., *Sir Martin Conway, Giorgione*, in « Pantheon », 4. Bleiblatt LII.

OETTINGER K.N., *Ein Bildnis des Giorgione*, in « Belvedere », p. 226.

PAOLETTI P., *La Scuola Grande di San Marco*, Venice.

POSSE H., *Die Staatliche Gemäldegalerie zu Dresden...*, Dresden.

ROZSAFFY D., *Giorgione...*, in « Magyar », p. 328.

SUIDA W., *Leonardo und sein Kreis*, Munich.

SUTER K.F., *Dürer und Giorgione*, in « Zeitschr. f. bild Kunst », LXIII, p. 182.

P.K.T., *Ausstellung im Burlington Fine Arts Club*, in « Cicerone », p. 110.

TIETZE H., *Wie eine internationale Kunstausstellung in Rom...*, in « Die Kunst », p. 321.

VENTURI A., *Due sconosciute opere di arte italiana nel Museo di Lilla*, in « L'Arte », p. 192.

VENTURI A., *Opere d'arte italiana ignote o misconosciute*, in « L'Arte », p. 7.

VERGA G., *Il rinvenimento del « Cristo Morto » di Giorgione*, Cremona.

VERGA G., *Il Cristo Morto di Giorgione*, in « Cremona », p. 11.

WALDMANN E., *Sir Martin Conway: Giorgione*, in « Kunst und Künstler », p. 444.

Giorgione as Landscape Painter by Sir Martin Conway, in « The Connoisseur », p. 237.

1930 BORENIUS T., *A Re-discovered work by Palma Vecchio*, in « Pantheon », p. 246.

CLARK K., *Die Londoner italienische Ausstellung*, in « Zeitschr. f. Bild. Kunst-Kunstchronik », p. 137.

CONSTABLE W.G., *Dipinti di raccolte inglesi alla Mostra d'arte italiana a Londra*, in « Dedalo », p. 723.

CONSTABLE W.G., *L'Exposition italienne de Londres*, in « Gazette des Beaux-Arts », p. 292.

EISLER R., *Jesous Basileus*, Heidelberg.

FRÖLICH-BUM L., *Venezianische Landschaft-Zeichnungen...*, in « Belvedere », p. 85.

GAMBA C., *Problemi artistici all'Esposizione di Londra*, in « Il Marzocco », 27 April.

GRONAU G., *Giovanni Bellini*, Stuttgart.

GRONAU G., *D. v. Hadeln, Venezianische Zeichnungen der Hochrenaissance*, in « Rep. f. Kunstwiss. », p. 47.

HENDY P., *The Christ Carrying the Cross at Fenway Court*, in « The Burlington Magazine », p. 197.

HOLMES C., *The Italian Exhibition*, in « The Burlington Magazine », p. 66.

HOOGEWERFF G.J., *Jan van Scorel or Zuan Fiamengo*, in « Oud Holland », p. 186.

HOURTICQ L., *Le Problème de Giorgione*, Paris.

HOURTICQ L., *La Légende de Giorgione*, in « Revue de Paris », p. 539.

MALKIEL-JIRMOUNSKY M., *Le Problème de Giorgione*, in « Gazette des Beaux-Arts », p. 400.

MORASSI A., *La Mostra d'Arte Italiana a Londra*, in « Emporium », p. 131.

PANOFSKY E., *Hercules am Scheidewege*, Leipzig.

STIX A., *Die Zeichnungen der Ausstellung italienischer Kunst in London*, in « Belvedere », p. 125.

SUIDA W., *Un second « homme au gant » de Titien au Louvre*, in « Gazette des Beaux-Arts », p. 83.

SUIDA W., *Die Ausstellung italienischer Kunst in London*, in « Belvedere », p. 42.

SUIDA W., *Francesco Zaganelli...*, in « Zeitschr. f. bild. Kunst », p. 248.

SUIDA W., *Die Italienischen Bilder der Sammlung Schloss Rohoncz*, in « Belvedere », p. 179.

WILDE J., *Wiedergefundene Gemälde des Erzherzogs Leopold Wilhelm*, in « Jahrbuch d. Kunst Samm. in Wien », p. 245.

WILENSKY R.H., *The Italian exhibition at Burlington House*, in « Studio », 99, p. 3.

1931 LORD BALNIEL-CLARK K., *A commemorative Catalogue...*, Oxford.

COPPIER A.C., *Le Problème de Giorgione*, in « L'Amour de l'Art », p. 317.

DELOGU G., *Novità Italiane al Kunsthistorisches Museum di Vienna*, in « Emporium », p. 240.

FIOCCO G., *Ausstellung venezianischer Kunst in München*, in « Zeitschrift f. bild. Kunst », p. 155.

GOMBOSI G., *L. Hourticq, Le Problème de Giorgione*, in « Zeitschr. f. bild. Kunst-Kunstchronik », p. 101.

HENDY P., *Catalogue of the Exhibited Paintings and Drawings...*, Boston.

HOURTICQ L. - JIRMOUSISKY M., *Correspondance*, in « Gazette des Beaux-Arts », p. 190.

HUYGHE R., *Ames et visages des XV et XVI siècles*, in « L'Amour de l'Art », p. 239.

LANFRANCHI G., *Il Giudizio di Paride...*, Chiavari.

J.M., *Louis Hourticq, Le Problème de Giorgione*, in « Gazette des Beaux-Arts », p. 130.

MALKIEL-JIRMOUNSKY M., *La Reconstruction du tableau de Giorgione « Venus avec l'amour »*, in « Gazette des Beaux-Arts », p. 327.

MAUCLAIR C., *Le Problème de Giorgione*, in « La Revue de l'Art », p. 131.

MAYER A.L., *Ein neues Bellini-Buch*, in « Pantheon », p. 430.

POPHAM A.E., *Italian drawings...*, London.

POSSE H., *Die Rekonstruktion der Venus mit dem Cupido von Giorgione*, in « Jahr. der P.K. », p. 29.

SUIDA W., *Zum Werke des Palma Vecchio*, in « Belvedere », p. 135.

VENTURI L., *Pitture Italiane in America*, Milan.

VENTURI L., *Le Problème de Giorgione*, in « La Revue de l'Art », p. 169.

WILDE J., *Ein unbeachtetes Werk Giorgiones*, in « Jahrb. der P.K. », p. 91.

1932 ARSLAN W., *Contributi alla storia della pittura veronese*, in « Bollettino della Società Letteraria di Verona », nov., p. 6.

BERENSON B., *Italian Pictures of the Renaissance*, Oxford.

BREITENBACHER A., *K dějinám arcibiskupské obrazárny v Kroměřìzi*, Olomouc.

BROCKWELL M.V., *Abridged Catalogue of the Paintings of Doughty House*, London.

DENUCÉ J., *The Antwerp Art Galleries...*, Antwerp.

LOCATELLI MILESI A., *La « Tempesta di Giorgione »*, in « Emporium », p. 117.

MAYER A.L., *Zur Giorgione-Tizian Frage*, in « Pantheon », p. 369.

OETTINGER K., *Giorgione und Tizian am Fondaco dei Tedeschi in Venedig*, in « Belvedere », p. 44.

PARIBENI R., *La Tempesta di Giorgione*, in « Bollettino d'Arte », p. 145.

PARPAGLIOLO L., *L'argomento della Tempesta di Giorgione*, in « Bollettino d'Arte », p. 282.

PLANISCIG L., *Maffeo Olivieri*, in « Dedalo », p. 34.

PLANISCIG L., *Per il Quarto Centenario della morte di Tullio Lombardo e di Andrea Riccio*, in « Dedalo », p. 901.

PORCELLA A., *Le pitture della Galleria Spada*, Rome.

RICCI C., *La Tempesta di Giorgione*, in « Nuova Antologia », p. 1.

RICHTER G.M., *A clue to Giorgione's late style*, in « The Burlington Magazine », p. 123.

ROTHSCHILD VON E., *Tizians Kirschenmadonna*, in « Belvedere », p. 107.

SPAHN A., *Palma Vecchio*, Lipsia.

STECHOW W., *Apollo und Daphne...*, Leipzig.

TROCHE E.G., *Giovanni Cariani als Bildnismaler*, in « Pantheon », Iº, I.

WALDMANN E., *Giorgiones « Sturm »...*, in « Kunst und Künstler ».

WILDE J., *Roentgenaufnahmen der Drei Philosophen Giorgiones und der Zigeunermadonna Tizians*, in « Jahrbuch der Kunst. Sammlg. in Wien », p. 141.

WILDE J., *Giorgione, Die Drei Philosophen, Vortrag*, in « Zeitschrift für Kunstgeschichte », p. 184.

La Tempesta di Giorgione alle Gallerie di Venezia, in « Rivista di Venezia », p. 339.

1933 BARBANTINI N., *Esposizione della pittura ferrarese del Rinascimento* (Catalogue), Ferrara.

CALVESI G. - BOTTI G., *Catalogo della Vendita all'asta della collezione del prof. J. Purves Cortes...*, Quinto.

FERRIGUTO A., *Attraverso i misteri di Giorgione*, Castelfranco.

FOSCARI L., *Autoritratti di maestri della Scuola Veneziana*, in « Rivista di Venezia », p. 261.

GRONAU G., *Titian's Ariosto*, in « The Burlington Magazine », p. 194.

HADELN D. VON, *Venezianische Zeichnungen der Sammlung F. Koenigs*, Frankfurt.

HERMANIN F., *Il Mito di Giorgione*, Spoleto.

HIND A.M., *Studies in English Engravings...*, in « The Connoisseur », p. 382.

MARLE R. VAN, *La collezione del Hans Wedells di Amburgo*, in « Dedalo », p. 237.

RICHTER G.M., *Conscious and Subconscious Elements in the Creation of Works of Art*, in « Art Bulletin », p. 275.

RICHTER G.M., *Landscape Motifs in Giorgione's Venus*, in « The Burlington Magazine », p. 211.

SANGIORGI G., *La scoperta di un'opera di Giorgione*, in « Rassegna Italiana », p. 789.

SUIDA W., *Tiziano*, Rome.

T.C., *La scoperta di un'opera di Giorgione*, in « Giornale d'Italia », 26 October and 1 November.

VENTURI L., *Giorgione*, in « Enciclopedia Italiana », Rome.

VENTURI L., *Italian Paintings in America*, Milan.

WILDE J., *Die Probleme um Domenico Mancini*, in « Jahrbuch der Kunsthist. Sammlg. in Wien », p. 97.

ZOCCA E., *La Galleria Estense*, Rome.

Illustration of the Donà Landscape, in « The Illustrated London News », p. 741.

1934 ARSLAN W., *La Pinacoteca Civica di Vicenza*, Rome.

BORENIUS T., *The new Lotto*, in « The Burlington Magazine », p. 228.

DE VRIES A.B., *Die Ausstellung altitalienischer Kunst in Amsterdam*, in « Pantheon », p. 313.

FIOCCO G., *L. Hourticq, A. Ferriguto, F. Hermanin*, in « Pan », p. 787.

FOGOLARI G., *La Venere di Dresda...*, in « Ateneo Veneto », p. 232.

LOCATELLI MILESI A., *Un ritratto di Giorgione al Museo di Vienna*, in « Emporium », p. 314.

LONGHI R., *Officina Ferrarese*, Rome.

LORENZETTI G. - PLANISCIG L., *La collezione dei Conti Donà delle Rose a Venezia*, Venice.

MESNIL G., *Le déjeuner sur l'herbe di Manet e il Concerto Campestre di Giorgione*, in « L'Arte », p. 250.

PACE B., *Metamorfosi figurate*, in « Bollettino d'Arte », p. 487.

PALLUCCHINI R., *Arnaldo Ferriguto: Attraverso i misteri di Giorgione*, in « Ateneo Veneto », p. 27.

PLANISCIG L., *Del Giorgionismo nella scultura veneziana all'inizio del Cinquecento*, in « Bollettino d'Arte », p. 146.

PROTTI R., *Nuove interpretazioni di Giorgione*, in « Rivista di Venezia », p. 51.

RICHTER G.M., *The Problem of the Noli me tangere*, in « The Burlington Magazine », p. 4.

RICHTER G.M., *Unfinished Pictures by Giorgione*, in « Art Bulletin », pp. 272, 401.

RICHTER G.M., *Italian pictures in Scandinavian Collections*, in « Apollo », p. 128.

TROCHE E.G., *Giovanni Cariani*, in « Jahrbuch der Preuss. Kunstsammlg. », p. 97.

WILDE J., *Über einige venezianische Frauenbildnisse der Renaissance*, in « Festschrift Alexis Petrovics », Budapest.

Italiaansche Kunst in Nederlandsch Bezit (Catalogue), Amsterdam.

1935 BOTTARI S., *La critica figurativa e l'estetica moderna*, Bari.

BRIZIO A.M., *K. Oettinger, « Giorgione und Tizian am Fondaco dei Tedeschi »*, in « L'Arte », p. 70.

BRIZIO A.M., *G.M. Richter, « Unfinished pictures by Giorgione »*, in « L'Arte », p. 70.

BRUNETTI M., *Una strana interpretazione del Concerto della Galleria Pitti*, in « Rivista di Venezia », p. 119.

BUSCAROLI A., *La pittura di paesaggio in Italia*, Bologna.

COLETTI L., *Treviso*, Rome.

DUSSLER L., *Tizian-Ausstellung in Venedig*, in « Zeitschrift f. Kunstgesch. », p. 236.

EISLER R., *New titles for old pictures*, London.

FOGOLARI G., *Le R. Gallerie dell'Accademia in Venezia*, Rome.

FOGOLARI G., *Catalogo della Mostra di Tiziano*, Venice.

GOMBOSI G., *The Budapest Birth of Paris X-rayed*, in « The Burlington Magazine », p. 157.

GOMBOSI G., *Palma Vecchio*, in « Pantheon », p. 27.

HARTLAUB G.F., *Der entzauberte Giorgione*, in « Deutsche Zukunst », p. 18.

HETZER T., *« Titian », Geschichte seiner Farbe*, Frankfurt.

ISARLOV G., *Les Pré-Caravagistes*, in « L'Art et les Artistes », p. 253.

MARLE R. VAN, *The Development of the Italian Schools of Paintings...*, The Hague.

MARLE R. VAN, *La pittura all'esposizione d'arte antica di Amsterdam*, in « Bollettino d'Arte », p. 389.

PALLUCCHINI R., *La formazione di Sebastiano del Piombo*, in « La Critica d'Arte », p. 40.

PARDUCCI D., *I tre Filosofi di Giorgione*, in « Emporium », p. 253.

RICHTER G.M., *The problem of the Noli me tangere* (letter), in « The Burlington Magazine », p. 46.

SUIDA W., *Giorgione, Nouvelles attributions*, in « Gazette des Beaux-Arts », p. 75.

TIETZE H., *Meisterwerke Europäischer Malerei in America*, Vienna.

ZORZI E., *La Madonna di Giorgione in una nuova cappella a Castelfranco*, in « Corriere della Sera », 21 September.

1936 BERENSON B., *I Pittori Italiani del Rinascimento*, Milan.

BERENSON B., *Pitture Italiane del Rinascimento*, Milan.

BUCHNER E., *Ältere Pinakothek*, Munich.

DE HEVESY A., *Rembrandt et Giorgione*, in « Revue de l'Art », p. 141.

DE MINERBI P., *Gli affreschi del Fondaco dei Tedeschi*, in « Bollettino d'Arte », p. 170.

JUSTI L., *Giorgione* (III ed.), Berlin.

MATHER F.J., *Venetian Painters*, Holt.

PIGLER A., *Intorno ai « Tre Filosofi » di Giorgione*, in « Bollettino d'Arte », p. 345.

POPHAM A.E., *Sebastiano Resta and his collections*, in « Old Master Drawings », n. 41, p. 3.

RICHTER G.M., *Frescoes by Giorgione?*, in « Apollo », p. 141.

SUIDA W., *New light on Titian's portrait*, in « The Burlington Magazine », p. 281.

TIETZE H., *Tizian*, Vienna.

TIETZE H., TIETZE CONRAT E., *Tizian-Studien*, in « Jahrbuch d. Kunst. Sammlg. in Wien », p. 137.

1937 BORENIUS T., *Four Giorgionesque panesl*, in « The Burlington Magazine », p. 286.

BORENIUS T., *Eine Neuerwerbung der National Gallery, London*, in « Pantheon », p. 374.

CLARK K., *Four Giorgionesque panels*, in « The Burlington Magazine », p. 199.

HARTLAUB G.F., *Arcana Artis...*, in « Zeitschrift für Kunstgeschichte », fasc. II.

MATHER F.J., *Richter: Giorgio da Castelfranco called Giorgione*, in « Art Bulletin », p. 596.

MORITZ R., *Giorgione und Tiziano, Il Tintoretto - Profili*, Trieste.

PHILLIPS D., *The Leadership of Giorgione*, Washington.

RICHTER G.M., *Giorgio da Castelfranco, called Giorgione*, Chicago.

RICHTER G.M., *Four Giorgionesque panels*, in « The Burlington Magazine », p. 286.

SWARZENSKI S., *Ein unbekannter Giorgione...*, in « Frankfurter Zeitung », 25 December.

TIETZE H. - TIETZE CONRAT E., *Contributi critici allo studio organico dei disegni veneziani del Cinquecento*, in « La Critica d'Arte », p. 77.

1938 BURROUGHS A., *Art criticism from a Laboratory*, Boston.

GRONAU G., *The Allendale Nativity*, in « Art in America », p. 95.

HARTLAUB G.F., *Der Paris Mythos bei Giorgione*, in « Zeitsch. f. Aesthetik und allgem. Kunstwiss. », vol. XXXII, III.

HARTLAUB G.F., *Der Mythos des erwählten Kindes bei Giorgione*, in « Geistige Arbeit », 5 July.

KIESLINGER F., *Gedanken zu einem neuaufgefundenen Giorgione-Bild*, in « Belvedere », p. 61.

MATHER F.J. JR., *When was Titian born?*, in « Art Bulletin », p. 13.

MEGREVY T., *The National Gallery's Giorgionesque panels*, in « Studio ».

PROTTI R., *Discussioni su quattro tavolette veneziane*, in « Illustrazione Vaticana ».

RICHTER G.M., *Note on Review by F.J. Mather, of Giorgio da Castelfranco*, in « Art Bulletin », p. 443.

RICHTER G.M., *A Giorgionesque panel at Frankfurt*, in « The Burlington Magazine », p. 185.

SCHARTEN-ANTINK C., *Der groote Zorzi*, Amsterdam.

SCHWARZWELLER K., *An early work by Giorgione*, in « Pantheon », fasc. II, p. 5.

SUTER K.F., *Giorgione's « Testa del Pastorello »*, in « Zeitsch. f. B. Kunst », p. 169.

WILDE J., *Katalog Kunsthistorisches Museum*, Vienna.

1938-39 FERRIGUTO A., *Ancora dei soggetti di Giorgione*, in « Atti del R. Ist. Veneto di S.L.A. », t. XCVIII, p. II, p. 281.

HARTLAUB G.F., *Triumph und Melancholie in den Bildern Bonifazios*, in « Belvedere », p. 10.

1939 CAPPUCCIO L., *Giorgione*, Milan.

CERVELLINI G., *Per una revisione di G.M. Urbani de Gheltof*, in « Civiltà Moderna », p. 291.

DE MINERBI P., *La Tempesta di Giorgione e l'Amor Sacro e Profano di Tiziano...*, Milan.

FIOCCO G., *Il Pordenone*, Udine.

MATHER F.J., *Notes and Review*, in « Art Bulletin », p. 192.

MOLAJOLI B., *Mostra del Pordenone* (Catalogue), Udine.

MORASSI A., *Esame radiografico della Tempesta*, in « Le Arti », p. 567.

RICHTER G.M., *Christ carrying the Cross*, in « The Burlington Magazine », II, p. 95.

1939-40 JUSTI L., *Giorgiones Bilder zur Ekloge Tebaldeos*, in « Das Werk des Künstler ».

1940 FASOLO G., *Guida del Museo Civico di Vicenza*, Vicenza.

GADDO G.A., *Misteri di Giorgione e di Tiziano...*, in « Rivista Rosminiana ».

PARIGI L., *Perché il Concerto di Giorgione non è di Tiziano*, Florence.

SUIDA W., *Die Sammlung Kress*, in « Pantheon », p. 273.

1941 BRUNETTI M., *Il Fondaco dei Tedeschi nella Storia e nell'Arte*, in « Il Fondaco Nostro dei Tedeschi », Rome.

FIOCCO G., *Giorgione*, Bergamo.

PALLUCCHINI R., *Vicende delle ante d'organo di Sebastiano del Piombo per S. Bartolomeo a Rialto*, in « Le Arti », p. 448.

1941-42 STEFANINI L., *Il Motivo della Tempesta*, in « Atti dell'Accademia di Padova ».

1942 CATURLA M.L., *Ferrando Yañez no es leonardesco*, in « Archivo Español de Arte », p. 35.

DE BATZ G., *Giorgione and his circle*, Baltimore.

DE BATZ G., *Giorgione Exhibit has been arranged*, Baltimore.

DE BATZ G. - RICHTER G.M., *Giorgione and his circle*, Baltimore.

DUSSLER L., *Sebastiano del Piombo*, Basel.

FIOCCO G., *Il segreto di Giorgione*, in « Primato », p. 166.

MORASSI A., *Giorgione*, Milan.

PANOFSKY E., *Conrad Celtes und Kunz von der Rosen...*, in « Art Bulletin », p. 40.

RICHTER G.M., *Lost and rediscovered works by Giorgione*, in « Art in America », p. 141 and 211.

RICHTER G.M., *Giorgione's evolution*, in « De Batz, Giorgione and his circle », Baltimore.

SHAPLEY J., *Giorgione and his circle*, in « Art in America », p. 125.

1943 FERRIGUTO A., *Ancora dei soggetti di Giorgione*, in « Atti Istituto Veneto di S.L.A. », CII, p. II, p. 403.

FIOCCO G., *Il Pordenone* (II ed.), Udine.

1944 OETTINGER K., *Die wahre Giorgione Venus*, in « Jahrbuch der Kunsthistorischen Sammlung in Wien », p. 113.

PALLUCCHINI R., *La pittura veneziana del Cinquecento*, Novara.

PALLUCCHINI R.², *Sebastian Viniziano*, Milan.

RICHARDSON E.P., *The Detroit Institute of Arts*, Detroit.

TIETZE H. - TIETZE CONRAT E., *The drawings of the Venetian Painters of the XVth-XVIth Century*, New York.

9145 FIOCCO G., *Giorgione*, Bergamo.

GILBERT G., *Milan and Savoldo*, in « Art Bulletin », p. 124.

MARIANI V., *Giorgione*, Rome.

PALLUCCHINI R., *La Galleria Estense*, Rome.

PALLUCCHINI R., *Cinque secoli di pittura veneta*, Venice.

TIETZE-CONRAT E., *The so-called Adulteress...*, in « Gazette des Beaux-Arts », I, p. 189.

VASARI G., *Le Vite* (ed. C.L. Ragghianti), Milan.

WISCHNITZER-BERNSTEIN R., *The Three Philosophers by Giorgione*, in « Gazette des Beaux-Arts », p. 193.

1946 FERRIGUTO A., *Del nuovo su La Tempesta di Giorgione...*, in « Misura ».

LONGHI R., *Viatico per cinque secoli di pittura veneziana*, Florence.

PALLUCCHINI R., *I capolavori dei Musei Veneti*, Venice.

TIETZE-CONRAT E., *Titian's Portrait of Paul III*, in « Gazette des Beaux-Arts », p. 73.

CATALOGUE, *National Gallery of Scotland*, Edinburgh.

1947 COLETTI L., *La crisi giorgionesca*, in « Le Tre Venezie », p. 255.

HANNAH A., *Glasgow Art Gallery*, in « The Studio », p. 68.

MARCHIG G., *La novità giorgionesca*, Florence.

TIETZE H., *La Mostra di Giorgione e la sua cerchia...*, in « Arte Veneta », p. 140.

1948 ANTAL F., *Observation on Girolamo da Carpi*, in « Art Bulletin », p. 81.

FIOCCO G., *Giorgione* (II ed.), Bergamo.

GLÜCK G., *Der Weg zum Bild*, Vienna.

1949 CLARK K., *Landscape into Art*, London.

DELL'ACQUA G.A., *Giambellino e Giorgione*, in « Vernice », n. 33-34, p. 16.

GILBERT C., *Ritrattistica apocrifa savoldesca*, in « Arte Veneta », p. 103.

GRONAU H.D., *Pitture veneziane in Inghilterra*, in « Arte Veneta », p. 182.

LANGTON-DOUGLAS R., *Giorgione's later period*, in « The Connoisseur ».

MARCONI S., *Le Gallerie dell'Accademia di Venezia*, Venice.

MOSCHINI V., *La Vecchia di Giorgione*, in « Arte Veneta », p. 180.

PALLUCCHINI R., *Un nuovo Giorgione a Oxford*, in « Arte Veneta », p. 178.

PARKER K.T., *The Tallard Madonna*, in « Ashmolean Museum, Report of the Visitors », p. 43.

POPHAM A.E. - WILDE J., *The Italian Drawings... at Windsor Castle*, London.

ROBERTSON G., *Art treasures from Munich and Vienna: Giorgione's Portrait of a Young Woman*, in « The Burlington Magazine », p. 233.

SCHARF A., *Art treasures from Munich and Vienna*, in « The Burlington Magazine », p. 214.

SCHEFFLER K., *Venezianische Malerei*, Berlin.

STOKES A., *Art and Science: A study of Alberti, Piero della Francesca and Giorgione*, London.

TIETZE H. - TIETZE CONRAT E., *The Allendale Nativity*, in « Art Bulletin », p. 11.

TIETZE H. - TIETZE CONRAT E., *L'« Orfeo » attribuito al Bellini della National Gallery di Washington*, in « Arte Veneta », p. 90.

1950 DELOGU G., *Tiziano*, Bergamo.

LANGTON DOUGLAS R., *Some early works of Giorgione*, in « Art Quarterly », p. 23.

MARINI R., *Giorgione*, Trieste.

PIGLER A., *Astrology and Jerome Bosch*, in « The Burlington Magazine », p. 132.

TIETZE H., *Titian*, London.

TREVISAN L.L., *Giorgione*, Venice.

1951 GODFREY F.M., *The Birth of Venetian Genre and Giorgione*, in « The Connoisseur », p. 1.

MORASSI A., *The Ashmolean Madonna...*, in « The Burlington Magazine », p. 212.

MORASSI A., *Giorgione*, in « Enciclopedia Cattolica », VI, p. 450.

PALLUCCHINI R., *Veneti alla Royal Academy di Londra*, in « Arte Veneta », p. 219.

SUIDA W., *Painting and Sculpture from the Kress Collection...*, Washington.

1952 GILBERT C., *On Subject and not subject in Italian Renaissance pictures*, in « Art Bulletin », p. 202.

MINGHETTI A., *Quadro inedito di Giorgione in una raccolta milanese*, Pavia.

NORDENFALK C., *Titian's Allegories on the Fondaco de' Tedeschi*, in « Gazette des Beaux-Arts », II, p. 101.

WATERHOUSE E.K., *Paintings from Venice for Seventeenth Century England*, in « Italian Studies », VII, p. 1.

1953 BALDASS L., *Zu Giorgiones Drei Philosophen*, in « Jahrb. der. K. Samml. in Wien », p. 121.

COLETTI L., *Pittura Veneta del '400*, Novara.

GALLO R., *Per la datazione della pala di S. Giovanni Crisostomo*, in « Arte Veneta », p. 152.

GIRON R., *La Peinture Vénitienne*, Bruxelles.

GODFREY F.M., *The new Giorgione at Oxford*, in « The Connoisseur », p. 9.

HARTLAUB G.F., *Zu den Bildmotiven des Giorgione*, in « Zeitschrift f. Kw. », p. 57.

MARIANI V., *Due quadri intriganti*, in « Idea », p. 3.

MARINI R., *La ritrattistica di Giorgione e un grande malnoto dipinto*, Trieste.

PALLUCCHINI R., *Tiziano...*, vol. I, Bologna.

PHILLIPS D., in « Les peintres Célèbres », Parigi, t. I.

RICCOBONI A., *Da Giorgione al Romanino*, in « Emporium », p. 195.

VENTURI L., *Giorgione*, Rome.

Catalogo della Mostra della Pittura Veneziana ad Amsterdam, Amsterdam.

Catalogo della Mostra della Pittura Veneziana a Bruxelles, Bruxelles.

Catalogo della Mostra della Pittura Veneziana a Sciaffusa, Sciaffusa.

1953-54 ALAZARD J., *Léonard da Vinci et Giorgione*, in « Études d'Art », nn. 8-9-10, p. 35.

1954 B.E., *Nachrichten von Überall. Ein Unbekannter Giorgione?*, in « Die Weltkunst », 15 october, p. 10.

BERENSON B., *Notes on Giorgione*, in « Arte Veneta », p. 145.

BERENSON B., *Attribuzioni nostalgiche*, in « Corriere della Sera », 15 April.

DELLA PERGOLA P., *Un quadro de man de Zorzon da Castelfranco*, in « Paragone », p. 27.

FIOCCO G., *Polemica su Giorgione*, in « Scuola e Vita », n. 8, p. 11.

GALLINA L., *Giovanni Cariani*, Milan.

GAMBA C., *Il mio Giorgione*, in « Arte Veneta », p. 172.

GENDEL M., *Art News from Roma...*, in « Art News », April, p. 48.

GNUDI C., *Polemica su Giorgione*, in « Scuola e Vita », n. 10, p. 6.

GRASSI L., *Polemica su Giorgione*, in « Scuola e Vita », n. 8, p. 10.

HENDY P., *More about Giorgione's Daniel and Susanna*, in « Arte Veneta », p. 167.

HEYNOLD V. GRAEFE B., *Zwei neue Giorgione*, in « Die Weltkunst », 15 February, p. 9.

LONGHI R., *Polemica su Giorgione*, in « Scuola e Vita », n. 9, p. 12.

MORASSI A., *Esordi di Tiziano*, in « Arte Veneta », p. 178.

MORASSI A., *Tiziano*, in « Enciclopedia Cattolica », vol. XII, p. 170.

PALLUCCHINI R., *Tiziano...*, vol. II, Bologna.

PIGNATTI T., *La giovinezza di Lorenzo Lotto*, in « Annali della Scuola Normale Superiore di Pisa », vol. XXVII, p. 166.

RAGGHIANTI C.L., *Arte*, in « Le Vie d'Italia », p. 632.

ROBERTSON G., *Vincenzo Catena*, Edinburgh.

RUHEMANN H., *The Adulteress...*, in « Scottish Art Review », p. 13.

SALVINI R., *Galleria degli Uffizi*, Florence.

STERLING C., *Notes brèves sur quelques tableaux vénitiens inconnus à Dallas*, in « Arte Veneta », p. 265.

SUIDA W,. *Spigolature giorgionesche*, in « Arte Veneta », p. 153.

VALSECCHI M., *La Pittura Veneziana*, Milan.

VENTURI L., *Giorgione*, Rome.

VENTURI L., *Polemica su Giorgione*, in « Scuola e Vita », n. 10.

WITTGENS F., *Polemica su Giorgione*, in « Scuola e Vita », n. 8, p. 11.

ZERI F., *Polemica su Giorgione*, in « Scuola e Vita », n. 10, p. 6.

ZERI F., *La Galleria Spada*, Florence.

ZIMMERMANN, *Ein neuer Giorgione...*, in « Berliner Museen », I, p. 2.

Corrispondenza-Giorgione - I Cantori, « Sele Arte », III, n. 15, p. 26.

1955 ARGAN G.C., *Giorgione*, in « Comunità », p. 53.

BALDASS L., *Die Tat des Giorgione*, in « Jahr. der Khs. Samml. in Wien », p. 102.

BIANCONI P., *Giorgione tra la folla*, in « Svizzera Italiana », p. 6.

BORDIGNON FAVERO G.P., *La Cappella Costanzo di Giorgione*, Vedelago.

BRENDEL O., *Borrowings from Ancient Art in Titian*, in « Art Bulletin », p. 114.

CASTELFRANCO G., *Note su Giorgione*, in « Bollettino d'Arte », p. 298.

CATURLA M.L., *Giorgione en 1955*, in « Archivo Español de Arte », p. 305.

CECCHI D., *Tiziano*, Milan.

CHASTEL A., *Giorgione*, in « Le Monde », 14 July.

COLETTI L., *Tutta la pittura di Giorgione*, Milan.

COLETTI L., *Un tema giorgionesco*, in « Emporium », p. 195.

DELL'ACQUA G.A., *Tiziano*, Milan.

DELLA PERGOLA P., *Giorgione*, Milan.

FIOCCO G., *Il mio Giorgione*, in « Rivista di Venezia », p. 194.

GOODFREY F.M., *The Venetian Venus and Giorgione*, in « Apollo », p. 69.

GREGORI M., *Altobello, il Romanino e il Cinquecento Cremonese*, in « Paragone », 69, p. 15.

KLAUNER F., *Zur Symbolik von Giorgione's « Drei Philosophen »*, in « Jahr. der Khst. Samml. in Wien », p. 145.

MARIANI V., *Giorgione*, Rome.

MORASSI A., *Un disegno e un dipinto sconosciuti di Giorgione*, in « Emporium », p. 147.

NARDI P., *Mito di Giorgione*, in « La Fiera Letteraria », 1 May.

NARDI P., *I Tre Filosofi di Giorgione*, in « Il Mondo », 23 August.

NARDI P., *Postilla giorgionesca*, in « Il Mondo », 13 September.

OPPO C.E., *L'Arte di Giorgione*, in « Fede e Arte », p. 245.

PALLUCCHINI R., *Guida alla Mostra di Giorgione*, in « Le Arti », p. 1.

PALLUCCHINI R.², *Giorgione*, Milan.

PALLUCCHINI R.³, *Giorgione e i giorgioneschi nel Palazzo dei Dogi*, in « Il Resto del Carlino », 11 June.

PALLUCCHINI R.⁴, *Sebastiano e Tiziano i « creati » di Giorgione*, in « Il Resto del Carlino », 16 June.

PEROCCO G., *La Mostra di Giorgione e i giorgioneschi*, in « Emporium », p. 3.

PIGNATTI T., *Giorgione*, Milan.

PIGNATTI T.², *Giorgione pittore aristocratico*, in « Nuova Antologia », p. 489.

RICCOBONI A., *Giorgione, Cavazzola e Romanino*, in « Emporium », p. 169.

RICCOBONI A., *Un'altra restituzione al Romanino*, in « Emporium », p. 59.

ROBERTSON G., *The Giorgione Exhibition in Venice*, in « The Burlington Magazine », p. 272.

ROH J., *Neuere Bildnis-Zuschreibungen an Giorgione*, in « Die Kunst und das Schöne Heim », October, p. 56.

RUHEMANN H., *The cleaning and restoration of the Glasgow Giorgione*, « The Burlington Magazine », p. 278.

SHAPLEY F. RUSK, « *The Holy Family* » *by Giorgione*, in « Art Quarterly », p. 383.

SERRA E., *Di un'opera perduta del Giorgione*, in « La Fiera Letteraria », 5 July, p. 7.

STEFANINI L., *Il motivo della « Tempesta » di Giorgione*, Padua.

TIETZE-CONRAT E., *Titian as a landscape painter*, in « Gazette des Beaux-Arts », p. 12.

VAUDOYER L., *Merveilles du Musée imaginaire*, in « Arts », 13-19 April, pp. 1 and 11.

WATERHOUSE E.K., *The Italian Exhibition at Birmingham*, in « The Burlington Magazine », p. 292.

ZAMPETTI P., *Giorgione e i giorgioneschi* (Catalogue of the Exhibition), Venice.

ZAMPETTI P., *Postille alla Mostra di Giorgione*, in « Arte Veneta », p. 54.

Venezia: La Mostra Giorgione e i giorgioneschi, in « Emporium », p. 221.

Giorgione's « The Tempest », in « The Connoisseur », p. 207.

1956 BOTTER M., *Ornati a fresco di cose Trivigiane*, Treviso.

BUSCHBECK E.H., *L'Écriture de Giorgione*, in « Venezia e l'Europa - Atti del XVIII Congresso Internazionale di Storia dell'Arte », p. 241.

CALVESI M., *Il « San Giorgio » Cini e Paolo Pino*, in « Venezia e l'Europa - Atti del XVIII congresso Internazionale di Storia dell'Arte », p. 254.

CASTELFRANCO G., *Intervento su Giorgione*, in « La Fiera Letteraria », 18 March, pp. 5 e 8.

FERRIGUTO A., *Giorgione e il dramma*, in « Venezia e l'Europa - Atti del XVIII Congresso Internazionale di Storia dell'Arte », p. 246.

FIERENS P., *Le Giorgionisme de Corot*, in « Venezia e l'Europa - Atti del XVIII Congresso Internazionale di Storia dell'Arte », p. 382.

FLORISOONE M., *Giorgione et la sensibilité moderne francaise*, in « Venezia e l'Europa - Atti del XVIII Congresso Internazionale di Storia dell'Arte », p. 249.

FOMITCHIOVA I., *La vera dimensione della Giuditta di Giorgione* (in lingua russa), in « Soobsenia », NIO, p. 19.

IVANOFF N., *Giorgione nel Seicento*, in « Venezia e l'Europa - Atti del XVIII Congresso Internazionale di Storia dell'Arte », p. 323.

LAZAREFF V., *La Mostra di Giorgione e i giorgioneschi*, in « Iskusstvo », n. 1, p. 58.

LUCCHESE R., *Giorgione e i giorgioneschi*, in « La Fiera Letteraria », 15 January.

MALTESE C., *Giorgione e i suoi critici*, in « oSocietà », XII, 102.

MORASSI A., *Tiziano - Gli affreschi della Scuola del Santo a Padova*, Milan.

MULLER HOFSTEDE C., *Das Selbstbildnis von Giorgione in Braunschweig*, in « Venezia e l'Europa - Atti del XVIII Congresso Internazionale di Storia dell'Arte », p. 252.

PIGNATTI T., *Giorgione*, in « Cronache Culturali », February, p. 2.

RAVA C.E., *Giorgione e i giorgioneschi a Venezia*, in « Prospettive », p. 55.

RUPPRICH H., *Dürer: Schriftlicher Nachlass*, [1956-66], Berlin.

SCHLOSSER MAGNINO J., *La Letteratura Artistica* (II ed.), Florence.

SUIDA W.E., *Miscellanea Tizianesca*, in « Arte Veneta », p. 79.

SUIDA W.E., *Giorgione in American Museums*, in « Art Quarterly », p. 144.

SVENSSON G., *Giorgione*, in « Konstrevy », n. 2, p. 50.

VENTURI L., *Four steps towards modern Art. Giorgione-Caravaggio-Monet-Cézanne*, New York.

Review of: *T. Pignatti, Giorgione*, in « Emporium », p. 95.

1957 ANSALDI G.R., *Di Giorgione e della Critica d'Arte*, in « L'Italia che Scrive », p. 137.

BALDASS L., *Tizian im Banne Giorgiones*, in « Jahrbuch d. Kunst. Sammlg. in Wien », p. 101.

BATTISTI E., *Un'antica interpretazione della « Tempesta » di Giorgione*, in « Emporium », p. 194.

BRAUER H., *Die Söhne des Noah bei Brizio und Giorgione*, in « Berliner Museen », p. 31.

BUCHNER E., *La Pinacoteca di Monaco*, Florence.

FEDAL M.P., *Le Concert Champêtre*, in « Journal of Aesthetics and Art Criticism », 2, December 1957.

FOSSI P., *Di Giorgione e della Critica d'Arte*, Florence.

GORE St. J., *Pictures in National Trust Houses*, in « The Burlington Magazine », p. 137.

GREGORI M., *Altobello e G. Francesco Bembo*, in « Paragone », 93, p. 16.

GROSSATO L., *Il Museo Civico di Padova...*, Venice.

HETZER T., *Tizians Bildnisse...*, Leipzig.

MÜLLER HOFSTEDE C., *Untersuchungen über Giorgiones Selbstbildnis...*, in « Mitteilungen der Kh. Ist. Florenz », 8.

NEUMANN I., *Giorgione ve Svetle Benáské*, in « Vystavy Umeni », cìslo 3, p. 199.

PIGNATTI T., *La Pittura Veneziana del Cinquecento*, Bergamo.

SPETH-HOLTERHOFF S., *Les peintres Flamands de Cabinets d'Amateurs au XVIIe Siècle*, Brussels.

1958 AUNER M., *Randbemerkungen zu zwei Bildern Giorgiones...*, in « Jahrbuch der Kh. Sammlg. in Wien », p. 151.

BAZIN G., *Bernard Berenson. Valutazioni a cura di A. Loria*, in « Gazette des Beaux-Arts », p. 60.

ELWERT W.T., *Pietro Bembo e la vita letteraria del suo tempo*, in « La Civiltà Veneziana del Rinascimento », Florence, p. 125.

KLAUNER F., *Venezianische Landschaftdarstellung von Jacopo Bellini bis Tizian*, in « Jahrbuch der Kh. Sammlg. in Wien », p. 121.

MARINI R., *Non è giorgionesco il primo Tiziano*, in « Emporium », p. 3.

VENTURI L., *Giorgione*, in « Enciclopedia Universale dell'Arte », Venezia-Roma, VI, p. 207.

1959 CASELLA M. T. - POZZI G., *Francesco Colonna, biografie e opera*, Padova.

EGAN P., *Poesia and the Fête Champêtre*, in « Art Bulletin », p. 303.

GIOSEFFI D., *Tiziano*, Bergamo.

PAATZ W., *Giorgione im Wetteifer mit Montagna...*, Heidelberg.

SHAPLEY F. RUSK, *A note on « The Three Philosophers » by Giorgione*, in « Art Quarterly », p. 240.

1959-60 PALLUCCHINI R., *Contributi alla pittura Veneta del Cinquecento*, in « Arte Veneta », p. 39.

1960 BATTISTI E., *Rinascimento e Barocco*, Turin.

DELLA PERGOLA P., *Gli inventari Aldobrandini*, I, in « Arte Antica e Moderna », p. 425.

HARTLAUB G.F., *Giorgione im graphischen Nachbild*, in « Pantheon », II, p. 76.

Italian Art and Britain, Royal Academy Exhibition Catalogue, London.

[KLAUNER F. - HEINZ G.], *Katalog der Gemäldegalerie*, I, Vienna.

MARTIN A., *L'Arte italiana e il collezionismo inglese*, in « Il Taccuino delle Arti », March, p. 1.

MURARO M., *Pitture murali nel Veneto e tecnica dell'affresco*, Venice.

NOË H.A., *Messer Giacomo en zijn « Laura »* (Een dubleportret von Giorgione), in « Nederlands Kunst. Jahrboek », II, p. 6.

NORMAN A.V.B., *A Paldron in the Scott Collection...*, in « Scottish Art Review », n. 3, p. 8.

SALERNO L., *The Picture Gallery of Vincenzo Giustiniani*, in « The Burlington Magazine », pp. 21, 93, 136.

SUTTON D., *Quattro secoli di connoisseurship*, in « Arte Figurativa Antica e Moderna », n. 43, p. 2.

SZABO KÀKAY G., *Giorgione o Tiziano*, in « Bollettino d'Arte », p. 320.

VALCANOVER F., *Tutta la pittura di Tiziano*, Milan.

VALSECCHI M., *I Giorgione di Sua Maestà*, in « L'Illustrazione Italiana », April, p. 58.

VEY H., *Anton Van Dyck über Maltechnik*, in « Musées Royaux des Beaux-Arts », Bulletin, n. 3-4, p. 197.

1961 BALDASS L., *Zur Erforschung des « Giorgionismo »...*, in « Jahrbuch d. Kh. Sammlg. in Wien », p. 69.

BOSELLI C., *Un Giorgione a Brescia?*, in « Brescia », p. 3.

EINSTEIN L., *Conversation at Villa Riposo*, in « Gazette des Beaux-Arts », p. 16.

FERRARI M.L., *Il Romanino*, Milan.

FERRIGUTO A., *Cose viste e cose vere*, in « Atti dell'Acc. di Agricoltura Scienze e Lettere di Verona », V, p. 67.

GARIN E., *La cultura filosofica del Rinascimento*, Florence.

GARZIA A., *Magia della luce e del colore nella pittura veneta*, in « Arte Figurativa », n. 54, p. 12.

GOULD C., *New light on Titian's Schiavona Portrait*, in « The Burlington Magazine », p. 335.

LEVEY M., *Minor aspect of Dürer's interest in Venetian Art*, in « The Burlington Magazine », p. 511.

PUPPI L., *Une ancienne copie du « Cristo e il Manigoldo » de Giorgione au Musée des Beaux-Arts »*, in « Bulletin du Musée National Hongrois des Beaux-Arts », n. 18, p. 39.

SALVINI R., *Giorgione: un ritratto e molti problemi*, in « Pantheon », p. 226.

STEER J., *Some influences from Alvise Vivarini in the Art of Giorgione*, in « The Burlington Magazine », p. 220.

1962 ARSLAN W., *Studi Belliniani*, in « Bollettino d'Arte », p. 40.

CALVESI M., *La Tempesta di Giorgione come ritrovamento di Mosè*, in « Commentari », p. 226.

FERRIGUTO A., *Cose viste e cose vere...*, in « Atti dell'Acc. di Agricoltura Scienze e Lettere di Verona », VI, p. 50.

HEINEMANN F., *Giovanni Bellini e i Belliniani*, Venice.

PALLUCCHINI R., *Il restauro del ritratto di Gentiluomo veneziano K 475*, in « Arte Veneta », p. 234.

PALLUCCHINI R., *Caratteri della pittura veneta*, in « Le Arti », 11-12, p. 1.

SCIORTINO G., *Disputa su un Giorgione*, in « La Fiera Letteraria », 9 December.

SERRA E., *Del « Cristo morto » di Giorgione, visto da Marcantonio Michiel*, Florence.

TSCHMELITSCH G., *Neue Bezüge in alter Bildern Giorgiones*, in « Speculum », n. 4, p. 14.

TSUJI S., *Sul tema di Giorgione*, in « Bijutsushi », Tokyo.

1963 BOTTARI S., *La visione della natura nella pittura veneziana del Quattrocento*, in « Umanesimo Europeo e Umanesimo Veneziano », Florence, p. 407.

BOUSQUET J., *Il Manierismo in Europa*, Milan.

BRANCA V., *Ermolao Barbaro e l'Umanesimo Veneziano*, in « Umanesimo Europeo e Umanesimo Veneziano », Florence, p. 193.

BROPHY J., *The Face in Western Art*, London.

DELLA PERGOLA P., *Gli inventari Aldobrandini*, II, in « Arte Antica e Moderna », n. 21, p. 61.

DIONISOTTI C., *Aldo Manuzio umanista*, in « Umanesimo Europeo e Umanesimo Veneziano », Florence, p. 213.

MORASSI A., *An Early Titian Portrait (of Raphael)*, in « The Burlington Magazine », p. 164.

MURARO M. - GRABAR A., *Les Trésors de Venise*, Geneva.

NARDI B., *La Scuola di Rialto e l'Umanesimo Veneziano*, in « Umanesimo Europeo e Umanesimo Veneziano », Florence, p. 93.

POZZI G. - CIAPPONI L.A., *La cultura figurativa di Francesco Colonna*, in « Umanesimo Europeo e Umanesimo Veneziano », Florence, p. 317.

STRINI A., *La « Copia integrativa »*, in « La Tecnica dell'Arte », n. 4, p. 1.

TESTORI G., *Da Romanino a Giorgione*, in « Paragone », n. 159, p. 45.

TSUJI S., *Giorgione e i giorgioneschi*, in « Kadokawa, Sekai Bijutsu Zenshu », Tokyo.

WITTKOWER R., *L'Arcadia e il giorgionismo*, in « Umanesimo Europeo e Umanesimo Veneziano », Florence, p. 473.

1964 BALDASS L. - HEINZ G., *Giorgione*, Vienna-Munich.

BENESCH O., *Meisterzeichnungen der Albertina*, Salzburg.

BONICATTI M., *Aspetti dell'Umanesimo nella pittura veneta dal 1455 al 1515*, Rome.

CANOVA G., *Paris Bordone*, Venice.

COLONNA F., *Hypnerotomachia Poliphili*, (ed. Possi-Ciapponi) Padova.

GARAS C., *Giorgione et giorgionisme au XVIIe siècle*, in « Bulletin du Musée Hongrois des Beaux-Arts », n. 25, p. 51.

HOURS M., *Les sécrets des chéfs-d'oeuvre*. Paris.

MORASSI A., *Tiziano*, Milan.

VOLPE C., *Giorgione*, Milan.

1965 BALLARIN A., *Osservazioni sui dipinti veneziani del Cinquecento nella Galleria del Castello di Praga*, in « Arte Veneta », p. 59.

BEAN J. - STAMPFLE F., *Drawings from New York Collections*, I, New York.

BORDIGNON FAVERO G.P., *Le opere d'arte e il tesoro del Duomo di S. Maria e S. Liberale di Castelfranco*, Castelfranco.

FENYÖ I., *North Italian Drawings...*, Budapest.

GARAS C., *Giorgione et giorgionisme au XVIIe siècle*, in « Bulletin du Musée Hongrois des Beaux-Arts », n. 27, p. 33.

MURARO M., *Studiosi, collezionisti e opere d'arte veneta dalle lettere al Cardinale Leopoldo de' Medici*, in « Saggi e Memorie », p. 65.

PALLUCCHINI R., *« Giorgione »*, in « Le Muse », vol. V, p. 263.

PALLUCCHINI R., *Tiziano*, Milan.

PARRONCHI A., *Chi sono « I tre Filosofi »*, in « Arte Lombarda », p. 91.

TROCHE G., *Venetian paintings of the Renaissance at the M.H. De Young Memorial Museum*, in « Art Quarterly », p. 94.

VALCANOVER F., *Il restauro del « S. Giorgio » Cini di Tiziano*, in « Arte Veneta », p. 199.

1966 BORDIGNON FAVERO G.P., *Una fascia dipinta in casa Costanzo*, in « Liceo Ginnasio Giorgione, Castelfranco Veneto », p. 83.

BOSCHINI M., *La Carta del Navegar pitoresco*, (ed. A. Pallucchini), Venice-Rome.

GARAS C., *Giorgione et giorgionisme au XVIIe siècle*, in « Bulletin du Musée Hongrois des Beaux-Arts »- n. 28, p. 69.

KAHR M., *Titian, the « Hypnerotomachia Poliphili » Woodcuts and Antiquity*, in « Gazette des Beaux-Arts », p. 119.

LOMBARDO PETROBELLI E., *Giorgione*, Florence.

MARIUZ A., *Appunti per una lettera del fregio giorgionesco di Casa Marta Pellizzari*, in « Liceo Ginnaio Giorgione, Castelfranco Veneto », p. 49.

MORASSI A., *Tiziano*, in « Enciclopedia Universale dell'Arte », Venice-Rome, vol. XIV, p. 15.

PRINZ W., *Vasaris Sammlung von Kunstlerbildnissen...*, in « Mitt. Kh. Inst. Florenz », Beiheft Band XII.

ROWLANDS J., *G. Heinz, Giorgione*, in « The Burlington Magazine », p. 588.

TURNER A.R., *The vision of landscape in Renaissance Italy*, Princeton.

1967 BORGHINI R., *Il Riposo* (ed. M. Rosci), Milan.

BYAM SHAW J., *Paintings by Old Masters at Christ Church Oxford*, London.

FIOCCO G., *Cornaro e gli ideali artistici del Rinascimento a Venezia*, in « Rinascimento Europeo e Rinascimento Veneziano », Florence, p. 187.

GARAS K., *The Ludovisi Collection of pictures in 1663, I*, in « The Burlington Magazine », p. 287; ibd., II, p. 339.

KLEIN R., *Die Bibliothek von Mirandola und das Giorgione zugeschriebene « Concert Champêtre »*, in « Zeitschrift f. Kunstgesch. », p. 199.

MORASSI A., *Giorgione*, in « Rinascimento Europeo e Rinascimento Veneziano », Venice, p. 187.

SCHULZ J., *Venetian painted Ceilings of the Renaissance*, Berkeley & Los Angeles.

VALCANOVER F., *Gli affreschi di Tiziano al Fondaco dei Tedeschi*, in « Arte Veneta », p. 226.

Stil und Überlieferung in der Kunst des Abendlandes, Berlin.

1967-68 *Raccolta Giacobone, Vendita Giudiziaria*, Milan.

1968 MARIACHER G., *Palma il Vecchio*, Milan.

MELCHIORI N., *Notizie di pittori...* (ed G.P. Bordignon Favero), Venice-Rome.

MORASSI A., *Una Salomè di Tiziano riscoperta*, in « Pantheon », p. 456.

VERHEYEN E., *Der Sinngehalt von Giorgiones « Laura »*, in « Pantheon », p. 220.

ZAMPETTI P., *Giorgione*, Milan.

1969 GAMULIN G., *Un'opera inedita del Giorgione*, in « Radovi Odsjeka... », Zagreb, n. 6, p. 29.

GOULD C., *The pala di S. Giovanni Crisostomo and the late Giorgione*, in « Arte Veneta », p. 206.

MORASSI A., *Ritratti giovanili di Tiziano*, in « Arte Illustrata », May-June, p. 21.

PALLUCCHINI A., in « Vienna, Kunsthistorisches Museum », Milan.

PALLUCCHINI R., *Tiziano*, Florence.

PANOFSKY E., *Problems in Titian, mostly iconographic*, New York.

PIGNATTI T., *Giovanni Bellini*, Milan.

PIGNATTI T., *Recenti studi sul Palma Vecchio*, in « Arte Veneta », p. 263.

POZZA N., *Processo per eresia*, Florence.

VALCANOVER F., *Tiziano*, Milan.

School of Giorgione, in « The Burlington Magazine », c. 3 after p. 410.

WETHEY H.E., *The Paintings of Titian, Complete Edition: I. The Religious Paintings*, London and New York.

WIND E., *Giorgione's Tempesta*, Oxford.

WORKS BY GIORGIONE

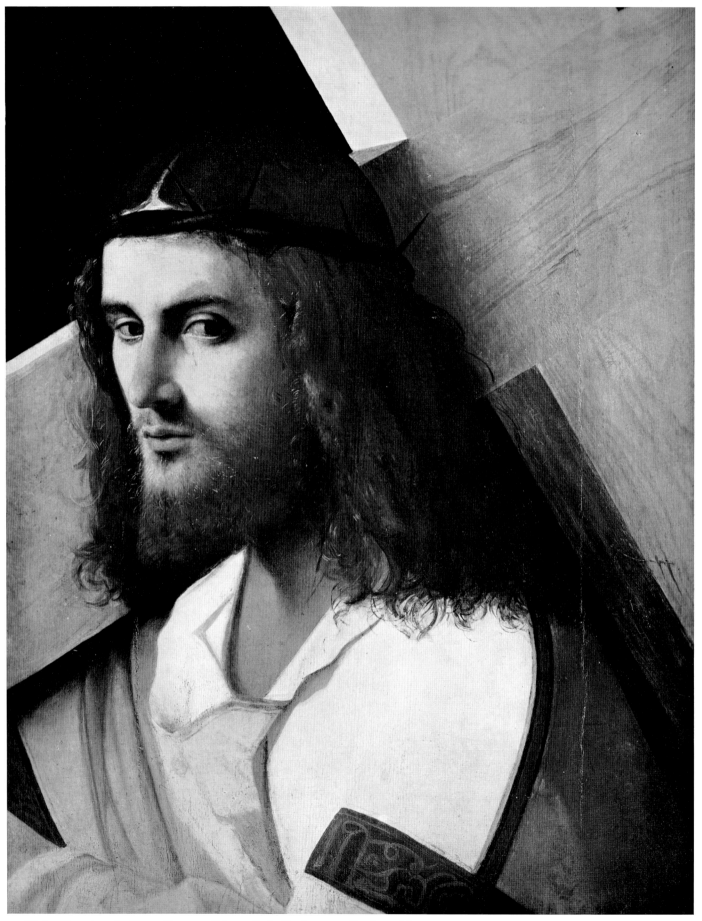

1. *Christ Carrying the Cross*. Boston, Mass., Isabella Stewart Gardner Museum

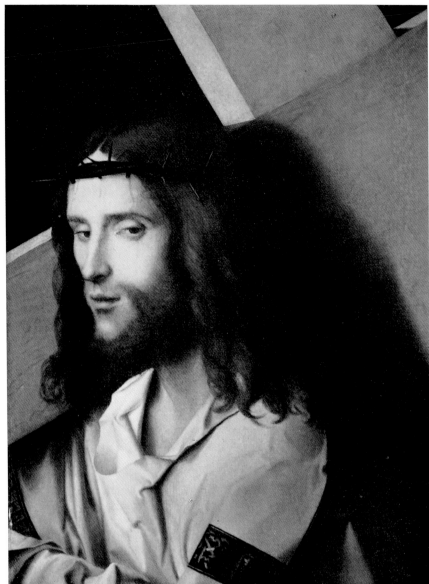

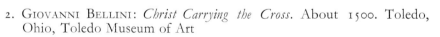

2. GIOVANNI BELLINI: *Christ Carrying the Cross*. About 1500. Toledo, Ohio, Toledo Museum of Art

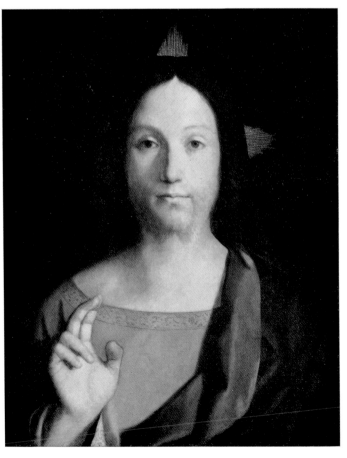

3. GIOVANNI BELLINI: *Christ Blessing*. About 1505. Ottawa, National Gallery of Canada

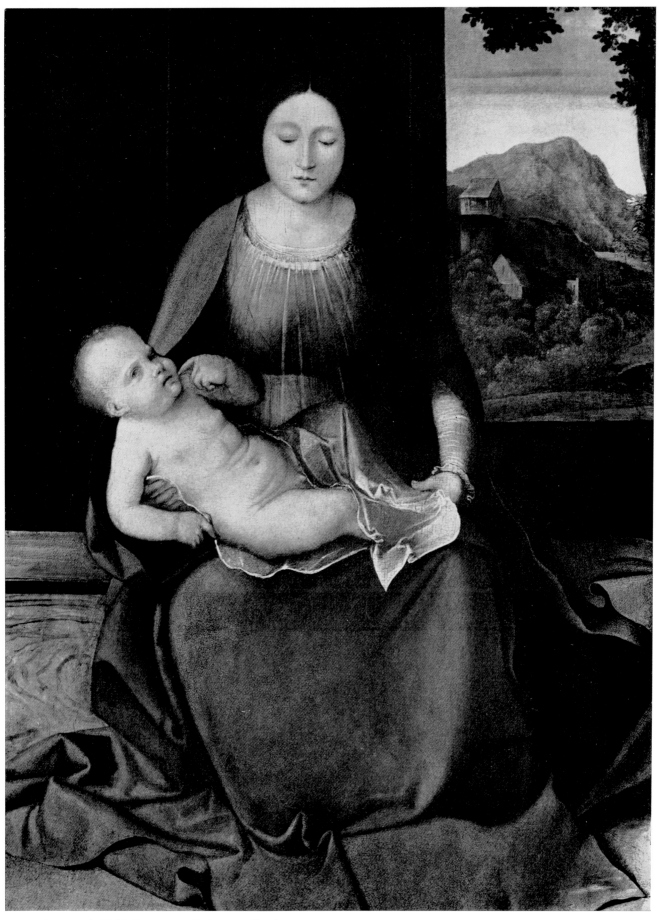

4. *Madonna and Child*. Bergamo, Private collection

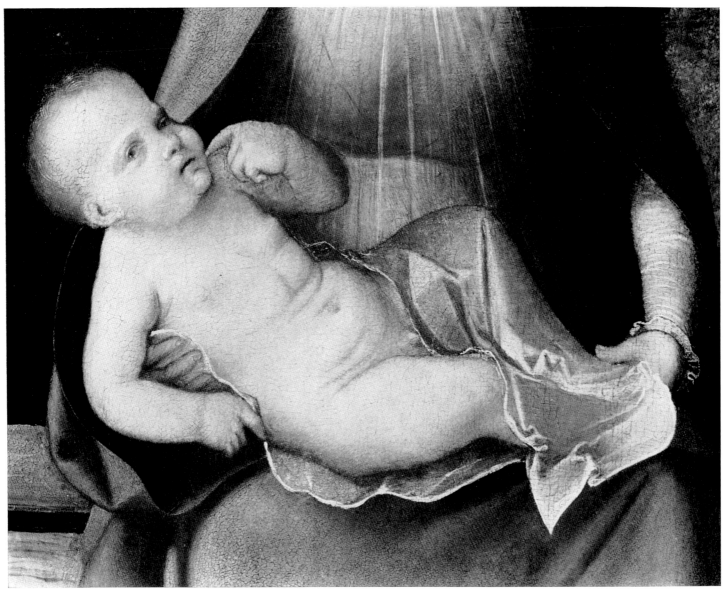

5. Detail from Plate 5

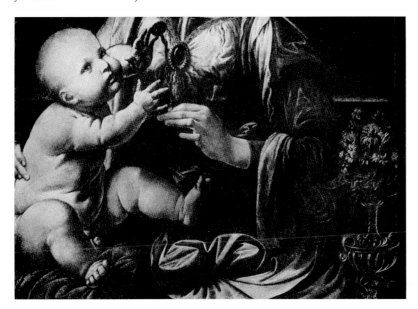

6. Leonardo (?): *Madonna with the Carnation* (detail). About 1480. Munich, Alte Pinakothek

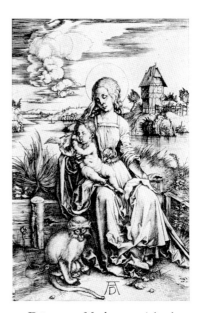

7. Dürer: *Madonna with the Monkey*. About 1498. Engraving

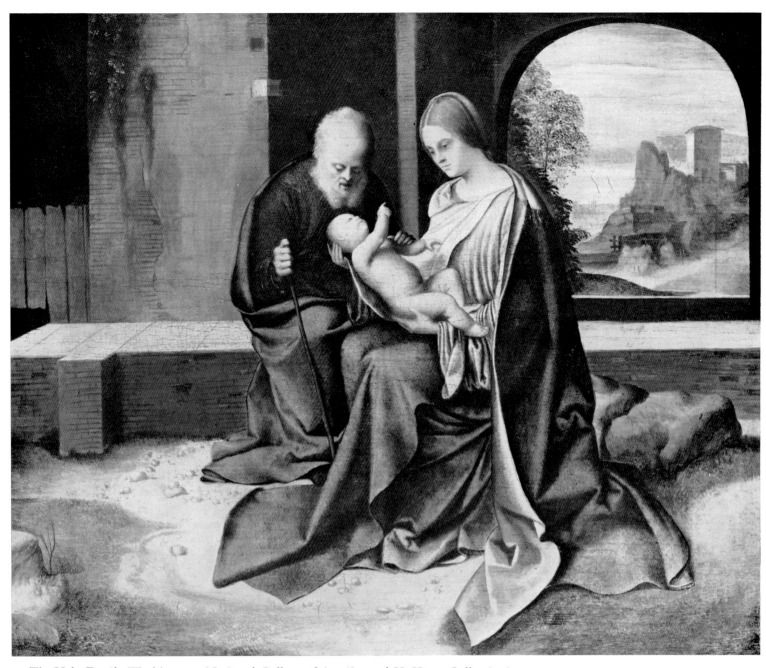

8. *The Holy Family*. Washington, National Gallery of Art (Samuel H. Kress Collection)

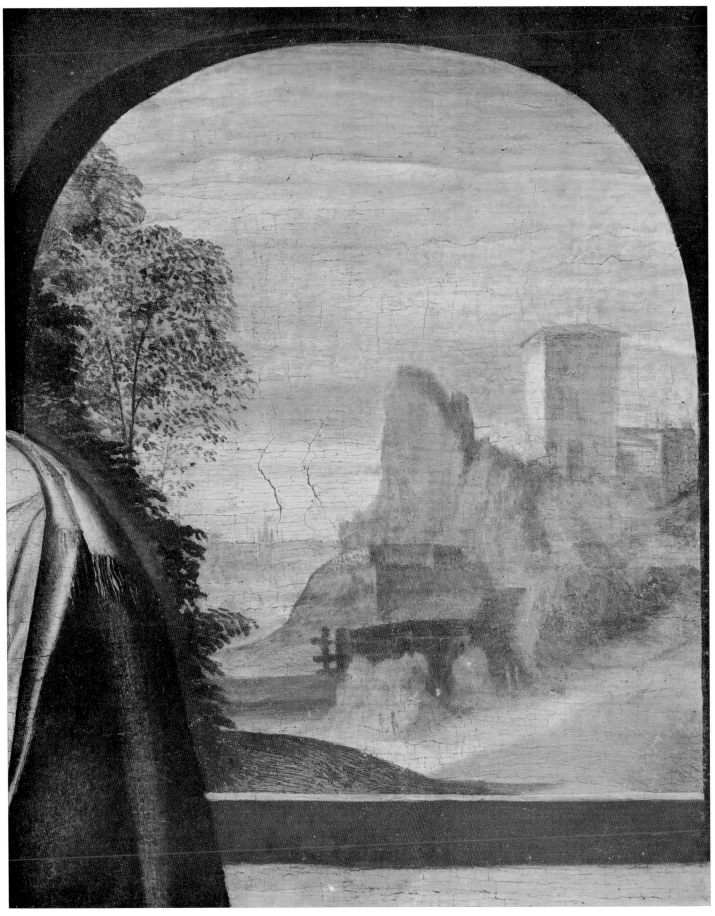

9. Detail from Plate 8

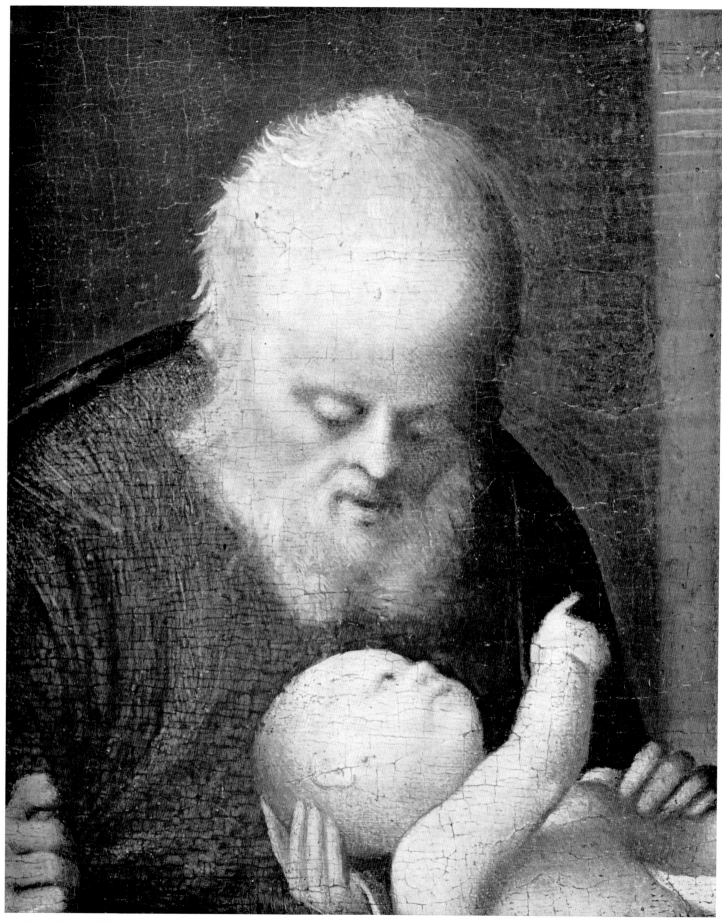

10. Detail from Plate 8

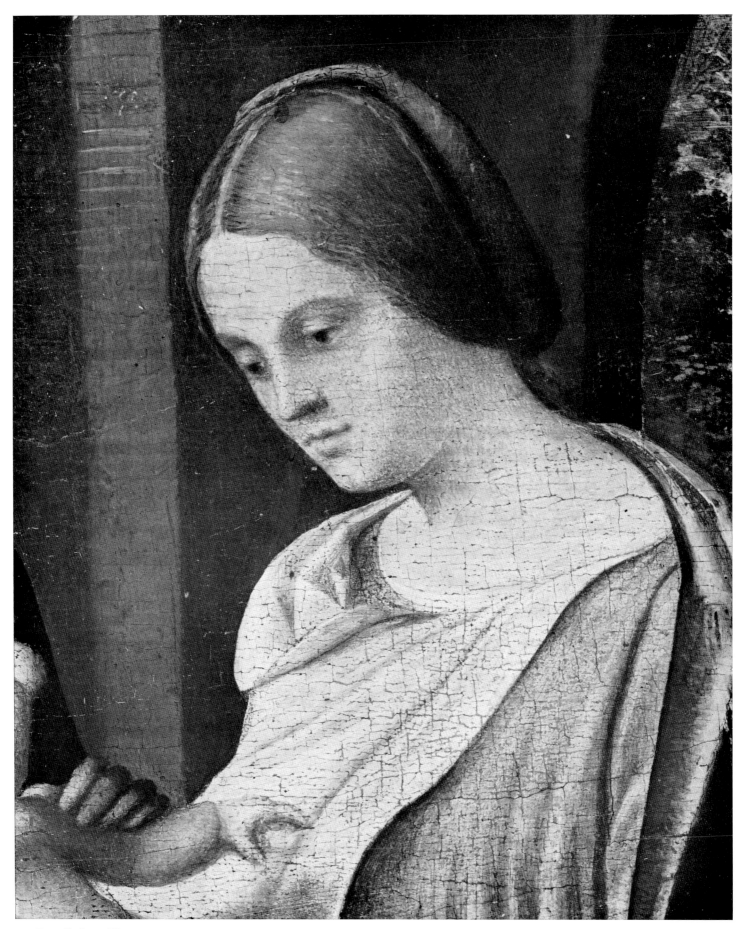

11. Detail from Plate 8

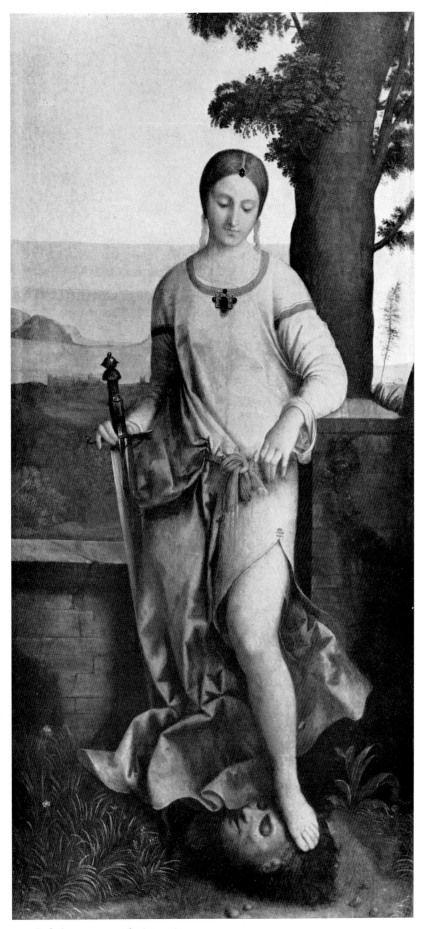

12. *Judith*. Leningrad, Hermitage

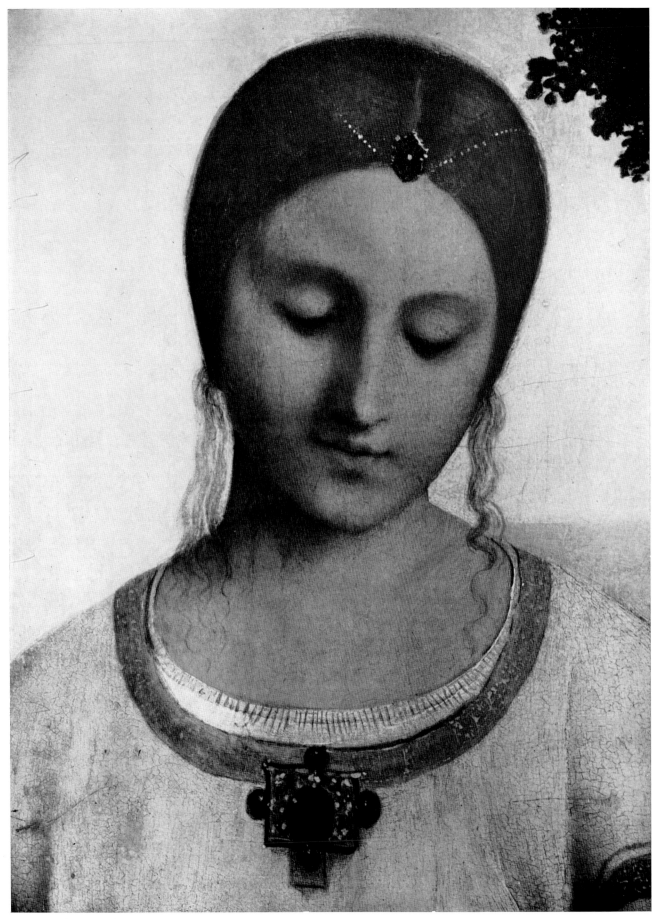

13. Detail from Plate 12

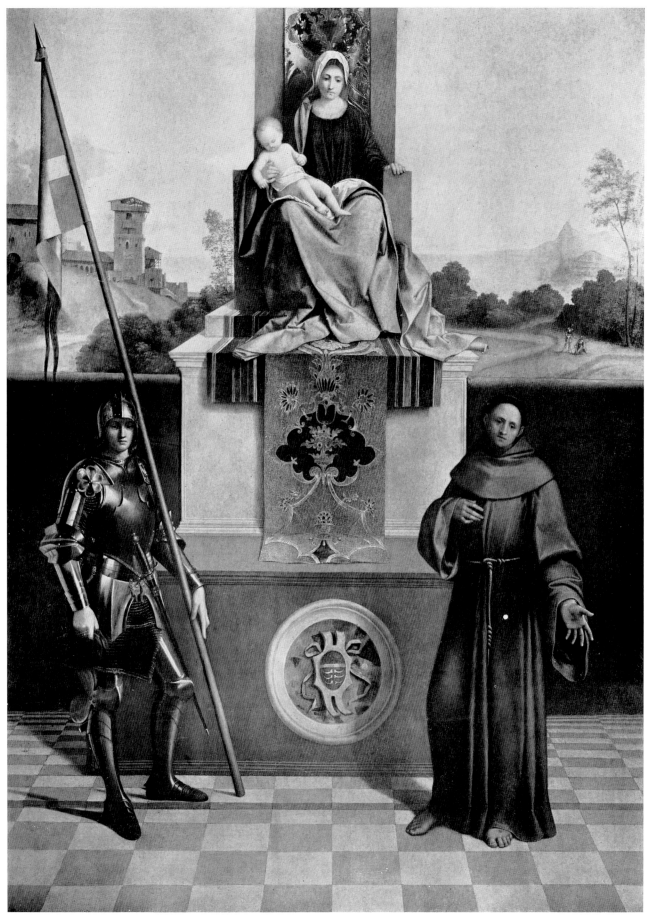

14. *Madonna and Child with Saints Francis and Liberale*. Castelfranco, Cathedral

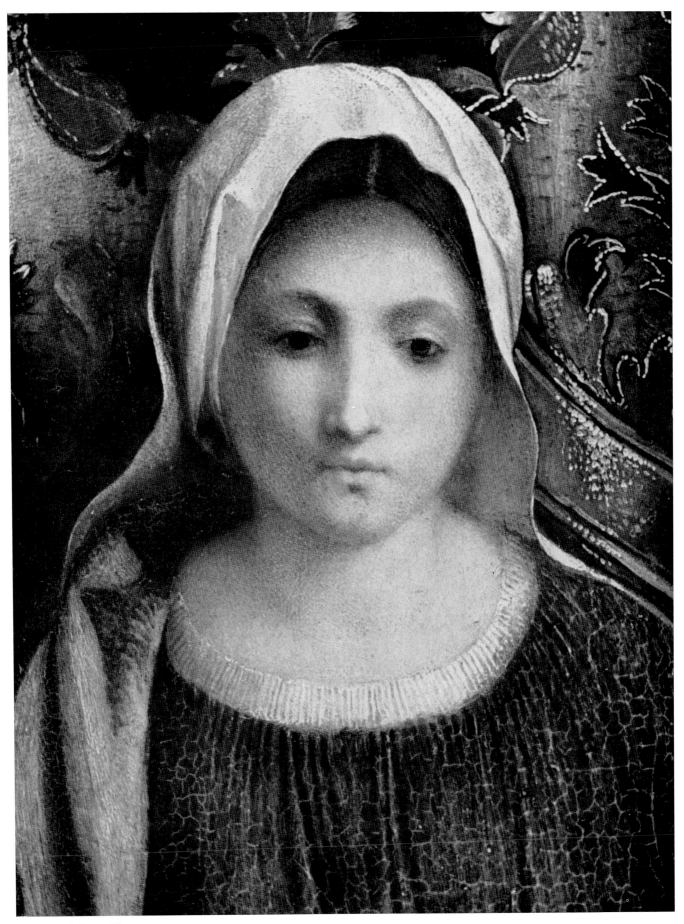

15. Detail from Plate 14

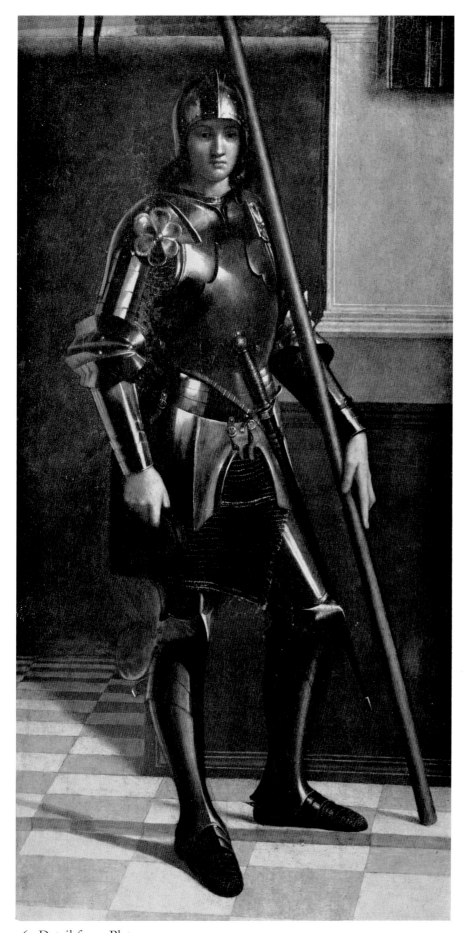

16. Detail from Plate 14

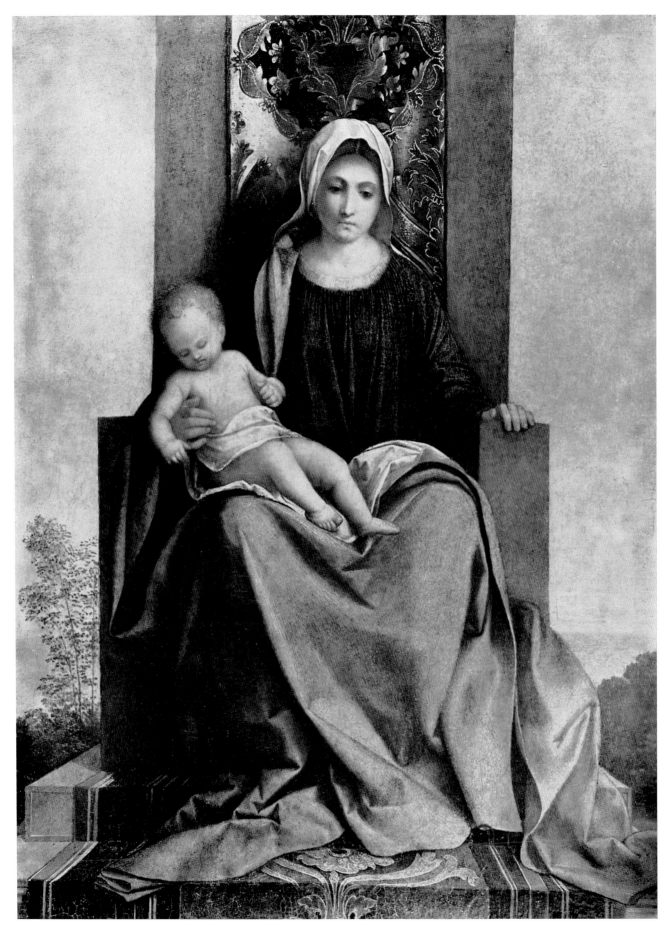

17. Detail from Plate 14

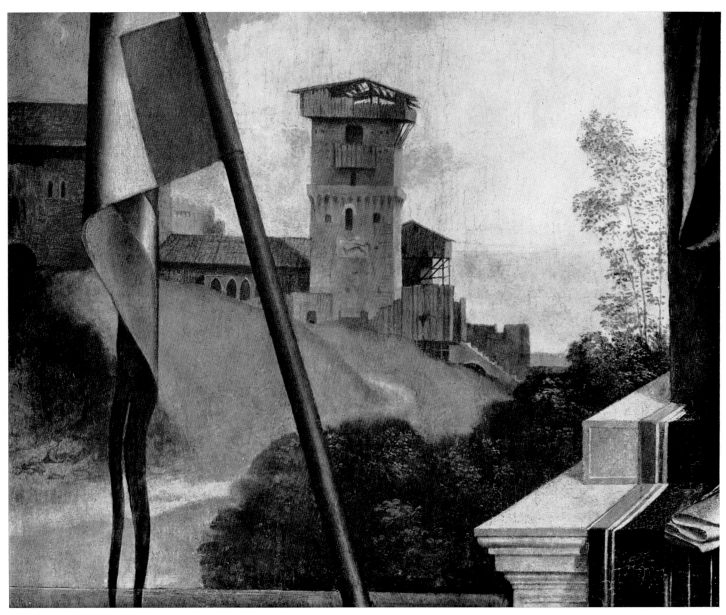

18. Detail from Plate 14

19. Detail from Plate 14

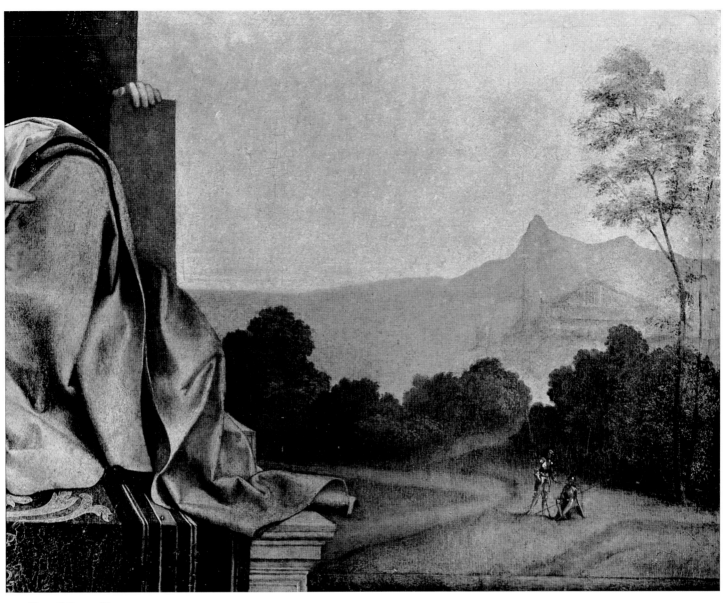

20. Detail from Plate 14

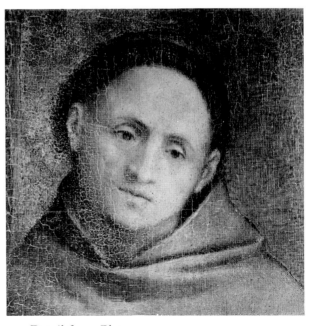

21. Detail from Plate 14

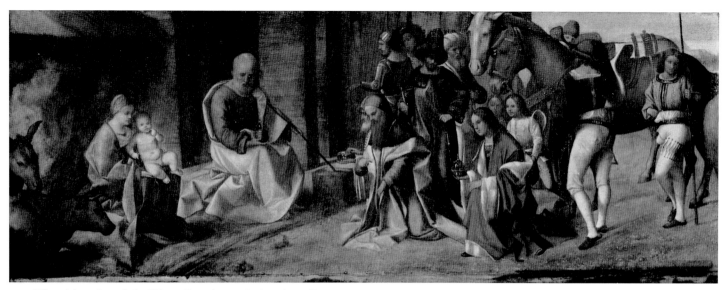

22. *The Adoration of the Kings*. London, National Gallery

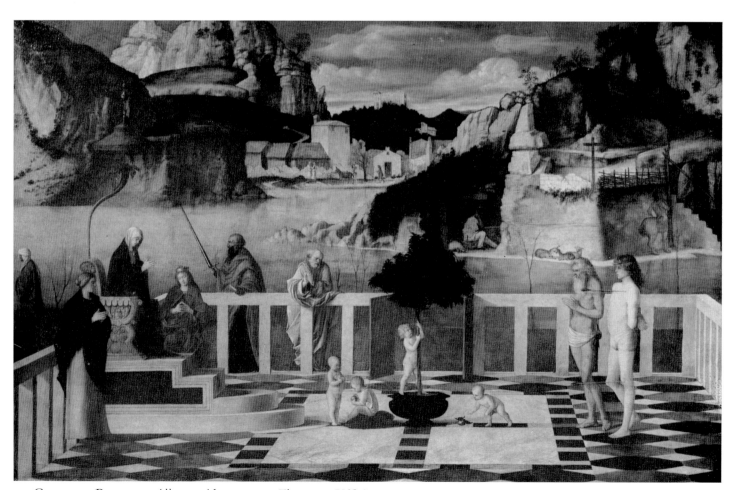

23. GIOVANNI BELLINI: *Allegory*. About 1490. Florence, Uffizi

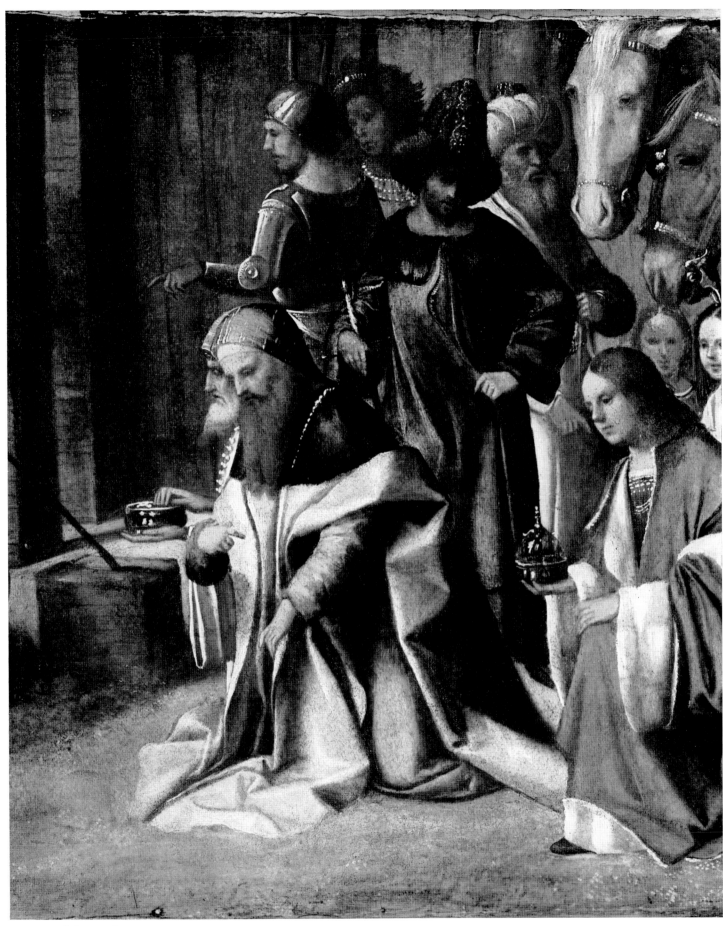

24. Detail from Plate 22

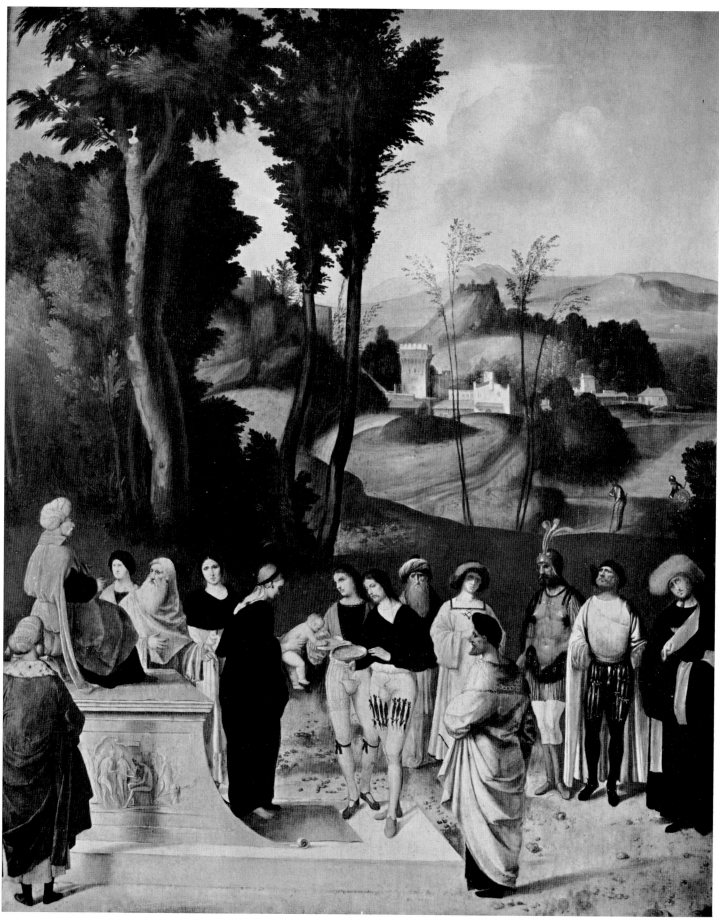

25. *The Trial of Moses*. Florence, Uffizi

27. Detail from *The Tempest* (Plate 50). Venice, Accademia

26. Detail from Plate 25

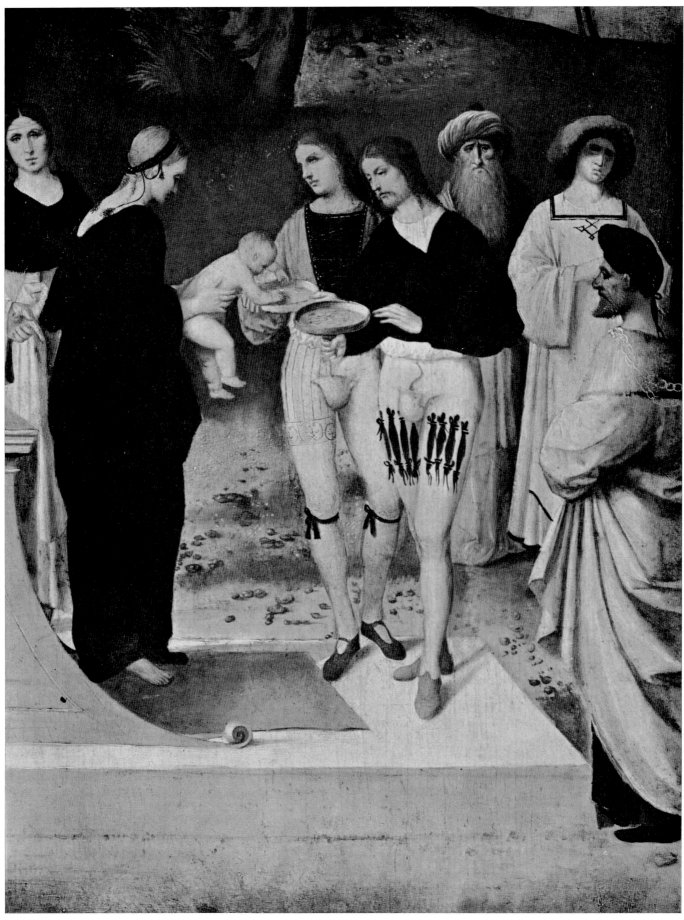

28. Detail from Plate 25

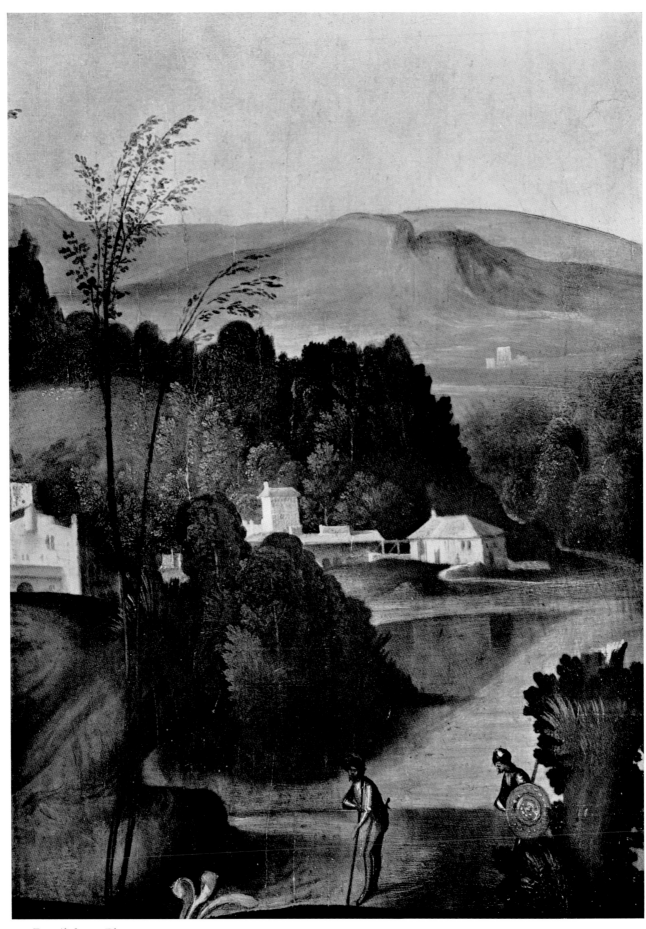

29. Detail from Plate 25

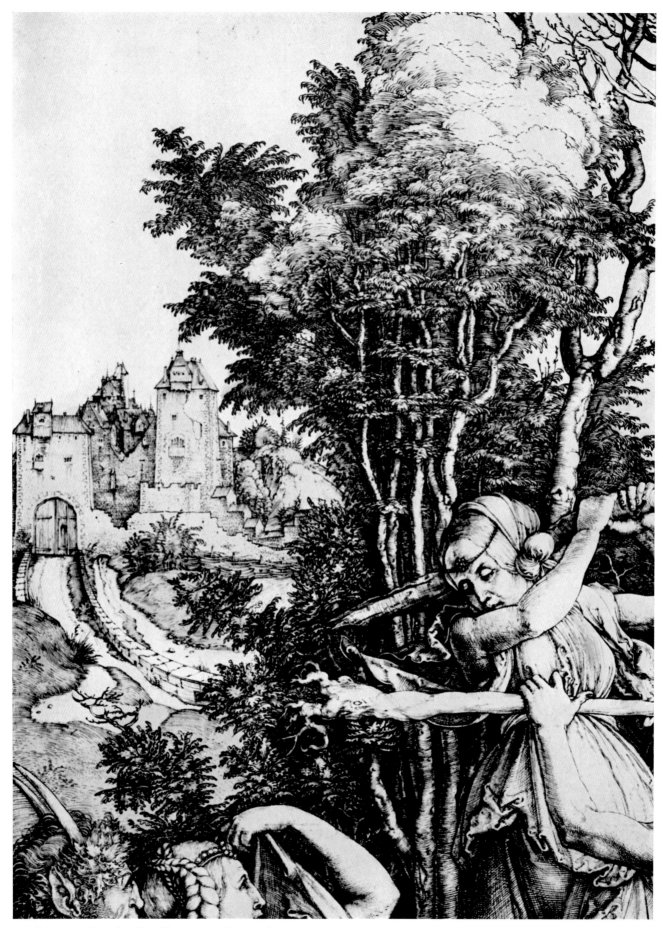

30. DÜRER: *Hercules* (detail). 1498-9. Engraving

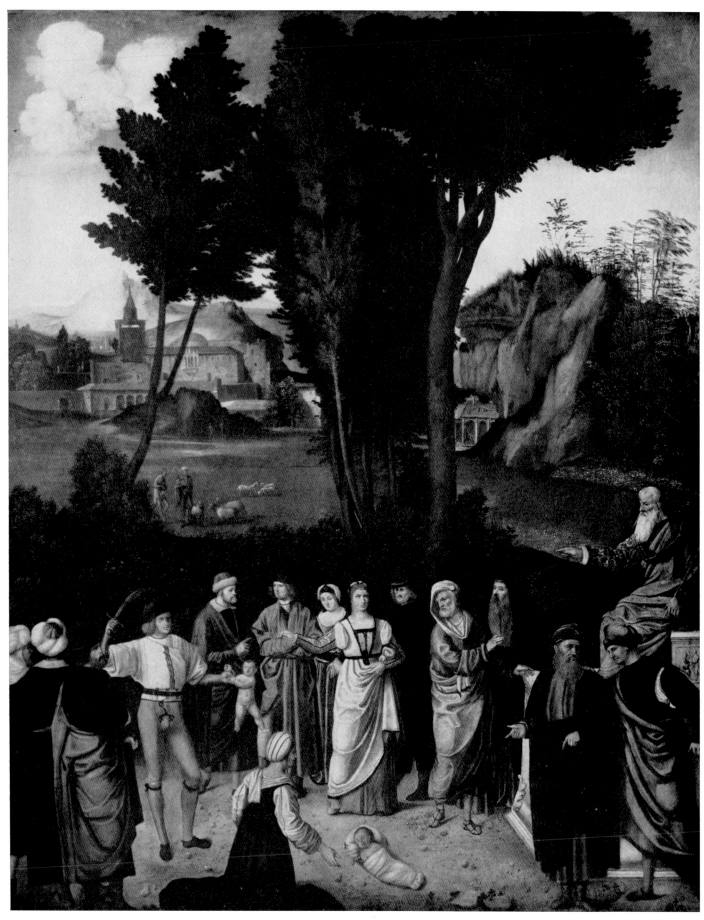

31. *The Judgement of Solomon*. Florence, Uffizi

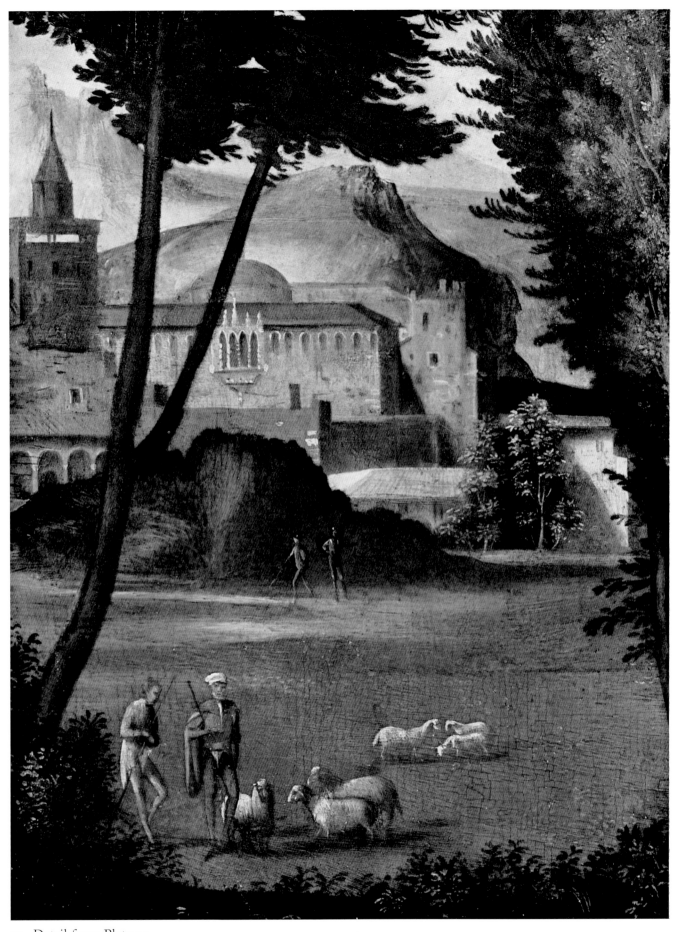

32. Detail from Plate 31

33. Detail from Plate 31

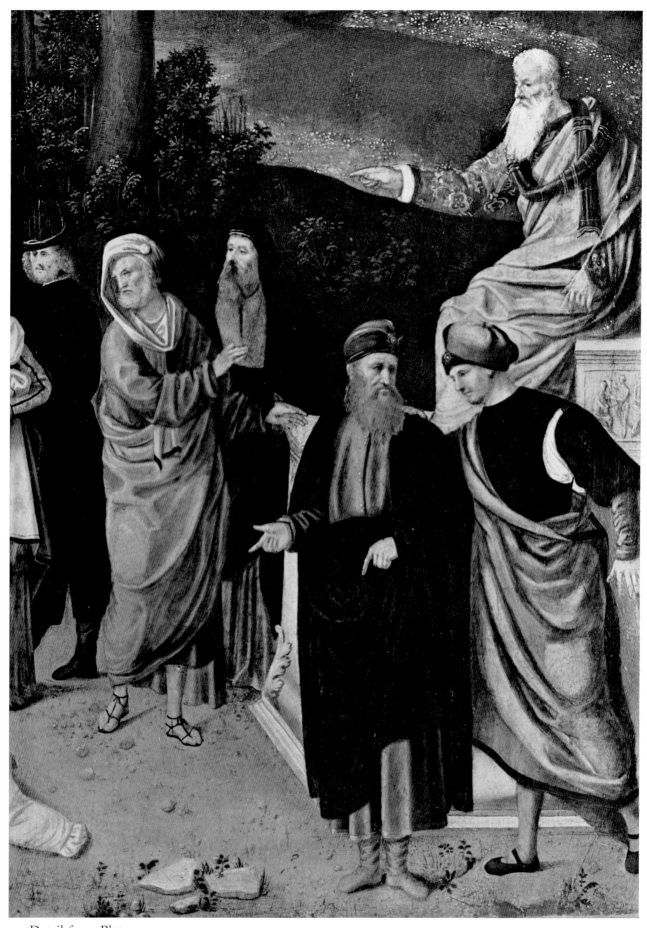

34. Detail from Plate 31

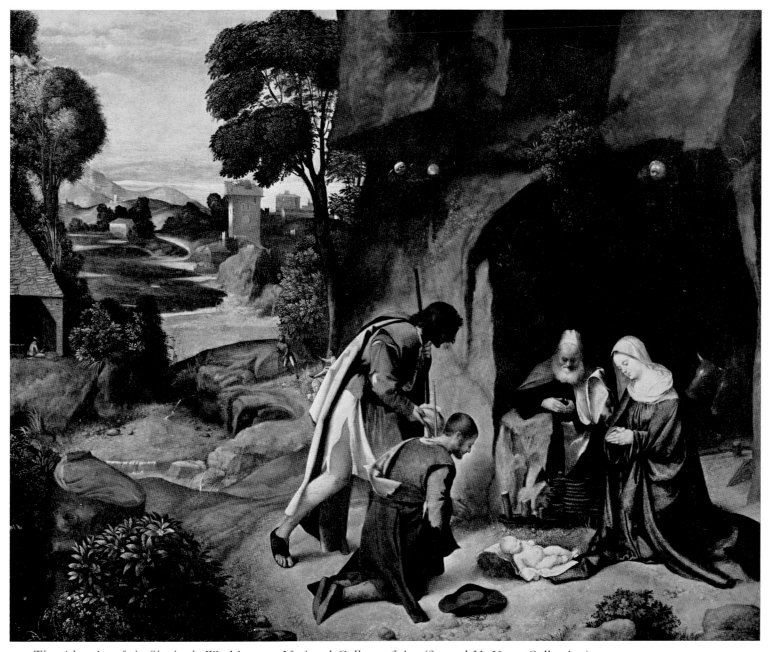

35. *The Adoration of the Shepherds*. Washington, National Gallery of Art (Samuel H. Kress Collection)

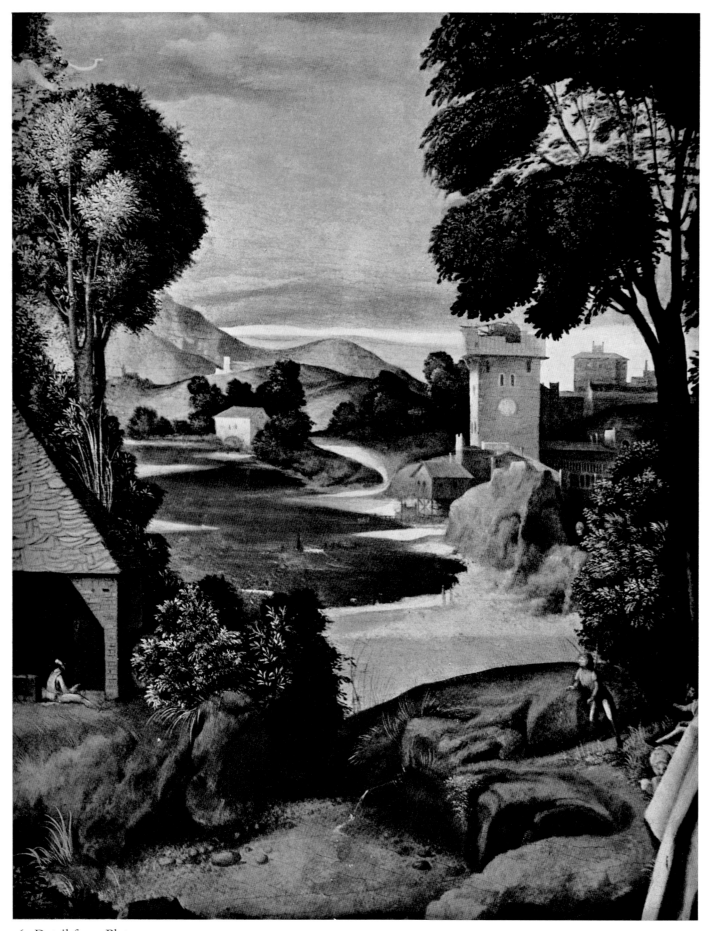

36. Detail from Plate 35

37. Detail from Plate 35

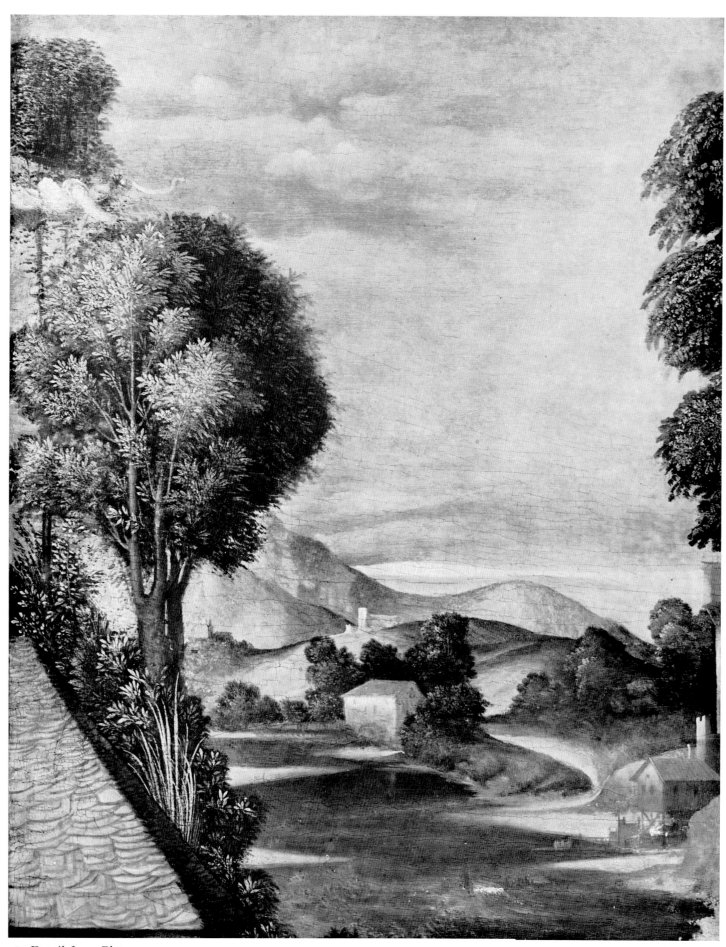

38. Detail from Plate 35

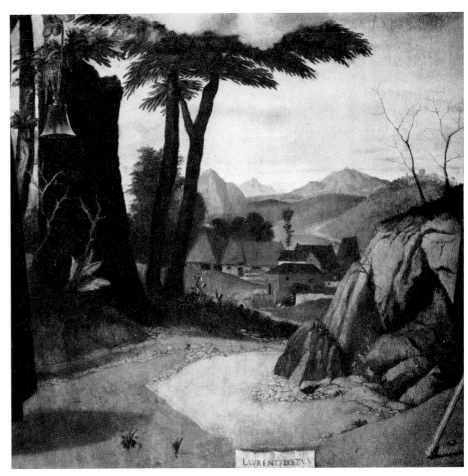

39. LORENZO LOTTO: Detail from *Madonna and Saints*. 1506. Asolo, Cathedral

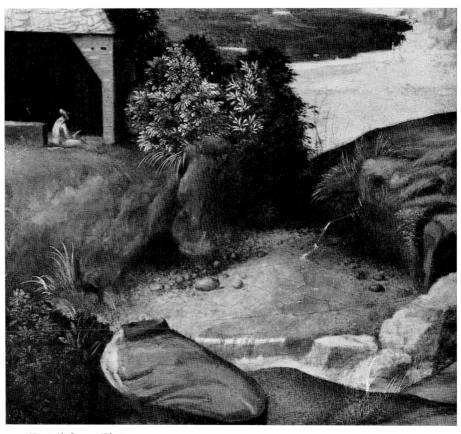

40. Detail from Plate 35

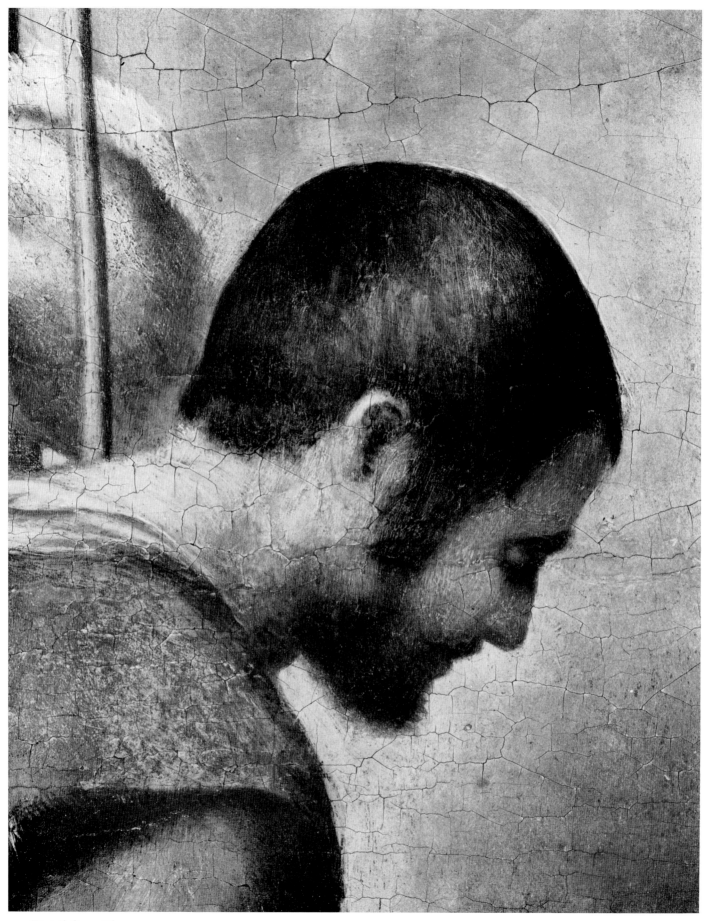

41. Detail from Plate 35

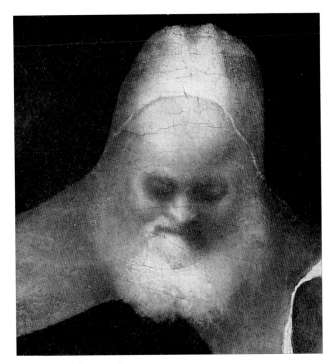

42. Detail from Plate 35

43. Detail from Plate 35

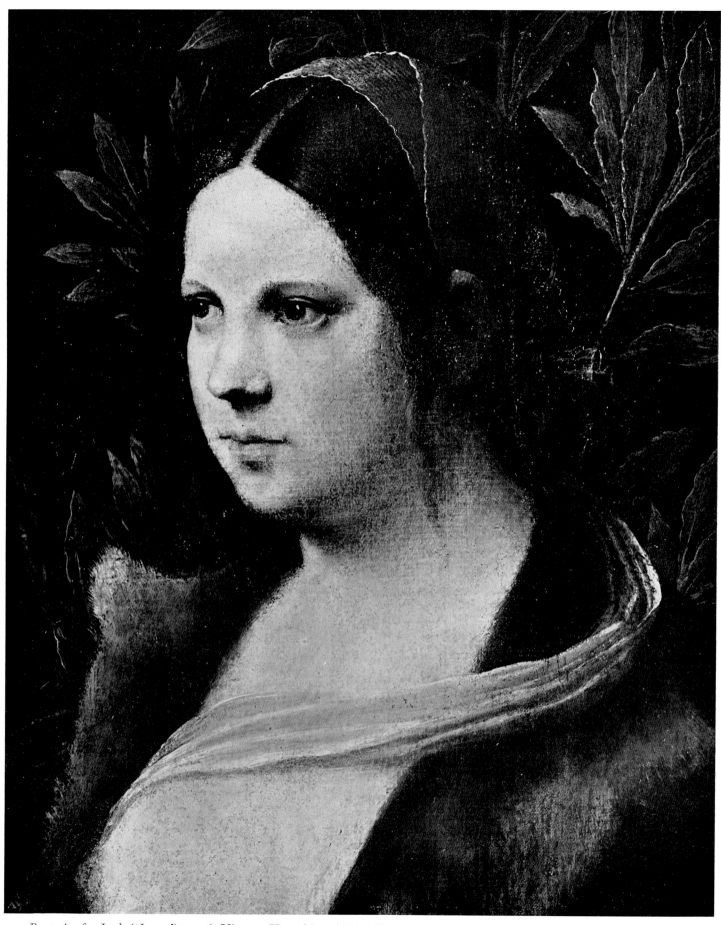

44. *Portrait of a Lady* ('*Laura*'). 1506. Vienna, Kunsthistorisches Museum

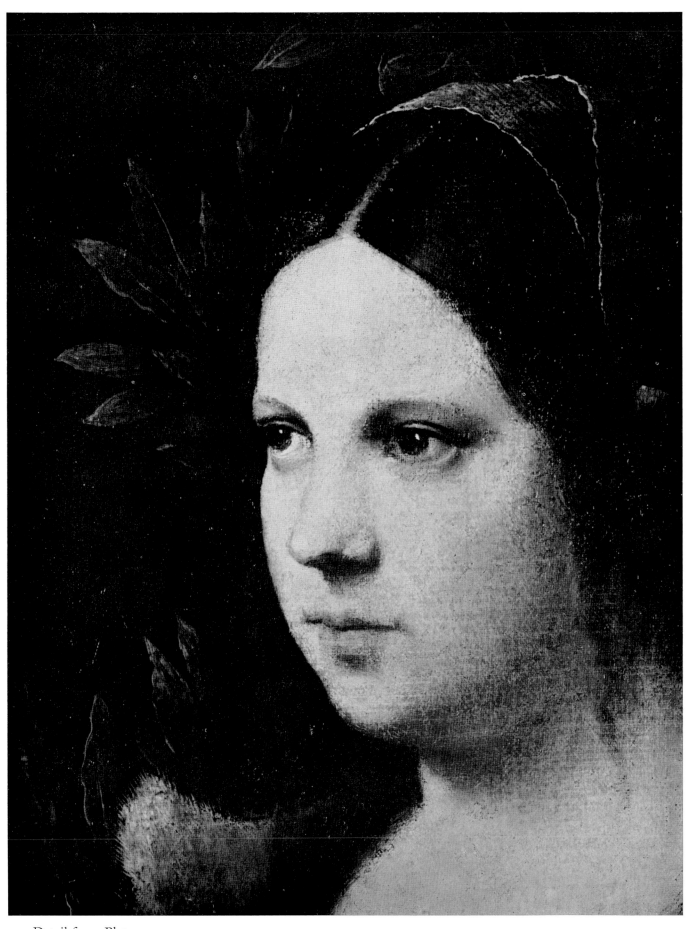

45. Detail from Plate 44

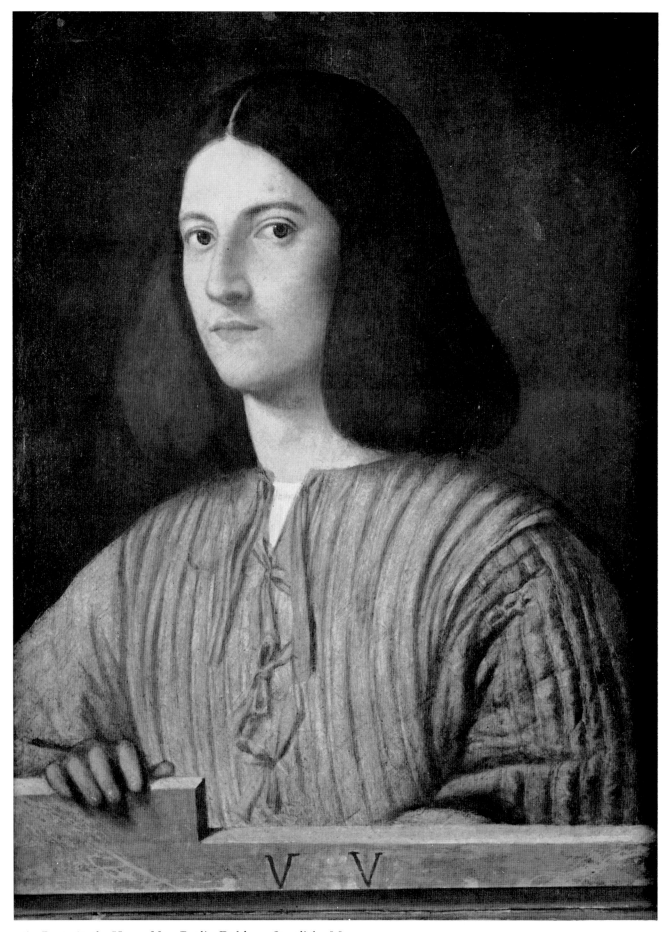

46. *Portrait of a Young Man*. Berlin-Dahlem, Staatliche Museen

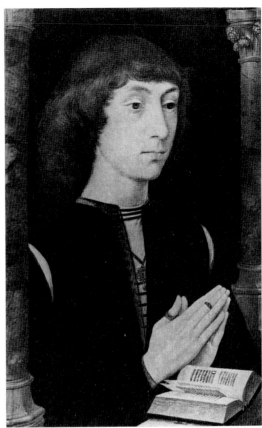

47. HANS MEMLING: *Portrait of a Young Man.*
About 1490. London, National Gallery

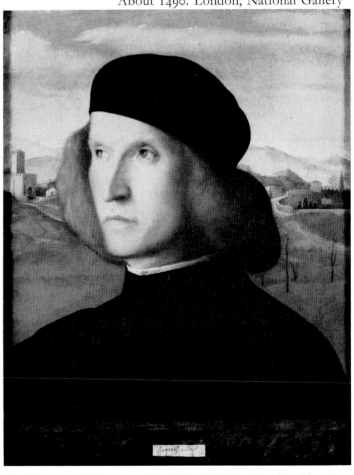

48. GIOVANNI BELLINI: *Portrait of Pietro Bembo.* About
1505. Hampton Court, Royal Collection

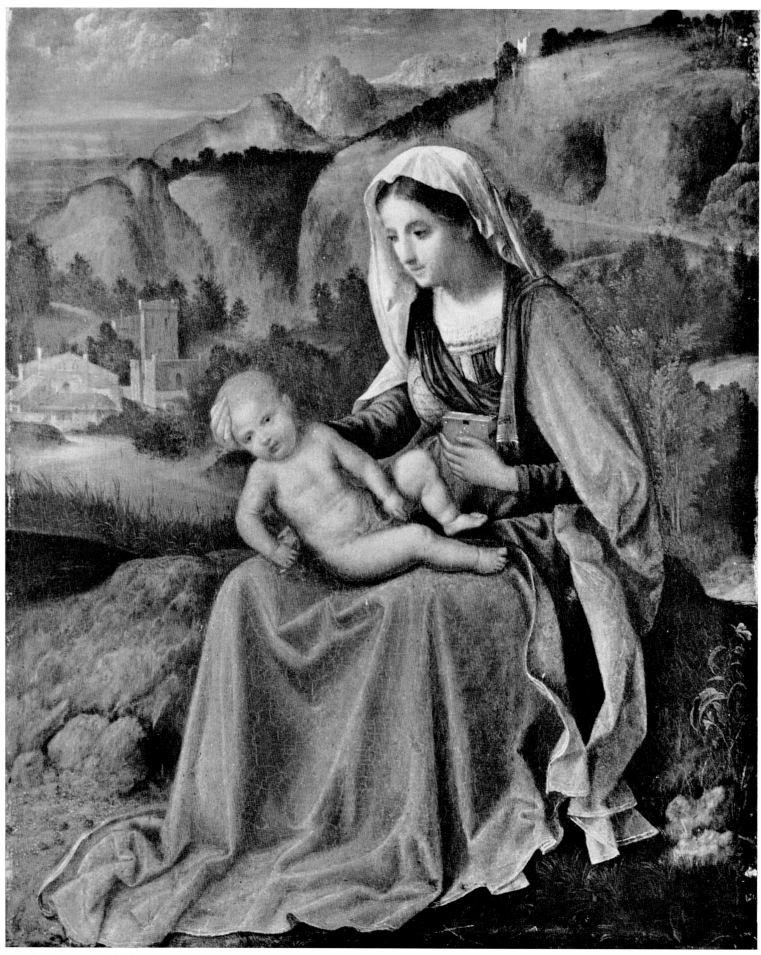

49. *Madonna and Child in a Landscape*. Leningrad, Hermitage

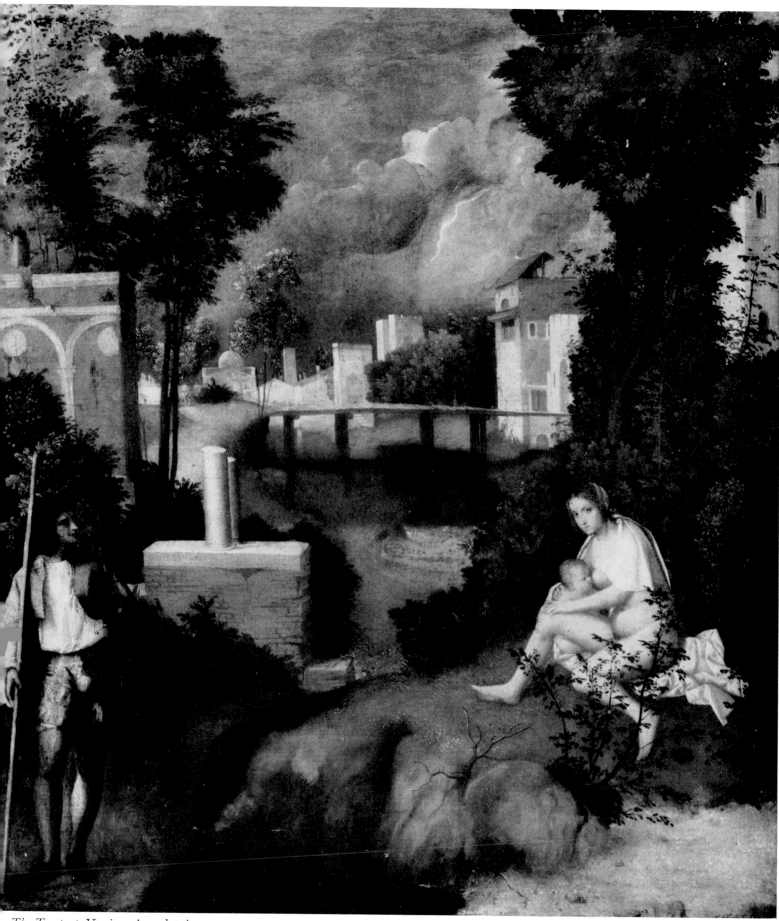

The Tempest. Venice, Accademia

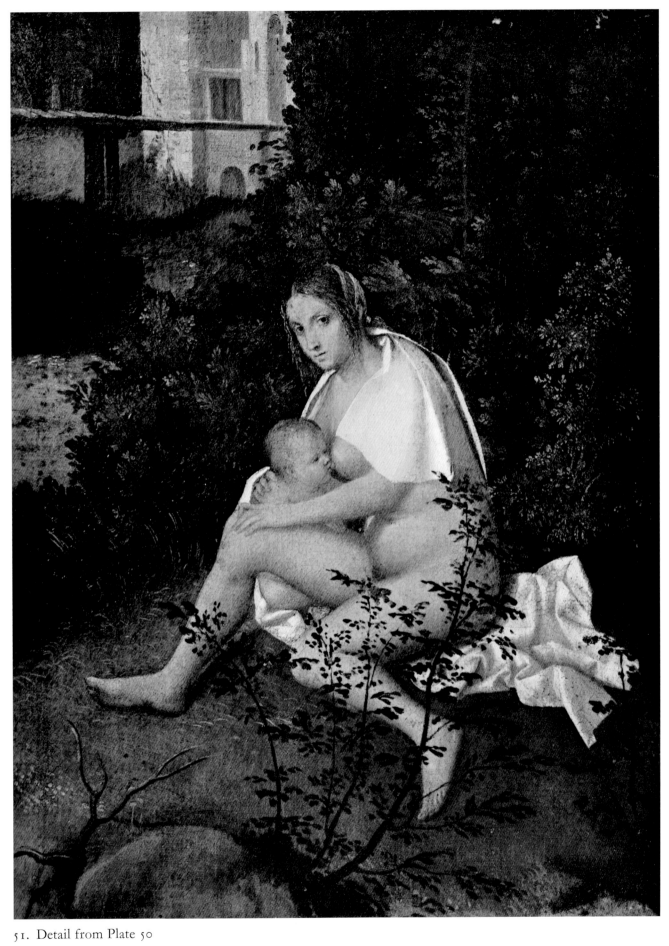

51. Detail from Plate 50

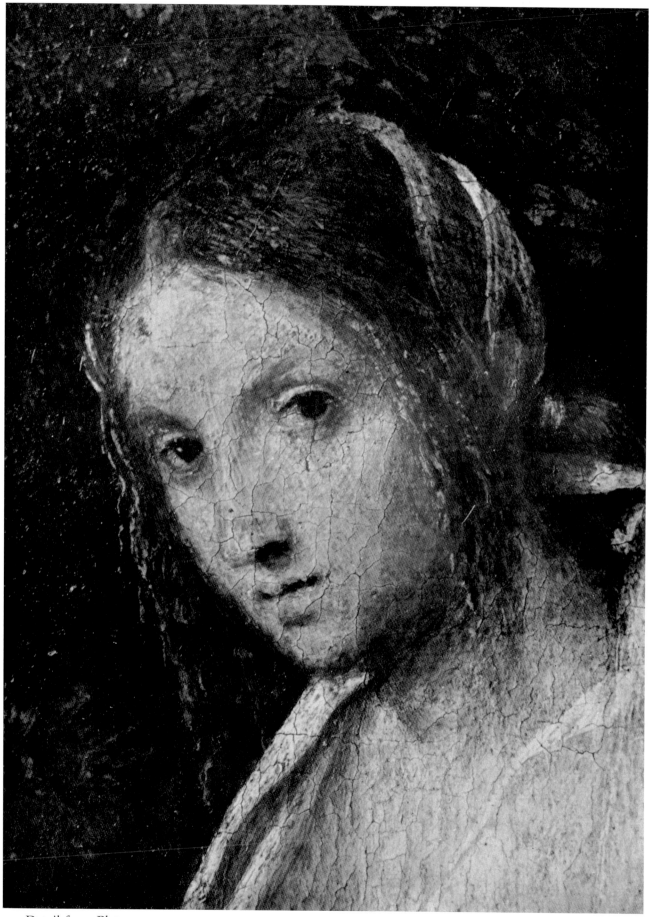

52. Detail from Plate 50

53. *Young Shepherd in a Landscape*. Drawing. Rotterdam, Museum Boymans-van Beuningen

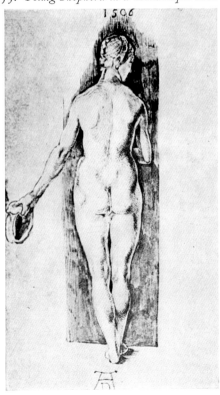

54. DÜRER: *Nude*. 1506. Berlin,
Print Room

55. A.M. ZANETTI: *The Nude by
Giorgione on the Fondaco dei
Tedeschi*. 1760. Engraving

56. *Standing Nude*. Fragment of a fresco, (detail). Venice, Accademia

57-59. *Frieze with Attributes of the Liberal Arts* (details). Castelfranco, Casa Marta-Pellizzari

60-62. *Frieze with Attributes of the Liberal Arts* (details). Castelfranco, Casa Marta-Pellizzari

63-65. *Frieze with Attributes of the Liberal Arts* (details). Castelfranco, Casa Marta-Pellizzari

66-68. *Frieze with Attributes of the Liberal and Mechanical Arts* (details). Castelfranco, Casa Marta-Pellizzari

AMANS·QVI
CVPIT
SIT
QVID·SAPIAT
NON·
VIDET

69-71. *Frieze with Attributes of the Liberal and Mechanical Arts* (details). Castelfranco, Casa Marta-Pellizzari

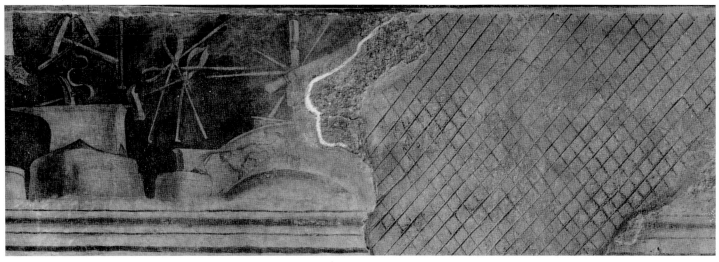

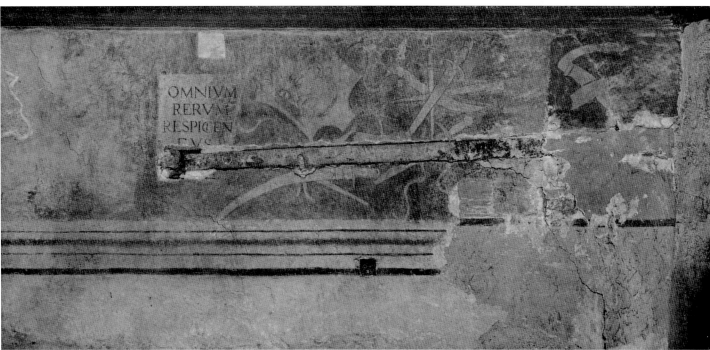

OMNIVM
RERVM
RESPICI EN
EVS

72-73. *Frieze with Attributes of the Liberal and Mechanical Arts* (details). Castelfranco, Casa Marta-Pellizzari

74. Coat of Arms of the Costanzo family. Detail from the Castelfranco *Madonna* (Plate 14)

76. Detail from Plate 70

75. Detail from Plate 25, *The Trial of Moses.*

78. Detail from Plate 64

77. Detail from Plate 64

79. Detail from Plate 57

80. Detail from Plate 62

82. *Emperor wearing a Laurel Crown.* Castelfranco, Casa Rostirolla-Piccinini.

81. Detail from Plate 65

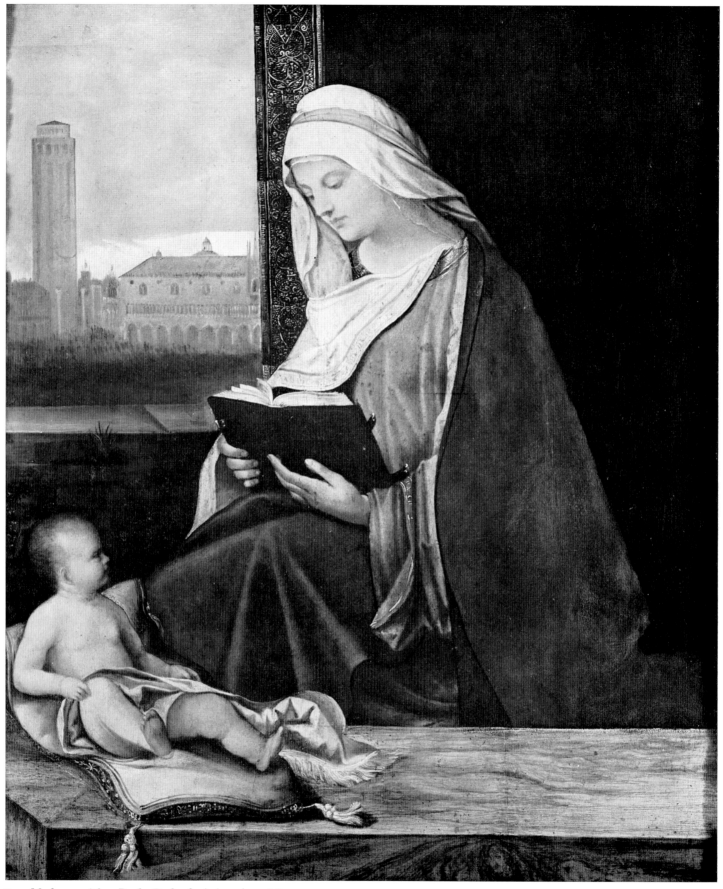

83. *Madonna with a Book*. Oxford, Ashmolean Museum

84. Detail from Plate 83

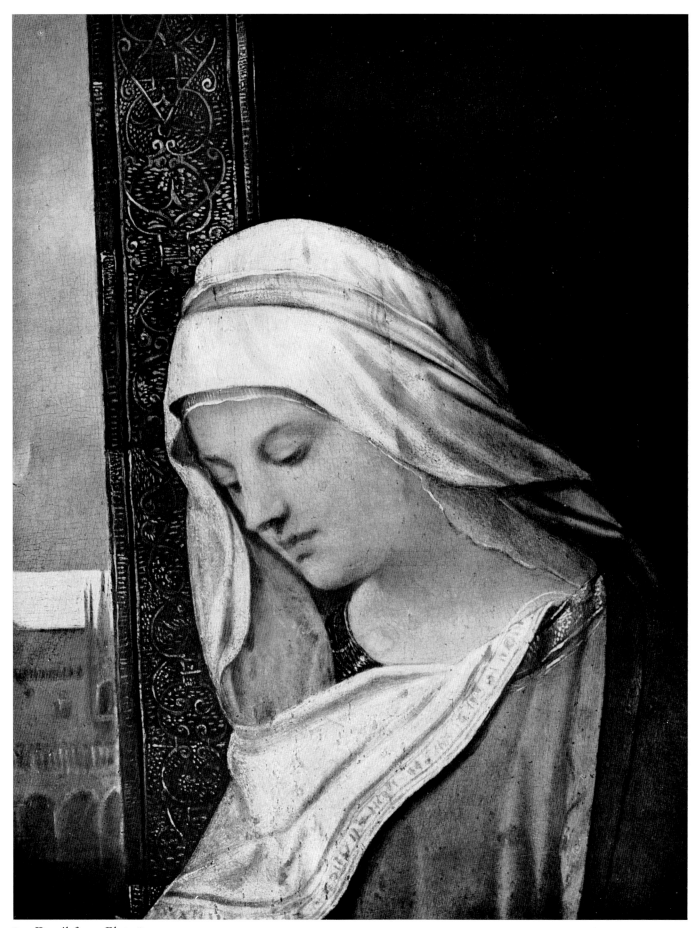

85. Detail from Plate 83

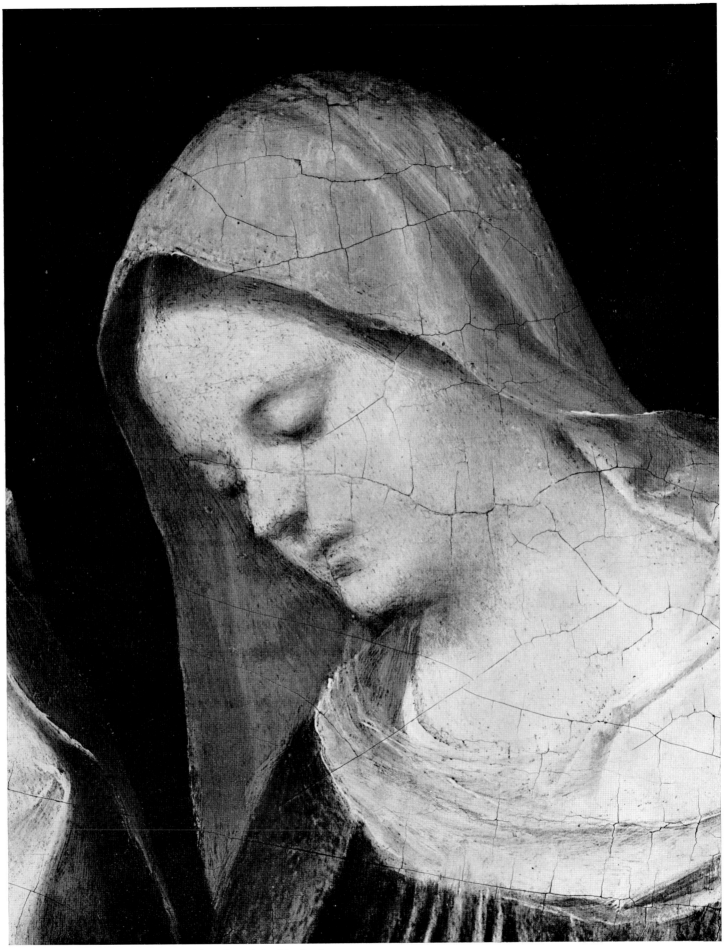

86. Detail from Plate 35, *The Adoration of the Shepherds*.

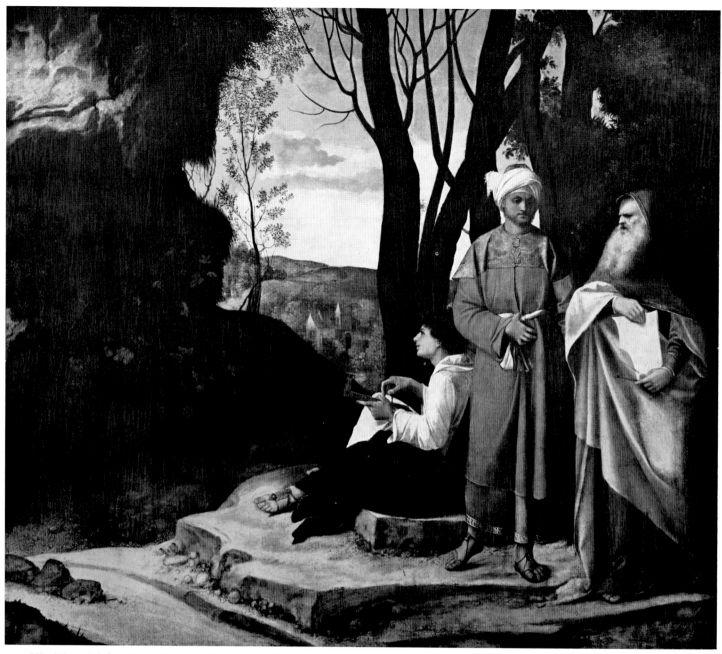

87. *The Three Philosophers*. Vienna, Kunsthistorisches Museum

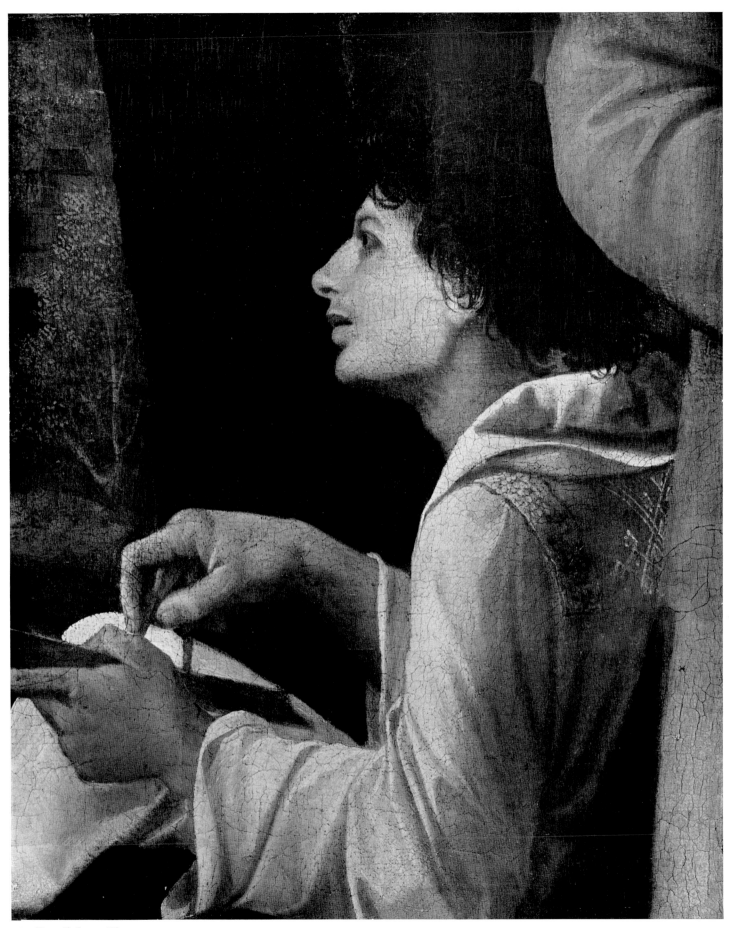

88. Detail from Plate 87

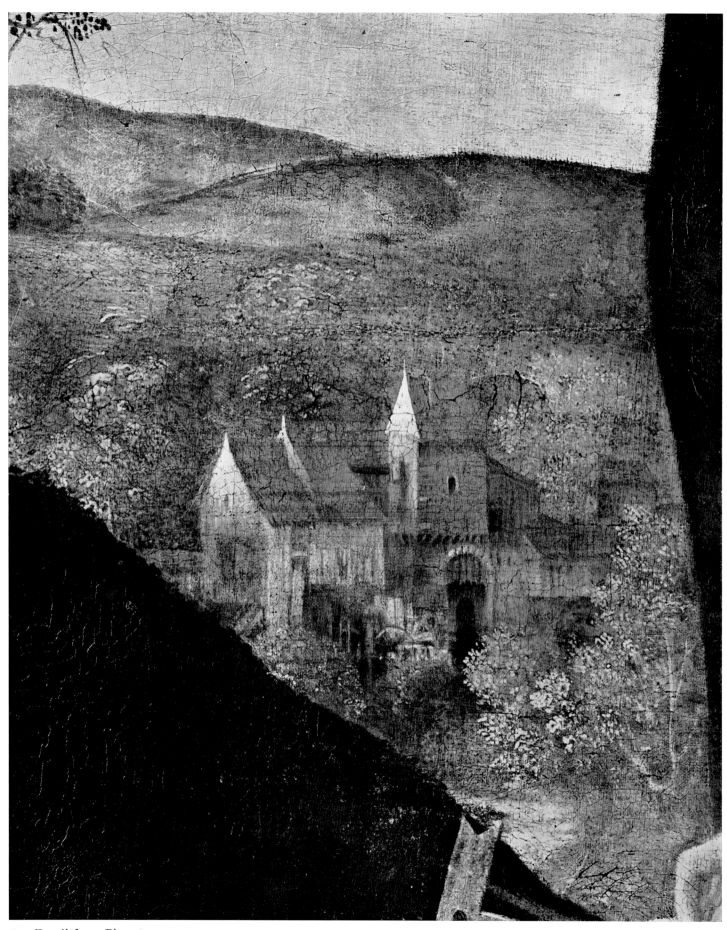

89. Detail from Plate 87

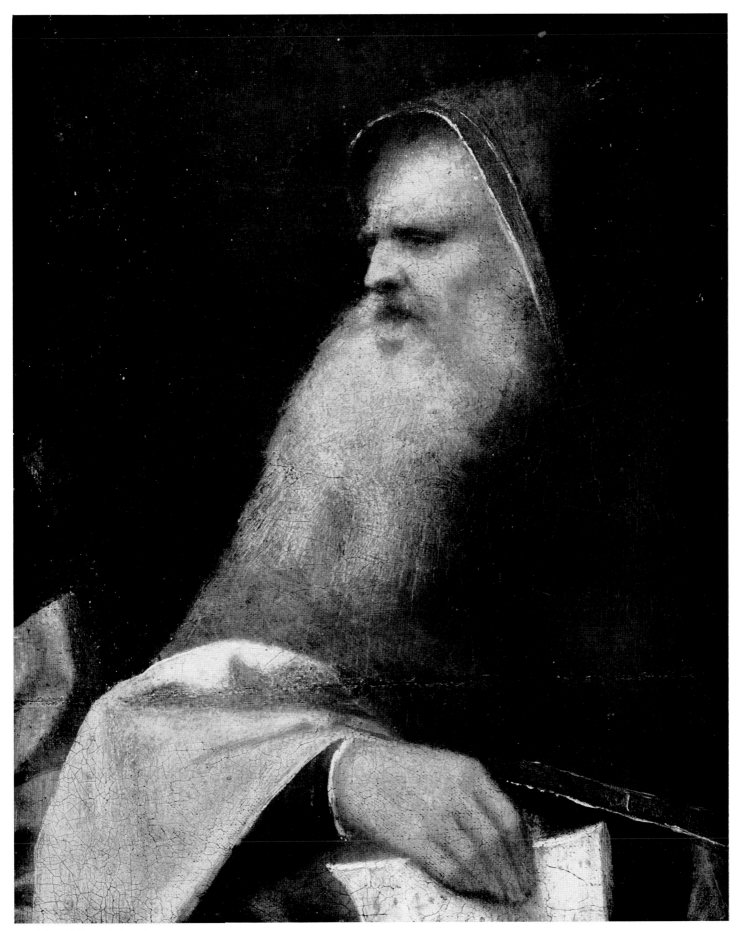

90. Detail from Plate 87

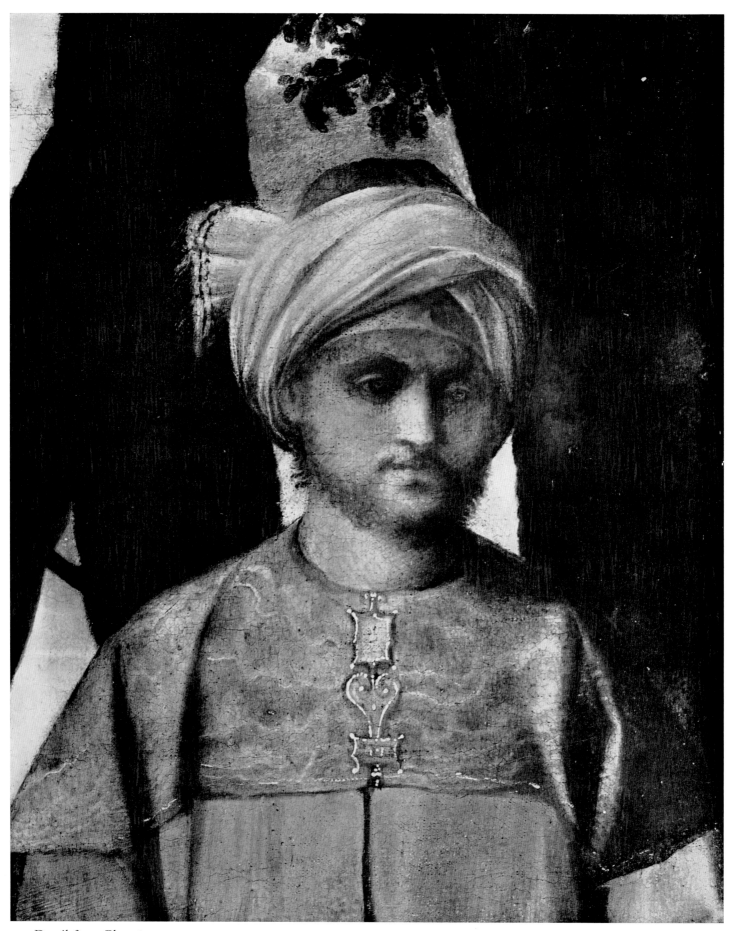

91. Detail from Plate 87

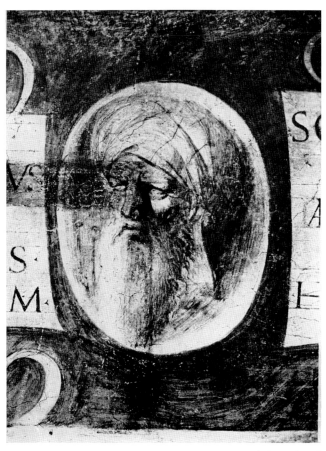

92. Detail from Plate 57, *Frieze with Attributes of the Liberal Arts*

93. Detail from Plate 87

94. Detail from Plate 59, *Frieze with Attributes of the Liberal Arts*

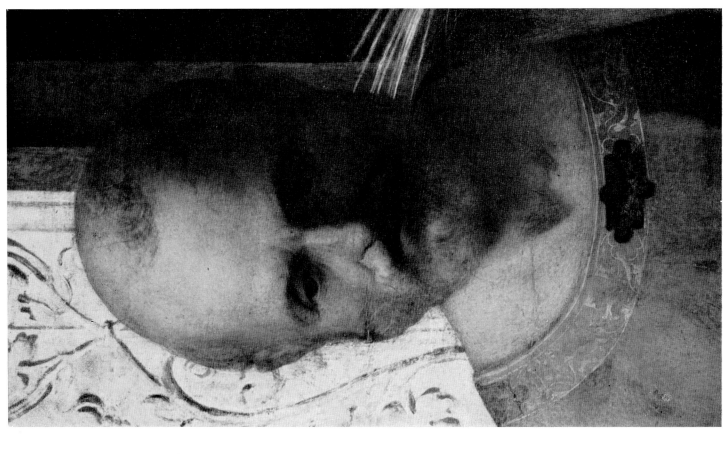

96. GIOVANNI BELLINI: Detail from *Madonna and Child with four Saints*. 1505. Venice, San Zaccaria.

95. *Head of an Old Man with a Beard*. Drawing (recto). Zurich, Private collection

97. *Head of an Old Man with a Beard*. Drawing (verso). Zurich, Private collection

24

98. *Philosopher*. Drawing. Oxford, Christ Church

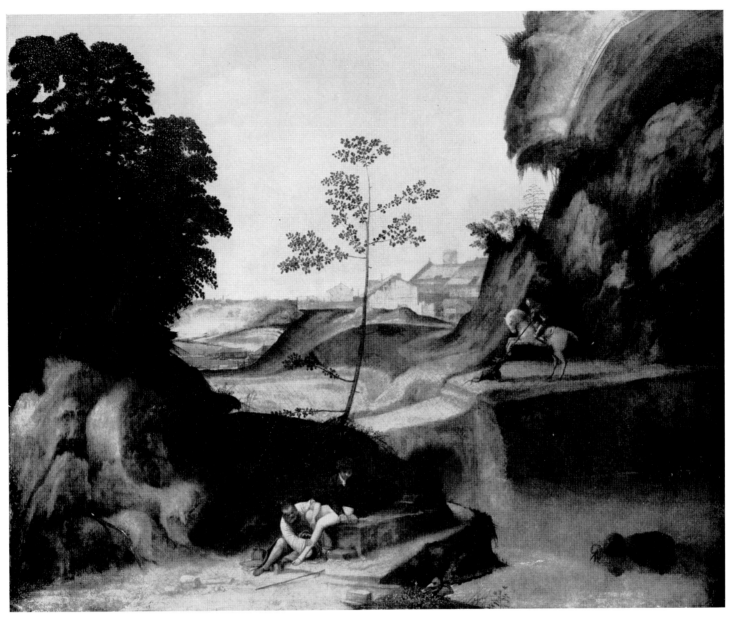

99. *Sunset Landscape*. London, National Gallery

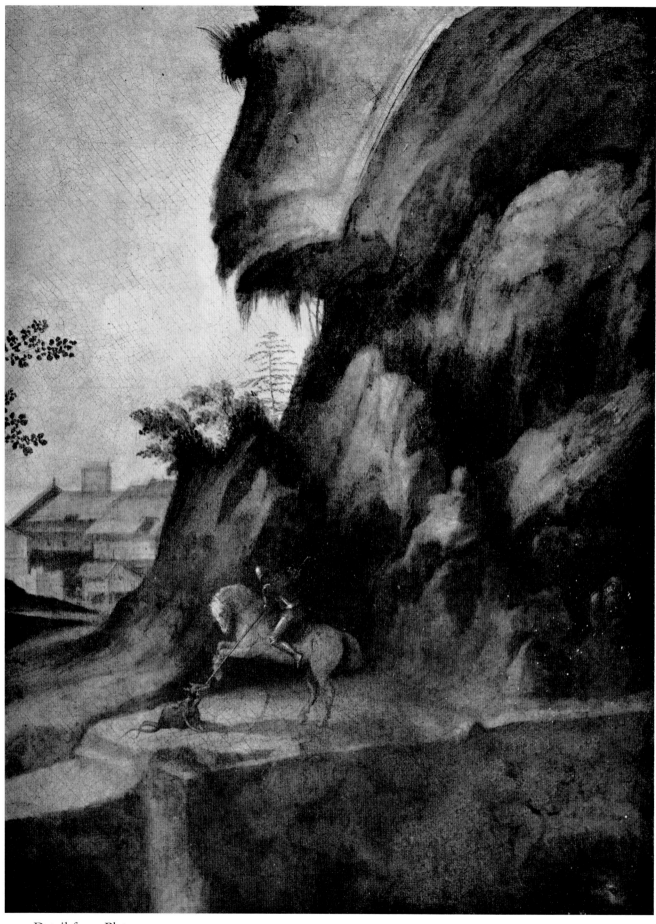

100. Detail from Plate 99

101. Detail from Plate 99

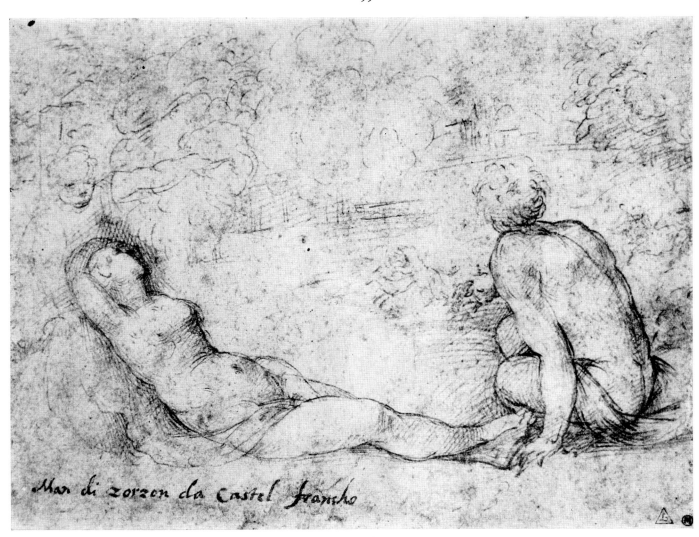

Man di zorzon da Castel francho

102. *Jupiter and Callisto*. Drawing. Darmstadt, Hessisches Landesmuseum

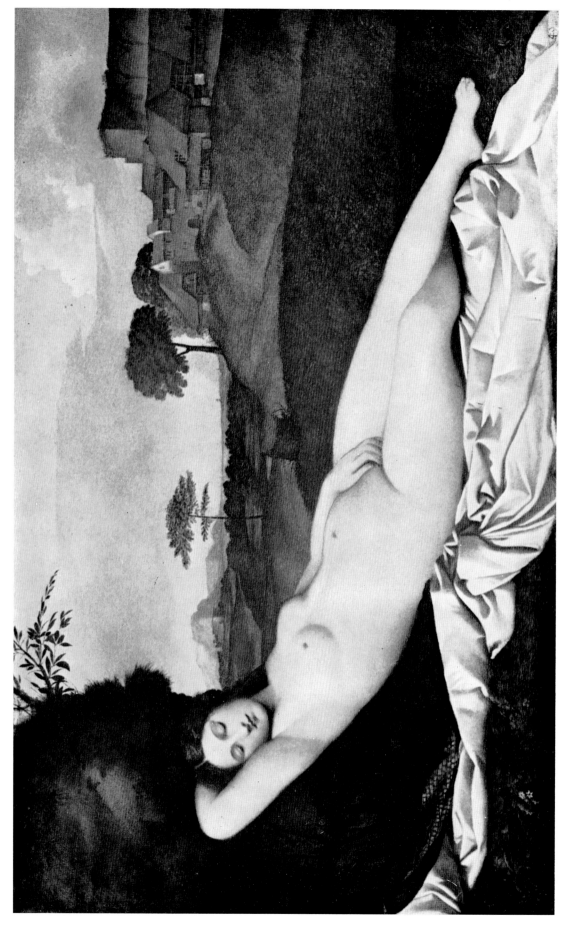

103. *Venus*. Dresden, Gemäldegalerie

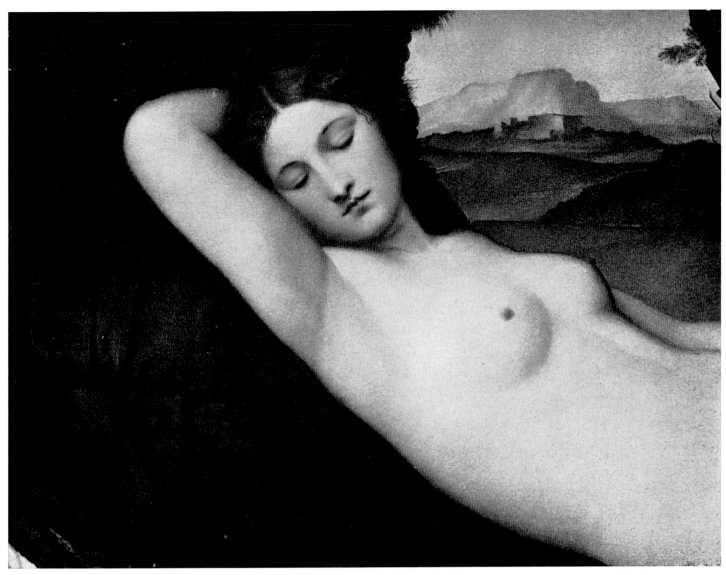

104. Detail from Plate 103

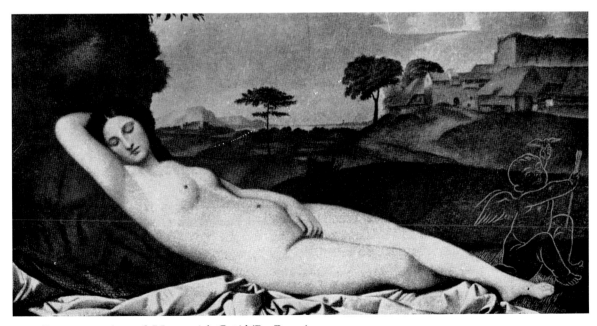

105. Reconstruction of *Venus with Cupid* (By Posse)

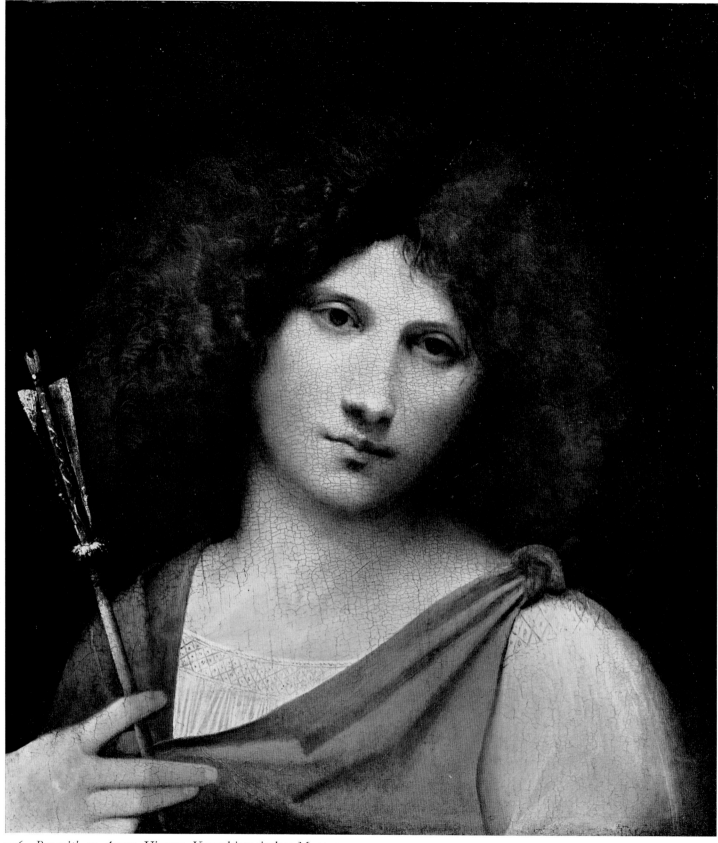

106. *Boy with an Arrow*. Vienna, Kunsthistorisches Museum

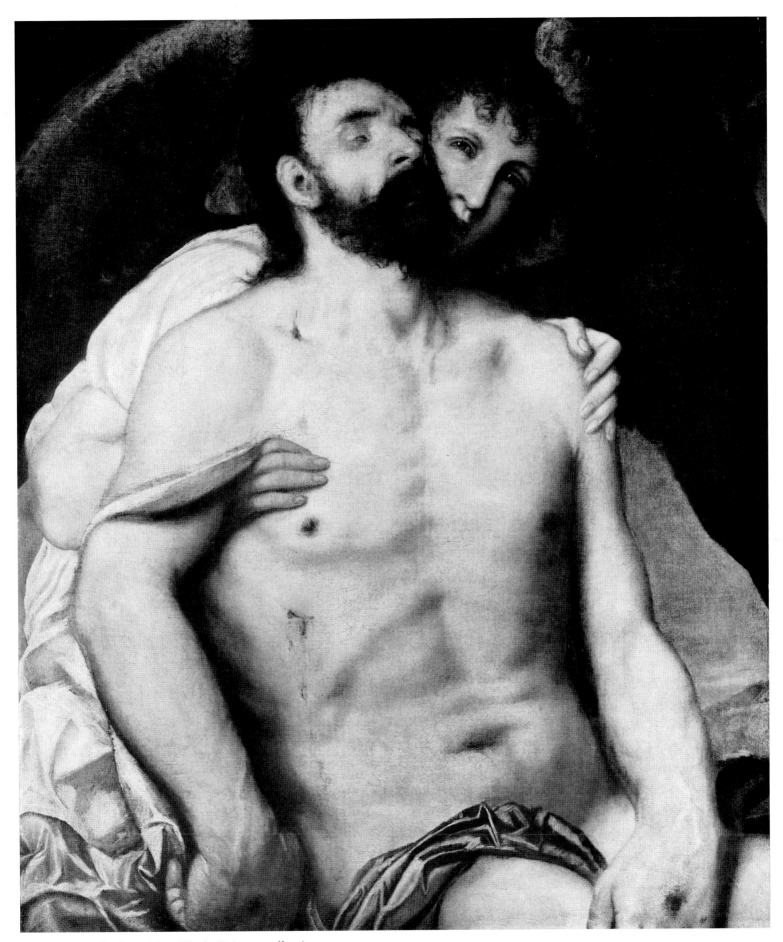

107. *The Dead Christ*. New York, Private collection

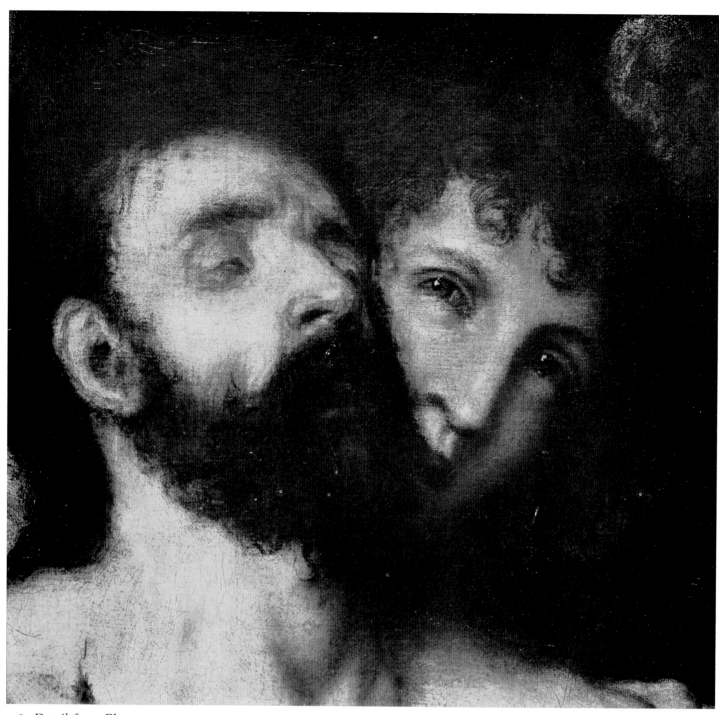

108. Detail from Plate 107

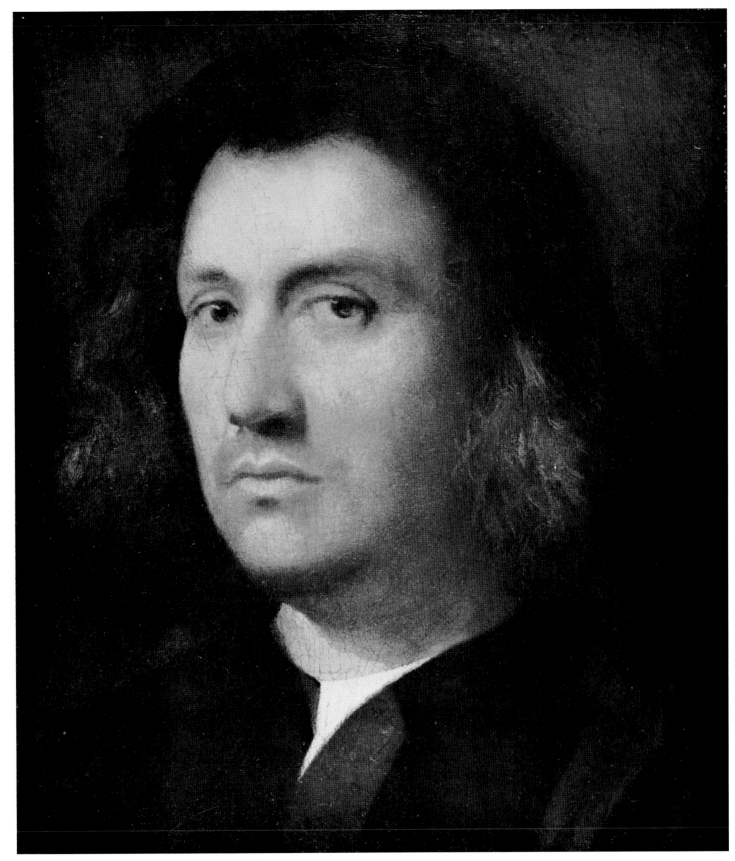

109. *Portrait of a Man.* 1510. San Diego, Fine Arts Gallery

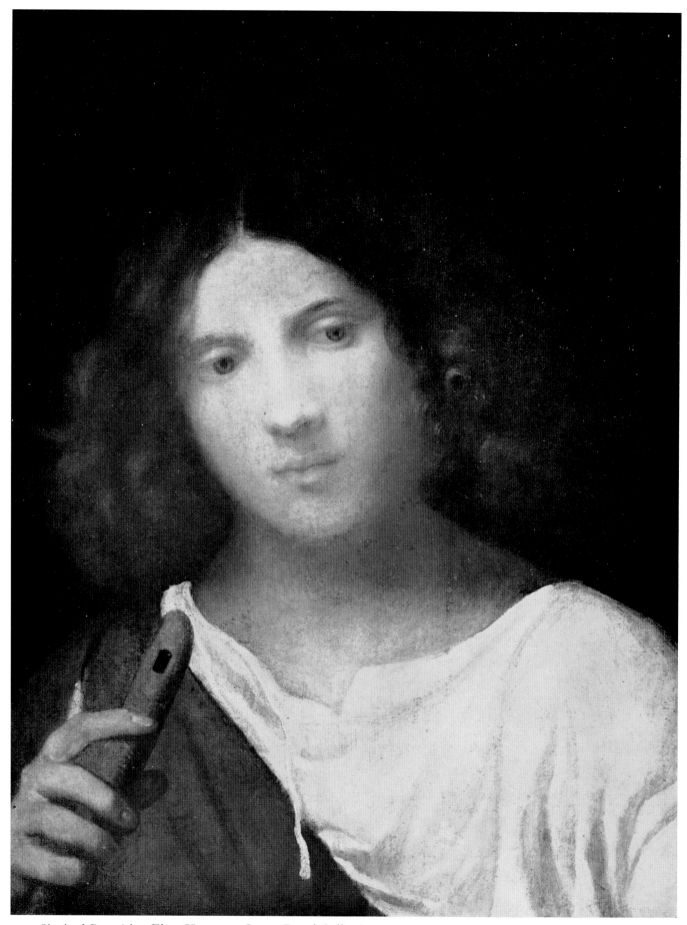

110. *Shepherd Boy with a Flute*. Hampton Court, Royal Collection

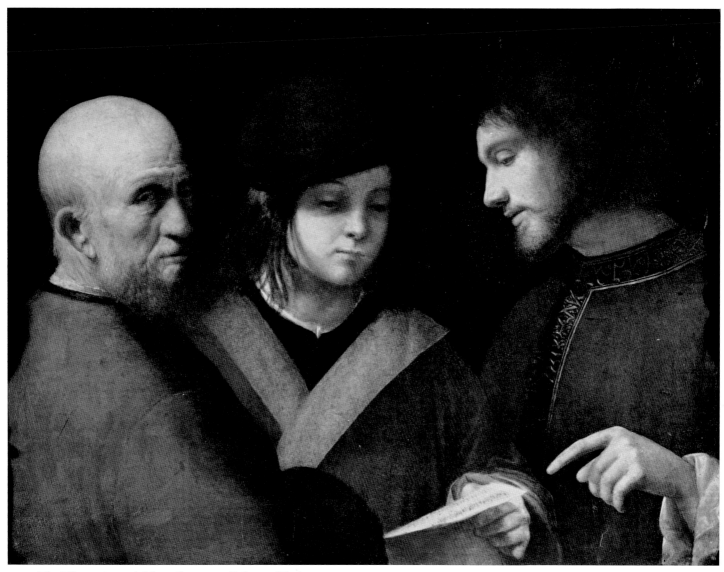

111. *The Three Ages of Man*. Florence, Palazzo Pitti

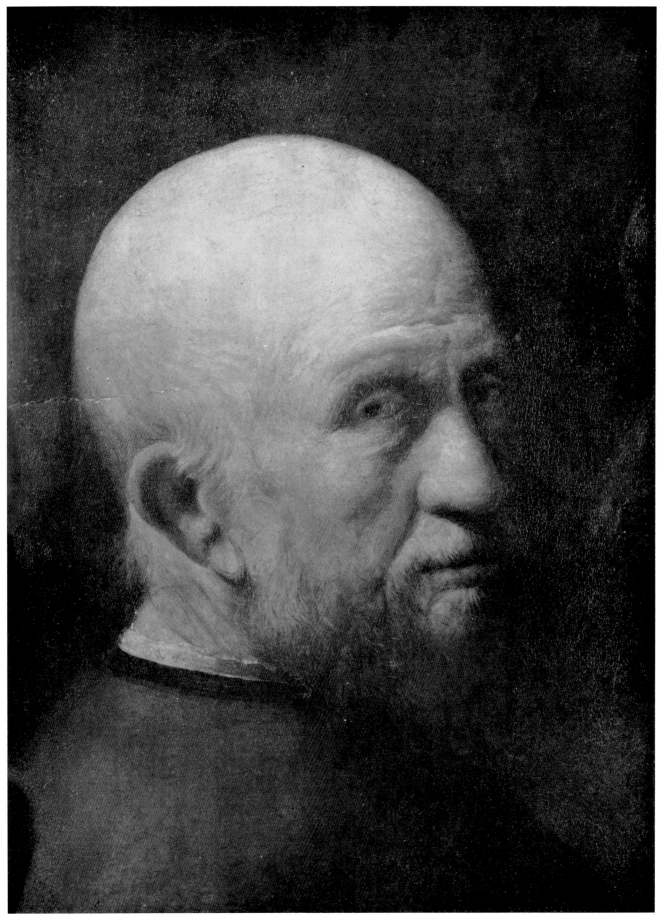

112. Detail from Plate 111

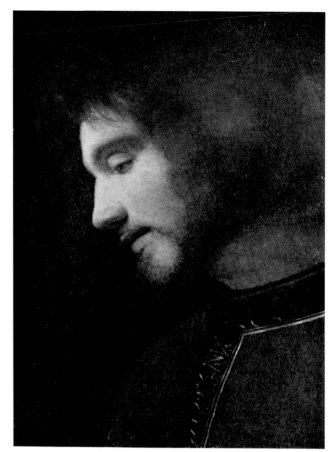

113. Detail from Plate 111

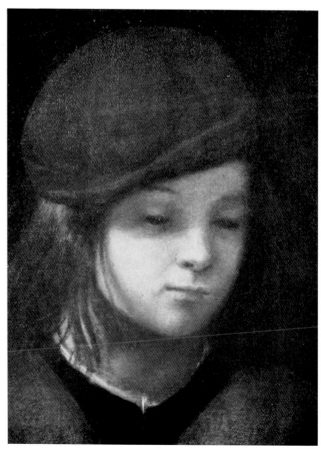

114. Detail from Plate 111

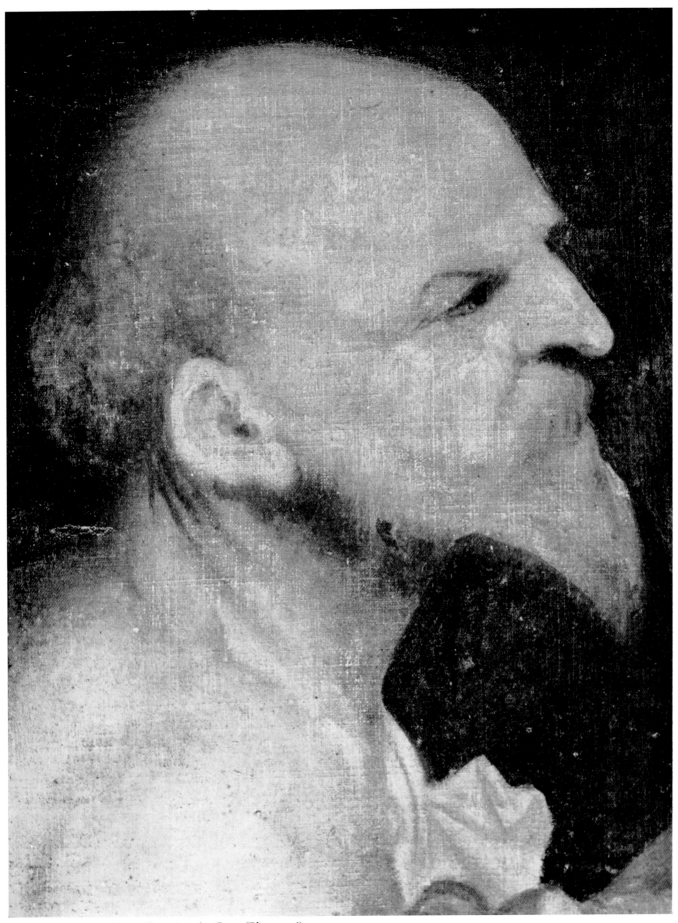

115. Detail from *Christ Carrying the Cross* (Plate 116)

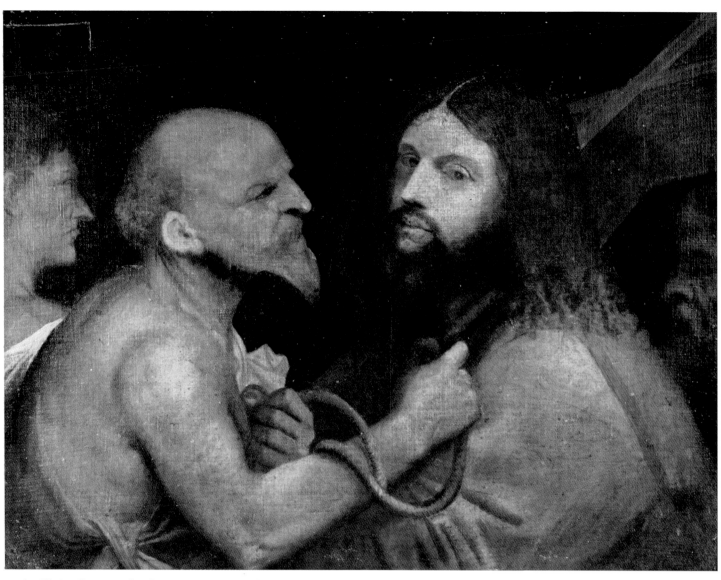

116. *Christ Carrying the Cross*. Venice, Scuola Grande di San Rocco

117. TITIAN: Detail from *The Miracle of the New-born Child*. 1511. Padua,
Scuola del Santo

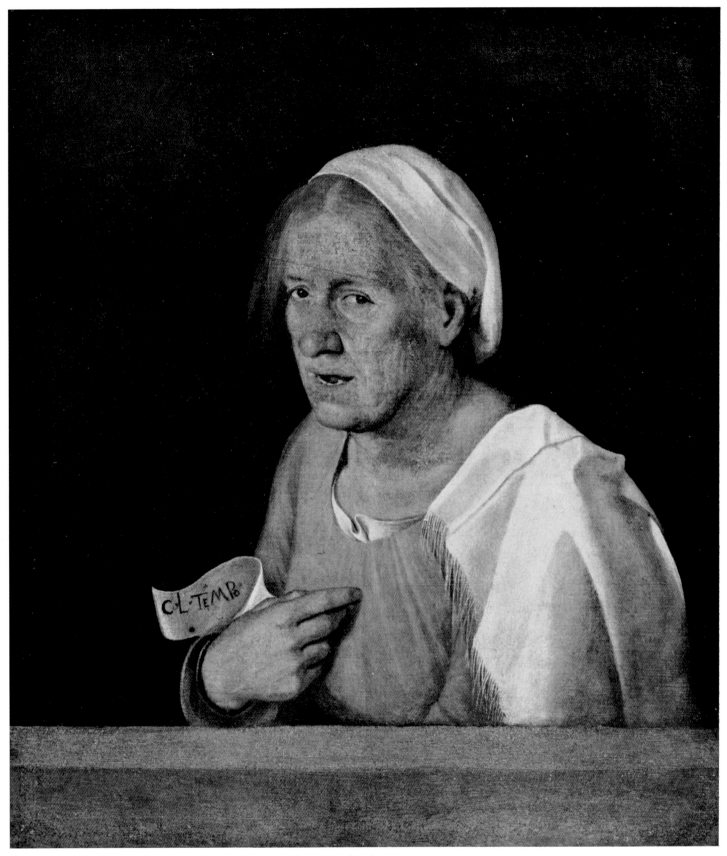

118. *Portrait of an Old Woman* ('*La Vecchia*'). Venice, Accademia

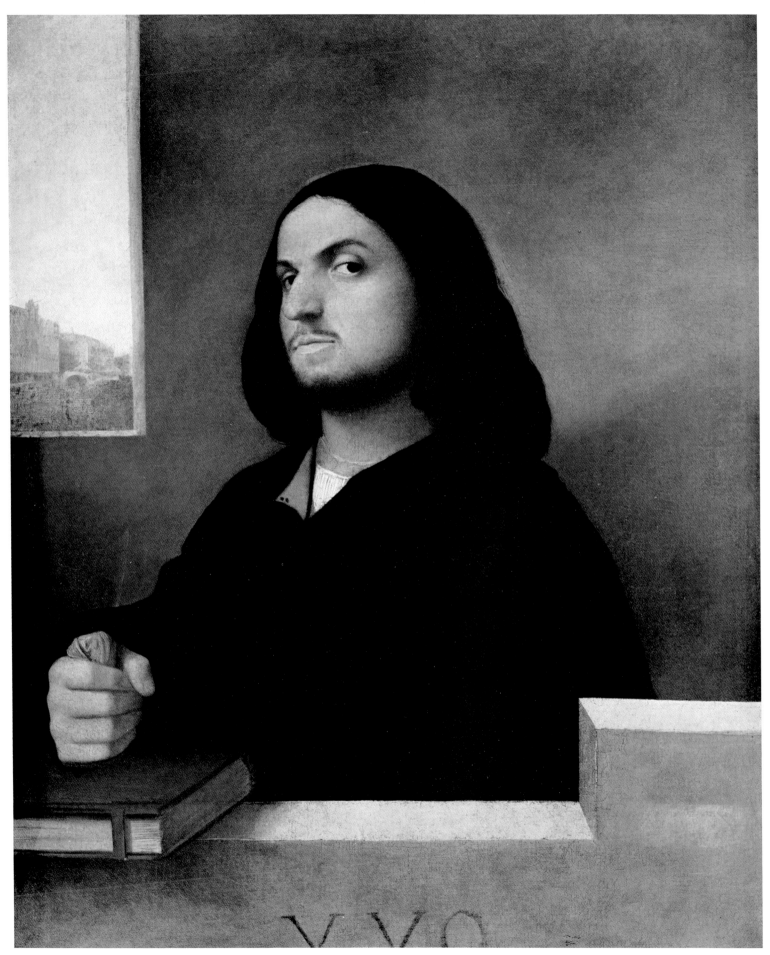

119. *Portrait of a Venetian Gentleman*. Washington, National Gallery of Art (Samuel H. Kress Collection)

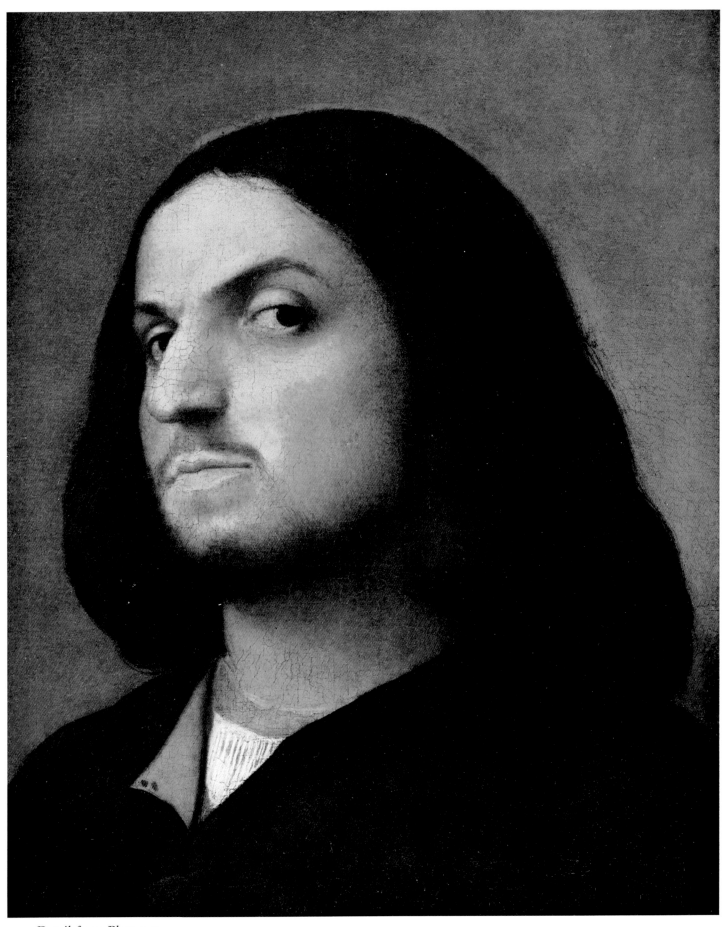

120. Detail from Plate 119

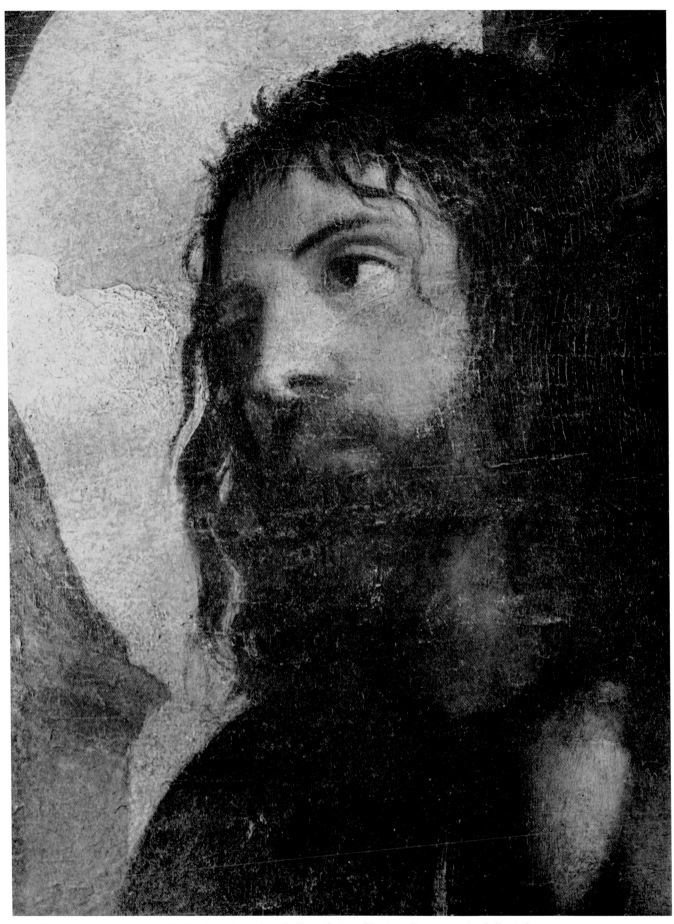

121. TITIAN: Detail from *St Mark enthroned with Four Saints*. Venice, Santa Maria della Salute

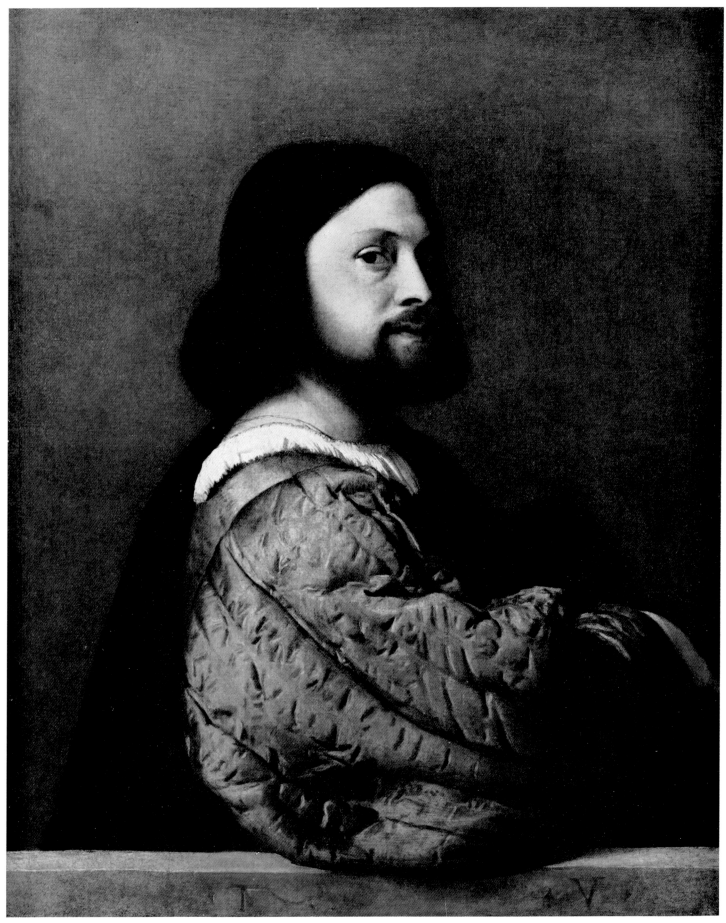

122. TITIAN: *Portrait of a Gentleman* ('*Ariosto*'). London, National Gallery

WORKS ATTRIBUTED TO GIORGIONE

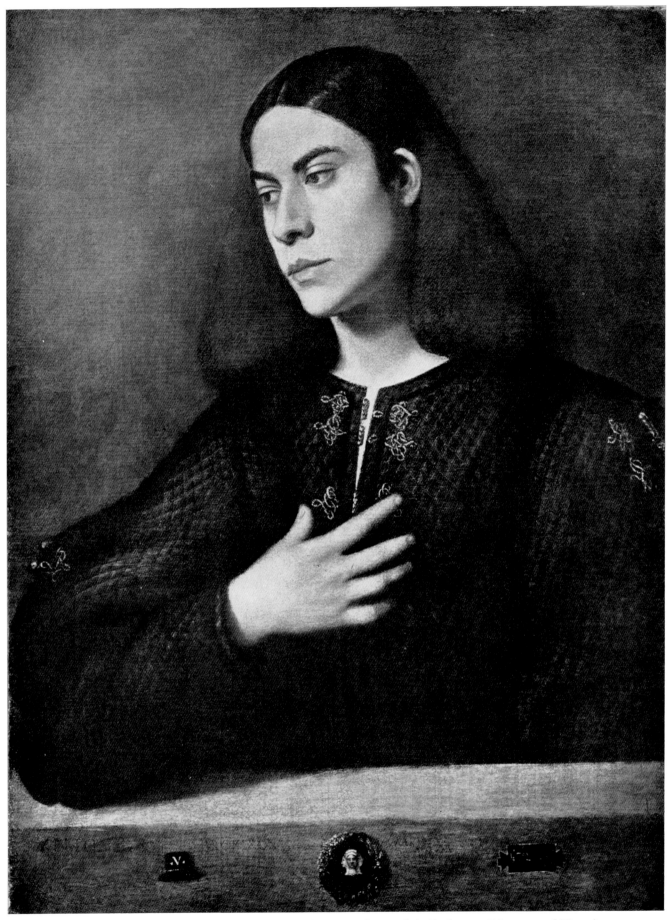

123. CIRCLE OF GIORGIONE: *Portrait of a Young Man* (Antonio Brocardo). Budapest, Museum of Fine Arts

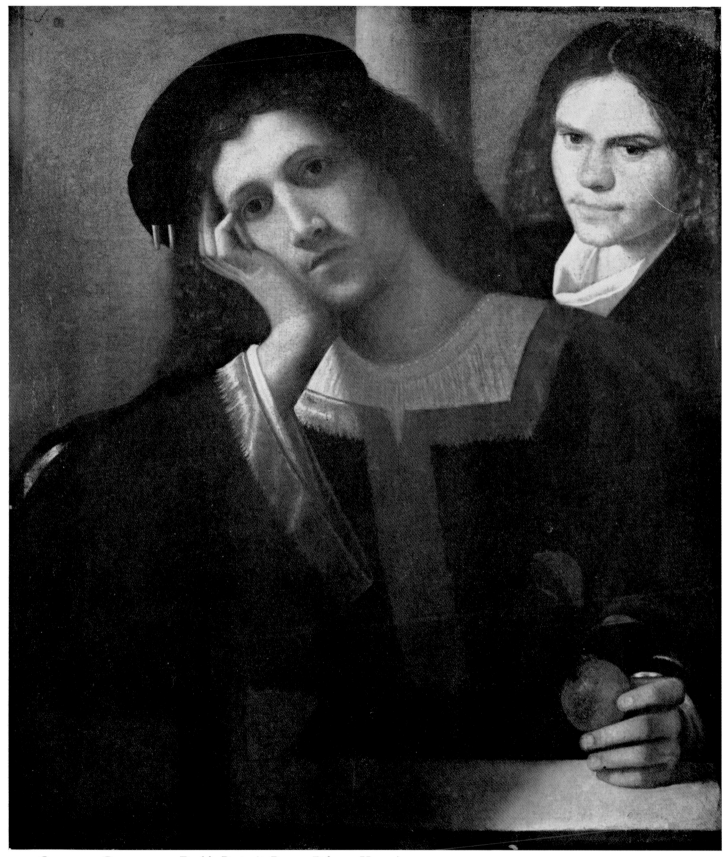

124. CIRCLE OF GIORGIONE: *Double Portrait*. Rome, Palazzo Venezia

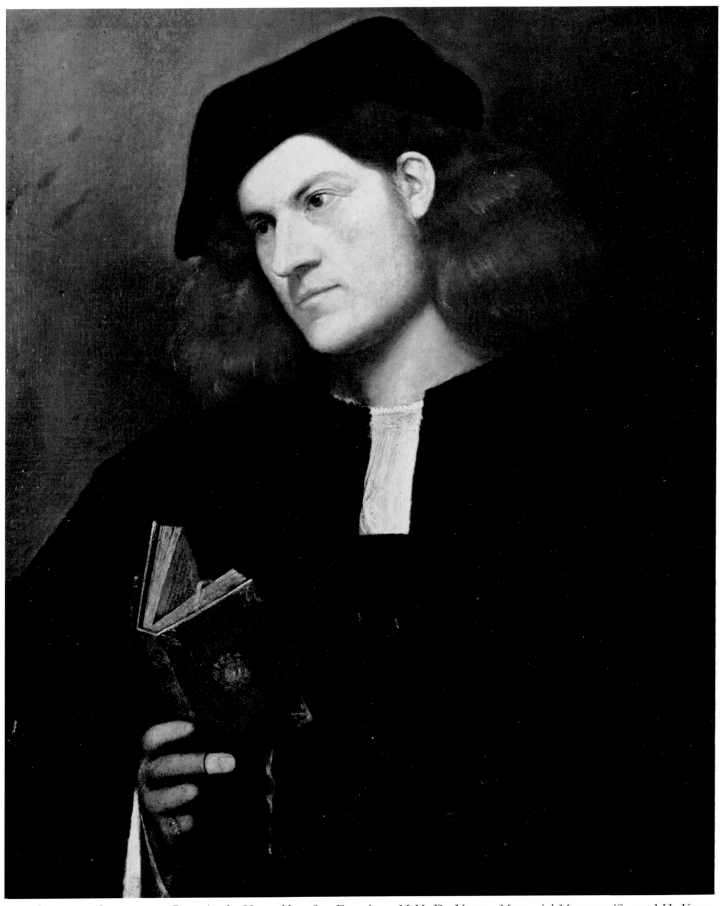

125. CIRCLE OF GIORGIONE: *Portrait of a Young Man*. San Francisco, M.H. De Young Memorial Museum (Samuel H. Kress Collection)

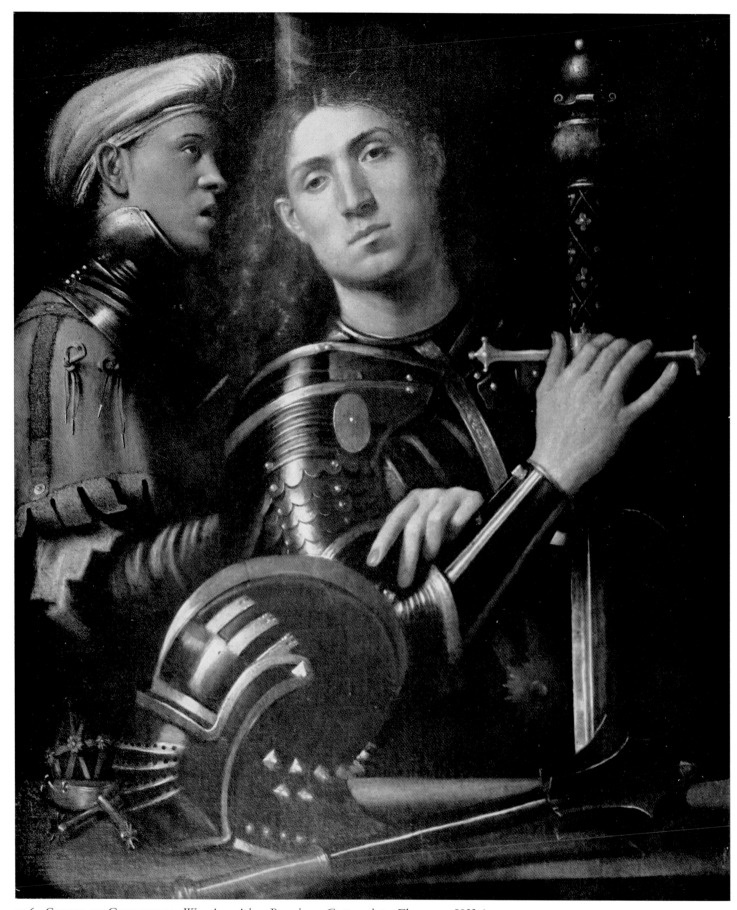

126. CIRCLE OF GIORGIONE: *Warrior with a Page-boy: Gattamelata*. Florence, Uffizi

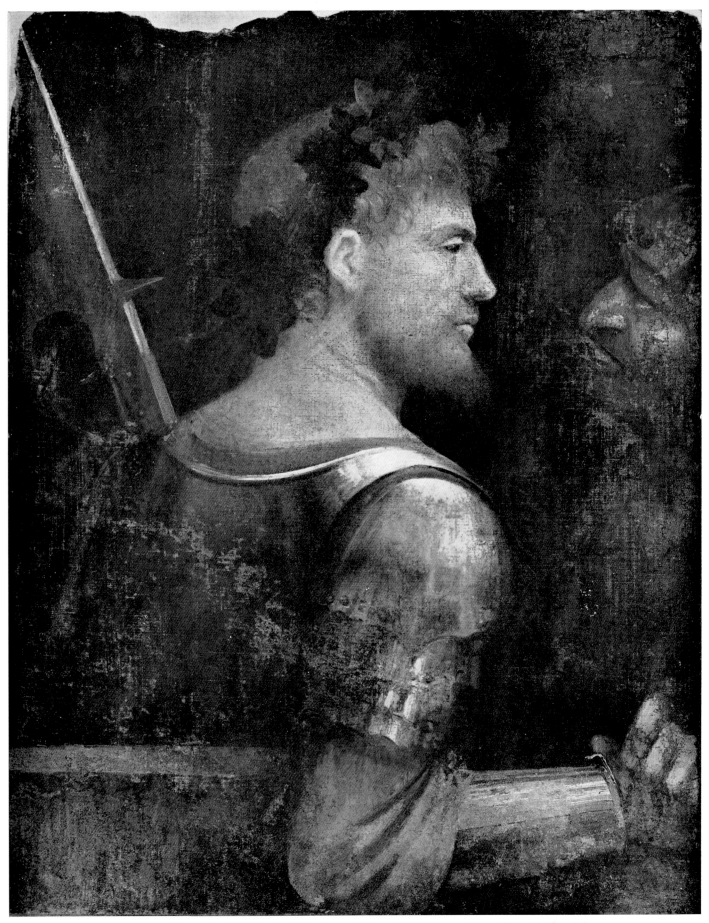

127. CIRCLE OF GIORGIONE: *Portrait of a Warrior* (Gerolamo Marcello). Vienna, Kunsthistorisches Museum

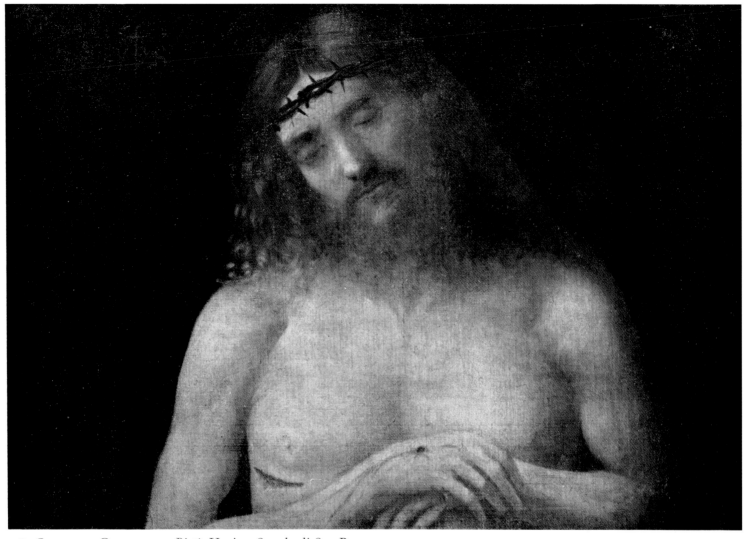

128. CIRCLE OF GIORGIONE: *Pietà*. Venice, Scuola di San Rocco

129. CIRCLE OF GIORGIONE: *Portrait of a Young Man with a Book*.
Brunswick, Herzog Anton Ulrich-Museum

130. FOLLOWER OF GIORGIONE: *Bust of a Lady*.
Hampton Court, Royal Collection

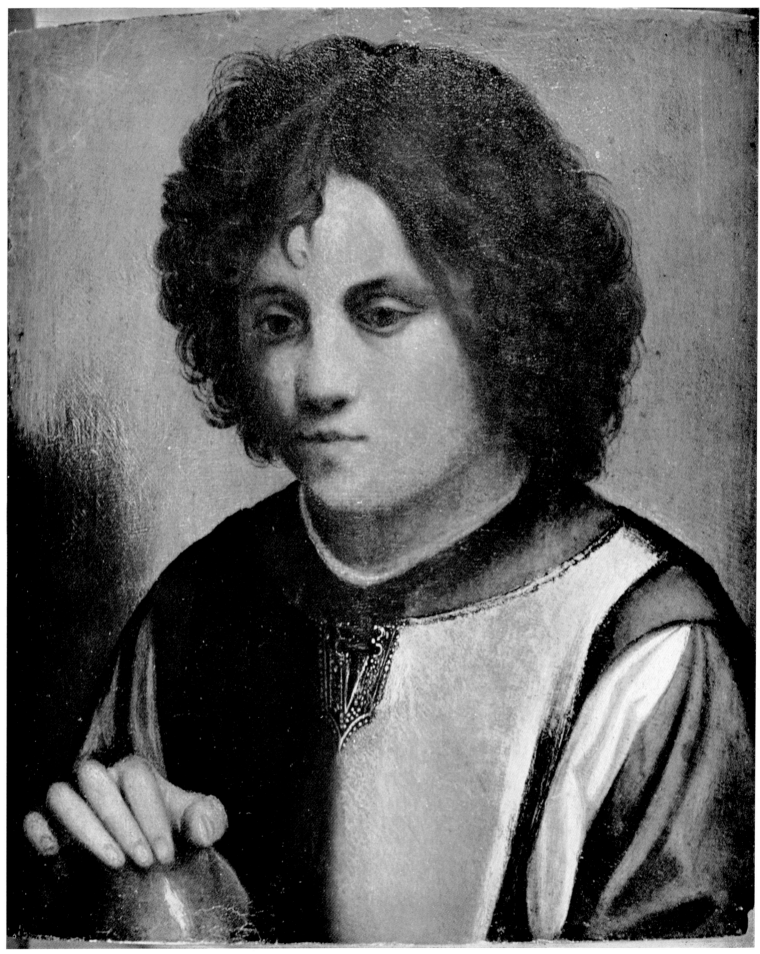

131. Domenico Mancini (?): *Young Shepherd with a Fruit*. Oxford, Strode-Jackson Collection

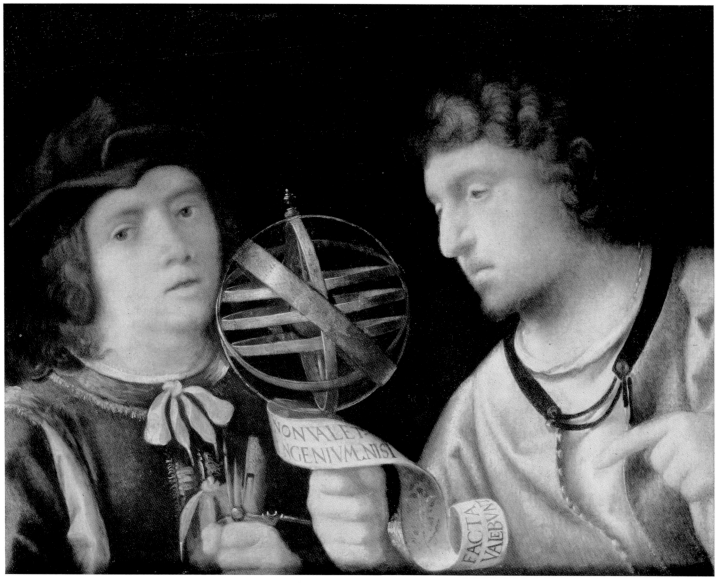

132. DOMENICO MANCINI (?): *Double Portrait*. Washington, Private collection

133-134. X-rays of *Double Portrait* (Plate 132)

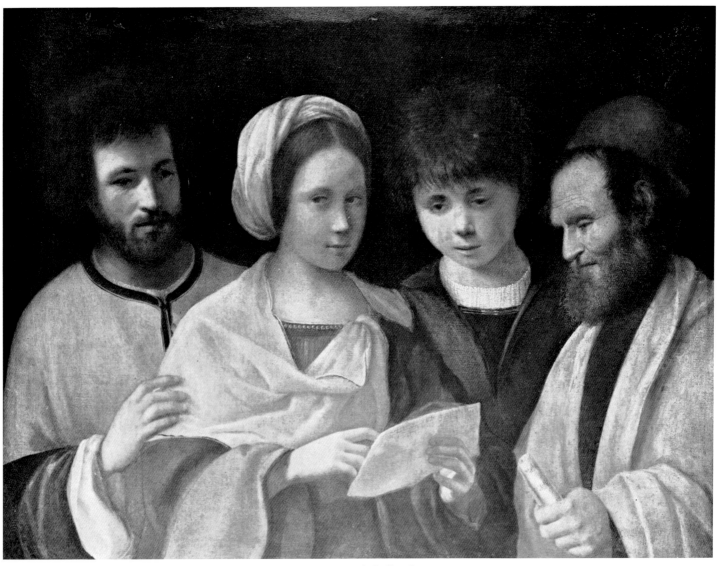

135. FOLLOWER OF GIORGIONE: *Concert*. Hampton Court, Royal Collection

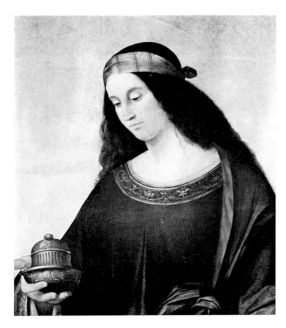

136. FOLLOWER OF GIORGIONE: *The Magdalene*. Milan, Private collection

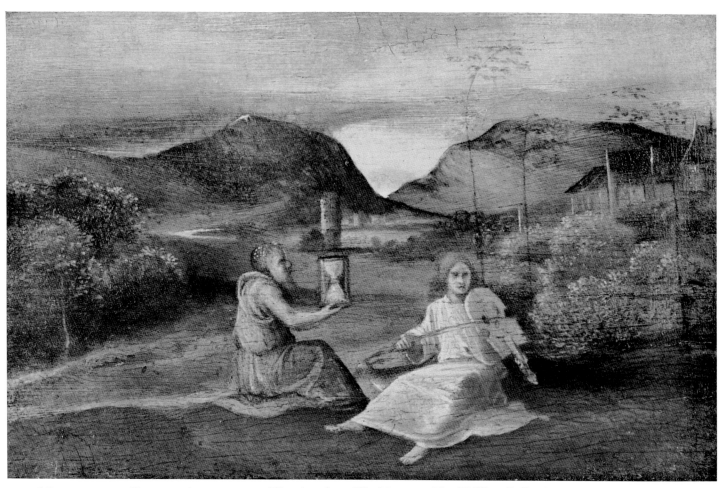

137. Master of the Phillips Astrologer: *The Astrologer*. Washington, The Phillips Collection

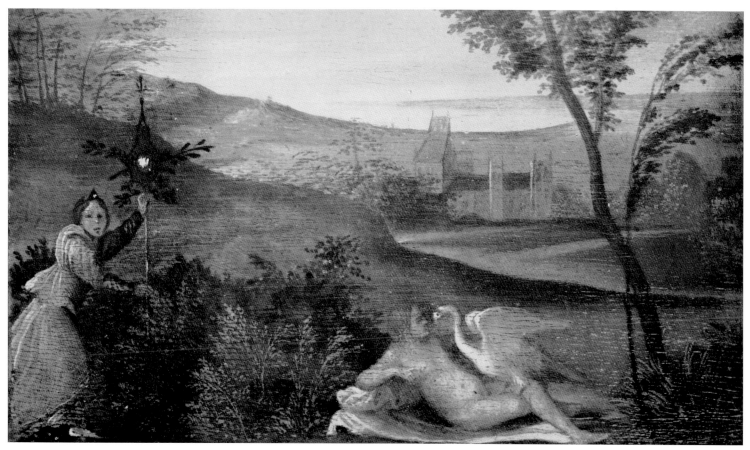

138. Master of the Phillips Astrologer: *Leda and the Swan*. Padua, Museo Civico

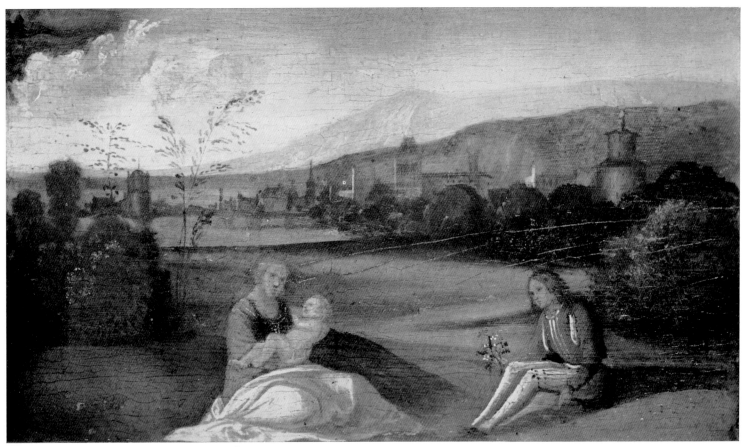

139. MASTER OF THE PHILLIPS ASTROLOGER: *Rustic Idyll*. Padua, Museo Civico

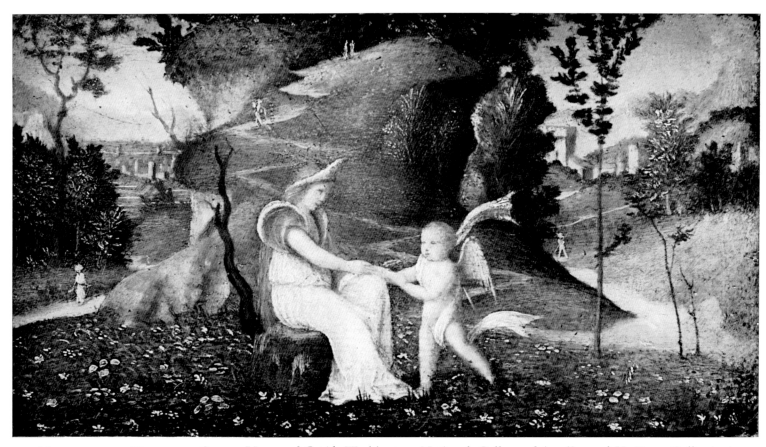

140. MASTER OF THE VENUS AND CUPID: *Venus and Cupid*. Washington, National Gallery of Art (Samuel H. Kress Collection)

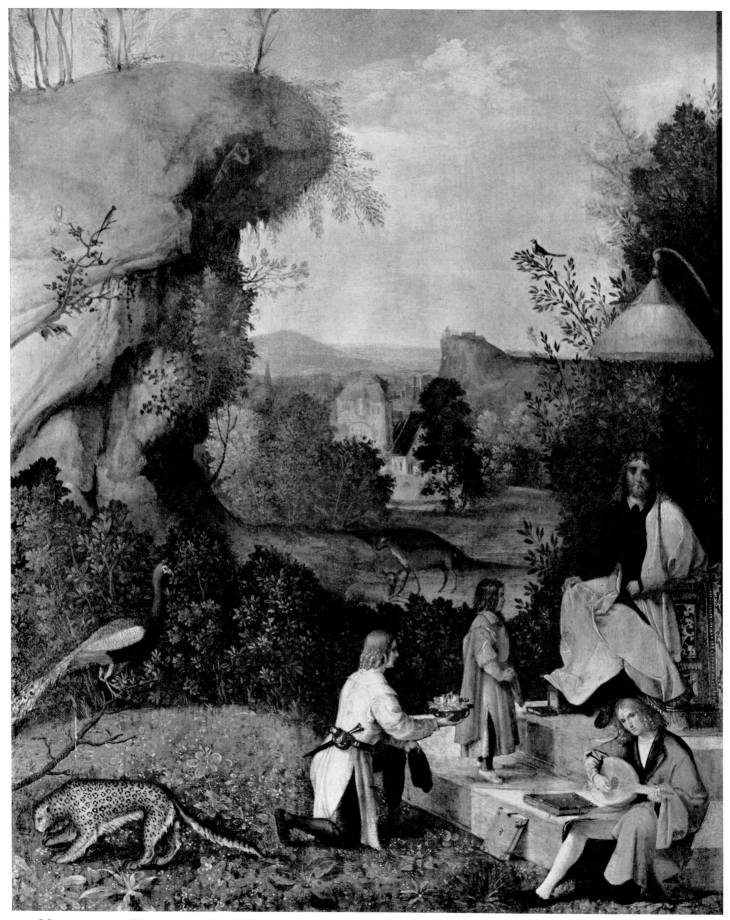

141. MASTER OF THE VENUS AND CUPID: *Homage to a Poet*. London, National Gallery

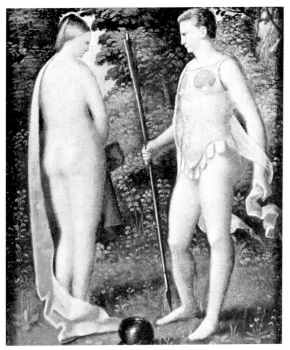

142. MASTER OF THE VENUS AND CUPID: *Venus and Mars*. New York, Brooklyn Museum

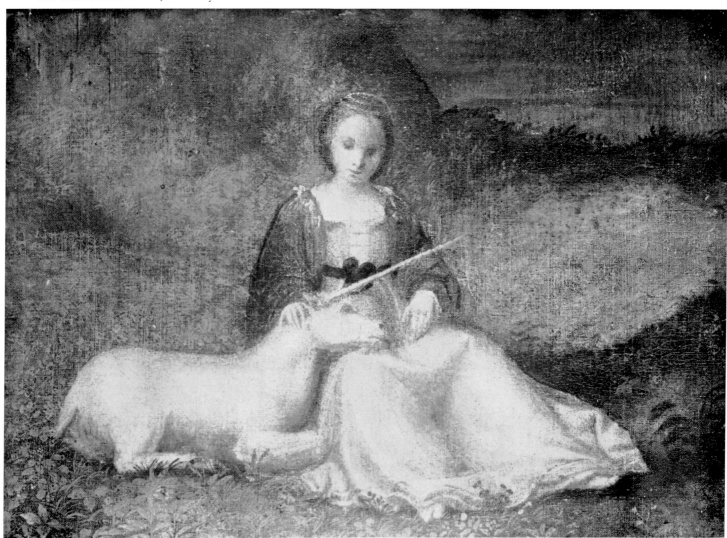

143. CIRCLE OF GIORGIONE: *Allegory of Chastity*. Amsterdam, Rijksmuseum

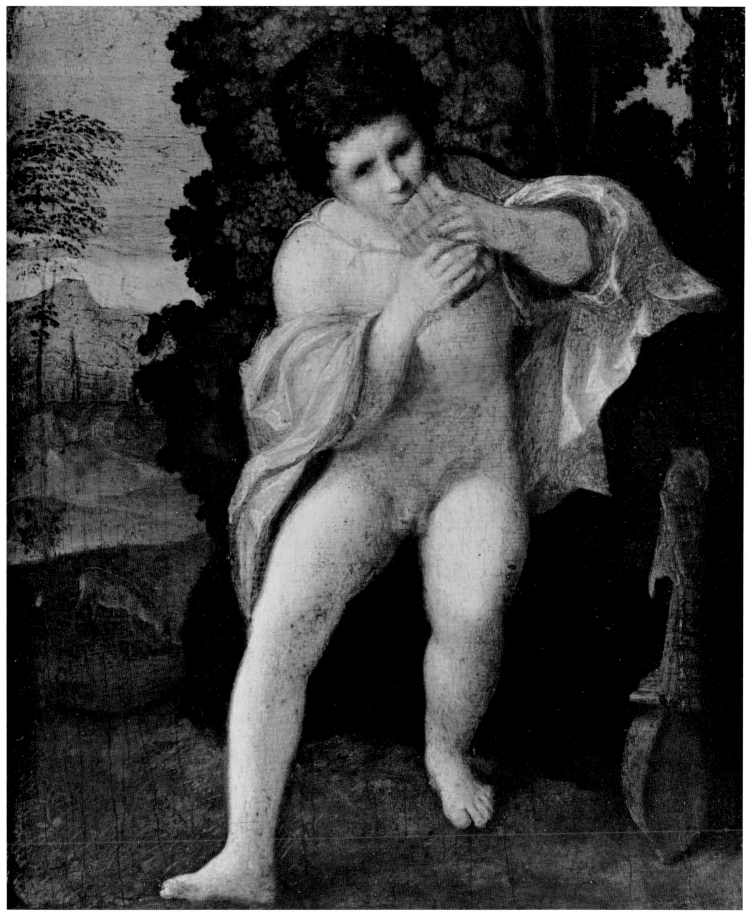

144. CIRCLE OF GIORGIONE: *Little Faun*. Munich, Alte Pinakothek

145. FOLLOWER OF GIORGIONE: *Adoration of the Infant Christ*. Brush drawing. Vienna, Albertina

146. FOLLOWER OF GIORGIONE: *The Adoration of the Shepherds*. Drawing. Windsor, Royal Library

147. STYLE OF GIULIO CAMPAGNOLA: *Landscape with Nude Man*. Pen drawing. New York, S. Schwarz Collection

148. STYLE OF GIULIO CAMPAGNOLA: *Landscape with a Castle*. Drawing. Rotterdam, Museum Boymans-van Beuningen

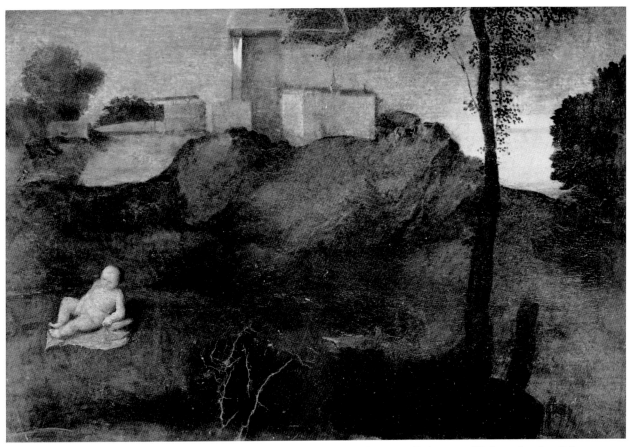

149. FOLLOWER OF GIORGIONE: *Paris exposed on Mount Ida*. Princeton, Princeton University Art Museum

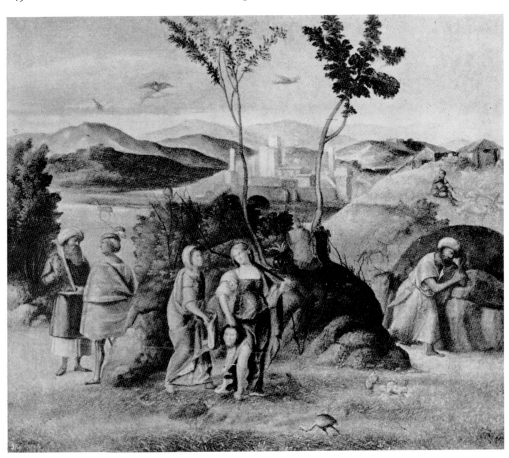

150. FOLLOWER OF GIORGIONE: *Judith*. Milan, Rasini Collection

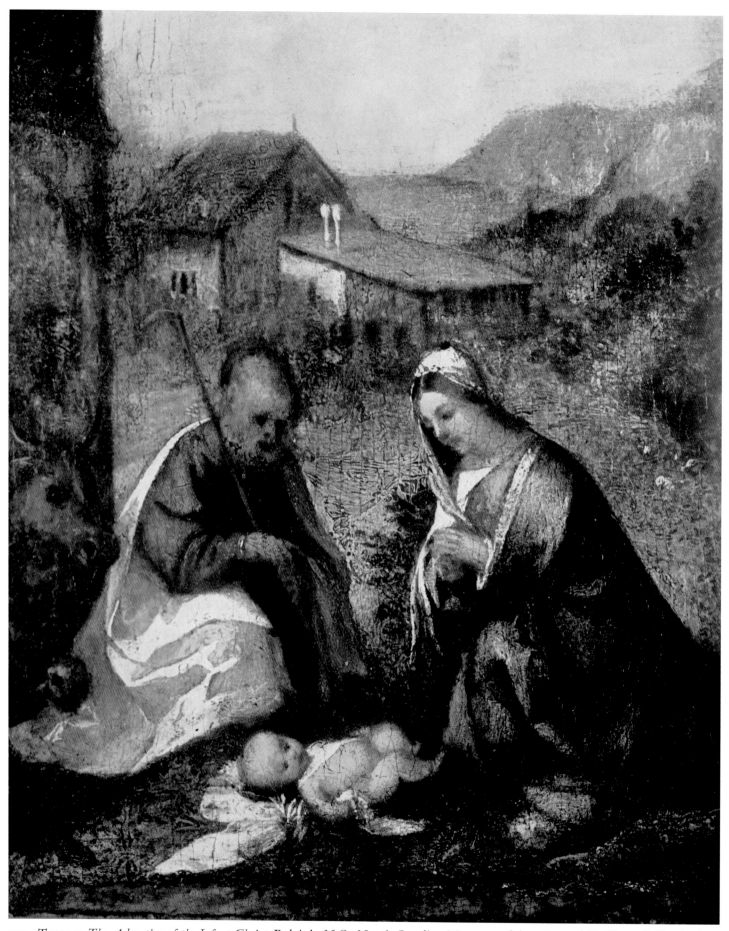

151. TITIAN: *The Adoration of the Infant Christ*. Raleigh, N.C., North Carolina Museum of Art (Samuel H. Kress Collection)

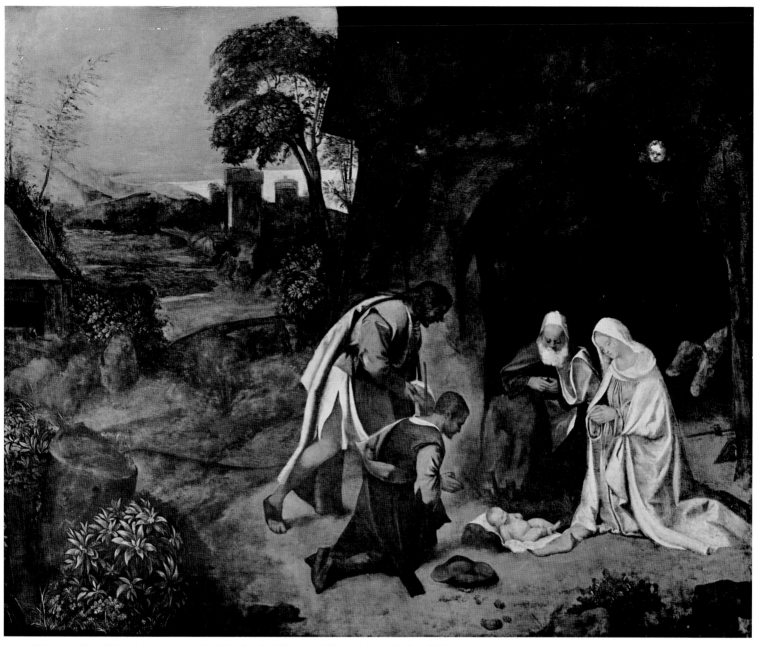

152. TITIAN (?): *The Adoration of the Shepherds*. Vienna, Kunsthistorisches Museum

153. TITIAN (?): *Saint Elizabeth with the Infant Saint John*. Drawing. Budapest, Museum of Fine Arts

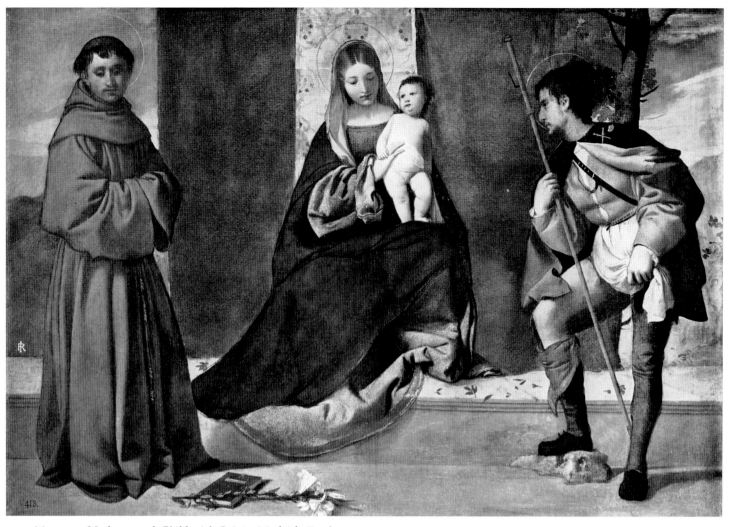

154. TITIAN: *Madonna and Child with Saints*. Madrid, Prado

155. TITIAN: Detail from *The Miracle of the New-born Child*. 1511. Padua, Scuola del Santo

156. TITIAN: Detail from Plate 157

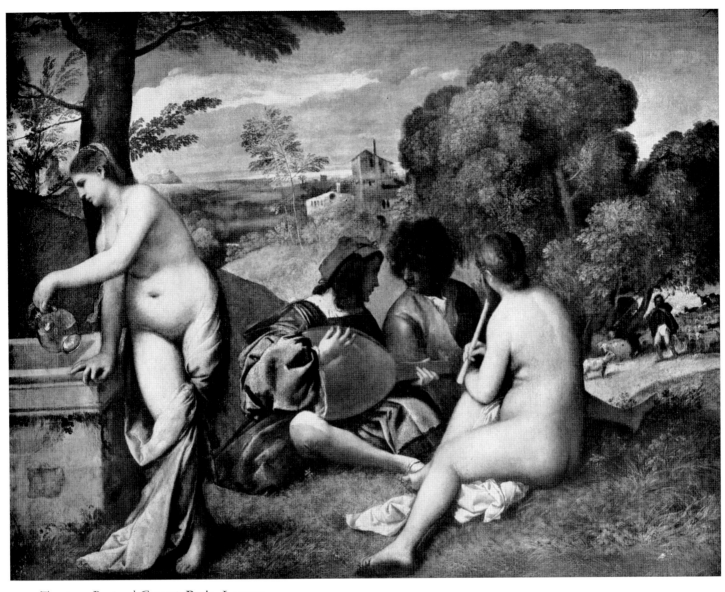

157. TITIAN: *Pastoral Concert*. Paris, Louvre.

158. TITIAN: Detail from *Justice* (Plate 245).
Venice, Accademia

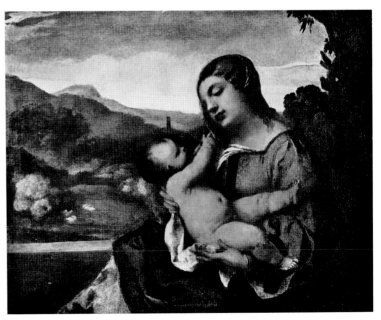

159. TITIAN: *Madonna in a Landscape*. Bergamo,
Accademia Carrara

160. Detail from Plate 157

161. Detail from Plate 157

162. TITIAN: Detail from *Christ and the Adulteress* (Plate 168)

163. Detail from Plate 157

164. Detail from Plate 157

165. GIORGIONE: Detail from Plate 50,
The Tempest

166. TITIAN (?): *Seated Nude*.
Lausanne, Stroelin Collection

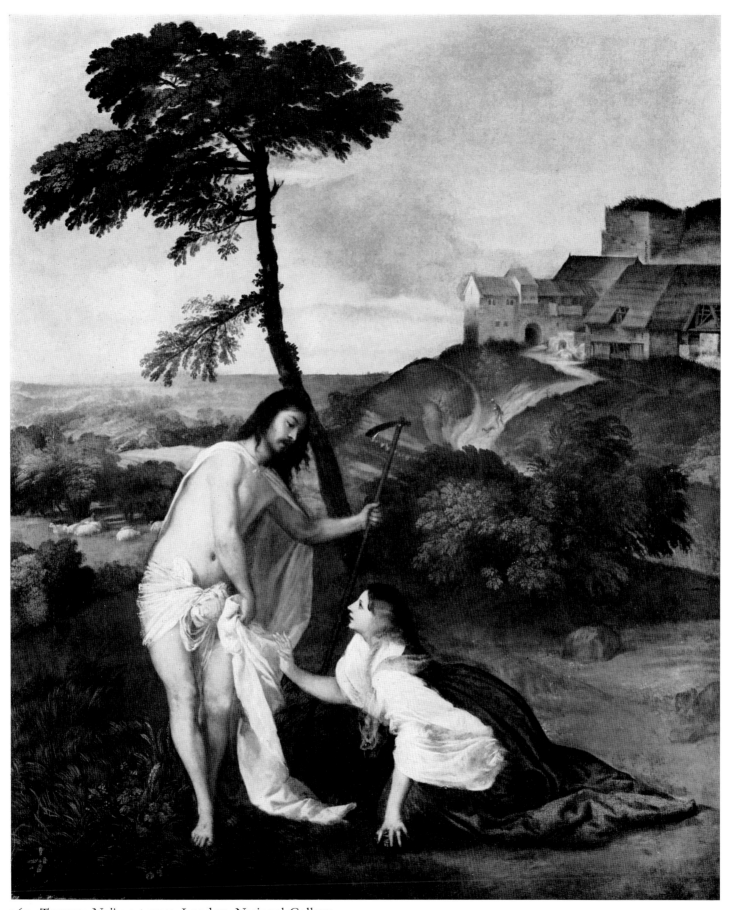

167. TITIAN: *Noli me tangere*. London, National Gallery

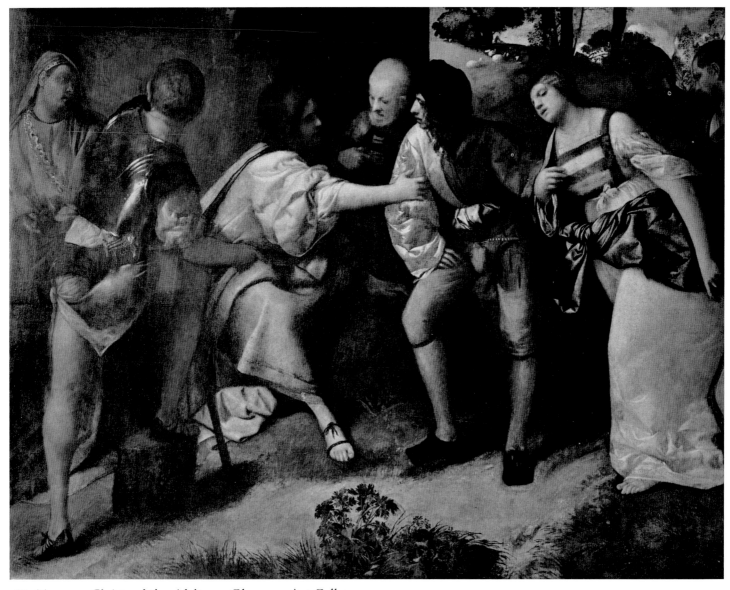

168. TITIAN: *Christ and the Adulteress*. Glasgow, Art Gallery

169. TITIAN: Detail from *The Miracle
of the New-born Child*. 1511.

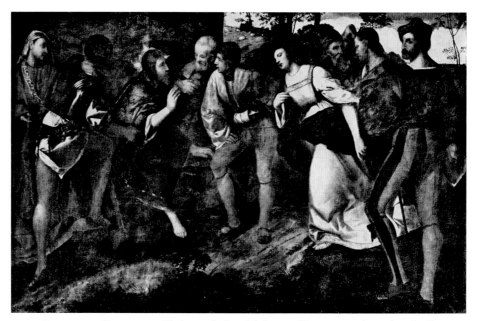

170. GIOVANNI CARIANI: *Christ and the Adulteress*. Bergamo, Accademia Carrara

171. TITIAN: *Soldier*. Fragment from *Christ and the Adulteress* in Glasgow (Plate 168). Private collection, formerly on loan to the National Gallery, London

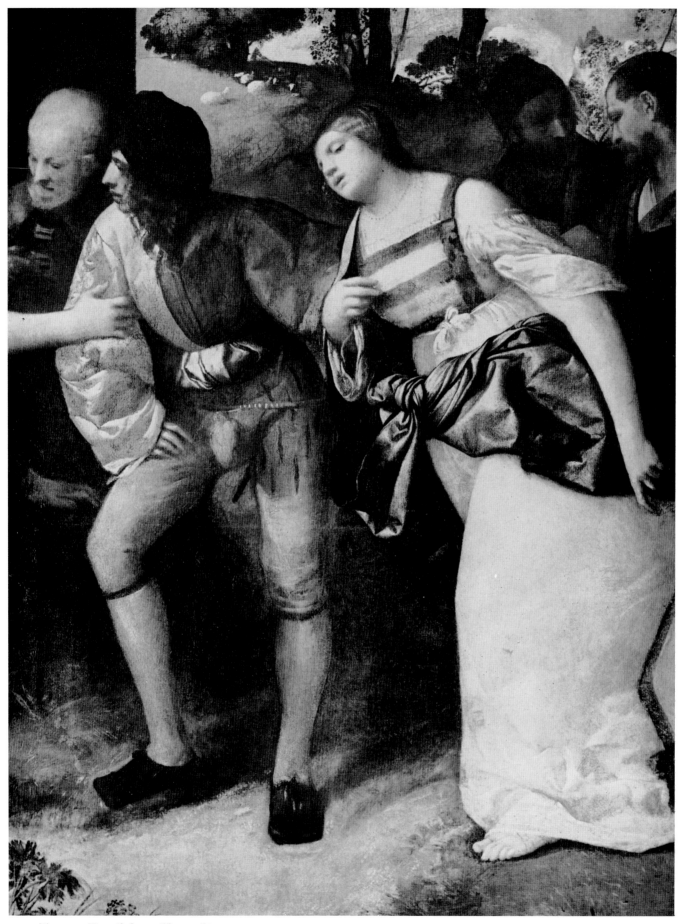

172. TITIAN: Detail from Plate 168

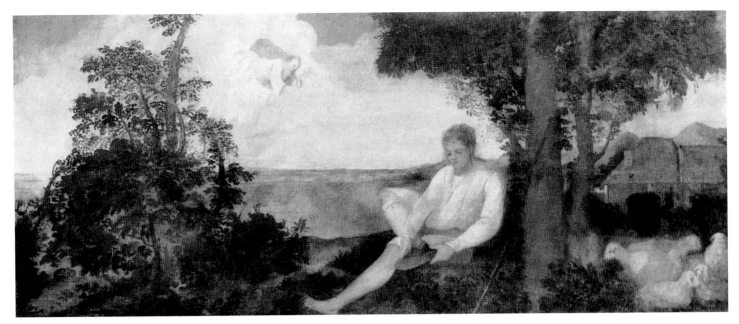

173. TITIAN: *Moses before the Burning Bush*. London, Courtauld Institute Galleries

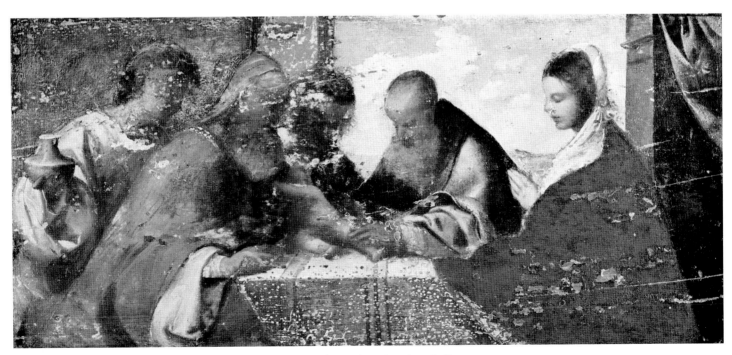

174. TITIAN: *The Circumcision*. New Haven, Conn., Yale University Art Gallery

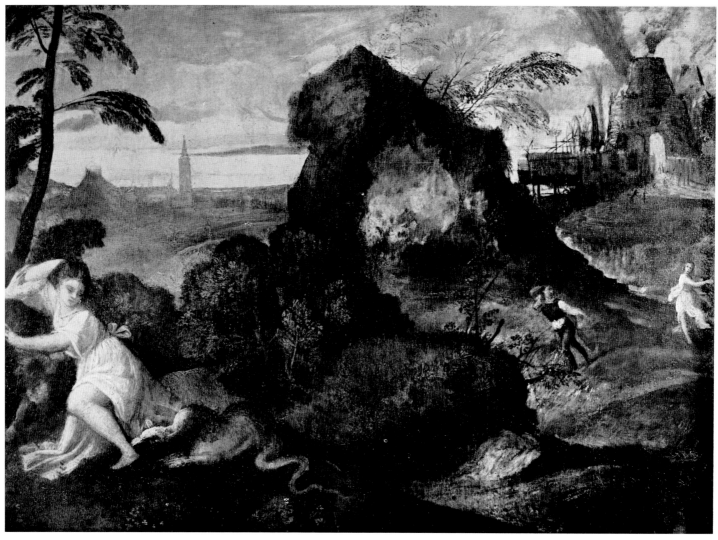

175. TITIAN: *Orpheus and Eurydice*. Bergamo, Accademia Carrara

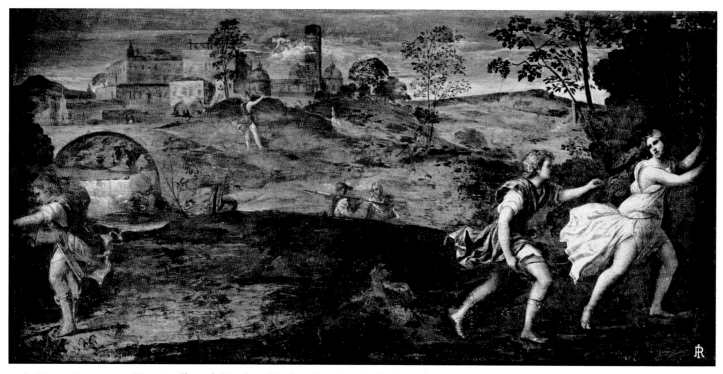

176. PARIS BORDONE (?): *Apollo and Daphne*. Venice, Seminario Patriarcale

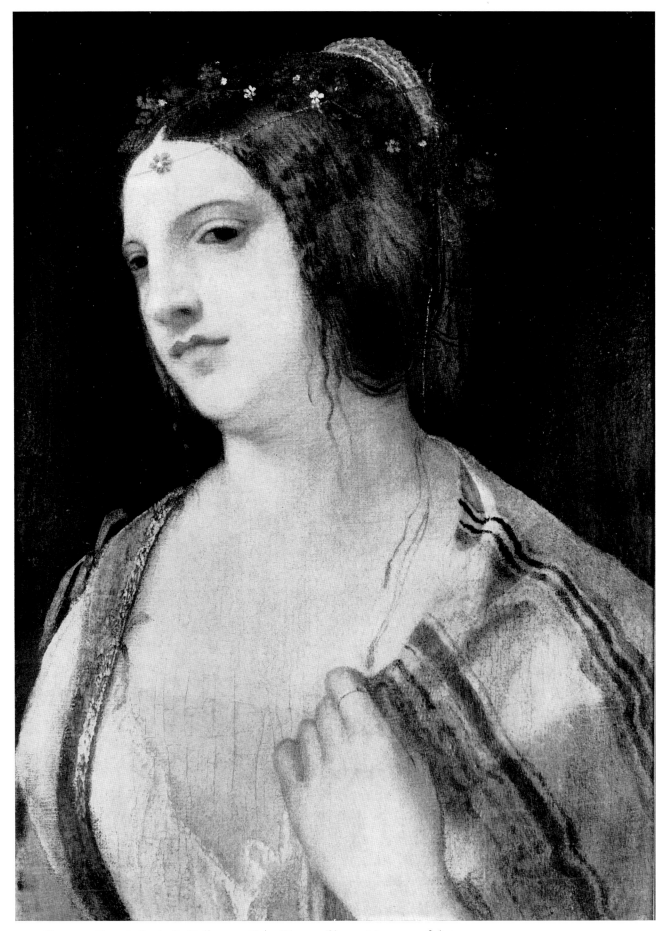

177. TITIAN: *Female Portrait*. Fullerton, Cal., Norton Simon Museum of Art

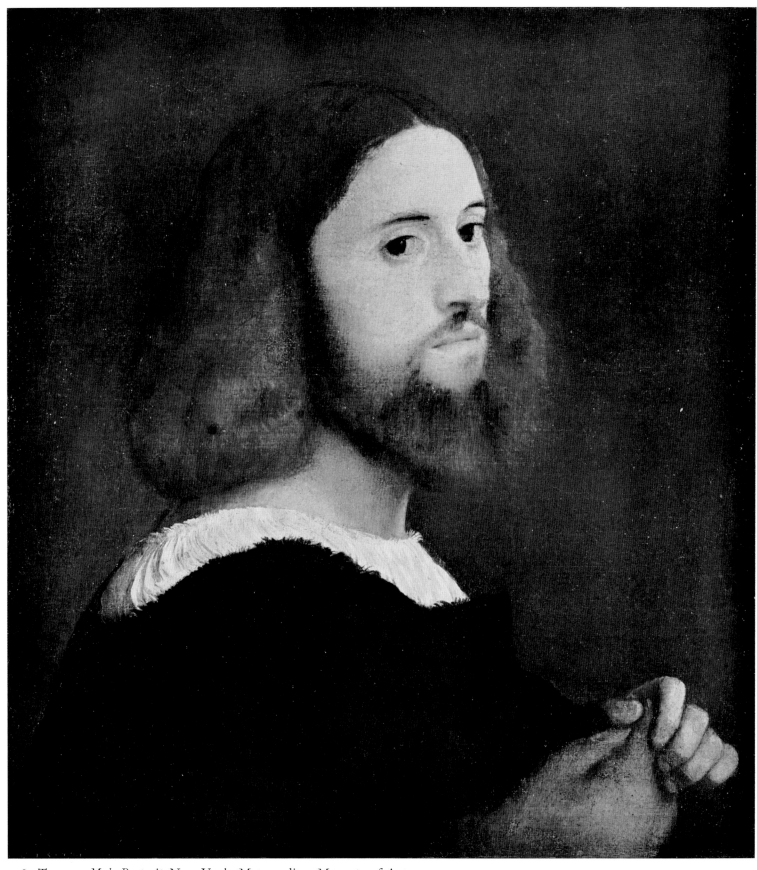

178. TITIAN: *Male Portrait*. New York, Metropolitan Museum of Art

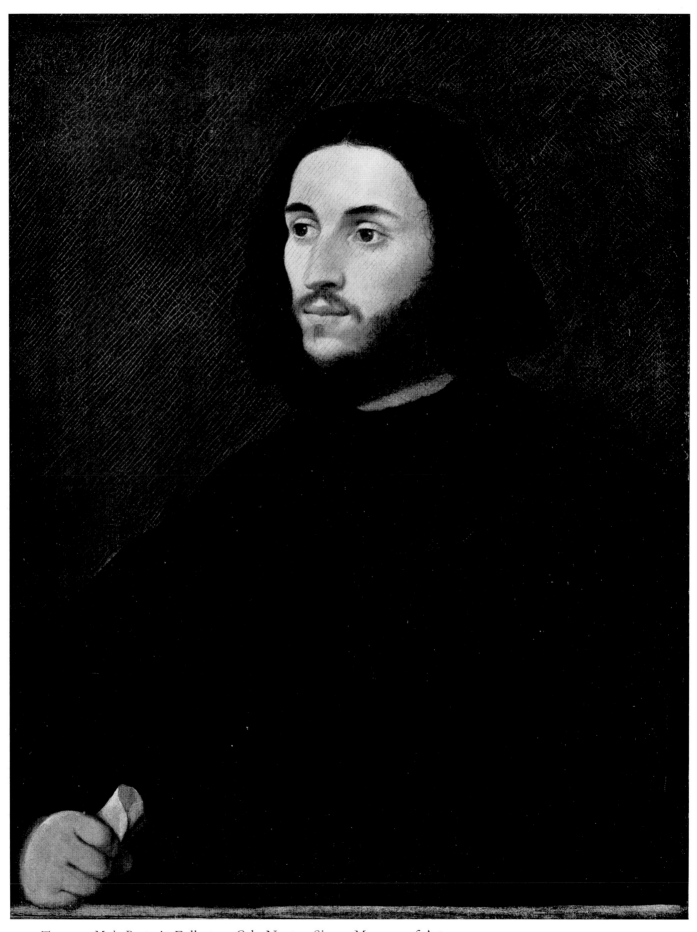

179. TITIAN: *Male Portrait*. Fullerton, Cal., Norton Simon Museum of Art

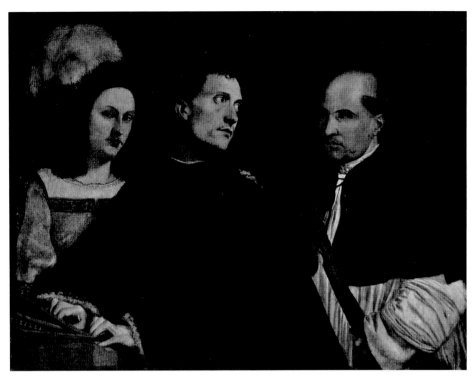

180. Titian: *The Concert*. Florence, Palazzo Pitti

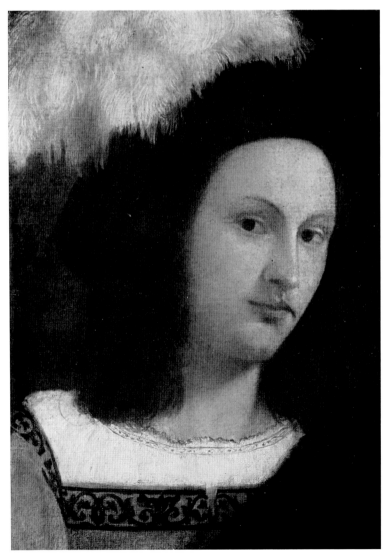

181. Detail from Plate 180

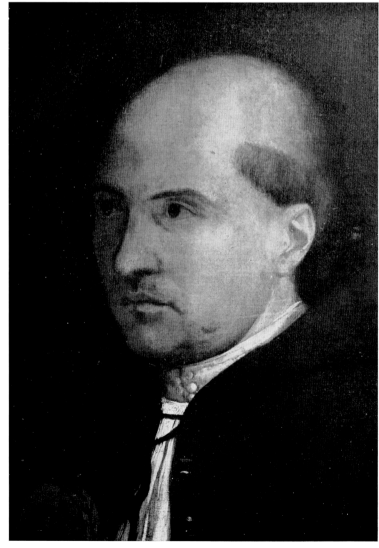

182. Detail from Plate 180

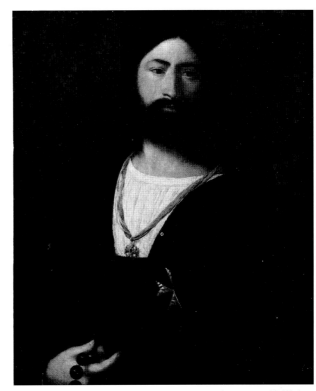

183. TITIAN: *The Knight of Malta*. Florence, Uffizi

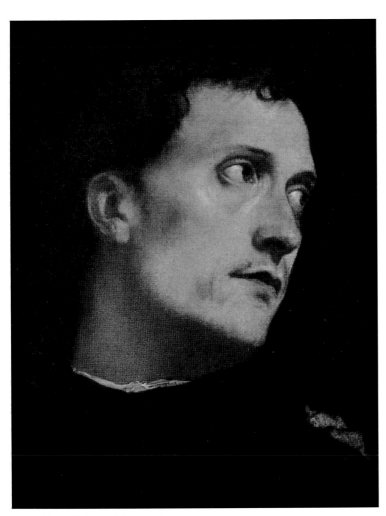

184. Detail from Plate 180

185. TITIAN: Detail from *The Miracle of the New-born Child*. 1511. Padua, Scuola del Santo.

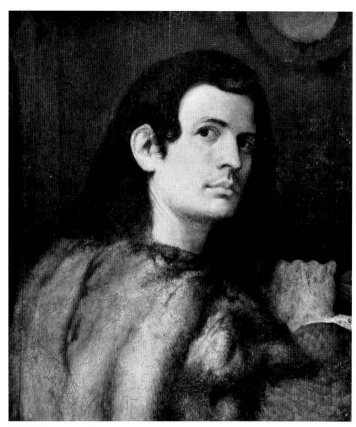

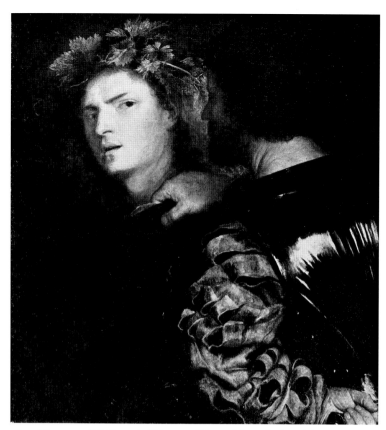

186. TITIAN: *Portrait of a Young Man in a Fur*. Munich, Alte Pinakothek

187. TITIAN: '*Il Bravo*'. Vienna, Kunsthistorisches Museum

188. TITIAN: *Cupid*. Drawing. New York, Metropolitan Museum of Art

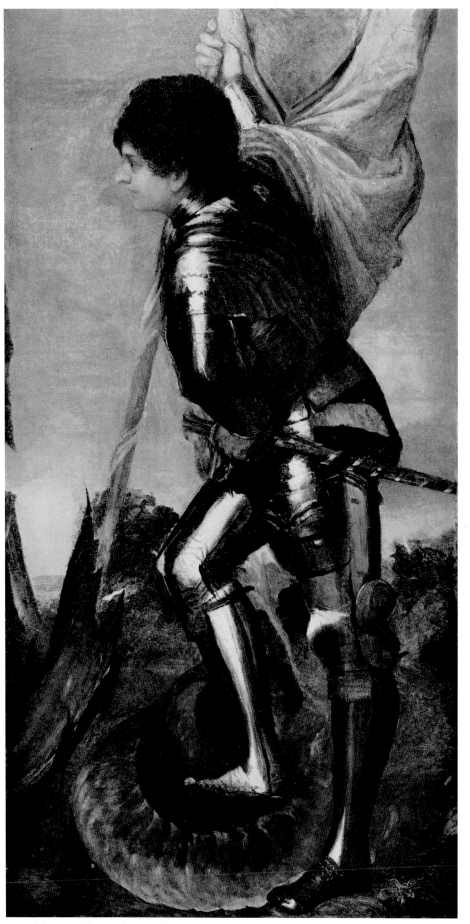

189. Titian: *Saint George*. Venice, Cini Collection

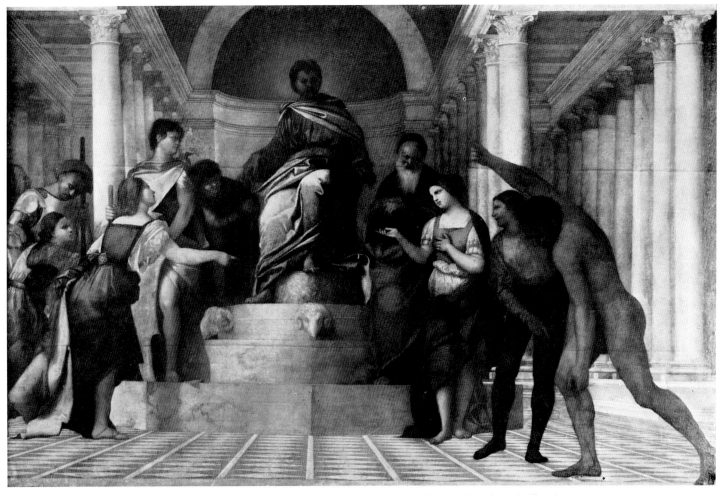

190. SEBASTIANO DEL PIOMBO: *The Judgement of Solomon*. Kingston Lacy, Dorset, Bankes Collection

191. FRANCESCO VECELLIO (?): *Allegory of Autumn*.
Kingston Lacy, Dorset, Bankes Collection

192. SEBASTIANO DEL PIOMBO: *Callisto and the Nymphs*.
Drawing. Paris, Louvre

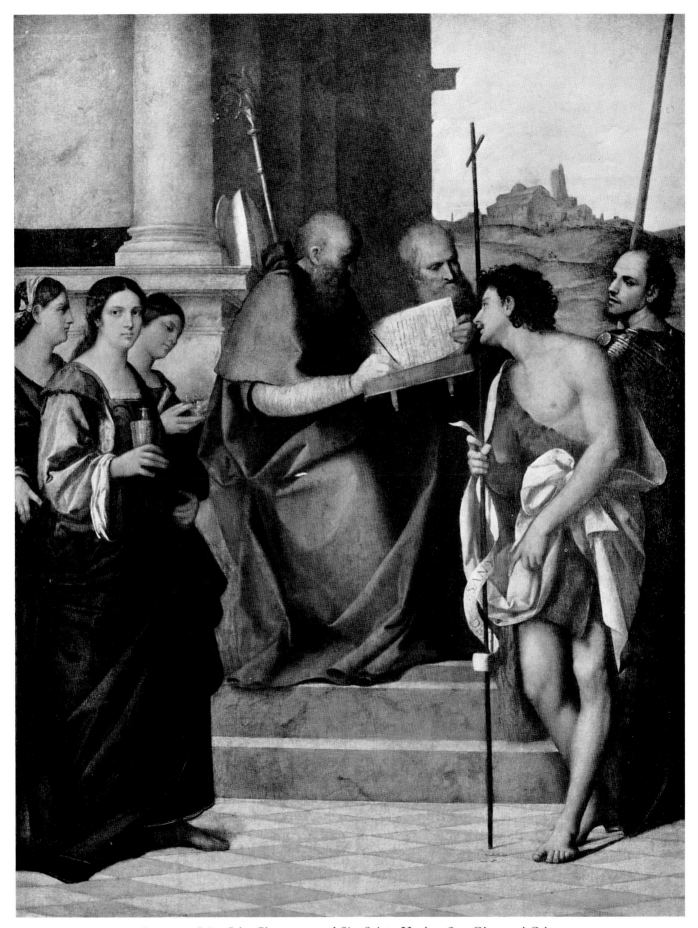

193. SEBASTIANO DEL PIOMBO: *Saint John Chrysostom and Six Saints*. Venice, San Giovanni Crisostomo

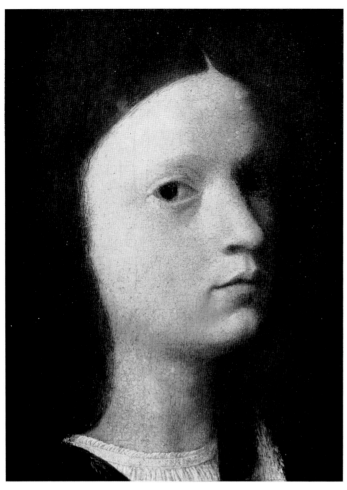

194. SEBASTIANO DEL PIOMBO: Detail from Plate 195

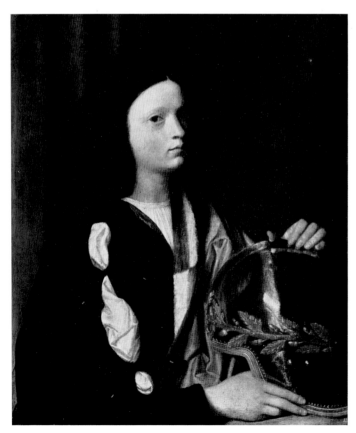

195. SEBASTIANO DEL PIOMBO: *Portrait of a Young Boy with a Helmet*. Vienna, Kunsthistorisches Museum

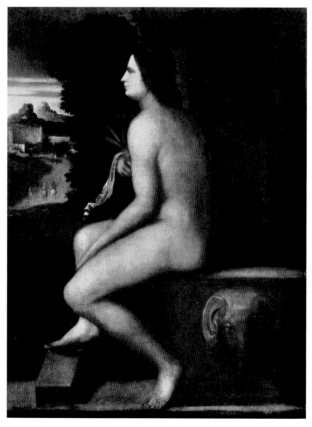

196. SEBASTIANO DEL PIOMBO: *Ceres*. Berlin-Dahlem, Staatliche Museen

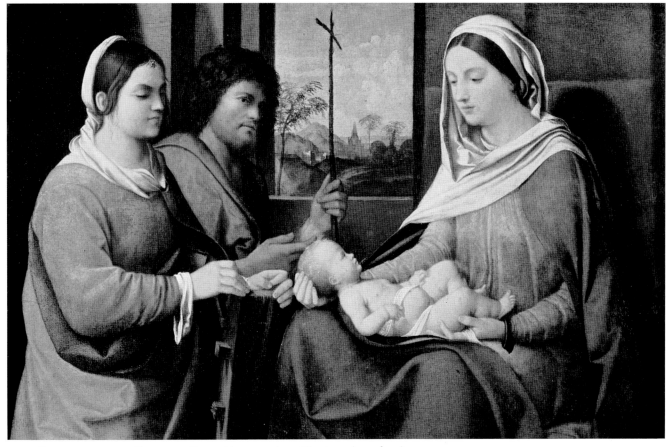

197. SEBASTIANO DEL PIOMBO: *Sacra Conversazione*. Venice, Accademia

198. Detail from Plate 197

199. SEBASTIANO DEL PIOMBO: Detail from *The Holy Family*.
Paris, Louvre

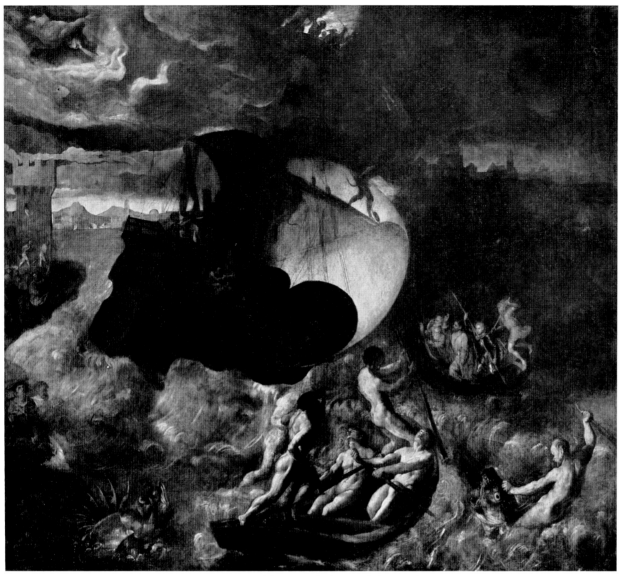

200. Jacopo Palma: *Storm at Sea*. Venice, Biblioteca dell'Ospedale Civile

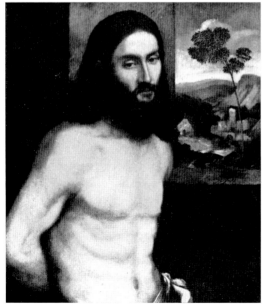

201. Jacopo Palma: *Ecce Homo*. Formerly
London, Private collection

202. Jacopo Palma: *Idyll*. Compton Wynyates,
Warwickshire, Collection of the Marquess
of Northampton

203. JACOPO PALMA: *Triple Portrait*. Detroit, Institute of Arts

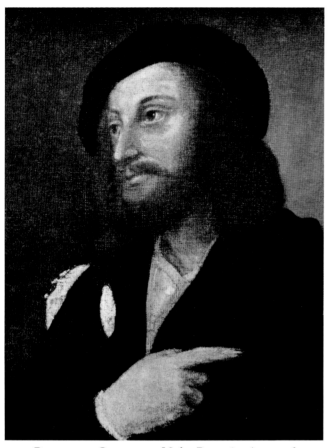

204. GIOVANNI CARIANI: *Male Portrait*. Amsterdam, Rijksmuseum

205. FOLLOWER OF GIORGIONE: *Portrait of Matteo Costanzo*. New York, Private collection

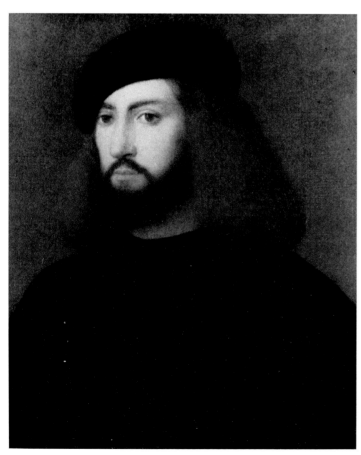

206. BERNARDINO LICINIO (?): *Portrait of Consigliere Bevilacqua*. Paris, Private collection

207. BERNARDINO LICINIO (?): *Portrait of a Lady*. Rome, Borghese Gallery

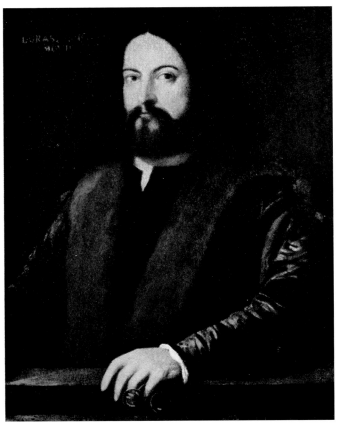

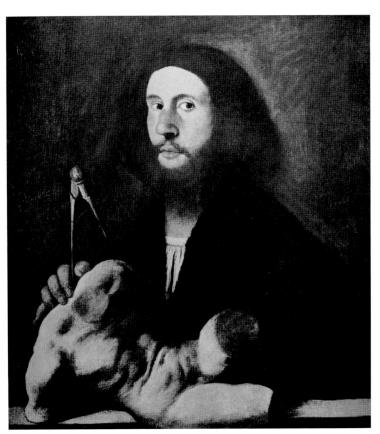

208. GIOVANNI CARIANI (?): *Portrait of L. Crasso.* Formerly London, Private collection

209. GIOVANNI CARIANI: *Portrait of an Antique Collector.* Formerly Bowood, Wiltshire, Collection of the Marquess of Lansdowne

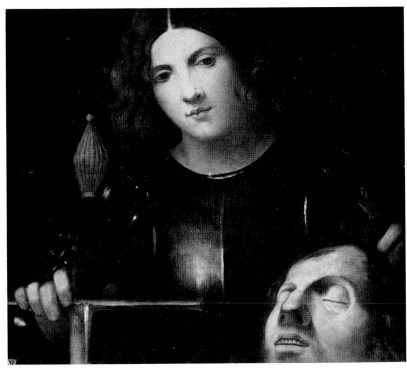

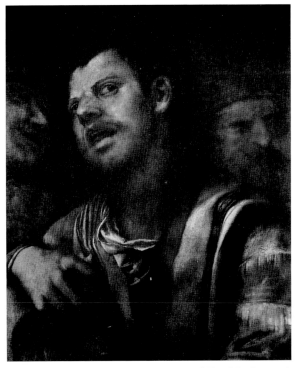

210. FOLLOWER OF GIORGIONE: *David with the Head of Goliath.* Vienna, Kunsthistorisches Museum

211. FOLLOWER OF GIORGIONE: *The Mocking of Samson.* Milan, Mattioli Collection

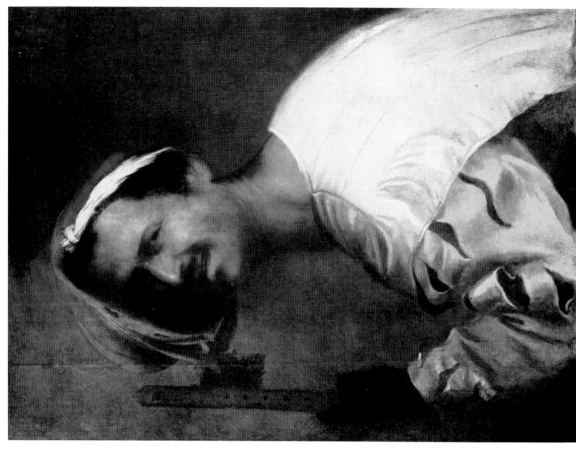

213. FOLLOWER OF GIORGIONE: *A Singer*. Rome, Borghese Gallery

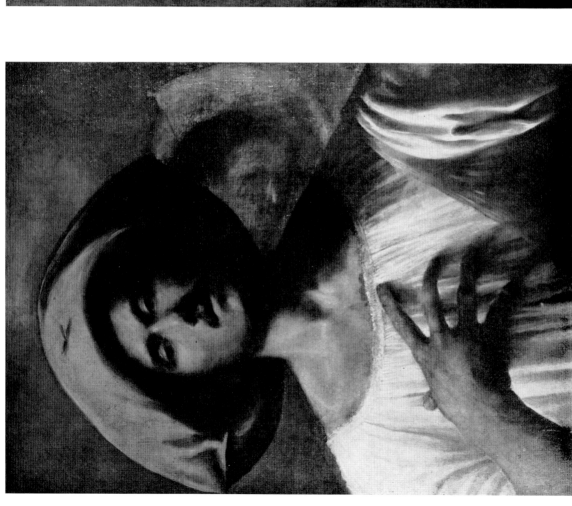

212. FOLLOWER OF GIORGIONE: *The Impassioned Singer*. Rome, Borghese Gallery

COPIES AND
OTHER RELATED WORKS

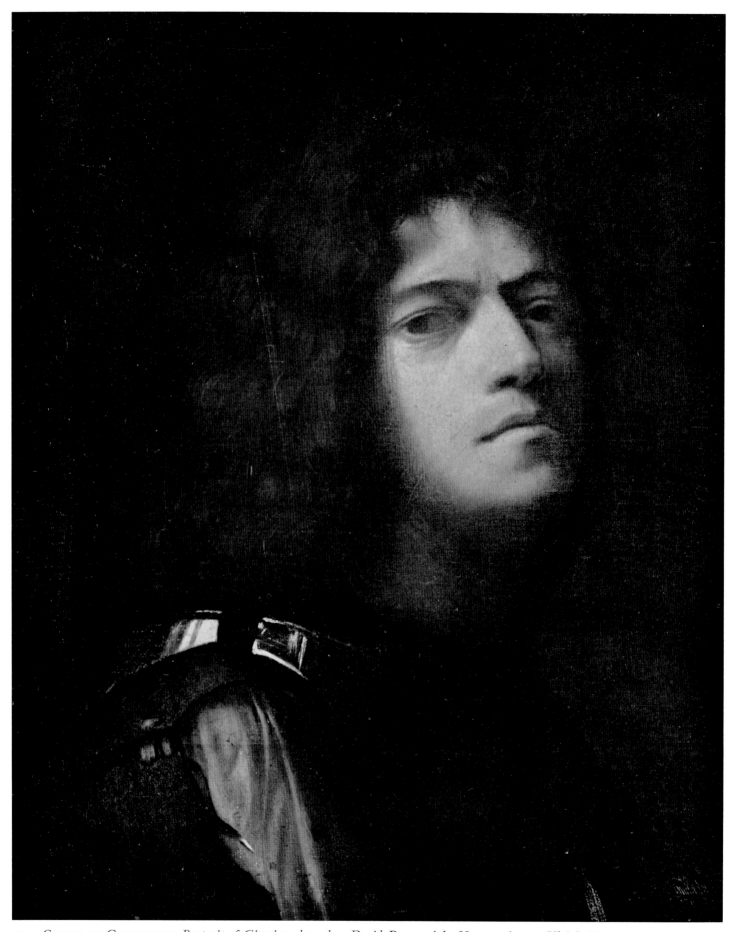

214. CIRCLE OF GIORGIONE: *Portrait of Giorgione dressed as David*. Brunswick, Herzog Anton Ulrich Museum

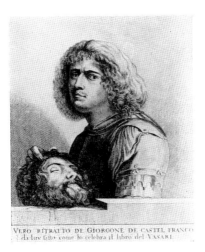

215. CORIOLANO: Engraving of the *Portrait of Giorgione*. From Vasari, 1568

216. WENCESLAUS HOLLAR: Engraving of the *Portrait of Giorgione*. 1650

217. X-ray of the *Portrait of Giorgione* in Brunswick (Plate 214)

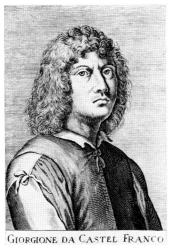

218. Engraving of the *Portrait of Giorgione*. From Ridolfi, 1648.

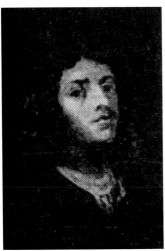

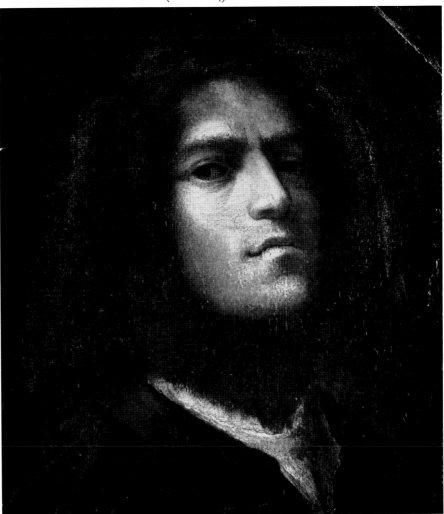

219. DAVID TENIERS THE YOUNGER: Copy of the *Portrait of Giorgione* in Budapest. About 1660

220. CIRCLE OF GIORGIONE: *Portrait of Giorgione*. Budapest, Museum of Fine Arts

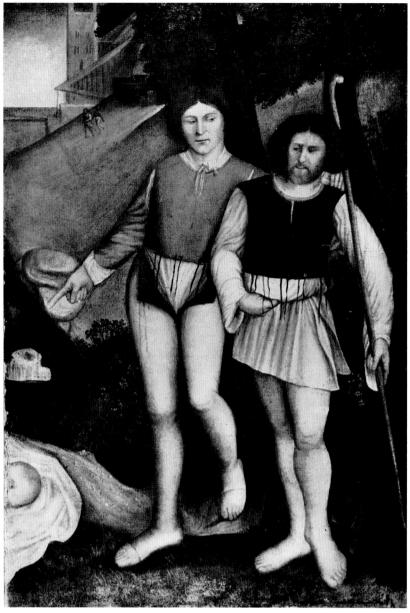

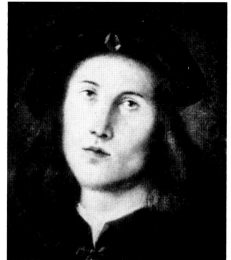

222. STYLE OF LORENZO LOTTO:
Portrait of a Young Man.
Formerly Florence,
Koudacheff Collection

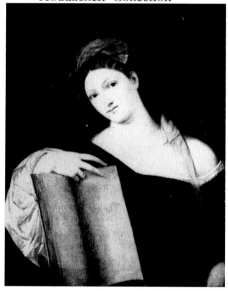

221. CIRCLE OF GIORGIONE: Fragment from *The Finding of Paris.*
Budapest, Museum of Fine Arts

223. STYLE OF JACOPO PALMA:
The Delphic Sibyl. Formerly
Marostica, Sorio Collection

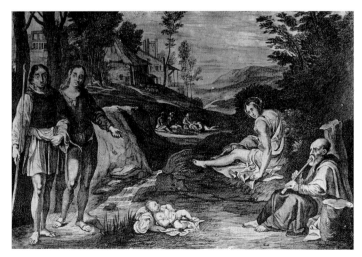

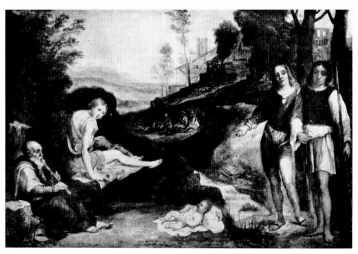

225. DAVID TENIERS THE YOUNGER: Copy of *The Fin-
ding of Paris.* Formerly Florence, Loeser Collection

224. DAVID TENIERS THE YOUNGER: Engraving of *The
Finding of Paris.* 1658

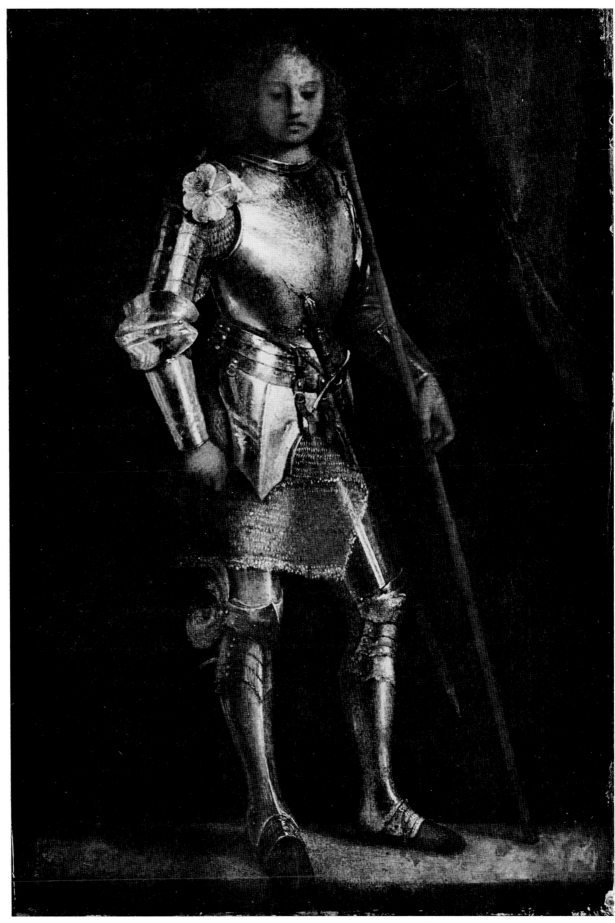

226. FOLLOWER OF GIORGIONE: *A Man in Armour*. London, National Gallery

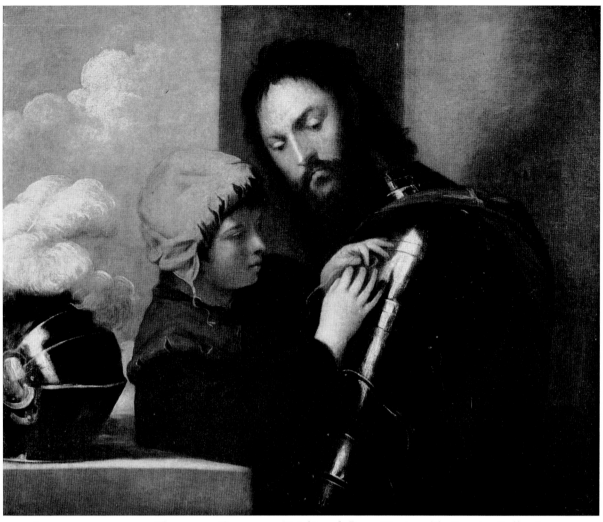

227. SIXTEENTH-CENTURY VENETIAN PAINTER: *Knight and Page*. Venice, T. Spanio Collection

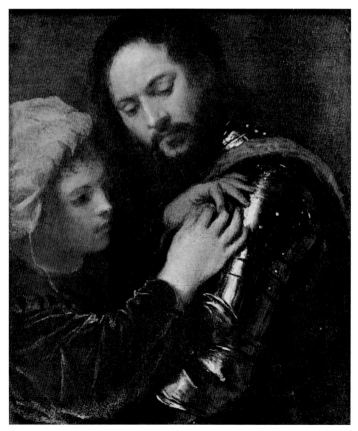

228. SIXTEENTH-CENTURY VENETIAN PAINTER: *Knight and Page*. Castle Howard, Howard Collection

229. STYLE OF JACOPO PALMA: *Portrait of a Young Lady*. Washington, Howard University (Kress Collection)

230. STYLE OF JACOPO PALMA: *Portrait of a Young Man in a Fur*. Leningrad, Hermitage

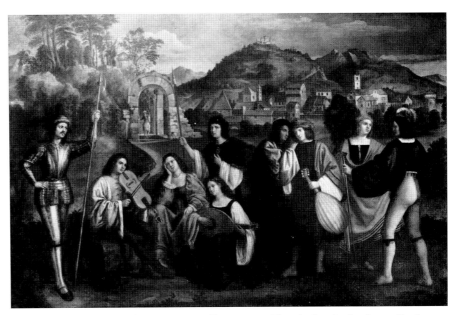

231. FOLLOWER OF GIORGIONE: *Concert outside Asolo*. Attingham Park, National Trust

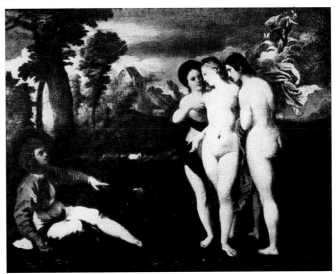

232. FOLLOWER OF TITIAN: *Judgement of Paris*. Chiavari, Lanfranchi Collection

233. FOLLOWER OF GIORGIONE: *The Adoration of the Holy Child*. Leningrad, Hermitage

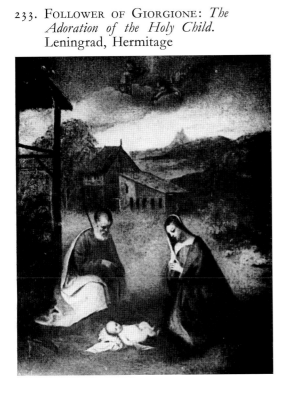

234. SIXTEENTH-CENTURY VENETIAN PAINTER: *The Astrologer*. Formerly Dresden, Gemäldegalerie

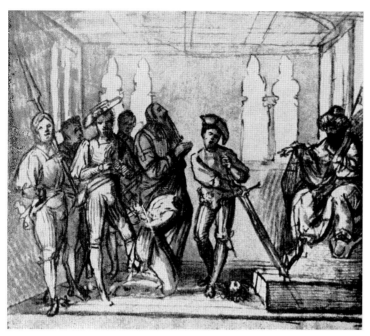

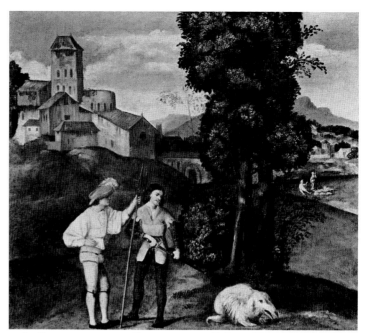

235. STYLE OF GIULIO ROMANO: *Martyrdom of a Saint*. Chatsworth, Devonshire Collection

236. FOLLOWER OF GIORGIONE: *Saint George and the Dragon*. Formerly Philadelphia, McIlhenny Collection

237. GIULIO CAMPAGNOLA: *The Violinist*. Paris, Ecole des Beaux-Arts

238. SIXTEENTH-CENTURY VENETIAN PAINTER: *The Admonished Lovers*. London, Guy Benson Collection

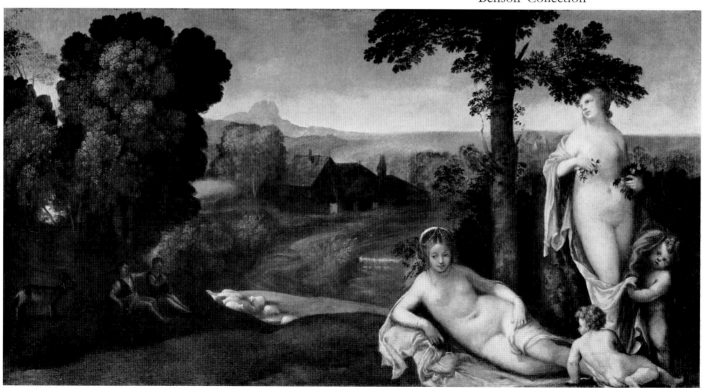

239. SIXTEENTH-CENTURY VENETIAN PAINTER: *Nymphs and Children in a Landscape*. London, National Gallery

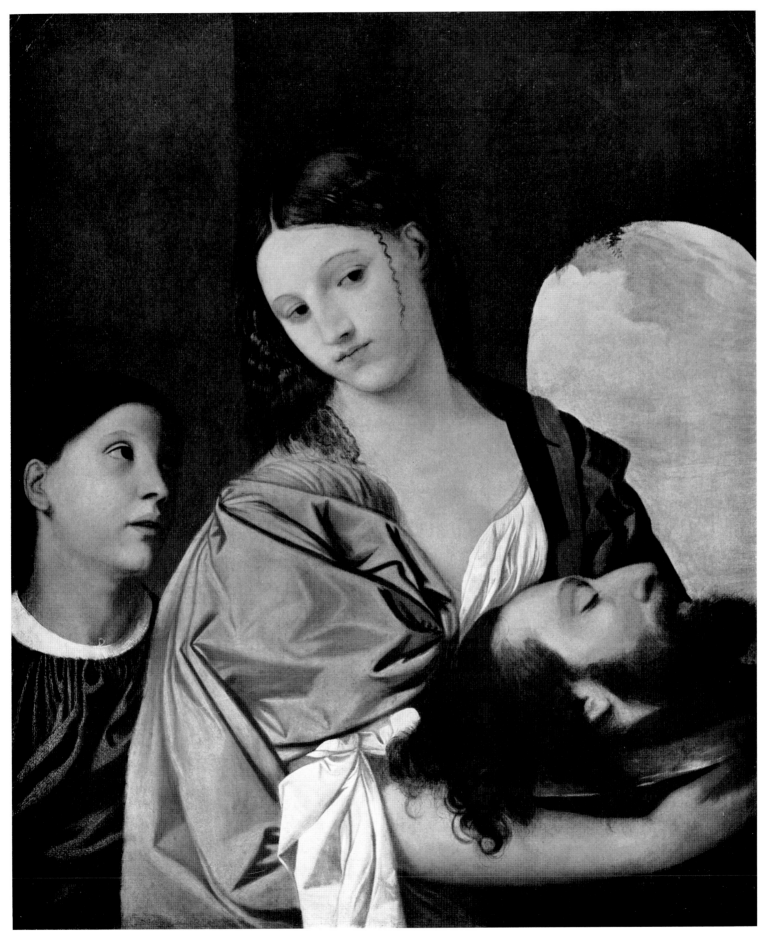

240. TITIAN (?): *Salome*. Formerly London, F.T. Sabin Collection

241. GEROLAMO ROMANINO (?): *Madonna and Child*. New York, Metropolitan Museum of Art

242. FOLLOWER OF PORDENONE: *The Dead Christ*. Treviso, Cassa di Risparmio

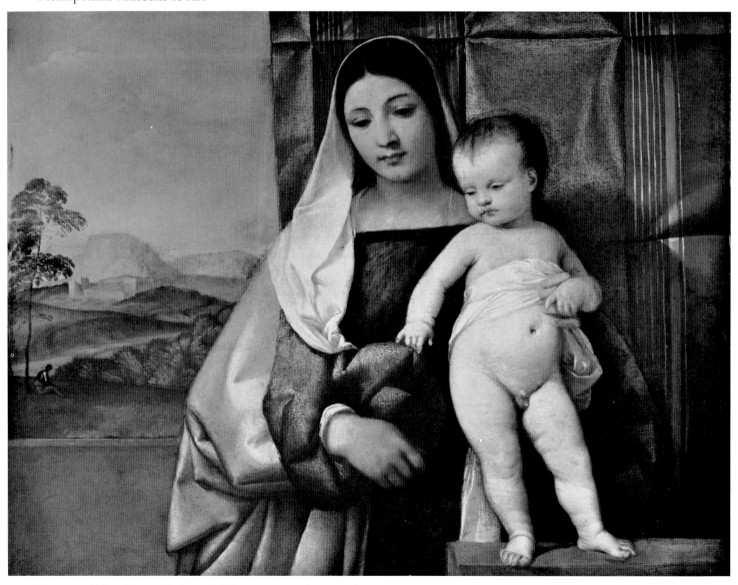

243. TITIAN: '*The Gipsy Madonna*'. Vienna, Kunsthistorisches Museum

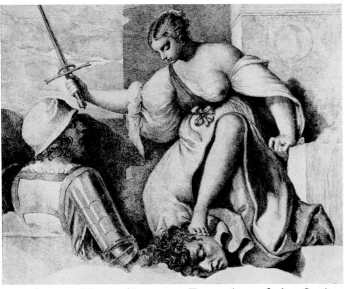

244. ANTON MARIA ZANETTI: Engraving of the *Justice* by Titian

245. TITIAN: *Justice*. Fresco. Venice, Accademia

246. TITIAN: *Frieze of Justice*. Venice, Accademia

247. TITIAN: *The 'Levantine'*. Fresco. Venice, Doge's Palace

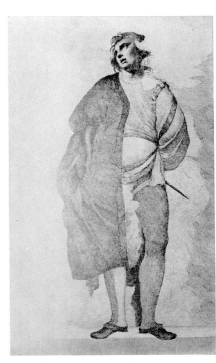

248. ANTON MARIA ZANETTI: Engraving of the *'Compagno della Calza'* (After Titian)

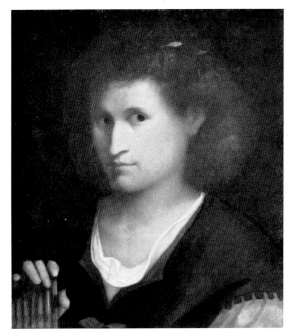

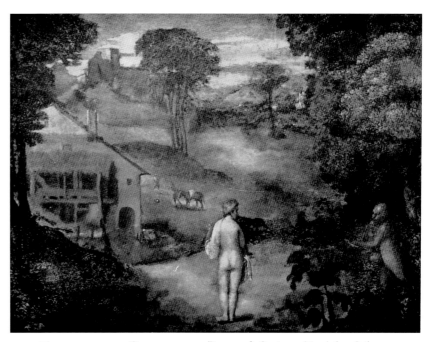

249. JACOPO PALMA: *Portrait of a Young Man*. Zurich, Private collection

250. FOLLOWER OF GIORGIONE: *Pan and Syrinx*. Zurich, Schwyzer Collection

SOURCES OF PHOTOGRAPHS

Plates. AMSTERDAM, Rijksmuseum, 204. BALTIMORE, J.H. Schaefer & Son, 137. BERLIN, Kupferstichkabinett, 54. BOSTON, Isabella Stewart Gardner Museum, 1. BRUNSWICK, Herzog Anton Ulrich-Museum, 129, 217. BUDAPEST, Museum of Fine Arts, 153, 220, 221. CHATSWORTH, Duke of Devonshire, 235. DARMSTADT, Hessisches Landesmuseum, 102. DETROIT, Institute of Art, 203. DRESDEN, Gemäldegalerie, 103, 104. DUBLIN, National Gallery of Ireland, 225. FLORENCE, Foto Alinari, 6, 123, 180, 184. FULLERTON, Norton Simon Museum of Art, 177, 179. HAMPTON COURT, Royal Collection, 48, 110, 130. KINGSTON LACY, Ralph Bankes Coll., 190. LENINGRAD, Hermitage, 12, 13, 49, 230, 233. LONDON, Courtauld Institute of Art, 173; National Gallery, 22, 24, 47, 99, 100, 122, 141, 167, 171, 226, 239; Frank T. Sabin, 240. LAUSANNE, Stroelin Collection, 166. MADRID, Prado, 219. NEW HAVEN, Yale University, 174. NEW YORK, Metropolitan Museum, 178, 188, 241; Schwarz Collection, 147. NÜRNBERG, Germanisches Nationalmuseum, 7, 30. OTTAWA, The National Gallery of Canada, 3. OXFORD, Christ Church, 98. PARIS, Louvre, 192. ROME, Foto Anderson, 154; Galleria Borghese, 207. ROTTERDAM, Museum Boymans-van Beuningen, 53 SAN DIEGO, Fine Arts Gallery, n. 109. TOLEDO, The Toledo Museum of Art, 2. TREVISO, Fini, 15. VENICE, A.F.I., 33, 75, 128, 144, 183, 186, 200, 227, 236; Fondazione G. Cini, 26, 31, 39, 46, 51, 55, 57, 58, 59, 60, 61, 62, 63, 64, 65, 66, 67, 68, 69, 70, 71, 72, 73, 76, 77, 78, 79, 80, 81, 82, 92, 94, 95, 97, 112, 113, 114, 124, 126, 135, 138, 139, 143, 149, 151, 156, 160, 161, 163, 164, 181, 182, 187, 189, 194, 202, 205, 211, 213, 224, 231, 237, 248, 249, 250; Foto Bohm, 16, 52, 56, 117, 125, 155, 157, 159, 170, 175, 176, 185, 228; Foto Ferruzzi, 21, 25, 28, 29, 32, 34, 83, 84, 85, 111, 115, 116, 136, 142, 162, 165, 172, 193, 197, 198, 199, 212, 214, 242; Foto Giacomelli, 19; Archivio Fotografico Museo Correr, 23, 96, 104, 196, 215, 216, 218, 234, 244; Soprintendenza alle Gallerie, 14, 18, 27, 50, 74, 121, 158, 245, 246; Soprintendenza ai Monumenti, 247. VIENNA, Albertina, 145; Kunsthistorisches Museum, 44, 45, 87, 88, 89, 90, 91, 93, 106, 127, 152, 195, 210, 243. WASHINGTON, Howard University, 229; National Gallery of Art, 8, 9, 10, 11, 35, 36, 37, 38, 40, 41, 42, 43, 119, 120, 140. WINDSOR, Royal Library, 146. OWNERS, 4, 5, 107, 108, 131, 132, 133, 134, 148, 150, 191, 201, 206, 208, 209, 222, 223, 232, 238.

Figures. BUDAPEST, Museum of Fine Arts, fig. 37. CHICAGO, The Art Institute, fig. 53. DUBLIN, National Gallery of Ireland, fig. 26. FLORENCE, Foto Alinari, figs. 13, 20. LONDON, British Museum, figs. 59, 60, 61, 62, 63, 64, 65, 66, 67, 68, 69, 70, 71, 72, 73. LUGANO, Foto Brunel, fig. 35. MADRID, Prado, fig. 14. SALZBURG, Universitäts Bibliothek, fig. 57. SAN DIEGO, Fine Arts Gallery, fig. 31. VENICE, A.F.I., fig. 15; Fondazione G. Cini, figs. 25, 40, 41, 42, 43, 44, 45, 46, 47, 48, 49, 50, 52, 54, 77; Foto Bohm, figs. 9, 11, 12, 30; Foto Ferruzzi, figs. 37, 38, 39, 56; Archivio Fotografico Museo Correr, figs. 1, 2, 3, 4, 5, 6, 7, 10, 15, 19, 20, 22, 23, 24, 34, 35, 58, 75, 76, 78, 79, 80, 81; Soprintendenza alle Gallerie, figs. 16, 18, 27, 28, 29. VIENNA, Kunsthistorisches Museum, figs. 17, 33. WASHINGTON, National Gallery of Art, figs. 7, 36.

Colour plates. MILAN, Claudio Emmer, plates IV, VI, VII, XI, XII, XXI, XXII; OWNERS, I, II, III, V, VIII, IX, X, XIII, XIV, XV, XVI, XVII, XVIII, XIX, XX, XXIII, XXIV.

INDEX OF NAMES

INDEX OF COLLECTIONS

Lost Works are not included in this index. They are listed on pages 155-162 in alphabetical order of location.